A WORLD OF ART

HENRY M. SAYRE

PRENTICE HALL Englewood Cliffs, New Jersey 07632

Library of Congress Cataloging-in-Publication Data

Sayre, Henry M.
 A world of art / Henry M. Sayre.
 p. cm.
 Includes index.
 ISBN 0-13-953845-3
 1. Arts. I. Title
NX620.S28 1994
700 ' . 1--dc20

93-33241
CIP

Editorial/production supervision: Jordan Ochs
Acquisitions editor: Bud Therien
Editorial assistant: Kathy Shawhan
Copyeditor: Steve Hopkins
Manufacturing coordinator: Robert Anderson
Photo editor: Lorinda Morris-Nantz
Photo research: Joelle Burrows
Interior design: Danielle Fagan
Cover design: Thomas Nery
Cover art (Clockwise from top of front cover):

 Toyokuni, *First Meeting in Snow*, 1809 (triptych).
 Woodblock print, 14 1/2 x 29 in. Courtesy Ronin Gallery, New York.
 Photograph by David Plakke.

 Christo, *The Umbrellas: Japan-U.S.A.*, 1984-91.
 ©Christo, 1991. Photography by the author.

 Gustave Caillebotte, *Place de l'Europe on a Rainy Day*, 1877.
 Oil on canvas, 83 1/2 x 108 3/4 in. Charles H. and Mary F.S. Worcester Collection, 1964.336.
 Photograph ©1993, The Art Institute of Chicago. All rights reserved.

 Christo, *The Umbrellas: Japan-U.S.A.*, 1984-91.
 Ibaraki, Japan site. ©Christo, 1991.

 Chou Yu Dong (Joe Earthstone), *Meditation Wild Lily*, 1990.
 Oil on canvas, 72 3/4 x 102 3/8 in. Courtesy of the artist.

For my boys, Rob and John, and for Sandy

 ©1994 by Prentice-Hall, Inc.
A Paramount Communications Company
Englewood Cliffs, New Jersey 07632

Printed in the United States of America
10 9 8 7 6 5 4 3 2 1

ISBN 0-13-953845-3

Prentice-Hall International (UK) Limited, *London*
Prentice-Hall of Australia Pty. Limited, *Sydney*
Prentice-Hall Canada Inc., *Toronto*
Prentice-Hall Hispanoamericana, S.A., *Mexico*
Prentice-Hall of India Private Limited, *New Delhi*
Prentice-Hall of Japan, Inc., *Tokyo*
Simon & Schuster Asia Pte. Ltd., *Singapore*
Editora Prentice-Hall do Brasil, Ltda., *Rio de Janeiro*

The cover of this book was conceived as a collage of umbrellas representing "a world of art." On the front and back covers are photographs of Christo's *The Umbrellas, Japan—U.S.A.*, a contemporary work bridging two cultures, East and West. Below them, wrapping around the spine of the book is Gustave Caillebotte's 1877 view of Paris, *Place de l'Europe on a Rainy Day*. Above the Christo on the front cover is Toyokuni's, *First Meeting in Snow*, a 19th-century Japanese print. And above the Christo on the back cover is a detail from the painting *Meditation Wild Lily* by the contemporary Chinese artist Chou Yu Dong. The umbrella is an image of shelter and protection; for all the diversity of its appearances, it is, therefore, a symbol of community life.

CONTENTS

PART I
THE VISUAL WORLD

UNDERSTANDING THE ART YOU SEE

PART II
THE FORMAL ELEMENTS AND THEIR DESIGN

DESCRIBING THE ART YOU SEE

PART III
THE FINE ARTS MEDIA

LEARNING HOW ART IS MADE

PART IV
THE VISUAL ARTS IN EVERYDAY LIFE
RECOGNIZING THE ART OF DESIGN

PART V
THE VISUAL RECORD
PLACING THE ARTS IN HISTORICAL CONTEXT

P R E F A C E

This book was written out of a felt need. I have been teaching the basic course introducing students to art as a discipline and practice ever since I first came to Oregon State University nearly a decade ago. It is a course I enjoy teaching, despite the vast numbers of students who populate it, because even in their anonymity, in the darkness of a large lecture hall illuminated only by the slide on the screen, I can sense their excitement. Sometimes, when I'm teaching color theory, or explaining a purposeful violation of perspective, or when I analyze a favorite painting, like David's *Brutus and the Lictors*, I feel like a magician. I can hear their oohs and ahhs, and I know that I've brought them something of the joy I feel before great art.

I have been, over the years, more or less happy with the books I have used, but as the aims and directions of American higher education have shifted over the last decade, I have become increasingly less satisfied. As we approach the 21st century, our mission, it seems to me, has changed, and our courses and our texts must change as well.

We live in a multicultural world. Our own nation is itself increasingly multicultural in character. We, in art departments, tend to forget that. How can we teach the art of other cultures, many of my colleagues ask, when our students don't even understand their own? And just what, I ask my colleagues in reply, is our students' culture? Is it, in fact, the great tradition of Western art that is narrated in Janson, Gardner, and Hartt? How many of our students are alienated from that tradition? The answer, of course, is a great many.

Furthermore, like many of my colleagues, I have become sensitized, as a teacher and historian, to the ways in which traditional art history has systematically excluded certain works and traditions from the "master" narrative. Over the last twenty years, we have witnessed the "admission" of works by women and black Americans into the canon. Over the last four or five years especially, their representation in the basic art texts and histories has dramatically increased. But even if we have begun to admit the works of people marginalized from our own culture into the mainstream, there is still much to do, much left for us to begin to see. I think it is safe to say that we remain blind to much that composes the world of art.

For instance, this past year I co-curated, with Western historian William G. Robbins, an exhibition on the occasion of the 150th anniversary of the Oregon Trail

at the Maryhill Museum on the Columbia River in Washington. Our aim was to expose some of the myths upon which the westward migration was based, myths that we continue to accept without question to the present day. My fellow curator came up with what I think to be a perfect example of the situation we find ourselves in. In the endless string of articles celebrating the western migration in the mass media, he discovered the following more or less "straight" set of facts: "The population of California in 1848 was 10,000. Forty-three years later it was 1.2 million." What the writer has, of course, forgotten, is that California's Native American population in 1848 was approximately 150,000. It takes little imagination to guess what happened to that apparently invisible population over the next forty-three years. To my mind, this is the kind of "oversight" that we must no longer allow ourselves. Much more is at risk that the mere distortion of history.

I feel, in other words, the need to teach art, from the earliest moment, from a perspective broader than most teachers—including myself—are either used to or trained for. That said, I also believe that we can take advantage of our training, however monocular and ethnocentric it may be. This book is designed around the cornerstones of the Western tradition. I have not forsaken it, nor do I believe that we should or must. It is, after all, what most of us are best equipped to explain and discuss. But I am convinced that by not comparing our tradition to others, we are unable to see how special, how unique it is in many of its assumptions. In comparing works of art from our own tradition to work from other traditions, I do not believe that we lose anything. Rather we gain a better sense of who we are and what we are about. And we are better equipped as people to recognize not only our achievements but our shortcomings.

There are many other things I have tried to do in this book to make it more suited to the changing educational environment. I have, in my choice of illustrations, tried to balance traditional works of art with work that is, to most audiences, unknown. I have tried to create, within each chapter and sub-chapter, a number of discussions around a coherent set of images or themes. I have tried to emphasize the social context and historical fabric out of which the art in question developed. Most of all I want this book to celebrate difference, the diversity of our cultural accomplishments. I hope it inspires confidence in our individual ways of seeing at the same time that it instills humility about our limitations. I hope its readers—teachers as well as students—will want to go on to explore in greater detail the many sides of a world of art that we have for too long ignored.

Acknowledgments

There is one other aspect of this book that will not be immediately evident to the reader but that has been fundamental to its creation. I cannot imagine a more collaborative venture. I owe much to the dedicated professionals who read this text in manuscript form. Though they could not have caught all my mistakes, without their help I would have made many, many more errors, in both tone and substance, than I have. Let me thank, particularly, Frederick J. Zimmerman, S.U.N.Y. College at Cortland; Pamela Awana Lee, Washington State University; Christie Nuell, Middle Tennessee State University; Dr. Marilyn Wyman, San Jose State University; William Disbro, Jamestown Community College; Frank La Pena, California State

University–Sacramento; Dr. William T. Squires, University of Georgia; Lily R. Mazurek Minassian, Broward Community College; Roy V. Schoenborn, Southeast Missouri State University; David J. Stanley, University of Florida; and Eugene M. Hood, Jr., University of Wisconsin–Eau Claire.

I suppose that without a sabbatical leave from Oregon State University, I would have one day finished this book, but I cannot imagine when. I want to thank both President John V. Byrne and the Dean of the College of Liberal Arts, Bill Wilkins, not only specifically for granting me my sabbatical, but for supporting the arts at OSU in general. They have created, in what some would think an unlikely place, an environment that encourages projects such as mine to thrive. It is not an exaggeration to say that under their stewardship, OSU is fast becoming known as a center of excellence in the arts. The Department of Art at OSU, under the leadership of my good friend and colleague David Hardesty, has, I think, led the way. To my colleagues in the department, all of whom at one point or another contributed their expertise to this book, my thanks (and to those who sacrificed the faculty computer lab to me—almost lock, stock, and barrel by the end—my even greater gratitude). But most of all, I have to thank David. No one could ask for a better Chair, one more responsive to the needs of his faculty. This book could not have been written without his encouragement, support, and, perhaps most of all, his vision. Quite simply, David's drive for excellence is infectious and exhilarating, and I hope this book reflects that.

Teaching art appreciation at OSU has fallen, over the years, to three of us—myself, Berk Chappell, and John Maul—and to both Berk and John this book owes a debt of considerable proportion. Both are men of considerable wit, and more than once their wit has been my solace. Berk's example—both the extraordinary range of his knowledge and his absolute dedication to his students—has served as a model for me, and his thinking is reflected particularly in the structure and shape this book takes. John has been an extraordinary resource for me. He knows the art appreciation field as well as anyone. He knows, almost instinctively, I think, what will work with students and what won't. He has read this manuscript cover to cover, over and over again. And, most importantly, he has written the Instructor's Resource Manual that accompanies it. I do not think there is a better Resource Manual in the field. Thanks also to Lisa Thorpe, my student assistant, without whom I might never have finished the index.

From the very first day I began writing, I did so with my designer, Danielle Fagan, at my side. As I wrote, Denny designed what I wrote, and I owe much of what this book is to her. The result, we both hope, is not only a visually appealing text, but one that makes visual sense as well. In fact, Denny's acute feeling for the visual sense of things time and again led me to make better sense in my discussion of them. As often as humanly possible, we have kept illustrations on the same or facing page as the discussion about them. We are particularly proud of the running time line that makes up the last section of the book. It is meant to be a visual chronicle as much as a written one, and we hope students will come to browse through it just for the pleasure of seeing. For the quality of the reproductions, however, I owe everything to my picture researcher, Joelle Burrows. If I had to have a reproduction, Joelle found it, sometimes against the longest odds. No substitute

she offered me ever required me to compromise quality or substance. In fact, many, many times, she discovered better images than I knew existed, and the book is far better for them. In short, I cannot imagine working with two people—Denny and Joelle—so sensitive to my own aims and needs as an author, and so willing to sacrifice of their own time and energy to help me. To you both, my endless thanks.

The people at Prentice Hall, Inc. have been especially wonderful to work with. Let me thank, in particular, my local and regional sales reps, Steve DeLancy, Sally McPherson, and Kevin Johnson, the latter of whom suggested I do this book in the first place. Jordan Ochs has overseen every trying detail of the book's production. But to Norwell "Bud" Therien, my editor at Prentice Hall, I owe more than the routine thank you. Without his initial enthusiasm, I would never have undertaken the project. Every caution or counsel he offered along the way went directly to the heart of the matter. Still, what I most deeply appreciate is his willingness to let me and the people working with me create the book we wanted. I cannot imagine anyone has ever been given more freedom, on a project this large, than Bud gave us. I feel this one's really our baby, and for all its newborn wrinkles, I am grateful that Bud had the confidence in us to allow it to be so thoroughly our own.

Finally, I owe the most to my wife, Sandy, and my boys, Rob and John. It has sometimes seemed, I know, that there was nothing other than the book. But the book, always, was for you.

Henry Sayre
Oregon State University
August 1993

THE NEW YORK TIMES PROGRAM

 THE NEW YORK TIMES and **PRENTICE HALL** are sponsoring **THEMES OF THE TIMES**: a program designed to enhance student access to current information of relevance in the classroom.

Through this program, the core subject matter provided in the text is supplemented by a collection of time-sensitive articles from one of the world's most distinguished newspapers, **THE NEW YORK TIMES**. These articles demonstrate the vital, ongoing connection between what is learned in the classroom and what is happening in the world around us.

To enjoy the wealth of information of **THE NEW YORK TIMES** daily, a reduced subscription rate is available. For information, call toll free: 1-800-631-1222.

PRENTICE HALL and **THE NEW YORK TIMES** are proud to co-sponsor **THEMES OF THE TIMES**. We hope it will make the reading of both textbooks and newspapers a more dynamic, involving process.

Photo Credits

Alinari/Art Resource: 26, 89, 103, 339, 487, 526, 532, 535, 542, 543, 545, 566, 580, 583, 584, 594, 611, 620
American Museum of Natural History: 505
AP/Wide World Photos: 322, 473
Arch. Phot. Paris/S.P.A.D.E.M.: 563
ARS: 34, 50, 51, 120, 161, 225
Artothek: 621
Art Resource: 141, 200
Asian Art & Archaeology/Art Resource: 268
Bildarchiv Preussischer Kulturbesitz: 517, 639
Boltin Picture Library: 519
Bridgeman/Art Resource: 341, 552, 553, 554, 609, 641
Bridgeman/John Bethell/Art Resource: 496
British Tourist Authority: 508
Joelle Burrows: 481
Canali Photobank: 478, 480, 547
A. C. Champagne: 577
Chicago Convention and Tourism Bureau: 404
C.N.M.H.S./ S.P.A.D.E.M.: 570
Gary Cralle/Image Bank: 500
Tim Davis/Photo Researchers: 475
John Deeks/Photo Researchers: 476
Werner Forman/Art Resource: 518, 565, 608
Four By Five/Superstock: 539
French Government Tourist Office: 557
Giraudon/Art Resource: 11, 32, 41, 84, 193, 199, 202, 204, 205, 214, 237, 301, 531, 560, 572, 578, 579, 581, 598, 625, 627, 628, 632, 636, 643, 646, 651, 668
Robert Harding Picture Library, London: 472
D.A. Harissiadis, Athens: 217
Hirmer Fotoarchive: 290, 474, 511, 513, 515 a/b, 516, 529
George Holton/Photo Researchers: 295, 567, 568
Italian Government Travel Office: 482
An Keren/PPS: 538
Kobal Collection/Superstock: 184
Kobal Collection Ltd., London: 185
Erich Lessing/Art Resource: 23, 29, 44, 90, 93, 128, 206, 540, 548, 551, 587, 596, 658
Magnum Photos: 43
Marburg/Art Resource: 304, 338, 345, 390, 417, 555, 556, 559, 561, 562, 564, 574, 600, 618
Rafael Marcia/Photo Researchers: 495
James Mellaart, London: 507
Jan Moline/Photo Researchers: 441
The National Trust Waddesdon Manor/Art Resource: 631
Nimatallah/Art Resource: 116, 334, 520
Oriental Institute, The University of Chicago: 510

Osaka Municipal Museum of Fine Arts/PPS: 590
Steve Proehl/Image Bank: 497
Reunion des musees nationaux: 86
Roger-Viollet, Paris: 179, 411
George Roos/Art Resource: 123
Scala/Art Resource, New York: 10, 64, 127, 131, 154, 203, 286, 291, 292, 293, 294, 296, 298, 416, 484, 486, 522, 534, 536, 546, 576, 582, 585, 586, 592, 595, 597, 601, 602, 603, 612, 613, 616, 617, 619, 622, 629, 635, 638, 642, 644, 652
Bob Schalkwiji/AMI/Art Resource: 309
Schles/Art Resource: 401
Edwin Smith: 575
G. E. Kidder Smith: 550
Standard Oil Co. (NJ): 571
Superstock: 3, 30, 31, 59, 126, 231, 514, 610
Gary Tartakov, University of Iowa, Ames: 489
Tate Gallery, London/Art Resource: 129, 142, 143, 350, 688
Vanni/Art Resource: 512, 525, 607
The Vatican Museums: 530
M.E. Warren/Photo Researchers: 229

PART I
THE VISUAL WORLD
Understanding the Art You See

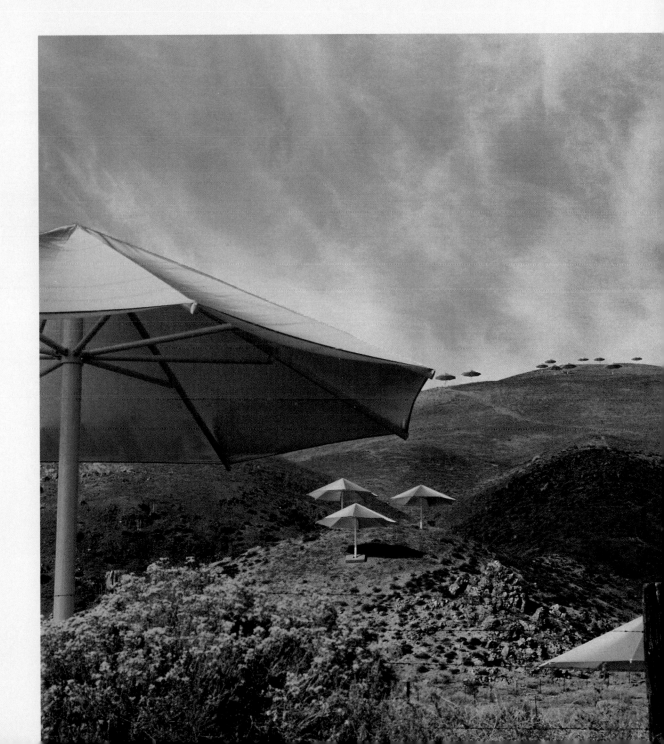

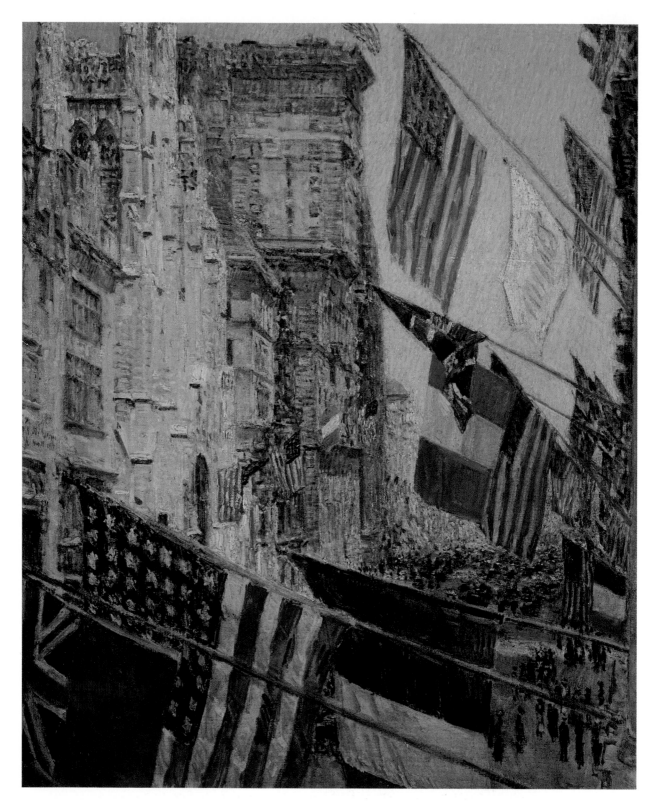

Fig. 1 Childe Hassam, *Allies Day, May 1917*, 1917. Oil on canvas, 36 3/4 × 30 1/4 in. © 1992 National Gallery of Art, Washington, D.C. Gift of Ethelyn McKinney in memory of her brother, Glenn Ford McKinney.

1 VISUAL EXPERIENCE

Many of us assume, almost without question, that we can trust in the reality of whatever we can see. Seeing, as they say, is believing. Our word "idea" derives, in fact, from the Greek word *idein*, meaning "to see," and it is no accident that when we say "I see" we really mean "I understand."

Nevertheless, though the visual dominates our perceptual knowledge of the world around us, it does not follow that we always understand what we see, or more to the point, that any group of us, seeing the same thing, will come to the same understanding of its meaning or significance. Consider the images on the two pages before you. Almost all of us can agree, I think without difficulty, on the subject matter. Both images depict flags. Childe Hassam's *Allies Day, May 1917* (Fig. 1) is patriotic in tone. It celebrates the American entry into World War I, something that the

nation had put off until April 6, 1917, after five American ships had been sunk in a span of nine days. The scene is Fifth Avenue in New York City, viewed from 52nd Street, and the flags decorated the route of the parades on May 9 and 11 held to honor the Allied leaders who had come to New York to consult on strategy.

But if Hassam's painting seems straightforward, Jasper Johns's *Three Flags* (Fig. 2) is, at first sight, a perplexing image. It is constructed out of three progressively smaller canvases that have been bolted to one another, and because the flag undeniably shrinks before your eyes, becoming less grand and physically smaller the closer it gets to you, it seems to many viewers to diminish the very idea of America for which it stands. The flag, in Johns's words, was something "seen but not looked at, not examined." Painted at a time when the nation was obsessed with a patriotism spawned by Senator Joseph McCarthy's

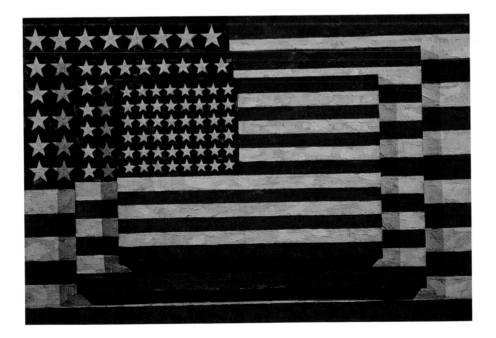

Fig. 2 Jasper Johns, *Three Flags*, 1958. Encaustic on canvas, 30 7/8 × 45 1/2 in. Collection of Whitney Museum of American Art. 50th Anniversary Gift of the Gilman Foundation, Inc., The Lauder Foundation, A. Alfred Taubman, an anonymous donor, and purchaser 80.32.

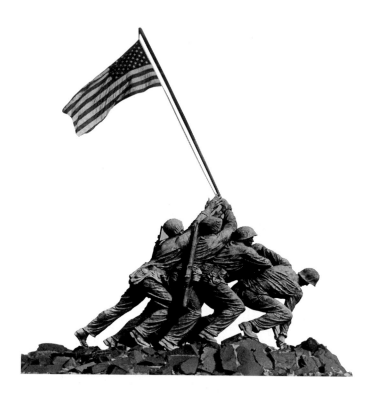

Fig. 3 Felix W. de Weldon, Marine Corps War Memorial, Arlington, Virginia, 1954. Cast bronze, over lifesize.

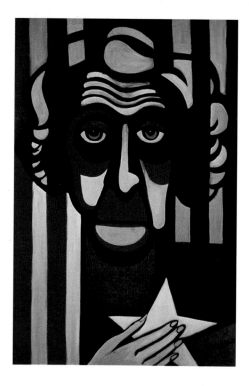

Fig. 4 Faith Ringgold, *God Bless America*, 1964. Oil on canvas, 31 × 19 in. © Faith Ringgold.

anti-Communist hearings in 1954, by President Eisenhower's affirmation of all things American, and by the Soviet Union's challenge of American supremacy, shown clearly by the launching of Sputnik in 1957, Johns's work asks us to consider just what the flag means to us. It asks us to examine our assumptions about ourselves.

However we feel about the Johns painting, however easily we all *read* it as the image of a flag, its *meaning* is not clear. In a book called *The Languages of Art*, Nelson Goodman suggests why. "The eye," he says, "functions not as an instrument self-powered and alone, but as a dutiful member of a complex and capricious organism. Not only how but what it sees is regulated by need and prejudice. It selects, rejects, organizes, discriminates, associates, classi-fies, analyzes, constructs. It does not so much mirror as take and make." There are at least two sets of eyes at issue when we discuss Johns's work: Johns's (what exact ideas influenced him when he chose to paint the flag?) and ours (what needs and prejudices regulate our vision?).

Seeing is both a physical and psycho-logical process. We know that, physically, visual processing can be divided into three steps:

reception→extraction→inference.
First, external stimuli enter the nervous sys-tem through our eyes—"we see the light." Next, the retina, which is a collection of nerve cells at the back of the eye, extracts the basic information it needs and sends this information to the visual cortex. There are approximately 100 million sensors in the retina, but only 5 million channels to the visual cortex. In other words, the retina does a lot of "editing," and so does the visual cortex. There, special mechanisms capable of extracting specific information about such features such as color, motion, orientation, and size "create" what is finally seen.

Seeing, in other words, is physically an inherently creative process. The visual system makes conclusions about the world. It actually "represents" it for you by selecting out information, deciding what is important and what is not. What sort of information, for example, have you visually assimilated about the flag? You know its colors—red, white, and blue—and that it has 50 stars and 13 stripes. You know, roughly, its shape—rectangular. But do you know its proportions? Do you even know, without looking back to the previous page, what color stripe is at the flag's top, or what color is at the bottom? How many short stripes are there, and how many long ones? How many horizontal rows of stars are there? How many long rows? How many short ones? Of course, even looking back at Johns's painting will not help you answer the last three questions, since it was finished before the admission of Hawaii and Alaska to the Union. The point is, not only do we each perceive the same things differently, remembering different details, but also we do not usually take things in visually as thoroughly as we might suppose.

If seeing is a physically creative process, psychologically it is even more so. Needing to draw a flag, for instance, we would concentrate on the kinds of formal details listed in the above paragraph. But the context in which we see a thing has a lot to do with how we see it. Everything we see is filtered through a long history of fears, prejudices, desires, emotions, customs, and beliefs—both our own and the artist's. In the Marine Corps War Memorial (Fig. 3), the flag becomes the symbol not merely of the nation but of freedom itself. In Faith Ringgold's *God Bless America* (Fig. 4), it has been turned into a prison. Painted during the Civil Rights movement, as Martin Luther King, Jr. was delivering the great speeches that mark that era, the star of the flag becomes a sheriff's badge and its

Seeing the French Flag

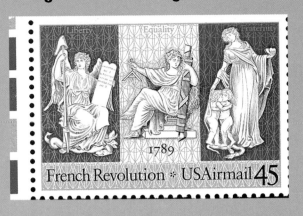

When the U.S. Postal Service issued its 1989 overseas airmail stamp commemorating the bicentennial of the French Revolution, it was accused of seeing the French flag—known as the "Tricolor"—through distinctly American eyes. The colors of the Tricolor are, from the left, blue, white, and red. On the American stamp, however, the colors read in the order of those of the Stars and Stripes—red, white, and blue.

The designer of the stamp, Richard Sheaff of Boston, denied that he had had any intention of representing the French flag. He pointed out that the horizontal and vertical proportions of the stamp do not match those of the Tricolor. Furthermore, though flags are traditionally depicted as if they hang from a pole at their left, it is common enough to see flags from the other side, pole on the right, as, in fact, the Tricolor is displayed in the lower left hand corner of Childe Hassam's *Allies Day, May 1917* (Fig. 1).

Nevertheless, if the U.S. Postal Service could declare its innocence in the matter, others could not. Burger King, for instance, advertised the "French" version of its chicken sandwich throughout the summer of 1989 with a French flag hanging on a pole, reading from the left out, red, white, and blue.

Fig. 5 Richard Sheaff, design for U.S. Postal Service 45¢ stamp, French Bicentennial Commemorative, 1989.

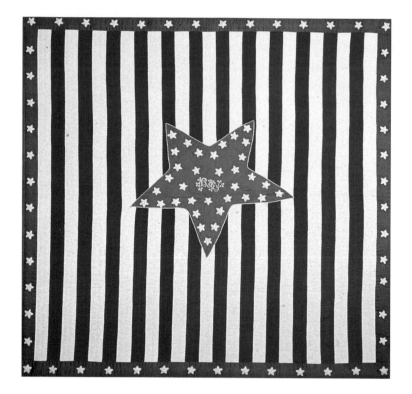

Fig. 6 Artist Unknown, "Baby" Crib Quilt, Kansas, c. 1861. Hand dyed, homespun cotton, 36 7/8 × 36 3/4 in. Collection of the Museum of American Folk Art, New York. Gift of Phyllis Haders. 1978.42.1

red and white stripes are transformed into the black bars of a jail cell. The white woman portrayed in the painting is the very image of contradiction, at once a patriot, pledging allegiance to the flag, and a racist, denying blacks the right to vote. In both these works the artists' intentions are different, and so, potentially, are our reactions to them.

The crib quilt (Fig. 6) was created in Kansas in about the year 1861, and it is a far more complex image than it might at first appear. The blue center star here contains 34 smaller white stars, and in this case we are able to date the quilt because Kansas joined the Union as the 34th state in 1861. The quilt celebrates two "newcomers," Kansas and the baby for whom it was sewn. It might even be said to transform the new state's motto into a parable of birth: "To the Stars Through Difficulty." But it is important to remember that the Kansas of 1861

was a state torn by the Civil War and the issue of slavery. John Brown had attempted to begin a war for the abolition of slavery at Potawatomie in 1856, and five years later the state was forced to choose between joining the Union or the Confederacy. This quilt, then, is a political statement—it could even be called Republican, the party of Lincoln—emphatically asserting the family's position concerning the issue of slavery.

2 VISUAL LITERACY

In each of these different historical moments, the flag has come to mean something different, not only to the artists but to each of us viewing it. In other words, the **subject matter** of each of these first five works of art is in one way or another the American flag, but the **content** of each is less certain. Understanding what a thing is and what it means are two different things.

Art that Angers:
What is the Proper Way to Display the American Flag?

When the School of the Art Institute of Chicago opened an exhibition of works of art by 66 students who are members of minority groups on February 20, 1989, one work in particular stirred enormous controversy. "Dred" Scott Tyler's installation *What is the Proper Way to Display the American Flag?* consisted of a 34 × 57 inch American flag draped on the floor beneath photographs of flag-draped coffins and South Koreans burning the flag. Beneath the photos was a ledger in which viewers were asked to record their opinions. The problem was not only that the flag was on the floor, but that it was difficult to write in the ledger without stepping on it. The flag had become a actual barrier to the very freedom of expression it was meant to defend. Viewers had to choose which they revered most—respect for the flag or freedom of speech.

Angry veterans wearing combat fatigues protested the exhibit soon after it opened, waving American flags, singing the national anthem, and carrying signs saying, "The American flag is not a doormat." Said one: "When I walked in there and saw those muddy footprints on the flag, I was disgusted. It would be different if it was his own rendering of the flag. But it was a real flag. And it belongs to the American people."

Tyler was quick to point out that he had purchased the flag at a store for $3.95. It had been made in Taiwan.

By February 24, school officials had closed the shop. A week later it reopened, and a school teacher from Virginia was arrested when she walked on the flag in order to write in the ledger. Finally, on March 12, 2,500 veterans and supporters from nine

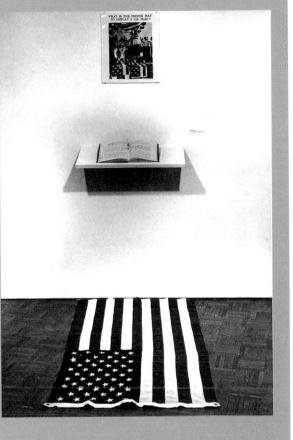

Fig. 7 Scott Tylor, *What is the Proper Way to Display the American Flag?*, 1989. Photo: Michael Tropea.

states marched on the Art Institute. Students staged a counterdemonstration, brawls broke out, and five more people were arrested, one veteran and four students. The exhibit itself was open for only a short time.

Because of the exhibition, the United States Senate, the Illinois Legislature, and the Chicago City Council all passed legislation banning display of the flag on the floor. These laws were all subsequently overturned when the United States Supreme Court ruled that even flag burning is protected by the First Amendment.

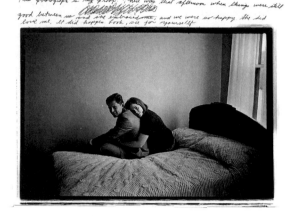

Fig. 8 Duane Michals, *This Photograph Is My Proof*, 1967 and 1974. Silver print,
8 × 10 in. © Duane Michals

The situation is even more problematic due to the fact that most of us take the visual world for granted. Because we see it, we assume we understand it. Those of us born into and raised in the television generation are often accused of being nonverbal, passive receivers like TV monitors themselves. If television—and the mass media generally, from *Life* to the Sunday funnies—has made us virtually dependent upon visual information, we have not necessarily become visually *literate* in the process. In order to develop our visual literacy, we need to begin to understand the complex relationship between the image and the world to which it refers.

Throughout the history of Western culture—indeed, in all cultures—visual images have periodically come under attack. There are real things, and pictures of real things, one argument goes. You can lie down in bed, but you can't lie down on a picture of a bed, at least not very comfortably. Images, in other words, are removed from reality. They are only real in the mind, or imagina-

tion, while what they depict is actually real in the physical world.

This is true even for photography, a medium most of us regard as the most objective form of representation, one that actually *records* visual reality. But whose reality? The subjective or imaginative content of Duane Michals's photograph of an embracing couple (Fig. 8) bears no necessary relation to what we see before our eyes. The man in this photograph insists on using it as if it were proof in a court of law, and we are the jury. Evidently the relationship is over, but the man wants us to believe that "once upon a time" he was loved by someone, that this woman was happy in his company. His insistence is embarrassing. We read his protestation as a fairy tale that he has created in order to deceive himself.

In years past, before the medium became virtually unavoidable, anthropologists often reported that their subjects often could see nothing of a representational nature in black-and-white photographs. In

his 1959 essay, "Art and Value," anthropologist M. J. Herskovits reports showing a Bush woman a black-and-white photograph of her son. She was only able to recognize it as his likeness—or as the likeness of anyone—after its details were systematically pointed out to her. "To those of us accustomed to the idiom of the realism of the photographic lens," Herskovits writes, "the degree of conventionalization that inheres in even the clearest, most accurate photograph, is something of a shock. For, in truth, even the clearest photograph is a convention; a translation of a three-dimensional subject into two dimensions, with color transmuted into shades of black and white." Indeed, the most readily apparent visual property of many a black-and-white photograph is the contrast between its stark white borders and the black/gray area these frames surround, not the actual objects represented. When we look at a photograph we pay attention to subtle shifts in tonal value through white, gray, and black in order to read it. The image itself has no literal connection to reality.

Another traditional argument against the validity of the visual image originates in God's declaration, in Genesis 1:26, "Let us make man in our own image, after our likeness." Biblical scholars throughout history have insisted that this passage should not be construed to mean that we look physically like God (who, after all, is never actually described in the Bible), but rather that we have been created in God's spiritual image. In this context it is easy to see why William Blake's *The Ancient of Days* (Fig. 9) was considered by some to be an outrageous violation of theological propriety. Not only had Blake chosen to name his God "Urizen," creating his own personal mythology in the place of Christianity, but his God was *nude*. This image was a little *too* human. Moreover, Blake attributes to God a quandary that is really his own. God

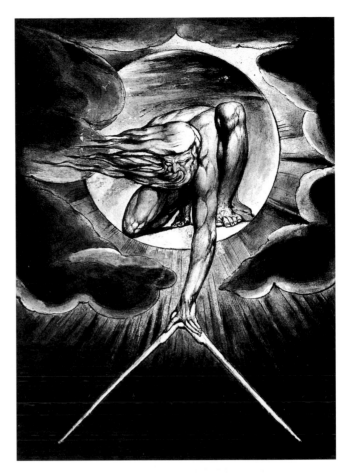

Fig. 9 William Blake, *The Ancient of Days*, from *Europe, A Prophecy*, frontispiece. 1794–1827. Watercolor, black ink, and gold paint on etched matrix, 9 × 6 ¾ in. Fitzwilliam Museum, University of Cambridge, England.

is depicted here as the powerful, but aged father of us all, a father, in Blake's view of things, less merciful than cruel. The scene is the second day of Creation, and God holds a pair of compasses as he measure out and delineates the firmament, imposing order upon chaos. This is not a particularly happy moment for Blake. The realization of a given order of things reduces the infinite possibilities available to Urizen before this moment. Urizen is "Your Reason"—a terrible rationality, terrible because it subsumes the potential of the imagination. Blake represents his own double bind here: to create and to make something—for example, an image—is limiting, because it sets boundaries upon the imagination, and yet the imagination is defined by its ability to create and make.

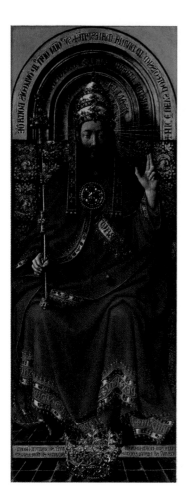

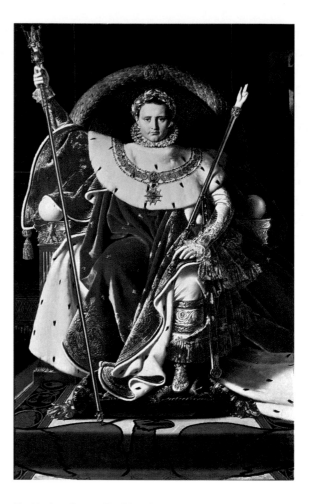

Fig 10 Jan van Eyck, *God*, panel from the Ghent Alterpiece, c. 1432. St. Bavo, Ghent.

Fig. 11 Jean-Auguste-Dominique Ingres, *Napoleon on His Imperial Throne*, 1806. Oil on canvas, 104 × 65 ½ in. Musée de l'Armée, Paris.

Blake's God is very different, at any rate, from Jan van Eyck's (Fig. 10), whose God is much frailer, younger, apparently more merciful and kind, and certainly more richly adorned. Indeed, in the richness of his vestments, van Eyck's God apparently values worldly things more than Blake's, but where Blake despised the material world—the world in which things get made—van Eyck admired and trusted it. He celebrates a materialism that is the proper right of benevolent Kings. Behind God's head, across the top of the throne, are the Latin words that, translated into English, read: "This is God, all powerful in his divine majesty; of all the best, by the gentleness of his goodness; the most liberal giver, because of his infinite generosity." God's mercy and love are indicated by the pelicans embroidered on the tapestry behind him, which in Christian tradition symbolize self-sacrificing love, for they were believed to wound themselves in order to feed their young on their own blood if other food was unavailable.

In the nineteenth century, when Ingres would come to paint Napoleon (Fig. 11), the van Eyck portrait of God was one model for his own portrait of the French emperor. Significantly, the pelicans have disappeared, and an eagle, symbol of imperial power, has taken their place on the carpet at Napoleon's feet. The relative grandness of Napoleon's pose—his wide shoulders, his raised right hand—suggests that he is not only a good deal closer to God than he is to us mortals but grander even than the

Christian God, an idea possible only in a France that had, during the Revolution, not 15 years earlier, banned the Church altogether. While the opulence of Ingres's figure refers to van Eyck's work, the pose here is in fact based on an engraved Roman gem representing Jupiter, the chief Roman god and god of the Roman state, and Ingres consciously substitutes the Roman imperial ideal for the Christian one.

For Pedro Perez, an artist born in Cuba who emigrated to the United States in 1966 at the age of 14, God is caught up in the collision of two cultures (Fig. 12). Here the rich imagery of traditional Spanish Catholicism, embodied in the actual gold leaf that Perez has used to decorate the cross, is countered not only by his use of gaudy costume jewelry but also by the deeply satiric depiction of God at the work's center, which transforms Him from a conventional, dignified, white-bearded patriarch to a mellow, aging hippie, a gurulike and undeniably "cool" Santa Claus.

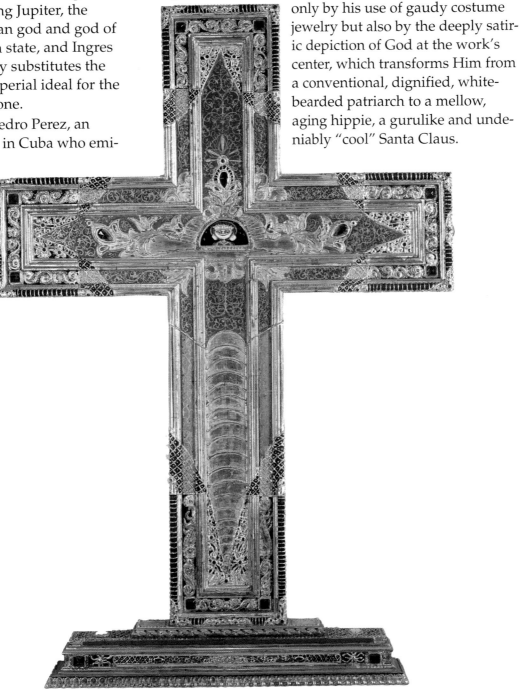

Fig. 12 Pedro Perez, *God* (detail), 1981. Gold leaf, acrylic, and costume jewelry on wood, 55 × 29 1/2 × 2 in. Collection Jock Truman and Eric Green; photo courtesy Marilyn Pearl Gallery.

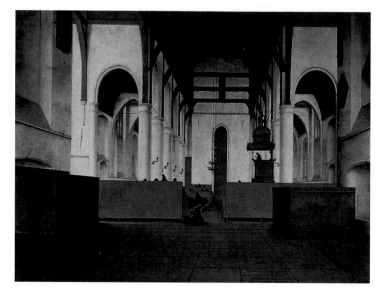

Fig. 13 Peter Saenredam, *Interior of the Church of Assendelft*, 1649. Panel, 19 5/8 × 28 7/8 in. Rijksmuseum, Amsterdam.

The idea of daring to represent God has, throughout history, aroused controversy. In seventeenth century Holland, images of God were in fact banned from Protestant churches, as Pieter Saenredam's stark architectural rendering of the interior of the Church of Assendelt attests (Fig. 13). As one contemporary Protestant theologian put it, "The image of God is His Word"—that is, the Bible—and "statues in human form, being an earthen image of visible, earthborn man [are] far away from the truth," a sentiment not shared by Catholics, who continued to make lavish use of painting and statuary in their churches.

Such antipictorial sentiments are surprisingly close to Muslim attitudes toward the representation of figures. In the traditional sayings of the prophet Muhammad, those who make pictures with human figures in them are labeled "the worst of men," and to possess such a picture is comparable to owning a dog, an animal held in the greatest contempt because it is associated with absolute filth. In creating a human

likeness, the artist is thought to be competing with the Creator himself, and such hubris, or excessive pride, is, of course, blasphemous. As a result, calligraphy—that is, the fine art of handwriting itself—is the chief form of Islamic art.

We are all aware that our individual handwriting expresses something about ourselves. Our signatures are legal marks that serve to identify us precisely because they are in some way unique. The Koran, on the other hand, is believed to be a direct transcription of Allah's actual words, spoken to humanity through the medium of the Prophet Muhammad. Since the Koran preserves the sacred knowledge of Allah, the ink with which the word is written is understood as comparable to the water of life itself. Thus all properly pious writing, especially poetry, such as the page from the poet Firdausi's *Shahnamah* at the right (Fig. 14), is sacred. The Muslim calligrapher does not so much express himself—in the way that we, individually, express ourselves through our style of writing—as act as a medium through which Allah can express himself in the most beautiful manner possible.

Arabic lettering is almost endlessly adaptable, sometimes geometric in inspiration and at other times curvilinear, and sacred texts are almost always completely abstract designs that have no relation to the world of things at all. They demand to be considered at least as much for their visual properties as for their literary or spiritual content. Until recent times, in the Muslim world, every book, indeed almost every sustained statement, began with the phrase "In the name of Allah"—the *bismillah*, as it is called—the same phrase that opens the Koran. On this folio page from the *Shahnamah*, the *bismillah* is in the top right-hand corner (Arabic texts read from right to left). To write the *bismillah* in as beautiful a form as possible is believed to bring the scribe forgiveness for his sins.

Fig. 14 Page from a manuscript of the *Shahnamah* of Firdausi, Iran and Turkey, 1562–1583. Watercolor and gold on paper, 18 1/2 x 13 in..
Museum of Fine Arts, Boston. Francis Bartlett Donation of 1912 and Picture Fund.

Yet words, however beautifully written, have their limitations as well. Consider the figure below, accepting that the image on the left is in fact a "real" tree and not a photograph of one. Why should we trust the word "tree" more than the image of it? It is no more "real" than the drawing. It is made from a series of pen strokes on paper—not an action radically removed, at least in a physical sense, from the set of gestures used to draw the tree. In fact, the word might seem even more arbitrary and culturally determined than the drawing. Most people, anywhere, would understand what the drawing depicts. Only English speakers understand "tree." In French the word is "*arbre*," in German "*baum*," in Turkish "*ağaç*," and in Swahili "*mti*."

An excellent case can be made, in other words, for the primacy of images over words. Most of us trust a photograph of an unusual event more than some witness's verbal description of it. "The camera never lies," we tell ourselves, while the reliability of a given witness is always in doubt. Cameras, of course, can and do lie. What should nevertheless be clear is that words and images need to work together. Each is insufficient in itself to tell the whole "truth."

It should be equally clear that any distrust of visual imagery we might feel is, at least in part, a result of the visual's power. When, in Exodus, the worship of "graven images" that is, idols, is forbidden, the assumption is that such images are powerfully attractive, even dangerously seductive. The page of Arab poetry reproduced previously (Fig. 14) depends for its power at least as much on its visual presence and beauty as it does upon what it actually says.

Visual imagery is powerfully persuasive in its own right, and one of the primary purposes of this book is to help you to recognize how this is so. Yet it is important for you to understand from the outset that you can neither recognize nor understand—let alone communicate—how visual imagery functions without language. In other words, one of the primary purposes of any art appreciation text is to provide you with a descriptive vocabulary, a set of terms, phrases, concepts, and approaches to visual imagery that will allow you to think critically about it . It is not sufficient to say, "I like this or that painting." You need to be able to recognize why you like it, how it communicates to you. This ability constitutes, in fact, real visual literacy.

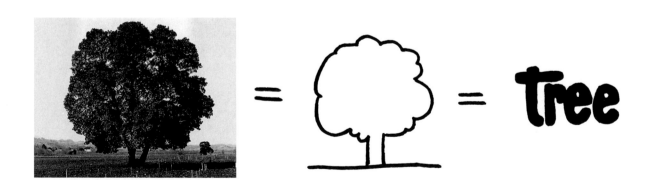

Fig. 15 Left: C. E. Watkins, *Arbutus Menziesii Pursh*, California. 1861. Albumen print, 14 x 21 1/4 in. Collection, Museum of Modern Art, New York. Purchase.

Arab Calligraphy: The Word as Image

Despite the emphasis on calligraphic, as opposed to figurative, art in Islam, a substantial number of figurative works exist that are formed by different combinations of letters. In a sentence with a series of connecting clauses, for instance, the letter "waw," meaning "and," might form the oars of the boat carrying the saved to the shores of Paradise. The form of the parrot reproduced on this page, which comes

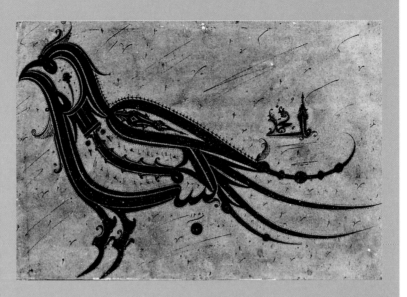

Fig. 16 *Bismallah* in the form of a parrot, Iran, 1834–1835. Cincinatti Art Museum. Franny Bryce Lehmer Fund. 1977.65.

from the beginning of an album of calligraphy assembled in nineteenth century Iran, is derived from the *bismallah*. The parrot "reads," as it were, from right to left, beginning over the large dot beneath its tail. The word "Allah" appears directly behind its head. The parrot is to humankind as humankind is to Allah. That is, it mimics human language without understanding it, just as humans speak the words of Allah without fully understanding them. Yet through repetition, especially in prayer, one can rise above one's earthly limitations.

Mastering the art of calligraphy itself required continual practice and repetition, and was, in that sense, a form of prayer in its own right. As a result, calligraphy was practiced with total dedication. There is a famous story about an incident that happened in the city of Tabriz during the great earthquake of c. 1776–1777. The earthquake struck in the middle of the night, and many were buried in the rubble. Survivors stumbled through the debris looking for any signs of life. A small light was seen glowing in the basement of a ruined

house. Rescuers desperately worked to open a path to the basement, and when they did, they discovered a man sitting on the floor absolutely absorbed in his work. He was writing. They yelled at him to hurry out, before an aftershock buried him for good. He didn't respond. They yelled again and again. Finally, with irritation, he looked up and protested the fact that they were disturbing him. They told him that thousands had been killed in an earthquake and that if he didn't hurry up he would be next. "What is all that to me?" he replied with vexation. "After many thousands of attempts I have finally made a perfect 'waw.'" He showed them the letter, indeed a very difficult letter to make. "Such a perfect letter," he exclaimed, "is worth more than the whole city."

Source: Anthony Welch, *Calligraphy in the Arts of the Muslim World* (Austin: University of Texas Press and the Asia Society, New York, 1979).

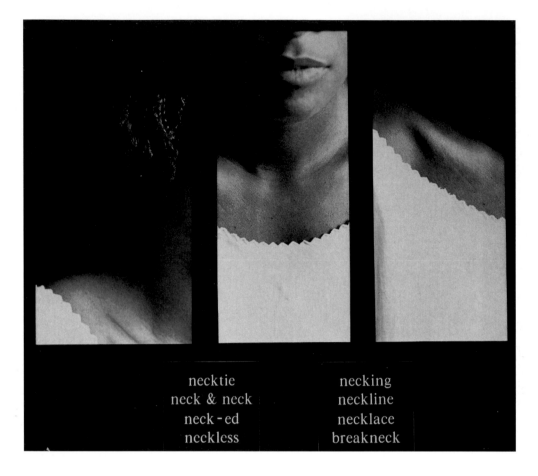

necktie
neck & neck
neck-ed
neckless

necking
neckline
necklace
breakneck

Fig. 17 Lorna Simpson, *Necklines*, 1989. Three silver prints, two plastic plaques, 68 1/2 × 70 in. Courtesy Josh Baer Gallery, New York.

3 WORDS AND IMAGES

Lorna Simpson's multi-panel *Necklines* (Fig. 17), above, is a good example of how words and images function together to make meaning. Simpson presents us with three different photographs of the same woman's neck and the neckline of her dress. Below these images are two panels with four words on each, each word in turn playing on the idea of the neck itself. The sensuality of the photographs is affirmed by words such as "necking" and "neck-ed" (that is, "naked"), while the phrases "neck & neck" and "breakneck," introduce the idea of speed or running. The question is, what do these two sets of terms have to do with one another? Necklaces and neckties

go around the neck. So do nooses at hangings. In fact, "necktie parties" conduct hangings, hangings break necks, and a person runs from a "necktie party" precisely because, instead of wearing a necklace, in being hanged one becomes "neckless."

If this set of verbal associations runs contrary to the sensuality and seeming passivity of Simpson's photographs, they do not run contrary to the social reality faced, throughout American history, by black people in general. The anonymity of Simpson's model serves not only to universalize the situation that her words begin to explore, but also depersonalizes the subject in a way that suggests how such situations become possi-

Fig. 18 James Valerio, *California Landscape*, 1984. Pencil on paper, 29 ³/₄ × 41 ³/₄ in. Glenn C. Janss Collection.

ble. Simpson seeks to articulate this tension—the violence that always lies beneath the surface of the black's world—by bringing words and images together.

Simpson's suggestive use of language is, of course, far more creative than we normally confront and more challenging even to a visually literate person than that normally encountered. To talk or write intelligently about works of art, most of us need a more basic set of terms, at least to begin with. Perhaps the most basic of all distinctions involves the relation of the visual image to the natural world—how closely, or not, the image resembles visual reality itself.

Generally we refer to works of art as **representational, abstract**, or **nonobjective** (or **nonrepresentational**). The more a work resembles real things in the real world, the more **representational** or **realistic** it is said to be. Traditional photography is, in many ways, the most representational medium, because its transcription of what lies before the viewfinder at least appears direct and unmanipulated. The photograph, therefore, seems to capture the immediacy of visual experience. James Valerio's *California Landscape* (Fig. 18) is actually a drawing, although it is so carefully rendered that it looks very much like a black-and-white photograph. Somewhat naively accepting that photography offers up an exact replica of the world, we call works of art that record the natural world as accurately as a camera **photorealistic**.

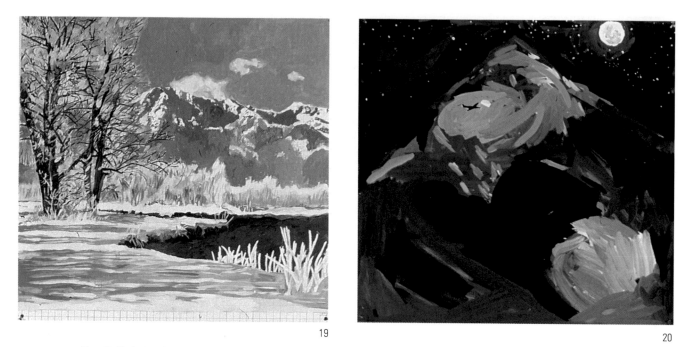

19

20

Figs. 19, 20, 21, 22 Jennifer Bartlett, details from *Rhapsody*, 1975-76. Enamel, baked enamel, silkscreen grid on steel plates, 12 × 12 in. each. Private collection, courtesy Paula Cooper Gallery, New York.

The four images on these pages (Figs. 19, 20, 21, & 22) are all by the same artist, Jennifer Bartlett, and they embody, as a series, the shift from the representational through the abstract to the nonobjective. The subject matter in each is the same—a mountain—although, as we will see, the last in the series could be said to be without subject matter even though it is formally related to the other three. Each of these works is an individual one-foot–square plate in a 987-plate piece that is arranged in 142 rows of approximately seven plates each. Entitled *Rhapsody*, the entire work requires 153 feet of wall space for installation. In the decade spanning 1976–1986, the work was installed in its entirety in 15 different locations, including the Whitney Museum of American Art in New York City, the Walker Art Center in Minneapolis, and the San Francisco Museum of Modern Art.

Rhapsody is an exploration of the possibilities of painting, and thus it is no surprise that virtually every approach to visual imagery is at one point or another taken up in it. The mountain is one of four images that Bartlett explores in the course of the work—the others are a house, trees, and the ocean—and each of these images is further worked out in terms of its relation to three primary shapes: the circle, the triangle, and the square. The image on the left (Fig. 19) is one of the most **representational** depictions of the mountain in the entire work, though it is by no means photorealist. The very obvious brushwork, for example, draws our attention to the fact that this is clearly a painting and not a photograph. In the second image (Fig. 20), an airplane can be seen flying by, even casting a shadow on the mountain. Though we can still recognize real things in this plate, it is much less realistic than the first. The less a work resembles real things in the real world the more **abstract** it is said to be. Abstract art does not try to duplicate the world exactly, but

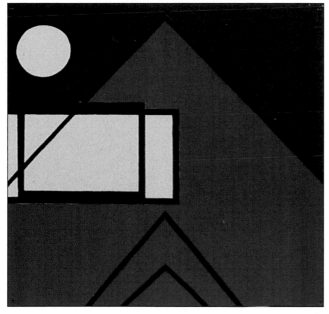

21

22

instead it is interested in reducing the world to its essential qualities. It is much more concerned with the formal qualities of an image, or in the emotions that may be expressed through it. The artist, for example, may want to create a violent mood though aggressive brushwork, as Bartlett does here, or she may seek to extract the formal essence of its subject matter, as Bartlett does in the third image (Fig. 21). This third image, in fact, has moved so far away from the representational that only in the context of the first two is its subject matter still recognizably the mountain. It is very close to becoming nonobjective.

The last image (Fig. 22) is, in fact, **nonobjective**. Though the triangle is related to the mountain shape, the actual subject matter is shape itself. The painting makes no reference to the physical world. In fact, within the context of *Rhapsody* as a whole, it is part of a long, 149-plate section of the work that is concerned with the ways in

which the square, the circle, and the triangle relate spatially and compositionally to one another.

It is not always easy, or even necessary, to make absolute distinctions between the representational, the abstract, and the "nonobjective. A given work of art may be more or less representational, more or less abstract. Very often certain elements of a representational painting will be more abstract, or generalized, than other elements. Likewise, a work may appear totally nonobjective until you read the title, and see that, in fact, it does refer to things in the actual world, however loosely.

Nonobjective art is a manifestation of a concern with the purely formal aspects of composition. When we speak of a work's **form**, we mean everything from the materials used to make it, to the way it employs the various formal elements, discussed in the next chapter, to the ways in which those elements are organized into a **composition**.

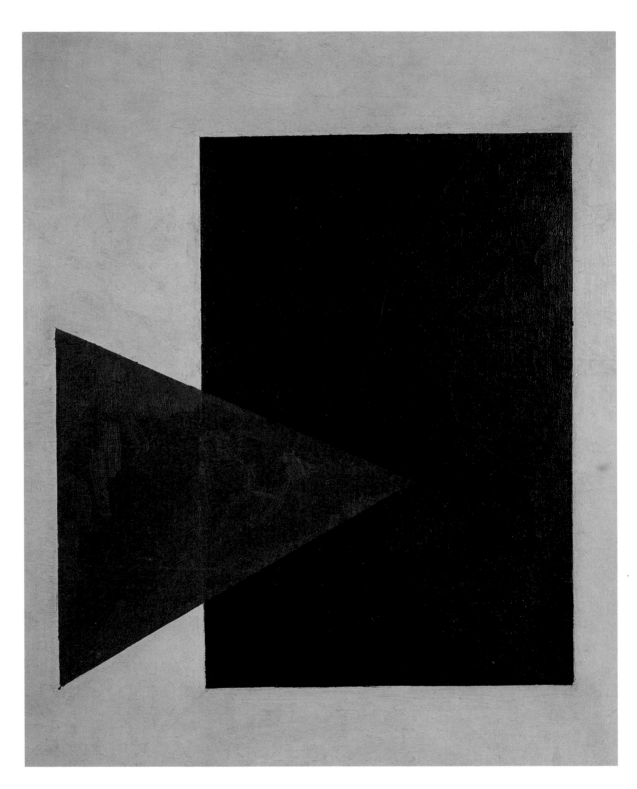

Fig. 23 Kasimir Malevich, *Suprematist Painting, Black Rectangle, Blue Triangle*, 1915. Oil on canvas, 26 1/8 × 22 1/2 in. Stedelijk Museum, Amsterdam.

Form, somewhat misleadingly, is generally opposed to **content** which, as has already been pointed out in distinguishing it from subject matter, is what the work of art expresses or means. Obviously, the content of nonobjective art *is* its form. Kasimir Malevich's painting at the left (Fig. 23) is really *about* the relation between the black rectangle, the blue triangle, and the white ground behind them. Though it is a uniform blue, notice that the blue triangle's color seems to be lighter where it intersects with the black triangle, and darker when seen against the white ground. That is because our perception of the relative lightness or darkness of a color depends upon the context in which we see it. If you stare for a moment at the line where the triangle crosses from white to black, you will begin to see a vibration. The two parts of the triangle

will seem, in fact, to be at different visual depths. Malevich's painting demonstrates how purely formal relationships can transform otherwise static forms into a visually dynamic composition.

Claude Monet uses the same forms in his composition (Fig. 24). In fact, compositionally, it is almost as simple as Malevich's. That is, the haystack is a triangle set on a rectangle, both set on a rectangular ground. Only the cast shadow adds compositional complexity. Yet Monet's painting has clear content. For nearly three years, from 1888 to 1891, Monet painted the haystacks near his home in Giverny, France, over and over again, in all kinds of weather and in all kinds of light. When these paintings were exhibited in May 1891, the critic Gustave Geffroy summed up their meaning: "These stacks, in this deserted field, are transient

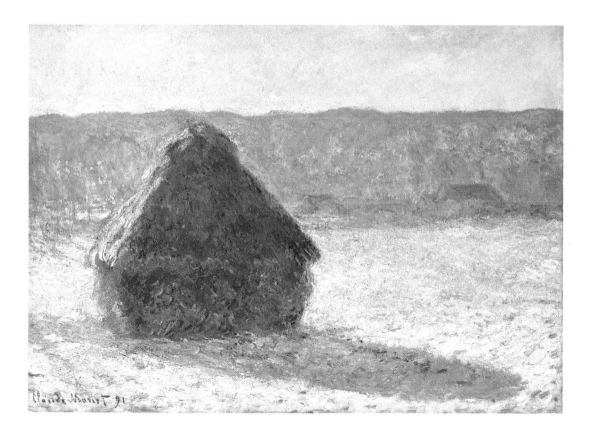

Fig. 24 Claude Monet, *Grainstack (Snow effect)*, 1891. Oil on canvas, 25 3/4 × 36 3/8 in. Museum of Fine Arts, Boston. Gift of Misses Aimee and Rosamond Lamb in memory of Mr. and Mrs. Horatio A. Lamb.

Mask as Dance: What a Baule Carver Sees

Fig. 25 Helmet mask, Baule, Ivory Coast, 19th-20th century. Woodwork sculpture. Metropolitan Museum of Art. Michael C. Rockefeller Memorial Collection, Gift of Adrian Pascal LaGamma, 1973. (1978.412.664).

Source: *Perspectives: Angles on African Art*, ed. Susan Vogel (New York: Abrams, 1987).

African masks, such as the Baule helmet mask illustrated here, have particularly fascinated modern art historians. But the properties for which we may value them—the abstractness of their forms and their often horrifying emotional expressiveness—are not necessarily those most valued by their makers. For the Baule carvers of the Yamoussoukio area of the Ivory Coast this mask is a pleasing and beautiful object. But it has another significance for them as well.

"This is the Dye sacred mask," they explain. "The god is a dance of rejoicing for me. So when I see the mask, my heart is filled with joy. I like it because of the horns and the eyes. The horns curve nicely, and I like the placement of the eyes and ears. In addition, it executes very interesting and graceful dance steps.... This is a sacred mask danced in our village. It makes us happy when we see it. There are days when we want to look at it. At that time, we take it out and contemplate it."

The Baule carvers pay attention to formal elements, but the mask is seen as much as part of a process, the dance, as an object. It is as if to the Baule eye it *projects* its performance. The mask is a vehicle through which the spirit world is made available to humankind. In performance, the wearer of the mask takes on the spirit of the place, and the carver quoted above apparently imagines this as he contemplates it.

If we do not immediately share with the Baule carvers the feelings evoked by the mask, we can be educated to see it in their terms. It is important for us to realize that when we see the mask only through the eyes of our own culture, then we not only radically alter its meaning and function but implicitly denigrate the African viewpoint, or at best refuse to acknowledge it at all.

objects whose surfaces, like mirrors, catch the mood of the environment.... Light and shade radiate from them, sun and shadow revolve around them in relentless pursuit; they reflect the dying heat, its last rays; they are shrouded in mist, soaked with rain, frozen with snow, in harmony with the distant horizon, the earth, the sky." This series of paintings, in other words, attempts to reveal the dynamism of the natural world, the variety of its cyclic change.

In a successful work of art form and content are inseparable. As content changes, so does form. Thus, though on one level Jennifer Bartlett's four plates may possess similar subject matter and explore the same formal shape, the mountain and the triangle, other aspects of her formal means change from plate to plate to accommodate changes in the content of each plate. And these changes can be dramatic; whereas in Figure 20 the mountain is wrapped in an eerie darkness, in Figure 22 it has been reduced to a geometric shape, the triangle.

Consider another two examples of the relation between form and content. To our eyes, the two heads at the right possess radically different formal characteristics, and, as a result, differ radically in content. Kenneth Clark compares the two on the second page of his famous book *Civilisation*: "I don't think there is any doubt that the Apollo embodies a higher state of civilization than the mask. They both represent spirits, messengers from another world— that is to say, from a world of our own imagining. To the Negro imagination it is a world of fear and darkness, ready to inflict horrible punishment for the smallest infringement of a taboo. To the Hellenistic imagination it is a world of light and confidence, in which the gods are like ourselves, only more beautiful, and descend to earth in order to teach men reason and the laws of harmony."

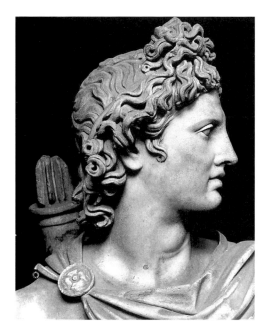

Fig. 26 Apollo Belvedere (detail), Roman copy after a 4th century B.C. Greek original. Vatican Museums, Rome.

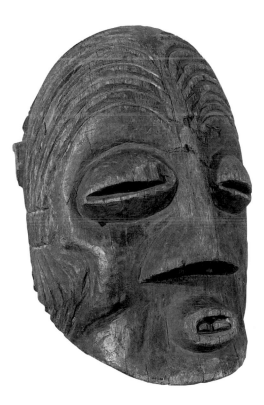

Fig. 27 African mask, Sang tribe, Gabon, West Africa. Courtauld Institute Galleries, London.

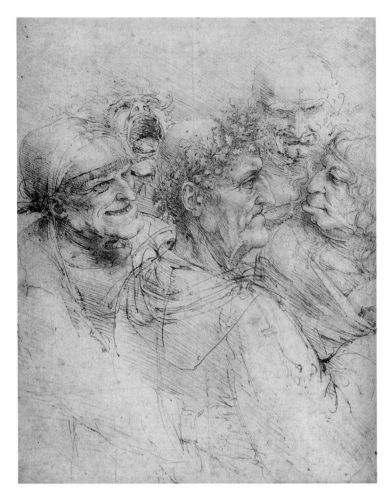

Fig. 28 Leonardo da Vinci, *Five Characters in a Comic Scene*, c. 1490. Pen and ink, 10 3/16 x 8 3/8 in. © 1992 Her Majesty Queen Elizabeth II, Royal Library, Windsor Castle.

Clark is, in fact, wrong about the African mask. He is reading it through the eyes of Western civilization, which has referred to the African continent as "darkest" Africa ever since the Europeans first arrived there in the sixteenth century. It is important to recognize that what we think we see expressed by the particular formal treatment of a subject is sometimes the result of prejudice, and often the result of our conventional expectations. The best light in which Clark's reading of the African mask can be seen is to think of it as the manifestation of a **convention** of Western thinking that can be traced back at least as far as Leonardo da Vinci's studies of grotesque heads (Fig. 28). Each of these

visages is *expressive* of the inner, psychological state of the being that lies behind what might be called the mask of its physical appearance. The face is the outer expression, we believe, of the reality within, and distortions in the human face indicate or imply distortions or aberrations in the human psyche beneath. Thus, when Clark sees an African mask, it may be that he simply reads into its features his own preconceptions of the psychic realities—violence, horror, or fright—that might create such a face.

Such a reading is *ethnocentric*. That is, it imposes upon the art of another culture the meanings and prejudices of our own. Individual cultures always develop a traditional or conventional repertoire of visual images that they tend to understand in a particular way. Another culture, however, might read the same image in an entirely different way. Even within a culture, the meaning of an image may change or be lost over time. When Jan van Eyck painted *The Marriage of Giovanni Arnolfini and Giovana Canami* in 1434 (Fig. 29), its repertoire of visual images was well understood, but today much of its meaning is lost to the average viewer. The bride's green dress, a traditional color for weddings, was meant to suggest her natural fertility. She is not pregnant—her swelling stomach was a convention of female beauty at the time, and she stands in a way to accentuate it. The groom's removal of his shoes is a reference to God's commandment to Moses to take off his shoes when standing on holy ground. A single candle burns in the chandelier above the couple, symbolizing the presence of Christ at the scene. And the dog, as most of us recognize even today, is symbolic of marital fidelity.

The study or description of such visual images or symbolic systems is called **iconography**. Each and every culture has its specific iconographic practices, its own sys-

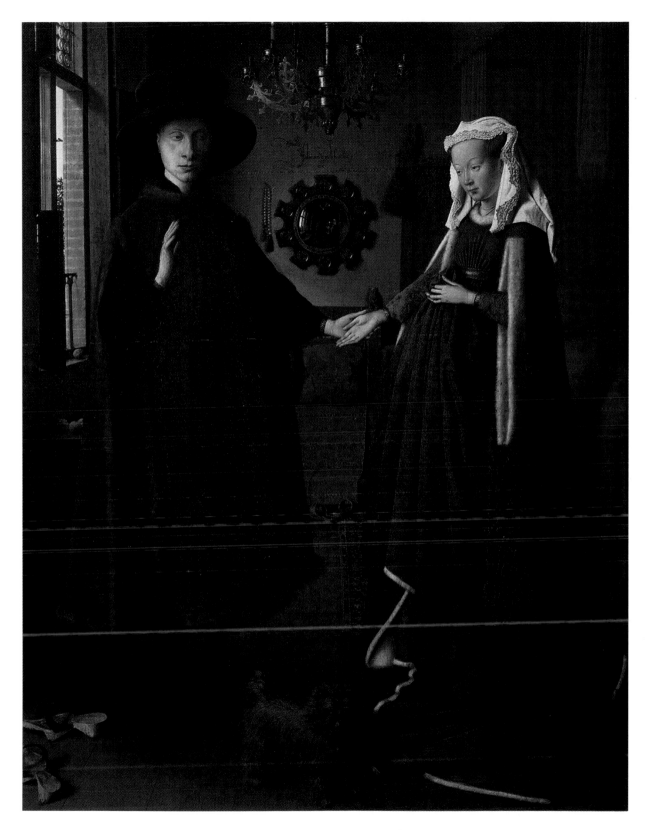

Fig. 29 Jan van Eyck, *The Marriage of Giovanni Arnolfini and Giovanna Canami*, 1434. Oil on oak panel, 32 1/2 × 23 1/2 in. The National Gallery, London.

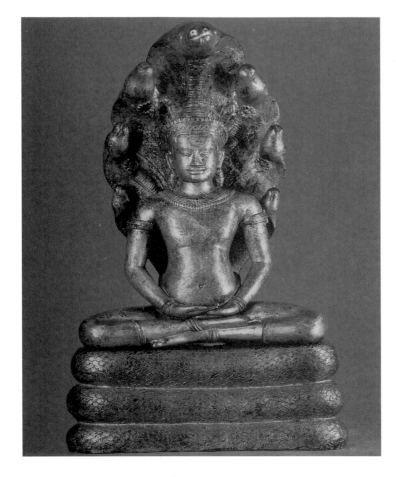

Fig. 30 Buddha, adorned, seated in meditation on the serpent Mucilinda, c. 1100–1150.

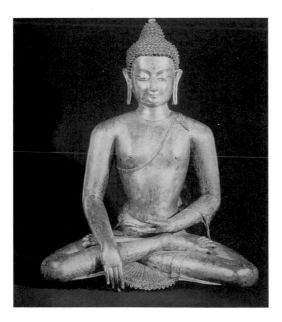

Fig. 31 Buddha subduing Mara, Nepal, late 14th century. Gilted copper.

tem of images that are understood by the culture at large to mean specific things. But what would Arab culture make of the dog in the van Eyck painting, since in the Muslim world the animal is traditionally viewed as the epitome of filth and degradation? From the Muslim point of view, the painting verges on nonsense.

Similarly, if most of us in the West would probably recognize a Buddha when we see one, we might not know that the position of the Buddha's hands carries iconographic significance. Buddhism, which originated in India in the fourth century B.C., is traditionally associated with the worldly existence of Sakyamuni, or Gautama, the Sage of Sakya clan, who lived and taught around 500 B.C. In his thirty-fifth year, Sakyamuni experienced Enlightenment under a tree at Gaya (near modern Patna), from which moment on he became Buddha. The religion spread to China in the third century B.C., and from there into Southeast Asia during the first century of the Christian era. Long before it reached Japan, by way of Korea in the middle of the fifth century A.D., it had developed a more or less consistent iconography, especially related to the representation of Buddha himself. The symbolic hand gestures, or *mudra* as they are known, refer both to general states of mind and to specific instances in the life of Buddha. The one most widely known to Westerners, the hands folded in the seated Buddha's lap, symbolizes meditation (Fig. 30). The snake motive, seen here, illustrates a specific episode from the life of the Buddha in which the serpent-king Mucilinda made a seat out of its coiled body and spread a canopy of seven heads over Buddha in order to protect him, as he meditated, from a violent storm.

One of the most popular of the *mudra*, especially in East India, Nepal, and Thailand, is the gesture of touching the earth, right hand down over the leg, the left

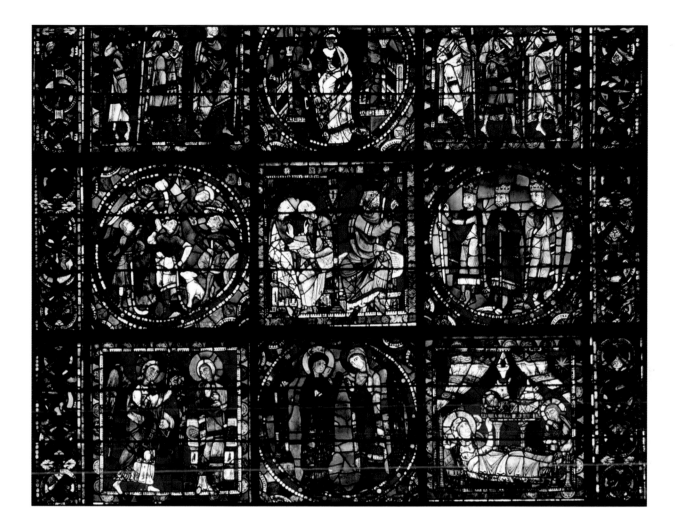

Fig 32 Lower nine panels of the center lancet window in the west front of Chartres Cathedral, showing the Nativity, Annunciation of the Shepherds, and the Adoration of the Magi, c. 1150. Chartres Cathedral, France.

lying in the lap (Fig. 31). Biographically, it represents the moment when Sakyamuni achieved Enlightenment and became Buddha. Challenged by the Evil One, Mara, as he sat meditating at Gaya, Sakyamuni proved his readiness to reach Nirvana, for Buddhists the highest spiritual state, by calling the earth goddess to witness his worthiness with a simple touch of his hand. The gesture symbolizes, then, not only Buddha's absolute serenity, but the state of Enlightment itself.

These gestures can be read by Buddhist audiences as readily as we, in the predominantly Christian West, read incidents from the story of Christ. Above are

the lower nine panels of the center window in the west front of Chartres Cathedral in France (Fig. 32). This window was made about 1150, and is one of the oldest and finest surviving stained-glass windows in the world. The story can be read like a cartoon-strip, beginning at the bottom left and moving right and up, from the Immaculate Conception through the Nativity, the Annunciation of the Shepherds, and the Adoration of the Magi. The window is usually considered the work of the same artist who was commissioned by the Abbot Suger to make the windows of the relic chapels at Saint-Denis, which portray many of the same incidents as those at Chartres. "The

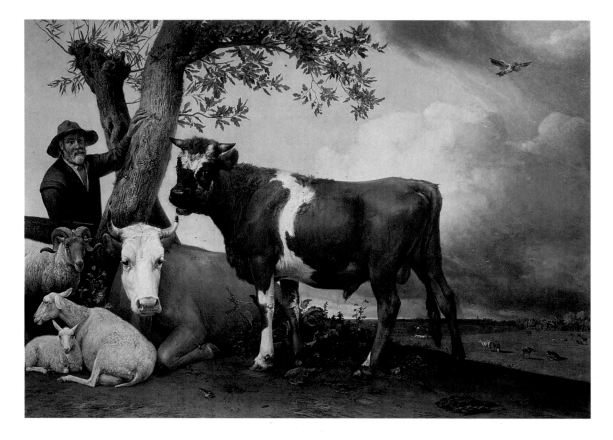

Fig. 33 Paulus Potter, *The Young Bull*, 1647. Oil on canvas, 93 × 133 in. Mauritshuis, The Hague.

pictures in the windows are there," the Abbot explains in his writings, "for the sole purpose of showing simple people, who cannot read the Holy Scriptures, what they must believe." But he understood as well the expressive power of this beautiful glass. It transforms, he said, "that which is material into that which is immaterial." This could be said to be the ambition of all Gothic architecture, which in the vastness of its scale, its vaulted ceilings, airy stonework, flying buttresses, and soaring spires, lends to stone an almost ethereal lightness of being. Suger understood, finally, that whatever story the pictures in the window tell, whatever iconographic significance they contain, and whatever words they generate, it is above all their art that lends them power.

4 INTERPRETATION AND EVALUATION

The previous discussion of iconography demonstrates a fundamental truth about our ability to appreciate works of art: The more we understand about them, the more we are likely to value them. For this simple reason, most of us value the artistic production of our own culture—of which, after all, we have some basic understanding—more than we do the artistic production of cultures unfamiliar to us.

But even within our own culture, we tend to value certain works more than others. It is fair to say, for instance, that as a culture we tend to value realist or representational works of art more than abstract or nonrepresentational works. The reason is very simple. We recognize what a realist or

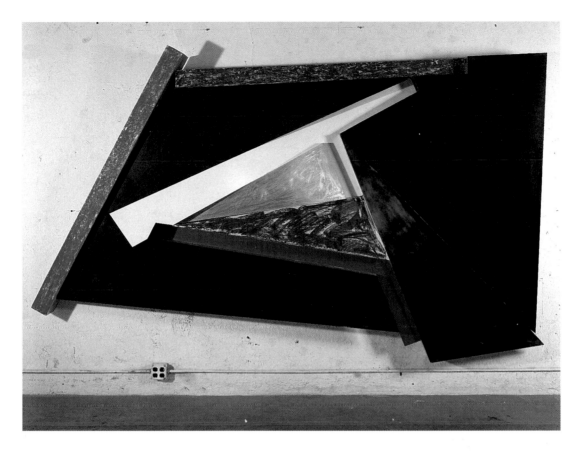

Fig. 34 Frank Stella, *Leblon II*, 1975. Mixed media on honeycombed aluminum, 80 × 116 in. Courtesy Knoedler & Co., New York.

representational work is about. We understand its subject matter, if not its content. We rarely approach abstract or nonrepresentational art with anywhere near the same level of immediate understanding. Abstract or nonobjective work often seems foreign to our sensibilities. It is as if it were the production of a mind alien to our own.

Consider the two paintings illustrated here, Paulus Potter's *The Young Bull* (Fig. 33) and Frank Stella's *Leblon II* (Fig. 34). Most people, asked to choose which they prefer, would unhesitatingly pick the Potter painting. The Stella, by comparison, is cryptic, even confusing. What? who? where? is "leblon" anyway? Animal, vegetable, or mineral? But to Stella's eye, the two paintings have very much in common. "One always loves paintings that are like one's own," Stella told an audience at Harvard

University, where he delivered the 1983–1984 Charles Eliot Norton Lectures. "In this case Potter's *Young Bull* is a faithful image of a painting of mine from 1975, *Leblon II*." As Stella points out, the Potter painting is asymmetrical, in its composition, empty and deep on the right, where there are no figures, full of "business" on the left—the peasant, the calves, cow, and bull, and the trees. "The heads of the peasant, cow, and bull," Stella explained at Harvard, "form a triangle within which the X-shape of the crossed tree trunks is inscribed." Stella's painting is formally similar. If the X-shape is itself only implicit in Stella's painting, the triangle remains, nestled beneath the green and brown strips that enclose the left of the painting. In both works, in Stella's words, "this triangle is the compositional focus."

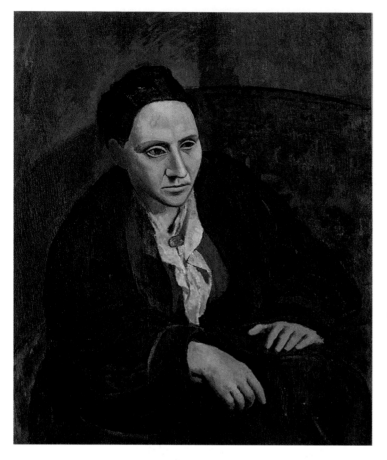

Fig. 35 Pablo Picasso, *Gertrude Stein*, 1906. Oil on canvas, 39 1/4 × 32 in. The Metropolitan Museum of Art, New York. Bequest of Gertrude Stein, 1946 (47.106).

Abstract and nonobjective art have always been open to the charge of being so subjective that they are virtually inaccessible to the average person. This subjectivity is, nevertheless, fundamental to the history of modern art. Picasso's portrait of *Gertrude Stein* (Fig. 35) is a case in point. The painting was begun in the winter of 1905–1906. Stein would visit Picasso's studio nearly every day to pose for the portrait as Picasso diligently tried to paint her likeness. But he had a terrible time with the face. He could not get it right. Finally in the late spring, after over eighty sittings, Picasso, in complete frustration, painted out Stein's head and departed for Spain, leaving a great blank in the middle of the canvas. In the late summer he returned, stood before the canvas, and painted the face from memory. When, some months later, Stein's friend Alice B. Toklas told Picasso how much she admired the painting, he thanked her. "Everyone says that she does not look like it," Picasso said, smiling, "but that does not make any difference, she will."

The story could be said to mark the moment when painters no longer felt compelled to represent the world as it is and were freed to paint what they felt or imagined it to be. In other words, for Picasso, his own subjective knowledge of Stein was more "real" than what she objectively looked like. This belief in the reality of the interior world dominates the history of modern art. In his 1928 book *Surrealism and Painting*, André Breton, the leader of the French Surrealists, asserted that the mistake of painters "has been to believe that a model could be derived only from the exterior world.... This is an unforgivable abdication [of their responsibility].... If the plastic arts are to meet the need for a complete revision of real values, a need on which all minds today are agreed, they must therefore either seek a *purely interior model* or cease to exist." **Surrealism** defines the reali-

Most viewers initially prefer the Potter painting because it seems more "real" to them than the Stella, whose subject matter, as we have seen, is not obvious. That is, just as an actual table is more objectively "real" than a painting of one, so the Potter is a more *objective* rendering of reality than the Stella. Stella's painting seems, by comparison, wholly *subjective*, manifesting his personal interest in purely formal matters. If most people are generous enough to grant Stella his intentions, they are not, most of them, readily able to share or participate in those formal concerns. They begin to appreciate what he is up to only when he begins to explain his intentions to them.

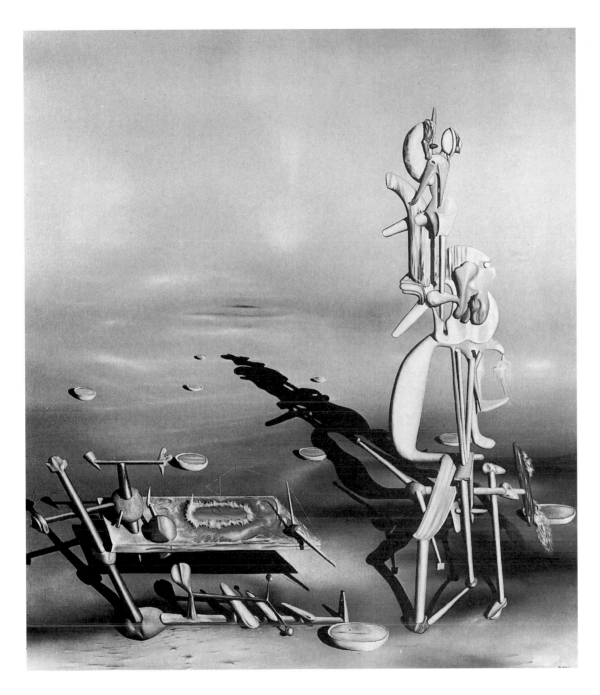

Fig. 36 Yves Tanguy, *Indefinite Divisibility*, 1942. Oil on canvas, 40 × 35 in. Albright-Knox Art Gallery, Buffalo, New York. Room of Contemporary Art Fund, 1945.

ty of the dream, or the subconscious mind, as more "real" than the surface reality of everyday life. Its reality is a higher reality. Yves Tanguy's world of semimechanical, semianimate forms (Fig. 36) was mysterious even to the artist himself. Whatever his forms are doing, they stand at the edge of a vast landscape that seems virtually limitless. In our very inability to interpret it definitively, the painting suggests that meaning is itself infinite, and that "reality"—the reality of the imagination, that is— is something we can never fully know, but can only pursue.

What Is More Real?

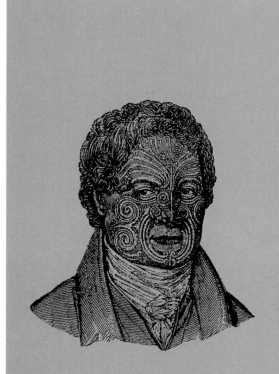

Fig. 37 A Maori, Tupai Kupa, after an old woodcut. Reproduced from Leo Frobenius, *The Childhood of Man*, 1909.

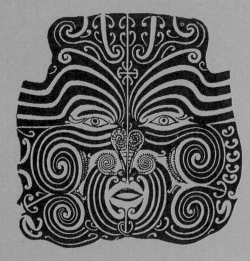

Fig. 38 A Maori, Tupai Kupa, after his own drawing. Reproduced from Leo Frobenius, *The Childhood of Man*, 1909.

Leo Frobenius was one of the first great investigators of so-called primitive culture in the Western world. His book *The Childhood of Man*, first published in English in 1909, contains an account of a Maori chief, Tupai Kupa, whose portrait was drawn by an Englishman, one John Sylvester, when Tupai Kupa was visiting Liverpool in the early part of the nineteenth century. "When this Maori was being painted...he looked on with great interest, but he presently shook his head, and declared that it was not at all the picture of Tupai Kupa. Those present and others coming in were greatly surprised. All were agreed that the features had been hit off with rare ability.... But still greater was the amazement when the Maori, asking for the pencil, with extraordinary skill drew his portrait as he conceived it.... This was not his actual portrait, but that of the ornamental lines tattooed on his face.... Tupai Kupa gave the name and the significance of each flourish, related the occasions when they were severally applied, and sketched the patterns of all the noble families." The Westerners' view of what constitutes a "true" or "real" likeness is not at all shared by the Maori. The implication is that the two cultures do not, in fact, share, in any real sense, a common view of what constitutes the self. And who is to say if one way of seeing is any better or worse than the other. It is probably better to think of them, rather, as *different*, and to accept that difference.

Source: Leo Frobenius, *The Childhood of Man: A Popular Account of the Lives, Customs and Thoughts of the Primitive Races* (London: Seeley and Company, 1909).

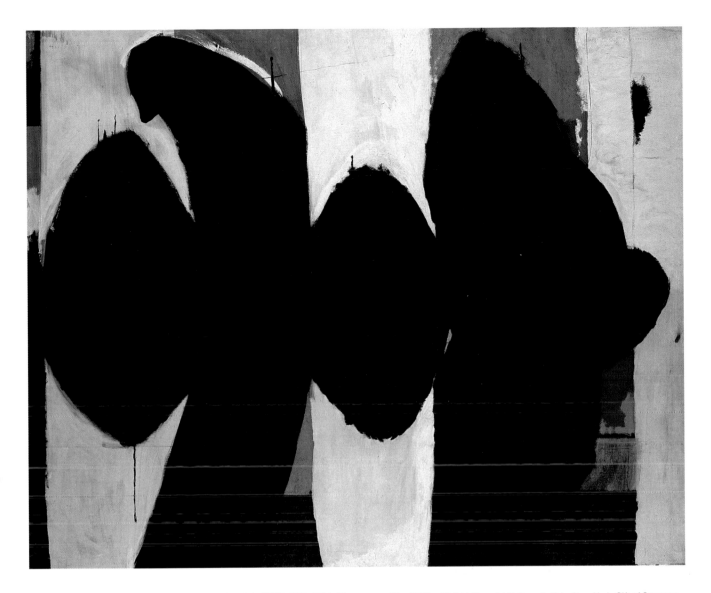

Fig. 39 Robert Motherwell, *Elegy to the Spanish Republic XXXIV*, 1953–1954. Oil on canvas, 80 × 100 in. Albright-Knox Art Gallery, Buffalo, New York. Gift of Seymour H. Knox, 1957.

Because he believed that he was directly presenting the reality of his own feelings and emotions on canvas, the abstract expressionist painter Robert Motherwell refused to admit that his paintings were abstract. Speaking of works such as *Elegy to the Spanish Republic XXXIV* (Fig. 39), he would write in 1955: "I never think of my pictures as 'abstract'…. Nothing can be more concrete to a man than his own felt thought, his own thought feeling. I feel most real to myself in the studio, and resent any description of what transpires there as 'abstract'—which nowadays…signifies… something remote from reality. From whose reality? And on what level?" The painting's title refers to the Fascist defeat of the democratic Spanish Republican forces by General Franco's forces just before World War II. It marks for Motherwell the terrible death of liberty itself, a reality he was unwilling to think of as being "abstract" in any sense of the word. The black forms and their lighter background he thought of as elemental "protagonists in the struggle between life and death."

Fig. 40 Audrey Flack, *Solitaire*, 1974. Acrylic on canvas, 60 × 84 in. Courtesy Louis K. Meisel Gallery, New York.

Audrey Flack's *Solitaire* (Fig. 40) would seem to lie at the opposite end of the spectrum from Motherwell's abstraction. As we said above, because painting of Flack's kind seems so photographic, it is often called **photorealism** or, alternatively, **super realism**. Yet Flack's painting is as intimate and personal as Motherwell's. It alludes, among other things, to her family's obsessive card playing. The clock and the pocket watch tell us the time, but it is unclear whether it is day or night. We know from the empty coffee cup and the untouched sherry glass that the game has gone on for a while and will continue on for a while more. In making her paintings, Flack first arranges a group of actual objects into a sort of still life, which she photographs. Finally, she paints from the photograph. In spite of the actual subject matter, and however fascinated we might be with the image itself and Flack's scrupulous rendering of it, what interests the artist herself is not so much the reality of the scene as its color. This is not "real" color. It is the highly intensified color of a slide transparency projected onto a white screen.

Flack's subject matter could be said, in fact, to be the reality of representation, the way in which, in contemporary life, reality is more often "image" than not. We know about the real world *through* film, *through* television, *through* photographs, as much or more as we know it through actual experi-

ence. But assuming that much of what we see in film, television, and photography is at least potentially manipulated, how "real" is our knowledge? What do we *really* know?

The point, simply put, is that we are likely to make a mistake if we judge works of art on the basis of their relative correspondence to "reality." One artist's realism is another's abstraction, and vice versa. Realism is a relative term. This is precisely the point of René Magritte's *The Treason of Images* (Fig. 41). We tend to look at the image of a pipe as if it were really a pipe, but of course it isn't. *Ceci n'est pas une pipe*— "This is not a pipe." Nor is the word "pipe" the same as an image of it. The word is an abstract set of marks that "represents," in language, both the thing and its image. Nor, finally, is "this" a "pipe." These two words are not the same: "This" is a pronoun, but it is not a "pipe."

But, you may ask, if we give up a work's relative "realism" as a criterion for judging it, then what other grounds for evaluating the work's value are available to us? *Beauty*, perhaps? But "beauty" is no less relative a term than "realism" or "truth." When the Greek philosopher Socrates was asked, "Come now, can you tell me what beauty is?" he was, he said, "confounded." Suppose two people are considering the same short-stemmed red rose. For one, the rose is absolutely beautiful, but to the other's eyes it is merely a mediocre specimen. In questioning each other's taste, they discover that they have applied different criteria in forming their opinions. One has considered only the brilliance of the rose's crimson petals, while the other, knowing from experience that long-stemmed roses cost more than the short-stemmed variety, has determined that this particular rose must be considered an inferior specimen since it could never be as valuable as a comparably colored long-stemmed bud.

Fig. 41 René Magritte, *The Treason of Images*, 1929. Oil on canvas, 21 1/2 × 28 1/2 in. Los Angeles County Museum.

Fig. 42 James Nachtwey, *Belfast, Northern Ireland*, 1981. Magnum Photos.

Fig. 43 Henri Cartier-Bresson, *Place de l'Europe, Paris*, 1932.

James Nachtwey's photograph, *Belfast, Northern Ireland* (Fig. 42) offers a precise example of the difficulties inherent in judging the beautiful. In many ways, the picture is reminiscent of Henri Cartier-Bresson's famous 1932 photograph of a man jumping a puddle in Paris (Fig. 43). Each involves an intricate choreography of leaps and arcs, a sense of the futility (and comedy) of human activity, and a dramatic sense of contrast between light and dark, stasis and motion, and in Nachtwey's photograph, fire and water. To the eye of the art historian, this analogy itself lends a certain beauty to Nachtwey's piece. That is, we judge a work's beauty very often by comparing it to other work that is generally acknowledged to be aesthetically pleasing. Yet, judged in the context of the ongoing civil war between Protestants and Catholics in Northern Ireland, Nachtwey's photograph becomes far less "beautiful." It is as if the innocence of Cartier-Bresson's photo has been stripped away, and the full brutality of modern life revealed in its stead.

Nachtwey's photograph causes us to ask some difficult questions. Can the ugly itself ever be art? Can the ugly be made, by the artist, to appear beautiful, and if so, does that cause us to ignore the reality of the situation? The central *Crucifixion* in Matthias Grünewald's *Isenheim Altarpiece* (Fig. 44) is one of the most tragic and horrifying depictions of Christ on the cross ever painted. Many people cannot bear to look at it. Rigor mortis has set in, Christ's body is torn with wounds and scars, his flesh is a greenish gray, his feet are mangled, and his hands are stiffly contorted in the agony of death. The painting portrays suffering, pure and simple, man's very inhumanity to man. Grünewald painted this altarpiece, in fact,

Fig. 44 Matthias Grünewald, *Crucifixion* (detail), from the *Isenheim Altarpiece*, c. 1512–1515. Oil on paper, height 117 ¹/₂ in. Musée Unterlinden, Colmar.

for a hospital chapel, and it was assumed that patients would find solace in knowing that Christ had suffered at least as much as they. In this painting, the ugly and horrible are indeed transformed into art, and not least of all because, as Christians believe, resurrection and salvation await the Christ revealed here in all his misery. The line that can be seen running down Christ's right side is, in fact, the edge of a double door that opens to reveal the Annunciation and the Resurrection behind. In the latter, Christ's body has been transformed into a pure, unblemished white, his hair and beard are gold, and his wounds are rubies.

Crash in Pthalo Green by Carlos Almaraz (Fig. 45), though at first glance virtually abstract, is actually the representation of a two-tier freeway with a violent, fiery automobile accident occurring on the top level. The horror of the scene is countered by the richness of the painting's color, its sensual and expressive brushwork, and, above all, by the work's very abstraction. It is as if Almaraz wants us to consider everything *but* the work's subject matter. Socrates, in fact, argued that painters should be exiled from the Greek Republic on just these grounds. To him, the painter's ability to attend to and delight in the sensory pleasures of seeing, to create an emotionally charged (and hence, he believed, illogical and irrational) sense of the beautiful, was destructive to a society that should strive, instead, to attain truth, wisdom, and order. But for an artist like Almaraz, it is precisely the disjunction between the horror of what he depicts and the beauty of how he depicts it that makes the work of interest. By making our relation to the painting so problematic, he creates a sense of tension that could be said to make the work *dynamic*. Our feelings about it are not easily resolved. The painting demands our active response.

Fig. 45 Carlos Almaraz, *Crash in Pthalo Green*, 1984. Oil on canvas, 42 × 72 in. Los Angeles County Museum of Art. Gift of 1992 Collectors Committee.

Many people value work like that of Almaraz precisely because it cannot easily be pigeonholed. It does not easily fit into predetermined categories of meaning, and it defies, in many ways, a straightforward response. One wonders, for instance, what led the Mobil Oil Corporation to purchase it (they have subsequently given it to the Los Angeles County Museum). If all we are left with, when we look at a work of art, is a series of questions, how can we begin to interpret it, let alone evaluate it? How do we know if it is good, or bad? What standards can we measure a work against, especially if ideas like "reality," "truth," and "beauty" are too relative to be of much use? And, if we do come to some decision about a work's merit or value, how can our judgments be substantiated and justified?

Carl Andre's *Stone Field Sculpture* (Figs. 46, 47, & 48), a work commissioned in 1977 for a triangular public green at the corner of Gold and Main Streets in downtown Hartford, Connecticut, offers a particularly clear example of how a work of art comes to be interpreted and evaluated precisely because the debate about its meaning and value occurred in such a public context. The work consists of 36 boulders, ranging in weight from 1,000 pounds to eleven tons, placed in eight rows, beginning with one boulder in the first row and increasing by one boulder in each subsequent row. The largest boulder is situated at the narrowest end of the green and the row containing the eight smallest boulders is at the other end. Andre's commission for creating and installing the sculpture was $87,000, an amount funded by the Hartford Foundation for Public Giving, with a matching grant from the National Endowment for the Arts. The stones themselves are uncut, natural boulders from a sand and gravel pit in nearby Bristol, Connecticut. About a third of them are Connecticut sandstone, the same material

Figs. 46 & 47 Carl Andre, *Stone Field Sculpture*, 1977. 36 glacial boulders, overall 51 × 290 ft. City of Hartford, Connecticut; photo courtesy Paula Cooper Gallery, New York.

Fig. 48 Carl Andre, *Stone Field Sculpture*, 1977. 36 glacial boulders, overall 51 × 290 ft. Hartford, Connecticut; photo courtesy Paula Cooper Gallery, New York..

used in many Hartford buildings, and the rest are granite, basalt, schist, gneiss, and serpentine. In realizing the project—labor, machinery, and insurance for transporting the stones from Bristol to Hartford, and his own transportation and living costs while completing the project—Andre spent only $12,000, leaving him with a considerable profit.

Many people in Hartford felt that the work hardly qualified as art at all. They were doubly incensed that so much money had been spent on it. For example, the

Republican candidate for mayor at the time called it "another slap in the face for the poor and elderly." Residents in the apartment tower across the street called meetings to discuss the possibility of having the boulders removed. "There was a lot of real hostility during the installation," Andre told the *New Yorker* magazine a couple of months later. "People would come up and start screaming at me—really screaming. People from all social and economic classes. I was quite startled by the vehemence." But as people came more and more to under-

stand Andre's intentions—and the issue was constantly before them in the press—they began to change their minds.

In the first place, Andre wanted to create a tranquil space that would parallel, both emotionally and physically, the 300-year-old graveyard of Center Church alongside it. He wanted, further, to juxtapose human time—the Church's first minister, appointed in 1633, was the great Puritan preacher Thomas Hooker—with the far vaster scale of geological time. He saw the sight as facilitating a sort of dialogue between gravestones and quarry stones, as the meeting place of human history and natural history. Finally, he wanted to create a different, and to his way of thinking better, kind of public sculpture. "What I really hate," he said, "is to see a piece of abstract art in a public space that's nothing more than a disguised man-on-horseback. That just doesn't interest me at all."

He thinks of his work, instead, in terms of movement in and around the work. "My idea of a piece of sculpture is a road," he has said (Fig. 49). "That is, a road doesn't reveal itself at any particular point or from any particular point…. We don't have a single point of view for a road at all, except a moving one, moving along it. Most of my works—certainly the successful ones—have been ones that are in a way causeways—they cause you to make your way along them or around them…. They're like roads, but certainly not fixed point vistas. I think sculpture should have an infinite point of view. There should be no one place, nor even group of places…where you should be."

The lesson of Andre's *Stone Field Sculpture* is that in interpreting and evaluating a work of art it is important to consider the *intention* of the artist in creating it. It is neither fair nor instructive to impose one's own values and assumptions upon a work of art before considering the values and assumptions that went into creating it.

Fig. 49 Carl Andre, *Secant*, 1977. 100 Douglas fir timbers, overall 12 × 12 × 3600 in. Nassau County Museum, Roslyn, New York; photo courtesy Paula Cooper Gallery, New York.

When we understand an artist's intentions we can judge or evaluate the work on far more defensible grounds. We can, in the first place, decide whether we think the intention of the work is worthwhile and we can, further, determine whether we believe the artist has successfully realized that intention. The people of Hartford seem to have decided that Andre's intentions were worthwhile and that the piece itself successfully realizes those intentions.

Richard Serra's controversial *Tilted Arc* (Figs. 50 & 51) was treated to an entirely different reception. When it was originally installed in 1981 in the Federal Plaza in lower Manhattan, there was only a minor flurry of negative reaction, but beginning in March 1985, William Diamond, newly appointed Regional Administrator of the General Services Administration, which had originally commissioned the piece and which was housed in a building on the Plaza, began an active campaign to have it removed. At the time, nearly everyone believed that the vast majority of people working in the Federal Plaza complex despised the work. In fact, of the approximately 12,000 employees in the complex,

Fig. 50 Richard Serra, *Tilted Arc*, 1981. Cor-Ten steel, 12 ft. x 120 ft. x 2 1/2 in. Federal Plaza, New York City. Destroyed by the U.S. Government, 3/15/89.

only 3,791 signed the petition to have it removed, and nearly as many—3,763—signed a petition to save it. Yet the public perception was that the piece was "a scar on the plaza" and "an arrogant, nose-thumbing gesture," in the words of one observer. During the night of March 15, 1989, over and against the artist's vehement protests and after he had unsuccessfully tried to block its removal with a lawsuit, the sculpture was dismantled and its parts stored in a Brooklyn warehouse. It has subsequently been destroyed.

From Serra's point of view, *Tilted Arc* was not merely dismantled, it was, even at that moment, destroyed. He had created it specifically for the site, and once removed from the site, it lost its reason for being. In Serra's words: "Site-specific works primarily engender a dialogue with their surroundings. There must be another language, dealing with the structure of the first but possessing a new structure to criticize the first.... It is necessary to work in opposition to the constraints of the context, so that the work cannot be read as an affirmation of questionable ideologies and political power." Serra clearly *intended* his work to be confrontational. He succeeded, probably more dramatically than he ever intended, and in the dialogue that ensued—a dialogue that verged at times on pitched battle—he lost. In this case, Serra made his intentions known, those intentions were understood, and the work was judged as fulfilling those intentions. But those in power judged his intentions negatively, which is hardly surprising considering that Serra was challenging their very authority. Whether they had the right to remove a work of art that they had commissioned is another question entirely, however, one that raises issues more complex than we can begin to address here.

Fig. 51 Richard Serra, *Tilted Arc*, 1981. Cor-Ten steel, 12 ft. x 120 ft. x 2 1/2 in. Federal Plaza, New York City. Destroyed by the U.S. Government, 3/15/89.

Fig. 52 Christo, *Surrounded Islands, Biscayne Bay, Greater Miami, Florida, 1980–1983*. 6,500,000 sq. ft. of pink polypropylene fabric floating around 11 islands. Courtesy of the artist. Photo: Wolfgang Volz.

The Bulgarian-born artist Christo creates large-scale public works that are intentionally temporary in nature. As a result, they have never met the fate of Serra's *Tilted Arc*, but they are at least as controversial. Christo works with fabric at a very large scale. Over the years he has wrapped a section of cliff on the Australian coast, extended a huge orange curtain across Rifle Gap, a valley in Colorado, run a 18-foot high nylon fence through more than 24 miles of Northern California countryside, wrapped the oldest bridge in Paris and an art museum in Berne, Switzerland, and surrounded eleven islands in Biscayne Bay in Greater Miami, Florida, with 6.5 million square feet of pink polypropylene fabric (Figs. 52 & 53). These enormously expensive projects are realized without public funds. Christo raises money for the projects by selling drawings, prints, and other preparatory works to collector-subscribers. In the case of the *Surrounded Islands* project, for instance, he raised nearly $3.5 million by selling 67 subscriptions for his work at approximately $50,000 each.

The work met with opposition at every level. In order to install it, Christo had to get permits from the Governor of Florida, the Dade County Commission, the Department of Environmental Regulation, the City of Miami Commission, the City of North Miami, the Village of Miami Shores, the U.S. Corps of Army Engineers, and the Dade County Department of Environmental Resources Management. Through the last, he met representatives of the Tropical Audubon Society, the Sierra Club, and the Izaak Walton League. He had to demonstrate that the fabric would have no negative impact on Biscayne Bay's seagrasses, its wading bird population, fishlife, and indigenous marine mammals, namely the mana-

tee. An environmentalist sought a restraining order and injunction to halt the project, but Christo reached a settlement with him. In short, in order to surround the islands, Christo was required to achieve a level of consensus for the project that is virtually unthinkable. And yet he succeeded.

Over the course of nearly three years, from the project's conception in December 1980 until its realization from May 7 to May 17, 1983, Christo explained his intentions again and again. Joseph Z. Fleming, one of Christo's lawyer's on the project, summed up the public's response—and the reason for Christo's success—probably better than anyone: "I had a tremendous feeling of relationship with people in a good way…local people that came into the project because they showed up at hearings. The project brought something very, very nice out. There was one attorney whom I've known for years and I think he's a very nice person. But he puts on a display of being hard and tough. He went out to look at the project in connection with his monitoring and he said 'I have to tell you this. I saw it and I cried.' That was a very, very good way of stating what the effect of the project was on a lot of people."

In order to be of value, to be thought of as "good," art need not achieve the level of consensus that Christo has managed in these projects. But it needs to achieve a certain level of consensus, even if only between itself and a single viewer. No one could ever pick up this book, thumb through its illustrations, and like every image in it, but, if they were to read the book, acquire greater skill in interpreting works of art in general, and come to a better understanding of each artist's intentions in particular, then they would value a great many more of the images in the book than they did at first glance.

The interpretation and evaluation of works of art requires, in other words, a certain familiarity with the *languages* of art,

Fig. 53　Christo, *Surrounded Islands, Biscayne Bay, Greater Miami, Florida, 1980–1983.* 6,500,000 sq. ft. of pink polypropylene fabric floating around 11 islands. Courtesy of the artist. Photo: Wolfgang Volz.

with the formal elements that go into making art, with the principles of design that are used to organize those elements, and with the specific qualities and capabilities of the different media out of which art is made. We need to understand what an artist's intentions are in making the work. But interpretation and evaluation are, above all, elements in a **comparative process**. The works discussed in this initial chapter, from the flags to the public sculptures, have come to make sense to you insofar as they have been compared *and* contrasted to other works with which they have something in common. By comparing and contrasting works of art, we come to understand the unique and special features of individual works better. In the next chapters, we will continually employ the comparative process in order to gain a greater familiarity with the languages of art as a whole.

PART II
THE FORMAL ELEMENTS AND THEIR DESIGN

Describing the Art You See

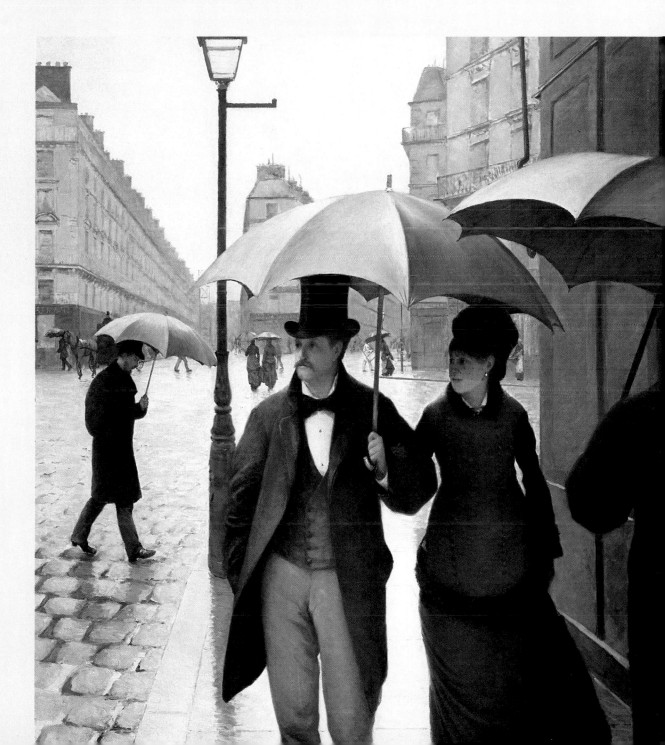

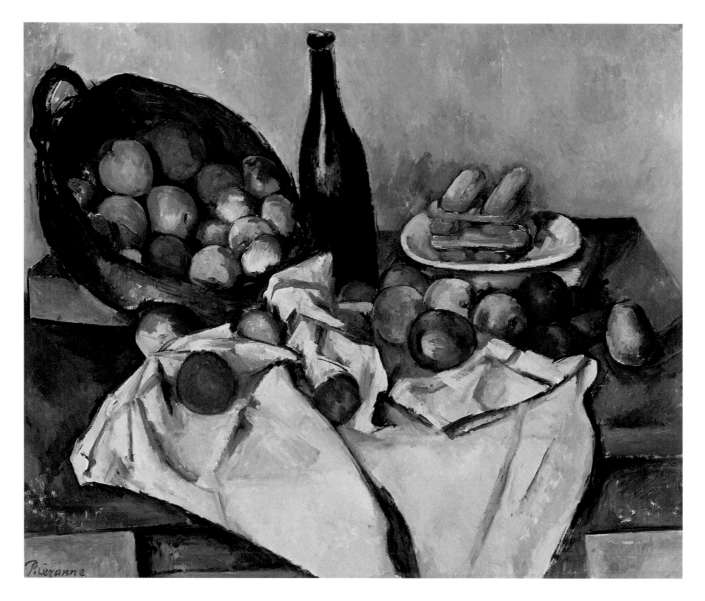

Fig. 54 Paul Cézanne, *The Basket of Apples*, © 1895. Oil on canvas, 21 3/8 × 31 in. © 1993, The Art Institute of Chicago, Helen Birch Bartlett Memorial Collection. All Rights Reserved.

Fig. 55 James Stirling and Michael Wilford, Clore Gallery, 1982–1986. Addition to the Tate Gallery, London.

5 THE FORMAL ELEMENTS

The painting at the left, Paul Cézanne's *Still Life with Basket of Apples* (Fig. 54), is a **still life**, a type of art work whose subject matter is an arrangement of inanimate objects. But it is also a complex arrangement of visual elements: lines and shapes, light and color, space, and, despite the fact that it is a "still" life, time. Upon first encountering the painting, most people sense immediately that it is full of what appear to be visual "mistakes." The edges of the table, both front and back, do not line up. The wine bottle is tilted sideways, and the apples appear to be spilling forward, out of the basket, onto the white napkin, which in turn, seems to project forward, out of the **picture plane**, the surface, that is, of the painting. Indeed, looking at this work, one feels compelled to reach out and catch that first apple as it seems to roll down the napkin's central fold and fall into our space.

Cézanne has not made any mistakes at all. Each decision is part of a strategy designed to give back life to the "still life"—which in French is *nature morte*, literally "dead nature." He wants to animate the picture plane, to make its space *dynamic* rather than *static*, to activate and engage the imagination of the viewer. He has taken the visual elements and deliberately manipulated them as part of his **composition**, the way he has chosen to organize the canvas.

James Stirling likewise seeks to animate the exterior of the Clore Gallery, his addition to the Tate Gallery in London (Fig. 55), which was commissioned to provide a home for the museum's collection of works by J. M. W. Turner. In order to create visual interest, Stirling combined a wide variety of materials and styles in his design. Bright green metal windows are set into the facade at a variety of depths. A grid of solid yellow squares is interrupted by a massive stonework entrance, and, as it approaches the neighboring building, changes to brick as if to match its neighbor. If such a diverse visual field seems disorganized, that is because we cannot begin to appreciate Stirling's composition, or Cézanne's either, until we understand how the visual elements routinely function. Then we can better appreciate how art's formal **conventions**—that is, the usual ways the visual elements are employed—can be manipulated by the individual artist to achieve the wide variety of effects we witness here.

Fig. 56 Timothy H. O'Sullivan, *Alkaline Lake, Carson Desert, Nevada*, 1868. Albumen photograph. National Archives.

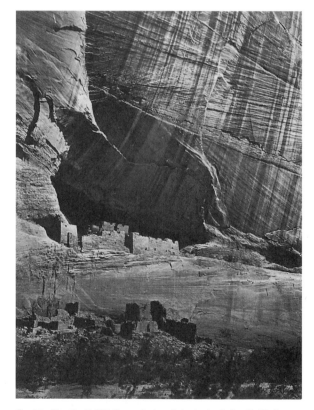

Fig. 57 Timothy H. O'Sullivan. *Ancient Ruins in the Cañon De Chelle, New Mexico*, 1873. Albumen print. George Eastman House, Rochester NY.

Line

Line is one of the most fundamental elements of art, and it is, besides, everywhere around us in nature: for example, in the molecular structure of aluminum, in the stripes on a zebra, in the ridge lines of a mountain range, in the horizon line as we look out across an expanse of landscape (Fig. 56), and in the discoloration made by rainwater down the face of a cliff (Fig. 57). One of the chief contributions of photography to human knowledge could be said to be its revelation of the formal elements—particularly line—that surround us in our everyday lives. Timothy H. O'Sullivan's pioneering photographic work, dating from the late 1860s, is not merely a record of the scenic wonders of the American landscape, but an exploration of the possibilities of photography itself, the ability of this newly discovered medium to reveal the visual elements in nature.

Varieties of Line

Each of these photographic works emphasizes two different kinds of line. The lines down the face of the cliff are *actual* lines, drawn, as it were, by nature on the rock wall in much the same way that an artist might draw a line on a canvas. The horizon line, on the other hand, defines the limits of our visual field, describing the edge of what we can actually see. We know that as we move the horizon line will move as well. Line, in this sense, is a *perceptual* phenomenon, more a function of our own point of view than of a physical reality in nature.

The edge of a three-dimensional form is called its **contour**. This contour can be indicated either directly, by means of an actual **outline**, as in Picasso's *Pitcher, Candle, and Casserole* (Fig. 59), or indirectly, as in David Ligare's painting *Woman in a Greek Chair* (Fig. 58). Ligare has not drawn lines in order to indicate the edges of the various elements of this composition, such

as the woman's arm, or her crossed leg under her dress. Rather, each edge is established by a shift in color. Within the figure itself, variations of contour are created by shifts between light and dark. From the point of view of the artist, there are no actual lines in this work, even though, perceptually, they are quite apparent. There are only volumes that make lines *appear* to us as they curve away. In Picasso's painting, on the other hand, each of the objects on the table and the table itself are established by *actual* black lines drawn at their edge. Picasso has then filled in each of the areas that he has outlined with large fields of color. Still, the contours established by these outlines serve the same function as Ligare's more perceptual lines, indicating the boundaries of our vision.

Fig. 58　David Ligare, *Woman in a Greek Chair (Penelope)*, 1980. Oil on canvas, 60 × 72 in. Courtesy Koplin Gallery, Los Angeles.

Fig. 59　Pablo Picasso, *Pitcher, Candle, and Casserole*, 1945. Oil on canvas, 32 1/4 × 41 3/4 in. Musée National d'Art Moderne, Centre National d'Art et de Culture Georges Pompidou, Paris.

Fig. 60 Eadweard Muybridge, *Woman Kicking*, Plates 647 from *Animal Locomotion*, 1887. Collotype, 7 1/2 × 10 1/4 in. Collection, The Museum of Modern Art, New York. Gift of the Philadelphia Commercial Museum.

Another variety of line that depends upon perception is *implied*. **Implied lines** are perceived by us even though they do not actually exist or mark the edge of our visual field. We visually "follow," for instance, the line indicated by a pointing finger. If someone nods toward us, we recognize the direction of that nod, the line of communication thus established between us. The body in motion also creates an implied line, something that Eadweard Muybridge's pioneering studies of the human body performing various tasks demonstrated in the late nineteenth century (Fig. 60). These photographs were enormously influential, not only answering many scientific questions about human anatomy in action but also prefiguring the art of film.

Of all the arts, perhaps dance depends most upon our ability to track implied lines as they are traced through space by the moving body. In his drawings of dancers (Fig. 61), Rodin sought to attain a feeling of "movement in the air," the rhythm of the body as it fills the area it inhabits. The imprecision of the drawing adds to this sense of action and movement, as we almost literally watch the leg rise higher and the back arch more fully.

As in dance, many **kinetic** works of art—that is, works of art that *move*—rely on our ability to remember the path that particular elements in the work have followed. Alexander Calder's mobiles (Fig. 62), composed of circular disks and wing-shaped discs that spin around their points of balance on arched cantilevers, are designed to create a sense of virtual volume as space is filled out by implied line. The sequence of photographs of *Dots and Dashes* (Fig. 63) clearly reveals how Calder's sculpture, set in motion by air currents in the room, or by viewers, who sometimes find it impossible to resist activating the mobile, changes as it moves. The lines generated here are equivalent, in Calder's mind, to the lines created by the human body as it moves through space, particularly the graceful lines created by the body of a moving dancer.

Fig. 61 Auguste Rodin, *Flying Figure*, c. 1900–1905. Lead pencil, 12 3/8 × 8 5/16 in. Musée des Beaux-Arts, Besancon, France.

Fig. 62 Alexander Calder, *Dots and Dashes*, 1959. Painted sheet metal, wire, width 60 in. Collection of Peter and Beverly Lipman,

Fig. 63 Alexander Calder, *Dots and Dashes*, 1959. Sequential sequence of mobile in motion, reproduced from *Alexander Calder and His Magical Mobiles* by Jean Lipman, Hudson Hills Press in Association with the Whitney Museum of American Art. Photos Jerry Thompson.

One of the most powerful kinds of implied line is a function of "line of sight," the direction the figures in a given composition are looking. In his *Assumption and Consecration of the Virgin* (Fig. 64), Titian ties together the three separate horizontal areas of the piece—God the Father above, the Virgin Mary in the middle, and the Apostles below—by implied lines that create simple, interlocking symmetrical triangles (Fig. 65) that serve to unify the worlds of the divine and the mortal. In his *Boys in a Pasture* (Figs. 66 & 67), Winslow Homer unites the boys in a compositional right triangle that is challenged by their lines of sight. As much as they share, as close as they are, they are very different. Not only does one sit almost upright while the other stretches out, not only does one wear a dark hat while the other wears a light one, but they are looking in *different* directions. As a result, Homer's painting becomes a powerful depiction of friendship, capturing particularly the kinds of difference that friendship overcomes.

Fig. 64 Titian, *Assumption and Consecration of the Virgin*, c. 1516–1518. Oil on wood, 22 1/2 × 11 4/5 ft. Santa Maria Gloriosa dei Frari, Venice.

Fig. 65 Line analysis of Titian's *Assumption and Consecration of the Virgin*.

Fig.66 Line analysis of Homer's *Boys in a Pasture*.

Fig. 67 Winslow Homer, *Boys in a Pasture*, 1874. Oil on canvas, 15 1/4 × 22 1/2 in. The Hayden Collection, Courtesy, Museum of Fine Arts, Boston.

Fig. 68 Pat Steir, from *Drawing Lesson, Part I, Line #1*, 1978. Portfolio of 7 aquatint etchings, each 16 × 16 in; edition of 25. Courtesy of Crown Point Press, San Francisco.

Fig. 69 Rembrandt Van Rijn, *The Three Crosses*, 1653. Etching, 15 1/4 × 17 3/4 in. Reproduced by courtesy of the Trustees of the British Museum.

Qualities of Line

As we have already seen, line: (1) *delineates form and shape*, and (2) *creates a sense of movement and direction*. A third attribute of line is that it *possesses certain intellectual, emotional, and/or expressive qualities*.

In a series of six works entitled *Drawing Lesson, Part I, Line*, Pat Steir has created what she calls "a dictionary of marks," derived from the ways in which artists whom she admires employ line. Each pair represents a particular intellectual, emotional, or expressive quality of line. One pair, of which Figure 68 at the left is an example, refers to the work of Rembrandt, particularly to the kinds of effects achieved by Rembrandt in works like *The Three Crosses* (Fig. 69). The center square of Steir's piece is a sort of "blow-up" of Rembrandt's basic line; the outside frame shows the wide variety of effects achieved by Rembrandt as he draws this line with greater or lesser density. The technique both Steir and Rembrandt employ is known as **crosshatching**, in which a series of parallel lines, or hatches, is intersected by one or more series of other parallel lines, so that the contrasts between light and dark that result overwhelm the orderly geometry of the lines themselves. In the Rembrandt, this pattern of crosshatched lines seems to be in the process of enveloping the scene, shrouding it in a darkness that moves in upon the crucified Christ like a curtain closing upon a play or a storm descending upon a landscape. Steir's work makes another characteristic of crosshatching evident. Notice how the single line, on the white square, seems two-dimensional, or flat, while the pattern of light and dark created by the crosshatching behind this square creates a sense of three-dimensional depth. This sense of *physical* depth imparts, in turn, a certain *psychological* depth to the work. It is as if Steir's line—and Rembrandt's too—becomes more charged emotionally as it becomes denser and darker.

The Formline

Northwest Coast Native American art is characterized by a type of line known as the **formline**. More than simply an outline of the figure depicted, the formline is an almost continuous line of varying width, narrower at the corners and wider down the straight lengths, that gives physical weight and substance to the figure, clarifying its anatomy as well as outlining it. One way to put it is to say that the formline and the figure are, in fact, one and the same.

In this appliqued shirt, collected from the Haida tribe in the 1890s, the formline consists of all the red or light-colored material sewn onto the dark material of the shirt. While there is a tendency to see the dark patterns on the body, wings, and tail feathers of the image as decorative elements added on to the lighter design—that is, as other lines drawn to indicate breast feathers and so on—these other "lines" are in actuality *negative* spaces created by turns and modulations in the primary formline. While there are a few independent ovals, in the wings and the eye, for the most part, the entire design is made from a single broad line.

Source: Bill Holm, "Form in Northwest Coast Art," in *Indian Traditions of the Northwest Coast*, ed. Roy L. Carlson (Burnaby, B. C.: Archaeology Press, Simon Fraser University, 1976).

Fig. 70 Appliqued shirt, Haida, c. 1890. Courtesy of the Thomas Burke Memorial Washington State Museum, catalog #1.

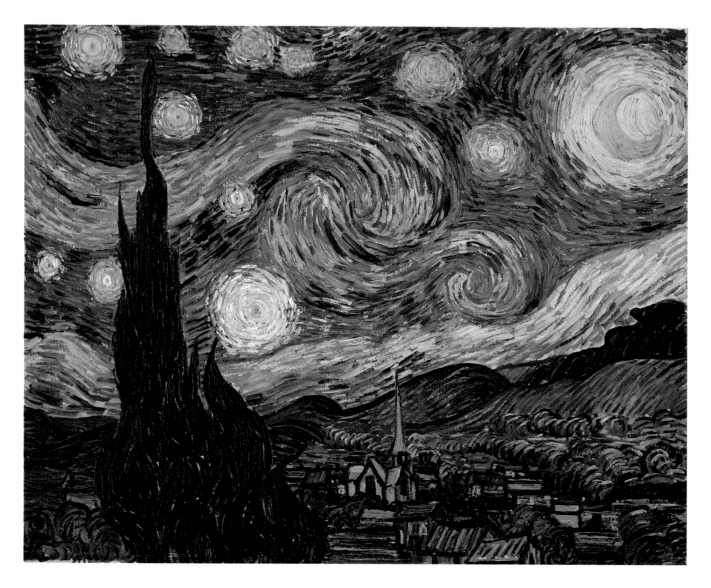

Fig. 71 Vincent van Gogh, *The Starry Night*, 1889. Oil on Canvas, 29 × 36 ¼ in. The Museum of Modern Art, New York. Acquired through the Lillie P. Bliss Bequest.

A second pair of Steir's "drawing lessons" is even more emotionally charged and *expressive*. The "lesson" at the right (Fig. 72) evokes, in its center, one of the basic "signatures" of contemporary abstract painting, the dripping line. A painter such as Robert Motherwell, whose recent etching *Riverrun* is illustrated here (Fig. 73), wishes to suggest, by allowing the paint to drip down the canvas, the very *activity* of painting. Drips also help to convey the sense that the artist's feelings and intuitions are directly and immediately realized before us. And, incidentally, when the canvas is nonobjective, the drips can show us how to hang the work, since they "run" toward the bottom edge.

The frame of Steir's work is meant to evoke the expressive gestures of Vincent van Gogh. Of the swirling turmoil of line that makes up *The Starry Night* (Fig. 71), van Gogh would write to his brother Theo, "Is it not emotion, the sincerity of one's feeling for nature, that draws us…[and are not] the emotions sometimes so strong that one works without knowing one works?" Steir has willingly submitted herself to van Gogh's emotion and style. "Getting into his mark," she says, "is like getting onto a merry-go-round, you can't stop…. It's like endless movement."

Van Gogh's paintings are, for many, some of the most *personally* expressive in the history of art. During the 15 months just before *Starry Night* was painted, while he was living in the southern French town of Arles, just south of the village of St. Remy depicted in the painting, van Gogh produced a truly amazing quantity of work, including 200 paintings, over 100 drawings and watercolors, and roughly 200 letters, mostly written to his brother Theo. Many of these letters help us understand the expressive energies released in this creative outburst. A year before *Starry Night* was painted, for instance, van Gogh wrote to his brother: "To look at the stars always makes me dream, as simply as I dream over the black dots of a map representing towns and villages. Why, I ask myself, should the shining dots of the sky not be as accessible as the black dots on the map of France? If we take the train to Tarascon or Rouen, we take death to reach a star. One thing undoubtedly true in this reasoning is this, that while we are alive we cannot get to a star, any more than when we are dead we can take the train." In *Starry Night*, life and death—the town and the heavens—collide, and they are connected both by the church spire and the swaying cypress, a tree traditionally used to mark graves in southern France and Italy. "My paintings are almost a cry of anguish," van Gogh wrote. On July 27, 1890, a little over a year after *Starry Night* was painted, the artist shot himself in the chest in a field near the village of Auvers, on the Oise River north of Paris. He died two days later at the age of 37.

The expressive line of van Gogh is loose and gestural, so much so that it seems almost out of control. It remains, nevertheless, consistent enough that it is recognizably van Gogh's. It has become, in this sense, *autographic*. Like a signature, it identifies the artist himself, his deeply anguished and creative genius.

Fig. 72 Pat Steir, *Drawing Lesson, Part I, Line #5*, 1978. Portfolio of 7 aquatint etchings, each 16 × 16 in., edition of 25. Courtesy of Crown Point Press, San Francisco.

Fig. 73 Robert Motherwell, *Riverrun*, 1988. Aquatint from one copper plate printed in yellow ochre; lift-ground etching and aquatint from one copper plate printed in black, 18 1/2 × 27 1/2 in. © Robert Motherwell/Dedalus Foundation.

Figs. 74 & 75 Sol LeWitt, *Lines from Four Corners to Points on a Grid*, 1976. Chalk on four painted walls. Installation, Museum of Modern Art, New York, 1978. Collection The Whitney Museum of American Art, New York. Photos: John Weber Gallery, New York.

Sol LeWitt, whose work is the source, incidentally, of another pair of Steir's *Drawing Lessons*, employs a line that is equally autographic, recognizably his own, but one that reveals to us a personality very different from Van Gogh's (Figs. 74, 75, & 76). LeWitt's line is *analytical* where van Gogh's is expressive. LeWitt's **analytic line** is precise, controlled, mathematically rigorous, logical, and rationally organized, where van Gogh's **expressive line** is imprecise, emotionally charged, and almost chaotic. One seems a product of the mind, the other of the heart.

A measure of the removal of LeWitt's art from the personally expressive gestures of van Gogh's is that very often LeWitt does not even draw his own lines. The works are usually generated by museum staff according to instructions provided by LeWitt. If a museum "owns" a LeWitt, it does not own the actual wall drawing but only the instructions on how to make it. As a result, LeWitt's works are temporary, but they are always resurrectable. From time to time, they can and do actually exist. *Lines from Four Corners to Points on a Grid* (Fig. 74) is, in fact, in the collection of the Whitney Museum—that is to say, the instructions for making it are in the Whitney's collection—but it was "borrowed" by the Museum of Modern Art for the installation illustrated here. Since LeWitt often writes his instructions so that the staff executing the drawing must make their own decisions about the placement and arrangement of the lines, it changes from appearance to appearance. Furthermore, the shape of a given wall will alter the way it looks from place to place. In the 1978 installation of *Lines to Points on a Grid* at the Museum of Modern Art, the yellow wall reproduced at the right (Fig. 76) faces the black wall (Fig. 75), but is somewhat narrower than the other three walls because the entrance to the installation occupies a section of its side.

LeWitt's analytic line is closely related to what is widely referred to as **classical line**.

Fig. 76 Sol LeWitt, *Lines from Four Corners to Points on a Grid*, 1976 (detail) Chalk on painted wall. Installation, Museum of Modern Art, New York, 1978. Collection the Whitney Museum of American Art, New York. Photo: John Weber Gallery, New York.

Line and Pattern in Chinese Carved Lacquer Ware

Not only can line possess intellectual, emotional, and expressive content, in certain traditions it can also be used as a stylistic shorthand to represent certain common elements and even to communicate symbolic content that will be recognizable to everyone familiar with the tradition.

The lacquer box illustrated here (Fig. 77) was made by applying dozens and dozens of layers of lacquer on a round box and then carving back into the material. Three distinct linear and geometrical patterns are traditionally used to represent the sky (Fig. 78), water (Fig. 79), and land (Fig. 80). Variations of these background patterns occur again and again in Chinese lacquer ware.

The sky is almost always represented in lacquer ware by a series of parallel horizontal lines formed in interlocking oblong shapes that are linked together to give the effect of a cloudless sky. Figure 81 represents two variations on this theme. Water, usually a lake or a river, is formed by diamond shapes used to indicate waves of various sizes, depending upon whether the water is meant to be calm

Fig. 77 Round box in carved lacquer, showing scene of releasing a crane, Ming dynasty, 1368–1628. National Palace Museum, Taipei, Taiwan, ROC.

Fig. 78 Detail with sky pattern.

Fig. 79 Detail with water pattern.

Fig. 80 Detail with ground pattern.

or turbulent (Fig. 82). The most common pattern representing land is a small flower within a circle or diamond, as on the round box illustrated here.

Another kind of land pattern, based on the Buddhist swastika, is more symbolic in content than these other more representational patterns. In Buddhist tradition, the swastika is a simplified version of the character *wan*, meaning "ten thousand" (Fig. 83). In clothing, furniture, and buildings, the swastika is often combined with the character *shou*, meaning "long life." In the tradition of lacquer ware it represents, more simply, a gathering of ten thousand blessings, or blessed and lucky ground.

Source: Wu Feng-p'ei, "Background Patterns in Lacquer," in *Pearls of the Middle Kingdom: A Selection of Articles from the National Palace Museum Monthly of Chinese Art* (Taipei, Taiwan, ROC: National Palace Museum, 1989), 124–127.

Fig. 81 Examples of sky pattern.

Fig. 82 Examples of water pattern.

Fig. 83 Examples of Buddhist swastika pattern.

Fig. 84 Jacques Louis David, *Study for the Death of Socrates*, 1787. Charcoal heightened in white on gray-brown paper, 20 1/2 × 17 in. Musée Bonnat, Bayonne.

Fig. 85 Jacques Louis David, *The Death of Socrates*, 1787. Oil on canvas, 51 × 77 1/4 in. Metropolitan Museum of Art, New York. Wolfe Fund, 1931. Catherine Lorillard Collection (31.45).

The word "classical" refers to the Greek art of the fifth century B.C., but by association it has come to refer to any art that is based on logical, rational principles, and that is executed in a deliberate, precise manner. In his *Study for the Death of Socrates* (Fig. 84), Jacques Louis David portrays Socrates, the father of philosophy, about to drink deadly hemlock as a result of charges brought against him by the Greek state for supposedly corrupting his students, the youth of Athens, through his teaching. He has submitted the figure to a mathematical grid, a horizontal and vertical framework of lines that organizes the entire painting in its finished version (Fig. 85). Notice especially the gridwork of stone blocks that form the wall behind the figures. The human body is not constructed of parallels and perpendiculars, of course, but David has almost rendered it so.

The structure and control evident in David's classical line is underscored by comparing it to Eugène Delacroix's much more expressive *Study for The Death of Sardanapalus* (Fig. 86). The last king of the second Assyrian dynasty at the end of the ninth century B.C., Sardanapalus was besieged in his city by an enemy army. He ordered all his horses, dogs, servants, and wives slain before him, and all his belongings destroyed, so that none of his pleasures would survive him when his kingdom was overthrown. The drawing, which seems virtually nonobjective at first glance, is a study for the lower corner of the bed, with its elephant-head bedpost, and, below it, on the floor, a pile of jewelry and musical instruments (Fig. 87). The figure of the nude leaning back against the bed in the finished work, perhaps already dead, can be seen at the right edge of the study. Delacroix's line is quick, imprecise, and fluid. His final painting, especially in comparison with the David, seems a flurry of curves, knots, and linear webs. It is emotional, almost violent, while David's painting is calm, in exactly the spirit of Socrates himself.

Fig. 86 Eugène Delacroix, *Study for The Death of Sardanapalus*, 1827–1828. Pen, watercolor, and pencil, 10 ¼ × 12 ½ in. Cabinet des Dessins, Musée du Louvre, Paris.

Fig. 87 Eugène Delacroix, *The Death of Sardanapalus*, 1828. Oil on canvas, 153 ½ × 195 in. Musée du Louvre, Paris.

Fig. 88 *Zeus*, or *Poseidon*, c. 460 B.C. Bronze, height 82 in. National Archeological Museum, Athens.

Fig. 89 Roman copy after Praxiteles, *Aphrodite of Knidos*, 4th century B.C. original. Marble, height 80 in. Vatican Museums, Rome.

One of the difficulties of comparing expressive and analytic and/or classical line is that the discussion can never be limited to a consideration of formal concerns. This is to suggest that, particularly in relation to the human figure, line carries with it a certain cultural burden, inevitably reflecting certain questionable cultural values. So-called classical line—the line of the grid, the line of clarity and precision—is "logical," "rational," and closely identified with the male. So-called expressive line is less clear, less "logical," more emotional and intuitive, and it is characteristically identified with the female form.

Compare, for example, the sculpture of the male figure on the left with the marble of the female on the right. The larger-than-lifesize Greek bronze (Fig. 88), identified by some as Zeus, king of the Greek gods, and by others as Poseidon, Greek god of the sea, has been submitted to very nearly the same mathematical grid as David's Socrates. This is especially evident in the definition of the

god's chest and stomach muscles, which have been sculpted with great attention to detail, and in the extraordinary horizontality of the outstretched left arm. The severe intensity and powerful muscularity of the male god is far removed from Praxiteles's more spontaneous and casual treatment of the female figure (Fig. 89). Completed more than 100 years after the Zeus, it renders Aphrodite, the Greek goddess of beauty and love, in virtually antimathematical terms. Every angle of her figure is softened and rounded, so that her body seems to echo the gentle folds of the drapery that she drops over the vase to her left. Her weight is shifted entirely over her right foot, and her hip is thus thrust out to the right, in order to emphasize the essential curvilinear structure of her anatomy.

Consider also Ingres's giant *Jupiter and Thetis* of 1811 (Fig. 90), not only is the adoring Thetis composed of an array of curves as soft as the folds of the drapery covering her lower body, but she is much smaller

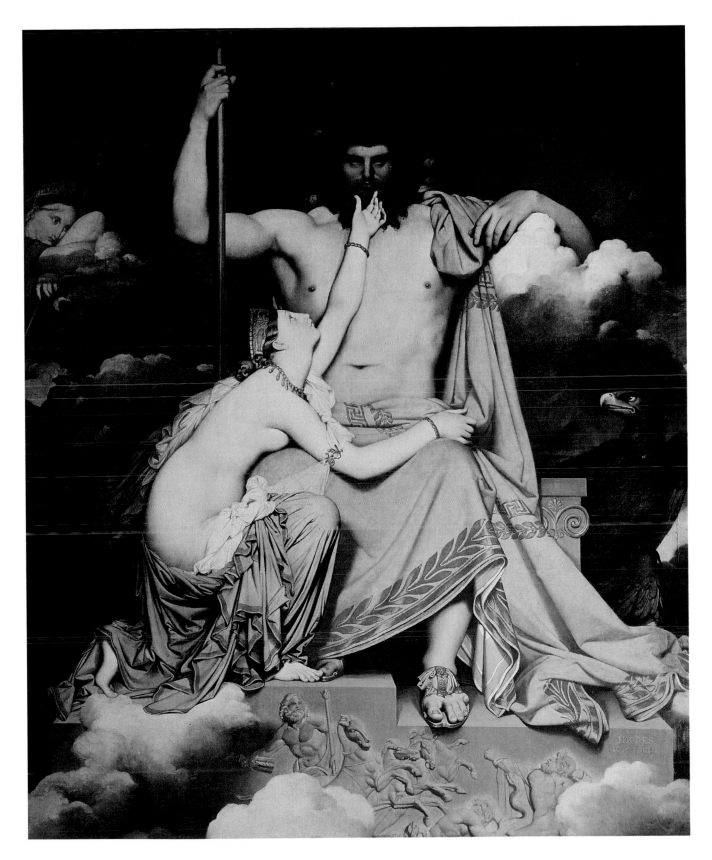

Fig. 90 Jean-Auguste-Dominique Ingres, *Jupiter and Thetis*, 1811. Oil on canvas, 130 ⅝ × 101 ¼ in. Musée Granet, Aix-en-Provence.

Fig. 91 Robert Mapplethorpe, *Lisa Lyon*, 1980. © 1980 The Estate of Robert Mapplethorpe.

than the giant god at whose feet she kneels. The grand and indifferent Jupiter, like the vertical and horizontal lines that define him, is the personification of reason and power—the male—while Thetis is the embodiment of the sensual and the submissive—the female.

While conventional representations of the male and female nude carry with them recognizably sexist implications—man as strong and rational, woman as weak and given to emotional outbursts—these same conventions can, of course, be undermined and reversed. Robert Mapplethorpe's photograph (Fig. 91) portrays Lisa Lyon, winner of the First World Women's Bodybuilding Championship in Los Angeles in 1979, in the pose of a male bodybuilder, a pose imitated by every male who has ever stood before a mirror and flexed.

Lyon has self-consciously composed herself, especially her upper torso and arms, in an arrangement of right angles, as hard as the rocks on which she stands. Sylvia Sleigh's *Philip Golub Reclining* (Fig. 92) depicts the male model in a distinctly feminine pose, reminiscent of Velázquez's *Rokeby Venus* (Fig. 93). Sleigh's portrait is composed of sensual, curvilinear lines (in stark contrast to the forceful and upright representation of the painter herself, reflected in the mirror).

Both artists reverse stereotypes in these works. Mapplethorpe not only subverts conventional representations of the female, but Lyon reveals the male position as a sort of posturing in its own right. Sleigh's reclining nude disconcertingly submits the male figure to a gaze that has culturally always been the right of the male. The point here is a simple one: we are able to recognize both of these works as *reversals* of the norm, because we approach representations of the male and female nude with certain culturally encoded expectations about the kinds of line and form that can and should be used to depict them.

Fig. 92 Sylvia Sleigh, *Philip Golub Reclining*, 1971. Oil on canvas, 42 × 60 in. Courtesy of the artist.

Fig. 93 Velázquez, *Venus and Cupid* (known as the *Rokeby Venus*), c. 1651. Oil on canvas, 48 1/4 × 69 3/4 in. National Gallery, London.

Pornography in the Public Eye

While many of Robert Mapplethorpe's studies of the nude figure are classical in character—notice, for instance, how the arms and shoulders of this model (Fig. 94) form an almost perfect pentagon—much of his work has been attacked as pornographic. Perhaps because Mapplethorpe was a homosexual, many have not been able to accept that his work possesses any artistic value; rather, they suppose that it is designed to appeal only to prurient, or lustful, interests.

After Mapplethorpe died of AIDS early in 1989, a traveling retrospective of his work was scheduled to open in July 1989 at the Corcoran Gallery in Washington, D.C. It included photographs from the "X" series, a group of sado-masochistic works. In the context of these photographs even entirely classical compositions such as the one above were considered by some to be obscene. When Senator Jesse Helms of North Carolina learned that the National Endowment for the Arts had in part funded the exhibition, he threatened in Congress to reduce or even eliminate the Endowment's budget. Wishing to avoid confrontation, the Corcoran canceled the show. It opened, nevertheless, in another small Washington gallery, Project for the Arts, where 40,000 people visited it in three weeks.

When the exhibition opened at the Contemporary Arts Center in Cincinnati, Ohio, in April 1990, it was raided by local authori-

ties, and the Museum's director, Dennis Barrie, was charged with pandering and with the use of a minor in pornography. These charges revolved around an image unrelated to the "X" photographs, a portrait of a little girl with her genitals exposed beneath her dress. It could more easily be understood, in fact, as an image of childhood innocence than as pornography. Barrie was subsequently acquitted, and attendance at the exhibition set records.

It is worth recalling, in this context, that when Horatio Greenough first unveiled his semi-nude representation of George Washington (Fig. 95) in the Capitol Rotunda in 1841, both Congress and the public by and large ignored its clear reference to classical Greek art, and instead expressed dismay at the figure's nudity. Greenough had Phidias's *Zeus* specifically in mind. Despite the nobility of the reference, the sculpture was removed from the Rotunda in 1843 and placed on the Capitol grounds. Subjected to snow, soot, and pigeons for many years, it was finally moved into storage in the Smithsonian Institution in 1908 where it remained for fifty years. Currently, it rests in one of the main corridors of the Museum of History and Technology in Washington.

Fig. 94 (left) Robert Mapplethorpe, *Ajitto*, 1981. © 1981 The Estate of Robert Mapplethorpe.

Fig. 95 (right) Horatio Greenough, *George Washington*, 1832–1841. Marble, height 12 ft. National Museum of American Art, Washington, D.C.

Fig. 96 Robert Adams, *North of Broomfield, Boulder County, Colorado*, 1973. From *To Make It Home: Photographs of the American West*, 1989.

Fig. 97 Robert Adams, *Lakewood, Colorado*, 1974. From *To Make It Home: Photographs of the American West*, 1989.

Space

A fourth, important characteristic of line is that it *serves to organize the work of art*. As it does so, it creates a sense of **space**.

Actual space is **three-dimensional**. The world that we live in (our homes, our streets, our cities) has been carved out, so to speak, of this space. It is, for instance, tempting to see Robert Adams's 1973 photograph of the landscape north of Broomfield, Colorado (Fig. 96) as *empty* space, waiting to be filled by the sort of development he has photographed going up in nearby Arvada (Fig. 97). In many ways, Adams's photographs, from a collection entitled *To Make It Home: Photographs of the American West*, are about the loss of the space that he knew as a boy. In an essay that accompanies this collection, Adams recalls as a youth in the early 1950s helping to take campers on horse pack trips through Rocky Mountain National Park (the tallest peak in the Park, incidentally—Long's Peak—can be seen rising above the other mountains exactly in the middle of Fig. 96):

> The landscapes I saw that season were for me formative, and have remained vivid in remembrance partly because of the hushed isolation in which we encountered them; it was unusual to meet anyone at all on the trail for days at a time. Twenty years later, however, it had become unusual to follow a major trail for more than five or ten minutes—minutes, not days—without meeting long lines of hikers.... When I have the strength to be honest, I do not hope to experience again the space I loved as a child. The loss is the single hardest fact for me to acknowledge.... How we depended on space, without realizing it—space which made easier a civility with each other, and which made plainer the beauty of light and thus the world.

If Adams's photographs represent the loss of one kind of space and the rise of another, both spaces are equally full, but full in different ways. We experience space in each instance in different terms. In the first, the space is open, and the possibilities before us seem almost limitless. In the second, space is closing in upon us. It is not hard to think of the landscape in this second photo-

graph as overrun by a profusion of lines—forming cities, streets, walls, and rooms—and it is easy to see in the geometry of these lines the image of civilization, with its rationality and order, burying nature beneath its weight.

In much the same way, painters begin with an empty canvas that is an open space, full of possibilities, though the canvas is a more neutral ground upon which to work than a landscape. Furthermore, the space of a canvas is in reality **two-dimensional**—that is, it is flat, possessing height and width, but no depth. A sense of depth can only be achieved by means of *illusion*.

The instant we place a black shape on the white surface of the picture plane, a sense of depth is achieved. In Figure 98, the black vase seems to sit in front of its white background. But when, conversely, we recognize this figure as two white heads seen in profile facing one another in front of a black background, our perceptual experience of the same space is radically altered. What was the foreground vase becomes the background space. Such *figure-ground* reversals help us recognize how our perceptual experience fundamentally depends upon our recognition of spatial relationships between a thing and what lies behind it, its background.

When we surround empty space in such a way as to frame it or outline it, the empty space becomes shaped and can acquire a sense of volume and form that, in reality, it does not possess. Such spaces are called **negative spaces** or **negative shapes**. In Richard Diebenkorn's *Two Nudes* (Fig. 99), the untouched white ground of the paper—also called the **reserve**—is surrounded by drawing in ink so that it seems to stand forward from the paper itself to become the nude's body. We no longer read this white space as background, but rather as an illuminated flesh. The body stands out as whiteness, which is the whiteness of the paper itself. The same sort of effects can

Fig. 98 Rubin vase.

Fig. 99 Richard Diebenkorn, *Two Nudes*, 1962. Graphite and gouache on paper, 13 15/16 × 16 7/8 in. Collection of Glenn C. Janss Collection.

Fig. 100 Barbara Hepworth, *Two Figures*, 1947–1948. Elmwood and white paint, 38 × 17 in. Frederick R. Weisman Art Museum, University of Minnesota, Minneapolis.

be achieved in three-dimensional terms. Barbara Hepworth's *Two Figures* (Fig. 100) consists of two vertical masses into which she has carved negative shapes that are painted white. Especially in the left-hand figure, these negative shapes suggest anatomical features, so that the top round indentation suggests a head, the middle hollow a breast, and the bottom hole a belly.

There are many ways to create the illusion of deep space on the really flat surface of the paper or canvas, and most are used simultaneously. Objects close to the viewer—in the foreground of the composition—appear larger than objects farther away, creating a change in *scale*. Objects closer to the viewer *overlap* and cover other objects behind them. In Caspar David Friedrich's *Sunday Morning* (Fig. 101), the woman looking out at the rising sun is *literally* larger than the mountains in the "distance," and

Fig. 101 Caspar David Friedrich, *Woman in Morning Light*, 1818. Oil on canvas, 8 3/4 × 11 3/4 in. Museum Folkwang, Essen, Germany.

she blocks out our view of the sun, but we do not think of her as a giant. Rather we simply recognize that she is closer to us in space. Her position is, in fact, metaphorically our own, as we look out, together, on the new day with all its possibility and promise. And just as the rays of the sun seem to fan out before her, her arms fan out from her sides in a corresponding gesture.

In her monumental multimedia work *Night Shade* (Fig. 102), Miriam Schapiro has chosen an explicitly feminine image, the fan with which fashionable women used to cool themselves. Partially painted and partially sewn out of fabric, it intentionally brings to mind the kinds of domestic handiwork traditionally assigned to women as well as the life of leisure of the aristocratic lady. The structure of Schapiro's painting, her use of line, closely resembles the fanlike rays of the sun that emanate from the center of Friedrich's painting. And yet, to our eyes, the Friedrich seems three-dimensional while the Schapiro is clearly two-dimensional and flat. This is partly due, of course, to the fact that Friedrich is interested in representing real space whereas Schapiro concerns herself more with abstract design. But it is also a result of the fact that Friedrich employs certain principles of **perspective** that we readily read as representing "real," that is, three-dimensional space.

Perspective itself is a system, known to the Greeks and Romans but not mathematically codified until the Renaissance, that in simplest form, allows the picture plane to function as a window through which a specific scene is presented to the viewer. In this system, lines are drawn on the picture plane in such a way to represent parallel lines converging at a point or points on the viewer's

Fig. 102 Miriam Schapiro, *Night Shade*, 1986. Acrylic and fabric collage on canvas, 48 × 96 in. Private Collection.

Fig. 103 Leonardo da Vinci, *The Last Supper*, c. 1495–1498. Mural (oil and tempera on plaster), 15 ft. 1 1/8 in. × 28 ft. 10 1/2 in. Refectory, Monastery of Santa Maria delle Grazie, Milan, Italy.

Fig. 104 Perspective analysis of *The Last Supper*.

horizon. This principle of construction informs Leonardo da Vinci's famous depiction of *The Last Supper* (Fig. 103) as well. The architectural lines of the room's ceiling and walls are all directed to a point directly behind Christ's head, as if in radiating from the Son of God, they are also rays coming from the "sun" (Fig. 104). This sun motif is echoed by the arc formed by the upper portion of the window behind Christ, which is the only curved line in the architecture of the room.

 The Last Supper is an example of **one-point linear perspective**. Not only does this system focus our attention on Christ, but because the painting's architecture, in a case of heightened illusion, appears to be continuous with the actual architecture of the Refectory of the Monastery of Santa Maria delle Grazie itself, it seems as if the world outside the space of the painting is thus organized around Christ as well. Everything in the architecture of the painting and the Refectory draws our attention to Him. His gaze controls our world.

Space in Japanese Woodblock Prints

Beginning in the late 1730s, Japanese artists became increasingly aware of Western perspective systems, and they began to incorporate this new way of seeing into their art. Harushige's *Beauty on the Balcony* (Fig. 105) combines highly skillful Western perspective, on the left, where the space of the veranda stretches out to the landscape beyond, with, on the right, a more traditional rendering of both the courtesan and the interior space behind her that, in its flatness, is typical of earlier Japanese woodblock prints. (Notice that the receding lines of the roof do not come close to meeting the vanishing point established by the veranda.)

By the 1850s, when Ando Hiroshige published his famous *One Hundred Famous Views of Edo*, this collision of local tradition and the new foreign way of seeing could be used to telling effect. In his view of Shinjuku (Fig. 106), a brothel quarter just outside the gates of Tokyo (Edo, as it was then known), the flat hindquarters of the horses, and the droppings at their feet, stand in stark contrast to the artificially perfumed world of the brothels beyond, rendered in deep perspective. Tradition thus comments upon the depraved contemporary scene.

These prints belong to a tradition known as Ukiyo-e, a Buddhist term that has come to mean "the floating world." The prints covered a wide range of subjects, but mainly centered on the pleasures of everyday life. They reflect, in this sense, the peace and prosperity of the Edo period in Japan (1615–1868). Beginning in the 1860s, large numbers of these prints made their way to Europe where they were to have a profound effect upon Western art.

Source: Kirk Varnedoe, *A Fine Disregard: What Makes Modern Art Modern* (New York: Abrams, 1990).

Fig. 105 Suzuki Harushige, *Beauty on the Balcony*, c. 1771. Woodblock print. Tokyo National Museum, Japan.

Fig. 106 Hiroshige, *Naito Shinjuku, Yotsuya*. From the series *One Hundred Famous Views of Edo*, 1857. Woodblock print, 13 1/4 × 8 5/8 in. The Brooklyn Museum, x896.86.

Fig. 107 A. M. Cassandre, *Nord Express*, 1927. Poster, ad for Belgian Railway's Nord Express. Collection Merrill C. Berman.

A. M. Cassandre's poster advertising the Belgian Railway's Nord Express, or "Northern Express" (Fig. 107), is another example of one-point linear perspective. But in this instance, the **vanishing point**—that is, the point on the horizon line where all the parallel lines seem to converge—is far to the right. In one-point perspective, the vanishing point is directly opposite the **vantage point**, that is, the point from which we view the scene. In the two drawings at the right (Fig. 108), the vanishing point changes as the vantage point changes. In the drawing above, the vanishing point recedes *frontally*—that is, directly away from our point of view—while in the drawing below it recedes *diagonally*, at an angle to the viewer. The train in Cassandre's poster recedes diagonally, while the electric wires above the viewer's head recede frontally.

Gustave Caillebotte's *Place de l'Europe* (Fig. 109), is an example of **two-point linear perspective**. Here, two (and even more) vanishing points organize a complex array of parallel lines emanating from the intersection of the five Paris streets depicted. Notice, however, that Caillebotte has imposed order on this complex scene by dividing the canvas into four equal rectangles formed by the vertical lamp post and the horizon line, which meet in the center of the painting.

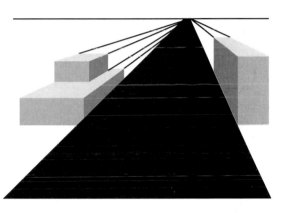

Fig. 108 Two examples of one-point linear perspective. Above, vantage point at center street-level (frontal recession); below, vantage point at elevated position, high right (diagonal recession).

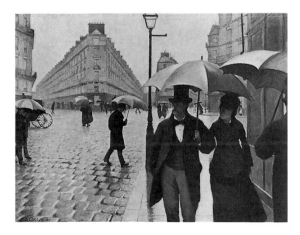

Fig. 109 Gustave Caillebotte, *Place de l' Europe on a Rainy Day*, 1877. Oil on canvas, 83 1/2 × 108 3/4 in. Charles H. and Mary F. S. Worcester Collection, © 1993, The Art Institute of Chicago, All Rights Reserved.

Fig. 110 Two-point linear perspective.

Fig. 111 George Barker, *Sunset—Niagara River (no. 609)*, c. 1870–1875. Stereograph. International Museum of Photography at George Eastman House, Rochester, NY.

The space created by means of linear perspective is closely related to the space created by photography, the medium we accept as representing "real" space with the highest degree of accuracy. The picture drawn in perspective and the photograph both employ a *monocular*, that is, one-eyed, point of view that defines the picture plane as the base of a pyramid, the apex of which is the single lens or eye. Our actual vision, however, is *binocular*. We see with both eyes. If you hold your finger up before your eyes and look at it first with one eye closed and then with the other, you will readily see that the point of view of each eye is different. Under most conditions, the human organism has the capacity to synthesize these differing points of view into a unitary image.

In the nineteenth century, the stereoscope was invented precisely to imitate binocular vision. Two pictures of the same subject, taken from slightly different points of view, were viewed through the stereoscope, one by each eye. The effect of a single picture was produced, with the appearance

Fig. 112 Photographer unknown, *Man with Big Shoes*, c. 1890. Stereograph.

of depth or relief, a result the divergence of the point of view. As George Barker's stereoscope of the *Niagara River* (Fig. 111) makes clear, the difference between the two points of view is barely discernible if we are looking at relatively distant objects. But if we look at objects that are nearby, as in the stereoscopic view of the *Man with Big Shoes* (Fig. 112), then the difference is readily apparent.

One disadvantage faced in both the linear perspective system and photography is that both can make objects close to the vantage point appear to be distorted or disproportionate in size in relation to the whole. In order to avoid the kind of prominence given the feet of the subject in *Man with Big Shoes*, the photographer would have had to change the position from which the shot was taken. As the cartoon (Fig. 113) suggests, the unsuspecting amateur would probably consider such a representation a "failure," though the comic effect of these large feet is probably intentional in the work of the anonymous photographer.

Fig. 113 F. Opper, *A Failure*, 1895. Ink drawing. Reproduced from *The Picture Magazine*, London.

Fig. 114 Albrect Dürer, *Draftsman Drawing a Reclining Nude*, from *The Art of Measurement*, c. 1527. Woodcut 3 × 8 ½ in. Museum of Fine Arts, Boston, Horatio Greenough Curtis Fund.

Fig. 115 Phillip Pearlstein, *Model on Dogon Chair, Legs Crossed*, 1979. Watercolor, 29 ½ × 49 ¼ in. Hirschl & Adler Modern, New York.

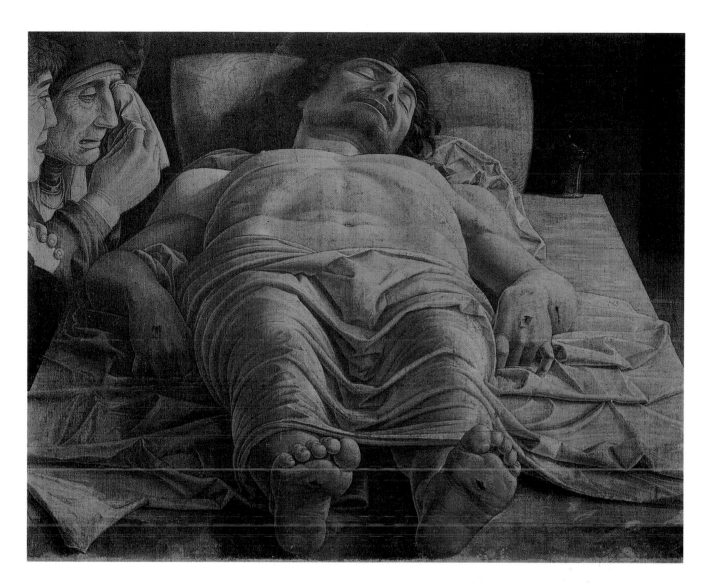

Fig. 116 Andrea Mantegna, *The Dead Christ*, c. 1501. Tempera on canvas, 26 × 30 in. Brera Gallery, Milan.

Painters can make up for such distortions in ways that photographers cannot. If the artist portrayed in Dürer's woodcut (Fig. 114) were to draw exactly what he sees before his eyes, he would end up with a composition not unlike that achieved by Phillip Pearlstein in his watercolor (Fig. 115), a nude whose feet and calves are much larger than the rest of her body. Pearlstein is deliberately painting exactly what he sees, in order to draw our attention to certain formal repetitions and patterns in the figure. Note, for instance, the way that the shape of the nearest foot repeats the shape of the shadowed area beneath the model's buttocks and thigh. But Andrea Mantegna was not interested at all in depicting *The Dead Christ* (Fig. 116) with disproportionately large feet. Such a representation would make comic or ridiculous a scene of high seriousness and consequence. It would be *indecorous*. Thus Mantegna has employed **foreshortening** in order to represent Christ's body. In foreshortening, the dimensions of the closer extremities are adjusted in order to make up for the distortion created by the point of view.

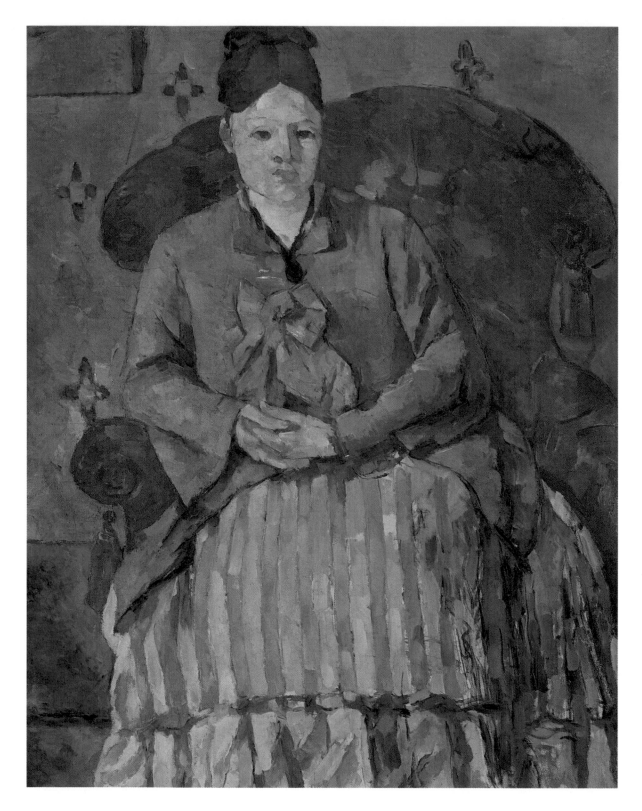

Fig. 117 Paul Cézanne, *Mme. Cézanne in a Red Chair*, 1877. Oil on canvas, 28 ¹/₂ × 22 in. Museum of Fine Arts, Boston. Bequest of Robert Treat Paine II.

In the modern era, artists have very often intentionally violated the rules of perspective in order to draw the attention of the viewer to elements of the composition other than its *verisimilitude*, or the apparent "truth" of its representation of reality. What one notices most of all in Cézanne's *Mme. Cézanne in a Red Chair* (Fig. 117) is its very lack of spatial depth. Although the arm of the chair seems to project forward on the right, on the left the painting is almost totally flat. The blue flower pattern on the wallpaper seems to float above the spiraled end of the arm, as does the tassel that hangs below it, drawing the wall far forward into the composition. The line that establishes the bottom of the baseboard on the left seems to ripple on through Mme. Cézanne's dress. But most of all, the assertive vertical stripes of that dress, which appear to rise straight up from her feet parallel to the picture plane, deny Mme. Cézanne her lap. It is almost as if a second, striped vertical plane lies between herself and the viewer.

By this means Cézanne announces that it is not so much the accurate representation of the figure that interests him as it is the *design* of the canvas and the activity of painting itself. We are looking not so much at a portrait of his wife as we are at a play of pattern and color. Cézanne draws our attention to the *act* of the composition—as opposed to the *subject matter* of the composition—even more dramatically in his *Still Life with Cherries and Peaches* (Fig. 118). In this painting, it is as if Cézanne has rendered two entirely different views of the same still life simultaneously. The peaches on the right are seen from a point several feet in front of the table, while the cherries on the left have been painted from directly above. As a consequence the table itself seems to broaden out behind the cherries. As in *The Basket of Apples* (Fig. 54), the artist's goal is to activate, to give animate life to, the *still* life. The painting is not so much a thing in itself, as it is an activity of mind, a process of the artist's perceiving.

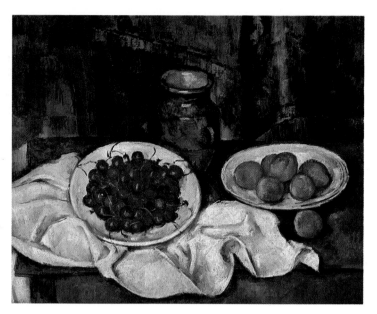

Fig. 118 Paul Cézanne, *Still Life with Cherries and Peaches*, 1883–1887. Oil on canvas, 19 3/4 × 24 in. Los Angeles County Museum of Art, Mrs. Armand S Deutsch.

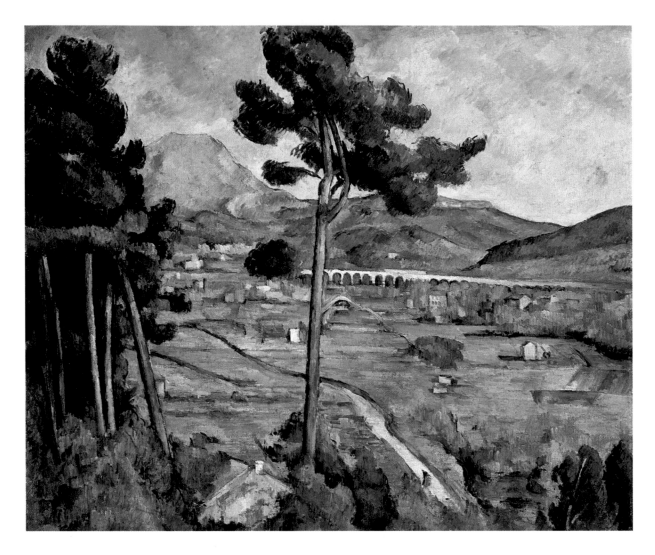

Fig. 119 Paul Cézanne, *Mont Sainte-Victoire, Seen from Bellevue*, also known as *The Viaduct*, 1882–1885. Oil on canvas, 25 ³/₄ × 32 ¹/₈ in. The Metropolitan Museum of Art, New York. Bequest of Mrs. H. O. Havemeyer, 1929. The H. O. Havemeyer Collection (29.100.64).

The history of modern art has often been summarized as the growing refusal of painters to represent three-dimensional space and the resulting emphasis placed on the two-dimensional space of the picture plane. It is perhaps better to think in terms of the modern artist's growing interest in bringing the three-dimensional into dialogue with the two-dimensional. Paul Cézanne's *Mont Sainte-Victoire* (Fig. 119) collapses the space between foreground and background by making a series of formal correspondences between them. The painting is divided, in two-dimensional terms, into more or less equal areas by elements that exist in widely separated three-dimensional space—the ver-

tical tree in the foreground and the horizontal viaduct at the base of the hills. The viaduct is itself confusing, reading to many first-time viewers as a lake with round-topped trees bordering it. Foreground and background are further drawn together by a repetition of shape in the lower righthand branch of the tree, the road below it, and the shape of the mountain itself. Finally, after viewing the painting for some time, it becomes apparent that it is logically impossible for the green tree at the left end of the viaduct to be as large as it appears to be. In fact, this giant tree is a branch of the tree in the foreground.

Georges Braque's *Houses at l'Estaque* (Fig. 120) takes many of the elements introduced by Cézanne a step further. The tree that rises from the foreground seems to meld into the roofs of the distant houses near the top of the painting. At the right, a large, leafy branch projects out across the houses, but its leaves appear identical to the greenery that is growing between the houses behind it. It becomes impossible to tell what is foreground, what is not. The houses that descend down the hill before us are themselves spatially confusing. Walls bleed almost seamlessly into other walls, walls bleed into roofs, roofs bleed into walls. Braque presents us with a design of triangles and cubes as much as he does a landscape. While the tree on the left and the leafy branch on the right create a strong diagonal pull into the space—a space reinforced by the roof lines of many of the houses—the actual recession of buildings in the space moves from bottom left to top right in a direction opposite that framed by the trees. Like the trees themselves, we visually enter the scene from the bottom right, but we are drawn around and up to the top right. The space of the painting is, as a result, intentionally destabilized. Nothing quite falls into place. The world depicted here is contradictory and ambiguous.

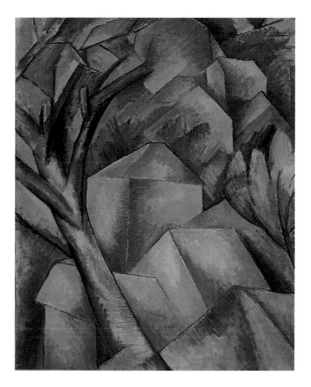

Fig. 120 Georges Braque, *Houses at l'Estaque*, 1908. Oil on canvas, 28 3/4 × 23 3/4 in. Kunstmuseum, Berne, Hermann and Margit Rupf Foundation.

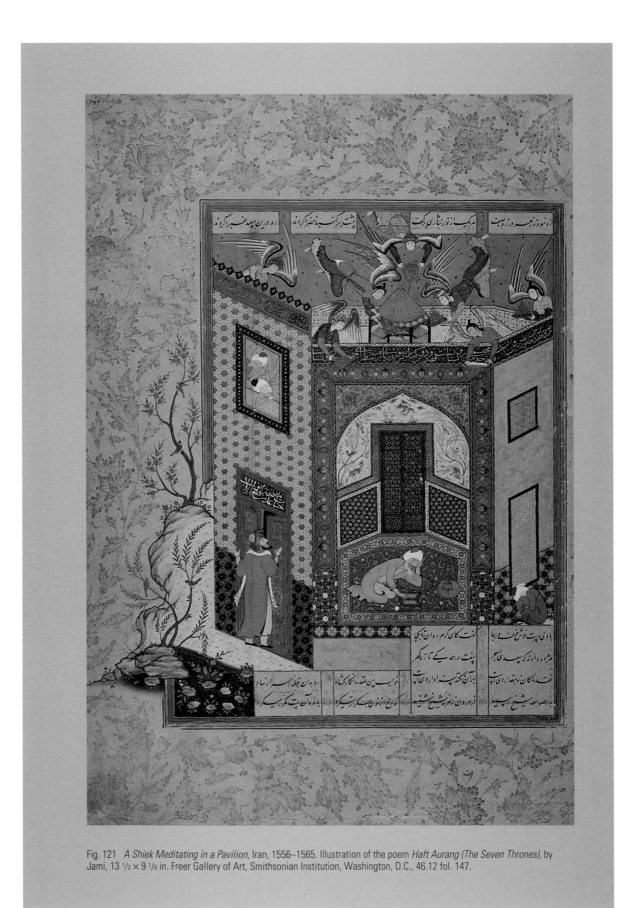

Fig. 121 *A Shiek Meditating in a Pavilion*, Iran, 1556–1565. Illustration of the poem *Haft Aurang (The Seven Thrones)*, by Jami, 13 1/2 × 9 1/8 in. Freer Gallery of Art, Smithsonian Institution, Washington, D.C., 46.12 fol. 147.

Space in Figurative Muslim Miniatures

Between the thirteenth and late seventeenth centuries, Muslim art was dominated by a rich tradition of figurative painting. The hadiths, or traditional legends, appended to the Koran forbid the depiction of living beings in works of art, but these miniatures, or manuscript illustrations, were not the product of an outlaw movement. On the contrary, this figurative work was widely accepted and enjoyed in the Muslim world.

The key to understanding this success is to recognize that the space depicted in these works is not "real," nor are the people depicted "living." What is forbidden in Muslim law is the portrait, the imitation of a particular individual, particularly a holy or religious person.

When the French explorer Chardin traveled to Persia between 1664 and 1677 and commented, with a definite air of superiority, that the Persians had no knowledge of perspective, he missed the point. The lack of perspectival "reality" in Muslim miniatures is intentional and emphasizes the artificiality of the scene.

Both reproductions here illustrate poems written by religious mystics, and, as a result, the figures depicted are themselves fictional. The way in which the landscape, in the painting on the left, melds into the two-dimensional design of the border emphasizes the scene's artificiality. Angels hover overhead, adding to the sense of fantasy. Similarly, the figures in the improbable landscape on the right seem to fly across the flattened space of the scene. Notice, in fact, how the horse on the right seems to fly into the picture from somewhere outside the frame. The space of these works is in fact entirely imaginary. Nothing here is "real."

Source: Alexandre Papadoupoulo, *Islam and Muslim Art* (New York: Abrams, 1979).

Fig. 122 *Darius and the Herdsman,* Iranian (Bukhara), mid-16th century. Ink, colors and gold paper, 11 1/2 × 7 3/4 in. The Metropolitan Museum of Art, New York. Frederick C. Hewitt Fund, 1911 (11.134.2).

In his large painting *Harmony in Red* (Fig. 123), Henri Matisse has almost completely eliminated any sense of three-dimensionality by uniting the different spaces of the painting in one large field of uniform color and design. The wallpaper and the tablecloth are made of the same fabric. The chair at the left seems abnormally large, as if very close to our point of view, and yet its back stands at the same height as the chair between the table and the wall. Shapes are repeated throughout: the spindles of the chairs and the tops of the decanters echo one another, as do the maid's hair and the white foliage of the large tree outside the window. The tree's trunk repeats the arabesque design of the tablecloth directly below it. Even the window can be read in two ways: it could, in fact, be a window opening to the world outside, or it could be the corner of a painting, a framed canvas lying flat against the wall. If, in traditional perspective, the frame functions as a window, now the window has been transformed into a frame.

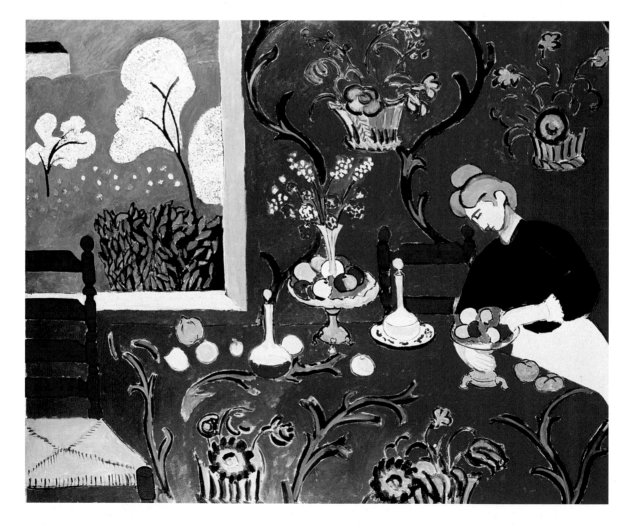

Fig. 123 Henri Matisse, *Harmony in Red (The Red Room)*, 1908. Oil on canvas, 70 7/8 × 86 5/8 in. The Hermitage, St. Petersburg.

Some Other Means of Representing Space

Linear perspective does manage to create the illusion of actuality. Other systems of projecting space, however, are available. These so-called **axonometric** projections (Fig. 124) are employed, in particular, by architects and engineers and have the advantage of translating space in such a way that all measurements are to the same scale and that the distortions of scale common in linear perspective are eliminated. In axonometric projections all lines remain parallel, rather than receding to a common vanishing point, and all sides of the object are at an angle to the picture plane.

Another related type of projection commonly found in Japanese art, especially before the introduction of Western perspective, is **oblique** projection. In this system, one face of the object is parallel to the picture plane. This hanging scroll (Fig. 125) depicts the three sacred Shinto-Buddhist shrines of Kumano, south of Osaka, Japan, in oblique perspective. The shrines are actually about 80 miles apart, the one at the bottom of the scroll high in the mountains of the Kii Peninsula in a cypress forest, the middle one on the eastern coast of the peninsula, and the top one near a famous waterfall that can be seen to its right. Although the artist gives a sense of distance by making each shrine smaller as we rise in the composition, all three shrines are linked up into a single scene, that is broken up by broad sweeps of landscape.

Fig. 124 Theo van Doesburg and Cornelius van Eesteren, *Color Construction*, Project for a private house, 1922. Gouache, 22 1/2 × 22 1/2 in. Collection, The Museum of Modern Art, New York. Edgar J. Kaufmann, Jr. Fund.

Fig. 125 *Kumano Mandala: The Three Sacred Shrines*, Kamakura period, c. 1300. Hanging scroll, ink and color on silk, 52 1/4 × 24 1/4 in. Cleveland Museum of Art. Purchase, John L. Severance Fund.

Fig. 126 Edouard Manet, *Bar at the Folies-Bergère*, 1881–1882. Oil on canvas, 37 ³/₄ × 50 in. Courtauld Institute Galleries, London.

This doubling of space, the sense that we are simultaneously looking at both two- and three-dimensional scenes, is also apparent in Edouard Manet's *Bar at the Folies-Bergère* (Fig. 126), where the mirror behind the barmaid at once flattens our field of vision and extends it. The barmaid is standing directly in front of us, behind a marble countertop. Behind her, reflected in a mirror that extends across the painting, we see the grand hall of the Folies-Bergère, a famous Paris nightclub. We are, apparently, on the second floor balcony. Across the way, behind us, patrons peer over the railing. In the upper lefthand corner, the feet of a trapeze artist swing into view. But where, in fact, are we standing? The barmaid, whose back is reflected in the mirror to the right, is being addressed by a gentleman who seems

to be standing in our place. But the barmaid ignores him (and us), lost in a mental space of her own. Manet activates multiple levels of "reality" here—our own, the barmaid's, and the gentleman's—that cannot be matched in real space.

Light

The manipulation of perspective systems is by no means the only way that space is created in art. For Leonardo da Vinci, light was at least as important to the rendering of space as perspective. The effect of the atmosphere on the appearance of elements in a landscape is one of the chief preoccupations of his *Notebooks*, and it is fair to say that Leonardo is responsible for formulating the "rules" of what we call **atmospheric** or **aerial perspective**. Briefly, as the

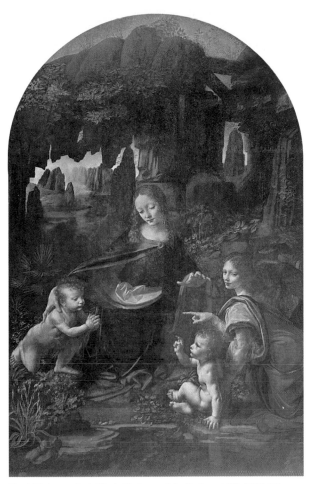

Fig. 127 Leonardo da Vinci, *Madonna of the Rocks*, c. 1495–1508. Oil on panel, 75 × 47 in. National Gallery, London.

distance between us and large objects, such as mountains, increases, the quality of the atmosphere (the haze and relative humidity) between us and the objects changes their appearance. Objects further away from us appear less distinct, often cooler or bluer in color, and the contrast between light and dark is reduced.

Clarity, precision, and contrast between light and dark dominate the foreground elements in Leonardo's *Madonna of the Rocks* (Fig. 127). The Madonna's hand extends over the head of the infant Jesus in an instance of almost perfect perspectival foreshortening. And yet perspective has little to do with the way in which we perceive the space of the distant mountains over the Madonna's right shoulder. We assume that the rocks in the far distance are the same brown as those nearer us, yet the atmosphere has changed them, making them appear blue. We know that of these three distant rock formations, the one nearest us is on the right, and the one farthest away is on the left. Since they are approximately the same size, if they were painted with the same clarity and the same amount of contrast between light and dark, we would be unable to place them spatially. We would see them as a horizontal wall of rock, parallel to the picture plane, rather than as a series of mountains, receding diagonally into space.

Fig. 128 J. M. W. Turner, *Rain, Steam, and Speed—The Great Western Railway*, 1844. Oil on canvas, 33 3/4 × 48 in. Clore Collection, Tate Gallery, London.

By the nineteenth century, aerial perspective had come to dominate the thinking of landscape painters. When, in 1807, J. M W. Turner was appointed Professor of Perspective at the Royal Academy he prepared many large drawings and watercolors to illustrate his lectures. These included many straightforward examples of linear perspective based on famous British buildings, including this bridge built in Bath in 1750 (Fig. 129). Though he was not considered a good speaker, his audience faithfully attended the lectures, which he continued until 1828, largely to see these drawings. Yet despite the time he devoted to linear perspective, Turner always insisted that it was less important to the painter than aerial perspective, which, he wrote in his lecture notes, "is the end…[and] means of all our toil, and to this every department of the art looks, and labours to attain."

A painting like *Rain, Steam, Speed—The Great Northern Railway* (Fig. 128) certainly employs linear perspective: we stare over the River Thames across the Maidenhead Bridge, which was completed for the Railway's new Bristol and Exeter line in 1844, the year Turner painted the scene. But the space of this painting does not depend upon linear perspective. Rather, it is light and atmosphere that dominate it, creating a sense of space that in fact overwhelms the painting's linear elements in luminosity. Turner's light is at once so opaque that it conceals everything behind it and so deep that it seems to stretch beyond the limits of vision. Describing the power of Rembrandt's *The Mill* (Fig. 130) in a lecture delivered in 1811, Turner would praise such ambiguity: "Over [the Mill] he has thrown that veil of matchless color, that lucid interval of Morning dawn and dewy light on which the Eye dwells…[and he] thinks it a sacrilege to pierce the mystic shell of color in search of form." With linear perspective one might adequately describe physical reality—a building, for instance—but through light one could reveal a greater spiritual reality.

Fig. 129 J. M. W. Turner, *Perspective Illustration: Pulteney Bridge*, c. 1810. Watercolor, 26 1/2 × 39 5/8 in. Clore Collection, Tate Gallery, London.

Fig. 130 Formerly attributed to Rembrandt van Rijn, *The Mill*, c. 1650. Oil on canvas, 34 3/8 × 41 1/2 in. National Gallery of Art, Washington, D.C.

Fig. 131 Tinteretto, *The Last Supper*, 1592–1594. Oil on canvas, 12 x 18 ²/₃ ft. San Giorgio Maggiore, Venice.

The dominance of light over line, fully developed in Turner's work, had begun to assert itself in painting as early as the late Renaissance. When compared to Leonardo's classical rendering of the scene (Fig. 103), painted almost exactly 100 years earlier, Tinteretto's version of *The Last Supper* (Fig. 131) seems much more expressive. It is, in large part, the dramatic play of light and dark in the painting that contributes to this expressivity. As in Leonardo's mural, Tinteretto's *Last Supper* places Christ in the center of the composition. But where the perspective system employed by Leonardo is used to focus our attention on Christ, it is light that draws our attention to His actions in the Tinteretto.

The heavenly light surrounding Christ contrasts dramatically with the darkness of the rest of the composition. Christ, in fact, is offering bread to the disciples, and in so doing performs the Eucharist of the Mass, symbolically offering them His body as nourishment. This purely spiritual act contrasts with the gluttonous worldly activity going on in the foreground, where a dog knaws at a bone and a cat searches for leftovers. Light here symbolizes the spiritual world, and darkness our earthly home.

The drama of this conflict between light and dark not only contributes to the narrative impact of Artemisia Gentileschi's *Judith and Maidservant with the Head of Holofernes* (Fig. 132), it is the measure of the painter's technical virtuosity. One of the most important painters of her day, Gentileschi mastered in this and other paintings the art of **chiaroscuro**. In Italian, the word *chiaro* means "light" and the word *oscuro* means "dark." Thus, the word *chiaroscuro* refers to the gradual transition around a curved surface from light to dark, light and dark revolving around, as it were, the rounded form of the "o" in the middle of the word. The use of chiaroscuro to represent light falling across a curved or rounded surface is called **modeling**.

Fig. 132 Artemisia Gentileschi, *Judith and Maidservant with the Head of Holofernes*, c. 1625. Oil on canvas, 72 1/2 x 55 3/4 in. © The Detroit Institute of the Arts, Gift of Mr. Leslie H. Green.

Gentileschi's painting is based on the tale in the book of Judith in the Bible in which the noble Judith seduces the invading general Holofernes and then kills him, thereby saving her people from destruction. The figures in the work are heroic, larger than lifesize, illuminated in a strong artificial light, and modeled in both their physical features and the folds of their clothing with a skill that lends them astonishing spatial real-ity and dimension. Not only does Judith's outstretched hand cast a shadow across her face, suggesting a more powerful, revealing source of light off canvas to the left, it invokes our silence. Like the light itself, dan-ger lurks just off stage. If Judith is to escape, even we must remain still. Gentileschi repre-sents a woman of heroic stature in a painting of heroic scale, a painting that dominates, even controls the viewer.

Fig. 133 A sphere represented by means of modeling.

Fig. 134 Gray scale.

One of the places that the effects of chiaroscuro can be most readily observed is in those drawings where the artist has worked on gray, blue, or brown tinted paper, indicating shadow by means of charcoal, ink, or dark crayon, and creating the impression of light with white chalk, crayon, or paint. Jacques Louis David's *Study for the Death of Socrates* (Fig. 84) is an example of just such a drawing, and so is Pierre Paul Prud'hon's *Study for La Source* (Fig. 133). The *reserve*—or the tinted paper upon which the drawing is made—functions as the light area (see Fig. 134). Thus, in the Purd'hon drawing all of the normally lit areas of the model's body are left, as it were, "blank"—they are not drawn upon. **Highlights**, which directly reflect the light source, are indicated by white chalk, and the various degrees of shadow are noted by darker and darker areas of black chalk. There are three basic areas of shadow: the **penumbra**, which provides the transition to the **umbra**, the core of the shadow, and the **cast shadow**, the darkest area of all. Finally, areas of reflected light, cast indirectly on the model off, for example, the nearby drapery, lighten the underside of surfaces such as the underside of her left thigh.

The gradual shift from light to dark that characterizes both chiaroscuro and atmospheric perspective is illustrated by the gray scale at the left (Fig. 135). The lighter or whiter an area or object, the more filled it is with light, the *higher* it is in **key** or **value**. The darker or blacker an area, the more it is shrouded in shadow, the *lower* it is in key or value. Colors, too, change key or value in similar gradients. Imagine, for example, substituting the lightest blue near the top of this scale, and the darkest cobalt near its bottom. The mountains in the back of Leonardo's *Madonna of the Rocks* (Fig. 127) are depicted in a blue of higher and higher key or value the farther they are away from us.

Fig. 135 Pierre Paul Prud'hon, *Study for La Source*, c. 1801. Black and white chalk, 21 3/4 x 15 1/4 in. Sterling and Francine Clark Art Institute, Williamstown, Massachusetts.

Fig. 136 Pat Steir, *Pink Chrysanthemum*, 1984. Oil on canvas, 5 x 15 ft. Robert Miller Gallery, New York.

Fig. 137 Pat Steir, *Night Chrysanthemum*, 1984. Oil on canvas, 5 x15 ft. Robert Miller Gallery, New York.

Likewise, light pink is high in key and dark maroon low in key. In terms of color, whenever white is added to the basic **hue** or color, we are dealing with a **tint** of that color. Whenever black is added to the hue, we are dealing with a **shade** of that color. Thus pink is a tint and maroon a shade of red. Pat Steir's two large paintings, *Pink Chrysanthemum* (Fig. 136) and *Night Chrysanthemum* (Fig. 137), are composed of three panels, each of which depicts the same flower in the same light viewed increasingly close-up, left to right. Not only does each panel become more and more abstract as our point of view focuses in on the flower, so that in the last panel we are looking at almost pure gestural line and brushwork, but also the feeling of each panel shifts, depending on its relative key. The light painting becomes increasingly energetic and alive, while the dark one becomes increasingly somber and threatening.

The more contrast between light and dark in a work of art, the more drama or tension there tends to be. Black-and-white photography very much depends upon this **high contrast** to achieve its effects. In his photograph, *Looking Northwest from the Shelton* (Fig. 138), taken in New York City in 1932, Alfred Stieglitz has transformed the three-dimensional space of the picture into a two-dimensional design of large, flat black-and-white shapes. This is especially evident on the right and in the foreground, where the composition has been reduced to a gridlike pattern that emphasizes the underlying structure at the expense of detail. By intentionally heightening the contrast between light and dark, and almost completely eliminating middle register grays, the photographer emphasizes not so much his objective subject matter—an architectural view—as his subjective point of view of the cityscape. "There is within me ever," Stieglitz would say, "an affirmation of light…. Each thing that arouses me is perhaps but a variation on the theme of how black and white maintain a living equilibrium."

Fig. 138 Alfred Stieglitz, *From the Shelton, New York*, 1931. Silver gelatin print. © 1993 National Gallery of Art, Washington, D.C. Alfred Stieglitz Collection.

Fig. 139 Eleanor Antin, from *Being Antinova*, 1983. Published by Astro Artz, Los Angeles, CA.

Fig. 140 George Brecht, *Event Score: Sink*, 1962. Courtesy the artist.

In a line drawing from her book *Being Antinova* (Fig. 139), Eleanor Antin utilizes this tension between dark and light to make a serious point about the exclusion of blacks from high culture. Antin is a performance artist who has created a persona, Eleanora Antinova, a fictional black ballerina who claims to have danced with Sergei Diaghilev's famous dance company, the Ballets Russes, in the 1920s. In her role as Antinova, the only black ballerina in a white company, Antin reminisces before live audiences about her life in the ballet, which she describes as a "white machine": "Imagine me," she says, "as the swan in *Swan Lake*. Whoever heard of a black swan?" Here, she portrays the conflict between herself and the ballet troupe as a whole. The image is a metaphor for the relationship between blacks and high culture generally. We at once recognize Antinova's ability and willingness to escape the regimen and uniformity of the troupe, but we also recognize how separate she is. As she flies free, the one black element in a white world, she is entirely ignored.

The dramatic play between black and white is so powerful an image that it can even be felt in *imageless* work. George Brecht's *Sink* (Fig. 140) is an example of **conceptual art**—that is, work that places importance more on the *idea* behind it than on its

Fig. 141 Thomas W. Dewing, *The Spinet*, 1902. Oil on wood, 15 1/2 × 20 in. National Museum of American Art, Smithsonian Institution, Washington, D.C. Gift of John Gallatly.

actual execution. We have to *imagine* the soap on the sink, but the contrast is striking, even to the mind's eye, and despite the scene's everyday banality.

Except where light strikes the woman's bare shoulder, Thomas W. Dewing's painting *The Spinet* (Fig. 141) is uniformly dark in key. This overall **low contrast** casts a somber spell across the scene. It is as if the woman has turned her back to the light, that she has chosen to face the darkness around her. Certainly, she does not seem to be playing the spinet. Hers appears to be a musicless world.

Light and dark have traditionally had strong symbolic meaning in Western culture. We have only to think of the Bible, and the first lines of the Book of Genesis, which very openly associates the dark with the bad and the light the good:

In the beginning God created the heaven and the earth. And the earth was without form, and void; and darkness was upon the face of the deep. And the Spirit of God moved upon the face of the waters. And God said, Let there be light: and there was light. And God saw the light, that it was good: and God divided the light from the darkness.

In the history of art, this association of light or white with good and darkness or black with evil was first fully developed in the late eighteenth- and early nineteenth-century color theory of the German poet and dramatist Johann Wolfgang von Goethe. For Goethe, colors were not just phenomena to be explained by scientific laws. They also had moral and religious significance, existing halfway between the goodness of pure light and the damnation of pure blackness. In heaven there is only pure light, but the fact that we can experience color—which, according to the laws of optics, depends upon light mixing with

Fig. 142 J. M. W. Turner, *Shade and Darkness—The Evening of the Deluge*, 1843. Oil on canvas, 30 ¹/₂ × 30 ¹/₂ in. Clore Collection, Tate Gallery, London.

Fig. 143 J. M. W. Turner, *Light and Colour (Goethe's Theory)—The Morning After the Deluge—Moses Writing the Book of Genesis*, 1843. Oil on canvas, 30 ¹/₂ × 30 ¹/₂. Clore Collection, Tate Gallery, London.

darkness—promises us at least the hope of salvation.

J. M. W. Turner was deeply impressed with Goethe's color theory and illustrated it in a pair of paintings executed late in life, though he is certainly accepting darkness here in a way that Goethe did not, recognizing that his painting depends on an equal give-and-take between light and darkness. *Shade and Darkness* (Fig. 142) is dominated by blues, grays, and browns, while *Light and Colour* (Fig. 143) is alive with reds and yellows. In the first, the figures are all passive, sleeping, or dead. In the second, bathed in an almost pure white light, and barely recognizable at the top center of the painting, Moses writes the words from Genesis quoted above. Figures swirl around him as if life itself is being born out of the vortex.

Although this opposition between dark and light is taken for granted in our culture, many people of color, with reason, find such thinking offensive. They are especially offended by the use of the term *value* to describe gradations of light and dark, so that black is "low" and white is "high" in value. Like Goethe's theory, the term *value* entered art discourse in the late eighteenth century, the first instance of its use in English being in the lectures of Sir Joshua Reynolds, with whom Turner probably studied at the Royal Academy between 1789 and 1792. Since then, artists and art historians alike use the term as part of a specialized descriptive vocabulary that, in itself, would seem to be at the furthest remove from issues of race and the relative "worth" of human beings. Nevertheless, it is clear that since Biblical times Western culture has tended to associate blackness with negative qualities and whiteness with positive ones, and it is understandable why people might take offense at this usage. For this reason, this book uses the word **key** instead of **value**, substituting the musical metaphor for the moral and economic one.

Black and White in a Nigerian Funerary Shrine Cloth

As we have seen, for Goethe, blackness is not merely the absence of color, it is the absence of good. But for African-Americans blackness is just the opposite. In poet Ted Wilson's words:

Mighty drums echoing the voices
of Spirits....
these sounds are rhythmatic
The rhythm of vitality,
The rhythm of exuberance
and the rhythms of Life
These are the sounds of blackness
Blackness—the presence of all color.

This Nigerian funeral cloth, commissioned by a collector in the late 1970s, similarly illustrates the limits of white Western assumptions about the meaning of light and dark, black and white. The cloth is the featured element of a shrine, called a *nwomo*, constructed of bamboo poles to commemorate the death of a member of Ebie-owo, a Nigerian warriors' association. A deceased elder, wearing a woolen hat, is depicted in the center of this cloth. His eldest daughter, at the left, pours liquor into his glass. The woman on the right wears the hairdo of a mourning widow. She is cooking two dried fish for the funeral feast.

But the dominant colors of the cloth—red, black, and white—are what is most interesting. While in the West we associate black with funerals and mourning, here it signifies life and the ancestral spirits. White, on the other hand, signifies death. Though red is the color of blood, it is meant to inspire the warrior's valorous deeds.

Source: Andrea Nicolls, "A Cloth of Honor" (Washington, D.C.: National Museum of African Art, Smithsonian Institution).

Fig. 144 Okun Akpan Abuje, Afaha clan, Ikot Obong village, Nigeria, Funerary shrine cloth, c 1975–1979. Patchwork-and-appliquéd textile. National Museum of African Art, Washington, D.C. Smithsonian Institution, Eliot Elisofon Archives; Photograph by Franko Khoury.

Color

Of all the formal elements, color is perhaps the most complex. Our perception of a given color can change as its relationship to other colors changes. The basic physical properties of colored pigment are completely different than the physical properties of colored light. Color is at least potentially as expressive as any other formal element: In 1928, for instance, the great football coach Amos Alonzo Stagg decided he needed two dressing rooms for his football team, a blue one in which they could rest and a red one for his pep talks. Color, too, can possess symbolic meaning.

It has conventional uses (for example, red and green are the colors we most closely associate with Christmas), and it can have great impact when employed in nonconventional ways (if, for instance, red and green were used in a portrait as the primary colors of the sitter's face). Color is so complex that no one—neither scientists, nor artists, nor theoreticians such as Goethe—has ever fully explained it to everyone's satisfaction.

Nam June Paik's *Fin de Siècle II* (Fig. 145) shows just how much a part of our lives color images are. Paik created the piece for a 1989 exhibition at the Whitney

Fig. 145 Nam June Paik, *Fin de Siècle II*, 1989. Video installation with 208 television sets and sound. Collection Laila and Thurston Twigg-Smith, Honolulu; Photos: Tibor Franyo.

Muscum of American Art, in New York, entitled "Image World: Art and Media Culture." The first work one encountered when exiting the elevator and entering the exhibition proper, Paik's work is a wall of color monitors, flashing with a variety of images, in a rhythm punctuated by a musical score. Looked at from one point of view, white "stars" composed of video monitors blinking against a blue ground begin to remind us of the Stars and Stripes. Looked at from another perspective, the wall of TVs could just as easily remind us of a television salesroom in a giant appliance warehouse. The most

disconcerting thing, finally, is just how appealing, even beautiful, such an installation really is. TV is a medium that increasingly controls our lives. The problem before us as we face the *fin de siècle*, literally "the end of the century," is, in Paik's words, "not really socialism or capitalism but technology, you know—how we manage that."

As a culture, we tend to value color images over black-and-white ones. All the technologies that support the major popular media—from print to film and television—have been driven by the need to invent color processes of greater and

Fig. 146 Joel Meyerowitz, *Bay/Sky, Provincetown*, 1984. Color photograph, 8 × 10 in. Courtesy the artist.

Fig. 147 Joel Meyerowitz, *Bay/Sky, Provincetown*, 1984. Color photograph, 8 × 10 in. Courtesy the artist.

greater fidelity, and the media has been increasingly dominated by these technologies. On February 17, 1961, when NBC first aired all of its programs in color, only 1 percent of American homes possessed color sets. By 1969, 33 percent of American homes had color TVs, and today they are virtually everywhere. So widespread has the use of color become in the film industry, where even original black-and-white movies have been "colorized" for television, that today it is more expensive to produce a black-and-white film than a color one.

The growing predominance of color in photographic art produced since 1970 mirrors this tendency. Early in his career the photographer Joel Meyerowitz worked mostly in black-and-white. But since the mid-1970s, in a continuing series of photographs undertaken at Cape Cod (Figs. 146 & 147), he has changed to color. "When I committed myself to color exclusively," he explained in 1977, "it was a response to a greater need for description.... [Color] makes everything more interesting. Color suggests more things to look at, new subjects for me. Color suggests that light itself is a subject. In that sense, the work here on the Cape is about light. Look. Black and white taught me about a lot of interesting things.... Black and white shows how things look when they're stripped of color. We've accepted that that's the way things are in a photograph for a long time because that's all we could get. That's changed now. We have color and it tells us more. There's more content! The form for the content is more complex, more interesting to work with." The sensibility here is very close to that of Claude Monet as he worked on the series of Haystack paintings in the early 1890s. From picture to picture, the view remains the same, but the mood of the scene shifts as dramatically as the change from day to night and calm to storm.

Basic Color Vocabulary

The human eye may be able to distinguish as many as 10 million different colors, but we have nowhere near that many words to differentiate among them. Different cultures, furthermore, tend to emphasize different ranges of color. Although apparently able to distinguish visually between green and blue, many cultures do not possess different words for them. Within our own culture, when shown an object that is turquoise, as many people will call it green as call it blue. The Maoris of New Zealand regularly employ over one hundred words for what most of us would simply call "red."

Color is a direct function of light. Sunlight passed through a prism breaks into bands of different colors like a rainbow (Fig. 148), what is known as the **spectrum**, a fact that has long been known. In 1666, the English scientist Sir Isaac Newton discovered that if this *refracted* light is passed through a second prism, it will recombine itself into the original white light. Newton was able to demonstrate that objects appear to be a certain color because they absorb and reflect different parts of the visible spectrum. In the simplest terms, when light strikes an object that appears blue, the object has absorbed all the colors of the spectrum but the blue wavelengths. If it appears yellow-green—or chartreuse—it has screened out all but yellow and green wavelengths.

By reorganizing the visible spectrum into a circle, we have what is recognized as the conventional **color wheel** (Fig. 149). The three **primary colors**—red, yellow, and blue—are those that, in theory at least, cannot be made by any mixture of the other colors. The **secondary colors**—orange, green, and violet—are mixtures of two primaries. The **intermediate colors** lie "in between" each primary and its neighboring secondary.

Each primary and secondary color of the visible spectrum is called a **hue**. Thus all

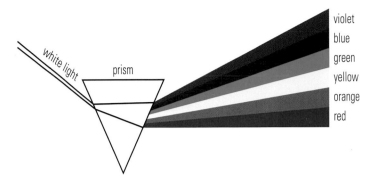

Fig. 148 Colors separated by a prism.

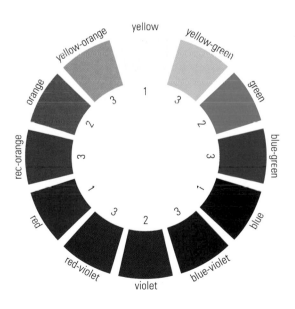

Fig. 149 Conventional color wheel.

Fig. 150 Color mixtures of reflected pigment—subtractive process.

Fig. 151 Color mixtures of refracted light—additive process.

shades and tints of red—from pink to deep maroon—are said to be of the same red hue, though they are different **keys** of that hue. One of the more complex problems presented to us by color is that the primary and secondary hues change depending upon whether we are dealing with *refracted* light or *reflected* pigment. The conventional color wheel illustrated on the previous page demonstrates the relationship among the various hues as reflected pigment. When we mix pigments, we are involved in a **subtractive** process (Fig. 150). That is, in mixing two primaries, the secondary that results is of a lower key and seems duller than either of the original two primaries because each given primary absorbs a different range of white light. Thus when we combine red and yellow, the resulting orange absorbs twice the light of either of its source primaries taken alone. Theoretically, if we combine all the pigments, we would absorb all light and end up with black, the absence of color altogether.

Refracted light, on the other hand, works in a very different manner. With refracted light, the primary colors are red-orange, green, and blue-violet. The secondaries are yellow, magenta, and cyan. When we mix light, we are involved in an **additive** process (Fig. 151). That is, if we mix two primaries of colored light, the resulting secondary is higher in key and seems brighter

than either primary. Our most usual exposure to this process occurs when we watch television. This is especially apparent on a large screen monitor, where yellow, if viewed close up, can be seen to result from the overlapping of many red and green dots. In the additive color process, as more and more colors are combined, more and more light is added to the mixture, and the colors that result are brighter than either source taken alone. As Newton discovered, when the total spectrum of refracted light is recombined, white light results.

One of the most successful and acclaimed works in the history of publicly funded art is Charles Ross's *27 Prisms from the Origin of Colors* (Figs. 152 & 153), an installation at the Federal Building and U. S. Courthouse in Lincoln, Nebraska, that consists entirely of refracted light. Presented within a long, dimly lit corridor and staircase, with only single windows at either end, both of which were cast in shadow by a large overhang, Ross discovered, in his own words, that "long prisms suspended from the ceiling could be used to pull light from outside into the space—bars of light absorbed and captured, turning from white light to rainbow colors and back again as you walk along.... A large, bright, curved bow was cast across the landing so that you pass through a sheet of spectrum as you climb the stairs."

Figs. 152 & 153 Charles Ross, *27 Prisms from the Origin of Colors*, 1976. Installation, 27 triangular acrylic prisms, each 104 in. long, 9 1/2 in. on each side. Federal Building, Lincoln, Nebraska. Courtesy of the GSA Art in Architecture program.

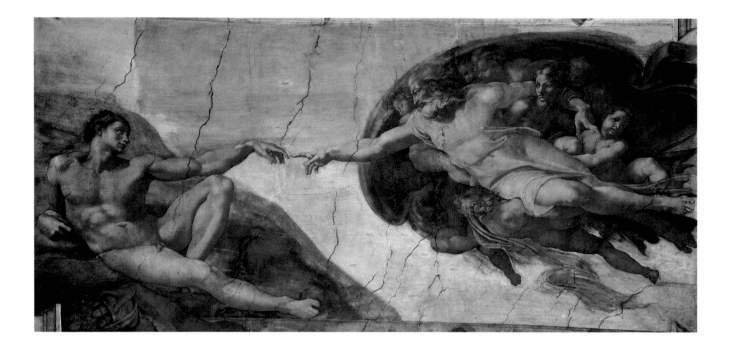

Fig. 154 Michelangelo, *The Creation of Adam* (unrestored), ceiling of the Sistine Chapel, 1508–1512. Fresco. The Vatican, Rome.

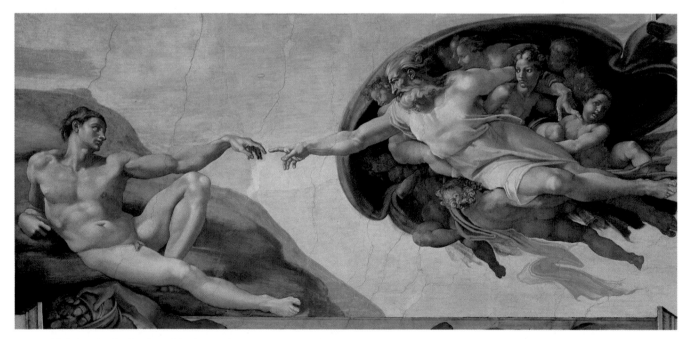

Fig. 155 Michelangelo, *The Creation of Adam* (restored), ceiling of the Sistine Chapel, 1508–1512. Fresco. The Vatican, Rome. © Nippon TV, Tokyo.

Color is described first by reference to its hue, then to its relative key, and then also by its **intensity** or **saturation**. Intensity is a function of a color's relative brightness or dullness. A lowering of the intensity of a hue is accomplished by adding to it either gray or the hue opposite it on the color wheel. Intensity may also be reduced by adding **medium**—a liquid that makes paint easier to manipulate—to the hue.

There is perhaps no better evidence of the psychological impact a change in intensity can make than to look at the newly restored frescoes of the Sistine Chapel at the Vatican in Rome, painted by Michelangelo between 1508 and 1512 (Figs. 154 & 155). Restoration was begun in 1980 and has just been completed. The process is relatively simple. A solvent called AB 57, mixed together with a fungicide and antibacterial agent and a cellulose gel so that it will not drip from the ceiling, is painted onto a small section of the fresco with a bristle brush. The AB 57 mixture is allowed to sit for three minutes, and then it is removed with a sponge and water that also removes the grime. The process is repeated in the dirtiest areas. The entire operation has been documented in great detail by the Nippon Television Network of Japan, which has funded the entire restoration project.

Restorers have discovered that the dull, somber hues always associated with Michelangelo were not the result of his **palette**, that is, the range of colors he preferred to use, but of years of accumulated dust, smoke, grease from burnt candle tallow, and varnishes made of animal glue painted over the ceiling by earlier restorers. The colors are in fact much more saturated and intense than anyone had previously supposed. Some experts in fact find them so intense that they seem, beside the golden tones of the unrestored surface, almost garish. As a result, there has been some debate about the merits of the cleaning. But, in the words of one observer: "It's not a controversy. It's culture shock."

Fig. 156 Komar and Melamid, *Post-Art No. 1 (Warhol)*, 1973. Oil on canvas, 42 × 42 in. Ronald Feldman Fine Arts, New York.

Pop Art "Restored"

Russian-born artists Vitaly Komar and Alexander Melamid began their career as a collaborative art team in the late 1960s in the Soviet Union by satirizing all manner of things Soviet. In the early 1970s they re-did Andy Warhol's famous *Campbell's Soupcan*, which they had seen in magazines, but in a tongue-in-cheek style that seemed to accord more with Soviet taste. "We had an idea of dark paintings," Komar explains. "Yes, of course, darkness," Melamid continues. "That's what we got from the painting available during the Stalin times. The paintings we saw were dark to begin with—traditional, pre-Impressionist canvases—and even darker because they were in such bad condition. Lighting in the Moscow museums was very dim, also.... In Russia, the older an icon, the more beautiful. Also, the more expensive. We thought American Pop art would have more beauty if it was older. So we used a blowtorch on the images, we covered them with dirt, everything to make them look like art from another time." In 1977, the two artists emigrated to Israel, then, a year later, to New York. In 1988, they became United States citizens.

Source: Carter Ratcliff, *Komar and Melamid* (New York: Abbeville, 1988).

Fig. 157 Joseph Albers, *Homage to the Square: Saturated*, 1951. Oil on masonite, 23 1/4 × 23 3/8 in. Yale University Art Gallery, New Haven. The Katherine Ordway Collection.

Color schemes

Colors can be employed by painters in different ways to achieve a wide variety of effects. Joseph Albers's *Homage to the Square: Saturated* (Fig. 157) is **monochromatic**. As its title implies, it employs a single hue—red—in three different keys, each equally saturated. We move, from outside to inside, through low, medium, and high keys of high-intensity red hues. The intervals between the squares are determined by a mathematical formula—each side of the outermost square is double the width of the adjacent sides of the middle square, and so on. This work is one of a series of more than 2,000 paintings and prints that Albers began when he became Chair of Yale University's Department of Design in 1950 and continued to work on for the remainder of his life. Though the color relations change in each piece, the format remains the same, and as a whole they constitute one of the most thorough investigations into the interaction of color ever undertaken.

Analogous color schemes are those composed of hues that neighbor each other on the color wheel. If we consider the central square of Albers's painting to be red-violet, not red, the painting is technically analogous. Such color schemes are often organized on the basis of color **temperature**. Most of us respond to the range from yellow through orange and red as *warm*, and to the opposite side of the color wheel, from green through blue to violet, as *cool*. Sanford Gifford's *October in the Catskills* (Fig. 158) is a decidedly warm painting—just like a sunny fall day. The color scheme, consisting of yellows and oranges in varying degrees of intensity and value, seems to overwhelm even the blue of the sky, which is barely perceptible through the all-consuming yellow atmosphere. The painting is a study in atmospheric perspective, though it modifies Leonardo's formula somewhat, since the distant hills do not appear "bluer," only softer in hue. Representing the effects of atmosphere was Gifford's chief goal in painting. "The really important matter," he would say, "is not the natural object itself, but the veil or medium through which we see it."

Fig. 158 Sanford R. Gifford, *October in the Catskills*, 1880. Oil on canvas, 36 3/8 × 29 3/8 in. Los Angeles County Museum of Art. Gift of Mr. And Mrs. Charles C. Shoemaker, Mr. and Mrs. J. Douglas Pardee, and Mr. and Mrs. John McGreevey.

Fig. 159 Romare Bearden, *She-ba*, 1970. Collage on composition board, 48 × 35 ⁷⁄₈ in. Wadsworth Atheneum, Hartford, Connecticut. Ella Gallup Sumner and Mary Catlin Sumner Collection.

Just as warm and cool temperatures literally create contrasting physical sensations, when both warm and cool hues occur together in the same work of art they tend to evoke a sense of contrast and tension. Romare Bearden's *She-ba* (Fig. 159) is dominated by cool blues and greens, but surrounding and accenting these great blocks of color are contrasting areas of red, yellow, and orange. "Sometimes, in order to heighten the character of a painting," Bearden wrote in 1969, just a year before this painting was completed, "I introduce what appears to be a dissonant color where the red, browns, and yellows disrupt the placidity of the blues and greens." Queen of the Arab culture that brought the Muslim religion to Ethiopia, Sheba here imparts a regal serenity to all that surrounds her. It is as if, in her every gesture, she cools the atmosphere, like rain in a time of drought, or shade at an oasis in the desert.

Color schemes composed of hues that lie opposite each other on the color wheel, as opposed to next to one another, are called **complementary**. Thus, on the traditional color wheel, there are three basic sets of complementary relations: orange/blue, yellow/violet, and red/green. Each intermediate color has its complement as well. When two complements appear in the same composition, especially if they are pure hues, each will appear more intense. The opposite result occurs when two complements are combined. In this instance, the colors will neutralize each other, and gray is the result. If placed next to each other, without mixing, complements seem brighter than if they appear alone. This effect, known as *simultaneous contrast*, is due to the physiology of the eye. If, for example, you stare intensely at the color red for about 30 seconds, and then shift your vision to a field of pure white, you will see not red but a variety of green. Physiologically, the eye supplies an *afterimage* of a given hue in the color of its complement.

Fig. 160 Henri Matisse, *The Idol*, 1942. Oil on canvas, 28 × 36 in. Private collection, courtesy Marlborough Gallery, New York.

Complements exist in a sort of love/hate relation. A sense of their opposition and contrast is always present, but they work to balance each other as well. In terms of relative warmth or coolness, a complementary color scheme can appear to moderate the extremes of color temperature within a composition. Matisse's painting *The Idol* (Fig. 160), for instance, is made up of two fields of red-orange, or vermilion, and blue. These have been composed in precisely such mutually moderating terms. Because darker colors generally appear heavier than lighter ones, Matisse has given more space to the field of orange behind the figure, and the painting thus seems perfectly balanced and composed.

In 1954, Mark Rothko painted an *Homage to Matisse* that has disappeared from the public domain, but the *Untitled* painting reproduced here is a related work on paper from 1953 (Fig. 161). The squares of blue and orange in the Rothko painting are close to Matisse's in relative size, but by stacking them, the artist imparts to the heavier and much deeper blue a sense of materiality and gravity—as if it were a body of water—and to the red-orange a feeling of airiness, even spirituality. The painting is like a sum equation, top and bottom balancing each other out.

Fig. 161 Mark Rothko, *Untitled*, 1953. Tempera on paper, 40 1/2 × 37 in. Pace Gallery, New York.

Color in Mexican Textiles

Today most dyes and pigments are made synthetically, but natural dyes are still used and preferred by many of the world's cultures. The cotton fabric pictured here is part of a Mixtec skirt woven on a traditional back-strap loom in Oaxaca, Mexico. The techniques used to produce it, including the dying process, date from before the conquest of Mexico, and may have been in place as early as 5000 B.C. In a letter written to the King of Spain at the time of the conquest, Hernán Cortés marveled: "Monteczuma gave me a large quantity of textiles which…were such that there could not be fashioned or woven anything similar in the whole world for the variety and naturalness of the colors."

The dark blue of this skirt comes from the indigo plant. The source of the red is the cochineal, an insect found on several species of cactus in southern Mexico. The insects are sun-dried or toasted on griddles, then ground into a powder capable of producing, according to the procedure employed, a wide variety of brilliant reds. In colonial times, cochineal was a leading export of Mexico to Spain, second only to precious metal. Today the insect is becoming increasingly rare, though it is domesticated in Oaxaca.

The violet in this fabric comes from a sea snail, threatened with extinction, that is picked off the rocks of the Pacific coast in southern Oaxaca at low tide during the winter months. The liquid secreted by the snail is initially colorless, but upon contact with the air it turns first yellow, then green, and finally violet. With time, the violet hue of the cotton fabric will turn into a soft lavender. Skirts incorporating this natural dye are among the most prized textiles made in Oaxaca today.

Source: Chloë Sayer, *Arts and Crafts of Mexico* (San Francisco: Chronicle Books, 1990).

Fig. 162 Mixtec skirt, Pinotepa de Don Luis, Oaxaca, Mexico. Dyed cotton, area shown 25 1⁄2 in. wide. Collection Chloë Sayer.

One of the more vexing issues that the study of color presents is that the traditional color wheel really does not do a very adequate job of describing true complementary color relations. For instance, the afterimage of red is not really green, but blue-green. In 1905, Albert Munsell created a color wheel based on five, rather than three, primary hues: yellow, green, blue, violet, and red (Fig. 163). The complement of each of these five is a secondary, so that the complementary pairs are yellow/blue-violet, green/red-violet, blue/orange, violet/yellow-green, and red/blue-green. Munsell's color wheel accounts for what is, to many eyes, one of the most powerful complementary color schemes, the relation between yellow and blue-violet. This Brazilian feather mask, known as a *Cara Grande* (Fig. 164), illustrates this contrast. The mask is worn during the annual Banana Fiesta in the Amazon basin; it is almost three feet tall. It is made of wood, and covered with pitch to which feathers are attached. The brilliantly colored feathers are not dyed, but are the natural plumage of tropical birds, and the intensity of their color is heightened by the simultaneous contrast between yellow and blue-violet, which is especially apparent at the outer edge of the mask.

Fig. 163 *Cara Grande* feather mask, Tapirapé, Rio Tapirapé, Brazil, c. 1960. Height 31 in. National Museum of the American Indian, New York.

Fig. 164 Munsell color wheel.

Fig. 165 Charles Searles, *Filàs for Sale* (from the *Nigerian Impressions* series), 1972. Acrylic on canvas, 72 × 50 in. National Center of Afro-American Artists, Roxbury, MA.

Artists working with either analogous or complementary color schemes limit the range of their color selection by choice. In his painting *Filàs for Sale* (Fig. 165), Charles Searles has rejected such a *closed* or *restricted palette* in favor of an *open palette*, in which he employs the entire range of hues in a wide variety of values and intensities. Such a painting is **polychromatic**. The painting depicts a Nigerian marketplace and was inspired by a trip Searles took to Nigeria, Ghana, and Morocco in 1972. "What really hit me," Searles says, "is that the art is in the people. The way the people carried themselves, dressed, decorated their houses became the art to me, like a living art." A pile of *filàs*, or brightly patterned skullcaps, occupies the right foreground of this painting. The confusion and turmoil of the crowded marketplace is mirrored in the swirl of the variously colored textile patterns. Each pattern has its own color scheme—yellow arcs against a set of violet dots, for instance, in the swatch of cloth just above the pile of hats—but all combine to create an almost disorienting sense of movement and activity.

Color in Representational Art

There are three different ways of using color in representational art. The green tree and the red brick building in Stuart Davis's *Summer Landscape* (Fig. 166) are examples of **local** color, or the color of objects viewed close-up in even lighting conditions. Local color is the color we "know" an object to be, in the way that we know a banana is yellow or a fire truck is red. But we are also aware that as the effects of light and atmosphere on an object change, we will perceive its color as different. As we know from the example of atmospheric perspective, we

Fig. 166 Stuart Davis, *Summer Landscape*, 1930. Oil on canvas, 29 × 42 in. Collection, The Museum of Modern Art, New York. Purchase.

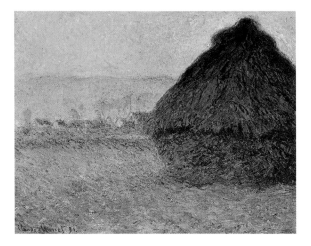

Fig. 167 Claude Monet, *Grainstack (Sunset)*, 1891. Oil on canvas, 28 7/8 × 36 1/2 in. Museum of Fine Arts, Boston. Juliana Cheney Edwards Collection.

actually *see* a distant pine-covered hill as blue, not green. The Impressionist painters were especially concerned with rendering such **optical** or **perceptual** colors. Monet painted his landscapes outdoors, in front of his subject—**plein-air painting** is the technical term, literally, the French word for "open air"—so as to be true to the optical colors of the scene before him. He did not paint a haystack yellow simply because he knew hay to be yellow. He painted it in the colors that natural light rendered it to his eyes. Thus this *Haystack at Sunset* (Fig. 167) is dominated by reds, with afterimages of green flashing throughout.

Fig. 168 Pierre Bonnard, *The Terrace at Vernon*, c. 1920-1221939. Oil on canvas, 57 11/16 × 76 1/2 in. The Metropolitan Museum of Art, New York. Gift of Mrs. Frank Jay Gould, 1968 (68.1).

Artists sometimes choose to paint things in colors that are not "true" to either their optical or local colors. Bonnard's painting *The Terrace at Vernon* (Fig. 168) is an example of the expressive use of **arbitrary** color. No tree is "really" violet, and yet this large foreground tree is. The woman at the left holds an apple, but the apple is as orange as her dress. Next to her a young woman carrying a basket seems almost to disappear into the background, painted, as she is, in almost the same hues as the landscape (or is it a hedge?) behind her. At the right, another young woman in orange reaches above her head, melding into the ground around her. Everything in the composition is sacrificed to Bonnard's interest in the play between warm and cool colors, chiefly orange and violet or blue-violet, which he uses to flatten the composition, so that fore-, middle-, and backgrounds all seem to coexist in the same space. "The main subject," Bonnard would explain, "is the surface which has its color, its laws, over and above those of the objects." He sacrifices both the local and optical color of things to the arbitrary color scheme of the composition.

Similarly, the trees van Gogh painted in *Les Alyscamps* (Fig. 169), are, of course, not "really" blue. He has rendered them so in order to create an interplay of complementary colors and to create a sense of emotional tension. "Les Alyscamps" is Provençal dialect for "Les Champs Elysées," or the Elysian Fields, the traditional resting place of the dead in Greek and Roman mythology. The scene is a long avenue of poplars near the center of the city of Arles, in southern France. A popular strolling place for the people of Arles, especially for lovers, the avenue is lined with empty sarcophagi, that is, stone coffins, from the Roman graveyard that occupied the site in antiquity. The sense of opposition created by van Gogh's arbitrary color scheme underscores a tension between life and death that is almost overwhelming, giving dramatic emphasis to the fall scene.

Fig. 169 Vincent van Gogh, *Les Alyscamps*, 1888. Oil on canvas, 28 3/4 × 36 1/4 in. Rijksmuseum Kröller-Müller, Otterlo, The Netherlands.

Fig. 170 Vincent van Gogh, *The Night Café*, 1888. Oil on canvas, 28 ¹/₂ × 36 ¹/₄ in. Yale University Art Gallery, New Haven, Connecticut. Bequest of Stephen Carlton Clark.

Symbolic Use of Color

Another way to describe van Gogh's expressive use of color is to recognize that he employs the complementary opposition between blue and orange in order to *symbolize* the larger thematic oppositions of the work. To different people in different situations and in different contexts, color symbolizes different things. There is no one meaning for any given color, though in a particular cultural environment, there may be a shared understanding of it. So, for instance, when we see a stop light, we assume that everyone understands that red means "stop," and green means "go." In China, however, this distinction does not exist. In the context of war, red might mean "death" or "blood," or "anger." In the context of Valentine's Day, it means "love." Most Americans, when confronted by the complementary pair of red and green, think first of all of Christmas.

In his painting *The Night Café* (Fig. 170), van Gogh employs red and green to his own expressive ends. In a letter to his brother Theo, written September 8, 1888, he described how the complements work to create a sense of visual tension and emotional imbalance:

> In my picture of the *Night Café* I have tried to express the idea that the café is a place where one can ruin oneself, run mad, or commit a crime. I have tried to express the terrible passions of humanity by means of red and green. The room is blood-red and dark yellow, with a green billiard table in the middle; there are four lemon-yellow lamps with a glow of orange and green. Everywhere there is a clash and contrast of the most alien reds and greens in the figures of little sleeping hooligans, in the empty, dreary room, in violet and blue. The blood-red and the yellow-green of the billiard table, for instance, contrast with the soft tender...green of the counter, on which there is a pink nosegay. The white coat of the patron, awake in a corner of that furnace, turns lemon-yellow, or pale luminous green.
>
> So I have tried to express, as it were, the powers of darkness in a low wine-shop, and all this in an atmosphere like a devil's furnace of pale sulphur.... It is color not locally true from the point of view of the stereoscopic realist, but color to suggest the emotion of an ardent temperament.

Fig. 171 Wassily Kandinsky, *Black Lines I*, 1913. Oil on canvas, 51 x 51 ⅝ in. Solomon R. Guggenheim Museum, New York. Gift, Solomon R. Guggenheim, 1937. Photo: David Heald © The Solomon R. Guggenheim Foundation, New York, FN 37.241.

While there is a sense of opposition in Wassily Kandinsky's *Black Lines* (Fig. 171) as well, the atmosphere of the painting is nowhere near so ominous. The work is virtually nonobjective, though a hint of landscape can be seen in the upper left where three mountainlike forms rise in front of and above what appears to be a horizon line defined by a lake or an ocean at sunset. The round shapes that dominate the painting seem to burst into flowers. Emerging like pods from the red-orange border at the painting's right, they suffuse the atmosphere with color, as if to overwhelm and dominate the nervous black lines that give the painting its title.

Color had specific symbolic meaning for Kandinsky. "Blue," he says, "is the heavenly color." Its opposite is yellow, "the color of the earth." Green is a mixture of the two; as a result, it is "passive and static, and can be compared to the so-called 'bourgeoisie'— self-satisfied, fat, and healthy." Red, on the other hand, "stimulates and excites the heart." The complementary pair of red and green juxtaposes the passive and the active. "In the open air," he writes, "the harmony of red and green is very charming," recalling for him not the "powers of darkness" that van Gogh witnessed in the pair, but the simplicity and pastoral harmony of an idealized peasant life.

Fig. 172 Michelangelo, *Pietà*, 1501. Marble, height 6 ft. 8 1/2 in. Vatican, Rome.

Texture

Texture is the word we use to describe the work of art's ability not only to affect us as a *visual* phenomenon but also to call forth certain *tactile* sensations and feelings—that is, to make us want to touch it. That's why signs in museums and galleries saying "Please Do Not Touch" are so necessary: if, for example, every visitor to the Vatican in Rome had touched the marble body of Christ in Michelangelo's *Pietà* (Fig. 172), the rounded, sculptural forms would have been reduced to utter flatness long ago.

Marble is, in fact, one of the most tactile of all artistic mediums. Confronted with Michelangelo's almost uncanny ability to transform marble into lifelike form, we are almost compelled to reach out and confirm that Christ's dead body is made of hard, cold stone and not the real, yielding flesh that the grieving Mary seems to hold in her arms.

Carved marble's similarity to skin does not correspond to its **actual texture**; rather, as touching the stone will tell us, its texture is **visual** or **implied**, a function of Michelangelo's skill in rendering the surface of the human body and the smooth fall of the drapery. In Maneul Neri's bronze sculpture from the *Mujer Pegada Series* (Fig. 173), the actual texture of the bronze is both smooth, to imply the texture of skin, and rough, to indicate the "unfinished" quality of the work. It is as if Neri can only begin to capture the whole woman who is his subject, just as she emerges only half way from the sheet of bronze, only half-realized. Our sense of the transitory nature of the image, its fleeting quality, is underscored by the enamel paint that Neri has applied in broad loosely gestural strokes to the bronze. This paint adds yet another texture to the piece, the texture of the brushstroke. This brushstroke helps, in turn, to emphasize the two-dimensional quality of the piece. It is as if Neri's three-dimensional sculpture is attempting to escape the two-dimensional space of the wall, which is the space of painting.

Fig. 173 Manuel Neri, *Mujer Pegada Series No. 2*, 1985–1986. Bronze with oil based enamel, 70 × 56 × 11 in. Courtesy Anne Kohs & Associates, San Francisco. Photo M. Lee Fatheree.

Fig. 174 Dorothea Rockburne, *Noli Me Tangere*, 1976. Gesso, varnish, glue, and oil on linen, 55 × 34 in. Courtesy Andre Emmerich Gallery, New York.

Fig. 175 Dorothea Rockburne, *White Angel #2*, 1981. Rives BFK paper on mat board with glue and blue pencil, 70 × 46 in. Virginia Museum of Fine Arts, Richmond. Gift of the Sydney and Frances Lewis Foundation.

One of the areas that Dorothea Rockburne has most thoroughly explored in her work is the idea of texture. The title of Rockburne's *Noli Me Tangere* (Fig. 174), literally "Do not touch me," may make us think of those signs warning against touching a work of art. But the words are actually Christ's to Mary Magdalene, uttered when He appeared to her outside the tomb after the Resurrection.

In this painting, a linen sheet has been covered with a coat of gesso (a white primer or undercoat) and then folded into geometric shapes. As the gesso dried, the soft linen hardened into shape, paradoxically becoming so stiff that the painting does not require a frame or support. Rockburne not only

painted each geometric area a different color, but the surface of each area has a distinct textural feel as well—from the smoothest black to the much coarser green—that helps to define it spatially.

Rockburne's works are based on her analysis of the formal structure of early Renaissance paintings, particularly the paintings of Duccio in the Siena Cathedral, in Italy, depicting stories from the life of Christ. *White Angel #2* (Fig. 175) is related to *Noli Me Tangere*, representing the angel who in another of Duccio's panels at Siena guards the open tomb as it is first approached by Mary. In this work, the white paper is folded and glued so that each geometric surface is distinguished from

Fig. 176　Joan Snyder, *Sea Moons*, 1989. Oil and velvet on linen, 11 1/4 × 19 1/2 in. Courtesy of Hirschl & Adler Modern, New York.

the other only by means of cast shadows. The space thus created seems at once tangible and intangible. As in *Noli Me Tangere*, it is as if we are witness to the vision of a space the actuality of which we would like to confirm by touching. Rockburne's point, like Christ's when he appeared to Mary, is that there are some spaces that we can only know through an act of faith or imagination.

When paint is applied in a thick, heavy manner, so that each brushstroke is not only evident but seems to have a "body" of its own, the textural effect is called **impasto**. Joan Snyder is known for the expressive impasto of her abstract "stroke" paintings of the late 1960s. Recently, Snyder has begun to use this brushstroke in landscape paintings done on a ground of red or black velvet. *Sea Moons* (Fig. 176), for example, consists of a canvas draped with a swath of black velvet. The thick impasto of the sea sweeps up from the canvas across the bottom of the hanging fabric; a night sky, dotted with van

Gogh-like moons and stars, descends across the painting like a shroud. The shift in texture, from paint to velvet, serves to differentiate space. Not only is the line between sea and sky, heaven and earth, underscored by this shift in texture, but traditional distinctions between "high" and "low" art are complicated and reversed as well. The sea is painted in a recognizably expressionist way—in the style, that is, of "high" art, whereas the sky is black velvet, a material traditionally associated with the "lowest" forms of art, what is commonly called **kitsch**. The term refers to low-quality, mass-produced art of the variety easily found in discount stores—day-glo images on velvet are a perfect example. By using velvet in her work, Snyder brings the textures of kitsch— the literal feel of the tasteless and the banal—into the space of painting. And in doing so, she causes us to question our presumptions about the low quality of kitsch in general.

The Texture of Plains Quillwork

In 1832, when the artist George Catlin first visited the Native Americans living on the upper Missouri, he said of their clothing: "There is no tribe, perhaps, on the Continent who dress more comfortably, and more gaudily, than the Blackfeet, unless it be the tribe of the Crows." One of the elements that most impressed Catlin was the decorative quillwork that adorned their clothes, of which he remarked, "There is a distinctive mode in each tribe, of stitching or ornamenting with porcupine quills, which constitute one of the principle ornaments to all their fine dresses."

Quillwork was strictly the province of the tribe's women, and the beauty of their work was considered equivalent to bravery in battle for men. There is, among the Sioux, a story about an old woman who is eternally quillworking that connects the craft to the life process itself. Each night, when she sleeps, her dog tears her work apart, and each day she must begin again. It is said that if she were ever to complete her work, the world would come to an end.

Not only is quillwork highly colored and of beautiful design, but it also contributes to the textural richness of the object on which it is applied. The almost varnished sheen of the quills contrasts with the soft hide on which it is sewn, giving the finished piece a sense of durability and strength.

A single porcupine would yield approximately 30,000 to 40,000 quills of various sizes. These were sorted by size, dyed, and then immediately before use, moistened in order to be made flexible. They were then flattened by pulling them between the teeth or fingernails, and slowly sewn into place. The cradleboard cover illustrated here is the work of a member of the Sioux, Mrs. Alex Wounded Horse. She was the daughter of Black Hawk, who joined Sitting Bull in self-imposed exile in Canada in 1877, shortly after Sitting Bull's victory over General Custer at the Little Big Horn.

Fig. 177 Mrs. Alex Wounded Horse, Wood Mountain Reserve, Saskatchewan, Sioux cradleboard cover, early 20th century. Collection of Glenbow Museum, Calgary, Alberta. AF 684.

Source: Julia M. Bebbington, *Quillwork of the Plains* (Alberta, Canada: Glenbow Museum, 1982).

Time and Motion

One of the most traditional distinctions made between the *plastic arts*—painting and sculpture—and the written arts such as music and literature is that the former are *spatial* and the latter *temporal* media. That is, we experience the former all at once; the work of art is before us in its totality at all times. But we experience music and literature over time, in a linear way; a temporal work possesses a clear beginning, middle, and end.

While there is a certain truth to this distinction, the temporal plays a greater role in the plastic arts than such a formulation might suggest. Even in the case where the depiction of a given event implies that we are witness to a photographic "frozen moment," an instant of time taken from a larger sequence of events, the single image may be understood as part of a larger *narrative* sequence. It can even serve as a mnemonic device (as an "aid" to memory), allowing us to reconstruct history, the flow of events in time, just as the incidents from the life of Christ in the stained glass windows at Chartres (Fig. 32) were designed to help the viewer remember the stories of the Bible.

A work of art can also, in and of itself, invite us to experience it in a linear or temporal way. *The Meeting of Saint Anthony and Saint Paul* (Fig. 178), for example, depicts Saint Anthony at three different points as he travels down a winding road away from the city in the distant background and toward his meeting with the hermit, Saint Paul. First, he enters a wood, then he confronts a unicorn, and finally he meets Saint Paul. The road here represents Saint Anthony's movement through space and time.

Likewise, we "read" Pat Steir's Chrysanthemum paintings (Figs. 136 & 137) from left to right, in linear progression. Each of Monet's Haystack paintings (Figs. 24 & 167) and Joel Meyerowitz's photographs of the sea at Cape Cod (Figs. 146 & 147) can be appreciated as a wholly unified totality. Each

Fig. 178 Sassetta, and workshop of Sassetta, *The Meeting of Saint Anthony and Saint Paul*, c. 1440. Tempera on wood, 18 3/4 × 13 5/8 in. © 1992 National Gallery of Art, Washington, D.C., Samuel H. Kress Collection.

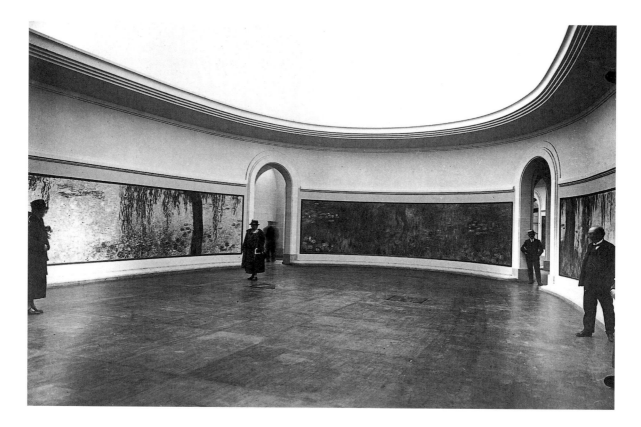

Fig. 179 Claude Monet, *Reflections of Trees* on the far wall, *Weeping Willow* composition on each side, Room II, Musée de l'Orangerie, Paris.

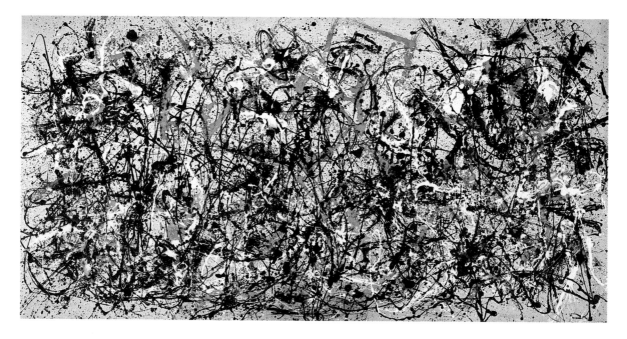

Fig. 180 Jackson Pollock, *Autumn Rhythm*, 1950. Oil on canvas, 105 × 207 in. The Metropolitan Museum of Art, George A. Hearn Fund, 1957 (57.92).

can also be seen as part of a larger whole. Viewed in series, they are not so much "frozen moments" removed from time as they are *about* time itself, the ways in which our sense of place changes over time.

To appreciate large-scale works of art, such as Christo's *Surrounded Islands* (Figs. 52 & 53), it may be necessary to move around and view them from all sides, or to see them from a number of vantage points—to view them over time. Monet's two famous paintings of his lily pond at Giverny, which were installed in the Orangerie in Paris in 1927, are also designed to compel the viewer to move (Fig. 179). They encircle the room, and to be in the midst of such a work is to find oneself suddenly in the middle of a world that has been curiously turned inside out: the work is painted from the shoreline, but the viewer seems to be surrounded by water, as if the room were an island in the middle of the pond itself. The paintings cannot be seen all at once. There is always a part of the work behind you. There is no focal point, no sense of unified perspective. In fact, the series of paintings seems to organize itself around and through the viewer's own acts of perception and movement.

According to Georges Clemenceau, the statesman who arranged for Monet's giant paintings to hang in the Orangerie, the paintings could be understood as "a representation of Brownian motion." First described by the Scottish scientist Robert Brown in 1827, Brownian motion is a result of the physical movement of minute particles of solid matter suspended in fluid. Any sufficiently small particle of matter suspended in water will be buffeted by the molecules of the liquid and driven at random throughout it. Standing in the midst of Monet's panorama, the viewer's eye is likewise driven randomly through the space of the paintings. The viewer is encircled by them, and there is no place for the eye to rest.

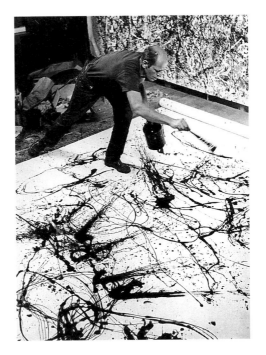

Fig. 181 Jackson Pollock painting *Autumn Rhythm*, 1950. Photograph by Hans Namuth.

Something of the same visual movement is generated by Jackson Pollock's Abstract Expressionist paintings (Fig. 180). While not as large as Monet's paintings at the Orangerie, his works are still large enough to overwhelm the viewer. The eye travels in what one critic has accurately called "galactic" space, following first one line, then another, unable quite ever to locate itself or complete its visual circuit through the web of paint. Work such as this has been labeled "Action Painting" not only because it prompts the viewer to become actively engaged with it, but also because the lines that trace themselves out across the sweep of the canvas seem to chart the path of Pollock's own motions as he stood over the canvas. The drips and sweeps of paint record his own action as a painter and document it, a fact captured by Hans Namuth in his famous series of photographs of Pollock at work (Fig. 181). In Namuth's work we are witness to the immediacy of Pollock's gesture as he flings paint across the canvas, moving around the work, the paint tracing his path.

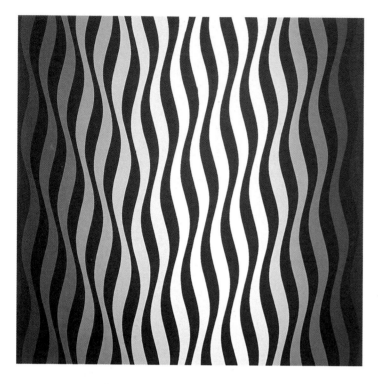

Fig. 182 Bridget Riley, *Drift 2*, 1966. Emulsion on canvas, 91 ¹/₂ × 89 ¹/₂ in. The Albright-Knox Art Gallery, Buffalo, NY. Gift of Seymour H. Knox, 1967.

Some art works are created precisely to give us the *illusion* of movement. In **Optical Painting**, or "Op Art" as it is more popularly known, the physical characteristics of certain formal elements—line and color particularly—are subtly manipulated to stimulate the nervous system into thinking it perceives movement. Bridget Riley's *Drift 2* (Fig. 182) is a large canvas that seems to wave and roll before our eyes even though it is stretched taut across its support. One of Riley's earliest paintings was an attempt to find a visual equivalent to heat. She had been crossing a wide plain in Italy: "The heat off the plain was quite incredible—it shattered the topographical structure of it and set up violent color vibrations.... The important thing was to bring about an equivalent shimmering sensation on the canvas." In *Drift 2*, we encounter not heat, but wave action, as though we were, visually, out at sea.

Other works of art, of course, do *actually* move. Often driven by motors, such works are examples of **kinetic** art. One of the most fascinating of kinetic sculptors was Jean Tinguely, who dedicated his career to making large machines out of the refuse of machine culture. On the rainy evening of March 7, 1960, he set in motion a machine in the sculpture garden of the Museum of Modern Art in New York (Fig. 183). The piece sputtered, stalled, started up again. A big balloon inflated over the mass of pulleys and gears. A player piano began to play. Fire erupted, the piano burned, stink bombs exploded, and a small wheeled machine was released and, all aflame, careened toward the audience, chasing a TV cameraman up a ladder. A fireman, in attendance as a safety precaution, was eventually summoned, and to the robust boos of the audience, finally doused the flames with a fire extinguisher. The piece—or the event, actually—was entitled *Homage to New York*. Asked what he thought of it, one critic replied, with tongue in cheek, "It's the end of civilization as we know it."

Fig. 183 Jean Tinguely, *Homage to New York*, March 7, 1960. Museum of Modern Art, New York. Photo: David Gahr.

Fig. 184 Edwin S. Porter, *The Great Train Robbery*, 1903.

Fig. 185 Walt Disney, *Steamboat Willie*, 1928. © 1928 Walt Disney Productions.

Fig. 186 Apollo XI Astronaut Neil Armstrong Stepping onto the Moon, July 20, 1969. Courtesy of NASA.

The spatial and the temporal have been most successfully combined in the twentieth century in the arts of film and video. In 1903, Edwin S. Porter released the ground-breaking film *The Great Train Robbery*, the first narrative action chase scene in the history of the cinema, which ended with the shockingly direct act of the bandit turning to fire his gun into the audience (Fig. 184). Fifteen minutes in length, the film opened in 1905 at John P. Harris's Nickelodeon in Pittsburgh, the first theater in the United States devoted to the showing of movies, where it played to packed houses. Within months, thousands of "nickelodeons" were springing up across the continent as millions of people rushed to experience "moving pictures." By the late 1920s Walt Disney had perfected the animated cartoon, and Mickey Mouse had become an American institution (Fig. 185). Hollywood was making over 450 movies a year by 1936, and the average American saw two films a week.

After World War II, this thirst for the moving image was satisfied more and more by television, the first medium in history to bring the primary image directly into the viewer's home. Many early television shows were actually "live"—that is, the show was broadcast live, before a live studio audience, without any taping or even tape delay. The directness, immediacy, and realism of the television image (further heightened by the rise of the color monitor, which began to have a real impact in the late 1950s) have made it, at least seemingly, the most *realistic* of media. Though its images are constantly manipulated, and its stage space almost totally artificial (notice how many television "families" sit on the same side of the kitchen table, facing the camera), we accept it as "real." When 400 million Americans watched Neil Armstrong step onto the moon in July 1969 (Fig. 186), only the most die-hard skeptics distrusted what they saw. It is fair to say, in

Fig. 187 Jamie Clay, Dream System, 1992. Computer generated image, using 3-D Studio. Courtesy Autodesk, Inc.

fact, that television has shrunk the world. In 1985, one-third of the world's population—approximately 1.6 billion people—watched the Live Aid Telethon together.

Most recently, video technology has combined with computer technology to create a medium that is variously known as **cyberspace**, **hyperspace**, or **virtual reality**. Virtual reality is a three-dimensional environment that the viewer experiences as real space. One "enters" this space by donning a set of goggles containing two small video monitors, one in front of each eye, and a glove covered with optic fibers for tracking purposes. Pointing a finger means "fly," and you dart into the space depicted on the monitors. Relax your hand, and you slow to a stop. You feel as if you inhabit and move in the space before your eyes, though you are actually in the completely controlled environment of the lab. "It's all about illusion," says Randal Walser of the Cyberspace Project at Autodesk, Inc., in Sausalito, California. "We're building imaginary worlds, and we're putting people in them.... Instead of being like TVs, which are windows you look through, cyberspace is a door. You walk through the door and you're *there*." By means of computer modems, it is possible for a person in one place to play a simulated racquetball game with a person across the continent. NASA has installed photographic and computer data about Mars into a cyberspace system in Palo Alto, California, allowing for a sort of "firsthand" exploration of the planet. All the formal elements come into play in virtual reality in order to create worlds that transcend time and space, and that viewers are free to explore as they choose.

Fig. 188 Exxon Emblem and preliminary logo design. From Raymond Loewy, *Industrial Design* (Woodstock, N.Y.: Overlook Press, 1979). Reprinted by permission of the Overlook Press.

6 PRINCIPLES OF DESIGN

The word *design* is both a verb and a noun, a process and a product. To design something is to organize its parts into a unified whole. We are able to see, in that totality, something we call its "design"—that is, we can recognize in the finished product the process of its organization and composition.

Everything made by human beings is, to a greater or lesser degree, designed. The Exxon logo (Fig. 188), for instance, was designed by Raymond Loewy. Loewy was one of the first and greatest of America's industrial designers, responsible for everything from the Coca-Cola bottle and the Lucky Strike package to the Greyhound bus and NASA's SkyLab habitats. In March 1966, he was approached by Standard Oil of New Jersey and told that they wished to change their product name—Esso, a phonetic expression of the company's initials, S.O., which stood for Standard Oil—while maintaining, as much as possible, their original identity. "In less than a week," Loewy recalls, "I found the name I wanted: Exxon, and I made seventy-six rough pencil sketches based on the word, placing the visual emphasis on the double x's.… I valued the double x for its neo-subliminal memory retention value and also for a certain similarity to the two s's in Esso." Loewy's final design, with its single diagonal crossbar pointing dynamically onward, suggests the word "express" as well and, with it, everything from fast cars to fast service.

Loewy's design is *purposeful*. It is meant to sell gasoline, and its success as design can be measured, at least to some degree, by how well it has accomplished that purpose over the years. It is less clear how to measure the success of a nonobjective painting's design, the sole purpose of which is to cause the viewer to have an aesthetic response to it. What seems well designed to one eye can seem badly designed to another. When the architect Frank Gehry remodeled his home in

Fig. 189 Frank Gehry, Gehry house, Santa, Monica, California, 1977–1978. Photo: Tim Street-Porter.

Santa Monica, California, in 1976 (Figs. 189 & 190), surrounding the original with an outer shell constructed of plywood, concrete blocks, corrugated metal, and chainlink fence, the resulting structure shocked and bewildered his neighbors. They could not understand what principles of design had guided the architect in both his choice of materials and their construction. To many it seemed that he had destroyed a perfectly good house, and in the process destroyed the neighborhood.

Certain principles of design did, of course, guide Gehry, and looking closely at the house we can begin to guess what they are. He apparently values common, everyday materials. It was important to him to establish a sense of discontinuity between the original house and its addition; they were not meant to blend into a harmonious, unified whole. Most of all, the house is different from its neighbors. It does not fit in—willfully, almost gleefully so.

Fig. 190 Axonometric drawing of the Gehry house.

Fig. 191 Leonardo da Vinci, *Illustration of Proportions of the Human Figure*, c. 1485–1490. Pen and ink, 13 1/2 × 9 3/4 in. Galleria dell'Accademia, Venice.

We recognize that Gehry's house intentionally violates certain principles of design. He is not playing by the "rules"—which is to say, we recognize that something like a set of principles does, in fact, govern design in general. Or put another way, we recognize that these principles provide a norm or context that allows us to determine what a given artist's design concerns might be. We usually think about the principles of design in terms of balance, emphasis, proportion and scale, rhythm and repetition, and, finally, unity and variety. Though it might seem to be a study of only one of these principles—proportion—Leonardo's famous *Illustration of Proportions of the Human Figure* (Fig. 191) is in many ways a compendium of all of them. The figure is perfectly balanced, that is, symmetrical. The very center of the composition is the figure's belly button, a focal point that represents the source of life itself, the fetus's connection by the umbilical cord to its mother's womb. Each limb is repeated, once to fit in the square, symbol of the finite, earthly world, and once to fit in the circle, symbol of the heavenly world, the infinite and the universal. Thus, all the various aspects of existence—mind and matter, the material and the transcendental—are unified by the design into a coherent whole.

Leonardo's illustration is a remarkable example of the "rules" of proportion, and yet the inventiveness and originality of Gehry's work teaches us, from the outset, that the "rules" guiding the creative process are, perhaps, made to be broken. In fact, the very idea of creativity implies a certain willingness on the part of the artist to go beyond the norm, to extend the rules, and to discover new principles around which artistic expression can organize itself. As we have seen, artists can easily create visual interest by purposefully breaking with conventions such as the traditional rules of perspective; likewise, any artist can stimulate our interest by purposefully manipulating the principles of design.

Balance

When we lose our balance: the weight of our body is, for whatever reason, no longer centered over our feet, our arms flail, we lurch forward, and we attempt to reestablish equilibrium. If we were to draw a line down the middle of our body, each side of it would be, more or less, a mirror reflection of the other. When as children we made "angels" in the snow, we created, almost instinctively, symmetrical representations of ourselves that recall Leonardo's *Illustration of Proportions of the Human Figure* (Fig. 191). When each side is exactly the same, we have **absolute symmetry**. But even when they are not, as is true of most human bodies, when there are minor discrepancies side to side, the overall effect will still be one of symmetry, or what we would call **bilateral symmetrical balance**. The two sides seem to line up.

Though in Alice Aycock's *Untitled (Shanty)* (Fig. 192), the door of the house is opened, creating a certain sense of imbalance, we see the piece as primarily symmetrical. It is based in part on the design of a medieval waterhouse and waterwheel used for grinding grain, an early form of technology. It also is intended to be a version of Leonardo's *Illustration of Proportions of the Human Figure*, but all of the transcendental aspects of Leonardo's drawing have disappeared. Aycock, it could be argued, is depicting the moment when materialism, the belief that matter is the final reality, substitutes itself as a cultural value for humanism, which places far greater emphasis on mind than matter, and on the "human" values that the mind creates for itself. The implication is that technology is at least as negative a force as it is a positive one, bringing with it the poverty of the shantytown even as it brings good to the community by generating power and creating such foodstuffs as wheat flour and cornmeal. Technology increases productivity, but at great human cost. Philosophically, at least, there are two sides to Aycock's piece, and they may or may not "balance" each other out.

Fig. 192 Alice Aycock, *Untitled (Shanty)*, 1978. Wood, shanty, 54 × 30 × 30 in. Collection of Whitney Museum of American Art, New York. Gift of Raymond J. Learsy. 84.71.1.

Fig. 193 Enguerrand Quarton, *Coronation of the Virgin*, 1453–1454. Panel painting, 72 × 86 ⅝ in. Musée de l'Hospice, Villeneuve-lès-Avignon.

One of the dominant images of symmetry in Western art is the crucifix. In Enguerrand Quarton's remarkable *Coronation of the Virgin* (Fig. 193), the crucifix at the lower center of the composition is a comparatively small detail in the overall composition. Nevertheless, its so-called *cruciform* shape dominates the whole, and all the formal elements in the work are organized around it. So God, the Father, and Jesus, the Son, flank Mary in almost perfect symmetry, identical in their major features (though the robes of each fall a little differently). On earth below, the two centers of the Christian faith flank the cross, Rome on the left and Jerusalem on the right. And at the very bottom of the painting, below ground level, Purgatory, on the left, out of which an angel assists a newly redeemed soul, balances Hell on the right. Each element balances out another, picturing a perfectly unified theological universe.

Compositions that have two apparently balanced halves that nevertheless are not reflections of one another are said to be

asymmetrically balanced. We intuitively know that Nancy Graves's *Zeeg* (Fig. 194) is balanced—otherwise it would topple over—but this bronze sculpture consisting, from the bottom up, of a billows, a squash, what appears to be a sweetroll, an English cucumber, and finally two large abstract expressionist drips is completely asymmetrical. And, in fact, Graves has weighted the bottom left of the sculpture so that the lighter upper thrust of the cucumber and its attendant drips do not fall to the right.

The change in actual weight that allows three-dimensional sculpture to achieve equilibrium has a number of visual equivalents in two-dimensional terms. We all remember from childhood what happened when an older and larger child got on the other end of the seesaw. Up we shot, like a catapult. In order to right the balance, the larger child had to move toward the fulcrum of the seesaw, giving our smaller selves more leverage and allowing the plank to balance. The illustrations below (Fig. 195) show, in visual terms, how this balance can be attained: (a) a large area closer to the fulcrum is balanced by a smaller area further away; (b) two small areas balance one large area; (c) a dark area closer to the fulcrum is balanced by a light area of the same size further away; (d) a large light area is balanced by a small dark one; (e) a textured area closer to the fulcrum is balanced by a light area further away.

Fig. 194 Nancy Graves, *Zeeg*, 1983. Bronze with polychrome patina, 28 1/2 × 14 × 11 in. Private collection.

Fig. 195 Some different varieties of asymmetrical balance.

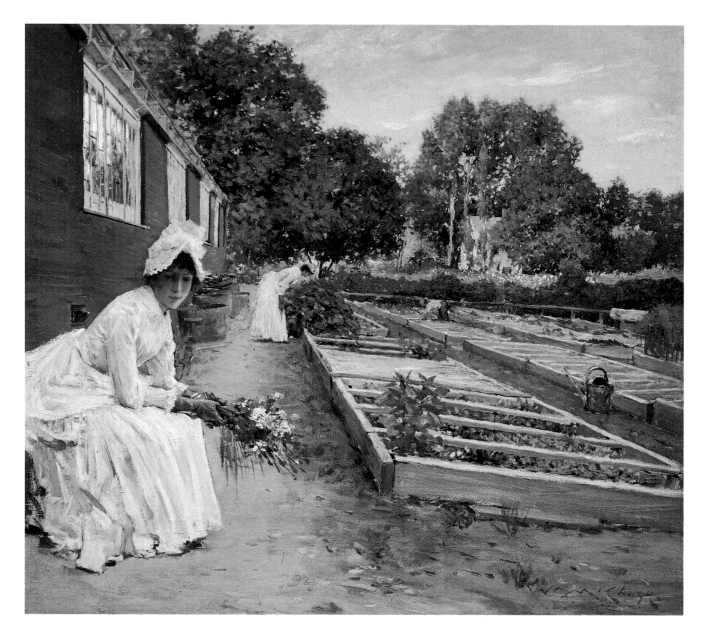

Fig. 196 William Merritt Chase, *The Nursery*, 1890. Oil on panel, 14 1/8 × 16 in. Manoogian Collection, Detroit.

William Merritt Chase's *The Nursery* (Fig. 196) is a perfect example of asymmetrical balance. The setting is the nursery in New York's Central Park, where seedlings are started each year and then transplanted to the flowerbeds throughout the park. It is evidently early summer and many of the plants have already been moved. The left side of this painting is much heavier than the right. The bright white dress of the seated young woman, together with the red building behind her, are the largest shapes in the composition. The complementary color scheme enforces our sense of asymmetrical balance. The larger right side is predominantly green, with only two hints of red. But the smaller left-hand side of the painting is dominated by a red that tints even the young woman's cheeks. Except for the leaves above the building, there is very little green on the left side, and the leaves are themselves more a warm yellow than anything else. If we were to imagine a fulcrum beneath the painting that would balance the composition, it would in effect divide the red from the green, exactly, as it turns out, below the vanishing point established by the building and the lines of planting frames. Instinctively, we place ourselves at this fulcrum, which is the painter's point of view as well. Both artist and spectator are equally objects of the young woman's gaze, and that gaze positions us at the balance point of the whole.

In terms of left and right, Seneca Ray Stoddard's late nineteenth-century photograph (Fig. 197) is radically unbalanced. Only the fact that the eye is drawn to a vanishing point in the empty expanse of the lake at the right relieves the massive weight of the hills and their reflection on the left. But the photograph is not balanced vertically, from left to right. It is organized in terms of **horizontal symmetry**, its top and bottom perfect mirror reflections of each other. The composition is, in fact, startlingly simple—each half is, in effect, composed of two right triangles, one light and one dark.

Fig. 197 Seneca Ray Stoddard, *Split Rock Mountain, Lake Champlain*, 1890. Silverprint photograph, 6 × 8 in. Library of Congress.

Balance in Maori Carving

The Maori, the people native to New Zealand, possess a tradition of woodcarving of exceptional intricacy and beauty that dates back close to 1,000 years. Noted for its symbolic force—its ability to excite in the viewer feelings of *wehi* (fear) before *ihi* (power) and *wana* (authority)—the carvings are the product of a talent thought to derive from the gods, and they embody, therefore, the supernatural itself.

This *poupou*, or side post for the inside of a house, was carved by Wero-Taroi of the Ngati Tarawhai tribe. One of the most reknowned Maori sculptors of the nineteenth century, his figures are distinguished particularly by their long slanting brows that form a chevron between the eyes. At first glance, Wero-Taroi's carving seems symmetrical, but studied in detail, one notices that this symmetry is repeatedly broken. The swirls that form the body, for instance, do not match up. It can be argued that the resulting tension is fundamental to Maori experience. In Maori life, things fit together, and yet they do not.

The well-known Maori creation myth is a perfect example. In the beginning, the male sky, Rangi, and the female earth,

Papa, were lovers, forever locked in an embrace. But, inevitably, they had children, and with no room to move between heaven and earth, their children found it pretty tough going. The children resolved to separate their parents so that they might be free. Their eventual "success" is responsible for the world as we know it.

Wero-Taori's carving is the aesthetic representation of this tension between the desire to unify experience and the knowledge that such unity can be stifling. The carving is thus both controlled and free, at once symmetrical as a whole and asymmetrical in detail.

Source: Allan Hanson, "Art and the Maori Construction of Reality," in *Art and Artists of Oceania*, ed. Sidney M. Mead and Bernie Kernot (New Zealand: Dunmore Press, 1983): 210–225.

Fig. 198 Poupou (side post), from Rangitihi, a house carved for Te Waata Taranui of Arawa by Wero of Ngati Tarawhai, 1867–1871. Height: 79 in. Auckland Institute and Museum, New Zealand.

Some works of art are simply **unbalanced**, either by design or, in the case of Chartres Cathedral (Fig. 199), by historical circumstance. The north tower, on the left, was constructed first in 1140, but without its pyramid-shaped spire; the south tower, on the right, and its tower were completed by 1142, but in those eight years, the architectural style had changed. Less massive in form than the earlier construction, it shows a subtle shift of architectural form from the heavier first story to the airier fourth story, and marks the transition from the simpler Romanesque to the more ornate Gothic style.

Most of the rebuilding of the facade of Chartres was completed by about 1220. But the north tower did not get a spire until the architect Hean de Beauce added one in 1513. Higher and airier than the south tower's spire, its latticed stonework seems to float into space like a soul rising toward heaven. Still, there remains, if not a visual balance between the two towers, something of an art historical one; the right marks the beginning of the Gothic era, the so-called Early Gothic period, the left its end and height, the period of the Late Gothic.

Connecting the towers is a facade built between 1140 and 1150. Its symmetry serves in many ways to unify the two radically different towers that abut it. The triple portal, the doorways and porches of the cathedral, and the three stained glass windows above it are perfectly balanced. They are topped by a large, dominating, and round stained-glass window (Fig. 200), called a rose window, that represents the Last Judgment. At its center is Jesus, surrounded by the symbols of Matthew, Mark, Luke, and John, the writers of the Gospels, and of angels and seraphim. The Apostles, depicted in pairs, surround these, and on the outer ring are scenes from the Book of Revelations. This rose window is a perfect example of **radial balance**, in which everything—in this case, both literally and figuratively—*radiates* from a central point.

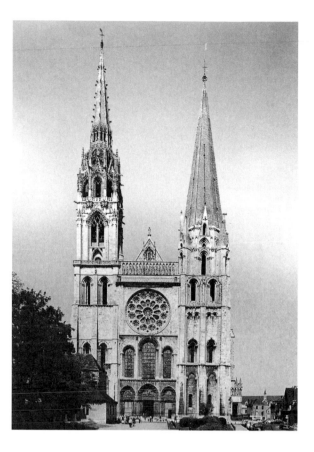

Fig. 199　Chartres Cathedral, west façade, 1140–1150; north spire, 1507–1513. Chartres, France.

Fig. 200　Rose window, west façade, Chartres Cathedral, c. 1215. Chartres, France.

Fig. 201 Anna Valayer-Coster, *Still Life*, 1767. Oil on canvas, 27 ³/₄ × 35 ¹/₄ in.
The Toledo Museum of Art, Toledo, Ohio. Gift of Edward Drummond Libbey.

Emphasis

Artists employ **emphasis** in order to
draw the viewer's attention to one area of the
work. We refer to this area as the focal point of
the composition. Very often the **focal point** of
a composition will be at or near the point or
line around which it is balanced. Thus, the
center of the rose window in the west facade
of Chartres Cathedral (Fig. 200) is its focal
point, and fittingly the crucified Christ occu-
pies the spot. The focal point of Quarton's
Coronation of the Virgin (Fig. 193) is Mary, who
is also, not coincidentally, the object of every-
one's attention. The focal point of Chase's *The
Nursery* (Fig. 196) is the vanishing point—
though the eye, in that painting, is quickly

drawn to the seated woman in the fore-ground, herself a second, important focus of the composition.

One important way that emphasis can be established is through the manipulation of light and color. The two paintings illustrated here employ the same complementary color scheme to widely different ends. Both are by women who painted in the court of the French king Louis XVI. Both were members of the Académie Royale, the official organiza-tion of French painters, though it is impor-tant to note that after Anna Valayer-Coster was elected to the Académie in 1770, mem-bership by women was limited to four, per-haps because the male-dominated Académie was threatened by their success.

By painting everything else in the com-position a shade of green, Anna Valayer-Coster focuses our attention in her *Still Life* (Fig. 201) on the delicious red lobster in the foreground. Lush in its brushwork, and with a sense of luminosity that we can almost feel, the painting celebrates Valayer-Coster's skill as a painter, her ability to control both color and light. In essence—and the double-enten-dre is intentional—the painting is an exercise in "good taste."

Elisabeth-Louise Vigée-Lebrun's por-trait of Marie Antoinette (Fig. 202) empha-sizes its subject by means of the same color contrast, the Queen's red dress contrasting to the predominantly green shades of her sur-roundings. Vigée-Lebrun was Marie Antoinette's favorite painter and, therefore, entrusted with the difficult task of portraying the unpopular Queen in a favorable light. Commissioned by the Court to restore the Queen's reputation among the people, the painting idealizes the unattractive Marie, not only by portraying her as the loving mother surrounded by her children but by sentimen-talizing that role as well—her young son points to an empty cradle that is meant to draw attention to the recent death of Marie's infant daughter.

Fig. 202 Elisabeth Vigée-Lebrun, *Portrait of Marie Antoinette with her Children*, 1787. Oil on canvas, 108 1/4 × 84 5/8 in. Musée de Versaille, France.

Fig. 203 Georges de La Tour, *Joseph the Carpenter*, c. 1645. Oil on canvas, 18 ¹/₂ × 25 ¹/₂ in. Musée du Louvre, Paris.

We have already seen, in Tinteretto's *Last Supper* (Fig. 131), how light, functioning like a stage spotlight, can draw the eye away from the perspectival lines of the scene and cause us to focus our attention elsewhere. The light in Georges de La Tour's *Joseph the Carpenter* (Fig. 203) draws our attention away from the painting's apparent subject, Joseph, the father of Jesus, and to the brightly lit visage of Christ himself. The candlelight here is comparable to the Divine Light, casting an ethereal glow across the young boy's face.

In his masterpiece *Las Meninas (The Maids of Honor)* (Fig. 204), Diego Velázquez creates competing points of emphasis. The scene is the Spanish court of King Philip IV. The most obvious focal point of the composition is the young princess, the *infanta* Margarita, who is emphasized by her position in the center of the painting, by the light that shines brilliantly on her as on no one else, and by the implied lines created by the gazes of the two maids of honor who bracket her. But the gazes outside this central group, that of the dwarf on the right, who is also a maid of honor, and that of the painter on the left, a self-portrait of Velázquez, are turned away from the *infanta*. In fact, they seem to be looking at us, and so too is the *infanta* herself. The focal point of their attention, in other words, lies outside the picture plane. In fact, they are looking at a spot that appears to be occupied by the couple reflected in the mirror at the opposite end of the room, over the *infanta's* shoulder—a couple that turns out to be the king and queen themselves. It seems likely that they are the subject of the painting that Velázquez depicts himself as painting, since they are in the position that would be occupied normally by persons sitting for a portrait. The *infanta* Margarita and her maids of honor have come, it would seem, to watch the royal couple have their portrait painted by the great Velázquez. And Velázquez has turned the table on everyone, painting his visitors instead of his sitters.

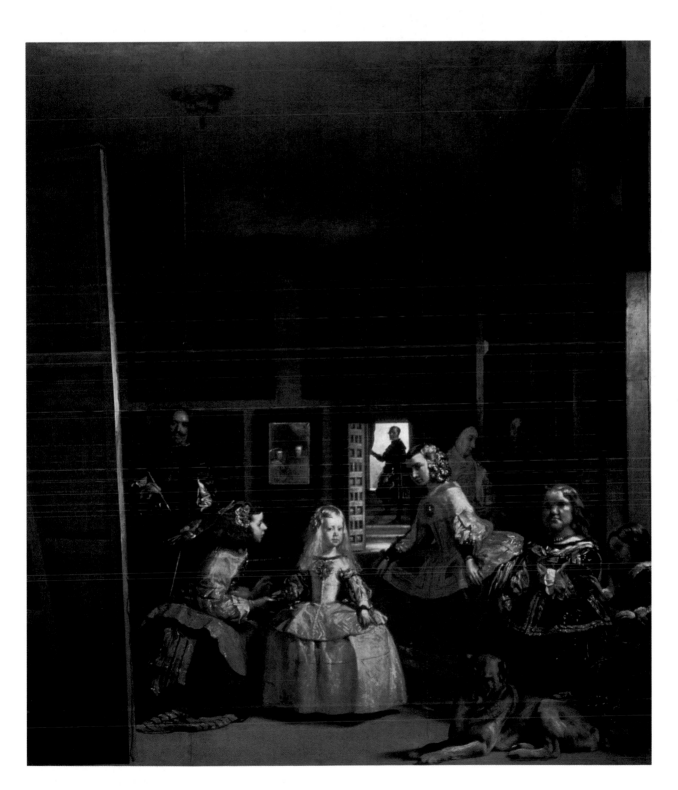

Fig. 204 Diego Velázquez, *Las Meninas (The Maids of Honor),* 1656. Oil on canvas, 10 ft. 5/4 in. × 9 ft. 3/4 in. Prado, Madrid.

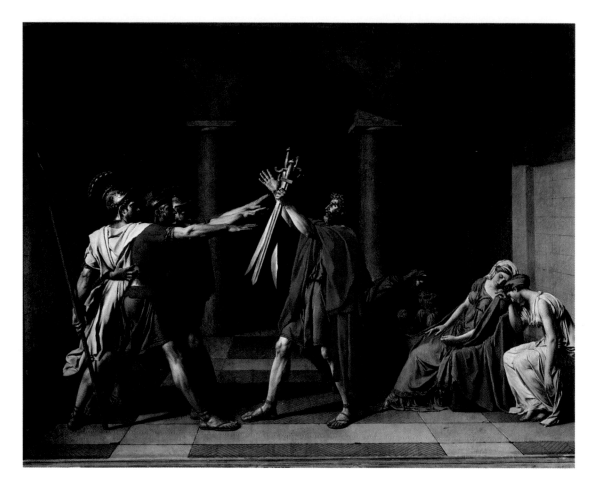

Fig. 205 Jacques Louis David, *The Oath of the Horatii*, 1784. Oil on canvas, approx. 11 × 14 ft. Musée du Louvre, Paris.

Sometimes, paradoxically, emphasis can be achieved by its very absence. Compare, for instance, these two large paintings by Jacques Louis David—*The Oath of the Horatii* (Fig. 205), painted in 1784, and *The Lictors Bringing Brutus the Bodies of His Sons* (Fig. 206), painted five years later, in 1789, just before the French Revolution. In the first painting, all the male figures are focused on a compositional "X" just to the left of center that is created by the central figure's outstretched right arm and the three swords he holds in his left hand. This focal point is, in fact, the subject of the painting, the oath being taken by the three figures on the left. The Horatii, the three Horatius brothers of Rome, are here swearing, before their father, to fight to the death the Curatii, the three sons of Curatius, who have been picked to

represent Rome's enemy, the Albans. Each set of sons has been chosen for this duty by their respective leaders, who have agreed that rather than sacrificing their entire armies in combat they will accept the outcome of a battle between these representatives. Behind the proud father, the women weep, as much for the Curatii as the Horatii, since Camilla, a sister of the Horatii, is engaged to be married to one of the Curatii. The loss of at least a single loved one is thus inevitable, the loss of more entirely probable. But such sacrifice, the painting suggests in its emphasis, is the necessary price of patriotism. The demands of civic responsibility must eclipse the joys of domestic life.

Now look at the second painting. The women, who have collapsed into an inactive heap in *The Oath of the Horatii*, are the single

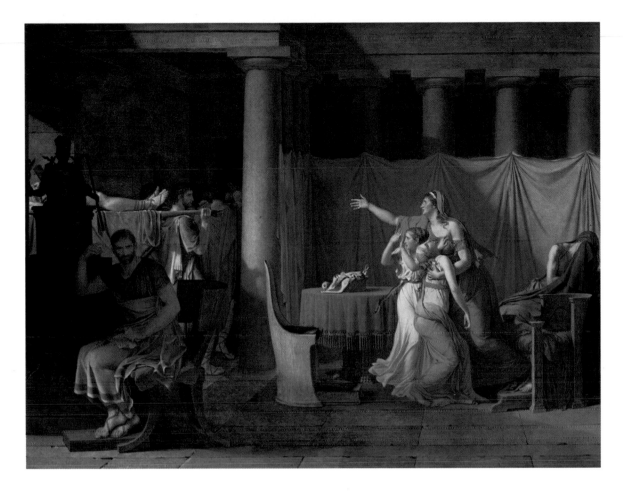

Fig. 206 Jacques Louis David, *The Lictors Bringing Brutus the Bodies of His Sons*, 1789. Oil on canvas, approx. 11 × 14 ft. Musée du Louvre, Paris.

source of animation in *The Lictors Bringing Brutus the Bodies of His Sons*. In the later work, there is no one point of emphasis. Instead, the focus is dispersed throughout the painting, as if to form a composite point of view. After the founding of the Roman Republic, Brutus was made consul, only to discover that his two sons, Titus and Tiberius, were part of a plot to overthrow the Republic and restore the empire. For this act of treason, he condemned them to death. Here, the two sons are being brought home for burial after their execution—the feet of one can be seen on a stretcher to the left. Brutus sits stoically alone in the shadows below, his back turned to them, his hand pointing to his head as if to emphasize the fact that his decision had to originate from his mind not his heart. The women, however, are all heart, all emotion. It is as if, in the outstretched hand of the wife, which directly echoes the outstretched hand of the father in *The Oath of the Horatii*, we can hear her cry. She reaches here toward emptiness, toward death, toward, in fact, the empty chair that sits at the center of the painting. It is one of the most expressive chairs in all of painting, the gentle curve of its back echoing the curves of the absent body, its emptiness symbolizing both the loss of Titus and Tiberius, their absence, and the gulf of feeling that now separates husband and wife, the state and the family. The kind of sacrifice that seemed inevitable and necessary in the earlier painting has become, as France braced herself for a revolution that seemed about to happen, much more deeply problematic, and this is reflected in the composition of the work itself.

Fig. 207 Larry Poons, *Orange Crush*, 1963. Acrylic on canvas, 80 × 80 in. Albright-Knox Art Gallery, Buffalo, New York. Gift of Seymour H. Knox, 1964.

Finally, it is possible, as the earlier example of Pollock's *Autumn Rhythm* (Fig. 180) indicates, to make a work of art that is **afocal**—that is, not merely a work in which no single point of the composition demands our attention any more or less than any other, but also one in which the eye can find no place to rest. In fact, if you stare for a while at the dots in at Larry Poons's painting *Orange Crush* (Fig. 207), and then transfer your attention quickly to the more solid orange area that surrounds them, dots of an even more intense orange will appear. Your vision seems to want to float aimlessly through the space of this painting, focusing on nothing at all.

Scale and Proportion

The painting on the right, John Singer Sargeant's *The Daughters of Edward Darley Boit* (Fig. 208) has a certain "Alice in Wonderland" feel to it. It is as if the young ladies depicted here had swallowed a piece of cookie and suddenly shrunk to a size smaller than a Chinese vase. The scale of the vases seems wrong. They appear to be too large. The painting, executed in 1882 in the Boit's Paris apartment, is not merely a group portrait, but a stunning psychological study, granting us access into the complicated reality of these young girls' lives. Writing about it in *Harper's Magazine*, Sargeant's contemporary, the novelist Henry James, found in this depiction of privileged children the same mysterious depth that he tried to convey in his own fiction—"the sense," he called it, "of assimilated secrets." The older girls are further back in space than the youngest child, in the darkness rather than the light, as if their psychological world were becoming increasingly private as they become more mature. The giant vases that loom over them, especially in combination with the bright red gash of the screen at the right, function like parental hands, at once threatening, on the right, and caressing on the left, but dominating their social world at every turn.

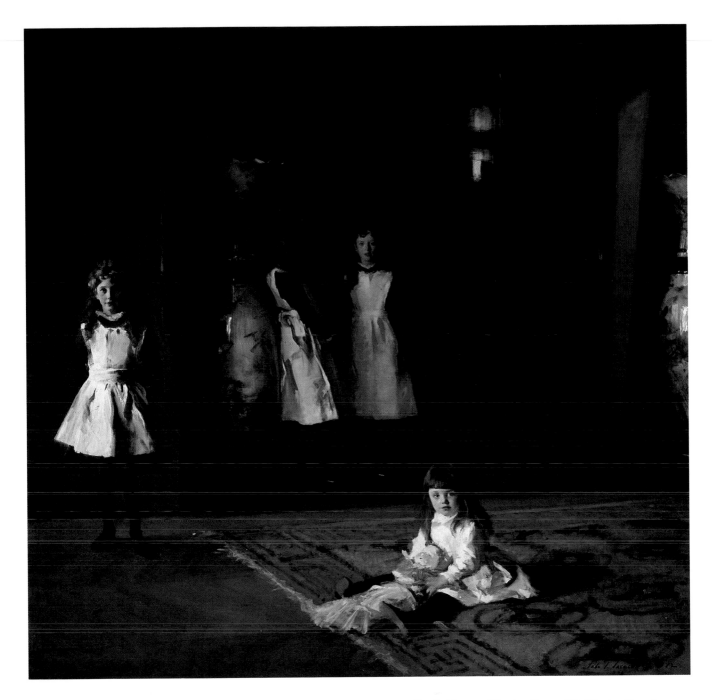

Fig. 208 John Singer Sargent, *The Daughters of Edward Darley Boit*, 1882. Oil on canvas, 87 5/8 × 87 5/8 in. Museum of Fine Arts, Boston. Gift of the daughters of Edward D. Boit in memory of their father.

Fig. 209 Helen Frankenthaler, *For E. M.,* 1981. Acrylic on canvas, 71 × 115 in. Collection of the artist, © Helen Frankenthaler 1993.

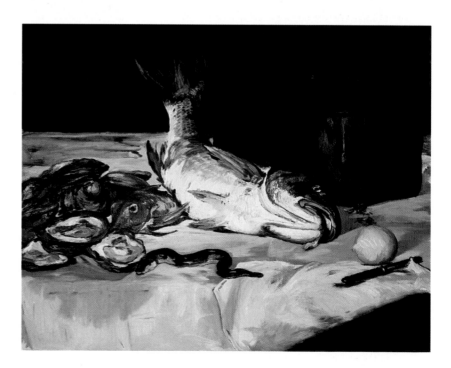

Fig. 210 Edouard Manet, *Still Life with Carp,* 1864. Oil on canvas, 28 $^7/_8$ × 36 $^1/_4$ in. Mr. and Mrs. Lewis Larned Coburn Memorial Collection. © 1993 The Art Institute of Chicago, All Rights Reserved.

Scale is the word we use to describe the dimensions of an art object in relation to the original object that it depicts or in relation to the objects around it. The vases in the Sargeant painting are large in scale relative to the size of the girls, and though, in fact, Edward Darley Boit did own two vases just this size, their large scale contributes to the disturbing psychological tone of the picture.

Scale is an issue that is always subtly at work in a textbook such as this. We have to understand that the reproductions we look at do not usually give us much sense of the actual size of the work. The scale is by no means consistent throughout. That is, a relatively small painting might be reproduced on a full page, and a very large painting on a half page.

Consider the two paintings on the left. As reproduced here, they are reasonably consistent in scale. The Frankenthaler painting (Fig. 209) is, in actuality, nearly three times bigger than the Manet (Fig. 210) to which it pays homage in nonobjective terms. (Notice, for instance, that the almost transparent white swatch in the middle of Frankenthaler's canvas is comparable to the belly of the carp in Manet's.) Yet, as reproduced, it is difficult to get a sense of the scale of the original paintings, that is, to understand how large they really are, both as individual works and in relation to each other. Scale, it must be understood, is a *relative* concept. We determine the scale of a given object as it relates to some usually unstated norm—in this case, the original paintings. Viewed in person, one immediately recognizes that Frankenthaler's painting is much grander is scale; it is a monumental abstraction beside Manet's intimate still life. In the same way, Claes Oldenberg's *Giant Trowel* (Fig. 211) monumentalizes the common everyday garden implement it depicts. It is an intentional exaggeration that parodies the very idea of garden sculpture.

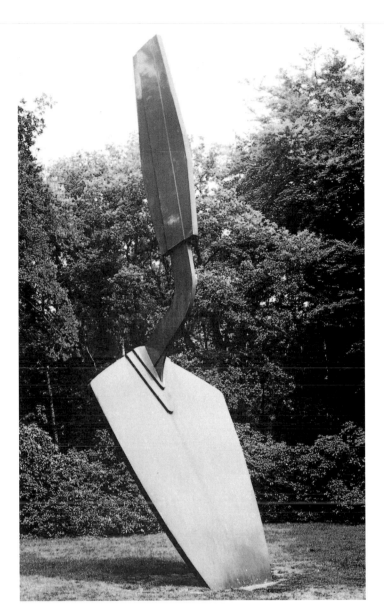

Fig. 211 Claes Oldenberg, *Giant Trowel*, 1971. Zinc-coated steel, 144 × 46 in. Rijksmuseum Kröller-Müller, Otterlo, The Netherlands.

Fig. 212 Charles Simonds, *Dwelling, East Houston Street, New York*, 1972. Unfired clay brick installation. Photograph: Charles Simonds.

Fig. 213 Passersby with *Dwelling, East Houston Street, New York*, 1972. Photograph: Charles Simonds.

By manipulating scale, and flouting the expectations of the viewer, the artist can achieve some startling effects. During the 1970s, Charles Simonds constructed over 300 dwellings and ritual structures—200 of them on the Lower East Side of Manhattan alone, the others all over the world, from Ireland to China—traces of an imaginary race of "Little People" who once inhabited them. Made of tiny unfired clay bricks deposited in the walls of our decaying urban environment, these cliff dwellings speak to us of a lost tribe of people who have abandoned the sites we now occupy, presumably because they have found them unlivable. Because this art exists literally in the streets, very few have survived. Passersby take souvenir bricks, children play games in the ruins, weather destroys them. It is evident that the Little People are not only smaller than us, but that time is contracted for them as well. They have come and gone in our midst, and we have been blind to them.

Fig. 214 Hokusai, *The Great Wave Off Kanagawa*, from the series *Thirty-six Views of Mount Fuji*, 1823–1829. Color woodcut, 10 × 15 in.

Scale and Space in a Japanese Print

As we know from our study of perspective, one of the most important ways to represent recessional space is to depict a thing closer to us as larger than a thing the same size farther away. This change in scale helps us to visually measure the space in the scene before us. When a mountain fills a small percentage of the space of a painting we know that it lies somewhere in the distance. We judge its actual size relative to other elements in the painting and our sense of the average real mountain's size.

Because everybody in Japan knows just how large Mount Fuji is, many of Hokusai's various views of the mountain take advantage of this knowledge and, by manipulating scale, play with the viewer's expectations. His most famous view of the mountain, *The Great Wave Off Kanagawa* (Fig. 214), is a case in point. In the foreground, two boats descend into a trough beneath a great crashing wave that hangs over the scene like a giant, menacing claw. In the distance, Fuji rises above the horizon, framed in a vortex of wave and foam. Hokusai has echoed its shape in the foremost wave of the composition. While the wave is visually larger than the distant mountain, our sense of scale causes us to diminish its importance. The wave will imminently collapse, Fuji will remain. For the Japanese, Fuji symbolizes not only the everlasting, but Japan itself, and the print juxtaposes the perils of the moment to the enduring life of the nation.

Fig. 215 Pablo Picasso, *Woman with Stiletto (Death of Marat)*, 1931. Oil on canvas, 18 1/8 × 24 in. Musée Picasso, Paris. Reunion des Musée Nationaux.

Artists can also manipulate proportion to interesting ends. Picasso's *Woman with Stiletto (Death of Marat)* (Fig. 215) depicts one of the most famous moments in French history, when Charlotte Corday assassinated the revolutionary hero Jean-Paul Marat in his bath, also the subject of one of Jacques Louis David's most famous paintings (Fig. 632). Every element in Picasso's painting is grotesquely disproportionate. Marat lies in his tub with a tiny head and tiny left arm in which he holds a pen. His right arm is somewhat larger; in it he holds the letter that Corday wrote in order to gain entrance to his house. His right leg is swollen to gigantic size. Corday stretches out above him like a praying mantis, her giant mouth opened as if to consume the minuscule Marat, her stiletto, the size of a sewing needle, piercing his heart, her lower body hugely distorted. Blood falls in a rush to the floor, and its red becomes, behind Marat's gigantic foot, part and parcel of the tricolor, the flag of the French Revolution. By radically distorting the normal proportions of the human body, Picasso is able convincingly to dramatize the horror of this scene.

When the proportions of the figure seem normal, on the other hand, the representation

is more likely to seem harmonious and balanced. The classical Greeks, in fact, believed that beauty itself was a function of proper proportion. In terms of the human body, these perfect proportions were determined by the sculptor Polykleitos, who not only described them in a now lost text called the *Canon* (from the Greek *kanon*, or "rule") but who also executed a sculpture to embody them. This is the *Doryphoros*, or "spear carrier," the original of which is also lost, although numerous copies survive (Fig. 216). The perfection of this figure is based on the fact that each part of the body is a common fraction of the figure's total height. According to the *Canon*, the head ought to be one-eighth, and the breadth of the shoulders one-fourth, of the total height of the body.

This sense of mathematical harmony was utilized by the Greeks in their architecture as well. The proportions of the facade of the Parthenon, constructed in the fifth century B.C. on the top of the Acropolis in Athens (Fig. 217), are based on the so-called Golden Section: the width of the building is 1.618 times the height. In terms of proportions, the height is to the width as 1 is to 1.618, or in less precise terms, approximately a ratio of 5:8. Plato regarded this proportion as the key to understanding the cosmos, and many years later, in the thirteenth century A.D., the mathematician Leonardo Fibonacci discovered that this ratio is part of an infinite sequence (1, 2, 3, 5, 8, 13, 21, 34, 55, 89, etc.) in which each number is the sum of the two numbers before it, and each pair of numbers is a ratio that, as the numbers increase, more and more closely approximates 1:1.618. That the Parthenon should be constructed according to this proportion is hardly accidental. It is a temple to Athena, not only the protectress of Athens but the goddess of wisdom, and the Golden Ratio represents to the ancient Greeks not merely beauty, but the ultimate wisdom of the universe.

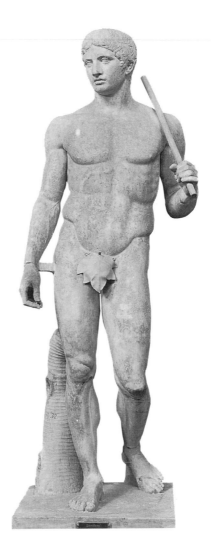

Fig. 216 Polykleitos, Doryphoros, 450 B.C. Marble, Roman copy after lost bronze original, height 84 in. National Museum, Naples.

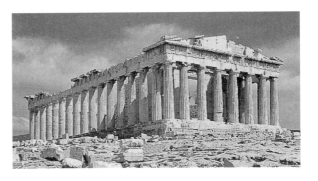

Fig. 217 Parthenon, 447–438 B.C. Pentelic marble, 111 × 237 ft. at base. Athens, Greece.

Fig. 218 Winslow Homer, *Eastern Point, Prout's Neck*, 1900. Oil on canvas, 30 1/4 × 48 1/2 in. Sterling and Francine Clark Art Institute, Williamstown, Massachusetts.

This Golden Section has continued to be widely used by artists down through the centuries. So, for example, the ratio of sky to sea in Winslow Homer's *Eastern Point, Prout's Neck* (Fig. 218) is approximately 5:8. The use of this ratio lends a sense of geometric classicism and order to a scene of crashing water and waves that would otherwise threaten to dissolve into chaos. The waves threaten to cast us into a state of vertigo so dizzying that the horizon line itself almost disappears. The actuality of the moment—the destructiveness of nature— is about to overtake the eternal truth of Homer's classical design, and yet, paradoxically, the moment is captured by the design forever. The chaos of the scene itself is captured in Homer's loose and expressive brushwork, but his control as an artist over this scene is asserted by his use of the Golden Section.

Repetition and Rhythm

Sameness seems to breed monotony and conformity, the sterile world of suburban life depicted in Frank Gohlke's photograph *Housing Development South of Fort Worth, Texas* (Fig. 219). Here we look down an endless vista of sidewalk, driveway, mailbox, and lawn, followed by sidewalk, driveway, mailbox, and lawn, punctuated by a few scrawny trees wired down to resist the flattening effects of the Texas winds. There is order here, but no beauty, nothing that sparks the imagination or creates a sense of visual delight. And yet the photograph is somehow appealing. It embodies a certain sense of hope and promise, of beginnings. It is as if the monotony of the scene promises someday to disappear when, for instance, the scrawny trees grow to full size.

This is also the world depicted by Pop artist Andy Warhol in his *100 Campbell's Soup Cans* (Fig. 220). The subject of Pop Art is, as its name implies, popular culture, and the subject of Warhol's painting is, more precisely, the incredibly banal "soup 'n sandwich" existence of everyday life in the early 1960s. Our visual landscape extends the length of a supermarket shelf. If the promise of Campbell's soup is "Um, um, good!" the reality is another thing. The variety of flavors depicted here is no variety at all.

Most of all, Warhol subverts the idea of painting as a unique creative act, expressive of the artist's individual (and usually tortured) psyche—an idea that became almost a myth with the abstract expressionists. No original subject matter here, just soup cans. And although Warhol's work is as large as the usual Jackson Pollock work, there is no revelation of the painter's psyche here, unless that psyche is understood as totally controlled by consumer culture. As much as it is social commentary, then, Warhol's *100 Campbell's Soup Cans* is a good-humored critique of the self-serious painting of the day and of the inflated artistic egos responsible for it.

Fig. 219 Frank Gohlke, *Housing Development South of Fort Worth, Texas*, 1978. Gelatin silver print, 36 x 44 cm. © 1978 Frank Gohlke, Collection of the Center for Creative Photography, Tucson.

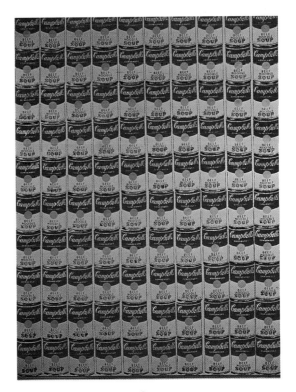

Fig. 220 Andy Warhol, *100 Campbell's Soup Cans*, 1962. Synthetic polymer paint on canvas, 72 × 52 in. © 1994 The Andy Warhol Foundation for the Visual Arts, Inc.

Fig. 221 Gertrude Stein, personal logo. Front cover of *The Autobiography of Alice B. Toklas*, 1933.

Fig. 222 Charles Demuth, *Poster Portrait: Love, Love, Love. Homage to Gertrude Stein*, 1928. Oil on panel, 19 1/2 × 23 1/2 in. Thyssen-Bornemisza Collection, Lugano, Switzerland.

Repetition can, on the other hand, reveal difference as much as similarity. Gertrude Stein's famous logo, "Rose is a rose is a rose is a rose," printed in circular form on the front of the first edition of her memoir, *The Autobiography of Alice B. Toklas* (Fig. 221), is a case in point. By her use of repetition Stein *emphasizes* the words themselves, forcing us to listen to them a little differently. If we listen carefully, we will recognize the kind of word-play for which Stein is famous: "Rose is a rose is a rose is a rose" becomes "eros is eros is eros is eros"—"love, love, love, love." In this context, Charles Demuth's startlingly minimal and enigmatic "picture-portrait" of Stein (Fig. 222) suddenly explains itself.

Conversely, apparently different things can suddenly reveal themselves to be the same. The *Gates of Hell* (Fig. 223), by Auguste Rodin, were conceived in 1880 as the entry for the Museum of Decorative Arts in Paris, which was never built. The work is based on the *Inferno* section of Dante's *Divine Comedy* and is filled with nearly 200 figures who swirl in hell fire, reaching out as if continually striving to escape the surface of the door. Rodin's famous *Thinker* sits atop the door panels, looking down as if in contemplation of man's fate, and to each side of the door, in its original conception, stand Adam and Eve. At the very top of the door is a group of three figures, the Three Shades, guardians of the dark inferno beneath.

What is startling is that the Three Shades are not different, but, in fact, all the same. Rodin cast his Shade three times and then arranged the three identical casts in a semicircular format. The figure remains the same, but it looks different when seen from different sides. Furthermore, the posture of the figure of Adam, in front and to the left, echoes that of the Shades above. This formal repetition, and the downward pull that unites all four figures, implies that Adam is not merely the father of us all, but, in his sin, the man responsible for hell itself.

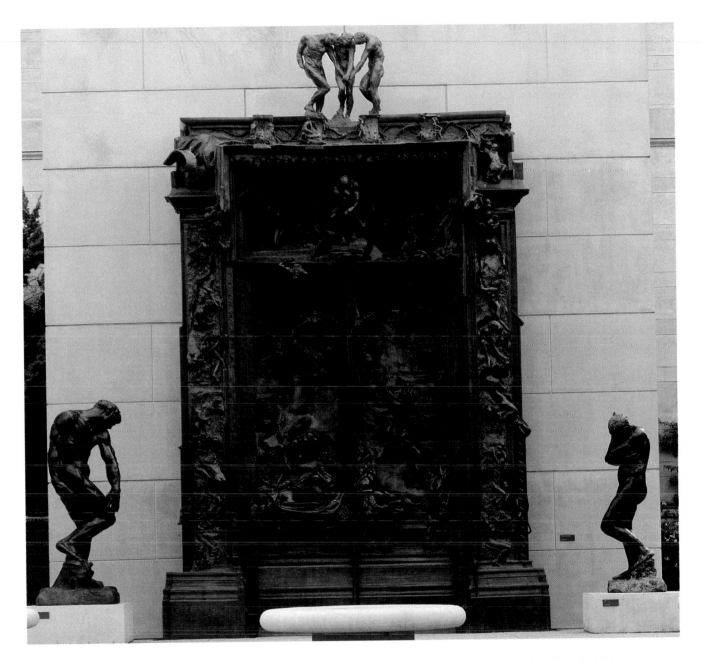

Fig. 223 Auguste Rodin, *Gates of Hell* with *Adam and Eve*, 1880–1917. Bronze, 251 × 158 × 33 in. Stanford University Museum of Art. Photo: Frank Wing.

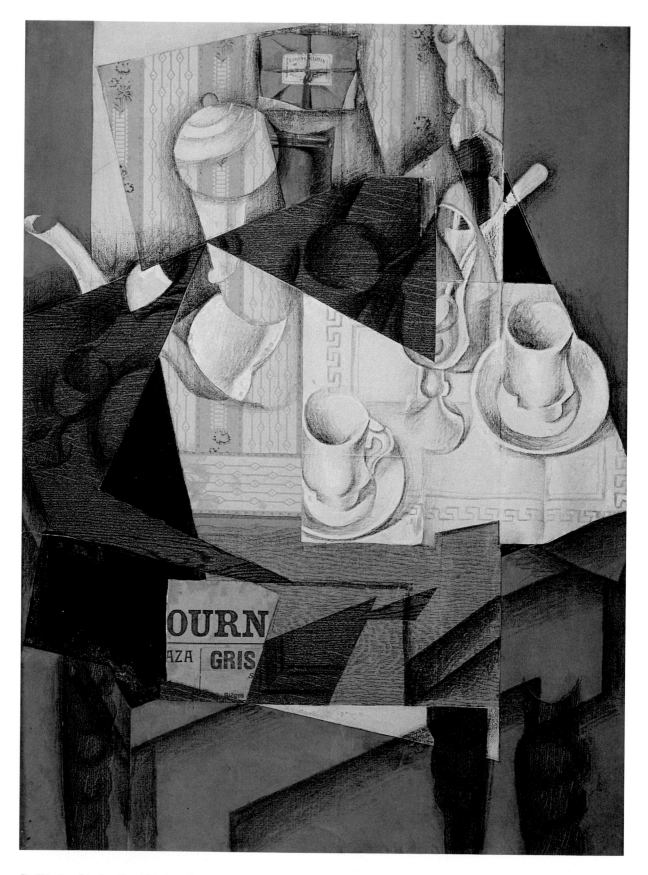

Fig. 224 Juan Gris, *Breakfast*, 1914. Cut-and-pasted paper, crayon, and oil over canvas, 31 7/8 × 23 1/2 in. The Museum of Modern Art, New York. Acquired through the Lillie P. Bliss Bequest.

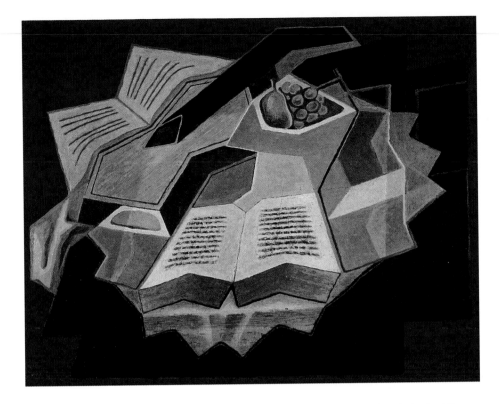

Fig. 225 Juan Gris, *The Open Book*, 1925. Oil on canvas, 28 3/4 × 36 1/4 in. Kunstmuseum, Bern, Switzerland, Hermann and Margit Rupf Foundation.

In *Breakfast* (Fig. 224), Juan Gris uses repetition to unify, in a pattern of circles and right angles, different views of a single still-life scene. The repetition of the two coffee cups on the right establishes a rhythm of circular shapes that extends around the painting. Between the two coffee cups is a tall glass with a spoon in it, and behind that, the bottom of a bottle. The top of this bottle is set at an angle to its base on the top right. In relation to the bottle's top, then, the circular shape in the wood grain above the central coffee cup would appear to be the top of the glass with the spoon in it. The spout of the teapot on the left is echoed by the handle of the spoon on the right. The shape of the egg cup on the far left seems to echo the bottle top. The tobacco pouch and pipe stem at the top repeat the vertical and horizontal rhythms of the table cloth and wallpaper pattern. This is, as the fragment of newspaper with headline "GRIS" insists, Juan Gris's composition. Gris's painting testifies to the multiplicity of visual experience itself, and the ways in which that multiplicitous reality can be unified by the artist in a single composition by means of the repetition of shape and pattern.

In later years, Gris would simplify his compositions, usually employing only a single point of view, but the repetition of forms remained the single most important element unifying the surface of his works. Notice, in *The Open Book* (Fig. 225), how a V or W shape is repeated again and again: in the sides of the book, for instance, in the dark gray area immediately above, which forms the side of a guitar, and in the neck of the guitar as well. The four-pointed pattern of the tablecloth is repeated to the right. The lines of print echo the staffs on the sheet music. Only the fruit in the bowl escapes this pattern of repetition, and as a result it is the focus of our attention.

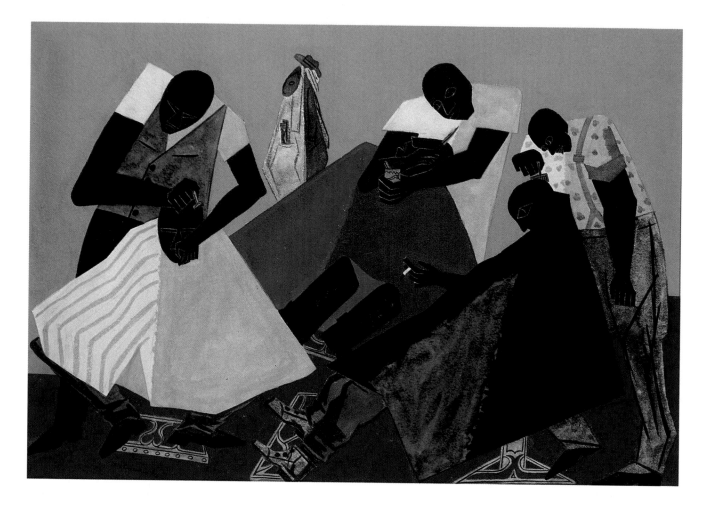

Fig. 226 Jacob Lawrence, *Barber Shop*, 1946. Gouache on paper, 21 3/8 × 29 1/8 in. The Toledo Museum of Art, Toledo, Ohio. Gift of Edward Drummond Libbey.

When the same or like elements—shapes, colors, or a regular pattern of any kind—are repeated over and over again in a composition, a certain visual **rhythm** will result. In Jacob Lawrence's *Barber Shop* (Fig. 226), this rhythm is established through the repetition of both shapes and colors. One pattern is based on the diamond-shaped figures sitting in the barber chairs, each of whom is covered with a different-colored apron: one lavender and white, one red, and one black and green. The color and pattern of the left-hand patron's apron is echoed in the shirts of the two barbers on the right, while the pattern of the right-hand patron's apron is repeated in the vest of the barber on the left. Hands, shoulders, feet—all work into the triangulated format of the design. "The painting," Lawrence explained in 1979, "is one of the many works…executed out of my experience…my everyday visual encounters." It is meant to capture the rhythm of life in Harlem, where Lawrence grew up in the 1930s. "It was inevitable," he says, "that the barber shop with its daily gathering of Harlemites, its clippers, mirror, razors, the overall pattern and the many conversations that took place there…was to become the subject of many of my paintings. Even now, in my imagination, whenever I relive my early years in the Harlem community, the barber shop, in both form and content…is one of the scenes that I still see and remember."

Unity and Variety

Repetition and rhythm are employed by Lawrence in *Barber Shop* in order to unify the different elements of the work. By repeating shapes and color patterns, he gives the painting a sense of coherence. Each of the principles of design that we have discussed leads to this idea of organization, the sense that we are looking at a unified whole—balanced, focused, and so on. Even Lawrence's figures, with their strange, clumsy hands, their oversimplified features, and their oddly extended legs and feet, are *uniform* throughout. Such consistency lends the picture its feeling of being complete. It is as if Lawrence is painting the idea of community itself, bringing together the diversity of the Harlem streets through the unifying patterns of his art.

By way of contrast, this untitled painting by Jean-Michel Basquiat (Fig. 227) seems purposefully to avoid any sense of unity. Basquiat was the middle-class son of a Brooklyn accountant who, at age 20, moved from painting graffiti on walls throughout Manhattan to painting and drawing on large canvases. His loose and expressionist brushwork is painted over a body of scrawled notations, the content of which is willfully arbitrary. On the one hand, we sense Basquiat's alienation from his community in the work, in the contorted masks that grin menacingly out of the space of the composition and in the very crudeness of his style, a purposeful affront to traditional notions of artistic "quality." Trying to make sense of the random marks and bits of text, we almost inevitably feel lost and confused. But on the other hand, Basquiat's painting is distinguished by the sheer energy and exuberance of its style, the vitality of his color, and the sense of freedom that his brushwork seems to embody. If Basquiat was himself alienated from an art world that had granted him instant success, he also always seemed to have fun with it, spoofing its high seriousness and mocking, particularly, its preoccupation with money and fame.

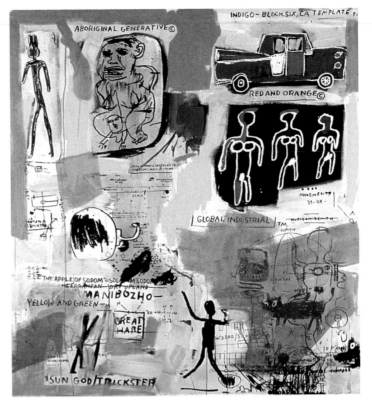

Fig. 227 Jean-Michel Basquiat, *Untitled*, 1984. Acrylic, silkscreen and oilstick on canvas, 88 × 77 in. © The Estate of Jean-Michel Basquiat. Courtesy Robert Miller Gallery, New York.

The Unity of a Chinese Painting

Wu Zhen's classic handscroll, *The Central Mountain* (Fig. 228), a masterpiece of Chinese art, was composed according to the most strict artistic principles of unity and simplicity. It elevates the most bland, plain, and uninteresting view—the kind of scene the Chinese call *p'ing-tan*—to the highest levels of beauty, revealing, in the process, the most profound truths about nature.

Wu Zhen is one of the Four Great Masters of the Yuan Dynasty, the period of history dominated by Mongol rulers and lasting from 1279 until 1368, when Zhu Yuanzhang drove the Mongols back to the northern deserts and restored China to the Han people. Wu Zhen worked in an intensely creative cultural atmosphere, dominated, on the one hand, by gatherings of intellectuals organized both for the appreciation and criticism of poetry, calligraphy, and painting, and for the appreciation of good wine, and, on the other hand, by deep interest in both Buddhist and Taoist thought. Of the Four Masters, Wu Zhen's tastes were perhaps the simplest, and most devout. *The Central Mountain* reflects his interest in the Tao.

In Chinese thought, the Tao is the source of life. It gives form to all things, and yet it is beyond description. It manifests itself, in our world, through the principle of complementarity known as *yin* and *yang*. Representing unity within diversity, opposites organized in perfect harmony, the ancient symbol for this principle is:

Fig. 228 Wu Chen, *The Central Mountain*, 1336. Handscroll, ink on paper, 26 × 90 cm. Collection of the National Palace Museum, Taipei, Taiwan, Republic of China.

Yin and *yang* are inseparable, but they represent different things. *Yin* is nurturing and passive, and is represented by the earth in general and by the cool, moist valleys of the landscape in particular. *Yang* is generative and active. It is represented by the sun and the mountain.

In the natural world, the variety of visual experience obscures these principles, making it difficult to recognize them. The goal of the artist, therefore, must be to reveal the Tao's presence. In Wu Zhen's hand scroll only trees and mountains are depicted. The trees are simple dots of ink; the grassy slopes of the mountainsides are painted in a uniform flat, gray wash. There are no roads, houses, or people to distract us. The scene is without action, devoid of any movement or sense of change. The mountains roll across the scroll with a regular rhythm, as if measuring the serene breath of the spectator. The entire composition is symmetrically balanced around the central mountain. The heavens become a negative shape balancing, on a horizontal axis, the mountains below. Heaven and earth, solid and void, fold into one, as if to reveal the absolute essence of *yin* and *yang*.

Source: Jerome Silbergeld, *Chinese Painting Style* (Seattle: University of Washington Press, 1982).

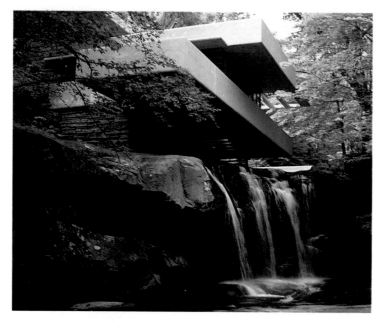

Fig. 229 Frank Lloyd Wright, *Fallingwater* (Kaufmann House), Bear Run, Pa., 1936–1937.

Fig. 230 Richard Meier, house at Harbor Springs, Michigan, 1971–1973. Photo: Ezra Stoller © Esto.

If we compare Frank Lloyd Wright's Kaufmann House, known as *Fallingwater* (Fig. 229), to a house designed by Richard Meier in Harbor Springs, Michigan (Fig. 230), we can quickly see that the former is integrated into the landscape whereas the latter is purposely alienated from its surroundings. Wright practiced what he called "organic" architecture. The Kaufmann House was built in the mid-1930s on a hillside in Bear Run, Pennsylvania, on a site dominated by stone cliffs and a beautiful, almost ethereal waterfall. Everything about Wright's plan is designed to fit the house into its environment. The stone for the walls was quarried near the site and is laid in wide, horizontal slabs to echo the horizontality of the cliffs. The balconies are made of reinforced concrete; in their scale, texture, and especially their extended thrust out over the waterfall, they too echo the ledges and hollows of the cliffs below. The floors in the interior are native stone, the walls of stone and natural woods.

The unity of building and landscape achieved by Wright is intentionally avoided by Meier. The house itself is a fully integrated design, an abstract grid of lines (created by railings), opaque planes (created by walls), and transparent surfaces (created by windows); the entirety composed both by the overall geometry and the uniform whiteness of color throughout. But just as its stark whiteness contrasts with the dense green woods that surround it, so does its precise, almost mechanical geometry contrast with the organic naturalness of the world in which it is sited. It boldly asserts that life is not lived at one with nature, that in the modern world we, as often as not, are frankly indifferent to our environment.

It is this sense of disjunction, the sense that the parts can never form a unified whole, that we have come to identify with what is commonly called **postmodernism**. In architecture, the discontinuity between the

Fig. 231 *Las Vegas, Nevada.*

old and the new that marks Frank Gehry's house (Fig. 189), discussed at the beginning of this section, is an example of this postmodern sensibility. So is Gehry's willingness to incorporate, in the "high" art of architecture, the most everyday and unartful materials. In postmodern art, kitsch and high culture collide.

In his important 1972 book, *Learning from Las Vegas*, the architect Robert Venturi announced that the collision of styles, signs, and symbols that marks the American "strip" in general and the world of Las Vegas in particular (Fig. 231) could be seen in light of a new sort of unity. "Disorder," Venturi writes, "[is] an order we cannot see.... The commercial strip with the urban sprawl...[is an order that] includes; it includes at all levels, from the mixture of seemingly incongruous land uses to the mixture of seemingly incongruous advertising media plus a system of neo-organic or neo-Wrightian restaurant motifs in Walnut Formica." The strip declares that anything can be put next to anything else. While traditional art has tended to keep things out that it deemed unartful, postmodern art lets everything in. In this sense, it is democratic. It could even be said to achieve a unity larger than the comparatively elitist art of high culture could ever imagine.

Elizabeth Murray's shaped canvas *Just in Time* (Fig. 232) is, at first glance, a two-panel abstract construction of rhythmic curves oddly, and not quite evenly, cut in half. But on second glance, it announces its postmodernity. For the construction is also an ordinary tea cup, with a pink cloud of steam rising above its rim. In a move that calls to mind the Pop sculpture of Claes Oldenberg, the scale of this cup—it is nearly nine feet high—monumentalizes her banal, domestic subject matter. Animal forms seem to arise out of the design—a rabbit on the left, an animated, Disneylike, laughing teacup in profile on the right. The title recalls pop lyrics—"Just in time, I found you just in time." Yet it remains an abstract painting, interesting as painting, and as design. It is even, for Murray, deeply serious. She has defined the significance of the break down the middle of the painting in a poem:

> The desert sighs in the cupboard
> The glacier knocks in the bed
> And a crack in the tea-cup opens
> A lane to the land of the dead.

Who knows what memories rise up out of this structural gap, a gap that could be said to define the openness of postmodernist art to anything and everything.

Fig. 232 Elizabeth Murray, *Just in Time*, 1981. Oil on canvas in two sections, 106 × 97 in. Philadelphia Museum of Art. Purchased: The Edward and Althea Budd Fund, the Adele Haas Turner and Beatrice Pastorius Fund and funds contributed by Marion Stroud Swingle and Lorine E. Vogt.

PART III
THE FINE ARTS MEDIA

Learning How Art is Made

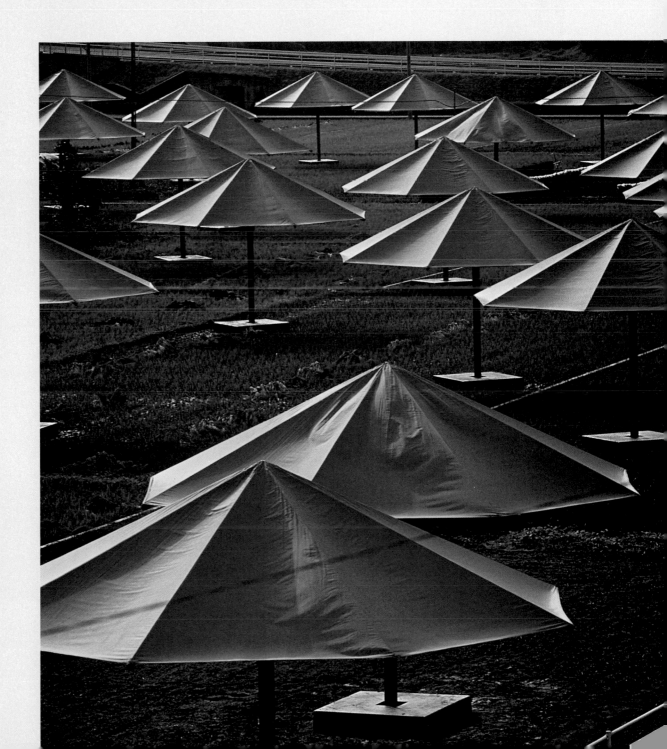

Fig. 233 Albert Bierstadt, *Cho-looke, The Yosemite Falls*, 1864. Oil on canvas, 34 × 27 in. The Putnam Foundation, Timken Museum of Art, San Diego, California.

7 THE FINE ARTS MEDIA

The history of the various media used to create art is, in essence, the history of the various *technologies* that have come to be employed by artists. These technologies have helped artists both to achieve the ends they desire more readily and to discover new modes of creation and expression. A technology, literally, is the "word" or "discourse" (from the Greek *logos*) about a "techne" (from the Greek word for art, which in turn comes from the Greek verb *tekein*, "to make, prepare, or fabricate"). A **medium** is, in this sense, a *techne*, a means for making art. Illustrated here is the same scene, Yosemite Falls, executed in two different media.

Even in August 1863, as the painter Albert Bierstadt made preparatory sketches on site for *Camping in the Yosemite* (Fig. 233), a small group of photographers had already begun to document the valley. They were able to do this because of the development of a new glass-plate process that had made outdoor photography in remote sites much easier. An earlier technology, the daguerreotype, created an image that could not be reproduced. But with the glass plate, it was possible to make multiple prints, so a photographer could, for the first time, sell many copies of the same successful shot. Furthermore, the daguerreotype required considerable quantities of mercury, iodine, and sheets of silvered copper, not to mention a developing box, making outdoor work cumbersome at best. Carlton E. Watkins's *Cho looke or Yosemite Falls, From the Upper House* (Fig. 234) is one of the largest, and one of the most beautiful, of the early photographs of the Yosemite region.

The public's taste for photographic landscapes grew rapidly in the last half of the nineteenth century, and photographs such as Watkins's made it clear that the West was a place of unparalleled, even breathtak-

Fig. 234 Carlton E. Watkins, *Cho looke or Yosemite Falls, From the Upper House,* c. 1865. Albumen print, 18 x 23 in. International Museum of Photography at George Eastman House, Rochester, New York.

ing beauty, with a scale as monumental as that depicted in Bierstadt's art. Yet such photography also revealed the painter to be inclined, as it were, to exaggeration. As large as the West was, it was not quite so large as Bierstadt would have it. Bierstadt's clouds shroud the summit on the cliff beside the falls, and imply that there is much more mountain above. The contrast between light and shade is dramatic. The scale of his scene is heightened by the placement of figures in the foreground, especially the tiny figure riding into the valley—how large must be the rocks and trees to his right! Bierstadt is not so much interested in depicting the scene per se as he is in revealing the landscape as *sublime*, that is, as capable of inspiring feelings of awe and grandeur. Watkins, by contrast, is documenting the place, giving us "the facts" about it. But Bierstadt is not so much "wrong" as he is a painter; Watkins not so much right as he is a photographer.

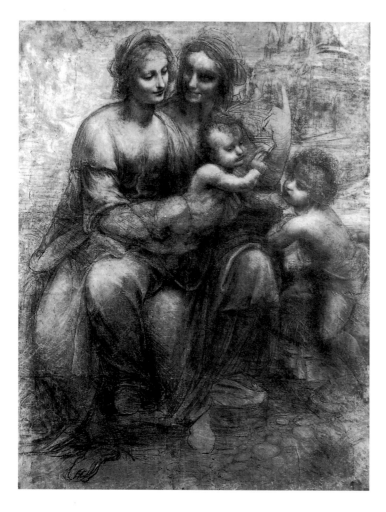

Fig. 235 Leonardo da Vinci, *Virgin and Child with St. Anne and Infant St. John*, c. 1505–1507. Black chalk, 55 3/4 × 41 in. The National Gallery, London.

Drawing

When Giorgio Vasari sat down to write his famous *Lives of the Painters* in 1550, his natural tendency was to see, in drawing, the foundation of Renaissance painting itself. He had, for one thing, one of the largest collections of fifteenth-century—or so-called *quattrocento*—drawings ever assembled, and referring to it constantly, he wrote as if these drawings were a dictionary of the styles of the artists who had come before him.

In the *Lives* he recalls how, in 1501, crowds rushed to see a **cartoon**—or drawing done to scale for a painting or a fresco—executed by Leonardo for his *Virgin and Child with St. Anne*: "The work not only won the astonished admiration of all the artists but when finished for two days it attracted to the room where it was exhibited a crowd of men and women, young and old, who flocked there, as if they were attending a great festival, to gaze in amazement at the marvels he had created." Though this cartoon apparently does not survive, we can get some notion of it from the later cartoon illustrated left (Fig. 235). Vasari's account, at any rate, is the earliest recorded example we have of the public actually admiring a drawing. Until about this time, drawing was understood as merely a stage in the development of the final work of art. It had relatively little value in itself, and was, as a result, almost never preserved, let alone signed or dated.

In the first place, drawing as we know it was an expensive medium. Although paper was invented in China in the second century A.D., it was not made commercially in Europe until 1276, when a paper mill was opened in Fabriano, Italy. But until about 1470, when printing presses began to spring up all over the country, papermaking did not seriously develop as an industry, and it remained expensive. Made by beating cloth into a pulp—wood products were not used in papermaking until the nineteenth century—

and then allowing this pulp to congeal on a fine wire mesh, it required large quantities of linen (for the highest quality paper), cotton, or rags. By the late fifteenth century, Venice had passed laws forbidding the export of rags in order to protect its own paper industry. Demand for paper was high, and quantities were limited.

Before the widespread use of paper, drawing was limited to work on parchment—prepared from sheep or goat skins, and even more costly than paper—or to very fragile media such as figwood or boxwood tablets, which could be planed down and reused. The young man on the right (Fig. 236), engrossed in his drawing, works on just such a wooden tablet. The drawing itself, however, is ink on paper. We are at a moment of transition. Because of the expense of paper, students continued to work with reusable means—even the dust on the studio floor—but their masters turned more and more to paper.

Probably the most important reason that it took so long for drawing to be recognized as an art was that, until the late fifteenth century, it was generally considered a student medium. Copying a master's work was the means by which a student learned the higher art of painting. Thus, in 1493, the Italian religious zealot Savonarola outlined the ideal relation between student and master: "What does the pupil look for in the master? I'll tell you. The master draws from his mind an image which his hands trace on paper and it carries the imprint of his idea. The pupil studies the drawing, and tries to imitate it. Little by little, in this way, he appropriates the style of his master. That is how all natural things, and all creatures, have derived from the divine intellect." If drawing is described by Savanarola as the banal, everyday business of beginners, he also understands it, in the hands of a master, as equal in its creativity to God's handiwork in nature. For Savanarola, the master's idea is comparable to

Fig. 236 Workshop of Pollaiuolo (?), *Youth Drawing,* late 15th century. Pen and ink with wash on paper, 7 5/8 × 4 1/2 in. By permission of the Trustees of the British Museum, London.

Fig. 237 Raphael, *Study for the Alba Madonna*. Lille, Musée des Beaux Arts.

"divine intellect." Drawing is, furthermore, autographic: it bears the master's imprint, his style.

By the end of the fifteenth century, then, drawing had come into its own. It was seen as embodying, perhaps more clearly than even the finished work, the artist's personality and creative genius. As one watched an artist's ideas develop through a series of preparatory sketches, it became possible to speak knowingly about the creative process itself. In a series of studies on the same sheet (Fig. 237), the artist might explore, for instance, the problems presented by grouping figures together into a coherent composition. "Sketch subjects quickly," Leonardo admonished. "Rough out the arrangement of the limbs of your figures and first attend to the movements appropriate to the mental state of the creatures that make up your picture rather than to the beauty and perfection of their parts." It is as if Raphael, in these sketches, had been instructed by Leonardo himself. We do know, in fact, that when Raphael arrived in Florence, in 1504, he was stunned by the freedom of movement and invention that he discovered in Leonardo's drawings.

In Leonardo's *Study for a Sleeve* (Fig. 238), we not only witness the extraordinary fluidity and spontaneity of the master's line but, even in the stillness of a resting arm, a compulsion to portray drapery as if it were a whirlpool or vortex. (The hand, which is comparatively crude, was probably added later.) Through the intensity of his line, Leonardo imparts a degree of emotional complexity to the sitter, who is revealed in the part as well as in the whole. But the drawing also reveals the movements of the artist's own mind. It is as if the still sitter were at odds with the turbulence of the artist's imagination, an imagination that will not hold still whatever its object of contemplation.

Fig. 238 Leonardo da Vinci, *Study for a Sleeve*, c. 1510–1513. Pen, lampblack and chalk, 3 1/8 × 6 3/4 in. Royal Library, Windsor Castle. © 1992 Her Majesty Queen Elizabeth II.

Fig. 239 Leonardo da Vinci, *Hurricane over Horsemen and Trees*, c. 1518. Pen and ink over black chalk, 10 1/4 × 16 1/8 in. Royal Library, Windsor Castle. © 1992 Her Majesty Queen Elizabeth II.

Movement, in fact, fascinated Leonardo. And nothing obsessed him more than the movement of water, in particular the swirling forms of the Deluge (Fig. 239), the great flood that would come at the end of the world. It is as if, even in this sleeve, we are witness to the artist's fantastic preoccupation with the destructive forces of nature. We can see it also in his famous notebooks, where he instructs the painter how to represent a storm:

> O what fearful noises were heard throughout the dark air as it was pounded by the discharged bolts of thunder and lightning that violently shot through it to strike whatever opposed their course. O how many you might have seen covering their ears with their hands in abhorrence at the uproar.... O how much weeping and wailing! O how many terrified beings hurled themselves from the rocks! Let there be shown huge branches of great oaks weighed down with men and borne through the air by the impetuous winds.... You might see herds of horses, oxen, goats and sheep, already encircled by the waters and left marooned on the high peaks of the mountains. Now they would be huddled together with those in the middle clambering on top of the others, and all scuffling fiercely amongst themselves.... The air was darkened by the heavy rain that, driven aslant by the crosswinds and wafted up and down through the air, resembled nothing other than dust, differing only in that this inundation was streaked through by the lines drops of water make as they fall.

Because we can see in the earlier drawing of the sleeve a fascination with swirling line that erupts in the later drawings of the Deluge, we feel we know something important not only about Leonardo's technique but about what drove his imagination. More than any other reason, this was why, in the sixteenth century, drawings began to be preserved by artists and, simultaneously, collected by connoisseurs, experts on and appreciators of fine art, of whom Vasari was one of the first.

Fig. 240 Rogier van der Weyden, *St. Luke Painting the Virgin and Child,* c. 1440. Oil and tempera on panel, 54 1/8 × 43 5/8 in. Museum of Fine Arts, Boston, Gift of Mr. and Mrs. Henry Lee Higginson.

Metalpoint

One of the most common tools used in drawing in late fifteenth- and early sixteenth-century Italy was **metalpoint** or, as it is often called, **silverpoint**. A stylus with a point of gold, silver, or some other metal was applied to a sheet of paper prepared with a mixture of powdered bones (or lead white) and gumwater. Sometimes pigments were added to this preparation in order to color the paper. When the metalpoint was applied to this ground, a chemical reaction resulted, and line was produced. In his painting of *St. Luke Drawing a Portrait of the Virgin* (Fig. 240), Rogier van der Weyden depicts St. Luke drawing with metalpoint on parchment. The figure of St. Luke is believed to be a self-portrait of Rogier himself. Probably executed for the chapel of the Painters Guild in Brussels, of which Rogier was the head, the painting is, then, a compendium of the artist's craft, and represents the entire process of making a painting from drawing to finished product.

A metalpoint line, which is pale gray, is very delicate, and cannot be widened by increasing pressure upon the point. Rather, a different, thicker point is required. Often, the same stylus would have a fine point on one end and a blunt one on the other, as does St. Luke's in the van der Weyden. Since a line cannot be erased without resurfacing the paper, drawing with metalpoint required extreme patience and skill. Raphael's metalpoint drawing of *Paul Rending His Garments* (Fig. 241) shows this skill. Shadow is rendered here by means of carefully drawn parallel lines, that are known as **hatching**. At the same time, a sense of movement and energy is evoked not only by the directional force of these parallels, but also by the freedom of Raphael's outline, the looseness of the gesture even in this most demanding of formats. The highlights in the drawing are known as **heightening**, and are created by applying an opaque white to the design after the metalpoint lines have been drawn.

Fig. 241 Raphael, *Paul Rending His Garments,* c. 1514–1515. Metalpoint heightened with white gouache on lilac-gray prepared paper, 9 1/16 × 4 1/16 in. Collection of the J. Paul Getty Museum, Malibu, California.

Fig. 242 Elisabetta Sirani, *The Holy Family with a Kneeling Monastic Saint*, c. 1660. Pen and brown ink, black chalk, on paper, 10 3/8 × 7 3/8 in. Private collection. Photo courtesy Christie's, London.

Pen and Ink

During the Renaissance, after the invention of paper, most drawings were made with *iron-gall ink*, which was made from a mixture of iron salts and an acid obtained from the nutgall, a swelling on an oak tree caused by disease. The characteristic brown color of most Renaissance pen and ink drawings results from the fact that this ink, though black at application, browns with age.

The *quill* pen used by most Renaissance artists, which was most often made from a goose or swan feather, allows for far greater variation in line and texture than is possible with a metalpoint stylus. As we can see in this drawing by Elisabetta Sirani (Fig. 242), one of the leading artists in Bologna during the seventeenth century, the line can be thickened or thinned, depending upon the artist's manipulation of the much more flexible quill and the absorbency of the paper (the more absorbent the paper, the more freely the ink will flow through its fibers). Diluted to a greater or lesser degree and applied with a brush, ink also provides her with a more fluid and expressive means to render light and shadow than the elaborate and tedious hatching that was necessary when using a stylus. Drawing with pen and ink is much faster, and much more expressive. Sirani, in fact, displayed such speed and facility in her compositions that, in a story that most women will find familiar, she was forced to work in public in order to demonstrate that her work was her own and not done by a man.

Because of its expressive capabilities, pen and ink was also van Gogh's favorite drawing medium, though he favored *reed* over quill pens. His view of a road in the south of France (Fig. 243) employs a wide range of strokes and gestures of varying width, length, and intensity, including his characteristic dotting and the dense swirl of line delineating the tree trunks. This draw-

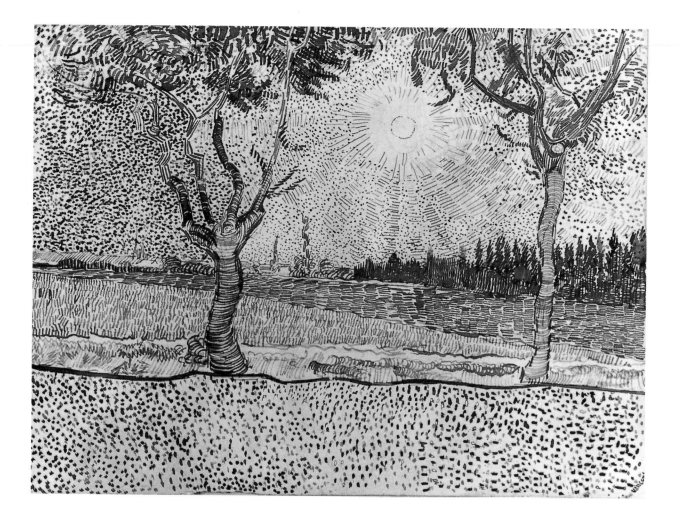

Fig. 243 Vincent van Gogh, *The Road to Tarascon*, 1888. Pencil and ink on wove paper, 9 1/8 × 12 9/16 in. Solomon H. Guggenheim Museum, New York. Justin K. Thannhauser Collection, 1978. Photo: Robert E. Mates © The Solomon R. Guggenheim Foundation, New York, FN 78.2514 T22

ing was one of several that van Gogh executed in late July and early August of 1888 *after* an original painting, that is, using the painting as model rather than the landscape itself. He intended that they be regarded as works in their own right, realizations of the original in a different medium that would reveal the sense of drawing that underlies all his painting.

This drawing's competing directional forces—a direct view toward the radiating sun seen between the trees and the diagonal thrust of the perspective established by the wall moving off to the left—disorient the eye. The road in the foreground, rather than lying flat upon the surface of the earth, seems to rise up like a wall. Each gestural dot competes with his bold stroke, each horizontal with his vertical line. Van Gogh captures here the contradictions of the Provençal landscape itself, its apparent stability even in the face of the hated mistral, the hard, cold wind that blows down the Rhone valley from the Alps. "We have the mistral down here," he wrote in September, a month after this drawing was finished, "the mistral sets one on edge. But what compensations, what compensations when there is a day without wind—what intensity of color, what pure air, what vibrant serenity."

Fig. 244 Pen case of Amen-mes. Dynasty
XVII, c. 1305–1196 B.C. Wood, 15 7/8 × 3 in.
Musée du Louvre, Paris; © Photo R.M.N.

Drawing in Ancient Egypt

For the ancient Egyptians, drawing was not only a preparatory medium—a design tool in the service of painting, sculpture, and architecture. It was also a self-sufficient medium that has survived in the form of papyrus illustrations (papyrus being a flat, paperlike material made from a water plant native to the Nile Valley), as well as in designs on pots, bowls, and other ceramic objects. Yet it is on what is known as *ostraka* that the majority of Egyptian drawings have come down to us.

Ostraka are limestone flakes upon which draftsmen have made preparatory sketches (papyrus being too valuable for such work). These sketches are often of the highest quality, and are similar in purpose to the *cartoons* prepared by Renaissance painters in the West over 2,000 years later. Most of the *ostraka* known to us come from a village called Deir el Medina, which was built to house the artisans who decorated the royal tombs in nearby Thebes. They date from 1554–1080 B.C., the period of the New Kingdom during which such notables as Tutankhamun (King Tut) ruled Egypt.

The equipment used by the Egyptian artist consisted of a palette and pen case like the one depicted here, which is decorated with a head drawn in profile on its reverse side (Fig. 244). The depressions in the palette carried cakes of pigment, the two most common being red ocher and black, which was obtained from soot. Rushes were used to create the pens. The rush was chiseled to a point, and then flattened to a greater or lesser degree depending upon the width of line the artist wished to use. The pen was then dipped in water, the wet nib mixed with pigment, and the artist was ready to draw.

The *ostraka* on the opposite page comes from the village of Deir el Medina and dates from the same period as the palette and pen case. It depicts one of the acrobatic dancers

Fig. 245 Acrobatic dancer, Ramesside, c. 1305–1080 B.C. Ink on limestone, 4 1/8 × 6 5/8 in. Egyptian Museum, Turin, Italy.

who were part of most religious ceremonies. Dancers such as this one even participated in funeral rituals. It is believed that their purpose was to create a mood of intense physical activity. Reporting on his Egyptian Expedition of 1925–1927, N. de Garis Davies wrote in the *Bulletin of the Metropolitan Museum of Art* that such acrobatic dancing was designed to help spectators and participants "reach a physical rhapsody, a throbbing emotion, which…must be induced by the sight of rapid physical action and the sound of strong monotonous rhythm." Notice that in this drawing, the dancer's large loop earring defies the laws of gravity, suggesting that the artist drew the body first, and then turned the limestone *ostraka* upside down to draw the head.

Source: William H. Peck, *Drawing from Ancient Egypt* (London: Thames and Hudson, 1978).

Fig. 246 Jean Dubuffet, *Corps de Dame*, (June-December) 1950. Pen, reed pen, and ink, 10 ⁵/₈ × 8 ³/₈ in. Collection, The Museum of Modern Art, New York. The Jean and Lester Avnet Collection.

The edginess of van Gogh's drawing is fully realized in Jean Dubuffet's series of drawings *Corps de Dames* (Fig. 246)—meaning both a group of ladies and the bodies of ladies. In the whorl of line, which ranges from the finest hairline to strokes nearly a half-inch thick, we can make out the female form, her two small arms raised as if to ward off the violent gestures of the artist's pen itself. Though many see Dubuffet's work as misogynistic—that is, the product of someone who hates women—it can also be read as an attack on academic figure drawing, the pursuit of formal perfection and beauty that has been used traditionally to justify drawing from the nude. Dubuffet does not so much render form with line as flatten it, and in a gesture that insists on the modern artist's liberation from traditional techniques and values, his use of pen and ink threatens to transform drawing into scribbling, conscious draftsmanship into automatism, that is, unconscious and random automatic marking.

Chalk and Charcoal

Both metalpoint and pen and ink are modes of drawing that are chiefly concerned with *delineation*—that is, with a descriptive representation of the thing seen through an outline or contour drawing. Effects of light and shadow are essentially "added" to the finished drawing by means of hatching or washes and heightening. With the softer media of chalk and charcoal, however, it is much easier to give a sense of the volumetric—that is, of three-dimensional form—through modulations of light and dark. While some degree of hatching is visible in Fra Bartolommeo's *Study for a Prophet Seen From the Front* (Fig. 247), the primary impression is not one of linearity or the two-dimensional. Instead, the artist uses *chiaroscuro* to realize the three-dimensional form of the figure in space.

Fig. 247 Fra Bartolommeo, *Study for a Prophet Seen from the Front*, 1499–1500. Black chalk, heightened with white chalk, on brown prepared paper, 11 5/8 × 8 5/8 in. Museum Boymans-Van Beuningen, Rotterdam, The Netherlands.

Fig. 248 Georgia O'Keeffe, *Banana Flower*, 1933. Charcoal, 21 3/4 × 14 3/4 in. Collection, The Museum of Modern Art, New York. Purchase.

dark in painting, it is equally applicable to drawing. A superb example of the volume achieved by means of *sfumato* is visible in Leonardo's black chalk cartoon for *The Virgin and Child with St. Anne and St. John the Baptist* (Fig. 235), where it has been used to give the Virgin and the infants Jesus and St. John a convincing weight and humanness.

Because of its tendency to smudge very easily, charcoal was not widely used during the Renaissance except in *sinopie*, the outlines of a composition traced on a wall before the painting of a fresco. Such sinopie have come to light only recently, as the plaster supports for frescoes have been removed for conservation purposes. In the hands of modern artists, who can prevent a charcoal drawing from smudging by spraying a **fixative** made of synthetic resins over the finished work, charcoal has become, in large part because of its expressive directness and immediacy, one of the more popular drawing media. In her drawing of a *Banana Flower* (Fig. 248), Georgia O'Keeffe achieves a sense of volume and space comparable to that realized by means of chalk. Though she is noted for her stunning flower paintings, this is a rare example in her work of a colorless flower composition. O'Keeffe's interest here is in creating three-dimensional space with a minimum of means, and the result is a study in light and dark in many ways comparable to a black-and-white photograph. Jim Dine's large-scale *Visiting with Charcoal II* (Fig. 249) is a disembodied self-portrait of the artist as his bathrobe. Dine returns here to one of the most traditional subjects of drawing, drapery, which since the Renaissance has been considered the best way to see an artist's skill in realizing volume by means of chiaroscuro. Dine achieves a sense of form not unlike that found in the Fra Bartolommeo study illustrated on the previous page, but without the support of any figure. Dine's robe is drapery actually without body and yet, eerily, seeming to possess it.

By the middle of the sixteenth century, natural chalks derived from red ocher hematite, white soapstone, and black carbonaceous shale were fitted into holders and shaved to a point. With these chalks, it became possible to realize the most gradual transitions from light to dark just by adjusting the pressure of one's hand or by merging individual strokes by gently rubbing over a given area with a finger, cloth, or eraser.

Such subtle modulation—a heightened form of chiaroscuro—is called **sfumato**, an Italian term literally meaning "smoky." Often used to describe transitions from light to

Fig. 249 Jim Dine, *Robe*, 1976. Oil and charcoal on paper, 30 × 22 ¼ in. Pace Gallery, New York.

Fig. 250 Edgar Degas, *Woman Drying Herself*, c. 1889–1890. Pastel on paper, 26 5/8 × 22 3/4 in. Courtauld Institute Galleries, London.

Pastel

Pastel is essentially a chalk medium with colored pigment and a nongreasy binder added to it. Pastels come in sticks the dimension of an index finger, and are labeled soft, medium, and hard, depending upon how much binder is incorporated in the medium. Since the pigment is, in effect, diluted by increased quantities of binder, the harder the stick, the less intense its color. This is why we tend to associate the word "pastel" with pale, light colors. Although the harder sticks are much easier to use than the softer ones, some of the more interesting effects of the medium can only be achieved with the more intense colors of the softer sticks.

The lack of binder in pastel drawings makes them extremely fragile. Before the final drawing is fixed, the marks created by the chalky powder can literally fall off the paper, despite the fact that, since the middle of the eighteenth century, special ribbed and textured papers have been made that help hold the medium to the surface.

Of all artists who have ever used pastel, perhaps Edgar Degas was the most proficient and inventive. He was probably attracted to the medium because it was more direct than painting, and its unfinished quality seemed particularly well suited to his artistic goal of capturing the reality of the contemporary scene. According to George Moore, an Irishman and friend of Degas' who began his career as a painter in Paris but gave it up to become an essayist and novelist, Degas told him that his intention in works such as *After the Bath, Woman Drying Herself* (Fig. 250) was to show "a human figure preoccupied with herself—a cat who licks herself; hitherto, the nude has always been represented in poses which presuppose an audience, but these women of mine are honest and simple folk, unconcerned by any other interests than those involved in their physical condition.... It is as if you looked through a key-hole." It

Fig. 251 Detail of Edgar Degas, *Woman Drying Herself.*

is disturbing that Degas is so comfortable in his position as voyeur, and that he assumes little or no intelligence in his models. His comparison of his model to a cat is simply demeaning. But he is also to be admired for giving up the academic point of view, the studio pose.

And his use of his medium is equally unconventional, incorporating into the "finished" work both improvised gesture and a loose, sketchlike drawing. Degas invented a new way to use pastel, building up the pigments in successive layers. Normally, this would not have been possible because the powdery chalks of the medium would not hold to the surface. But Degas worked with a fixative, the formula for which has been lost, that allowed him to build up layers of pastel without affecting the intensity of their color. Laid on the surface in hatches, these successive layers—see the detail of the woman's left hip (Fig. 251)—create an optical mixture of color that shimmers before the eyes in a virtually abstract design.

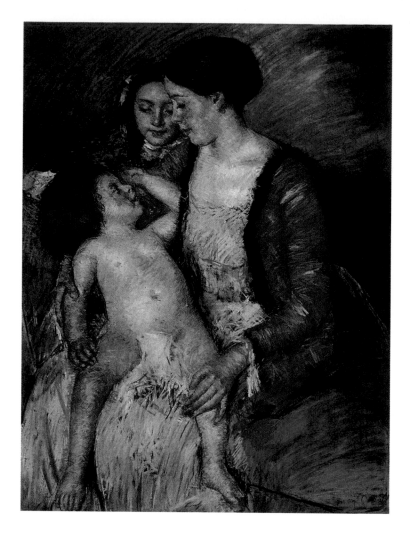

Fig. 252 Mary Cassatt, *Young Mother, Daughter, and Son*, 1913. Pastel on paper, 43 ¼ × 33 ¼ in. Memorial Art Gallery of the University of Rochester, Marion Stratten Gould Fund.

The American painter Mary Cassatt met Degas in Paris in 1877, and he became her artistic mentor. Known for her pictures of mothers and children, Cassatt learned to use the pastel medium with an even greater freedom and looseness than Degas. In this drawing of *Mother, Young Daughter, and Son* (Fig. 252), one of Cassatt's last works, the gestures of her pastel line again and again exceed the boundaries of the forms that contain them, and loosely drawn, arbitrarily blue strokes extend across almost every element of the composition.

The collector, Mrs. H. O. Havemeyer, Cassatt's oldest and best friend, saw in works such as this one, which she owned, an almost virtuoso display of "strong line, great freedom of technique and a supreme mastery of color." When Mrs. Havemeyer organized a benefit exhibition of Cassatt's and Degas' works in New York in 1915, its proceeds to be donated to the cause of Woman's Suffrage, the right of women to vote, she wished to include works such as this one because Cassatt's freedom of line was the very symbol of the strength of women in general and their equality to men. Seen beside the works by Degas, it would be evident that the pupil had equaled, and in many ways surpassed, the achievement of Degas himself.

Graphite

Graphite was discovered in 1564 in Borrowdale, England. As good black chalk became more and more difficult to obtain, the lead pencil, graphite enclosed in a cylinder of soft wood, increasingly became one of the most common of all drawing tools. It became even more popular during the Napoleonic Wars when, because supplies of English graphite were cut off from the continent, the Frenchman Nicholas-Jacques Conté invented, at the request of Napoleon himself, a substitute for imported pencils that then became known as the **Conté crayon** (not to be confused with the so-called Conté Crayons marketed today, which are made with chalk). By adding clay to refined graphite, Conté was able to use less graphite, creating a very soft point. This technology was quickly adapted to the making of pencils generally: the relative hardness of the pencil could be controlled, and thus a greater range of lights and darks became available to the artist.

Georges Seurat's Conté crayon studies (Fig. 253) indicate the powerful range of tonal effects afforded by the new medium. As he presses harder, in the lower areas of the composition depicting the shadows of the orchestra pit, the coarsely textured paper is filled by the crayon. Above, pressing less firmly, Seurat creates a sense of light dancing on the surface of the stage. Where he has not drawn on the surface at all—across the stage and on the singer's dress—the glare of the white paper is almost as intense as light itself.

Don Eddy's drawing for *Glassware I* (Fig. 254) is an example of a highly developed photorealist graphite drawing. About the size of a standard sheet of typing paper, the drawing is an extraordinarily detailed rendering of three glass shelves packed with a variety of glassware. The front of each of the top two shelves is represented by a hard black horizontal line. The drawing is a fully finished representation of reflected light in which all sense of the sketch is lost.

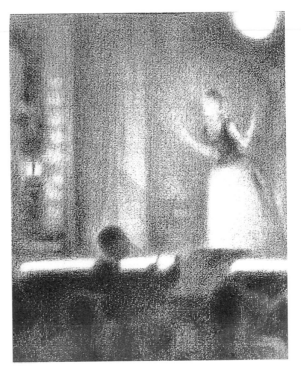

Fig. 253 Georges Seurat, *Café Concert*, c. 1887–1888. Conté crayon with white heightening on Ingres paper, 12 × 9 1/4 in. Museum of Art, Rhode Island School of Design, Providence. Gift of Mrs. Murray S. Danforth.

Fig. 254 Don Eddy, drawing for *Glassware I*, 1978. Graphite on paper, 8 9/16 × 11 3/16 in. Collection of Glenn C. Janss.

Fig. 255 Larry Rivers, *Willem de Kooning,* 1961. Pencil on paper, 10 ¾ × 10 in. © The Detroit Institute of Arts, Founders Society Purchase, Director's Discretionary Fund.

Graphite drawings, furthermore, can be erased, and erasure itself can become an important element in the composition. In 1953, a young Robert Rauschenberg, just at the beginning of his career, was thinking about the possibility of making an entire drawing by erasing. He told Willem de Kooning, a generation older than himself and an established abstract expressionist, about his musings. "I'd been trying with my own drawings, and it didn't work, because that was only 50 percent of what I wanted to get. I had to start with something that was 100 percent art, which mine might not be; but his work was definitely art." De Kooning reluc-

tantly agreed to give Rauschenberg a drawing to erase. "It was a drawing done partly with a hard line, and also with grease pencil, and ink, and heavy crayon. It took me a month, and about forty erasers, to do it." The result is not easy to reproduce. It is a white sheet of paper, with a faint shadow of its original gestures barely visible.

Larry Rivers's *Full Figure of Willem de Kooning* (Fig. 255) is a more traditional homage of a younger artist to his mentor, but it too is concerned with erasure. Rivers has described the process, and the rationale behind the process: "I tend to erase it, erase it, erase it, keep trying, erase, keep trying, erase, and finally…well, let the observer make up more than I can represent.… This drawing is in the tradition of those kinds of work in which the history of the work became part of the quality of the work. De Kooning's work is full of that. His whole genre is that. His work is all about sweeping away, putting in…struggle, struggle, struggle and poof—masterpiece!"

Innovative Drawing Media

Drawing is by its nature an exploratory medium. It invites experiment. Taking up a sheet of heavy prepainted paper, Matisse was often inspired, beginning in the early 1940s, to cut out a shape in the paper with a pair of wide-open scissors, using them like a knife to carve through the paper. "Scissors," he says, "can acquire more feeling for line than pencil or charcoal." Sketching with the scissors, Matisse discovered what he considered to be the essence of a form. Cut-outs, in fact, dominated Matisse's artistic production from 1951 until his death in 1954. In this *Venus* (Fig. 256), the figure of the goddess is revealed in the negative space of the composition. It is as if the goddess of love—and hence love itself—were immaterial. In the blue positive space to the right we discover the profile of a man, as if love springs, fleetingly, from his very breath.

Fig. 256 Henri Matisse, *Venus*, 1952. Paper cut-out, 39 7/8 × 30 1/8 in. © 1992 National Gallery of Art, Washington, D.C., Ailsa Mellon Bruce Fund.

Fig. 257 Walter De Maria, *Las Vegas Piece*, 1969. Overall length: 3 mi. Desert Valley, Nevada. All reproduction rights reserved: © Walter De Maria.

Walter De Maria's *Las Vegas Piece* (Fig. 257) is a "drawing" made in 1969 in the central Nevada desert with the six-foot blade of a bulldozer. The photograph here is of one side of a square, one-half mile on each side. Two sides of this square extend an additional half-mile at opposite corners. As the photograph suggests, the piece is never entirely visible except from the air. Oriented on precise North-South and East-West coordinates, it has something of the mystery of the famous Nazca lines in Peru (Fig. 258). These lines, drawn by sweeping away the top layer of the desert with a broom, have been roughly dated in the first century A.D. Their significance is enormously controversial. They have been seen as highways, as part of a calendar system, as representative of kinship lines between clans, as ritual dance grounds, as UFO landing strips, and so on. Writing in *Artforum* in 1975, sculptor Robert Morris described them as marks drawn by a culture obsessed with "space as a palpable emptiness."

To fully comprehend such drawings it would seem necessary that they be seen from an aerial vantage point. Of course,

Fig. 258　Marilyn Bridges, *Overview*, Nazca, Peru, 1979.

this was impossible for a first-century Peruvian. Even today, viewing De Maria's piece from the air involves chartering a helicopter or plane at ridiculous expense. But the aerial point of view requires, literally for the ancient Peruvian and figuratively for the modern observer, an imaginative flight more than a real one. It is as if both the Nazca lines and De Maria's simultaneously lay claim to two discontinuous spaces. From the air, one imagines they would be experienced as huge tracings across the vastness of the earth's surface. But encountered on the ground, these huge scars seem rather innocent. As Elizabeth Baker, the editor of *Art in America*, put it in 1976 when describing *Las Vegas Piece*: "This piece requires that you walk on it. At ground level…knee-high scrub growth hides it unless one is right on it—its track is shallower than all sorts of natural washes and holes." On the ground one's attention quickly moves from the drawing itself. In Baker's words: "It provides an experience of a specific place, random apprehension of surroundings, and an intensified sense of self which seems to transcend visual apprehension alone."

Fig. 259 Jennifer Bartlett, *Untitled,* 1986. From *Painting with Light,* a BBC television series by Griffin Productions produced on the Quantel Paintbox ®, a registered trademark of Quantel.

Fig. 260 Jennifer Bartlett, *Untitled,* 1986. From *Painting with Light,* a BBC television series by Griffin Productions produced on the Quantel Paintbox ®, a registered trademark of Quantel.

Increasingly, drawing is accomplished by electronic means, especially with the aid of computers. The introduction of relatively inexpensive personal microcomputers, electronic palettes, and increasingly sophisticated, though user-friendly, software "paint" programs has made drawing on the computer more and more commonplace. Computers make experimentation easy. It is possible to explore in a matter of minutes what might have actually taken years at the drawing board.

It is best to think of the computer as an electronic sketchpad. At the left, the painter Jennifer Bartlett is at work on a digitized tablet provided for her use by Quantel, the manufacturer of the computer hardware system

Fig. 261 David Hockney, *?*, 19?. From *Painting with Light*, a BBC television series by Griffin Productions, produced on the Quantel Paintbox ®, a registered trademark of Quantel.

Paintbox (Fig. 260). A glass of water, her subject, sits before her. As she moves her light pen on the pad, each line is traced onto the screen above. She can choose a variety of colors, line widths, textures, and so on from a software menu, and change them at will. The ability of the program to adopt to a given artist's style is obvious if we compare Bartlett's final computer drawing (Fig. 259) with a landscape by David Hockney (Fig. 261), also done in 1986 at the invitation of Quantel. Once the artist learns to coordinate the hand with the image on the screen, the process is essentially the same as work in traditional media, only faster and more versatile because a vast array of possible effects of line, color, and so on, can be rapidly explored.

Fig. 262 Hartmann Schedel, *Venice*, illustration for *The Nuremberg Chronicle*, 1493. Woodcut, illustration size 10 × 20 in. Metropolitan Museum of Art, New York, Rogers Fund, 1921 (21.36.145).

Printmaking

The **print** is a single **impression**, or example, of a multiple **edition** of impressions, made on paper from the same **plate**, or master image. The medium of printmaking originated in the West very soon after the appearance of the first book printed with movable type, the Gutenberg Bible (1450–1456). At first, printmaking was used almost exclusively as a mode of illustration. In post-medieval Western culture, prints not only served to codify and regularize scientific knowledge, which depends upon the dissemination of exact reproductions, but they were fundamental to the creation of our shared visual culture.

Since World War II, the art world has witnessed what might well be called an explosion of prints. The reasons for this are many. For one thing, the fact that prints

exist in multiple numbers seemed to many artists absolutely in keeping with an era of mass production and distribution. The print has also provided the contemporary artist, in an age increasingly dominated by the mass media and mechanical modes of reproduction, such as photography, with a ready medium with which to investigate the meaning of mechanically reproduced imagery itself. An even more important reason is the fact that the unique work of art—a painting or a sculpture—has become, during the twentieth century, too expensive for the average collector, and the size of the purchasing public has, as a consequence, diminished considerably. Far less expensive than unique paintings, prints are an avenue through which artists can more readily reach a wider audience.

As collectors have come to value prints more and more highly, the somewhat confus-

ing concept of the **original print** has come into being. How, one wonders, can an image that exists in multiple be considered "original"? By and large, an original print consists of an image that the artist alone has created, and that has been printed by the artist or under the artist's supervision. Since the late nineteenth century each impression is usually signed by the artist and numbered—for example, the number 3⁄35 at the bottom of a print means that this is the third impression in an edition of thirty-five. Very often the artist will reserve a small number of additional **proofs**—trial impressions made before the final edition is run—for personal use. These are usually designated "AP," meaning "artist's proof." After the edition is made, the original plate is destroyed, or canceled by incising lines across it. This is done to protect the collector against a misrepresentation about the number of prints in a given edition.

Relief Processes

The first prints were **woodcuts**. A design is drawn on the surface of a wood block, and the parts that are to print white are cut or gouged away, usually with a knife. This process leaves the areas that are to be black elevated, so that, for instance, a black line is created by cutting away the block on each side of it. This elevated surface is then rolled with a relatively viscous ink, thick and sticky enough that it will not flow into the hollows (Fig. 263).

The printing is finally done on a press that operates exactly like a type printing press. In fact, since woodblocks can be printed together with type, the woodcut was the standard means of book illustration well into the nineteenth century. This illustration for *The Nuremberg Chronicle* (Fig. 262) was published in 1493 by one of the first professional book publishers in history, Anton Koberger. Appearing in two editions, one in black-and-white, and another much more costly edition with

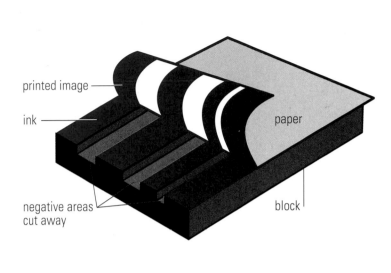

Fig. 263 Relief printing technique.

hand colored illustrations, *The Nuremberg Chronicle* was intended as a history of the world. A best-seller in its day, it contained over 1,809 pictures, though only 654 different blocks were employed. Forty-four images of men and women were repeated 226 times to represent different famous historical characters, and depictions of many different cities were printed using the same woodcut.

The woodcut print offers the artist a means of achieving not only great contrast between light and dark, but as a result, dramatic emotional effects. In the twentieth century, the expressive potential of the medium was recognized, particularly by the

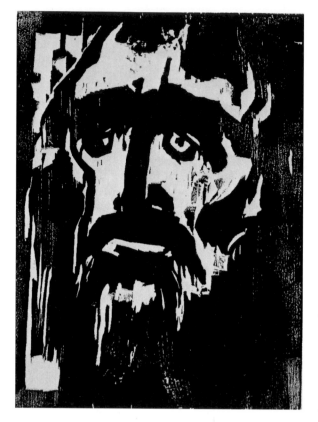

Fig. 264 Emile Nolde, *Prophet*, 1912. Woodcut, 12 ⁵/₈ × 8 ⁷/₈ in. National Gallery of Art, Washington, D.C. Rosenwald Collection.

Fig. 265 Paul Gauguin, *Watched by the Spirit of the Dead (Manao Tupapau)*, 1893. Woodcut, printed in black, block, 8 ¹/₁₆ × 14 in. Collection, The Museum of Modern Art, New York. Lillie P. Bliss Collection.

German Expressionists. In Emile Nolde's *Prophet* (Fig. 264), we do not merely sense the pain and anguish of the prophet's life, the burden that prophecy entails, but it is as if we could feel the portrait emerging out of the very gouges Nolde's knife made in the block.

It was in large part the example of Paul Gauguin's great woodcuts (Fig. 265) that led the Germans to experiment with the method. By the late nineteenth century, woodcut illustration had reached a level of extraordinary refinement. Employing a method known as **wood engraving**, in which fine lines are cut into the surface of the block and thus print as white lines on a black ground, extremely delicate modeling of the figure could be achieved by means of careful hatching. Gauguin detested such effects, which, he said, were "loathsome" because they made the print look more like a photograph than a woodcut. He considered his own prints interesting because, he said, they "recall the primitive era of wood engraving."

Gauguin gave up the detailed linear representation achieved by expert cutting, and opted instead to compose with broad, bold, purposely coarse gestures. Traditionally most of the surface of the block would be cut away leaving black line on a predominantly white surface, but Gauguin chose to leave large areas of surface uncut so that it would print in black. In an unrefined example of the wood engravers' method, he would scratch raggedly across this black surface to reveal form by means of white line on black. Every detail of Gauguin's print reveals the presence of the artist at work—poking, gouging, slicing, scraping, and scratching into the block.

Louisa Chase recognized the expressive potential of the woodcut after seeing the exhibition "Expressionism: A German Invention" in 1980 at the Guggenheim Museum in New York. Like the expensive version of *The Nuremberg Chronicle*, Chase's print *Red Sea* (Fig. 266) is hand-tinted, but it is the carving that interests her most. "I love carving the

Fig. 266 Louisa Chase, *Red Sea*, 1983. Woodcut with hand coloring on Sekishu paper, 33 × 38 ¹/₂ in. Mount Holyoke College Art Museum. The Henry Rox Memorial Fund for the Acquisition of Works by Contemporary Women Artists.

marks," Chase says, "and just as my paintings are about brushstrokes, in the woodcuts you can really feel the separate marks."

Color can also be added to a print by creating a series of different blocks, one for each different color, each of which is *registered* to line up with the others. In 1959, Picasso, working with linoleum instead of wood, simplified the process. This **linocut**, as it is called, is made from one linoleum block. After each successive stage of carving is completed, the block is printed. An all-yellow run of the print at the right (Fig. 267) was first made from an uncarved block. Picasso then cut into the linoleum, hollowing out the areas that now appear yellow on the print, so that they would not print again. Then he printed in blue. The blue area was then hollowed out, the plate reprinted again, in violet, and so on, through red, green, and finally black.

Fig. 267 Pablo Picasso, *Luncheon on the Grass, after Edouard Manet*, 1962. Linoleum cut on Arches paper, 24 ³/₈ × 29 ⁵/₈ in. The Metropolitan Museum of Art, New York. The Mr. and Mrs. Charles Kramer Collection, 1979 (1979.620.50).

Ukiyo-e:
The Classic Japanese Woodcut

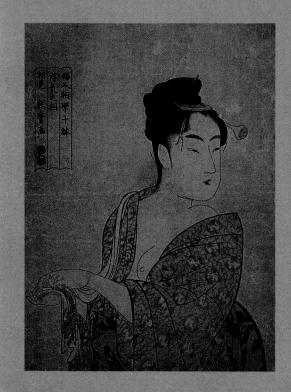

Fig. 268 Kitagawa Utamaro, *The Fickle Type*, from the series *Ten Physiognomies of Women*, c. 1793. Woodcut, 14 × 9 7/8 in.

Most Japanese prints are examples of what is called *ukiyo-e*, or "pictures of the transient world of everyday life." Inspired in the late seventeenth century by a Chinese manual on the art of painting entitled *The Mustard-Seed Garden*, which contained many woodcuts in both color and black-and-white, *ukiyo-e* prints were commonplace by the middle of the eighteenth century. Between 1743 and 1765, Japanese artists developed their distinctive method for color printing from multiple blocks.

The subject matter of these prints is usually concerned with the pleasures of contemporary life—hairdos and wardrobes, daily rituals such as bathing, theatrical entertainments, life in the Tokyo brothels, and so on, in endless combination. Utamaro's depiction of *The Fickle Type*, from his series *Ten Physiognomies of Women* (Fig. 268) embodies the sensuality of the world that the *ukiyo-e* print so often reveals. Hokusai's views of the eternal Mount Fuji (Fig. 214), which we have already read about in connection with their play with questions of scale, were probably conceived as commentaries on the self-indulgence of the genre of *ukiyo-e* as a whole. The mountain—and by extension, the values it stood for, the traditional values of the nation itself—is depicted in these works as transcending the fleeting pleasures of daily life.

Traditionally, the Japanese print involves two people—an artist and a cutter. The artist makes a drawing in brush and ink that is pasted onto a block. The cutter then carves both the block and the paper, producing a *key* block. Black-and-white prints of this design are returned to the artist, who indicates the colors on these prints, one color to a sheet. The cutter then carves each sheet on a separate block. The final print is, in essence, a cumulation of the individually colored blocks, requiring a separate printing for each color.

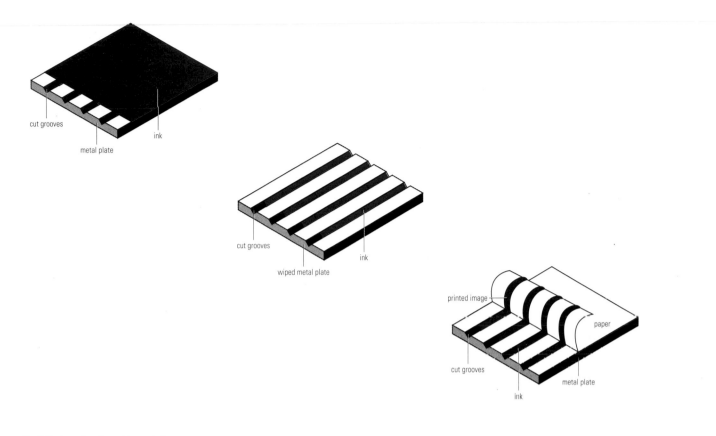

Fig. 269 Intaglio printmaking technique.

Intaglio Processes

Relief processes rely on a *raised* surface for printing. With the **intaglio** process, on the other hand, the areas to be printed are *below* the surface of the plate. *Intaglio* is the Italian word for "engraving," and the method itself was derived from engraving techniques practiced by goldsmiths and armorers in the Middle Ages. In general, intaglio refers to any process in which the cut or incised lines on the plate are filled with ink (Fig. 269). The surface of the plate is wiped clean, and a sheet of dampened paper is pressed with a very powerful roller into the plate so that the paper picks up the ink in the depressed grooves. Since the paper is essentially pushed into the plate in order to be inked, a subtle, but detectable elevation of the lines that result is always evident in the final print. Modeling

and shading are achieved in the same way as in drawing, by hatching, cross-hatching, and often **stippling**—where, instead of lines, dots are employed in greater and greater density the deeper and darker the shadow.

One of the greatest of the early masters of the intaglio process was Albrecht Dürer. Trained in Nuremberg from 1486 to 1490, he was the godson of Anton Koberger, publisher of *The Nuremberg Chronicle*. As an apprentice in the studio of Michael Wolgemut, who was responsible for many of the major designs in the *Chronicle*, Dürer may, in fact, have carved several of the book's woodcuts. By the end of the century, at any rate, Dürer was recognized as the prominent woodcut artist of the day, and he had mastered the art of engraving as well. **Engraving** is accomplished by pushing a small V-shaped metal rod, called a *burin*, across a metal plate, usually of copper or zinc,

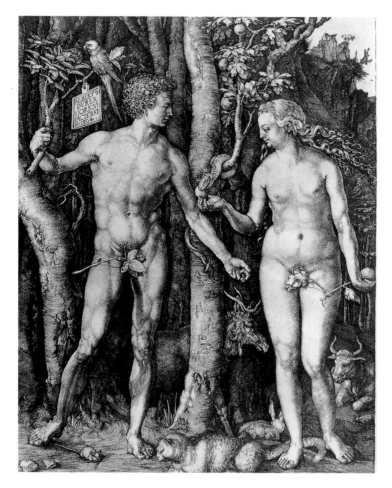

Fig. 270 Albrecht Dürer, *Adam and Eve*, 1504. Engraving, 9 7/8 × 7 5/8 in. The Metropolitan Museum of Art, Fletcher Fund, 1919 (19.73.1).

forcing the metal up in slivers in front of the line. These slivers are then removed from the plate with a hard metal scraper. Depending upon the size of the burin used and the force with which it is applied to the plate, the results can range from the almost microscopically fine lines to ones so broad and coarse that they can be felt with a finger tip.

Dürer's engraving of *Adam and Eve* (Fig. 270) is one of his finest. It is also the first of his works to be "signed" with the artist's characteristic tablet, including his Latinized name and the date of composition, here tied to a bough of the tree above Adam's right

shoulder. The print is rich in iconographical meaning. The cat at Eve's feet—a symbol of deceit, and perhaps sexuality as well—suggests not only Eve's feline character but, as it readies to pounce on the mouse at Adam's feet, the male's weakness as well, Adam's susceptibility to the female's wiles. The parrot perched over the sign is the embodiment of both wisdom and language. It contrasts with the evil snake that Eve is feeding. Spatially, then, the parrot and its attributes are associated with Adam, the snake and its characteristics with Eve. An early sixteenth-century audience would have immediately understood that the four animals on the right were intended to represent the four *humors*, the four bodily fluids thought to make up the human constitution. The elk represents melancholy (black bile), the cat anger and cruelty (yellow bile), the rabbit sensuality (blood), and the ox sluggishness or laziness (phlegm).

Dürer was one of the first artists to investigate the potential of another intaglio process, **etching**. But it was Rembrandt, 100 years later, who became the master of the medium. Etching is a much more fluid and free process than engraving and is capable of capturing something of the same sense of immediacy as the sketch. As a result, it satisfied Rembrandt's love for spontaneity of line. Yet the medium requires, in addition, the utmost calculation and planning, an ability to manipulate chemicals, which verges, especially in Rembrandt's greatest etchings, on wizardry, and a certain willingness to risk losing everything in order to achieve the desired effect.

The process is essentially twofold, consisting of a drawing stage and an etching stage. The metal plate is first coated with an acid-resistant substance called a **ground**, and this ground is drawn upon. If a hard ground is chosen, then an etching needle is required to break through the ground and expose the plate. Hard grounds are employed for finely

detailed linear work. Soft grounds, made of tallow or petroleum jelly, can also be utilized, and virtually any tool, including the artist's finger, can be used to expose the plate. The traditional soft-ground technique is often called *crayon* or *pencil manner* because the final product so closely resembles pencil and crayon drawing. In this technique, a thin sheet of paper is placed on top of the ground and is drawn on with a soft pencil or crayon. When the paper is removed, it lifts the ground where the drawing instrument has been pressed into the paper.

Whichever kind of ground has been employed, the drawn plate is then set in an acid bath, and those areas that have been drawn are eaten into, or *etched*, by the acid. The undrawn areas of the plate are, of course, unaffected by the acid. The longer the exposed plate is left in the bath, and the stronger the solution, the greater the width and depth of the etched line. The strength of individual lines or areas can be controlled by removing the plate from the bath and *stopping out* a section by applying a varnish or another coat of ground over the etched surface. The plate is then resubmerged in the bath. The stopped-out lines will be lighter than those that are again exposed to the acid. When the plate is ready for printing, the ground is removed with solvent, and the print is made in the intaglio method.

Rembrandt's *The Angel Appearing to the Shepherds* (Fig. 271) is one of the most fully realized etchings ever printed, pushing the medium to its very limits. For this print Rembrandt altered the usual etching process. Fascinated by the play of light and dark, he wanted to create the feeling that the angel, and the light associated with her, was emerging *out* of the darkness. Normally, in etching, the background is white, since it is unetched and there are no lines on it that would hold ink. Here Rembrandt wanted a black background, and he worked first on the darkest areas of the composition, creating an intri-

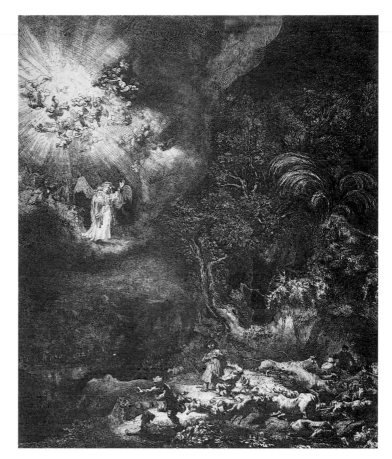

Fig. 271 Rembrandt van Rijn, *The Angel Appearing to the Shepherds*, 1634. Etching, 10 1/4 × 8 1/2 in. Rijksmuseum, Amsterdam.

cately crosshatched landscape of ever-deepening shadow. Only the white areas bathed in the angel's light remained undrawn. At this point, the plate was placed in acid and bitten as deeply as possible. Finally, the angel and the frightened shepherds in the foreground were worked up in a more traditional manner of etched line on a largely white ground. It is as if, at this crucial moment of the New Testament, as the angel announces the birth of Jesus, Rembrandt reenacts, in his manipulation of light and dark, the opening scenes of the Old Testament—God's pronouncement in Genesis, "Let there be light."

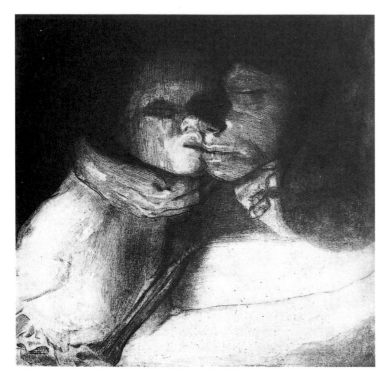

Fig. 272 Käthe Kollwitz, *Death and a Woman Struggling for a Child*, 1911. Etching, 16 1/8 × 16 3/16 in. Museum of Modern Art, New York. Gift of Mrs. Theodore Boettger.

Fig. 273 Mary Cassatt, *The Map* (*The Lesson*), 1890. Drypoint, 6 3/16 × 9 3/16 in. Joseph Brooks Fair Collection, © 1993 The Art Institute of Chicago, All Rights Reserved.

The dynamic play between dark and light achieved by Rembrandt would be used to great expressive effect in the work of the German Expressionist artist Käthe Kollwitz. Kollwitz, renowned for the quality of her graphic work, chose as her artistic subject matter the poor and downtrodden, especially mothers and children. Deliberately avoiding the use of color in her work, she preferred the sense of emotional conflict and opposition that could be realized in black and white.

In 1914, at the beginning of World War I, Kollwitz's son Peter was killed. The drama of the battle between the life-giving mother and the forces of death that we witness in *Death and a Woman Struggling for a Child* (Fig. 272) painfully foreshadows her own tragedy. It is hard to say just whose hand is reaching around the child's throat—the mother's or death's. What is clear, however, is that in the dark and deeply inked shadow created where the mother presses her child's forehead hard against her own face is expressed a depth of feeling and compassion virtually unsurpassed in the history of art.

A third form of intaglio printing is known as **drypoint**. The drypoint line is scratched into the copper plate with a metal point that is pulled across the surface and not pushed as is the case in engraving. A ridge of metal, called a *burr*, is pushed up along each side of the line, and this gives a rich, velvety, soft texture to the print when inked, as is evident in Mary Cassatt's *The Map* (Fig. 273). The softness of line generated by the drypoint process is especially appealing to Vija Celmins, whose obsessive attention to detail in *Drypoint—Ocean Surface* (Fig. 274) results in an almost photorealist representation of the sea. It is as if a haze sits over these waves, the softness of the drypoint burr imitating the thickness of the atmosphere itself. Because this burr quickly wears off in the printing process, it is rare to find a drypoint edition of more than 25 numbers, and the earliest numbers in the edition are often the finest.

Fig. 274 Vija Celmins, *Drypoint—Ocean Surface*, 1984. Etching, 26 × 20 ¼ in. Courtesy of McKee Gallery, New York.

Fig. 275 Prince Rupert, *The Standard Bearer*, 1658. Mezzotint. The Metropolitan Museum of Art, New York. Harris Brisbane Dick Fund, 1933 (32.52.32).

Two other intaglio techniques should be mentioned, **mezzotint** and **aquatint**. Mezzotint is, in effect, a negative process. That is, the plate is first ground all over using a sharp, curved tool called a *rocker*, leaving a burr over the entire surface that, if inked, would result in a deeply rich but solid black print. The surface is then lightened by scraping away the burr to a greater or lesser degree. One of the earliest practitioners of the mezzotint process was Prince Rupert, son of Elizabeth Stuart of the British royal family and Frederick V of Germany, who learned the process from its inventor in 1654. Rupert is credited, in fact, with the invention of the rocking tool used to darken the plate itself. His *Standard Bearer* (Fig. 275) reveals the deep blacks from which the image has been scraped.

Like mezzotint, aquatint does not rely on line for its effect but on tonal areas of light and dark. Invented in France in the 1760s, the method involves coating the surface of the plate with a porous ground through which acid can penetrate. Usually consisting of particles of resin or powder, the ground is dusted onto the plate, then set in place by heating it until it melts. The acid bites around each particle into the surface of the plate, creating a sandpaperlike texture. The denser the resin, the lighter the tone of the resulting surface. Line is often added later, usually by means of etching or drypoint.

Jane Dickson's *Stairwell* (Fig. 276) is a pure aquatint, printed in three colors, in which the roughness of the method's surface serves to underscore the emotional turmoil and psychological isolation embodied in her subject matter. "I'm interested," Dickson says, "in the ominous underside of contemporary culture that lurks as an ever present possibility in our lives.... I aim to portray psychological states that everyone experiences." In looking at this print, one can almost feel the acid biting into the plate, as if the process itself is a metaphor for the pain and isolation of the figure leaning forlornly over the bannister.

Lithography

Lithography—meaning, literally, "stone writing"—is the chief **planographic** printmaking process, meaning that the printing surface is flat. There is no raised or depressed surface on the plate to hold ink. Rather, the method depends upon the fact that grease and water don't mix.

The process was discovered accidentally by a young German playwright named Alois Senefelder in the 1790s in Munich. Unsuccessful in his occupation, Senefelder was determined to reduce the cost of publishing his plays by writing them backwards on a copper plate in a wax and soap ground and then etching the text. But with only one good piece of copper to his name, he knew he needed to practice writing backwards on less expensive material, and he chose a smooth piece of Kelheim limestone, the material used to line the Munich streets and abundantly available. As he was practicing one day, his laundry woman arrived to pick up his clothes and, with no paper or ink on the premises, he jotted down what she had taken on the ground of the prepared limestone slab. It dawned on him to bathe the stone with nitric acid and water, and when he did so, he found that the acid had etched the stone and left his writing raised in relief above its surface.

Recognizing the commercial potential of his invention, he abandoned playwrighting to perfect the process. By 1798, he had discovered that if he drew directly on the stone with a greasy crayon, and then treated the entire stone with nitric acid, water, and gum arabic (a very tough substance obtained from the acacia tree that attracts and holds water), then ink would stick to the grease drawing but not to the treated and dampened stone. He also discovered that the acid and gum arabic solution did not actually *etch* the limestone. As a result, the same stone could be used again and again. The essential processes of lithography had been invented.

Fig. 276 Jane Dickson, *Stairwell*, 1984. Aquatint on Rives BFK paper, 35 3/4 × 22 3/4 in. Mount Holyoke College Art Museum. The Henry Rox Memorial Fund for the Acquisition of Works by Contemporary Women Artists.

Fig. 277 Edouard Manet, *The Races*, 1865. Lithograph, 14 ⅝ × 20 ½ in. National Gallery of Art, Washington, D.C. Rosenwald Collection.

Possibly because it is so direct a process, actually a kind of drawing on stone, lithography has been the favorite printmaking medium of nineteenth- and twentieth-century artists. The gestural freedom it offers the artist, the sense of spontaneity and immediacy that can be captured in its line, is readily apparent in Edouard Manet's *The Races* (Fig. 277). More than a simple sketch of the event, the print is almost abstract, a whirl of motion and line that captures the furious pace of the race itself.

In the hands of Honoré Daumier, who turned to the medium in order to depict actual current events, the feeling of immediacy that the lithograph could inspire was most fully realized. Daumier was employed by the French press as an illustrator and political caricaturist, an occupation to which he devoted his talents from the early 1830s until his

death in 1872. Recognized as the greatest lithographer of his day, Daumier did some of his finest work in the 1830s for the monthly publication *L'Association Mensuelle*, each issue of which contained an original lithograph. His famous print *Rue Transnonain* (Fig. 278) is direct reportage of the outrages committed by government troops during an insurrection in the Parisian workers' quarters. He illustrates what happened in a building at 12 rue Transnonain on the night of April 15, 1834, when police, responding to a sniper's bullet that had killed one of their number and had appeared to originate from the building, revenged their colleague's death by slaughtering everyone inside. The father of a family, who had evidently been sleeping, lies dead by his bed, his child crushed beneath him, his dead wife to his right and an elder parent to his left. The foreshortening of the scene draws

Fig. 278 Honoré Daumier, *Rue Transnonain, April 15, 1834*, 1834. Lithograph, 11 1/2 × 17 5/8 in. The Charles Derring Collection, © 1993 The Art Institute of Chicago. All Rights Reserved.

us into the lithograph's visual space, making the horror of the scene all the more real.

Beginning in 1835, Daumier routinely published in *Le Charivari*, a four-page daily devoted to social satire printed on a single folded sheet with one lithographic page and three pages of text. Speed of execution became paramount, and Daumier worked directly on the stone without making preliminary sketches. *The Dangerous Children* (Fig. 279) of 1848 is typical of his efforts. Here, a terrified middle-class couple retreats from a group of children playing soldier when junior anarchists were organizing to bring down the state. In the context of the Revolution of 1848, which saw the abdication of King Louis-Philippe in February and class warfare in the streets of Paris in June, the middle classes did indeed have something to fear, but not from the likes of this group.

Fig. 279 Honoré Daumier, *The Dangerous Children*, 1848. Lithograph.

Fig. 280 Elaine de Kooning, *Lascaux #4*, 1984. Lithograph on Arches paper, 15 × 21 in. Mount Holyoke College Art Museum. Gift of the Mount Holyoke College Printmaking Workshop.

While lithography flourished as a medium in the twentieth century, it has enjoyed a marked increase in popularity since the late 1950s. In 1957 Tatyana Grosman established Universal Limited Art Editions (ULAE) in West Islip, New York, and then, three years later, the Tamarind Lithography Workshop was begun in Los Angeles by June Wayne with the help of a grant from the Ford Foundation. While Grosman's primary motivation was to make available to the best artists a quality printmaking environment, one of Wayne's primary purposes was to train the printers themselves. Due to her influence, workshops sprang up across the country, including Gemini G.E.L. in Los Angeles, Tyler Graphics in Mount Cisco, New York, Landfall Press in Chicago, Cirrus Editions in Los Angeles, and Derrière l'Etoile in New York. The prints by contemporary women artists that have been included in this section on printmaking all derive from a 1987 exhibition of prints by women artists at the Mount Holyoke College Art Museum, an exhibition inspired by the Mount Holyoke College Printmaking Workshop founded by Nancy Campbell in 1984. Elaine de Kooning was the first resident artist at this workshop, and the series of prints she created there, one of which is reproduced here (Fig. 280), was inspired by the prehistoric cave drawings at Lascaux, France (see Chapter 5, "The Earliest Art"). The medium of lithography allows de Kooning to use to best advantage the broad painterly gesture that she developed as an abstract expressionist painter in the 1950s and 1960s. In these prints she develops a remarkable tension between what might be

called "the present tense" of her gesture, the sense that we can feel the very motion of her hand, and the "past tense" of her chosen image, the timelessness and permanence of the drawings at Lascaux.

Robert Rauschenberg's *Accident* (Fig. 281) was printed at Universal Limited Art Editions in 1963 and represents the spirit of innovation and experiment found in so much contemporary printmaking. At first, Rauschenberg, a post-abstract expressionist painter who included everyday materials and objects in his canvases, was reluctant to undertake printmaking. "Drawing on rocks," as he put it, seemed to him archaic. But Grosman was insistent that he try his hand at making lithographs at her West Islip studio. "Tatyana called me so often that I figured the only way I could stop her was to go out there," Rauschenberg says. He experimented with pressing all manner of materials down on the stone in order to see if they contained enough natural oil to leave an imprint that would hold ink. He dipped zinc cuts of old newspaper photos that he purchased from the *New York Times* morgue in *tusche*—a greasing liquid made of wax, tallow, soap, shellac, and lampblack that is the best material for drawing on a lithographic stone. *Accident* was created with these zinc cuts.

As the first printing began, the stone broke under the press, and Rauschenberg was forced to prepare a new version of the piece on a second stone. Only a few proofs of this second state had been pulled, when it too broke, an almost unprecedented series of catastrophes. It turned out that a small piece of cardboard was lodged under the press's roller and was causing uneven pressure to be applied to the stones. Rauschenberg was undaunted. He dipped the broken chips of the second stone in tusche, set the two large pieces back on the press, and lay the chips beneath them. Then, with great difficulty, his printer, Robert Blackburn, printed the edition

Fig. 281 Robert Rauschenberg, *Accident*, 1963. Lithograph on paper, 41 × 29 in. In the Collection of The Corcoran Gallery of Art, Gift of the Women's Committee.

Fig. 282 Andy Warhol, *30 Are Better than One*, 1963. Silkscreen ink and synthetic polymer paint on canvas, 110 × 82 in. © 1994 The Andy Warhol Foundation for the Visual Arts, Inc.

of 29 plus artist's proofs. *Accident* was awarded the grand prize at the Fifth International Print Exhibition in Ljubljana, Yugoslavia, in 1963. Says Grosman: "Bob is always bringing something new, some new discovery" to the printmaking process.

Serigraphy

Serigraphs—literally from the Greek *graphos*, "to write," and the Latin *seri*, "silk"—are commonly called **silkscreens**. Unlike other printmaking media, no expensive, heavy machinery is needed to make one. The principles used are essentially the same as those required for stenciling, where a shape is cut out of a piece of material and that shape is reproduced ad infinitum on other surfaces by spreading ink or paint over the cutout.

In serigraphy proper, shapes are not actually cut from silk (or, more commonly today, nylon and polyester). Rather the fabric is stretched tightly on a frame, and a stencil is made by painting a substance such as glue across the fabric in the areas where the artist does not want ink to pass through to the second surface. Alternately, special films can be cut out and stuck to the fabric. The areas that are cut out are those that will print. Silkscreen inks are very thick, so that they will not run beneath the edge of the cutout, and must be pushed through the open areas of the fabric with the blade of a tool called a *squeegee*.

Serigraphy is the newest form of printmaking, though related stencil techniques were employed in textile printing in China and Japan as early as 550 A.D. Until the 1960s, it was used primarily in commercial printing, especially by the advertising industry. In fact the word "serigraphy" was coined in 1935 by the curator of the Philadelphia Museum of Fine Arts in order to differentiate the work of artists using the silkscreen in creative ways from that of their commercially oriented counterparts.

In the 1960s, serigraphy became an especially popular medium for Pop artists.

Both Andy Warhol's *30 Are Better Than One* (Fig. 282) and Claes Oldenberg's *Design for a Colossal Clothespin Compared to Brancusi's Kiss* (Fig. 283) take advantage of the fact that photographs can be transferred directly to the screen. Warhol repeats Leonardo's *Mona Lisa* thirty times, emphasizing its status as an artistic cliché and a commodity comparable, in terms of the way American culture has come to think of it, to a can of Campbell's tomato soup. Oldenberg's print compares his own giant clothespin to Brancusi's famous sculpture *The Kiss* not merely to underscore their formal similarity—and it is striking—but, with tongue in cheek, to lend his own design the status of Brancusi's modern masterpiece. The print not only celebrates, with intentional irony, the commonplace and our culture's ability to monumentalize virtually anything, but also makes fun of art criticism's tendency to regard art in formal terms alone, the logic that might lead one to see the Brancusi and the clothespin in the same light.

Fig. 283 Claes Oldenberg, *Design for a Colossal Clothespin Compared to Brancusi's Kiss*, 1972. Silkscreen, 21 1/2 × 13 7/8 in. Philadelphia Museum of Art: From the Friends of the Philadelphia Museum of Art.

Fig. 284 Giorgio Vasari, *La Pittura*, 1542. Fresco. Arezzo, Casa Vasari.

Painting

Early in the fifteenth century, a personified figure known as *La Pittura*—literally, "the picture"—began to appear in Italian art (Fig. 284). As art historian Mary D. Garrard has noted, the emergence of the figure of *La Pittura* could be said to announce the cultural arrival of painting as an art. In the Middle Ages, painting was never included among the liberal arts, those areas of knowledge that were thought to develop general intellectual capacity, among them rhetoric, arithmetic, geometry, astrology, and music. While the liberal arts were understood to involve inspiration and creative invention, painting was considered merely a mechanical skill, involving, at most, manual dexterity, that is, the ability to copy. The emergence of *La Pittura* announces that painting could finally be seen as something more than mere copywork, that it was an intellectual pursuit equal to the other liberal arts, all of which had been given similar personification early in the Middle Ages.

In her *Self-Portrait as an Allegory of Painting* (Fig. 285), Artemisia Gentileschi presents herself as both a real person and as the personification of *La Pittura*. Iconographically speaking, Gentileschi may be recognized as *La Pittura* by virtue of the pendant around her neck that symbolizes *imitation*. In Renaissance terms, imitation was more than simply copying nature; it was the representation of nature as seen by and through the idealizing imagination of the artist. Gentileschi's unruly hair stands for the imaginative frenzy of the artist's temperament, and her multicolored garment alludes to her skill as a painter. In place of an idealized figure, however, Gentileschi presents us with her actual self. It is commonplace even today for men to think of women as intellectually inferior,

Fig. 285 Artemisia Gentileschi, *Self-Portrait as the Allegory of Painting*, 1630. Oil on canvas, 35 1/4 × 29 in. London, Kensington Palace. Collection of Her Majesty the Queen. Copyright reserved to Her Majesty Queen Elizabeth II.

Fig. 286 Cimabue, *Madonna Enthroned*, c. 1280. Tempera on panel, 12 ft 7 1/2 in. × 7 ft. 4 in. Galleria degli Uffizi, Florence.

and in Gentileschi's time, it was a popular maxim that "women have long dresses and short intellects." In this painting, Gentileschi not only represents artistic genius, she *is* artistic genius. She possesses all the intellectual authority and dignity of a Leonardo or a Michelangelo.

From the earliest times, one of the major concerns of painting in the Western world has been representing the appearance of things. There is a famous story told by the historian Pliny about a contest between the Greek painters Parrhasius and Zeuxis as to who could make the most realistic image:

> Zeuxis produced a picture of grapes so dexterously represented that birds began to fly down to eat from the painted vine. Whereupon Parrhasius designed so lifelike a picture of a curtain that Zeuxis, proud of the verdict of the birds, requested that the curtain should now be drawn back and the picture displayed. When he realized his mistake, with a modesty that did him honor, he yielded up the palm, saying that whereas he had managed to deceive only birds, Parrhasius had deceived an artist.

This tradition, wherein the painter's task is to rival the truth of nature, has survived to one degree or another to the present day.

In the late Middle Ages, Dante wrote in the *Purgatory* section of his *Divine Comedy* of the painters Cimabue and Giotto: "Once, Cimabue was thought to hold the field / In painting; now it is Giotto's turn." If we compare altarpieces painted by both artists (Figs. 286 & 287), Giotto's only 30 years after Cimabue's, we can readily see that Giotto's is the more "realistic," though it is clearly far less so than the realism to which we have since grown accustomed in, for instance, photography. For one thing, the Madonna and Child are far larger than the angels, raising all sorts of problems in scale. To early Renaissance eyes, however, Giotto's painting was a significant "advance" over the work of Cimabue. It is possible, for instance, to feel the volume of the Madonna's knee in Giotto's altarpiece, to sense actual bodies beneath the draperies that clothe his models. The neck of Cimabue's Madonna

is a flat surface while the neck of Giotto's Madonna is modeled and curves round beneath her cape. Cimabue's Madonna is chinless, her nose almost rendered in profile; the face of Giotto's Virgin is far more sculptural, as if real bones lie beneath her skin.

By this measure, the more faithful to nature a painting is, the more accurately it represents the real world, the greater is its aesthetic value. But if this were all there were to painting, then abstraction would be of little or no value (as, indeed, is true for the many people who still think of painting exclusively in terms of realism). Historically speaking, from the Byzantine art of the Middle Ages to the abstract painting of the twentieth century, truth to nature has not always seemed of paramount importance. Even in the Renaissance, the concept of imitation, or *mimesis*, involved the creation of representations that transcended mere appearance, that implied the sacred or spiritual essence of things.

Painting, in other words, can outstrip physical reality, leave it behind. Even when it is fully representational, it need not be merely *indexical*. It need not simply point at what it represents. It can suggest at least as much, and probably more, than it portrays. Another way to say this is that painting can be *connotative* as well as *denotative*. What a painting denotes is clearly before us: both Cimabue and Giotto have painted a Madonna and Child surrounded by angels. But what these paintings connote is something else again. To a thirteenth- and fourteenth-century Italian audience, both altarpieces would have been understood as depicting the ideal of love that lies between mother and child. This image also suggests the greater love of God for mankind, His sacrifice of his only son in order to lead mankind to salvation. The meaning, then, of these altarpieces exits on many levels. And although the relative realism of Giotto's painting is what secures its place in art history, its didactic function—that is, its ability to

Fig. 287 Giotto, *Madonna and Child Enthroned*, c. 1310. Tempera on panel, 10 ft. 8 in. × 6 ft. 8 1/4 in. Galleria degli Uffizi, Florence.

Fig. 288 Carlos Alfonzo, *On Hold in the Blue Line*, 1984. Acrylic on canvas, 72 × 96 in. Collection Peter Menendez, Coral Gables, Florida.

teach, to elevate the mind, in this case, to the contemplation of salvation—was at least as important to its thirteenth- and fourteenth-century audience. Its truth to nature was, in fact, probably inspired by Giotto's desire to make an image with which its audience could readily identify.

If modern abstraction seems to ignore intentionally Zuexis's aim of representing the world as realistically as possible, it does depend upon the connotative suggestiveness of its imagery for its meaning. At first glance, Carlos Alfonzo's *On Hold in the Blue Line* (Fig. 288) may seem nonobjective, except for the solitary eye that occupies the upper center of the canvas. Then we begin to notice other eyes emerging from the composition's chaotic line, toothy grins leer at us, and crownlike paws reach through the painting's space. What do their bizarrely distorted fingers grip? Given the title, apparently telephones, which suddenly appear everywhere in the work. It is as if we were caught in the nightmare world of being perpetually "on hold." To the right, a knife pierces an eye, or is it a breast, or is it simply a telephone receiver? For Alfonzo, who is Cuban-born, the knife, which is part of the Afro-Cuban religious tradition, can ward off the evil eye. If it pierces the tongue (or the tongue's surrogate, the telephone receiver?), it is capable of keeping evil quiet. Such a reading hardly exhausts the meanings of the painting, but it does indicate the connotative suggestiveness even of abstract imagery.

Encaustic

Encaustic, made by combining pigment with hot wax, is one of the oldest media in painting. It was widely used in classical Greece, most famously by Polygnotus, but very few paintings from that period survive. (The contest between Zeuxis and Parrhasius was probably conducted in encaustic.) The Hellenistic Greeks used it as well.

The largest number of surviving encaustic paintings comes from Faiyum in Egypt which, in the second century A.D., was a thriving Roman province about 60 miles south of present-day Cairo. The Faiyum paintings are funeral portraits which were attached to the mummy cases of the deceased, and they are the only indication we have of the painting techniques used by the Greeks. A transplanted Greek artist may, in fact, have been responsible for *Mummy Portrait of a Man* (Fig. 289), though we cannot be sure.

What is clear, though, is the artist's remarkable skill with the brush. The encaustic medium is a very demanding one, requiring the painter to work quickly so that the wax will stay liquid. Looking at *Mummy Portrait of a Man*, we will notice that while the neck and shoulders have been rendered with simplified forms, which gives them a sense of strength that is almost tangible, the face has been painted in a very naturalistic and sensitive way. The wide, expressive eyes and the delicate modeling of the cheeks make us feel that we are looking at a "real" person, which was clearly the artist's intention.

Fresco

Wall painting was practiced by the Egyptians, Greeks, and Romans as well. The preferred medium was **fresco**, in which pigment is mixed generally with limewater (a solution containing calcium hydroxide, or slaked lime), and then applied to a lime plaster wall that is either still wet or hardened and dry. If the paint is applied to a wet wall, the

Fig. 289 *Mummy Portrait of a Man*, Faiyum, c. 160–170 A.D. Encaustic on wood, 14 × 18 in. Albright-Knox Art Gallery, Buffalo, New York. Charles Clifton Fund, 1938.

Fig. 290 *Geese of Medum*, c. 2530 B.C. Tempera on plaster, approx. 18 × 68 in. Egyptian Museum, Cairo.

process is called *buon fresco* (Italian for "good" or "true fresco"), and if applied to a dry wall, *fresco secco*, or "dry fresco". In *buon fresco*, the wet plaster absorbs the wet pigment, and the painting literally becomes part of the wall. The artist must work quickly, plastering only as much wall as can be painted before it dries, but the advantage of the process is that it is extremely durable. In *fresco secco*, on the other hand, the pigment is combined with binders such as egg yolk, oil, or wax, and applied separately, at virtually any pace the artist desires. As a result, the artist can render an object with extraordinary care and meticulousness, as is evident in these paintings of geese from ancient Egypt (Fig. 290). The disadvantage of the *fresco secco* technique is that moisture can creep in between the plaster and the paint, causing the paint to flake off the wall. This is what happened to Leonardo da Vinci's *Last Supper* in Milan, which has peeled away to such a tragic degree that the image has almost disappeared, though it is today being carefully restored.

In the eighteenth century, many frescoes were discovered at Pompeii and nearby Herculaneum where they had been buried under volcanic ash since the eruption of Mt. Vesuvius in A.D. 79. A series of still life paintings was unearthed in the years 1755–1757

that proved so popular in France that they led to the renewed popularity of the still life genre. This *Still Life with Eggs and Thrushes* (Fig. 291), from the Villa of Julia Felix, is particularly notable, especially the realism of the dish of eggs, which seems to hang over the edge of the painting and push forward into our space. The fact that all the objects in the still life have been painted lifesize adds to the work's sense of realism.

One of the most remarkable frescoes to survive Roman times is a wall-size rendering of a garden, found in the Villa of Livia, wife of the Emperor Augustus, in Prima Porta near Rome (Fig. 292). Not unlike certain back-lighted beer advertisements of rushing mountain streams commonly found in taverns today, the painting is designed to "open" the closed room to the out-of-doors, lending it the airiness and light of a cool summer evening. The artist is attempting to render an illusionistic, that is, realistic, space by means of both linear and atmospheric perspective.

This goal of creating the illusion of reality dominates fresco painting from the early Renaissance in the fourteenth century through the Baroque period of the late seventeenth century. It is as if painting at the scale of the wall invites, even demands, the cre-

Fig. 291 *Still Life with Eggs and Thrushes*, Villa of Julia Felix, Pompeii, before A.D. 79. Fresco, 35 × 48 in. National Museum, Naples.

Fig. 292 *Garden*, Villa of Livia, Prima Porta, near Rome, late 1st century B.C. Fresco, height 10 ft. Museo delle Terme, Rome.

Fig. 293 Giotto, *Lamentation*, c. 1305. Fresco, approx. 70 × 78 in. Arena Chapel, Padua, Italy.

ation of "real" space. In one of the great sets of frescoes of the early Renaissance, painted by Giotto in the Arena Chapel in Padua, Italy, this realist impulse is especially apparent.

The Arena Chapel was designed, possibly by Giotto himself, especially to house frescoes, and it contains 38 individual scenes that tell the stories of the lives of the Virgin and Christ. In the *Lamentation* (Fig. 293), the two crouching figures with their backs to us extend into our space in a manner similar to the bowl of eggs in the Roman fresco. Here, the result is to involve us in the sorrow of the scene. As the hand of the left-most figure cradles Christ's head, it is almost as if it were our own. One of the more remarkable aspects of this fresco, however, is the placement of its focal point—Christ's face—in the lower left-hand corner of the composition, at the base of the diagonal formed by the stone ledge. Just as the angels in the sky above seem to be plummeting toward the fallen Christ, the tall figure on the right leans forward in a sweeping gesture of grief that mimics their descending flight.

The fresco artist's interest in illusionism culminated in the Baroque ceiling designs of the late seventeenth century. Among the most remarkable of these is *The Glorification of St. Ignatius* (Fig. 294), which Fra Andrea Pozzo painted for the church of Sant' Ignazio in Rome. Standing in the nave, or central portion of the church, and looking upward, the congregation had the illusion that the roof of the church had been removed, revealing the glories of Heaven. A master of perspective, about which he wrote an influential treatise, Pozzo realized his effects by extending the architecture in paint one story above the actual windows in the vault. St. Ignatius, the founder of the Jesuit order, is depicted being transported on a cloud toward the waiting Christ. The foreshortening of the many figures, becoming ever smaller in size as they rise toward the center of the ceiling, greatly adds to the realistic, yet awe-inspiring effect.

Fig. 294 Fra Andrea Pozzo, *The Glorification of Saint Ignatius*, 1691–1694. Ceiling fresco. Nave of Sant' Ignazio, Rome.

Fig. 295 *Lord Buddha as Prince Mahasanka with his Queen and Lady Attendants Tempting Him to Renounciation of Life*, 5th century A.D. Wall painting. Cave No. 1, Ajanta, Mahrashtra (?), India.

Early Wall Painting in India

The earliest wall paintings in India are found in a series of caves cut out of cliffs at Ajanta in the mountains north of Bombay. These caves served as Buddhist temples from about 200 B.C. to A.D. 600, and were divided into two sections called *chaityas* and *viharas*. A *chaitya* is something like an early Christian church, with a long nave, or central section, with a pillared aisle to each side, at the end of which is a domelike, semicircular structure that contains a relic of the Buddha or a Buddhist saint. The *vihara* is a rectangular hall open to the outside that contains cells for the monks on the inside. In essence, the *chaitya* and *vihara* are equivalent to a church and its accompanying monastery.

The frescoes in Caves I and II, which were painted in the fifth century A.D., are the best preserved and most magnificent of the Ajanta wall paintings. They are especially notable because of the absence of evident *joins*, or seams, between one day's plastering and the next, a sign of the incredible skill of the artist who made them.

Many of the paintings are known as *Mahajanaka jatakas*, or stories from the Buddha's previous lives on earth. The Buddha is represented here (Fig. 295) in his incarnation as a prince being tempted to the sensual pleasures of court life by his Queen and her attendants. Perhaps in response to the rising popularity in the sixth and seventh centuries A.D. of Hinduism, which defined carnal love as an aspect of spiritual love, this Buddhist painting depicts the Buddha, his formal dignity and spiritual essence unsullied, in an openly erotic environment.

Source: Douglas Barrett and Basil Gray, *Painting of India* (Geneva: Skira, 1963).

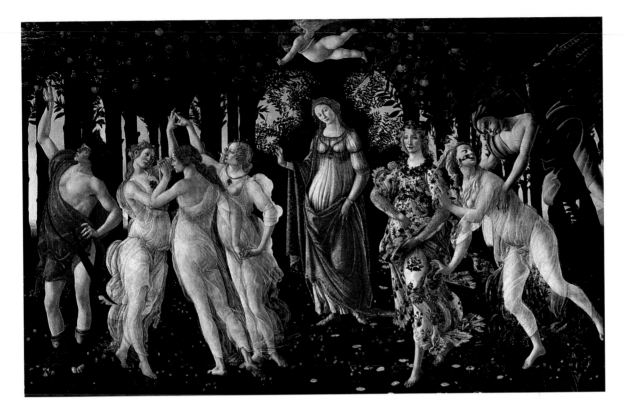

Fig. 296 Sandro Botticelli, *Primavera*, c. 1482. Tempera on poplar on a gesso ground, 80 × 123 ¼ in. Galleria degli Uffizi, Florence.

Tempera

Until the end of the Middle Ages, most paintings were done in **tempera**, a medium made by combining water, pigment, and some gummy material, usually egg yolk. The paint was meticulously applied with the point of a fine red sable bursh. Colors could not readily be blended, and, as a result, effects of *chiaroscuro* were accomplished by means of careful and gradual hatching. In order to use tempera, the painting surface, often wood panel, had to be prepared with a very smooth **ground** not unlike the smooth plaster wall prepared for *buon fresco*. **Gesso**, made from glue and plaster of Paris or chalk, is the most common ground, and like wet plaster, it is fully absorbent, combining with the tempera paint to create an extremely durable and softly glowing surface unmatched by any other medium.

Sandro Botticelli's *Primavera* (Fig. 296), painted for a chamber next to the bedroom of his patron Lorenzo di Pierfrancesco de' Medici, is one of the greatest tempera paintings ever made. As a result of its restoration in 1978, we know a good deal about how it was painted. The support consists of eight poplar panels, arranged vertically and fastened by two horizontal strips of spruce. This support was covered with a gesso ground that hid the seams between the panels. Botticelli next outlined the trees and his human figures on the gesso and then painted the sky, laying blue tempera directly on the ground. The figures and trees were painted on an undercoat, white for the figures, black for the trees. The transparency of the drapery was achieved by layering thin yellow washes of transparent medium over the white undercoat. As many as thirty coats of color, transparent or opaque depending on the relative light or shadow of the area being painted, were required to create each figure.

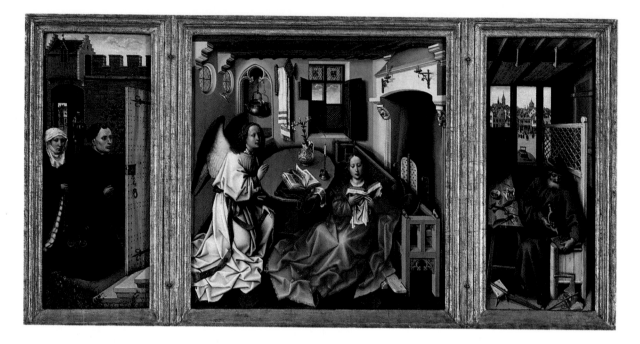

Fig. 297 The Master of Flémalle (Robert Campin?), *Merode Altarpiece*, c. 1425–1430. Oil on wood panels, center 25 1/4 × 24 7/8 in.; each wing 25 3/8 × 10 3/4 in. The Metropolitan Museum of Art, New York. The Cloisters Collection, 1956 (56.70).

Oil Painting

Oil paint is a far more versatile medium than tempera. It can be blended on the painting surface to create a continuous scale of tones and hues, many of which, especially darker shades, were not possible before. As a result, the painter was able to render the most subtle changes in light and achieve the most realistic three-dimensional effects, rivaling sculpture in this regard. Perhaps most important, oil painting is slow to dry. Whereas with other painting media artists had to work quickly, with oil they could work almost endlessly to perfect their images.

It was the so-called Master of Flémalle, probably the artist Robert Campin, who first recognized the realistic effects that could be achieved with the new medium. In the *Merode Altarpiece* (Fig. 297), the Annunciation of the Virgin takes place in a fully realized Flemish domestic interior. The scene is not idealized. In the right-hand panel, Joseph the carpenter works as a real fifteenth-century carpenter might have. In the left-hand panel, shown kneeling outside the door are the

donors, the couple who commissioned the altarpiece, dressed in fashionable fifteenth-century clothing.

The Master of Flémalle's contemporary, Jan van Eyck, developed oil painting even further. Van Eyck was particularly skilled both at realizing the effects of atmospheric perspective, creating a gradual softening of tone—ever more hazy—as space recedes away from the spectator's point of view, and at rendering the visible world in the utmost detail. What fascinates the viewer, in fact, about a painting like *The Madonna of Chancellor Rolin* (Fig. 298) is at least as much what can be seen out the window—from the garden to the distant mountains—as what is seen in the figures of the chancellor and the Virgin and Child who occupy the foreground. Our interest, like that of the two figures who lean over the wall beyond the garden, is drawn from the interior scene to the world beyond, almost as if we were being drawn away from the representation of an ideal world in art and into the representation of a real one.

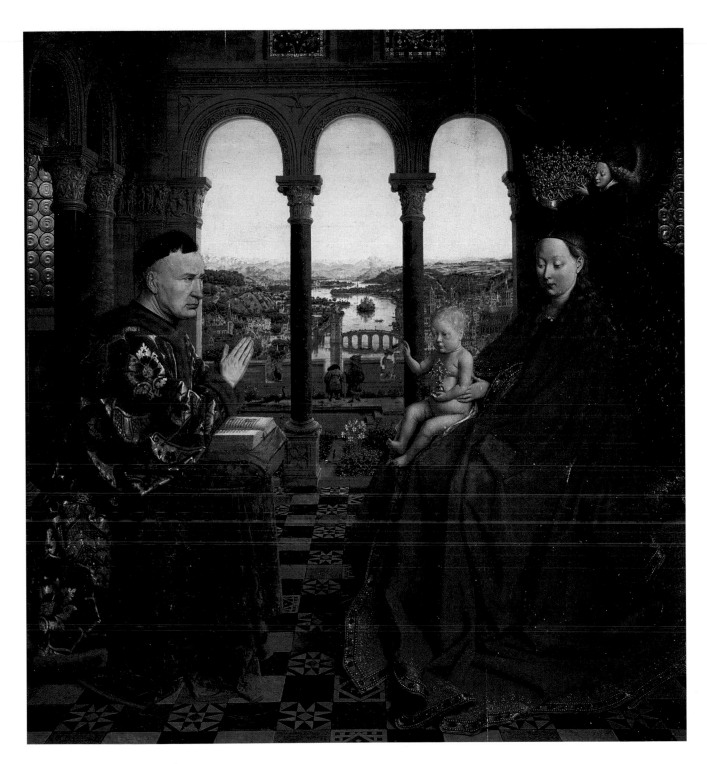

Fig. 298 Jan van Eyck, *The Madonna of Chancellor Rolin*, c. 1433–1434. Oil on panel, 26 × 24 3/4 in. Musée du Louvre, Paris.

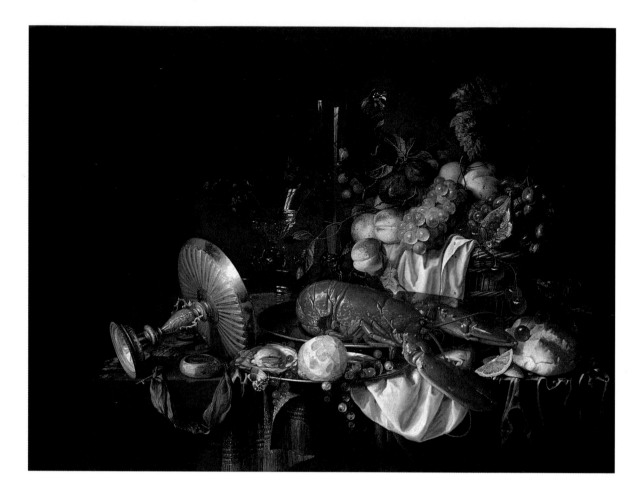

Fig. 299 Jan Davidsz de Heem, *Still Life with Lobster*, c. 1650. Oil on canvas, 25 1/8 × 33 1/4 in. The Toledo Museum of Art, Toledo, Ohio. Gift of Edward Drummond Libbey.

By the time the Netherlands freed itself of Spanish rule in 1608 to become, by virtue of its almost total dominance of world trade, the wealthiest nation in the world, artists had themselves become extremely skillful at representing these material riches—with the medium of oil paint. One critic has called the Dutch preoccupation with still life "a dialogue between the newly affluent society and its material possessions." In a painting such as Jan de Heem's *Still Life with Lobster* (Fig. 299), we are witness to the remains of a most extravagant meal, most of which has been left uneaten. This luxuriant and conspicuous display of wealth is deliberate. Southern fruit in a cold climate is a luxury, and the peeled lemon, otherwise untouched, is a sign of almost wanton

consumption. And though we might want to read into this image our own sense of its decadence, for de Heem the painting was more a celebration, an invitation to share, at least visually, and thus imaginatively, in its world. The feast on the table was a feast for the eyes.

The ability to create such a sense of tactile reality is a virtue of oil painting that makes the medium particularly suitable to the celebration of material things. By **glazing** the surface of the painting with thin films of transparent color, the artist is able to create a sense of luminous materiality. Light penetrates this glaze, bounces off the opaque underpainting beneath, and is reflected back up through the glaze. Painted objects thus seem to reflect light as if they were real, and

the play of light through the painted surfaces gives them a sense of tangible presence.

The more real a painting appears to be, the more it is said to be an example of **trompe l'oeil**, a French phrase meaning "deceit of the eye." It is precisely painting's ability to deceive the eye, to substitute itself for reality, that is the subject of René Magritte's *Euclidean Walks* (Fig. 300). Here a painting-within-a-painting is set in front of a window so that it hides, but exactly duplicates, the scene outside. The painting confuses the interior of the room with the exterior landscape, and by analogy, the world of the mind with the physical world outside it. In Magritte's words, this is "how we see the world: we see it as being outside ourselves even though it is only a mental representation of it that we experience inside ourselves." The artificial nature of this superficially trompe l'oeil scene is underscored by the way in which the shape of the tower is identical to the shape of the avenue receding to a distant vanishing point. A painting is, after all, a mental construction, an artificial reality, not reality itself.

If oil painting exists in the mind, and for the mind, it need not necessarily reflect the world outside it. Since virtually its inception, oil painting's *expressive* potential has also been recognized. Much more than in fresco, where the artist's gesture was lost in the plaster, and much more than in tempera, where the artist was forced to use brushes so small that gestural freedom was absorbed by the scale of the image, oil paint could record and trace the artist's presence before the canvas. In the swirls scored into his hair with the butt end of his brush, Rembrandt's *Self Portrait as a Young Man* (Fig. 301), painted when the artist was 23 years old, reflects the young artist's personality, his aggressiveness and his daring. Gesture is autographic, at least as much a record of Rembrandt's unique creative genius as it is a representation of his wild and unkempt head of hair. Oil painting frees Rembrandt to express feeling through his brushwork.

Fig. 300 René Magritte, *Euclidean Walks*, 1955. Oil on canvas, 64 × 51 1/2 in. The Minneapolis Institute of the Arts.

Fig. 301 Rembrandt van Rijn, *Self Portrait as a Young Man*, 1629. Oil on panel, 6 1/8 × 5 in. Alte Pinakothek, Munich.

Fig. 302 Elaine de Kooning, *Sunday Afternoon*, 1957. Oil on Masonite, 36 × 42 in. Collection Ciba-Geigy Corporation, Ardsley, New York.

In her painting *Sunday Afternoon* (Fig. 302), Elaine de Kooning uses **impasto**—paint applied in heavy layers or strokes—in order to convey not only the depth of her reaction to the bullfights she witnessed on a trip to Juárez, Mexico in 1957, but also the majesty of the bull, the ferocious speed of the event, the dignity of the ritual slaughter, even the physical space of the Western landscape. This is a painting that captures, through the fluidity of the medium itself, the ease with which it can be manipulated with a brush or palette knife, feelings not things, the texture of experience rather than its details.

Many of Elaine's attitudes about painting were developed as she worked alongside her husband, the abstract expressionist Willem de Kooning, from whom she was amicably separated in 1956. In paintings like Willem's *Door to the River* (Fig. 303) there is no reference to visual reality at all. Willem described the subject matter of this painting, and others like it, as a mixture of raw sensations: "landscapes and highways and sensations of that, outside the city—with the feeling of going to the city or coming from it." What we feel here, especially, is energy, the energy of the city translated into the energy of painting itself.

Fig. 303 Willem de Kooning, *Door to the River*, 1960. Oil on canvas, 80 × 70 in. Collection of Whitney Museum of American Art. Purchase, with funds from the Friends of the Whitney Museum of American Art. 60.63.

Fig. 304 Rembrandt van Rijn, *A Sleeping Woman*, c. 1660–1669. Brush drawing in brown ink and wash, 9 5/8 × 8 in. The British Museum, London.

Fig. 305 John Marin, *Sunset, Maine Coast*, 1919. Watercolor, 16 1/4 × 19 1/4 in. Columbus Museum of Art, Ohio. Gift of Ferdinand Howald.

Watercolor

Of all the painting media, **watercolor** is at least potentially one of the most expressive. The ancient Egyptians used it to illustrate papyrus scrolls, and it was employed intermittently by other artists down through the centuries, notably by Albrecht Dürer and Peter Paul Rubens. But it was not until artists began to exploit the expressive potential of painting, rather than pursuing purely representational ends, that the characteristics of the medium were fully explored.

Watercolor paintings are made by applying pigments suspended in a solution of water and gum arabic to dampened paper. Working quickly, it is possible to achieve gestural effects that are very close to those possible in drawing with brush and ink, as a comparison of Rembrandt's drawing of *A Woman Sleeping* (Fig. 304) with John Marin's watercolor *Sunset, Maine Coast* (Fig. 305) makes evident. Both ink and watercolor readily spread through the fibers of the paper ground, which is generally left white to indicate the background of the composition, though both Rembrandt and Marin apply washes of medium to indicate middle distances. In both of these works, it is as if we can see the artist's brush move on the paper.

The expressive potential of watercolor is fully realized in Georg Baselitz's *Untitled* (Fig. 306). At first glance, the painting seems to be an almost totally abstract sunset landscape, close in mood to Marin's, representing perhaps a lake, at the left, emptying into a distant sea. Baselitz's title, however, indicates that our temptation to read this image figuratively is probably mistaken. When we realize that, viewed upside down, this is not a landscape, but the image of a man eating a drumstick or singing into a microphone, we begin to understand that Baselitz wishes us to value his painting *as* painting, subject matter aside. For Baselitz, painting reveals the mind, not the world, an idea realized in his transformation of the representational into the abstract.

Fig. 306 Georg Baselitz, *Untitled*, 1981. Watercolor and chalk pastel on white paper, 23 3/4 × 16 3/4 in. Harvard University Art Museums (Fogg Art Museum). Acquired through the Deknatel Purchase Fund.

樹總發筆溪
閒凍榱閬仙
居寓上層不
稱枋枢間甦
偏�ま山早兄
氣如茶
己卵春月
澂慧

Fig. 307 Guo Hsi, *Early Spring*, 1072 A.D. (Northern Song dynasty). Hanging scroll, ink and slight color on silk, length 60 in. Collection of the National Palace Museum, Taipei, Taiwan, R.O.C.

Chinese Landscape Painting

After calligraphy, traditional Chinese culture always valued landscape painting as the highest form of artistic endeavor. For them, the very activity of painting was a search for the absolute truth embodied in nature. This search was not so much intellectual as intuitive, an effort to understand the *li*, or "principle," upon which the universe is founded, and in the universe, every gesture and every form is endowed with symbolic meaning and feeling.

The composition of Guo Xi's *Early Spring* (Fig. 307), with its tall central mountain flanked by two smaller ones, is based on the Chinese written character for mountain:

山

The fluid gestures of the calligrapher's hand are mirrored here in both the organization of the whole and the brush-and-ink strokes of the artist's detailed rendering of his ideal landscape. Just as a calligrapher would be, Guo Xi is interested in the balance, rhythm, and movement of his line. The scene that he depicts is almost secondary.

Yet the scene is important. The human presence in this landscape goes by almost unnoticed so vast is the scale of the central mountain. Small figures occupy the lower foreground to both left and right, and in the middle distance on the right, a village is tucked between the hills. Nature, embodied here by the mountain, is all embracing, a powerful and imposing symbol of eternity that dwarfs humanity.

A court painter during the reign of Emperor Shenzong (1068–1885), Guo Xi was given the task of painting all the murals in the Forbidden City, the imperial compound in Beijing that foreigners were prohibited from entering. His ideas about landscape painting were recorded by his son, Guo Si, in a book entitled *The Lofty Message of the Forests and Streams*. According to this book, the central peak here symbolizes the Emperor himself, its tall pines the gentlemanly ideals of the court. Around the Emperor the masses assume their natural place, as around this mountain, the trees and hills fall, like the water itself, into the order and rhythms of nature.

Everything has its appropriate place in the Chinese universe, and accordingly, each part of the painting is constructed at the appropriate "distance," as traditionally understood. The central mountain is painted so that we gaze up to it in "high distance," as we would properly gaze up to the Emperor. On the left side of the painting, we gaze far off into a "level distance," creating a sense of limitless, eternal space. While to the right, we stare down into the humbling "deep distance" of the gorge, a space that underscores our own insignificance in relation, literally, to nature, and symbolically, to the Emperor.

Sources: Torao Miyagawa, *Chinese Painting* (New York and Tokyo: Weatherhill/Tankosha, 1983); and Michael Sullivan, *Symbols of Eternity: The Art of Landscape Painting in China* (Stanford, Calif.: Stanford University Press, 1979).

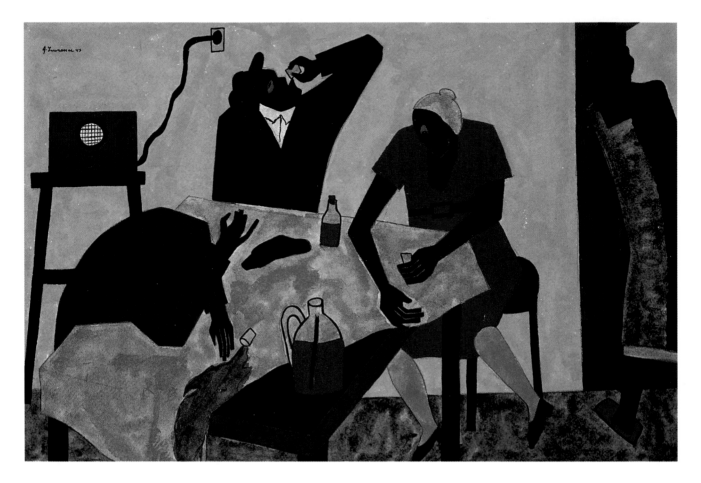

Fig. 308 Jacob Lawrence, *No. 15: You can buy bootleg whiskey for twenty-five cents a quart*, from the *Harlem Series*, 1942–1943. Gouache on paper, 15 ¹/₂ × 22 ¹/₂ in. Collection of the Portland Art Museum; Helen Thurston Ayer Fund.

Gouache

Derived from the Italian word *guazzo*, meaning "puddle," **gouache** is essentially watercolor mixed with Chinese white chalk. The medium is opaque, and, while gouache colors display a light-reflecting brilliance, it is difficult to blend brushstrokes of gouache together. Thus the medium lends itself to the creation of large flat, colored forms. It is this abstract quality that attracted Jacob Lawrence to it. Everything in the painting *You can buy bootleg whiskey for twenty-five cents a quart* (Fig. 308), from a series of 30 representations of life in Harlem in the late 1930s and early 1940s, tips forward, creating not only a sense of disorienting and drunken imbalance, but emphasizing, as well, the flat two-dimensionality of the painting's space. Lawrence's dramatically intense complementary colors blare like the jazz we can almost hear coming from the radio.

Synthetic Media

Because of its slow-drying characteristics and the preparation necessary to ready the painting surface, oil painting lacks the sense of immediacy so readily apparent in more direct media like drawing or watercolor. For the same reasons, the medium is not particu-

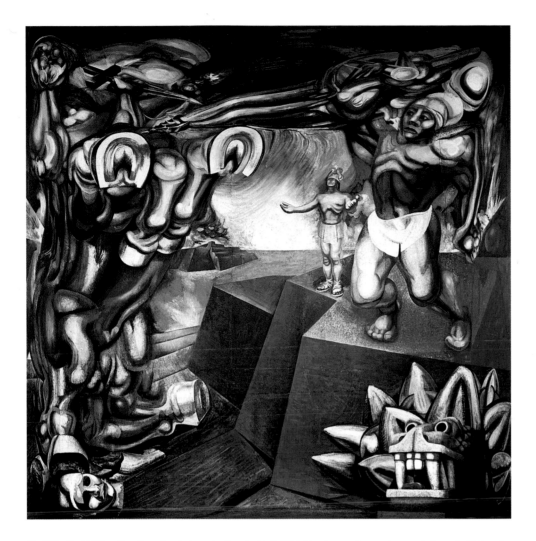

Fig. 309 David Alfaro Siqueiros, *Cuauhtémoc Against the Myth*, 1944. Mural, pyroxylin on celotex and plywood, 1000 sq. ft. Teepan Union Housing Project, Tlatelco, Mexico. INAH/CNCA.

larly suitable for painting out-of-doors, where one is continually exposed to the elements.

The first artists to experiment with synthetic media where a group of Mexican painters, led by David Alfaro Siqueiros, whose goal was to create a large-scale revolutionary mural art. Painting outdoors, where their celebrations of the struggles of the working class could easily be seen, Siqueiros, Diego Rivera, and José Clemente Orozco first worked in fresco, then oil paint, but the sun, rain, and humidity of Mexico quickly ruined their efforts. In 1937 Siqueiros organized a workshop in New York, closer to the chemical industry, expressly to develop and experiment with new synthetic paints. One of the first media used at the workshop was pyroxylin, commonly known as Duco, a lacquer developed as an automobile paint. Housed in the Union Housing Project at Tlatelco since 1964, *Cuauhtémoc Against the Myth* (Fig. 309) depicts the story of the Aztec hero who shattered the myth of the conquering Spanish army's invulnerability to attack. Meant as a commentary on the vulnerability of the Nazi army as well, the mural was painted on a 1,000 square foot panel instead of a wall in order to withstand damage from earthquakes.

Australian Aboriginal Acrylic Painting

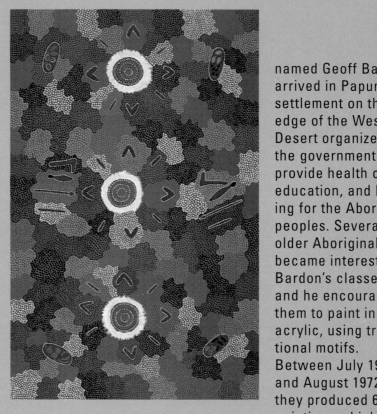

Fig. 310 Erna Motna, *Bushfire and Corroboree Dreaming*, 1988. Acrylic on canvas 48 × 32 in. Australia Gallery, New York.

The organizing logic of most Aboriginal art is what is called the Dreaming, a system of belief unlike that of most other religions in the world. The Dreaming is not literally dreaming as we think of it, not what goes on in that other world we inhabit in our sleep. For the Aborigine, the Dreaming *is* the presence, or mark, of an Ancestral Being in the world. Images of these Beings—representations of the myths about them, maps of their travels, depictions of the places and landscapes they inhabited—make up the great bulk of Aboriginal art. The Australian landscape is thought of, in fact, as a series of marks made upon the earth by the Dreaming, a record, as it were, of the Ancestral Being's passing. Geography itself is thus full of meaning and history. And painting is understood as a concise vocabulary of abstract gestures conceived to render the essence, both present and past, of the Australian landscape.

Ceremonial body, rock, and ground paintings were made for centuries by the Aboriginal peoples of Central Australia's Western Desert region. Acrylic paintings, similar in form and content to these traditional works, began to be produced in the region in 1971. In that year a young white art teacher named Geoff Bardon arrived in Papunya, a settlement on the edge of the Western Desert organized by the government to provide health care, education, and housing for the Aboriginal peoples. Several older Aboriginal men became interested in Bardon's classes, and he encouraged them to paint in acrylic, using traditional motifs. Between July 1971 and August 1972, they produced 620 paintings which were subsequently sold for between $25 and $30 each at the Stuart Art Centre in Alice Springs. By 1987, prices for works executed by well-known painters ranged from $2,000 to $15,000.

Money was clearly a major factor in prompting this explosion of work—in 1984, for instance, the women of one village took up painting in order to buy a truck—but it was by no means the sole motivation. Each design still carries with it its traditional ceremonial power and is actual proof of the identity of those involved in making it. Each painting depicts a Dreaming for which the artist is usually what is called *kirda*. Artists are *kirda* if they have inherited the "rights" to the Dreaming from their father. Every Dreaming is also inherited through the mother's line, and a

small red dots at the edge of each circle), they are caught by the women and hit with digging sticks, also visible around each fire, and then carried with fruit and vegetables to the central fire, the site of the *corroboree* itself. Other implements that will be used by the men to kill larger animals driven out of the bush by the fires are depicted as well— boomerangs, spears, *nulla nullas* (clubs), and *woomeras* (spear throwers).

Unlike most other forms of Aboriginal art, acrylic paintings are permanent and are not destroyed after serving the ceremonial purposes for which they were produced. In this sense, the paintings have tended to turn dynamic religious practice into static representations, and even worse, into commodities. Conflicts have arisen over the potential revelation of secret ritual information in the paintings, and the star status bestowed upon certain, particularly younger, painters has had destructive effects on traditional hierarchies within the community. On the other hand, these paintings have tended to revitalize and strengthen traditions that were, as late as the 1960s, thought doomed to extinction.

Source: *Dreamings: The Art of Aboriginal Australia*, ed. Peter Sutton (New York: George Braziller and The Asia Society Galleries, 1988).

person who is related to a Dreaming in this way is said to be *kurdungurlu*. Thus a woman who is *kirda* for a particular Dreaming will have children who are *kurdungurlu* for that same myth and landscape associated with it. *Kurdungurlu* must insure that the *kirda* fulfill their proper social and ritual obligations to the Dreaming. As a result, several people usually work on a given painting. The *kirda* who is most knowledgeable about the Dreaming might direct it, overseen by *kurdungurlu* who make sure everything is properly depicted. Another *kirda* skillful with the brush might paint it, and still other *kirda*, and because the process of composing with so many small dots of paint is so arduous, sometimes *kurdungurlu,* help with the painting as well. The person that Westerners designate as the "artist"—a distinction not employed in Aboriginal culture before the advent of acrylic painting—is generally the person who has chosen the specific Dreaming to be depicted.

Erna Motna's *Bushfire and Corroboree Dreaming* (Fig. 310) depicts the preparations for a *corroboree*, or celebration ceremony. The circular features at the top and bottom of the painting represent small bush fires that have been started by women. As small animals run from the fire (symbolized by the

Fig. 311 Morris Louis, *Blue Veil*, 1958–1959. Acrylic resin paint on canvas, 100 1/2 × 149 in. Courtesy of the Fogg Art Museum, Harvard University; Gift of Lois Orswell and Gifts for Special Uses Fund.

Fig. 312 Helen Frankenthaler, *Flood*, 1967. Synthetic polymer on canvas, 10 ft. 4 in. × 11 ft. 8 in. Collection of Whitney Museum of American Art. Purchase, with funds from the Friends of the Whitney Museum of American Art. 68.12.

In the early 1950s, Helen Frankenthaler gave up the gestural qualities of the brush loaded with oil paint and began to stain raw, unprimed canvas with greatly thinned oil pigments, soaking color into the surface in what has been called an art of "stain-gesture." Her technique soon attracted a number of painters, Morris Louis among them, who were themselves experimenting with Magna, a paint made from **acrylic resins** mixed with turpentine. Staining canvas with oil created a messy, brownish "halo" around each stain or puddle of paint, but Louis quickly realized that the "halo" disappeared when he stained canvas with Magna, the paint and canvas really becoming one.

At almost exactly this time, researchers in both Mexico and the United States discovered a way to mix acrylic resins with water, and by 1956 water-based acrylic paints were on the market. These media were inorganic and, as a result, much better suited to staining raw canvas than turpentine or oil-based media, since no chemical interaction could take place that might threaten the life of the painting.

Louis's *Blue Veil* (Fig. 311) consists of multicolored translucent washes of acrylic paint thinned to the consistency of watercolor. Inevitably, Frankenthaler gave up staining her canvases with oil and moved to acrylic in 1963. With this medium she was able to create such intensely atmospheric paintings as *Flood* (Fig. 312). Working on the floor, and pouring paint directly on canvas, the artist was able to make the painting seem spontaneous, even though it is quite large. "A really good picture," Frankenthaler says, "looks as if it's happened at once.... It looks as if it were born in a minute." This sense of spontaneity manifests itself as a sort of aggressive good humor in the giant poured pieces of Lynda Benglis (Fig. 313). Her liquid rubber materials find their own form as they spill, not onto canvas, but directly onto the floor, creating what might be called "soft" painting.

Fig. 313 Lynda Benglis, *Contraband*, 1969. Poured pigmented latex, 33 ft. 9 in. × 9 ft. × 1 in. Courtesy Paula Cooper Gallery, New York.

Fig. 314 William Henry Fox Talbot, *Mimosoidea Suchas, Acacia,* c. 1839. Photogenic drawing. Fox Talbot Collection, Science Museum, London.

Photography

In 1839, simultaneously in both England and France, the public was introduced to a new way of representing the world. In England, William Henry Fox Talbot presented a process for fixing negative images on paper coated with light-sensitive chemicals, which he called **photogenic drawing** (Fig. 314). In France, a different process, which yielded a positive image on a polished metal plate, was named the **daguerreotype** (Fig. 315), after one of its two inventors, Louis Jacques Mandé Daguerre (Joseph Nicéphore Niépce had died in 1833, leaving Daguerre to perfect the process and reap the laurels). Public reaction was wildly enthusiastic, and the French and English press faithfully reported every development in the greatest detail.

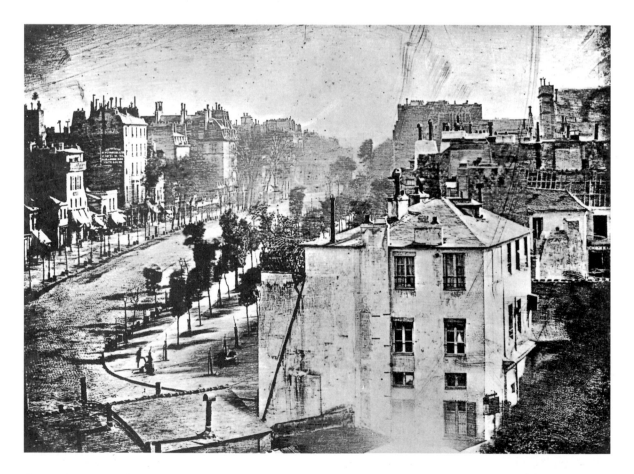

Fig. 315 Louis Jacques Mandé Daguerre, *Le Boulevard du Temple*, 1839. Daguerreotype. Bayerisches National Museum, Munich.

When he saw his first daguerreotype, the French painter Paul Delaroche is reported to have exclaimed: "From now on, painting is dead!" Delaroche may have overreacted, but he nevertheless understood the potential of the new medium of photography to usurp painting's historical role of representing the world. In fact, photographic portraiture quickly became a successful industry. As early as 1841, a daguerreotype portrait could be had in Paris for as little as 15 francs. That same year in London, Richard Beard opened the first British portrait studio bringing a true sense of showmanship to the entire process. One of his first customers, the novelist Maria Edgeworth (Fig. 316), described having her portrait done at Beard's in a breathless letter dated May 25, 1841: "It is a wonderful mysterious operation. You are taken from one room into another upstairs and down and you see various people whispering and hear them in neighboring passages and rooms unseen and the whole apparatus and stool on a high platform under a glass dome casting a snapdragon blue light making all look like spectres and the men in black gliding about…. I have not time to tell you more."

In the face of such a "miracle," the art of portrait painting underwent a period of rapid decline. Of the 1,278 paintings exhibited at the Royal Academy in London in 1830, over 300 were miniatures, the most popular form of the portrait; in 1870, only 33 miniatures were exhibited. In 1849 alone, 100,000 daguerreotype portraits were sold in Paris. Not only had photography replaced painting as the preferred medium for portraiture, it had democratized the genre as well, making it available to not only the wealthy but almost everyone.

The daguerreotype itself had some real disadvantages as a medium. In the first place, it required considerable time to prepare, expose, and develop the plate. Iodine was vaporized on a copper sheet to create light-sensitive silver iodide. The plate then had to be kept in total darkness until the camera lens

Fig. 316 Richard Beard, *Maria Edgeworth*, 1841. Daguerreotype, 2 1/8 × 1 3/4 in. National Portrait Gallery, London.

was opened to expose it. At the time Daguerre first made the process public in 1839, imprinting an image on the plate took from eight to ten minutes in bright summer light. His own view of the Boulevard du Temple (Fig. 315) was exposed for so long that none of the people in the street, moving about their business, has left any impression on the plate, save for one solitary figure, at the lower left, who is having his shoes shined. By 1841, the discovery of chemical so-called "accelerators" had made it possible to expose the plate for about a minute, but a sitter could not move in that time for fear of blurring the image. The plate was finally developed by suspending it face down in heated mercury, which deposited a white film over the exposed areas. The unexposed silver iodide was dissolved with salt. The plate then had to be rinsed and dried with the utmost care.

Fig. 317 William Henry Fox Talbot, *The Open Door*, 1843. Calotype. Fox Talbot Collection, Science Museum, London.

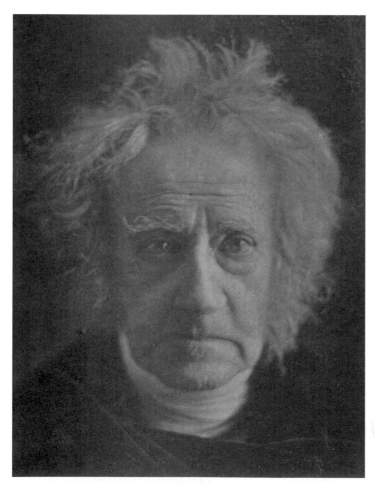

Fig. 318 Julia Margaret Cameron, *Sir John Herschel*, Collodion/albumen print, 12 ¾ × 10 ¼ in. Gift of Mrs. J. D. Cameron Bradley, Courtesy, Museum of Fine Arts, Boston.

An even greater drawback of the daguerreotype was that it could not be reproduced. Utilizing paper instead of a metal plate, Fox Talbot's photogenic process made multiple prints a possibility. Talbot quickly learned that he could reverse the "negative" image of the photogenic drawings by placing sheets of sensitized paper over them and exposing both again to sunlight. Talbot also discovered that sensitized paper, exposed for even a few seconds, held a *latent* image that could be brought out and developed by dipping the paper in gallic acid. This **calotype** process is the basis of modern photography.

In 1843, Talbot made a picture, which he called *The Open Door* (Fig. 317), that convinced him that the calotype could not only document the world as we know it, but become a work of art in its own right. When he published this calotype in his book *The Pencil of Nature*, the first book of photographs ever produced, he captioned it as follows: "A painter's eye will often be arrested where ordinary people see nothing remarkable. A casual gleam of sunshine, or a shadow thrown across his path, a time-withered oak, or a moss-covered stone may awaken a train of thoughts and feelings, and picturesque imaginings." For Talbot, at least, painter and photographer saw the world as one.

In 1850, the English sculptor Frederick Archer introduced a new **wet-plate collodion** photographic process that was almost universally adopted within five years. In a darkened room, he poured liquid collodion—made of pyroxyline dissolved in alcohol or ether—over a glass plate bathed in a solution of silver nitrate. The plate had to be prepared, exposed, and developed all within 15 minutes and while still wet. The process was cumbersome, but the exposure time short and the rewards quickly realized. On her forty-ninth birthday, in 1864, Julia Margaret Cameron, the wife of a high-placed British civil servant and friend to many of the most famous people of her day, was given a camera and collodion-

processing equipment by her daughter and son-in-law. "It may amuse you, Mother, to photograph," the accompanying note said.

Cameron, who was friends with Sir John Herschel, the scientist with whom Fox Talbot had most often consulted, turned out to be one of the greatest of all portrait photographers. She set up a studio in a chicken coop at her home on the Isle of Wight, and over the course of the next ten years convinced almost everyone she knew to pose for her. Commenting on her photographs of famous men like Herschel (Fig. 318), she wrote in her *Annals of My Glass House*, "When I have had such men before my camera, my whole soul has endeavored to do its duty towards them in recording faithfully the greatness of the inner man as well as the features of the outer man. The photograph thus taken has been almost the embodiment of a prayer."

More than anything else, it was the ability of the portrait photographer to expose, as it were, the "soul" of the sitter that led the French government to give photography the legal status of art as early as 1862. But from the beginning, photography served a **documentary** function as well. At the outbreak of the American Civil War, Matthew Brady spent the entirety of his, in those days, considerable $100,000 fortune to outfit a band of photographers to document the war. When Brady insisted that he owned the copyright for every photograph made by anyone in his employ, whether or not made on the job, several of his best photographers quit, among them Timothy O'Sullivan (Fig. 319). One of the first great photojournalists, O'Sullivan is reported to have photographed calmly during the most horrendous bombardments, twice having his camera hit by shell fragments.

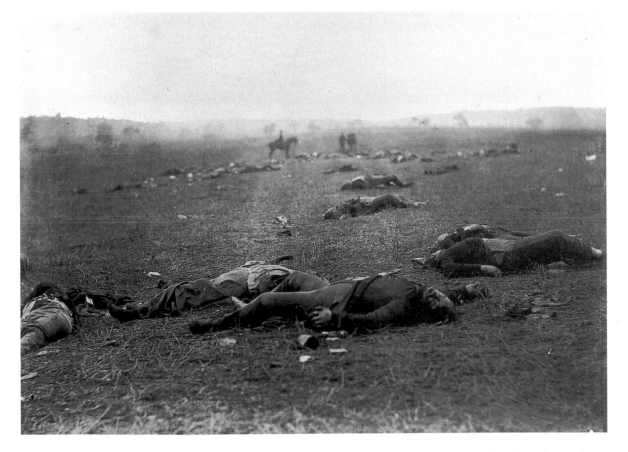

Fig. 319 Timothy O'Sullivan, *Harvest of Death, Gettysburg, Pa.*, 1863. Collodion print. International Museum of Photography at George Eastman House, Rochester, New York.

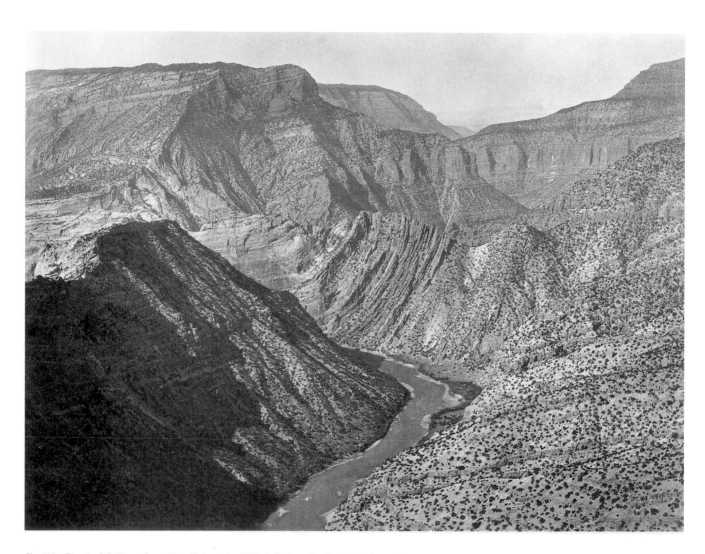

Fig. 320 Timothy O'Sullivan, *Green River (Colorado)*, c. 1868. Collodion print, 8 × 10 in. Library of Congress.

After the war, O'Sullivan packed his photography wagon, laden with glass plates, chemicals, and cameras, and joined Clarence King's Survey of the Fortieth Parallel in order to document a landscape few Americans had ever seen, the rugged, sometimes barren terrain stretching along the Fortieth Parallel between Denver and Virginia City, Nevada (see Figs. 56 & 57). Hired to record the geological variety of the region, O'Sullivan quickly realized that, on the two-dimensional surface of the photograph, the landscape yielded sometimes stunningly beautiful formal plays of line and texture. In his view of the Green River canyon (Fig. 320), brush dots the land-scape in small, isolated flecks that create an almost dimensionless space, especially on the right. A geological upthrust, through which the river has apparently cut its way, sweeps up from the left, ending abruptly at the picture's center, almost reminding us of the broad brushwork of an abstract expressionist canvas.

It could be said, in fact, that every photograph is an abstraction, a simplification of reality that substitutes two-dimensional for three-dimensional space, an instant of perception for the seamless continuity of time, and, in black-and-white work at least, the gray scale for color. If the photographer additionally manipulates the space of the photograph in

order to emphasize formal elements over representational concerns, as O'Sullivan seems to have done in his picture of the Green River canyon, then this abstract side of the medium is further emphasized. One of the greatest sources of photography's hold on the popular imagination lies in this ability to aestheticize the everyday—to reveal as beautiful that which we normally take for granted. When Charles Sheeler was hired by Henry Ford to photograph the new Ford factory at River Rouge in the late 1920s (Fig. 321), this was precisely his task. The photographs which were immediately recognized for their artistic merit and subsequently exhibited around the world, were designed to celebrate industry, to reveal in the smokestacks, conveyors, and iron latticework of the factory a grandeur and proportion not unlike that of the great Gothic cathedrals of Europe.

Even when the intention is not to aestheticize the subject, as is often true in photojournalism, the power of the photograph will come from its ability to focus our attention on that from which we would normally avert our eyes. The impact of Eddie Adams's famous photograph of Brigadier General Nguygen Ngoc Loan summarily executing the suspected leader of a Vietcong commando unit in Saigon, South Vietnam, February 1, 1968 (Fig. 322) lies in its sheer matter-of-factness. The photograph not only records the immediacy of death and the cold, ruthless detachment of its agent, it is unrelenting in its insistence on what might be called the "truth factor" of the photographic image. This *really* happened, and the photograph became, like Abraham Zapruder's film of John F. Kennedy's assassination or the television coverage of Jack Ruby shooting Lee Harvey Oswald, an icon of the political and moral ambiguity of the age.

Both Sheeler's and Adams's photographs depend upon much more sophisticated photographic equipment and film than was available to early practitioners like O'Sullivan. Since the day in 1888 when

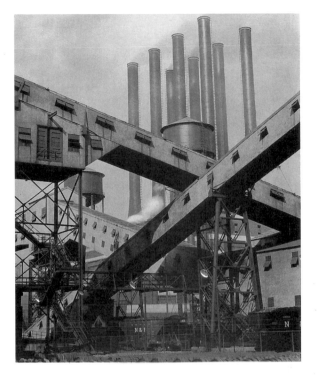

Fig. 321 Charles Sheeler, *Criss-Crossed Conveyors—Ford Plant*, 1927. Gelatin-silver print, 10 × 8 in. The Lane Collection, Courtesy, Museum of Fine Arts, Boston.

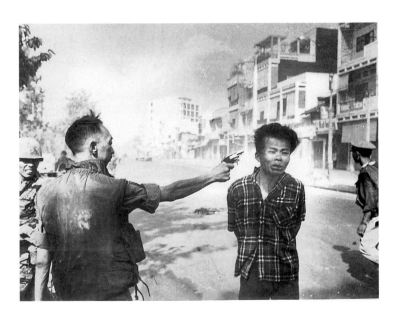

Fig. 322 Eddie Adams, Brigadier General Nguygen Ngoc Loan summarily executing the suspected leader of a Vietcong commando unit, Saigon, South Vietnam, February 1, 1968. Wide World Photos.

Kodak introduced the hand-held camera, the technological advances made by that company alone have been staggering. But technological advances have only made more explicit what has remained, almost from the outset, the medium's primary, and almost inevitable, concern with the tension and distance between form and content—between the photographic object, which exists out of time in aesthetic space, and the real event, the content, which takes place in both historical time and actual space.

Talking about the ways in which he arrives at the photographic image, Henri Cartier-Bresson has described the relation between form and content in the following terms:

> We must place ourselves and our camera in the right relationship with the subject, and it is in fitting the latter into the frame of the viewfinder that the problems of composition begin. This recognition, in real life, of a rhythm of surfaces, lines, and values is for me the essence of photography.... We compose almost at the moment of pressing the shutter.... Sometimes one remains motionless, waiting for something to happen; sometimes the situation is resolved and there is nothing to photograph. If something should happen, you remain alert, wait a bit, then shoot and go off with the sensation of having got something. Later you can amuse yourself by tracing out on the photo the geometrical pattern, or spatial relationships, realizing that, by releasing the shutter at that precise instant, you had instinctively selected an exact geometrical harmony, and that without this the photograph would have been lifeless.

Thus, in looking at this photograph (Fig. 323), we can imagine Cartier-Bresson walking down a street in Athens, Greece, one day in 1953, and coming across the second-story balcony with its references to the classical past. Despite the doorways behind the balcony, the second story appears to be a mere facade. Cartier-Bresson stops, studies the scene, waits, and then spies two women walking up the street in his direction. They pass beneath the two female forms on the balcony above, and, at precisely that instant, he releases the shutter. Cartier-Bresson called this "the decisive moment." Later, in

Fig. 323 Henri Cartier-Bresson, *Athens*, 1953. Magnum Photos.

Fig. 324 Margaret Bourke-White, *At the Time of the Louisville Flood*, 1937. Black-and-white photograph, *Life* Magazine © 1954, Time, Inc.

the studio, the parallels and harmonies between street and balcony, antiquity and the present moment, youth and age, white marble and black dresses, stasis and change, all captured in this photograph, became apparent to him, and he prints the image.

These same conflicts between the ideal and the real animate Margaret Bourke-White's *At the Time of the Louisville Flood* (Fig. 324). Far less subtle than Cartier-Bresson's image, Bourke-White juxtaposes the dream of white America to the reality of black American lives. The dream is a flat, painted surface, the idealized space of the advertising billboard. In front of it, real people wait, indifferent in their hunger.

Fig. 325 Kenneth McGowan, *Steak Billboard*, 1977. Courtesy of Brian Hagiwara, New York.

Black-and-white photography lends itself so well to investigating the relation between opposites not only because it is, by definition, both "real" and "not real," but also because, as a formal tool, it depends so much upon the tension between black and white. In color photography, this formal tension is lost, but complementary color schemes often serve the same ends. Kenneth McGowan's *Steak Billboard* (Fig. 325), like Bourke-White's *At the Time of the Louisville Flood*, depends for its effects upon a picture within a picture. There is, for instance, the enormous contrast in scale between the giant steak sizzling on the billboard and the real world passing by. But it is the stunning contrast between the deep blue sky and the hot yellow, orange, and red fire on the grill that provides the greatest contrast. This color scheme is echoed in details throughout the photograph—by the red pantsuit of the woman waling down the street, by the yellow median strip, and by the car's taillights, all opposed to the blues of the Goodyear sign and even the pavement itself, which appears almost blue-violet.

Harry Callahan's *Morocco* (Fig. 326) is an exotic version of the same basic color scheme, now flattened in a simplified formal composition. As with O'Sullivan's landscapes, the photograph verges on abstraction. Nan Goldin's *Brian with the Flintstones* (Fig. 326), a portrait of Goldin's boyfriend, uses color to different ends. Here the color is flat, the image unfocused, the scene depressingly familiar. From a series of photographs called *The Ballad of Sexual Dependency*, Goldin is self-consciously undermining what she calls "the mythology of romance." Her camera has bumped up against her boyfriend's almost numbing blank stare, in which we see an emptiness outdone only by the vapidity of Fred Flintstone. "A part of me," she says, "is challenged by the opacity of men's emotional makeup." Romance here is claustrophobic, and the romance is as dead as the color.

Fig. 326　Harry Callahan, *Morocco*, 1981. Hallmark Photographic Collection, Kansas City, Missouri.

Fig. 327　Nan Goldin, *Brian with the Flintstones, New York City*, 1981. From *The Ballad of Sexual Dependency* (Aperture Books, 1982). Pace/MacGill Gallery, New York.

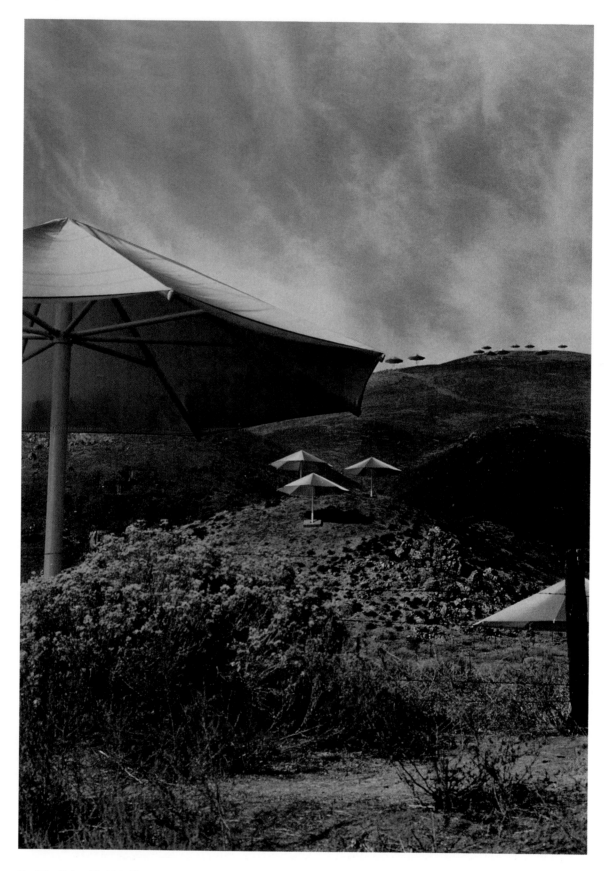

Fig. 328 Christo, *The Umbrellas, Japan–U.S.A.*, 1984–1991. © Christo, 1991. Photography by the author.

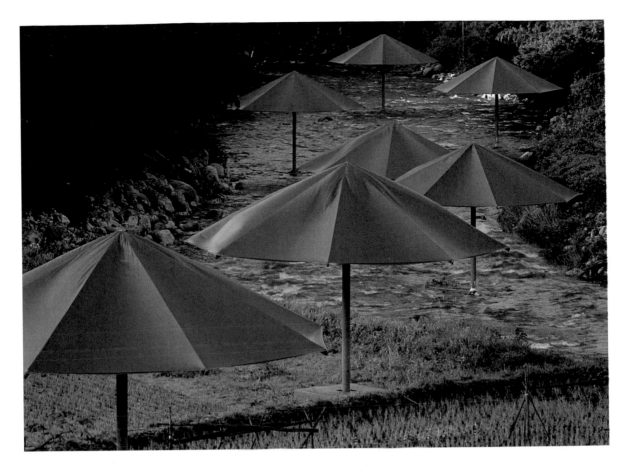

Fig. 329 Christo, *The Umbrellas, Japan–U.S.A.*, 1984–1991. Ibaraki, Japan Site. © Christo, 1991.

Sculpture

Throughout the morning of October 9, 1991, along an 18-mile stretch of Interstate 5 at Tejon Pass, 60 miles north of downtown Los Angeles, 1,760 yellow umbrellas, each 19 feet 8 inches in height, 28 feet 5 inches in diameter, and weighing 448 pounds, slowly opened across the parched gold hills and valleys of the Tehachapi Mountains (Fig. 328). Sixteen hours earlier—but that same morning, given the time change—1,340 blue umbrellas opened in the prefecture of Ibaraki, Japan, 75 miles north of Tokyo, 90 of them in the valley's river (Fig. 329). Built at a cost of $26 million, raised by the artist Christo entirely through the sale of his work, the umbrellas were engineered to withstand gale-force winds of up to 65 miles per hour. They were originally to remain in place until the end of

the month, but on October 27, in California, unseasonably violent winds ripped one umbrella from its mooring and propelled it across a road where it crushed a woman visitor to death and injured two other bystanders. In shock, Christo immediately ordered the umbrellas closed in both countries. Four days later, in Japan, a worker removing a closed umbrella was killed by electrical shock when current from a 65,000-volt high-tension wire was drawn down to the boom of the crane he was operating six feet below the wire.

As tragic as these two incidents were, they underscore one of the fundamental characteristics of sculpture, one of the things that differentiates it most from other media: Sculpture exists in real space. Its effects are real effects, from the shadows it casts to, more

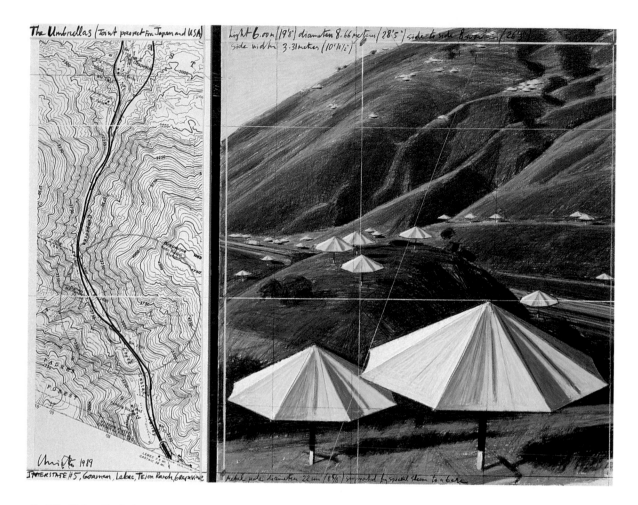

Fig. 330 Christo, *The Umbrellas, Joint Project for Japan and USA*, 1989. Pencil, fabric, pastel, charcoal, enamel paint, crayon and map, in two parts, 30 1/2 × 12 in. and 30 1/2 × 26 1/4 in. © Christo 1989. Photo: Wolfgang Volz.

horrifically in the instance of Christo's *Umbrellas*, the reality of its physical presence in our midst. Sculpture is not something we just see. It is something we experience with our whole being. This is what Christo meant when he said that one of the principle aims of *The Umbrellas* was "to reflect the similarities and differences between the two countries, in the ways people move around in space and utilize it." The umbrellas somehow help us to define the actual space in which we, Americans and Japanese, live our daily lives.

In the difference between Christo's drawing for *The Umbrellas* project (Fig. 330) and the experience of it in actual space (Fig. 331), we can understand something of the difference between the experience of two- and three-dimensional forms. The drawing

(Fig. 330) represents space, but it is really flat. Christo made the drawing two years before the event, and its purpose was to allow us to imagine what the final work might look like. The photograph (Fig. 331), on the other hand, documents what it was like to experience one of the actual umbrellas on Thursday afternoon, October 17, 1991, when this photograph was taken. If we allow ourselves to forget, for just an instant, that this photograph is no less an image than the drawing, if we allow ourselves to imagine that our eye is focused behind the camera lens, by the side of the road just outside the small town of Gorman on this Thursday afternoon, then we will realize that when we experience sculpture we confront something more complex than just the visible. In one of the surprising-

ly few books to try to understand the aesthetics of sculpture—most theory is more interested in painting—Herbert Read's *The Art of Sculpture* describes the medium as "an art of *palpation*—an art that gives satisfaction in the touching and handling of objects."

Earlier, in the section on texture, we discussed this urge to touch the sculptural object. But, again, the art of sculpture involves more than just adding the tactile to the visible. The urge to touch is part and parcel of a larger necessity. Sculpture requires the viewer to move around and through it, to experience its space as real space. In this sense, as we have also said earlier, sculpture is a *kinetic* medium, though the object itself does not necessarily move; rather, the viewer must move. As the viewer moves, the sculpture reveals itself, and the viewer's experience of it changes.

As the photographs of *The Umbrellas* begin to demonstrate, each view of the same object—a 19 foot 8 inch yellow umbrella repeated 1,760 times over 18 miles in the U.S.A. and 1,340 times over 12 miles in Japan—appears different, varying with each change of point of view, with each change of light and weather. Its aspects—yellow or blue, seen from near or far, above or below, surrounded by many others or isolated on a ridge—are virtually infinite in number.

Anyone who visited the Tejon Pass site will remember, as one of its most striking features, the vast numbers of visitors—2.5 million in the U.S.—passing through it, in private cars and on tour buses, young and old alike, everyone congenial and courteous, as if out of respect for the event. They will remember, as well, the entrepreneurs, who, in a typically American gesture, were everywhere hawking souvenirs—posters, T-shirts, and commemorative coffee mugs—none of them authorized by Christo, but tolerated by him because they seemed to define the American experience of his work. No single photograph of *The Umbrellas* can capture the many different experiences of it. Add to this the fact that to

Fig. 331 Christo, *The Umbrellas, Japan–U.S.A.*, 1984–1991. © Christo, 1991. Photography by the author.

have experienced the work in California was to experience only half of it, literally like knowing only half the world. There remained the 1,340 blue umbrellas in Japan, identical but for their color to the yellow ones in California, and yet completely different in the context of the fertile, green Japanese valley, with its small villages, farms, gardens, and fields. Not only was the sense of the work's scale different in the Japanese context—in the precious and limited space of Japan, the umbrellas were placed close together—but also the shift in scale seemed to embody crucial differences between the two cultures.

Christo's *The Umbrellas* is a particularly useful example of the experiential dimension

Figs. 332 & 333 David Smith, *Blackburn: Song of an Irish Blacksmith*, profile view left, frontal view above, 1949–1950. Steel and bronze, 46 1/4 × 49 3/4 × 24 in. Wilhelm Lehmbruck Museum, Duisburg, Germany.

of sculpture because it is so large, its aspects so many. Yet even a single work on a pedestal can offer much of the same richness. Looked at from different points of view, David Smith's *Blackburn: Song of an Irish Blacksmith* (Figs. 332 & 333) appears to be two entirely different works of art. The frontal view is airy and open, the work seeming to float in space like a series of notes and chords, while the profile view reveals the sculpture as densely compacted, a confusing jumble of forms from which two seem to want to escape, one at the top left, the other on the extreme right. The frontal view is almost symmetrical, the profile view radically asymmetrical. Similarly, the piece is at once nonobjective, a fanciful construction of linear steel and bronze, and representational, the torso and head of a singing blacksmith. If Smith's piece is figurative—a sort of "portrait" of Blackburn—then evidently what Smith most wants us to understand about the blacksmith is his unpredictability, our own inability to pin him down.

Carving

Carving is a **subtractive** process in which the material being carved is subtracted or removed from an inert, raw block of material, thereby transforming it into a fully realized form. "The best artist," Michelangelo wrote, "has no concept which some single marble does not enclose within its mass.... Taking away...brings out a living figure in alpine and hard stone, which...grows the more as the stone is chipped away." But carving is so difficult that even Michelangelo often failed to realize his concept. In his *"Atlas" Slave* (Fig. 334), he has given up. The block of stone resists Michelangelo's desire to transform it, as if refusing to release the figure it holds enslaved within. Atlas, condemned to bearing the weight of the world on his shoulders forever as punishment for challenging the Greek gods, is literally captured in the stone.

Fig. 334 Michelangelo, *"Atlas" Slave*, c. 1513–1520. Marble, 9 ft. 2 in. Accademia, Florence.

Fig. 335 Patrocinio Barela, *Nativity*, c. 1966. Juniper wood, height of tallest figure 33 in. Private collection.

Nativity (Fig. 335), by the Taos, New Mexico–born Hispanic sculptor Patrocinio Barela, is carved out of the aromatic juniper tree that grows across the arid landscape of the Southwest. Barela's forms are clearly dependent upon the original shape of the juniper itself. The lines of his figures verging on abstraction even as they remain recognizable, follow the natural contours of the wood and its grain. The group of animals at the far left, for instance, are supported by a natural fork in the branch that is incorporated into the sculpture. The human figures in Barela's work are closely related to *santos*, images of the saints. Those who carve *santos* are known as *santeros*. Both have been an important part of Southwestern Hispanic culture since the seventeenth century, serving to give concrete identity to the abstractions of Catholic religious doctrine. By choosing to work in local wood, Barela literally ties the local world of the everyday to the universal realm of religion, uniting material reality and the spiritual.

This desire to unify the material and the spiritual worlds has been a goal of sculpture from the earliest times. In Egypt, for example, larger-than-lifesize stone funerary figures (Fig. 336) were carved to bear the *Ka*, or individual spirit, of the deceased into the eternity of the afterlife. The very permanence of the stone was felt to guarantee the *Ka's* immortality. For the ancient Greeks, only the gods were immortal. What tied the world of the gods to the world of humanity was beauty itself, and the most beautiful thing of all was not the female body but the perfectly propor-

tioned, usually athletic male form. Egyptian sculpture was known to the Greeks as early as the seventh century B.C., and Greek sculpture is indebted to it, but the Greeks quickly evolved a much more *naturalistic* style.

Compared with the rigidity of the Egyptian figures, this *Kouros*, or youth (Fig. 337), is both more at ease and more lifelike. Despite the fact that his feet have been lost, we can see that the weight of his body is on his left leg, allowing his right leg to relax completely. This is one of the earliest known examples of the principle of **ponderation**, or weight shift. The sense of movement created by the shifting of weight around the axis of the spine would lead, eventually, to the rise of **contrapposto**, from the Latin word for "counter-positioning." (Compare, for instance, the posture of the Praxiteles *Aphrodite* (Fig. 89), in which the hips and legs of the figure are turned in opposition to the shoulders and chest in fully developed contrapposto.) This youth, then, begins to move, and, furthermore, he is much more anatomically correct than his Egyptian forbearer. In fact, by the fifth century B.C., the practice of medicine had established itself as a respected field of study in Greece, and anatomical investigations were commonplace. A century before, Alcmaeon of Croton, in Greece, had discovered the difference between veins and arteries, as well as the connection between the brain and sensing organs. Hippocrates, the "Father of Medicine," was born in 460 B.C. At the time that the *Kouros* was sculpted, the body was an object of empirical study, and its parts were understood to be unified in a single, flowing harmony.

The Kouros is an example of **freestanding** sculpture, or sculpture **in-the-round**. It invites us to walk around it, to see it from all sides. The Greeks also perfected the sculptural art of **relief**, which is intended to be seen head on, as a means to decorate and embellish the beauty of their great architectural achievements. Forms and figures carved in relief are

Fig. 336 *Mycerinus and His Queen, Kha-Merer-Nebty II, Giza*, c. 2599–2571 B.C. Slate schist, height 54 1/2 in. Museum of Fine Arts, Boston.

Fig. 337 *Kouros* (also known as the *Kritian Boy*), c. 480 B.C. Marble fragment, height 36 in. Acropolis Museum, Athens.

Fig. 338 *Maidens and Stewards*, fragment of the *Panathenaic Procession*, from the east frieze of the Parthenon, Acropolis, Athens, c. 440 B.C. Marble, height approx. 43 in. Musée du Louvre, Paris.

Fig. 339 *Atlas Bringing Herakles the Golden Apples*, the Temple of Zeus, Olympia, c. 470–456 B.C. Marble, height 63 in. Archaeological Museum, Olympia.

spoken of as done in either **low (bas-)** relief or **high (haut-)** relief. The *Maidens and Stewards*, for example, a fragment in low relief from the frieze, or sculptural band, on the Parthenon (Fig. 338) project only a little distance from the background, and no sculptural element is detached entirely from it. By contrast, *Atlas Bringing Herakles the Golden Apples* (Fig. 339), from the Temple of Zeus at Olympia, is an example of high relief. Here the figures project from the background at least half their circumference. Some elements, like the left arm of Herakles, may even float free.

Of the two, the relief from the Temple of Zeus is the more simple and direct in carving style. It depicts the moment in the story of Herakles when the giant Atlas returns from the Hesperides with the Golden Apples of immortality. In Atlas's absence, Herakles had assumed the giant's normal task of holding up the heavens on his back, assisted by a pillow that rests upon his shoulders. In the relief, his protectress, Athena, the goddess of wisdom, helps Herakles to support the weight of the sky so that he can exchange places with Atlas. The frontality of Athena's body is countered by the pure profile of her face, a profile repeated in the positioning of both Herakles and Atlas. The composition of this relief is in fact dominated by right angles, and as a result, it is stiff and rigid, as if the urge to naturalism, realized, for instance, in the figure of Herakles is as burdened by tradition as Herakles is himself weighed down.

The naturalism of the Parthenon frieze is much more fully developed. Figures overlap one another and are shown in three-quarter view, making the space seem far more natural and even deeper than that at Olympia, though it is, in fact, much shallower. The figures themselves seem almost to move in slow procession, and the garments they wear reveal real flesh and limbs beneath them. The carving of this drapery invites a play of light and shadow that further activates the surface, increasing the sense of movement.

Fig. 340 Carved boxwood brush holder, depicting the Gathering of Aesthetes in the Western Garden, Ch'ing Dynasty. Collection of the National Palace Museum, Taipei, Taiwan, R.O.C.

A Chinese Bamboo Brush Holder

Some of the most beautiful of all relief sculpture has been executed by the Chinese. This tiny bamboo brush holder, only 6 inches high, depicts a famous literary gathering that took place during the Western Jin dynasty, A.D. 265–317, between the poet Ji Kang and a group of friends who became known as the Seven Sages of the Bamboo Grove. The Seven Sages are portrayed around the circumference of the cup. Those on the right gaze up into the pine-covered rocks and mountains, while those on the left discuss some point of philosophy. Beneath them, a stream passes under a small bridge, and they themselves sit before an entire bamboo grove minutely carved into this single piece of bamboo. At such aesthetic gatherings, the group would begin by enjoying wines, and then, their inhibitions put to rest by the spirited drink, they would turn to philosophical discussion, poetry reading, and the art of painting. The cup itself was designed to bring the pleasure and spirit of the historic occasion to its user hundreds of years later.

Source: Chi Jo-hsi, "Scenes of Celebrated Literary Gatherings," *Pearls of the Middle Kingdom* (Taipei, Taiwan, ROC: National Palace Museum, 1989).

Fig. 341 *Three Goddesses*, from the east pediment of the Parthenon, Acropolis, Athens, c. 438–432 B.C. Marble, over lifesize. British Museum, London.

Nowhere has the sculptural potential of drapery been more fully realized than in the grouping *Three Goddesses* (Fig. 341) on the east pediment, or triangular roof gable, of the Parthenon. Though actually free-standing when seen from the ground, with the wall of the pediment behind them, Aphrodite, the goddess of beauty, her mother Dione, and Hestia, the goddess of the hearth, would have looked as if they had been carved in high relief. As daylight shifted across the surface of their bodies, it is easy to imagine the goddesses seeming to move beneath the swirling, clinging, almost transparent folds of cloth, as if brought to life by light itself.

Casting

When the sculptor Henry Moore visited Greece in 1951, he was immediately enthralled by the use of drapery in classical sculpture. "Drapery can emphasize the tension in a figure," he wrote, "For where the form pushes outwards such as on the shoulders, the thighs, the breasts, etc., it can be pulled tight across the form (almost like a bandage)." These out-

A Carved Inuit Mask

In Inuit culture, the art object is believed to be endowed with an ability to mediate between the three realms of existence—the supernatural world, the everyday world of human social life, and the natural world of plants, animals, and inorganic things. The origin of the work of art is, after all, in the natural world, in an ivory tusk or a piece of wood. This raw material is transformed, by the hands of the artist, into an object that circulates in the world of humans. Art also bridges the gap between the human world and the transcendent realm of the supernatural and eternal. For example, the famous cat's cradle string designs, elaborately executed between the fingers of the Inuit's two hands and accompanied by song, are believed to entangle the sun and prevent its disappearance in the autumn months as darkness descends on the Arctic.

The art object's role in mediating between the three realms of existence is made clear by an Inuit creation myth. One day, the spirit figure Raven saw Man emerging from a pea pod (Raven's relation to Man is parallel to Man's relation to plants). Reacting to this sight, Raven pushed his beak to the top of his head (removing it in the same way a human would a mask), and, to his astonishment, found himself to look just like Man. Raven made a clay figure in Man's image, attached a bunch of water grass to the back of the figure's head, and waved his wings over it. The clay figure was transformed into a beautiful young woman.

The implications of this tale are interesting. First, Raven appears to be like Man after he *removes* his beak, an idea that is made literal in the mask reproduced here. In what amounts to a reversal of the process, when an Inuit shaman dons a mask, he *becomes* the spirit he represents. The mask mediates

Fig. 342 Inuit Mask, collected c. 1880. Wood, with white and red pigment, seal-gut lashing, and, originally, feather plumes at the top, height 15 in. Phoebe Hearst Museum of Anthropology, The University of California at Berkeley.

between the supernatural world and the world of man. Furthermore, Raven transformed raw material—clay—into a Woman, just as Man himself emerged from the plant world. Both Man and Woman were created out of the natural world.

Source: Richard L. Anderson, *Art in Small-Scale Societies* (Englewood Cliffs, N.J.: Prentice Hall, 1989).

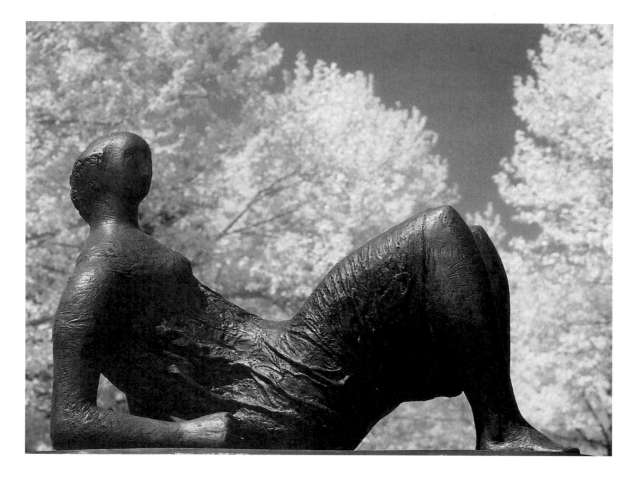

Fig. 343 Henry Moore, *Draped Reclining Figure*, 1952–1953. Bronze, 40 7/8 × 66 5/8 × 34 1/8 in. Hirshhorn Museum and Sculpture Garden, Smithsonian Institution; Gift of Joseph H. Hirshhorn, 1966.

ward pressure points were emphasized by what he called "the crumpled slackness of the drapery" lying between them. Inspired by what he saw in Greece, Moore made several draped figures (Figs. 343 & 344). "Although static," he said of *Draped Reclining Figure*, "this figure is not meant to be in slack repose, but, as it were, alerted." Of *Draped Torso*, which he made to stand on his own lawn, he would say: "What pleased and surprised me about it was how Greek it looks."

Moore's works are cast in bronze. **Casting** is an invention of the Bronze Age, where it was first utilized to make various utensils by simply pouring liquid bronze into open-faced molds. Small figures made of bronze can be produced by making a simple mold of the original, filling it with bronze, and then breaking the mold away. The early

Greek *Girl Running* (Fig. 345) is a small, solid cast-bronze figure almost certainly made by this most straightforward of bronze casting methods. More complicated and sophisticated methods had to be developed for larger pieces. One of the most enduring of these is the **lost-wax** method, also known as **cire-perdue**, which was perfected by the Greeks if not actually invented by them. In the lost-wax method, the sculpture is first **modeled**—or shaped by **hand**—in some soft pliable material such as clay, wax, or plaster in a putty state. As opposed to carving, which is a substractive process, modeling is an **additive** technique. The form is built up, shaped, and enlarged, until it reaches its final state. This model looks just like the finished sculpture, but, of course, the material of which it is composed is nowhere near as durable as bronze.

A mold is then made of the model (today, synthetic rubber is most commonly used to make this mold), and when it is removed, we are left with a *negative* impression of the original. This impression's relation to the original is comparable to a Jello mold's relation to the finished Jello salad. Molten wax is then poured or brushed into this impression to the same thickness desired for the final sculpture—about an eighth of an inch. The space inside this wax lining is filled with an **investment**—a mixture of water, plaster, and powder made from ground-up pottery. The mold is then removed, and we are left with a wax casting, identical to the original model, that is filled with the investment material. Rods of wax are then applied to the wax—they stick out from it like giant hairs. They will carry off melted wax during baking and will eventually provide channels through which air can escape when the molten bronze is poured. Bronze pins are driven through the wax into the investment.

The wax cast, with wax rods sticking out and pins penetrating into the core, is then covered with an outer mold, usually of the same material as the investment. When this mold cures, it is then baked in a kiln with the wax replica inside it at a temperature of 1500° F. The wax rods melt, providing channels for the rest of the wax to run out as well—hence the term *lost-wax*. What remains is the core, separated from the outer mold by the bronze pins. Molten bronze is poured into a *casting gate*, a large opening in the top of the mold, and fills the cavity that once was filled with wax. When the bronze has cooled, the mold and the investment are removed and we are left with a bronze replica of the wax form complete with rods. The rods are cut from the bronze cast and the surface smoothed and finished.

Large pieces such as Moore's *Draped Reclining Figure* must be cast in several pieces and then welded together. Bronze is so soft and malleable that the individual pieces can

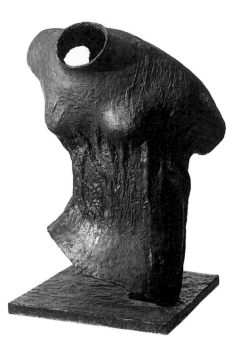

Fig. 344 Henry Moore, *Draped Torso*, 1953. Bronze, height 35 in. Ferens Art Gallery, Hull, England.

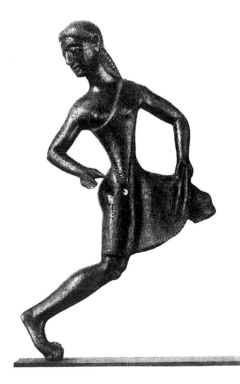

Fig. 345 *Girl Running*, Greece, probably Sparta, c. 500 B.C. Height 4 1/2 in. British Museum, London.

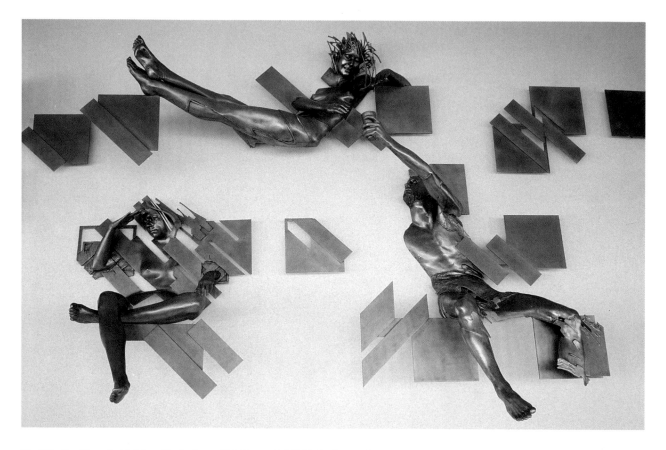

Fig. 346 Tom Morandi, detail from *The Audience*, 1991. Bronze, 2 of 10 lifesize figures. Fine and Performing Arts Building, Eastern Oregon State College, La Grande, Oregon.

easily be pounded back together with a hammer, the procedure used in Greek times, or else welded, the more usual procedure today, and the shell is finally reassembled to form a perfect hollow replica of the original. In fact, when Moore saw the torso part of his *Draped Reclining Figure*, cast separately from the rest, he was struck by what he called "its completeness and impressiveness just as a thing in its own right." Thus, after the *Draped Reclining Figure* was completed, he had a wax version of the figure's torso made, and he reworked it, alternately modeling and carving it until it looked appropriately poised in an upright position. *Draped Torso* is the result.

It is possible that the making of armor might have suggested to the Greeks that the living human body could be used to create

molds for the cast bronze sculptures such as the magnificent Zeus described in Section 2's discussion of line (Fig. 88). In his huge bronze relief *The Audience* (Fig. 346), contemporary sculptor Tom Morandi has, in fact, cast his figures from real people by wrapping small sections of their bodies in cheese cloth that has been impregnated with plaster. Small "hinges" were left in the material so that after drying it could be easily opened and removed. These plaster casts were then used as molds in a lost-wax casting process.

The Audience is composed of ten figures in all, stretched above the main lobby doors of a theater. They variously stare down upon the arriving theatergoers or ignore them, as the couple illustrated here seems to. The piece is a compendium of styles and refer-

ences, ranging from the Greek pediment to the Pop icon, from realism to idealism (the outstretched arms of these two figures parody the Creation scene in Michelangelo's Sistine Chapel), from the minimalist geometric pattern of the backdrop to the expressive gesture and abstraction of areas such as the bottom figure's left calf and foot.

Assemblage

Many of the same concerns that we saw in Michelangelo's *"Atlas" Slave* (Fig. 334) are at work in David Hammons's *Spade with Chains* (Fig. 347). By means of **assemblage**, another additive sculptural process, Hammons has combined "found" materials—a common spade and a set of chains—into a face that recalls an African mask. The piece actually represents a wealth of transformations, and just as Michelangelo could see in the raw block of stone the figure within it, Hammons can see, in the most common materials of everyday life, the figures of his world. This transformation of common materials into art is one of the most defining characteristics of assemblage. As a process, assemblage evokes the myth of the phoenix, the bird that, consumed by fire, is reborn out of its own ashes. That rebirth, or rejuvenation, is also expressed at a cultural level, as Hammons rediscovers in the transformation of the destructive materials of slave labor—the spade and the chain—into a mask, an affirmation of the American slave's African heritage. The richness of this transformation is embodied in the double-entendre of the word "spade"—at once a racist epitaph and the appropriate name of the object in question. But before this image, it is no longer possible, in the words of a common cliché, to "call a spade a spade." The piece literally liberates us from that simple and reductive possibility.

To the degree that they are composed of separately cast pieces later welded together, works like Moore's *Draped Reclining Figure* and Morandi's *The Audience* are themselves

Fig. 347 David Hammons, *Spade with Chains*, 1973. Spade, chains, 24 × 10 × 5 in. Courtesy Jack Tilton Gallery, New York. Photo: Dawoud Bey

Fig. 348 Clyde Connell, *Swamp Ritual*, 1978. Mixed media, 81 × 24 × 22 in. Collection Tyler Museum of Art, Tyler, Texas.

assemblages. Morandi reveals the seams of his assemblage—the way it has been put together—much more than Moore, and insofar as he does, the piece is both less naturalistic and, quite intentionally, less unified. Clyde Connell's sculpture (Fig. 348) is fabricated of parts from rusted-out tractors and machines, discarded building materials and logs, and papier-mâché made from the classified sections of the *Shreveport Journal and Times*. The use of papier-mâché developed out of Connell's desire to find a material capable of binding the wooden and iron elements of her work. By soaking the newsprint in hot water until its ink began to turn it a uniform gray, and then mixing it with Elmer's Glue, she was able to create a claylike material possessing, when dry, the texture of wasps' nests or rough gray stone.

Connell developed her method of working very slowly, over the course of about a decade, beginning in 1959 when, at age 58, she moved to a small cabin on Lake Bistineau, 17 miles southeast of Shreveport. She was totally isolated. "Nobody is going to look at these sculptures," she thought. "Nobody was coming here. It was just for me because I wanted to do it.... I said to myself, 'I'm just going to start to make sculpture because I think it would be great if there were sculptures here under the trees.'"

In the late 1960s, now in her late sixties, Connell discovered the work of another assembler of nontraditional materials, the much younger artist Eva Hesse, who died at age 34 in 1970. Hesse's work is marked by its use of the most outlandish materials—rope, latex, rubberized cheesecloth, fiberglass, and cheap synthetic fabrics—which she used in strangely appealing, even elegant assemblages. While Connell's work rests firmly on the ground, Hesse's work often *hangs*, falling from the ceiling, or drooping from its support, sometimes just a nail pounded into the wall. But Connell particularly admired Hesse's

desire to make art in the face of all odds. Before the Women's Movement of the early 1970s, Hesse was feminist. "A woman is sidetracked by all her feminine roles," Hesse wrote in 1965. "She's at a disadvantage from the beginning.... She also lacks the conviction that she has the 'right' to achievement.... [But] we want to achieve something meaningful and to feel our involvements make of us valuable thinking persons." Made in 1969, during a period when she was extremely ill from a brain tumor, a work like *Contingent* (Fig. 349) embodies Hesse's fortitude. For the catalogue that accompanied its first exhibition in the fall of 1969, Hesse described these floating forms as if they embodied her own mental toughness at the same time that they admitted a sense of vulnerability and depth of feeling resulting from her confrontation with her own mortality: "They are tight and formal," she wrote, "but very ethereal, sensitive, fragile."

Connell sensed in Hesse's work an almost obstinate insistence on *being*: "No matter what it was," she said about Hesse's work, "it looked like it had life in it." Connell wanted to capture this sense of life in her own sculpture—what she calls Hesse's "deep quality." In *Swamp Ritual*, the middle of Connell's figure is hollowed out, creating a cavity filled with stones. Rather than thinking of this space in sexual terms—as a womb, for instance—it is, in Connell's words, a "ritual space" in which she might deposit small objects from nature. "I began to think about putting things in there, of having a gathering place not for mementos but for things you wanted to save. The ritual place is an inner sanctuary.... Everybody has this interior space." Encouraged by Hesse's heroic desire to make art, Connell had her first two solo exhibitions, in 1973, at age 72, at the Shreveport and Alexandria campuses of Louisiana State University. Her reputation has grown ever since, first regionally and

Fig. 349 Eva Hesse, *Contingent*, 1969. Reinforced fiberglass and latex over cheesecloth, height each of 8 units, 114–118 in; width each of 8 units, 36–48 in. Collection of the National Gallery of Australia, Canberra. © The Estate of Eva Hesse. Courtesy Robert Miller Gallery, New York.

Fig. 350 Anthony Caro, *Early One Morning*, 1962. Painted metal, 114 × 244 × 132 in. Tate Gallery, London.

then nationally and internationally. Now in her nineties, she continues to make art.

While both Hesse's and Connell's pieces are assembled from many parts, they seem unified and coherent wholes. Anthony Caro's *Early One Morning* (Fig. 350), made of sheet metal, I-beams, pipe, and bolts, lacks this sense of unity. Indeed, it seems to insist on the fact that it is a *construction*—man-made, even artificial. Through the materials of which it is made, the materials of contemporary industrial construction, it boldly declares itself separate from the natural world, rather like the geometric white house, discussed earlier, that Richard Meier set into a wooded hillside of Michigan (Fig. 230). Like David Smith's *Blackburn: Song of the Irish Blacksmith* (Figs. 332 & 333), the sculpture changes dramatically

depending upon the side from which it is seen. Seen directly on—that is, slightly to the right of the view here—both the large vertical sheet at the back and the two central I-beams below it visually combine into an almost solid backdrop, and all of the other elements seem to project off the "flat" rear surface in *relief*. Seen from the side, however—and the reader must imagine this—the work appears as a series of separate architectural units dispersed along a low horizontal beam over 20 feet long. Like Smith's *Blackburn*, from one side it is airy, almost light, and from the other, it is densely packed, almost two-dimensional. Not only is the work itself an assemblage of disparate elements, but our visual experience of it is itself an assemblage, a construction of multiple points of view.

The Imunu of New Guinea

The supernatural element that dominates the lives of the numerous tribes that inhabit New Guinea's southern coast along the Papuan Gulf is called *imunu*. Defined as "vital strength" or "life principal," it lends everything its unique identity. The more individual a thing is, the more unlike anything else—the more strangely twisted a stick is, for instance—the more it possesses *imunu*. All ritual objects are in contact with *imunu*, which accounts for their sanctity and power. Furthermore, the older a figure is, the more its *imunu* increases.

The *imunu* is an example of a "found object"—that is, it is discovered in nature by an artist who recognizes that it looks like an animal or a human figure, sometimes both, as in the case of the *imunu* illustrated here (Fig. 351), bent forward on one or two arms in an animal-like posture. The resemblance to human form is emphasized by the addition of some carving or painting—facial features are almost always added, for instance—but never so much that the object's obviously "found" characteristics, the sense of the object's spontaneous discovery or appearance in nature are hidden.

The various tribal cultures that produced such *imunu* were originally headhunters, and many practiced cannibalism. For that reason, the *imunu* have, in the West, been associated with extreme violence, even with social pathology. As recently as 1984, in the catalogue to an exhibition at the Museum of Modern Art, "Primitivism in 20th Century Art," William Rubin, the exhibit's director, called the *imunu* illustrated above a "monster" that was "divined" by the artist "while it still lurked in

Fig. 351 *Imunu* figure, Namau. Gulf Province, Papua New Guinea. Wood, height 21 in. Friede Collection, New York.

the raw material of nature." It should be pointed out that many Papuan stools and headrests are not only similarly "found" forms but are similarly decorated. These peoples did not routinely sleep or sit on "monsters." The *imunu* was sacred, endowed with magic, and not evil.

Source: Douglas Newton, *Art Styles of the Papuan Gulf* (New York: Museum of Primitive Art, 1961).

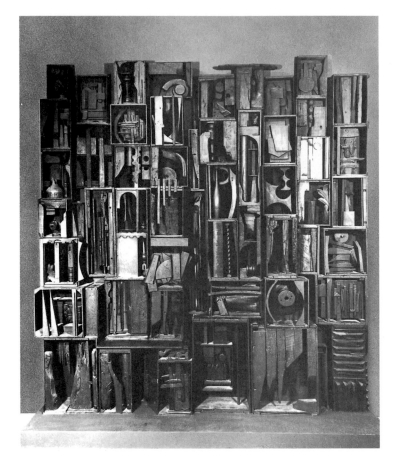

Fig. 352　Louise Nevelson, *Sky Cathedral*, 1958. Assemblage: wood construction painted black, 11 ft. 3 ½ in. × 10 ft. ¼ in. × 18 in. Collection, The Museum of Modern Art, New York. Gift of Mr. and Mrs. Ben Mildwoff.

Color is one of the major elements that serves to unify Caro's *Early One Morning*—it's uniformly painted bright red. The uniform black paint of Louise Nevelson's *Sky Cathedral* (Fig. 352) functions in much the same way. The piece itself is a giant melange of wooden boxes, woodworking remnants and scraps, and found objects, such as the bowling pin in the middle of the piece. It functions like a giant altar—hence its name—transforming and elevating its materials to an almost spiritual dimension. The real accomplishment here—and it is substantial—is that Nevelson has been able to make a piece of almost endless variety appear unified and coherent. This is accomplished, on the one hand, by the grid structure formed by the boxes, a structure that underscores the rational and organizing logic of the composition. Furthermore, there is a certain repetition of forms, curves, and lines throughout the work, in both the positive space and the negative space of the shadows. The black paint, though, is an even more powerful organizing tool. "It means totality," Nevelson has explained. "It means: contains all.... Because black encompasses all colors. Black is the most aristocratic color of all. The only aristocratic color. For me this is the ultimate. You can be quiet and it contains the whole thing.... I have seen things that were transformed into black, that took on just greatness. I don't want to use a lesser word." This transformation into uniform "greatness" is precisely Nevelson's goal in *Sky Cathedral*.

The unity of Nevelson's work is especially apparent if we compare it with a piece like Judy Pfaff's *Rock/Paper/Scissors* (Fig. 353). This assemblage has not only escaped the grid, it has escaped the wall, spilling out onto the gallery floor. It quite clearly insists on its disunity. What it *transforms*, as a matter of fact, is the unified architectural space of the gallery itself, turning it into a chaotic clutter of line, form, and color. The architecture of the room

Fig. 353 Judy Pfaff, *Rock/Paper/Scissor*, 1982. Mixed media installation at the Albright Knox Art Gallery, September 1982. Albright Knox Art Gallery, Buffalo, New York.

Collage, Environments, Performance

virtually disintegrates before our eyes. Both Nevelson's and Pfaff's pieces are equally afocal—that is, no part or area is any more or less important than any other—but the energies of Pfaff's piece seem to explode around us centrifugally whereas Nevelson's are concentrated before us centripetally. Nevelson has called herself "The Architect of Shadow". "Shadow is fleeting," she says, "and I arrest it and I give it architecture as solid as anything can be." In Pfaff's work, the shadow of architecture can barely be recognized. Her assemblage disassembles the architecture in which it is located.

The process of pasting or gluing fragments of printed matter, fabric, natural material—anything that is relatively flat—onto the two-dimensional surface of a canvas or panel is called **collage**. The process creates, in essence, a very low relief assemblage.

The motives for doing collage are many, but there are two particularly important ones. From a painter's point of view, collage violates the integrity of the medium—that is, it introduces into the space of painting materials from the everyday world. The world of art collides with real life. In his collage work,

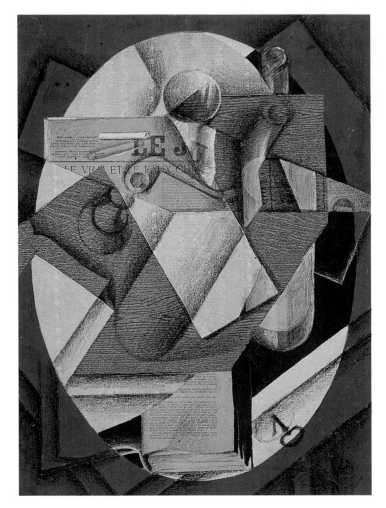

Fig. 354 Juan Gris, *Still Life* (*The Table*), 1913. Oil on canvas, 23 1/2 × 17 1/2 in. Philadelphia Museum of Art: A. E. Gallatin Collection.

the painter Juan Gris purposely confuses the realm of painting with the realm of real life. *The Table* (Fig. 354) is an example. The lack of realism underscores the artificiality of the composition. Within this composition, however, are *real* things—a page from a novel, a fragment of the French newspaper *Le Journal*, imitation wood-grain wallpaper. Taken together, these elements undermine our easy understanding of just what is "real" here. Imitation wood-grain wallpaper is real wallpaper, but artificial wood. A novel might be fiction, but the page really exists. The headline in the paper reads "Le Vrai et le Faux," French for "the true and the false." Which realm is more true, which more false, the world of art or the world of everyday experience, the world of the imagination or the world of "fact"? There is no clear answer.

This confusion of realms is heightened by the second factor that most motivates an artist's choice of the collage medium. Collage is an inclusive—not exclusive—medium. It admits anything and everything into its world. In this sense, it shares much with photography. As one of the great collage artists of the twentieth century, Robert Rauschenberg, has put it: "The world is essentially a storehouse of visual information. Creation is the process of assemblage. The photograph is a process of instant assemblage, instant collage." Walker Evans's photograph *Roadside Store Between Tuscaloosa and Greensboro, Alabama* (Fig. 355) is an example of just such "instant collage." Evans's mission as a photographer was to capture every aspect of American visual reality, and his work has been called a "photographic equivalent to the Sears, Roebuck catalog of the day."

Unifying the jack-of-all-trades world that he depicts—the roadside store at once a fish market, a fruit stand, and a place where we can find a house mover—is the symmetrical grid structure of the composition. Rauschenberg's own collage, *Rebus* (Fig. 356), uses essentially the same formal structure.

Across the canvas he disposes various printed images, including a reproduction of Sandro Botticelli's *Birth of Venus* next to a page from the Sunday funnies (a juxtaposition that could be taken to embody the collision of art and life). As the title suggests, we are invited to "read" the sequence, solve its puzzle. We have a starting place, the phrase "That Repre (sents?)," at the upper left. There does seem to be a message here, but our efforts to grasp it are frustrated just as surely as we can only intuit—and never really know—the meaning of the gestural brushstrokes and drips that also energize the work. Rauschenberg's *Rebus* is an icon of modern life. It makes concrete the ceaseless rush of information that we experience everyday, and that we, most often unsuccessfully, attempt to make sense of.

Fig. 355 Walker Evans, *Roadside Store between Tuscaloosa and Greensboro, Alabama*, 1936. Library of Congress.

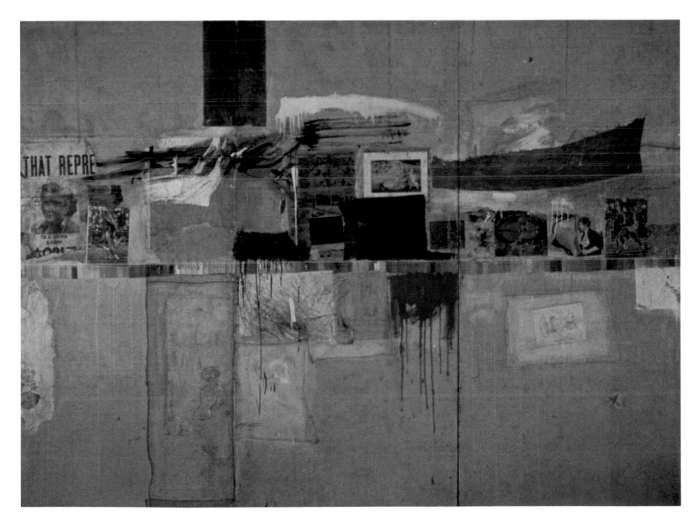

Fig. 356 Robert Rauschenberg, *Rebus*, 1955. Oil, pencil, paper, fabric on canvas, 96 × 131 × 2 in. © Robert Rauschenberg/VAGA, New York 1993.

Fig. 357 Claes Oldenburg, *Bedroom Ensemble*, 1963. Wood, vinyl, metal, artificial fur, cloth, and paper, approx. 17 × 21 ft. National Gallery of Canada, Ottawa.

Fig. 358 Rhonda Zwillinger, *Post Minimal Glitz*, 1985. Mixed-media installation at Gracie Mansion Gallery, New York.

An **environment** is an assemblage that moves from the two-dimensional space of the wall into the three-dimensional space of the world. Judy Pfaff's *Rock/Paper/Scissors* (Fig. 353), which we have already considered in terms of assemblage, is also an environment. It surrounds the viewer, and cannot be experienced at a glance.

One of the pioneers of the medium of the the environment was Claes Oldenburg, who, in December 1961, opened an exhibition called "The Store" in an actual shop front at 107 East Second Street in New York. It contained garishly painted plaster replicas of all manner of actual merchandise—pies, cakes, ice cream sundaes, hamburgers, apparel, jewelry. Oldenburg's fascination with Americana is captured in a piece called *Bedroom Ensemble* (Fig. 357), which was inspired by the decorating scheme of a famous motel near Malibu called Las Tunas Islas. Each suite was decorated in a distinctive animal-skin motif, and in this work Oldenburg concocted an almost horrifying bestiary of decorative "effects." The "satin" sheets are white vinyl, and the spread is leatherette. A material known as Zebra-velour covers the couch and decorator pillows. The "fur" rug is synthetic. The vanity is marbleized green formica. And the Pollock-like paintings on the wall are actually textiles bought in a local fabric shop for 29¢ a yard. Everything in Oldenburg's satiric attack on American taste is fake and, above all, *kitsch*.

Rhonda Zwillinger's *Post Minimal Glitz* (Fig. 358) is a "contemporary" living-room ensemble executed in the same spirit as Oldenburg's motel suite. Zwillinger covered ordinary furniture with bits of mirror and glass, sequins, costume jewelry, plastic straws, and kitsch paintings. Zwillinger wants, she says, to reach out "beyond the connoisseur crowd. One of my biggest goals is to reach the masses with my work." But not only do Oldenburg and Zwillinger reduce art to decoration, their decoration is entirely tasteless—glitz—intentionally and uproarously so.

Fig. 359 Nancy Holt, *Sun Tunnels*, Great Basin Desert, Utah, 1973–1976. Four tunnels, each 18 ft. long × 9 ft. 4 in. diameter; each axis 86 ft. long. Courtesy John Weber Gallery, New York.

Since the late 1960s, one of the focuses of modern sculpture has been the creation of large-scale out-of-doors environments. Nancy Holt's *Sun Tunnels* (Figs. 359 & 360) consists of four 22-ton concrete tunnels aligned with the rising and setting of the sun during the summer and winter solstices. The holes cut into the walls of the tunnels duplicate the arrangement of the stars in four constellations—Draco, Perseus, Columba, and Capricorn—and the size of each hole is relative to the magnitude of each star. The work is designed to be experienced on site, imparting to viewers a sense of their own relation to the cosmos. "Only 10 miles south of *Sun Tunnels*," Holt writes, "are the Bonneville Salt Flats, one of the few areas in the world where you can actually see the curvature of the earth. Being part of that kind of landscape…evokes a sense of being on this planet, rotating in space, in universal time."

Fig. 360 Nancy Holt, *Sun Tunnels*, Great Basin Desert, Utah, 1973–1976. Four tunnels each 18 ft. long x 9 ft. 4 in. diameter; each axis 86 ft. long. Courtesy John Weber Gallery, New York.

Fig. 361 Walter de Maria, *Lightning Field*, near Quemado, New Mexico, 1977. Stainless-steel poles, average height 20 ft. 7 ½ in.; overall dimensions 5,280 × 3,300 ft. All reproduction rights reserved: © Dia Center for the Arts. Photo: John Cliett.

In an isolated region near the remote town of Quemado, New Mexico, Walter de Maria has created an environment entitled *Lightning Field* (Fig. 361). Consisting of 400 steel poles laid out in a grid over nearly one square mile of desert, the work is activated between three and 30 times a year by thunderstorms that cross the region. At these times lightning jumps from pole to pole across the grid in a stunning display of pyrotechnics, but the site is equally compelling even the clearest and driest weather.

Visitors to the *Lightning Field* are met in Quemado and driven to the site, where they are left alone for one or two nights in a comfortable cabin at its edge. De Maria wants visitors to his environment to experience the space in relative isolation and silence, to view it over a number of hours, to see the stainless-steel poles change as the light and weather changes, to move in and out of the grid at their leisure. He wants them to experience the infinite, to have some sense, posed in the vastness around them, of limitless freedom and time without end.

The term used to describe this feeling is the *sublime*—a notion that also includes, as well, the sense of terror and horror that one might feel before de Maira's work when it is alive with thunder and lighting. But perhaps no environment evokes the vastness and immensity of the sublime better than James Turrell's *Roden Crater Project* (Fig. 362), a site that he has been working on since 1975. Located in the Painted Desert of Arizona, about 50 miles northeast of Flagstaff, the

Fig. 362　James Turrell, *Roden Crater Project*, 1975– . Courtesy Skystone Foundation, Inc., Arizona.

Roden Crater is a 500,000 year old extinct volcano with a base two and one-half miles wide and an interior bowl 1,200 feet in diameter. The crater was purchased by Turrell in the late 1970s, after he has spent several years modifying its shape, moving literally tons of earth in order to even out the bowl's diameter, though the changes are barely perceptible in "before" and "after" photographs. From a platform in the center of the crater, viewers lie on their back and look up at the bowl's rim. Lying there the sky appears like a huge dome vaulting up from the rim's edge. It is as if the viewer were at the center of an enormous sphere the size of the cosmos itself, tiny and insignficant in the total scheme of things.

The environment has been designed as a giant study center where visitors—who, as at de Maria's *Lightning Field*, will be admitted in small numbers for stays up to 24 hours and more—will witness the effects of space and light on their own visual perception. The crater, Turrell explains, "is located in an area of exposed geology…where you feel geologic time. You have a strong feeling of standing on the surface of the planet. Within that setting, I am making spaces that will engage celestial events. Several spaces will be sensitive to starlight and will be literally empowered by the light of stars millions of light years away." When the project is completed, sometime in the late 1990s, viewers will move through a variety of interior and exterior spaces that will alter and modify their perceptions of their constantly changing natural world.

Fig. 363 Gaho Taniguchi, *Plant Body*, 1987. Installation at Spiral Garden, Wacoal Art Center, Tokyo. Soybeans, millet, rice, rope, straw mats, urethane, metal mesh, clay, 14 ft. 6 ³/₄ in. × 26 ft. 9 in. Spiral Garden Tokyo/PPS.

Two Contemporary Japanese Environments

Gaho Taniguchi's *Plant Body* (Fig. 363) and Hideho Tanaka's *Vanishing (Season to Season)* (Figs. 364 & 365) were inspired by *ikebana*, the ancient Japanese art of flower arranging. The philosophy behind *ikebana* stresses the notion of *mono no aware*, a sense of the poignancy of things, an attitude and feeling that can be traced back to early forms of Japanese Zen Buddhism. Both the ephemeral nature of flower arranging and the transient fluidity of the flower itself bear witness to the fact that all things beautiful must die. *Ikebana*, then, seeks to capture the vanishing moment, and by this to celebrate the continual cycle of birth, death, and renewal, a process also celebrated by Taniguchi and Tanaka in their environments.

Taniguchi was herself trained in the art of *ikebana*. In her *Plant Body*, she implanted soybeans, rice, millet, straw, and rootlike rope into a surface of dried clay that seemed barely to cling to the wall. Taniguchi's work has been described as symbolically compressing the time of the seasons "from the wetness of planting to the dryness of the harvest and [thus alluding] to the endlessness of such agricultural cycles."

Tanaka's piece, constructed for an open-air exhibition in 1986, consisted of a large cloth stretched on the beach. The wind was, in effect, the artist's collaborator. In place for one week—about the same amount of time a flower arrangement might be expected to last—it was slowly covered with sand by the wind, then uncovered and covered again, in a process of constant flux.

Source: Janet Koplos, *Contemporary Japanese Sculpture* (New York: Abbeville, 1991).

Fig. 364 Hideho Tanaka, *Vanishing (Season to Season)*, 1986. Fabric, sand, wind, 65 ft. 7 ³/₈ in sq. Photograph courtesy the artist.

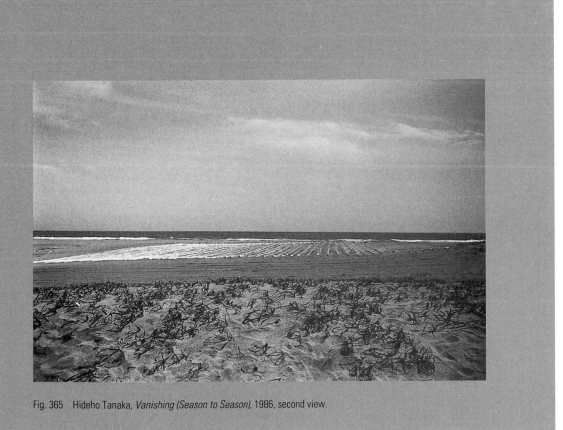

Fig. 365 Hideho Tanaka, *Vanishing (Season to Season)*, 1986, second view.

Fig. 366 Jackson Pollock, *Full Fathom Five*, 1947. Oil on canvas with nails, tacks, buttons, key, coins, cigarettes, matches, etc., 50 $^7/_8$ × 30 $^1/_8$ in. Collection, The Museum of Modern Art, New York. Gift of Peggy Guggenheim.

Fig. 367 Allan Kaprow, *Household*.

One of the characteristics of the environment is that it extends what might be called "the space of art." If this space was once the picture frame—if art was once understood as contained within that boundary—it quickly became, in the hands of environmental artists, first, the room or gallery space as a whole, and then, as in the case of De Maria and Turrell, or Christo, whose work we have discussed earlier, the world at large.

In **performance art**, the idea of the space of art is even more broadly defined, to include not only physical space but the human activity going on within it. One of the innovators of this artform was Allan Kaprow, who in the late 1950s "invented" what he called the *Happening*. He defined Happenings as "assemblages of events performed or perceived in more than one time and place.… A Happening…is art but seems closer to life." It was, in fact, the work of Jackson Pollock that inspired Kaprow to invent the form. The inclusiveness of paintings such as *Full Fathom Five* (Fig. 366)—it contains nails, tacks, buttons, a key, coins, cigarettes, matches, and other things buried in the paint that swirls across its surface—gave Kaprow the freedom to bring everything, including the activity of real people acting in real time, into the space of art. "Pollock," Kaprow wrote in 1958, "left us at the point where we must become preoccupied with and even dazzled by the space and objects of our everyday life, either our bodies, clothes, rooms, or, if need be, the vastness of Forty-Second Street.… Objects of every sort are materials for the new art: paint, chairs, food, electric and neon signs, smoke, water, old socks, a dog, movies, a thousand other things will be discovered by the present generation of artists.… The young artist of today need no longer say, 'I am a painter,' or 'a poet' or 'a dancer.' He is simply an 'artist.' All of life will be open to him."

In the Happening *Household* (Fig. 367), there were no spectators, only participants, and the event was choreographed in advance

by Kaprow. The site was a dump near Cornell University in Ithaca, New York. At 11 A.M. on the day of the Happening, the men who were participating built a wooden tower of trash, while the women built a nest of saplings and string. A smoking, wrecked car was towed into the site, and the men covered it with strawberry jam. The women, who had been screeching inside the nest, came out to the car and licked the jam as the men destroyed their nest. Then the men returned to the wreck, and slapping white bread over it, began to eat the jam themselves. As the men ate, the women destroyed their tower. Eventually, as the men took sledge hammers to the wreck and set it on fire, the animosity between the two groups began to wane. Everyone gathered round and watched until the car was burned up, and then left quietly. What this Happening means, precisely, is not entirely clear, but it does draw attention to the violence of relations between men and women in our society and the frightening way in which violence can draw us together as well.

Not all performance is as orchestrated as Kaprow's Happening. Often it is much more free form and open to improvisation. In October 1969, for instance, Vito Acconci spotted a man on the corner of 14th Street and Broadway in New York City and followed him for three hours. It was the first installment of a three-week-long series of works known as the *Following Piece* (Fig. 368). Everyday Acconci followed a person until that person entered a private place. The shortest episode lasted six minutes, ending when someone got into a car. Others lasted four to five hours. These works are explorations of the dynamics of the space of the street. In *Following Piece*, Acconci acts as an aggressor interfering in the "private" activities of others, charting the private path they make through public space in a manner that "creates" feelings of hostility and paranoia in the person followed. Seen in the gallery space, the documentary photographs evoke contradictory feelings in us. We are at once the follower and the followed, the voyeur and his prey.

Fig. 368 Vito Acconci, *Following Piece*, October 1969. Courtesy Barbara Gladstone Gallery, New York.

Fig. 369 Joseph Beuys, *I Like America and America Likes Me*, 1974. © 1974 Caroline Tisdall, courtesy Ronald Feldman Fine Arts, New York.

One of the most interesting and powerful of artists who worked in performance was Joseph Beuys, who died in 1985, an artist who created what he preferred to call "actions." These were designed to reveal what he believed to be the real function of art—teaching people to be creative so that, through their creativity, they might change contemporary society. As he put it: "The key to changing things is to unlock the creativity in every man. When each man is creative, beyond right and left political parties, he can revolutionize time." Beuys's aims may have been didactic, but they were, nevertheless, almost always expressed in hauntingly poetic and moving images. In 1974, Beuys performed a three-day piece at the René Block Gallery in Manhattan, entitled *I Like America and America Likes Me* (Fig. 369). He had refused to visit the United States until it pulled out of Vietnam, and this performance not only celebrated his first visit to the country but addressed the still unhealed wounds of the Vietnam War, which had so divided the American people. When Beuys arrived at Kennedy International Airport, he was met by medical attendants, wrapped in gray felt, and driven by ambulance to the gallery, where, lying on a stretcher, he was placed behind a chain-link fence to live for three days and nights with a live coyote.

The coyote was comparable to the Native American in Beuys's eyes, a mammal subject to the same attack and persecution as they had been. For Beuys, the settling (or, rather, conquest) of the American West was a product of the same imperialist mentality that had led to the Vietnam War. Felt is Beuys's most characteristic medium. It refers to his own rescue by Tartar tribesmen in the Crimea during World War II when his plane crashed in a driving snowstorm. The Tartars restored him to health by covering his body in fat and wrapping him in felt. Thus wrapped in felt, Beuys introduced himself as an agent of healing into the symbolic world of the threatened coyote.

Fig. 370 Suzanne Lacy and Leslie Labowitz, *In Mourning and in Rage*, 1977. Photo Susan R. Mogul.

The two quickly developed a sort of mutual respect, mostly ignoring one another. About 30 times over the course of the three days, however, Beuys would imitate the coyote's every movement for a period of one or two hours, so that the two moved in a strangely harmonious "dance" through the gallery space. Often, when Beuys moved into a corner to smoke, the coyote would join him. For many viewers, Beuys's performance symbolized the possibilities for radically different "types" to coexist in the same space.

The political drift of Beuys's work characterizes much American performance art, especially feminist performance. But the collaborative performance piece created by Suzanne Lacy and Leslie Labowitz, *In Mourning and in Rage* (Fig. 370), which was performed in December 1977 outside the Los Angeles City Hall to protest violence against women in America's cities, owes much more to works like Kaprow's *Household*, with its sense of sexual confrontation and violence. It

was Kaprow, also, who provided the model for bringing art and politics together, not just in the gallery, but in public space. *In Mourning and in Rage* was timed to coincide with a Los Angeles city council meeting, thus assuring media coverage of the performance. Ten women stepped from a hearse wearing veils draped over headdress-like structures that made each figure seven-feet tall. Representing the ten victims of the Hillside Strangler, each, in turn, addressed the media, linking the so-called Strangler's crimes to a national climate of violence against women and the sensationalized media coverage that supports it. As Lacy and Labowitz have explained: "The *art* is in making it compelling; the *politics* is in making it clear.... *In Mourning and in Rage* took this culture's trivialized images of mourners as old, powerless women and transformed them into commanding seven–foot–tall figures angrily demanding an end to violence against women." In order to maximize the

an an an

OLOGY OF
OLOGY OF
OLOGY OF
OLOGY OF
OLOGY OF
OLOGY OF

chance operations
con cep t art
INDETERMINACY
anTi-arT
IMPROVISATiON
meanIngless work
natural disasters

STORIES POETRY ESSAYS
plans of action diagrams MUSIC
DANCE constructions mathematics COMPOSITIONS

BY GEORGE BRECHT, CLAUS BREMER, EARLE BROWN, JOSEPH BYRD, JOHN CAGE, DAVID DEGENER, WALTER DEMARIA, HENRY FLYNT, YOKO ONO, DICK HIGGINS, TOSHI ICHIYANAGI, TERRY JENNINGS DENNIS, DING DONG, RAY JOHNSON, JACKSON MAC LOW, RICHARD MAXFIELD, ROBERT MORRIS, SIMONE MORRIS, NAM JUNE PAIK, TERRY RILEY, DITER ROT, JAMES WARING, EMMETT WILLIAMS, CHRISTIAN WOLFF, LA MONTE YOUNG, LA MONTE YOUNG - EDITOR, GEORGE MACIUNAS-DESIGNER

Fig. 371 George Maciunas, title pages of *An Anthology*, edited by La Monte Young, 1963. Collection Gilbert B. and Lila Silverman. © 1963 by La Monte Young and Jackson Mac Low.

educational and emotional impact of the event, the performance itself was followed up by a number of talk show appearances and activities organized in conjunction with a local Los Angeles rape hot line program.

Performance art, it should be clear, exceeds the visual, the sense to which we normally think of art as primarily appealing, and, as a result, it tends to be interdisciplinary, often combining elements not only of drama and poetry, but of music and dance as well. One of the major advocates of such an approach in the early 1960s was a loosely knit group of European, Japanese, Korean, Canadian, and American artists, many of them trained first as musicians, which came to be identified by the name of Fluxus. Beuys often associated himself with

the group, but more directly involved were people such as avant-garde musician La Monte Young, George Brecht, whose *Event Score: Sink* we have already seen (Fig. 140), Dick Higgins, an accomplished assemblage artist, poet Jackson Mac Low, Yoko Ono, and, on occasion, John Lennon of the Beatles. The composer John Cage's classes at the New School in New York were a catalyst for the group. Many of Cage's students began to investigate the implications of compositions such as his *4'33"* in their own work. The composition *4'33"* is literally four minutes and 33 seconds of silence, during which the audience becomes aware that all manner of noise in the room, incidental and otherwise, is, in the context of the piece, "music." Thus Jackson Mac Low created poetry of chance-derived nouns and verbs improvised upon by the performer. La Monte Young's *X for Henry Flynt* required the performer to play an unspecified sound, or group of sounds, in a distinct and consistent rythmic pattern for as long as the performer wished, which, in Young's own performance, consisted of 600-odd beats on a frying pan. Dick Higgins's *Winter Carol* consisted of everyone going outdoors to listen to the snow fall for a specified amount of time. Events such as this were soon organized into Fluxus "concerts," events that admitted anything, including the audience's outrage. One of the first collections of Fluxus-like work, which served as something of a model for these concerts, was a publication called *An Anthology*, collected by La Monte Young and designed by George Maciunas. The innovative graphic design of its six title pages (Fig. 371), and its willingness to accept almost everything—even "anti-art"—as art are indicative of inclusiveness of the movement as a whole.

Perhaps the most successful of the multimedia performance artists has been Laurie Anderson, who not only performs before large enthusiastic audiences in essentially commercial rock concert settings, but has successfully marketed both films and

recordings of her work as well. Her performances—the most ambitious of which is the seven-hour, four-part, two-evening *United States* (Fig. 372)—involve a wide variety of technological effects. An electronic harmonizer lends her voice a deep male resonance that she describes as "the Voice of Authority…a corporate voice, a kind of 'Newsweekese.'" A "black box" delays, alters, and combines tapes of her voice so that she sounds like a chorus. Her "violin" is actually a tape playback head and her "bow" a strip of prerecorded audiotape that is transmitted as she draws it, at various speeds, in long or short sweeps, across the head. These audio effects are matched by equally sophisticated choreography, lighting changes, and a wealth of complex visual imagery that inundates the audience in wave after wave of Americana. Anderson's performances wander through the psychological and emotional terrain of the United States, not so much in an effort to understand it as in submission to the impossibility of ever understanding it. "I mean my mouth is moving," she admits in *United States*, "but I don't really understand what I'm saying." It is as if she has no real voice of her own, only the voice of technology. She is not so much a person, a performer, as an assemblage, fabricated out of the American scene.

Film and Video

In *Live/Taped Video Corridor and Performance Corridor* (Fig. 373), artist Bruce Nauman mounted a closed-circuit video camera on the ceiling of a narrow corridor and placed two TV monitors at its end. In the top monitor, a video tape of the empty corridor continually plays; in the bottom one, viewers watch themselves enter the space. The act of entering disrupts the tranquillity of the empty corridor, and the tranquillity of the black screen. It is as if the viewer becomes a performer in front of the camera, committing an act of aggression upon the space.

Fig. 372 Laurie Anderson, *United States Part II*, 1980. Photo: Paula Court.

Fig. 373 Bruce Nauman, *Live/Taped Video Corridor and Performance Corridor*, 1968–1970. Video installation. Collection of Giuseppe Panza di Biumo, Milan. © 1993 Bruce Nauman/ARS New York.

Fig. 374 Fernand Léger, *Ballet Mécanique*, 1924. Courtesy the Humanities Film Collection, Center for the Humanities, Oregon State University.

Both video and film, as art media, are closely tied to the performance sensibility we have been discussing. Describing his own involvement with them, Nauman puts it this way: "Originally a lot of the things that turned into videotapes and films were performances. At the time no one was really interested in presenting them, so I made them into films. No one was interested in that either, so the film is really a record of the performance. After I made a few films I changed to videotape, just because it was easier to get at the time." This is, in essence, a short history of film and video as they have come to be used in the art world since the 1960s.

It was, however, originally the formal, rather than the narrative potential of film that first attracted artists to it. Specifically, it seemed a medium through which rhythm and repetition could be explored as formal elements. In his 1924 film *Ballet Mécanique* (Fig. 374), the Cubist painter Fernand Léger chose a number of different images—smiling lips, wine bottles, metal discs, working mechanisms, and a number of pure shapes, such as circles, squares, and triangles. By repeating the same image again and again at separate points in the film, Léger was able to create a visual rhythm that, to his mind, embodied the beauty—the ballet—of machines and machine manufacture in the modern world.

Stan Brakhage, who has been making experimental films since the early 1950s, has continued to explore the formal and essentially abstract connections that can be established between the shape and color of different objects. He is interested in the sense of rhythm that can be generated from the repetition of things related in no logical way other than their formal similarity and juxtaposition in the film itself. *Mothlight* (Fig. 375) is a handmade film that is an assemblage of actual flower petals, moth wings, leaves, and grasses of various sorts, laid onto a 16mm film strip. Every object in the piece is transparent, like the celluloid on which they rest, and thus,

after the original collaged filmstrip was printed so that it could be projected, the film appeared to be back lit, as if the light came not from the projector but from within in it. Because the objects themselves are larger than a single frame, they seem to appear and dissolve simultaneously. The viewer's eye can never capture the object, hold it in place, and each object thus has a gestural quality, as if it were a mark traced across the celluloid.

Although the movies may seem true to life, as if they were occurring in real time and space, this effect is only an illusion, accomplished by means of the editing "cut." It is very rare, in fact—Louis Malle's *My Dinner with André* comes to mind—for a commercial movie to be made in "real" time. It was Andy Warhol—painter of the Campbell's soup can—who equated, in the words of one critic, "reel" time with "real" time. Many of Warhol's films are the visual equivalent of John Cage's *4'33"*. In *Sleep* (1963), he filmed the poet John Giorno sleeping. The only action in the six-hour–long film is that every 30 minutes the camera changes position when the film runs out and has to be reloaded, a change accompanied by a white flash on the screen resulting from the film's exposure to light. For *Empire* (1964) (Fig. 376), Warhol filmed the Empire State Building for eight straight hours through the afternoon and evening, with a stationary camera set up on the 44th floor of the Time-Life building. To view either film is to understand the idea of *duration* in terms one might never before have thought possible. In a darkened theater, where there is relatively little other visual stimulus, the viewer's attention, as in Cage's *4'33"*, is soon drawn beyond the screen to other elements in the surrounding environment. The slightest movement or sound in the theater becomes interesting in itself. The drama in these films, in fact, lies in the audience's reaction in real time to the monotony of the image.

One of the primary difficulties faced by artists who wish to explore film as a medi-

Fig. 375 Stan Brakhage, from *Mothlight*, 1963. Anthology Film Archive.

Fig. 376 Andy Warhol, Filmstill from *Empire*. © 1994 The Andy Warhol Foundation for the Visual Arts, Inc.

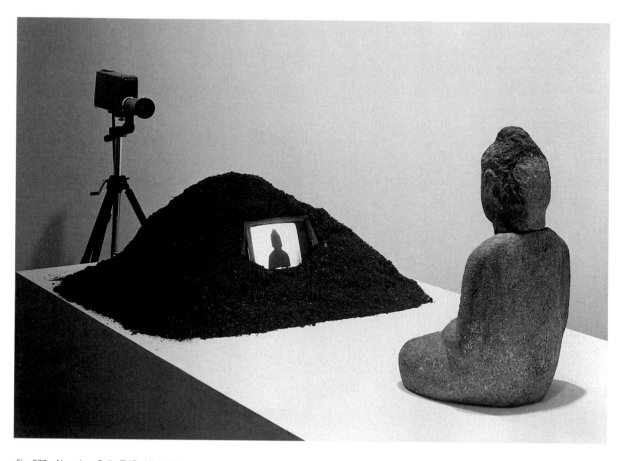

Fig. 377 Nam June Paik, *TV Buddha*, 1974–1982. Mixed media, 55 × 115 × 36 in. Photo © Peter Moore, 1982.

um is the sheer expense of using it. The more sophisticated a film is in terms of its camera work, lighting, sound equipment, editing techniques, and special effects, the more expensive it will be to produce. With the introduction in 1965 of the relatively inexpensive hand-held video camera, the Sony Portapak, artists were suddenly able to explore the implications of seeing in time. Video is also more immediate than film— that is, what is seen on the recorder is simulataneously seen on the monitor. While video art tends to exploit this immediacy, commercial television tends to hide it by attempting to make it look like film.

Originally a member of the Fluxus group, and one of the first people in New York to buy a Portapak, Nam June Paik had been making video installations since the late 1950s that explored the limits and defining characteristics of the medium. His

TV Buddha (Fig. 377), for example, perpetually contemplating itself on the screen, is a self-contined version of Warhol's exercises in filmic duration. The work is deliberately and playfully ambiguous, both "live" on TV and an inanimate stone object, both peacefully meditative and mind-numbingly boring, simultaneously an image of complete wholeness and absolute emptiness. It represents, in short, the best and worst of TV.

The playfulness that Paik employs in *TV Buddha* is equally evident in the wordplay that underlies his *TV Bra for Living Sculpture* (Fig. 378), a literal realization of the "boob tube." The piece is a collaborative work, executed with the avant-garde musician Charlotte Moorman. Soon after Paik's arrival in New York in 1964, he was introduced to Moorman by the composer Karlheinz Stockhausen. Moorman wanted to perform a Stockhausen piece called

Originale, but the composer would grant permission only if it was done with the assistance of Paik, who had performed the work many times. Paik's role was to cover his entire head with shaving cream, sprinkle it with rice, plunge his head into a bucket of cold water, and then accompany Moorman's cello on the piano as if nothing strange had occurred. So began a long collaboration. Like all of Paik's works, *TV Bra's* humor masks a serious intent. For Paik and Moorman, it was an attempt "to humanize the technology…and also stimulate viewers…to look for new, imaginative, and humanistic ways of using our technology." *TV Bra*, in other words, is an attempt to rescue the boob tube from mindlessness.

The clichéd mindlessness of commercial television, especially the duplicity of TV advertising has been hilariously investigated in a vast number of short videos by William Wegman. In one, called *Deodorant*, the artist simply sprays an entire can of deodorant under one armpit while he extols its virtues. About the length of a normal television commercial, the video seems to go on forever, amusingly dripping exercise in consumerism run amok. In *Rage and Depression* (Fig. 379), Wegman sits smiling at the camera as he speaks the following monologue:

> I had these terrible fits of rage and depression all the time. It just got worse and worse and worse. Finally my parents had me committed. They tried all kinds of therapy. Finally they settled on shock. The doctors brought me into this room in a straight jacket because I still had this terrible, terrible temper. I was just the meanest cuss you could imagine and when they put this cold, metal electrode, or whatever it was, to my chest, I started to giggle and then when they shocked me, it froze on my face into this smile and even though I'm still incredibly depressed—everyone thinks I'm happy. I don't know what I'm going to do.

Wegman completely undermines the authority of visual experience here. What our eyes see is an illusion. He implies that we can never trust what we see, just as we should not trust television's objectivity as a medium.

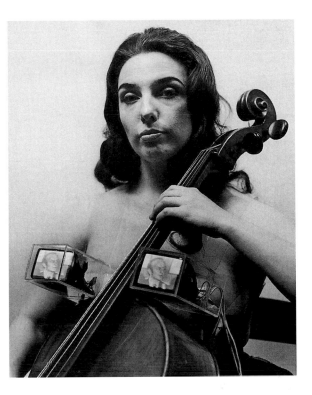

Fig. 378 Nam June Paik, *TV Bra for Living Sculpture*, 1969. Performance by Charlotte Moorman with television sets and cello. Photo © Peter Moore, 1969.

Fig. 379 William Wegman, *Still from Rage and Depression*, Reel 3, 1972–1973. Video, approx. 1 min. Courtesy of the artist.

Fig. 380 Dara Birnbaum, *Technology/Transformation: Wonder Woman*, 1978–1979. Color, stereo videotape, 7 min. Electronic Arts Intermix.

Fig. 381 Lynn Hershman, *Lorna*, 1983. Interactive video disk. Courtesy of the artist.

At least in part because they have been denied ready acceptance as painters and sculptors, women artists have tended to dominate video art as a medium, using it particularly to critique the ways in which women have been depicted and defined in our culture. Dara Birnbaum's *Technology/Transformation: Wonder Woman* (Fig. 380) is a ground-breaking example of this direction in contemporary video art. It consists of a series of taped loops from the Linda Carter television series *Wonder Woman*, in which Wonder Woman transforms herself, like some spinning dervish, from her "normal" self into an all-powerful agent in the never-ending fight of good against evil. By accompanying this transformation with a sound track of Wonder Woman and the Disco Land Band singing "Wonder Woman Disco," with its sexually suggestive lyrics ("This is your Wonder Woman talking to you / Said I want to take you down/ Show you all the powers that I possess/ Shake thy wonder maker"), Birnbaum wants to expose the underlying message of the series that being a normal woman somehow isn't enough. The show may seem to entertain the possibility that women can be powerful, but actually it does not.

Lynn Hershman's interactive art video disk, *Lorna* (Fig. 381) allows the viewer to participate in the story of Lorna, a middle-aged agoraphobic, fearful of leaving her tiny apartment. "The premise," according to Hershman, "[is] that the more she stayed home and watched television, the more fearful she became—primarily because she was absorbing the frightening messages of advertising and news broadcasts." In the disk, each object in her room is numbered and becomes a chapter in her life that viewers activate by means of their remote control device. The plot has multiple variations, and three separate endings. Viewers are no longer helpless, like Lorna. Where the mass media made a captive of her, we are now empowered to manipulate the media ourselves.

PART IV
THE VISUAL ARTS IN EVERYDAY LIFE

Recognizing the Art of Design

Fig. 382 Josiah Wedgwood, copy of Portland Vase, c. 1790. Black Jasper ware, height 10 in. The Wedgwood Museum, Barlaston, England.

8 DESIGN AND ARCHITECTURE

During the 1920s in the United States many people who had once described themselves as involved in the graphic arts, the industrial arts, the craft arts, or the arts allied to architecture—even architects themselves—began to be referred to as *designers*. They were seen as serving a unique function in modern society. Their job was to resolve the problems facing modern urban people and to mediate between art and industry. They could take any object or product—a shoe, a chair, a book, a poster, an automobile, or a building—and make it appealing, and thereby persuade the public to buy it or a client to build it, not merely because it looked good, but also because it functioned well.

Today a designer's task can be defined even more broadly. The designer organizes all levels of modern life, and the architect is, in many ways, the designer of last resort, the one who incorporates all other design—the products which surround us—into livable space. Today designers and architects are in charge of what could be called the art of everyday living, but the origins of their discipline can be traced back to the very beginnings of the industrial age.

Design, Craft, and Fine Art

On May 1, 1759, in Staffordshire, England, a 28-year-old man by the name of Josiah Wedgwood opened his own pottery manufacturing plant. With extraordinary foresight, Wedgwood chose to make two very different kinds of pottery, one he called "ornamental ware," the other "useful ware." The first were elegant luxury items; the second were described in his catalogue as "a species of earthenware for the table, quite new in appearance...manufactured with ease and expedition, and consequently cheap."

Though the Wedgwood factory has continued to produce various kinds of ornamental ware, the most famous are the Jasper ware

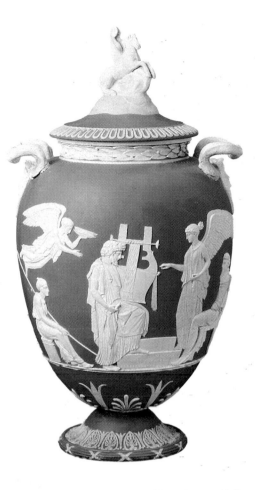

Fig. 383 Josiah Wedgwood, Apotheosis of Homer Vase, 1786. Blue Jasper ware, height 18 in. The Wedgwood Museum, Barlaston, England.

ceramics invented by Wedgwood himself, which are notable for their usual light blue color and their raised white, cameo decorations (Fig. 383). Wedgwood's copy of the Portland Vase (Fig. 382) is his crowning achievement. The original, made around 25 B.C. in Rome, is a cameo deep blue (virtually black) glass vase that the Dowager Duchess of Portland purchased in 1784 for her private museum. The duchess, however, died within a year of her purchase, and her entire estate was auctioned off, but the vase stayed in the family when the third Duke of Portland bought it in June 1786. It was subsequently lent to Wedgwood so that he might copy it, and he contracted to sell a number of these copies to a group of "gentlemen" subscribers.

Fig. 384 Wedgwood Queen's Ware kitchen ware, c. 1850. The Wedgwood Museum, Barlaston, England.

It took Wedgwood four years to reproduce the vase successfully. He was able to match the deep blue-black of the original, but the ornamental ware for which he is best known is generally of a much lighter blue, as pictured on the previous page. Some fifty numbered and unnumbered first edition copies of the Portland vase survive, and the factory has continued to produce editions over the years, most recently in 1980 for the 250th anniversary of Josiah's birth.

But Wedgwood's success as a manufacturer did not depend upon such "ornamental" wares of refined taste and elegance. Rather it was his "useful" ware that supported his business (Fig. 384). His cream-colored earthenware (dubbed Queen's Ware because the English royal family quickly became interested in it), though sometimes used for ornament, was used predominantly for useful wares. The tableware was made by casting liquid clay in molds instead of by throwing individual pieces and shaping them by hand. Designs were chosen from a pattern book (Fig. 385) and printed by mechanical means

directly on the pottery (Fig. 386). Since Wedgwood could mass-produce his earthenware both quickly and efficiently, a reliable, quality tableware was made available to the middle-class markets of Europe and America.

Wedgwood's business illustrates very clearly how the art of **design** has been differentiated from, on the one hand, the traditional **crafts** and, on the other, the so-called **fine arts**, like painting or sculpture. When we speak of crafts, we are generally referring to *handmade* objects created by highly skilled but nevertheless uninventive artisans to serve useful functions. Designers are different from crafts-people in that they often have nothing to do with the actual making of the object, which is produced by mechanical means. Their job is to determine how the object will look and, most important, to make it attractive to as large a public as possible. They must, as a result, appeal to the vagaries of fashion. The objects they design must, in short, sell.

In these terms, craftspeople and fine artists have more in common with one anoth-

er than either do with designers. They both equally share a hands-on relation to the objects they make. Wedgwood's Portland Vase, upon which he himself worked, is more craft than is his tableware, which was mechanically produced. During the Renaissance, the crafts were distinguished from the fine arts on intellectual grounds, which we have already briefly discussed in relation to the "invention" of painting as a fine art. To qualify as a fine art, a given artistic practice had to require a large measure of genius and inspiration. It had to result, generally, in a unique object (hence the difficulty printmakers had in being recognized as fine artists). And, most important, its purpose had to be *aesthetic*. That is, its primary purpose was to satisfy the mind's desire for beauty, not the needs of everyday life. Thus any medium associated with daily life—ceramics, silver and gold objects, textiles, glass, and furniture—was generally designated a craft medium as opposed to a fine art medium. Nevertheless, a work like Wedgwood's Portland Vase is aesthetic in its intention and was meant to be received as an object of fine art. Queen's Ware was meant to be used daily, on the table. Another way of putting this is to say that the word "ornamental" serves, in Wedgwood's usage, to remove the object from the ordinary, to separate it from the "useful," to lend it the status of art.

Yet it is often difficult to decide whether an object is an example of craft, fine art, or design. At any given cultural moment, questions of aesthetic beauty or practical usefulness or the demands of fashion and taste may dominate design decisions. Nevertheless, successful design must address itself to all these concerns. Not only do aesthetic and utilitarian questions come into play, but fashion and taste inevitably have an impact on what is produced and, perhaps more tellingly, on what continues to be produced over the course of time.

Fig. 385 First Wedgwood pattern book with border designs for Queen's Ware, 1774–1814. The Wedgwood Museum, Barlaston, England.

Fig. 386 Transfer-printed Queen's Ware, c. 1770. The Wedgwood Museum, Barlaston, England.

Fig. 387 Plate. Ming Dynasty, late 16th-early 17th century. Porcelain, diameter 14¼ in. The Metropolitan Museum of Art, New York. Rogers Fund, 1916 (16.13).

Fig. 388 Vase, Ch'ing Dynasty, late 17th–early 18th century. Porcelain painted in *famille verte* enamels and gilt, height 18 in. The Metropolitan Museum of Art, New York. Bequest of John D. Rockefeller, Jr., 1961 (61.200.66).

Chinese Porcelain

The first true porcelain was made in China during the T'ang Dynasty (A.D. 618–906), and by the time of the Ming Dynasty (1368–1644) the official kilns at Chingtehchen had become a huge industrial center producing ceramics for export. Originally, Islam was the primary market for the distinctive blue-and-white patterns of Ming porcelain (Fig. 387), but as trade with Europe increased, so too did Europe's demand for Ming design.

The export trade flourished even after the Manchus overran China in 1644, establishing the Ch'ing Dynasty, which lasted into the twentieth century, and this had a profound effect on Chinese design. Not only did the Chingtehchen potters quickly begin to make two grades of ware, one for export and a finer "Chinese taste" ware for internal, royal use, but they became dedicated to satisfying European taste. As a result, consistency and standardization of product were of chief concern.

One of the more beautiful Ch'ing Dynasty porcelains is this remarkable *famille verte* vase (Fig. 388), so-called because the palette of enamel paints used is marked by its several distinctive shades of green. Here birds, rocks, and flowers create a sense of the vibrancy of nature itself.

By the end of the eighteenth century, huge workshops dominated the Chinese porcelain industry, and by the middle of the nineteenth century the demands of mass production for trade led, throughout China, to the same lack of creative vitality evident in Western manufacturing.

Source: Suzanne G. Valenstein, *A Handbook of Chinese Ceramics* (New York: Metropolitan Museum of Art, 1989).

Fig. 389 Colt Walker Revolver, c. 1847. Courtesy of Colt's Manufacturing Company, Inc.

The Arts and Crafts Movement

During the first half of the nineteenth century, as mass production became more and more the norm in England, the quality and aesthetic value of mass-produced goods declined. Even in utilitarian terms, it had become evident, by mid-century, that the Americans, obsessed with standardization and the logical organization of the factory and its production methods, were producing much more practical objects. The most famous of these objects in the mid-nineteenth century was the Colt revolver. In 1846, Captain Samuel H. Walker of the United States Army, and Sam Colt, who had been making guns since 1836, collaborated on designing a new revolver for use in the Mexican War (Fig. 389). An order of 1,000 was filled in mid-1847, and before the year was out, Colt's new factory in Hartford, Connecticut was capable of producing 5,000 guns a year. The 1849 model of the Colt revolver, first exhibited in England in 1851, when Colt opened a plant there, fascinated the English not only because all its parts were standardized and interchangeable but because they were assembled so that the fact of their machine manufacture was obvious. Despairing of his nation's ability to produce anything that one might label excellent in terms of either quality or value, one British industrialist lamented, as early as 1835: "I have never found a good designer in England."

Quite literally in response to such negative sentiments, a Normal School of Design was established in 1837 by the London Board of Trade, and by 1846 eleven other schools had been established across England, all under the control of Henry Cole, a British civil servant who would later help to found London's renowned Victoria and Albert Museum and who was himself a designer, working under the pseudonym of Felix Summerly. The primary force in British design for nearly a quarter of a century, Cole also established the *Journal of Design and Manufacture*, in which he advocated the integration of the practical and aesthetic. "Mechanical contrivances are like skeletons without skin, like birds without feathers," one writer in the *Journal* put it, "pieces of organization, in short, without the ingredient [namely, aesthetic ornament] which renders natural productions objects of pleasure to the senses."

Fig. 390 Joseph Paxton, Crystal Palace, Great Exposition, London, 1851. 1,848 ft. long, 408 ft. wide

Fig. 391 Philip Webb, The Red House, Bexley Heath, 1859. Photo courtesy the National Monuments Record, Great Britain.

In order to expose England to the pace of modern design in the country, Cole organized the Great Exposition of 1851. The industrial production on exhibit demonstrated, once and for all, just how bad the situation was. Almost everyone agreed with the assessment of Owen Jones: "We have no principles, no unity; the architect, the upholsterer, the weaver, the calico-painter, and the potter, run each their independent course; each struggles fruitlessly, each produces in art novelty without beauty, or beauty without intelligence."

The building that housed the exhibition in Hyde Park was an altogether different proposition. A totally new type of building, which became known as the Crystal Palace (Fig. 390), it was designed by Joseph Paxton, who had once served as gardener to the Duke of Devonshire and had no formal training as an architect. Constructed of over 900,000 square feet of glass set in prefabricated wood and cast iron, it was three stories tall and measured 1,848 by 408 feet. It required only nine months to build, and it hailed in a new age in construction. As one architect wrote at the time, "From such beginnings what glories may be in reserve.... We may trust ourselves to dream, but we dare not predict."

Not everyone agreed. A. W. N. Pugin, who had collaborated on the new Gothic-style Houses of Parliament, called the Crystal Palace a "glass monster," and the essayist and reformer John Ruskin, who likewise had championed a return to a preindustrial Gothic style in his book *The Stones of Venice*, called it a "cucumber frame." Under their influence, William Morris, a poet, artist, and ardent socialist, dedicated himself to the renewal of English design through the renewal of medieval craft traditions. In his own words: "At this time, the revival of Gothic architecture was making great progress in England.... I threw myself into these movements with all my heart; got a friend [Philip Webb] to build me a house

very medieval in spirit…and set myself to decorating it." Built of traditional red brick, the house was called the Red House (Fig. 391), and nothing could be further in style from the Crystal Palace. Where the latter reveals itself to be the product of manufacture—engineered out of prefabricated, factory-made parts and assembled, with minimal cost by unspecialized workers, in a matter of a few months—the former is a purposefully rural, even archaic building that rejects the industrial spirit of Paxton's Palace. It signaled, Morris hoped, a return to craft traditions in which workers were intimately tied to the design and manufacture of their products from start to finish.

As a result of the experience of building the Red House, and attempting to furnish it with things of a medieval, handcrafted nature, a project that was frustrated at every turn, Morris decided to take matters into his own hand. In 1861 he founded the firm that would become Morris and Company. It was dedicated "to undertake any species of decoration, mural or otherwise, from pictures, properly so-called, down to the consideration of the smallest work susceptible of art beauty." To this end the company was soon producing stained glass, painted tiles, furniture, embroidery, table glass, metalwork, chintzes, wallpaper, woven hangings, tapestries, and carpets.

In his design, Morris constantly emphasized two principles, simplicity and utility, but it is, at first glance, difficult to see "simplicity" in work such as *The Woodpecker* (Fig. 392). For Morris, however, the natural and organic were by definition simple. Thus the pattern possesses, in Morris's words, a "logical sequence of form, this *growth* looks as if it could not have been otherwise." Anything, according to Morris, "is beautiful if it is in accord with nature." "I must have," he said, "unmistakable suggestions of gardens and fields, and strange trees, boughs, and tendrils."

Morris's desire for simplicity—"simplicity of life," as he put it, "begetting simplicity of taste"—soon led him to create what he

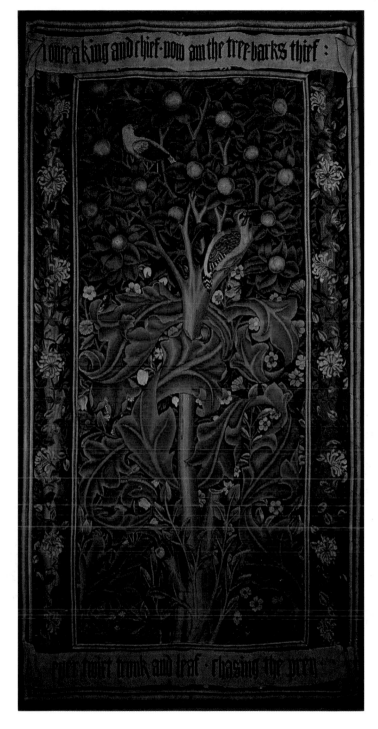

Fig. 392 Morris and Company, *The Woodpecker*, 1885. Wool tapestry designed by Morris. William Morris Gallery, Walthamstow, England.

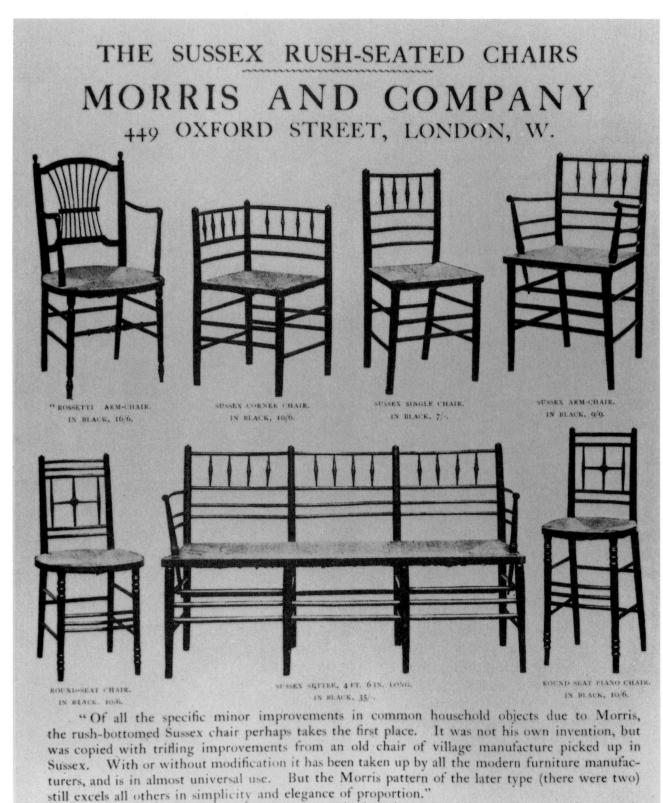

Fig. 393 Morris and Company, Sussex rush-seated chairs. Fitzwilliam Museum.

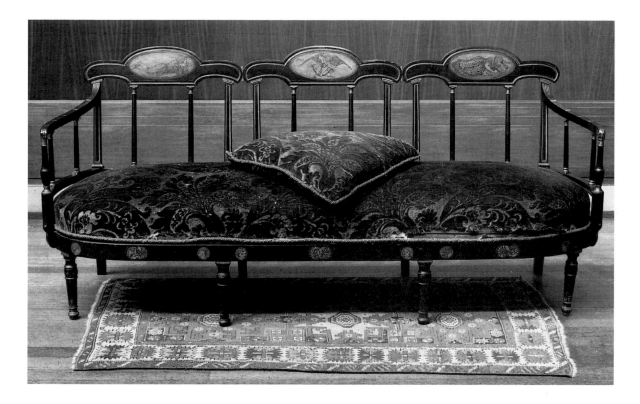

Fig. 394 Dante Gabriel Rossetti, Sofa, 1862. Wood, upholstered in velvet, width 74 7/8 in. Fitzwilliam Museum, University of Cambridge.

called "workaday furniture," the best examples of which are the company's line of Sussex rush-seated chairs (Fig. 393). Such furniture was meant to be "simple to the last degree" and to appeal to the common man. Just as Wedgwood had 100 years earlier, Morris quickly came to distinguish this "workaday" furniture from his more costly "state furniture," for which, he wrote, "we need not spare ornament…but [may] make them as elaborate and elegant as we can with carving or inlaying or paintings; these are the blossoms of the art of furniture." A sofa designed by Morris's friend, the painter Dante Gabriel Rossetti, and displayed by Morris and Company at the International Exhibition of 1862 (Fig. 394), is the "state" version of the Sussex settee. Covered in rich, dark green velvet, each of the three panels in the back contains three personifications of Love, hand-painted by Rossetti. As Morris's colleague Walter Crane put it: "The great advantage…of the Morrisian method is that it leads itself to either simplicity or splendor. You might be almost plain

enough to please Thoreau, with a rush bottomed chair, piece of matting, and oaken trestle-table; or you might have gold and luster gleaming from the side-board, and jeweled light in your windows, and walls hung with rich arras tapestry."

Morris claimed that his chief purpose as a designer was to elevate the circumstances of the common man. "Every man's house will be fair and decent," he wrote, "all the works of man that we live amongst will be in harmony with nature…and every man will have his share of the *best*." But common people were in no position to afford the elegant creations of Morris and Company. It was, furthermore, the more expensive productions—the state furniture, tapestries, and embroideries—that kept the firm financially afloat. Inevitably, Morris was forced to confront the inescapable conclusion that to handcraft an object made it prohibitively expensive. With resignation and probably no small regret, he came to accept the necessity of mass manufacture.

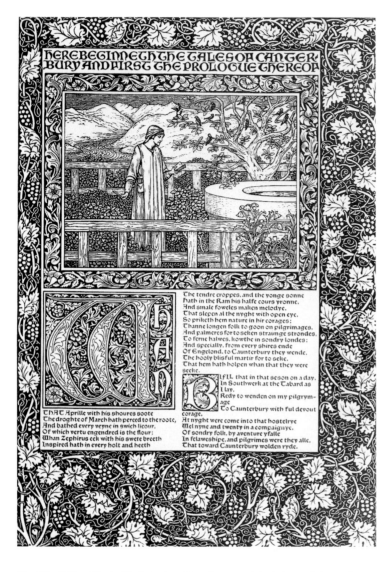

Fig. 395 William Morris, *The Canterbury Tales*, first page of the Prologue, Kelmscott Press, 1896. Fitzwilliam Museum, University of Cambridge.

a sensation like that of soothing a cat.… It was to express the sensuous pleasure that he used to say that all good designing work was felt in the stomach."

Between 1891 and 1898, two years after his death, the Kelmscott Press produced 18,000 volumes of 53 titles, the most famous of which is what has become known as the Kelmscott Chaucer (Fig. 395). While wanting to maintain the character of the original script of Chaucer's *Canterbury Tales*, written in the fourteenth century, Morris recognized that, to the modern eye, it would be almost illegible. He, therefore, designed a Gothic type wider than the original, made curved characters rounder, and increased the differences between similar characters. His book, he said, "[should be] beautiful by force of mere typography." But the beauty of its pages is due at least as much to the organic and floral patterns of the border designs, the ornamental capitals, and the woodblock illustrations, all of which echo the forms of the type.

In the end, Morris designed 664 different blocks, including capitals, borders, frames, and title pages. Many of these were specifically designed to be interchangeable. These modules, repeated again and again throughout a given book, served to establish a continuity of layout and design, the same sense of standardization and uniformity that mark modern industrial production.

Morris's example helped initiate the Arts and Crafts movement throughout England. In order to foster artistic collaboration, workers' guilds were begun, based on the medieval model of a community of artists and artisans working together for the common good. One of the first was the Art-Workers' Guild, founded in 1884, which looked upon Morris as its spiritual father. But the Art-Workers' Guild functioned more like a private club than a real guild, and several members, believing that the crafts needed more public exposure, deserted ranks and formed the Arts and Crafts Exhibition Society, which gave the Arts and

Perhaps Morris's greatest achievement was as a book designer. Though driven by a spirit in every way medieval, characterized by careful hand printing, handmade papers, and hand-cut woodblocks, Morris's Kelmscott Press, founded in 1891, followed a surprisingly modern model of production. For Morris, everything about the book—paper, ink, type, spacing, margins, illustration, and ornament—should be of a piece. A well-designed book would be like good architecture, a total work of art. His friend Charles Letheby described Morris's working method: "The forms were stroked into place, as it were, with

Embroidery at Morris and Company

By the 1870s, embroidered wall hangings were among the most popular items produced by Morris and Company. At first, Morris's wife, Jane, headed a large group of women, some of whom worked for the company on a full-time basis and others who worked more occasionally. In 1885, his daughter May, then 23 years old, took over management of the embroidery section.

For a quarter of a century, until about 1910, May Morris trained many women in the art of embroidery at her Hammersmith Terrace workshops, and many designs attributed to her father after 1885 are actually her own (apparently, she thought it important, at least from a commercial point of view, to give her father the credit).

In 1916 May Morris designed a set of bed-hangings for a lady's bedroom, "in which elaboration and luxury have been purposefully avoided" (Fig. 396). These were shown at the Arts and Crafts Exhibition in London in the same year. The embroidery work itself was done by May Morris, the teacher Mary Newill, and Newill's students at the Birmingham School of Art. In 1920–1921, the hangings were displayed at an exhibition in Detroit organized by the Detroit Society of Arts and Crafts, where they were purchased by George Booth, the founder of the famous American design school, the Cranbrook Academy of Art.

The fact that most of the women who worked for Morris and Company were relegated to the embroidery division demonstrates the rigidity of sex roles in English society at the turn of the century. Nevertheless, May Morris, a successful business person,

Fig. 396 May Morris, Bed Hangings, 1916. Wood crewel on linen, lined, 76 ³/₄ × 54 in. Collection of Cranbrook Academy of Art Museum, Gift of George G. Booth. Photo: R. H. Hensleigh.

author, and lecturer, was an important role model for the women of her day. In 1907, she helped to found the Women's Guild of Art, the purpose of which was to provide a "centre and a bond for the women who were doing decorative work and all the various crafts."

Source: Linda Parry, *William Morris Textiles* (New York: Viking, 1983).

Fig. 397 Embroidered *rumal*, late 18th century. Muslin and colored silks. Victoria and Albert Museum, London.

Indian Embroidery

From the early eighteenth century onward, the town of Chamba was one of the centers of the art of embroidery in India. It was known, particularly, for its *rumals*, embroidered muslin textiles that were used as wrappings for gifts. If an offering was to be made at a temple, or if gifts were to be exchanged between families of a bride and groom, an embroidered *rumal* was always used as a wrapping.

The composition of the Chamba rumals is consistent. A floral border encloses a dense series of images embroidered on a plain white muslin background. The designs were first drawn in charcoal and then embroidered. A gift to a deity such as Krishna, the most voluptuous of the human incarnations of the Hindu god Vishnu, the Destroyer, might include scenes from the life of Krishna. For a wedding gift, as in the *rumal* illustrated here, the designs might depict the wedding itself. The designs were double-darned, so that an identical scene appeared on both sides of the cloth.

Because of its situation in the foothills and mountains of the Himalayas, offering relief from the heat of the Indian plains, the region around Chamba was a favorite summer retreat for British colonists, and its embroidery arts became very popular in nineteenth-century England.

Source: John Gillow and Nicholas Barnard, *Traditional Indian Textiles* (London: Thames and Hudson, 1991).

Crafts movement its name. The Society's aim was to promote craft ideas and achievement at an international level, and it held its first exhibition in November 1888.

Another important guild was C. R. Ashbee's Guild of Handicraft, founded in 1888. Himself a designer of metalwork and jewelry (Fig. 398), Ashbee dreamed of creating a utopian community of guild workers, which he founded in 1902 in the village of Chipping Campden. Unable to support itself by the manufacture of the crafts alone, however, the enterprise lasted only five years.

In the United States, Gustav Stickley's magazine *The Craftsman*, first published in 1901 in Syracuse, New York, was the most important supporter of the Arts and Crafts tradition. The magazine's self-proclaimed mission was "to promote and to extend the principles established by [William] Morris," and its first issue was dedicated exclusively to Morris. Likewise, the inaugural issue of *House Beautiful*, published in Chicago in 1896, included articles on the English Arts and Crafts movement in general and on Morris in particular.

The Craftsman was a truly avant-garde, forward-looking magazine. It promoted the crafts, actively supported all the arts, published stories by the likes of Leo Tolstoy, poetry by Robert Frost, and in one notable, visionary instance, an article entitled "Is There Sex Distinction in Art? The Attitude of the Critic Towards Women's Exhibits."

Stickley's furniture became popular throughout the United States. Machine manufactured, it was massive in appearance and usually lacked ornamentation (Fig. 399). It s aesthetic appeal depended, instead, on the beauty of its wood, usually oak. Inspired by Ashbee's attempt to create a worker's community in England, Stickley planned to build a model farm and small family community on land he owned near Morris Plains, New Jersey. But also like Ashbee, Stickley did not succeed in realizing his dream.

Fig. 398 C. R. Ashbee, silver cup, c. 1893. Victoria & Albert Museum, London.

Fig. 399 Gustav Stickley, Settee (for the Craftsman Workshops), 1909. Oak and leather, back 38 × 71 7/16 × 22 in.; seat 19 × 62 in. Gift of Mr. and Mrs. John J. Evans, Jr., © 1993 The Art Institute of Chicago, All Rights Reserved.

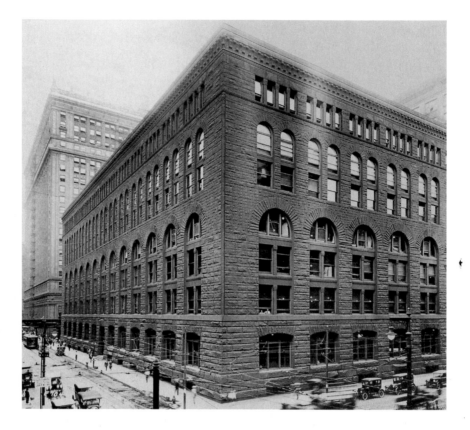

Fig. 400 H. H. Richardson, Marshall Field Wholesale Store, Chicago, 1885–87. Photo courtesy of the Art Institute of Chicago.

The Chicago School

When C. R. Ashbee, representing the British National Trust, visited America in 1900, he was especially struck by what he saw in Chicago: "Chicago is the only American city I have seen where something absolutely distinctive in the aesthetic handling of material has been evolved out of the Industrial system." A young architect named Frank Lloyd Wright impressed him most, but it was Wright's mentor, Louis Sullivan, who was perhaps most responsible for the sense of vitality that Ashbee was responding to.

In 1870 fire had destroyed much of downtown Chicago, providing a unique opportunity for architects to rebuild virtually the entire core of the city. For Sullivan, the foremost problem that the modern architect had to address was how the building might transcend the "sinister" urban conditions out of which, of necessity, it had to rise. Most urban buildings, of which Henry Hobson Richardson's Marshall Field Wholesale Store (Fig. 400), built after the fire, is a good example, were massive in appearance. Although Richardson employed a skeletal iron framework within the building to support its interior structure, its thick walls carried their own weight, just as they had for centuries. Richardson's genius lay in his ability to lighten this facade by means of the three- and two-story window arcades running from the second through the sixth floors. But from Sullivan's point of view, the building still appeared to squat upon the city block rather than rise up out of the street to transcend its environment.

For Sullivan, the answer rested in the development of steel construction techniques combined with what he called "a system of ornament." A fire-proofed steel skeletal frame freed the wall of load-bearing necessity, opening it both to ornament and to large numbers of exterior windows. The horizontality of Richardson's building is replaced by a vertical emphasis as the building's exterior lines echo the upward sweep of the steel skeleton. As a result, the exterior of the tall building needed no longer to seem massive; rather, it might rise with an almost organic lightness into the skies.

The building's real identity depended upon the ornamentation that could now freely be distributed across its facade. Ornament was, according to Sullivan, "spirit." The inorganic, rigid, and geometric lines of the steel frame would flow, through the ornamental detail that covered it, into "graceful curves," and angularities would "disappear in a mystical blending of surface." Thus at the top of Sullivan's Bayard Building (Fig. 401)—actually a New York rather than a Chicago building—the vertical columns that rise between the windows blossom in a neo-Gothic explosion of floral decoration.

Such ornamentation might seem to contradict completely the dictum that Sullivan is most famous for—"Form follows function." If the function of the urban building is to provide a well-lighted and ventilated place in which to work, then the steel frame structure and the abundance of windows on the building's facade does make sense. But what about the ornamentation? How does it follow from the structure's function? Isn't it simply an example of purposeless excess?

Down through the twentieth century, Sullivan's original meaning has largely been forgotten. He was not promoting a notion of design akin to the sense of practical utility that can be discovered in a Colt pistol or a Model T Ford. For Sullivan, "the function of all functions is the Infinite Creative Spirit,"

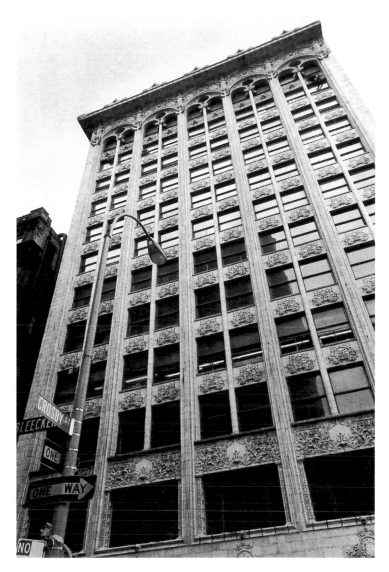

Fig. 401 Louis H. Sullivan, Bayard (Condict) Building, New York, 1897–1898.

Fig. 402 Frank Lloyd Wright,
Photo of wild flowers, in
William C. Gannett, *The House
Beautiful*, 1896–1897.

Fig. 403 Frank Lloyd Wright, Ornamental detail, in
William C. Gannett, *The House Beautiful*, 1896–1897.

and this spirit could be revealed in the
rhythm of growth and decay that we find in
nature. Thus the elaborate, organic forms that
cover his buildings, were intended to evoke
the Infinite. For Sullivan, the primary func-
tion of a building was to elevate the spirit of
those who worked in it.

Almost all of Sullivan's ornamental exu-
berance seems to have disappeared in the
architecture of Frank Lloyd Wright, whom
many consider the first truly modern archi-
tect. But from 1888 to 1893, Wright worked as
chief draftsman in Sullivan's Chicago firm,
and Sullivan's belief in the unity of design
and nature can still be understood as instru-
mental to Wright's work. In an article written
for the *Architectural Record* in 1908, Wright
emphasized that "a sense of the organic is
indispensable to an architect," and as early as
the 1890s, he was routinely "translating" the

natural and the organic into what he called
"the terms of building stone." In the orna-
mental detail Wright designed for William C.
Gannett's book *The House Beautiful*, Wright lit-
erally transformed the organic lines of his
own photograph of some wildflowers into a
geometric design dominated by straight lines
and rectangular patterns (Figs. 402 & 403).

The ultimate expression of Wright's
intentions is the so-called Prairie House, the
most notable example of which is the Robie
House in Chicago, designed in 1906 and built
in 1909 (Fig. 404). Although the house is
extraordinarily contemporary in feeling—
with its cantilevered roof extending out into
space (made possible by newly invented steel
and reinforced concrete construction tech-
niques), its fluid, open interiors, and its rigid-
ly geometric lines—it was, from Wright's
point of view, purely "organic" in conception.

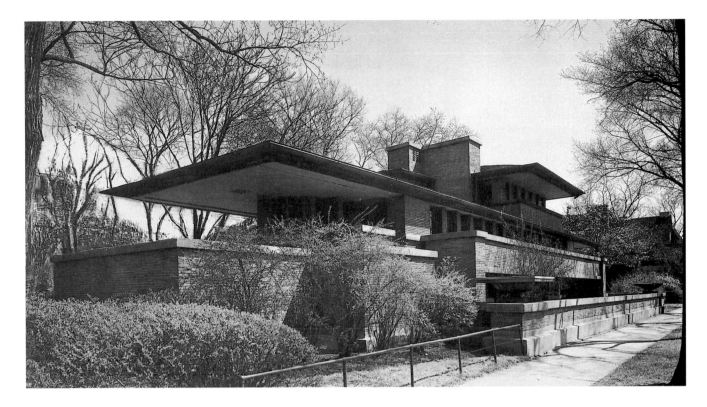

Fig. 404 Frank Lloyd Wright, Robie House, exterior, Chicago, 1909.

Wright spoke of the Prairie Houses as "of" the land, not "on" it, and the horizontal sweep of the roof and the open interior space reflect the flat expanses of the Midwestern prairie landscape. The cantilever, which allowed one to be simultaneously both outside and under a roof, was intended to tie together the interior space of the house and the natural world outside. Furthermore, the house itself was built of materials—brick, stone, and wood, especially oak—native to its surroundings.

Like Morris before him, Wright also felt compelled to design furniture for the interiors of his Prairie Houses that matched the design of the building as a whole (Fig. 405). "It is quite impossible," Wright wrote, "to consider the building as one thing, its furnishings another and its setting and environment still another. The Spirit in

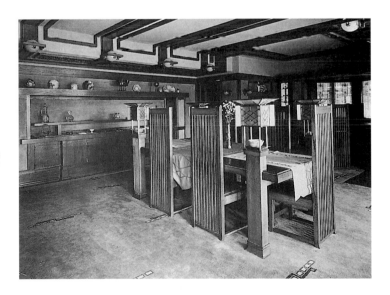

Fig. 405 Frank Lloyd Wright, Robie House, dining room with original furniture designed by Wright, 1909. The Domino's Center for Architecture & Design.

Fig. 406 Frank Lloyd Wright, Table lamp, Susan Lawrence Dana House, Springfield, Illinois, 1903. Bronze, leaded glass.

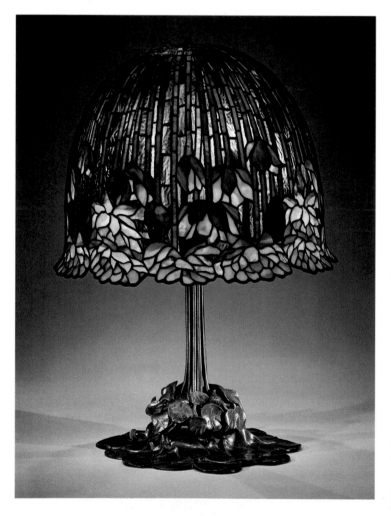

Fig. 407 Louis Comfort Tiffany, Lamp with leaded glass shade and bronze base, c. 1910. Height 26 1/2 in.; diameter 18 1/2 in. The Metropolitan Museum of Art, New York. Gift of Hugh J. Grant, 1974 (1974.214.15).

which these buildings are conceived sees these all together at work as one thing." The table lamp designed for the Lawrence Dana House in Springfield, Illinois (Fig. 406) is meant to reflect the dominant decorative feature of the house—a geometric rendering of the sumac plant that is found abundantly in the neighboring Illinois countryside, chosen because the site of the house itself was particularly lacking in vegetation. Given a very large budget, Wright designed 450 glass panels and 200 light fixtures for the house that are variations on the basic sumac theme.

Art Nouveau

The day after Christmas in 1895, a shop opened in Paris named the Galeries de l'Art Nouveau. It was operated by one S. Bing, whose first name was Siegfried, though art history almost universally has referred to him as Samuel, perpetuating a mistake made in his obituary in 1905. Bing's new gallery was a success, and in 1900, at the Universal Exposition in Paris, he opened his own pavilion, Art Nouveau Bing. By the time the Exposition ended the name **Art Nouveau** had come to designate not merely the work he displayed but a decorative arts movement of international dimension.

Bing had visited the United States in 1894. The result was a short book entitled *Artistic Culture in America*, in which he praised American architecture, painting, and sculpture, but most of all its arts and crafts. The American who fascinated him most was the glassmaker Louis Comfort Tiffany, son of the founder of the famous New York jewelry firm, Tiffany and Co. The younger Tiffany's work inspired Bing to create his new design movement, and Bing contracted with the American to produce a series of stained glass windows designed by such French artists as Henri Toulouse-Lautrec and Pierre Bonnard. Since oil lamps were at the very moment being replaced by electric lights—Thomas Edison had startled the French public with his demonstration of electricity at the 1889

Fig. 408 Louis Comfort Tiffany, Peacock Vase, c. 1910. Iridescent "favrile" glass, height 14 1/8 in.; width 11 1/2 in. The Metropolitan Museum of Art, New York. Gift of H. O. Havemeyer, 1896 (96.17.10).

Ancient Glass

Until the invention of glassblowing techniques late in the first century B.C., glassware was made by either forming the liquid glass on a core or casting it in a mold. Glassblowing so revolutionized the process that, in the Roman world, it quickly became a major industry.

This two-handed vase (Fig. 409) was probably made in the second half of the first century A.D. in Syria, then part of the Roman Empire. It is made of transparent blue glass that was rolled on a surface strewn with chips of blue, white, red, and yellow opaque glass. These chips expanded and elongated in the blowing process, creating a decorative patchwork of dripping blobs and splotches. By the time this vase was made, demand for glass was so great that many craftsmen moved to Italy to be near the expanding European markets.

International Exhibition—Bing placed considerable emphasis on new, modern modes of lighting. From his point of view, a new light and a new art went hand in hand. And Tiffany's stained-glass lamps (Fig. 407), back-lit by electric light, brought a completely new sense of vibrant color to interior space.

Even more than his stained glass, Bing admired Tiffany's iridescent Favrile glassware, which was named after the obsolete English word for handmade, "fabrile." The distinctive feature of this type of glassware is that nothing of the design is painted, etched, or burned into the surface. Instead, every detail is built up by the craftsperson out of what Tiffany liked to call "genuine glass." In the vase illustrated here (Fig. 408), we can see many of the design characteristics most often associated with Art Nouveau, from the wavelike line of the peacock feathers to the self-conscious asymmetry of the whole. In fact, the formal vocabulary of Art Nouveau could be said to consist of young saplings

Fig. 409 Two-handled vase in dappled glass, Syrian, 1st century A.D. Height: 4 5/8 in. Corning Museum of Glass, Corning, New York.

Source: Robert J. Charleston, *Masterpieces of Glass: A World History from the Corning Museum of Glass* (New York: Abrams, 1980).

Fig. 410 Jan Toorop, poster for *Delftsche Slaolie* (salad oil), 1894. Library of Congress.

and shoots, willow trees, buds, vines—anything organic and undulating, including snakes and, especially, women's hair. The Dutch artist Jan Toorop's advertising poster for a peanut-based salad oil (Fig. 410) flattens the long, spiraling hair of the two women preparing salad into a pattern very like the elaborate wrought-iron grillwork also characteristic of Art Nouveau design.

A brilliant example of this grillwork is provided by Hector Guimard's designs for the new Paris underground, the métropolitan, or the métro as it came to be called, which opened during the 1900 Universal Exposition (Fig. 411). The organic and undulating forms chosen by Guimard are symbolic not only of spring but also of the dawn of the new century. The entrances sometimes spread open to welcome the prospective rider like a flower opening to the sun, as seen to the right. At other stops, iron tendrils, painted green in order to appear more organic, rose beside the entrances, capped by buds containing electric lights—also a first, since only with the opening of the métro did Paris begin to be fully electrified. Guimard's intention was to make the new transportation system seem not only inviting but stylish and fashionable as well.

At first, the design sensibility of Art Nouveau might seem completely different from that of Frank Lloyd Wright. If we compare the ornate asymmetry of a Tiffany lamp with the geometrical symmetry of a lamp by Wright, for instance, they would appear to have little in common. Yet each designer looked to the natural world for his inspiration. More important, perhaps, both Tiffany and Wright share a desire to define an elegance of taste. Both wanted to create an environment of absolute beauty and sophistication.

Where the two differ is in how they sought to accomplish this design goal. Wright emphasized the simple. He designed furniture for his houses because, he said, "simple things…were nowhere at hand. A

Fig. 411 Hector Guimard, Paris Métro entrance, 1900.

Fig. 412 Eugène Gaillard, Buffet, 1900. Walnut. Museum of Decorative Art, Copenhagen.

piece of wood without a moulding was an anomaly, plain fabrics were nowhere to be found in stock." So he tended to emphasize the constructive basis of his design, that is, horizontal and vertical line. The practitioners of Art Nouveau, on the other hand, rejected, or at least suppressed, such simplicity. Describing a diningroom buffet by Eugène Gaillard (Fig. 412), exhibited by Bing at the 1900 Universal Exposition, one writer put it this way: "Despite the fact that the cabinet's principle lines go in vertical and horizontal direction…they never meet at an angle.… The encounter of the two lines becomes a conflict between two heterogeneous forces which, eventually, meet as an embrace. With this

coming together the ornamenting art is born—an indescribable curving and whirling ornament, which laces and winds itself with almost convulsive energy across the surface of the furniture!"

The Scottish designer Charles Rennie Mackintosh tried, in his work, to combine these competing impulses. In the enormous poster he designed for *The Scottish Musical Review* (Fig. 413), round organic elements are composed with an aggressively vertical and symmetrical geometry. In furniture such as the famous chair (Fig. 414) he designed for his own home, Hill House, the severe grid of the chair back, softened only by the round legs and rungs, dominates the design.

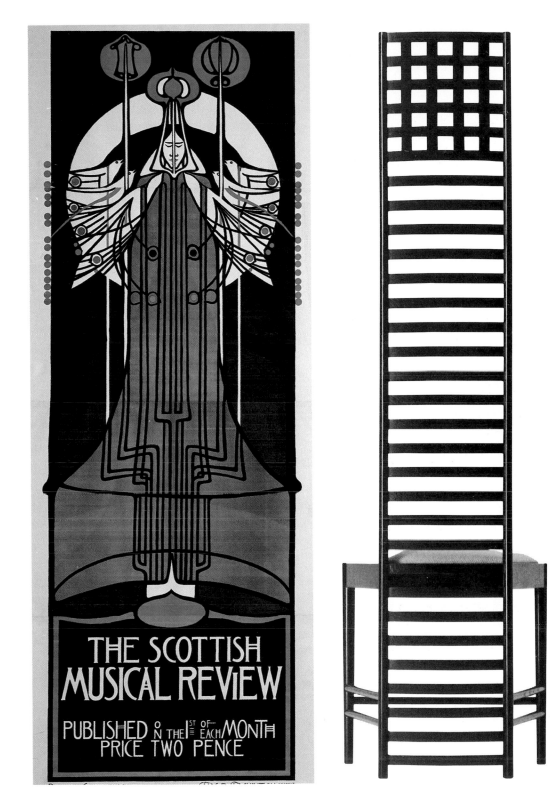

Fig. 413 Charles Rennie Mackintosh, *The Scottish Musical Review*, 1896. Lithograph, printed in color, 97 x 39 in. Collection, The Museum of Modern Art, New York. Acquired by exchange.

Fig. 414 Charles Rennie Mackintosh, Ladderback Chair, 1902. Ebonized wood, velvet upholstery. Chair, 55 1/4 x 16 x 13 1/2 in.; cushion, 1 3/4 x 14 3/8 x 11 3/4 in. Overall seat height, 17 1/2 in. Manufactured by Cassina S.p.A., Switzerland, 1974. Collection, The Museum of Modern Art, New York. Estee and Joseph Lauder Design Fund.

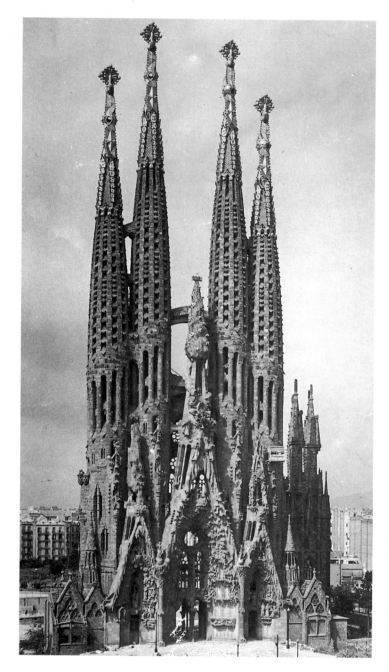

Fig. 415 Antoni Gaudí, Church of the Sagrada Familia, Barcelona, Spain, 1883–1926.

The organic, curvilinear qualities of Art Nouveau easily lent themselves to the development of an intensely personal and expressive style. In the hands of a master, such as the Spanish architect Antoni Gaudí, a level of formal invention was achieved that constitutes one of the most important artistic expressions of the period. Gaudí's Church of the Sagrada Familia (Fig. 415) is a twisting, spiraling, almost fluid mass of forms. In the architect's hands, masonry has been transformed into some pliable, natural material that seems as infinitely manipulable as his fantastic imagination is large.

Yet, for many, Art Nouveau seemed excessively subjective and personal, especially for public forms such as architecture. In Vienna, particularly, where Art Nouveau had flourished under the banner of the *Jugendstil*—literally, "the style of youth"—the curvilinear and organic qualities of Art Nouveau gave way to symmetry and simple geometry. Consider, for instance, the Palais Stoclet in Brussels (Fig. 416), designed by the Viennese architect Josef Hoffman. The exterior is starkly white and geometrical, and quite plain. But the interior was luxurious. Hoffman ringed the walls of the dining room, for instance, in marble inlaid with mosaics of glass and semiprecious stones including onyx and malachite designed by the Viennese painter Gustav Klimt. The theme of the mosaics was openly sexual. They were designed in the same spirit as paintings such as his *Salomé*, illustrated here (Fig. 417), which depicts a decadent society woman as if she were a temptress. For Hoffman, the interior of the house was private space, a place where fantasy and emotion could have free reign. Through the example of buildings like the Palais Stoclet, Art Nouveau became associated with an interior world of aristocratic wealth, refinement, and even emotional abandon, but it was also a style that realized the necessity of presenting, in its exteriors, a public face of order, simplicity, and control.

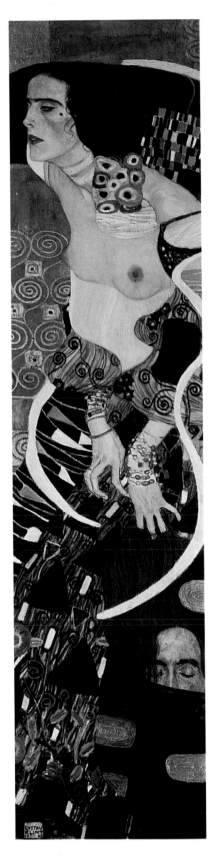

Fig. 416 Gustav Klimt, *Salomé*, 1909.

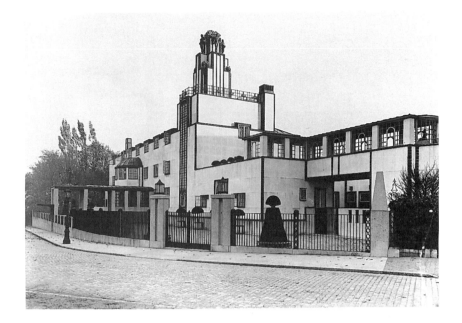

Fig. 417 Josef Hoffman, Palais Stoclet, Brussels, 1905–1911.

Fig. 418 Louis Süe and Andre Mare, Cabinet, 1927. Ebony, mother-of-pearl, silver, 61 7/8 × 35 3/8 × 15 1/2 in. Virginia Museum of Fine Arts, Richmond. Gift of Sydney and Frances Lewis Foundation.

Fig. 419 Paul T. Frankl, *Skyscraper Bookcase*, 1925–1930. Maple wood and bakelite, height 79 7/8 in.; width 34 3/8 in.; depth 18 7/8 in. The Metropolitan Museum of Art, New York. Theodore R. Gamble, Jr. Gift, in honor of his mother, 1982 (1982.30ab).

Art Deco

In 1925, the Exposition Internationale des Arts Décoratifs et Industriels Modernes opened in the center of Paris. Planned as early as 1907, during the height of Art Nouveau, logistical problems, especially the outbreak of World War I, postponed the exhibition for almost 20 years. A very influential event, the exposition was the most extensive international showcase of the style of design then called *Art Moderne* and, since 1968, better known as **Art Deco**.

Not only did individual designers build their own exhibition spaces, but every great French department store, as well as the leading French manufacturers, built lavish pavilions as well. Throughout, the emphasis was on a particularly French sense of fashionable luxury. There was no evidence anywhere of the practical side of design—no concern with either utility or function. In fact, the whole affair was so luxurious in tone that Herbert Hoover, then Secretary of Commerce in the Coolidge administration, declined to enter an American exhibit. "Works admitted to the Exposition must show new inspiration and real originality," Hoover explained. "They must be presented by artisans, artists, manufacturers, who have created the models…whose work belongs to modern decorative and industrial art.… Americans cannot meet the requirements." Hoover definitely underestimated the abilities of his countrymen. But he did understand the absolute difference between the functionalist ethic, epitomized by Henry Ford's Model T automobile, that dominated design in the United States and the opulence of French design taste.

The cabinet designed by the French furniture company Süe et Mare (Fig. 418) is typical of the most elaborate form of the Art Deco style featured at the 1925 exposition. Made of ebony, the preferred wood of Art Deco designers because it was extremely rare and, therefore, expensive, and inlaid with mother-of-pearl, abalone, and silver, the cabinet is

extraordinarily opulent. This richness of materials, together with the slightly asymmetrical and organic floral design of the cabinet door, link the piece to the earlier style of Art Nouveau.

But there was another type of Art Deco that, while equally interested in surface decoration, preferred more up-to-date materials—chrome, steel, and Bakelite plastic—and sought to give expression to the speed of everyday *"moderne"* life. The *Skyscraper Bookcase* by the American designer Paul T. Frankl (Fig. 419), made of maple wood and Bakelite, is all sharp angles that rise into the air like one of the brand-new skyscrapers that were beginning to dominate America's urban landscape.

One of the primary showcases for Art Deco design of both these types was the fleet of luxury ocean liners launched by the French in the early 1920s. Furnishings for the ships were commissioned from all the great French Art Deco designers, and travelers must have felt as if they were in a floating exhibition. A poster designed by A. M. Cassandre to promote a new cruise ship called the *Atlantique* (Fig. 420), shows a successful blending of the organic and geometrical aspects of Art Deco. The severity of the composition is softened by important organic details—the elegant curves of the ship's prow and smokestacks and especially the whirling drifts of smoke emerging from those smokestacks. The effectiveness of the design depends on an elimination of detail, the simplification of forms, and the repetition of elements—the shape of the large boat and the small tug on the horizon line, the rectangle of the ship and that of its reflection in the water. Even the typography—the letter shapes themselves—seems to echo the forms of the boats. Tragically, within fifteen months of its christening, the *Atlantique* was gutted by a fire, and a vast quantity of the best Art Deco design was lost with it.

Fig. 420 A. M. Cassandre, *L'Atlantique*, 1931. Lithograph, 39 3/4 × 25 in. Collection Merrill C. Berman.

Fig. 421 Benito, cover illustration, *Vogue*, May 25, 1929. *Vogue*
Copyright © 1924, 1929 (renewed 1952, 1957) by The Conde Nast
Publications Inc.

Fig. 422 Unidentified illustrator, corset, *Vogue*,
October 25, 1924. The Conde Nast Publications Inc.

Cassandre's ability to harmonize the organic and the geometric is perhaps the defining characteristic of Art Deco. Even the leading fashion magazines of the day reflect this in their covers and layouts. In Edouardo Benito's *Vogue* magazine cover (Fig. 421), we can see an impulse toward simplicity and rectilinearity comparable to Cassandre's poster design. It is no surprise that both Cassandre's and Benito's direction was mirrored in the world of fashion. In the early 1920s, the boyish silhouette became fashionable. The curves of the female body were suppressed (Fig. 422), and the waistline disappeared in tubular, "barrel"-line skirts. Even long, wavy hair, one of the defining features of Art Nouveau style, was abandoned, and the schoolboyish "Eton crop" became the hairstyle of the day.

The Avant-Gardes

At the 1925 Paris Exposition, one designer's pavilion stood apart from all the rest, not because it was better than the others, but because it was so different. As early as 1920, a French architect by the name of Le Corbusier had written in his new magazine *L'Esprit Nouveau* (The new spirit) that "decorative art, as opposed to the machine phenomenon is the final twitch of the old manual modes; a dying thing." He proposed a *"Pavillon de l'Esprit Nouveau"* (Pavilion of the New Spirit) for the exposition that would contain "only standard things created by industry in factories and mass-produced; objects truly of the style of today."

This "new spirit" was radically at odds with the handcrafted sensibility that dominated the other pavilions, and the organizers

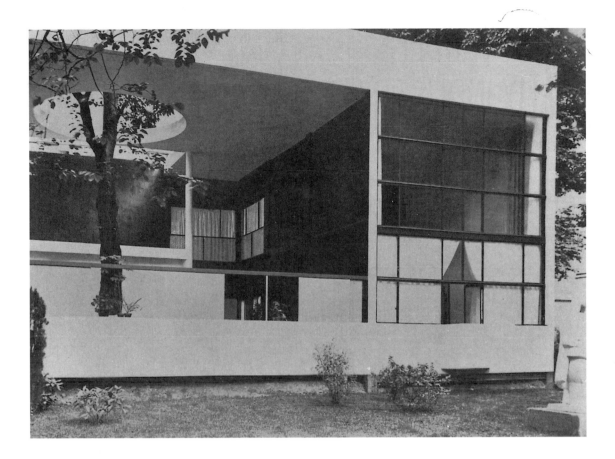

Fig. 423 Le Corbusier, Pavillon de l'Esprit Nouveau. Exposition Internationale des Arts Décoratifs et Industriels Modernes, Paris, 1925.

were horrified. Accordingly, they gave Le Corbusier a parcel of ground between two wings of the Grand Palais, with a tree, which could not be removed, growing right in the middle of it. Le Corbusier built his pavilion around the tree, cutting a hole in the roof to accommodate it (Fig. 423). The pavilion was built of concrete, steel, and glass, and its walls were plain white. So distressed were Exposition officials that they ordered a high fence to be built completely around the site in order to hide it from public view. Le Corbusier appealed to the Ministry of Fine Arts, and finally the fence was removed. "Right now," Le Corbusier announced in triumph, "one thing is sure: 1925 marks the decisive turning point in the quarrel between the old and the new. After 1925, the antique lovers will have

virtually ended their lives, and productive industrial effort will be based on the 'new.'"

To Le Corbusier, to make expensive, handcrafted work objects, such as the cabinet by Süe et Mare (Fig. 418), amounted to making antiques in a contemporary world. From his point of view, the other designers at the 1925 exposition were out of step with the times. The modern world was dominated by the machine, and though designers had shown disgust for machine manufacture ever since the time of Morris and Company, they did so at the risk living forever in the past. "The house," Le Corbusier declared, "is a machine for living."

The geometric starkness of Le Corbusier's design had been anticipated by developments in the arts that began to take

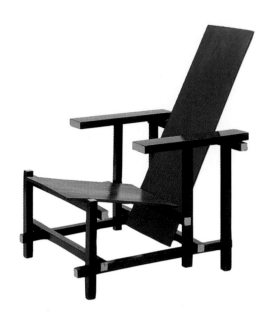

Figs. 424 & 425 Gerrit Rietveld, *Red and Blue Chair*, c. 1918. Wood, painted, 34 1/8 × 26 × 33 in.; seat height: 13 in. Collection, The Museum of Modern Art, New York. Gift of Philip Johnson.

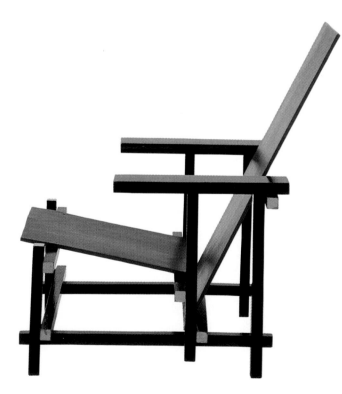

place in Europe before World War I. A number of new **avant-garde** (from the French meaning "advance guard") groups had sprung up, often with radical political agendas, and dedicated to overturning the traditional and established means of art-making through experimental techniques and styles.

One of the most important was the **De Stijl** movement in Holland. De Stijl, which is Dutch for "The Style," took its lead, like all the avant-garde styles, from the Cubist painting of Pablo Picasso and Georges Braque (see Fig. 120), in which the elements of the real world were simplified into a vocabulary of geometric forms. The De Stijl artists simplified the vocabulary of art and design even further, employing only the primary colors—red, blue, and yellow—plus black and white. Their design relied on a vertical and horizontal grid often dynamically broken by a curve or a circle or a diagonal line. Rather than enclosing forms, their compositions seemed to *open* out into the space surrounding them.

Gerrit Rietveld's famous chair (Figs. 424 & 425) is a summation of these De Stijl design principles. The chair is designed *against*, as it were, the traditional elements of the armchair. Both the arms and the base of the chair are insistently locked in a vertical and horizontal grid. But the two planes that function as the seat and the back seem almost to float free from the closed-in structure of the frame. Rietveld dramatized their separateness from the black grid of frame by painting the seat blue and the back red.

Rietveld's Schröder House, built in 1925, is an extension of the principles guiding his chair design. The interior of the box-shaped house is completely open in plan. The view represented here (Fig. 426) is from the living and dining area toward a bedroom. Sliding walls can shut off the space for privacy, but it is the sense of openness that is most important to Rietveld. Space implies movement. The more open the space, the more possibility for movement in it. Rietveld's design, in other words, is meant to immerse those who live in it in a dynamic situation that might, idealistically, release their own creative energies.

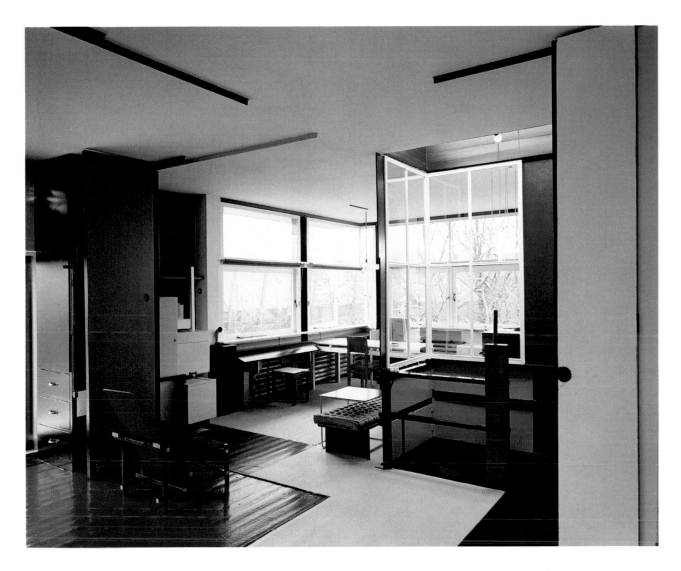

Fig. 426 Gerrit Rietveld, Living room, Schröder House, Utrecht, The Netherlands, 1925. Collection Centrall Museum Utrecht.

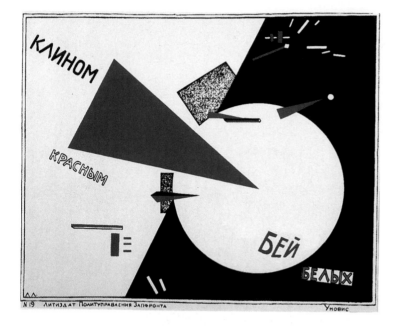

Fig. 427 El Lissitzky, *Beat the Whites with the Red Wedge*, 1919. Lithograph. Collection Stedelijk Van Abbemuseum, Eindhoven, The Netherlands.

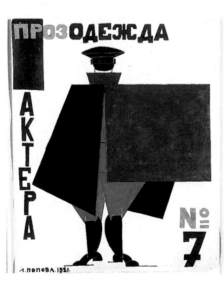

Fig. 428 Liubov Popova, *Production Clothing for Actor No. 7* for Fernand Crommelynch, *Le Cocu magnifique*, State Institute of Theatrical Arts, Moscow, 1922. Ink, gouache, varnish, and collage on paper, 12 ⁷/₈ × 9 ¹/₈ in. Collection Merrill C. Berman.

This notion of dynamic space can also be found in the work of the Russian **Constructivists**, who worked in the new postrevolutionary Soviet state and who dreamed of uniting art and everyday life through mass-production and industry. The artist, they believed, should "go into the factory, where the real body of life is made." They believed, especially, in employing nonobjective formal elements in functional ways. El Lissitzky's design for the poster *Beat the Whites with the Red Wedge* (Fig. 427), for instance, is a formal design with propagandistic aims. It presents the "Red" Bolshevik cause as an aggressive red triangle attacking a defensive and static "White" Russian circle. While the elements employed are starkly simple, the implications are disturbingly sexual—as if the Reds are male and active, while the Whites are female and passive—and the sense of aggressive action, originating both literally and figuratively from "the left," is unmistakable.

This same sense of geometrical simplification can be found in Liubov' Popova's Constructivist costume design (Fig. 428). Prior to World War I and the revolutions in Russia that followed, the Russian textile industry had relied on French fabric designs. Popova's use of the large brown square, almost burying the figure in its plain geometry, suggests the new direction Soviet design would follow. She sought to break from former styles—to create a sense of "revolutionary" dress. The nonobjective forms of Constructivism were, in her view, free of all reference, and so they were the ideal place upon which to build a "classless" dress, a universal and egalitarian costume. But most important, this was not a "static" design, but a dynamic one. By definition, as the body moved beneath it, this block of geometric fabric would move as well.

Perhaps nowhere has the dynamism of Russian Constructivism been more powerfully expressed than in Vladimir Tatlin's visionary *Monument to the Third International* (Fig. 429). Though it was never constructed, Tatlin

did make a large-scale model of the *Monument* for the U.S.S.R. pavilion at the 1925 Paris Exposition, and its affinities to Le Corbusier's Pavillon de l'Esprit Nouveau were noticed immediately. Its skeletal steel frame deliberately reminiscent of the Eiffel Tower, the *Monument* was intended to eclipse that Paris landmark and to become, at about 1,300 feet tall, the highest building in the world. The spiraling open-work construction was to have contained three monumental glass elements—a cube, a pyramid, and a cylinder, the essential forms of the Constructivist vocabulary—that would revolve on their axes at different speeds, one at a revolution of once per year, the second once a month, and the third once a day. The geometric forms were also intended to house the administrative, political, cultural, and scientific offices of the Communist International. For Tatlin, the spiral represented the inevitable advance of humanity under communism, the revolutionist's dream of never-ending progress toward a utopian workers' paradise.

Le Corbusier's l'Esprit Nouveau pavilion and Tatlin's *Monument* were not the only examples of the new rigorously geometric design sensibility at the 1925 Paris Exposition. The French abstract painter Sonia Delaunay also made a contribution in the form of daily fashion shows. Every evening during the run of the exposition, Delaunay dressed 20 models in her new geometric designs and paraded them through the grounds. Writing in the magazine *Surréalisme* in 1925, Claire Goll described the new dynamic Delaunay woman: "The black, white and red stripe runs down her almost like a new meander, giving her movements her own rhythm. And when she goes out, she slips into the delightful mole-coat, which is covered with wool embroidery, so it looks almost woven, and its lines filled in nuances of brown, rusty red and violet. When she has friends visiting, she wears an afternoon gown, in which a gaudy triangle cheerfully recurs. But in the evening

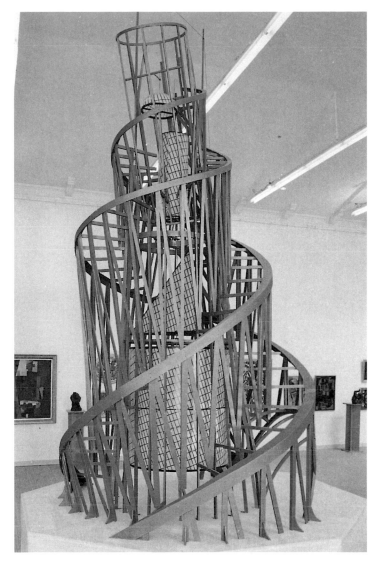

Fig. 429 Vladimir Tatlin, Model for *Monument to the Third International*, 1919–1920. Original model destroyed; reconstruction 1968. Wood, iron, and glass with motor, height 15 ft. 5 in. Moderna Museet, Stockholm.

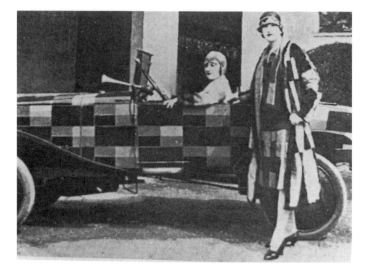

Fig. 430 Models wearing Sonia Delaunay designs with a Delaunay–customized Citroën B-12. From *Maison de la Mode*, 1925.

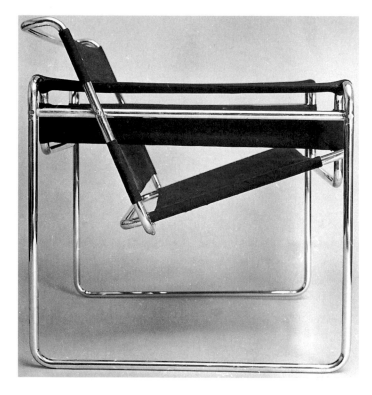

Fig. 431 Marcel Breuer, Armchair, Model B3. Late 1927 or early 1928. Chrome-plated tubular steel, canvas, 28 1/8 × 30 1/4 × 27 3/4 in. Collection, The Museum of Modern Art, New York. Gift of Herbert Bayer.

she wears the coat that is worthy of the moon and that was born of a poem." For the exposition, Delaunay transposed the design of her motoring ensemble onto a Citroën B-12 roadster (Fig. 430). Here, Delaunay announces, is the design for a new machine age.

The Bauhaus

At the German pavilion at the 1925 Paris Exposition one could see a variety of new machines designed to make the trials of everyday life easier—for instance, an electric washing machine and an electric armoire in which clothes could be tumbledried. Sonia Delaunay visited the pavilion with Walter Gropius, who in 1919 had founded a school of arts and crafts in Weimar, Germany known as the **Bauhaus**. She asked him who could afford such things. "To begin with, royalty," Gropius replied. "Later on, everybody."

Like Le Corbusier, Gropius saw in the machine the salvation of humanity. And he thoroughly sympathized with Le Corbusier whose major difficulty in putting together his Pavillon de l'Esprit Nouveau had been the unavailability of furniture that would satisfy his desire for "standard things created by industry in factories and mass-produced; objects truly of the style of today." Ironically, at almost exactly that moment, Marcel Breuer, a furniture designer working at Gropius's Bauhaus was doing just that.

In the spring of 1925, Breuer purchased a new bicycle manufactured out of tubular steel by the Adler company. Deeply impressed by the bicycle's strength—it could easily support the weight of two riders—its lightness, and its apparent indestructibility, Breuer began to envision furniture made of this most modern of materials. "In fact," Breuer later recalled, speaking of the armchair that he began to design soon after his purchase (Fig. 431), "I took the pipe dimensions from my bicycle. I didn't know where else to get it or how to figure it out."

The chair is clearly related to Rietveld's *Red and Blue Chair* (Figs. 424 & 425), consisting of two diagonals for seat and back set in a cubic frame. It is easily mass-produced—and, in fact, is still in production today. But its appeal was due, perhaps most of all, to the fact that it looked absolutely new, and it soon became an icon of the machine age. Gropius quickly saw how appropriate Breuer's design would be for the building he had designed for the new Bauhaus in Dessau, and by early 1926, Breuer was at work designing modular tubular-steel seating for the school's auditorium, as well as stools and side chairs to be used throughout the educational complex. As a result, Breuer's furniture became totally identified with the Bauhaus.

But the Bauhaus was much more. In 1919, Gropius had defined an official program for the school. He was determined to break down the barriers between the crafts and the fine arts and to rescue each from its isolation by training craftspeople, painters, and sculptors to work on cooperative ventures. There was, Gropius said, "no essential difference" between the crafts and the fine arts. There were, in fact, no "teachers" either; there were only "masters, journeymen, and apprentices." The curriculum, which has influenced many art school programs to this day, was founded upon a basic course, consisting of two-dimensional design, three-dimensional design, color theory, and, subsequently, in-depth study of each of the media. All of this led to what Gropius believed was the one place where all of the media could interact and all of the arts work cooperatively together. "The ultimate aim of all creative activity," Gropius declared, "is the building," and, in fact, the name is derived from the German words for building (*Bau*) and house (*Haus*).

We can understand Gropius's goals if we look at Herbert Bayer's design for the cover of the first issue of *Bauhaus* magazine, which was published in 1928 (Fig. 432). Each of the three-dimensional forms—cube, sphere, and cone—

Fig. 432 Herbert Bayer, Cover for *Bauhaus 1*, 1928. Photomontage. Bauhaus–Archiv, Berlin.

casts a two-dimensional shadow. The design is marked by the letter forms Bayer employs in the masthead. This is Bayer's Universal Alphabet, which he created to eliminate what he believed to be needless typographical flourishes, including capital letters. Bayer, furthermore, constructed the image in the studio and then photographed it, relying upon the means of mechanical reproduction instead of the handcrafted, highly individualistic medium of drawing. The presence of the pencil and triangle, in fact, suggests that any drawing to be done is mechanical drawing, governed by geometry and mathematics. Finally, the story on the cover of the first issue of *Bauhaus* is concerned—it should come as no surprise—with architecture, to Gropius the ultimate creative activity.

Oriental Carpets

It is quite probable that pile carpet was developed by nomadic herding families to cover floors with a single, unbroken sweep of material instead of a collection of disparate animal skins. Over the centuries what began as a craft for personal use developed into a trade item and eventually into complex manufactures, with professional designers and weavers often at the service of a ruler or potentate.

The carpet illustrated here (Fig. 433) was probably made in Anatolian Turkey in the sixteenth century. A pattern woven in Anatolia for many decades, it was apparently based on a widely available master cartoon, and it rarely changed. The distinctive design may well have originated among Asian nomads. It developed as a court design in central Turkey and subsequently spread through exportation to Europe, where it became very fashionable. It was, at any rate, copied by local manufacturers in Spain, Flanders, England, and Italy, as well as in North Africa and India.

Much of the best evidence for dating a particular carpet pattern comes from its reproduction in Western paintings of the late fifteenth and sixteenth centuries when traders flooded the European markets with fine examples of carpets from Turkey, Persia, and Asia. This carpet is an example of the "Lotto" pattern, so named because it appears in two paintings by the sixteenth-century Venetian artist Lorenzo Lotto, in a *Family Group* of 1523 in the National Gallery, London, and in *Saint Antonino Pierozzi Giving Alms,* in the Church of Saints Giovanni and Paolo in Venice.

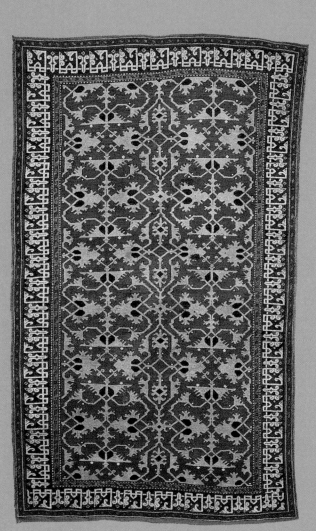

Fig. 433 "Lotto" rug, Konya (?), Anatolia, 16th century. Wool, 6 ft. 9 in. × 4 ft. 1 in. Philadelphia Museum of Art: The Joseph Lees Williams Memorial Collection.

Source: Charles Grant Ellis, Oriental Carpets in the Philadelphia Museum of Art (Philadelphia: Philadelphia Museum of Art, 1988).

Bayer led the typography section of the school, but there were also workshops in metal, glass, stage design, ceramics, and textiles. In 1922, a young woman named Anni Fleischmann entered the Bauhaus to pursue her studies in textiles. She concentrated on this area because it was the only one open to woman students. By 1925, when she married a master at the school, Josef Albers (whose studies in color theory we have already seen [Fig. 157]), she had become one of the most important textile designers of the century. The wall hanging at the right (Fig. 434) was done on a twelve-harness loom. Consequently, Anni Albers designed it as a 12-unit horizontal grid, each unit of which is a vertical rectangle variable only in its patterning, which is solid or striped. The striped rectangles are themselves divided into units of twelve alternating stripes. Occasional cubes are formed when two rectangles of the same pattern appear side by side.

Anni Albers regarded such geometric play as rooted in nature. Inspired by a reading of Goethe's *Metamorphosis of Plants*, she was fascinated by the way a simple basic pattern could generate, in nature, infinite variety. There is, in the design here, no apparent logic to the occurrence of solid or striped rectangles or in the colors employed in them. This variability of particular detail within an overall geometric scheme is, from Albers's point of view, as natural and as inevitable as the repetition itself.

In 1930, Anni Albers received her Bauhaus degree. Her final project was a stage curtain for an auditorium in Bernau that had been designed by Hannes Meyer, who had succeeded Gropius as director in 1928. Made of cotton, chenille, and cellophane, the curtain reflected light as well as absorbing sound. When Adolf Hitler closed the Bauhaus in 1933—he found its combination of leftist thinking and experimental, abstract art "decadent"—Anni moved with her husband to the United States.

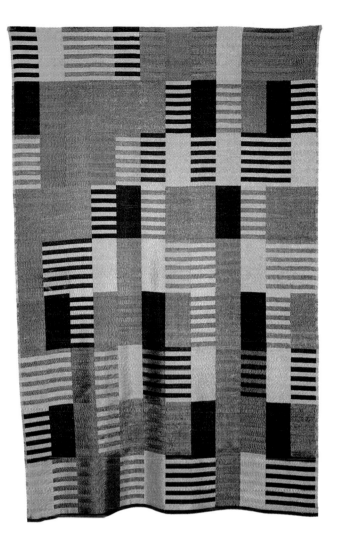

Fig. 434 Anni Albers, Tapestry, 1926. Three-ply weave, 72 × 48 in. Courtesy of The Busch-Reisinger Museum, Harvard University; Association Fund.

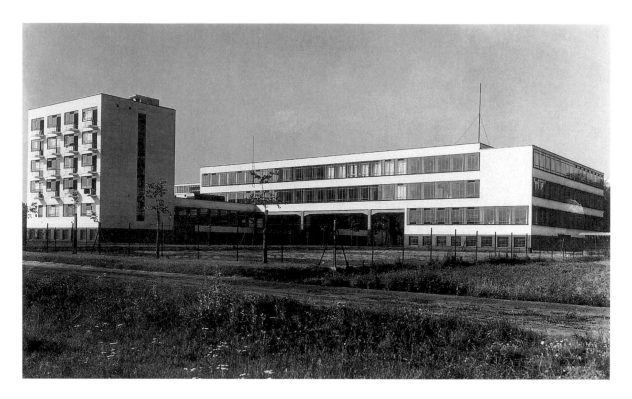

Fig. 435 Walter Gropius, Bauhaus, Dessau, Germany, 1925–1926. Photograph courtesy Museum of Modern Art, New York.

The International Style

With the closing of the Bauhaus in 1933, and the ever-increasing threat of Nazism, a large number of the school's faculty emigrated to the United States. Walter Gropius accepted a chair in Architecture at Harvard University. Ludvig Miës van der Rohe, the school's third and final director, accepted a position at the Massachusetts Institute of Technology, and Josef and Anni Albers went to Black Mountain College in North Carolina.

Already, in 1932, Alfred H. Barr, Jr., a young curator at the Museum of Modern Art in New York, who would later become one of the most influential historians of modern art, had written, in the catalogue for an exhibition entitled "Modern Architecture, International Exhibition," that a new "International Style…based primarily upon the nature of modern materials and structure" had taken hold. He elaborated: "Slender steel posts and beams, and concrete reinforced by steel have made possible structures of skeletonlike

strength and lightness. The modern architect working in the new style conceives of his building…as a skeleton enclosed by a thin light shell. He thinks in terms of volume—of space enclosed by planes and surfaces—as opposed to mass and solidity. This principle of volume leads him to make his walls seem thin flat surfaces by eliminating moldings and by making his windows and doors flush with the surface."

In many ways, Barr might have been describing a Breuer chair. He definitely had in mind the architectural work of Gropius and Miës, whom he identified as two of the founders of the new style. In fact, a scale model of Gropius's design for the Bauhaus school at Dessau (Fig. 435) was chosen by the show's organizers to represent Gropius's work. The building was praised for its "bold rhythms and walls of glass," and for "its masterly adjustment of a variety of rhythms of monotonous regularity to produce a general composition at once rich and serene." These

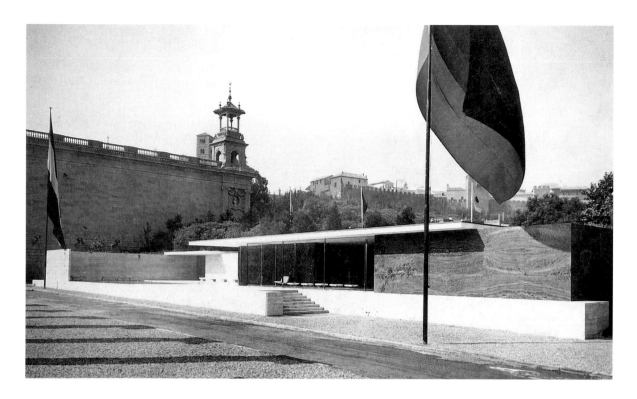

Fig. 436 Ludvig Miës van der Rohe, German Pavilion, International Exposition, Barcelona, Spain, 1929. Photograph courtesy, Miës van der Rohe Archive, The Museum of Modern Art, New York.

last words are as appropriate a description of Anni Albers's wall hanging as they are of the building, and they indicate the stylistic foundation of the Bauhaus aesthetic.

In Miës van der Rohe's German Pavilion for the 1929 International Exposition in Barcelona (Fig. 436), the bold horizontal rhythms of Gropius's Bauhaus are simplified to an extreme. As the floor plan (Fig. 437) makes clear, Miës wants most of all to open the space of architecture. The bands of marble walls and sheets of glass held between stainless steel poles extend back from the entry steps under a daringly cantilevered roof. The back wall encloses, but only barely, a large pool, visible in the lower left of the floor plan, that reflects both building and sky so that, as the visitor climbs the short set of stairs approaching the pavilion, the entire structure seems to shimmer in light. Built, in fact, to showcase the German marble industry, the perfectly proportioned and immaculate building shines like a jewel.

Fig. 437 Ludvig Miës van der Rohe, German Pavilion, International Exposition, Barcelona, Spain, 1929. Final scheme. Plan. Drawing made for publication. 1929. Ink, pencil on paper, 22 1/2 × 38 1/2 in. Collection, Miës van der Rohe Archive, The Museum of Modern Art, New York. Gift of Ludwig Miës van der Rohe.

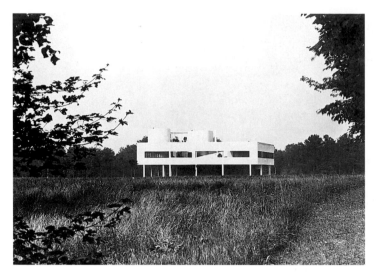

Fig. 438 Le Corbusier and Jeanneret, Villa Savoye, Poissy-sur-Seine, France, 1928–1930. Photograph courtesy, The Museum of Modern Art, New York.

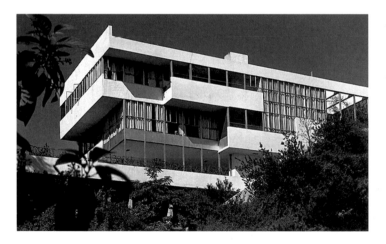

Fig. 439 Richard Neutra, Lovell House, Los Angeles, California, 1927–1929. Photo: Julius Shulman.

For Barr, the other great founder of the International Style was Le Corbusier. Taking advantage of the strength of concrete-and-steel construction, Le Corbusier lifted his houses on stilts (Fig. 438), thus creating, out of the heaviest of materials, a sense of lightness, even flight. The entire structure is sublimely simple, composed of primary forms (that is, rectangles, circles, and so on). Writing in his first book, *Towards a New Architecture*, translated into English in 1925, Le Corbusier put it this way: "Primary forms are beautiful forms because they can be clearly appreciated."

One of the first International Style homes built in the United States was designed by the Vienna-born architect Richard Neutra (Fig. 439). This concrete-and-glass volume, supported by an entirely visible steel frame, was conceived to take full advantage of the mild southern California climate. Miës van der Rohe's Farnsworth House (Fig. 440), which was built in 1950, proving how enduring the style was, likewise opens itself to its surroundings. At once an homage to Le Corbusier's Villa Savoye, and a reincarnation of the architect's own German Pavilion, the house is virtually transparent—both opening itself out into the environment and inviting it in.

While Barr had been quick to acknowledge Frank Lloyd Wright as the forerunner of the International Style, Wright himself disavowed the style. In his Kaufmann House, known as "Fallingwater," because it is literally constructed over a waterfall, Wright did employ the basic architectural vocabulary of Le Corbusier, Miës, and Neutra, using concrete-and- steel cantilevered construction. But where their houses seem separate from their surroundings, Wright's house seems integrated into its site. Its cantilevers echo the strata of the cliffs. It employs natural stone in its rising chimney. Even though the house is dominated by glass, providing its owners with a sense of being literally in the midst of the landscape, it remains private in a way that the interiors of the other houses do not.

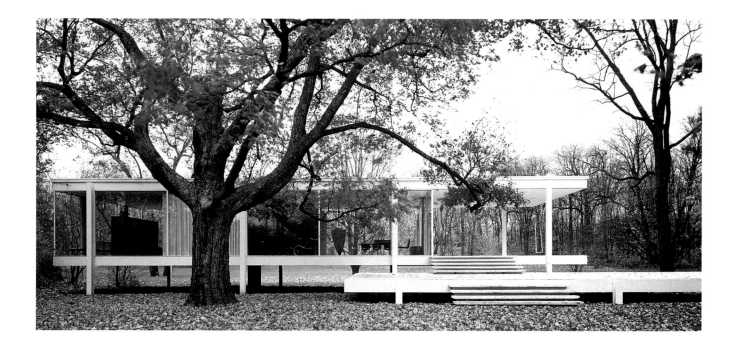

Fig. 440 Ludvig Miës van der Rohe, Farnsworth House, Fox River, Plano, Illinois, 1950. Photo: Bill Hedrich, Hedrich-Blessing.

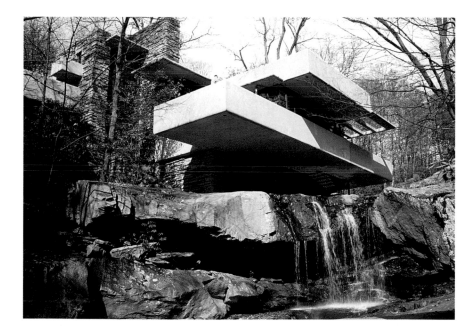

Fig. 441 Frank Lloyd Wright, "Fallingwater," Kaufmann House, Bear Run, Pennsylvania, 1936.

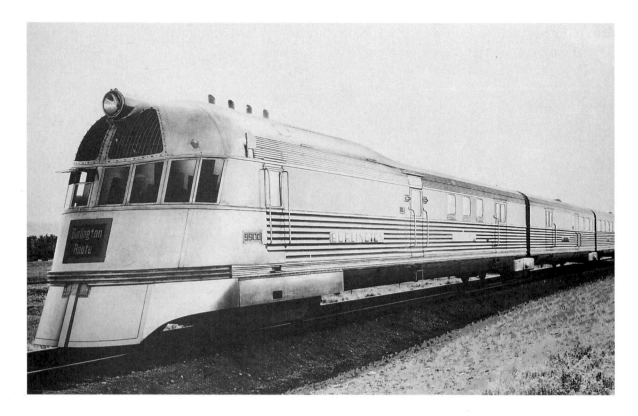

Fig. 442 Burlington *Zephyr #9900*, 1934. Manufactured by the Edward G. Budd Company for the Chicago, Burlington and Quincy Railroad. Photo courtesy Burlington Northern Co.

Streamlining

Even as the geometries of the International Style came to dominate architectural design in the early 1930s, a much more organic and curvilinear notion of design was rapidly gaining acceptance as a result of advances in scientific knowledge. In 1926, the Daniel Guggenheim Fund for the Promotion of Aeronautics granted $2.5 million to the Massachusetts Institute of Technology, the California Institute of Technology, the University of Michigan, and New York University to build wind tunnels. Designers quickly discovered that by eliminating extraneous detail on the surface of a plane, boat, automobile, or train, and by rounding its edges so that each subform merged into the next by means of smooth transitional curves, air would flow smoothly across the surface of the machine. Drag would thereby be dramatically reduced, and the machine could move faster

with less expenditure of energy. "Streamlining" became the transportation cry of the day.

The nation's railroads were quickly redesigned to take advantage of this new technological information. One engineer had calculated that a standard train engine would expend 350 horsepower more than a streamlined one operating at top speed. At 70 to 110 mph, streamlining would increase pulling capacity by 12 percent. It was clearly economical for the railroads to streamline.

At just after five o'clock on the morning of May 26, 1934, a brand new streamlined train called the Burlington *Zephyr* (Fig. 442) departed Union Station in Denver bound for Chicago. Normally, the 1,015 mile trip took 26 hours, but this day, averaging 77.61 mph and reaching a top speed of 112 mph, the *Zephyr* arrived in Chicago in a mere 13 hours and 5 minutes. The total fuel cost for the

haul, at 5¢ per gallon, was only $14.64. When the train arrived later that same evening at the Century of Progress Exposition on the Chicago lakefront, it was mobbed by a wildly enthusiastic public. If the railroad was enthralled by the streamlined train's efficiency, the public was captivated by the its speed. It was, in fact, through the mystique of speed that the Burlington Railroad meant to recapture dwindling passenger revenues. Ralph Budd, president of the railroad, deliberately chose not to paint the *Zephyr's* stainless-steel sheathe. To him it signified "the motif of speed" itself.

But the *Zephyr* was more than its sheathe. It weighed one-third less than a conventional train, and its center of gravity was so much lower that it could take curves at 60 mph that a normal train could only negotiate at 40. Because regular welding techniques severely damaged stainless steel, engineers had invented and patented an electric welding process to join its stainless-steel parts. All in all, the train became the symbol of a new age. After its trips to Chicago, it traveled over 30,000 miles, visiting 222 cities. Well over 2 million people paid a dime each to tour it, and millions more viewed it from the outside. Late in the year, it became the feature attraction of a new film, *The Silver Streak*, a somewhat improbable drama about a high-speed train commandeered to deliver iron lungs to a disease-stricken Nevada town.

Wind-tunnel testing had revealed that the ideal streamlined form most closely resembled a teardrop. A long train could hardly achieve such a shape—at best it resembled a snake. But the automobile offered other possibilities. As early as 1930, R. Buckminster Fuller was studying the airflow effects around a conventional car contour and around the contour of the ideal teardrop streamlined form (Fig. 443). In 1933, he rented a factory in Bridgeport, Connecticut, built a prototype of his ideal car, and introduced it that same year. But by the time it was presented to the nation at the

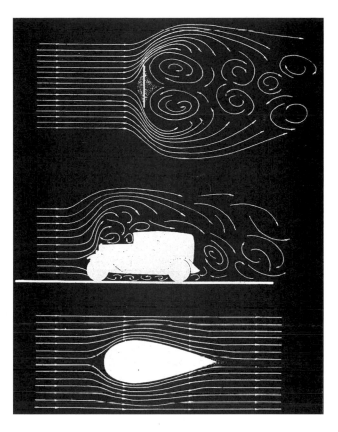

Fig. 443 R. Buckminster Fuller, Airflow Diagram, 1930. ©1960 The Estate of Buckminster Fuller; Courtesy, Buckminster Fuller Institute, Los Angeles.

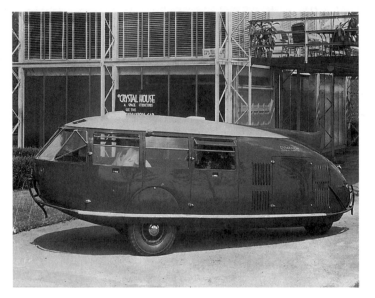

Fig. 444 R. Buckminster Fuller, *Dymaxion* car in front of the Crystal House, Chicago, 1934. © 1960 The Estate of Buckminster Fuller; Courtesy, Buckminster Fuller Institute, Los Angeles.

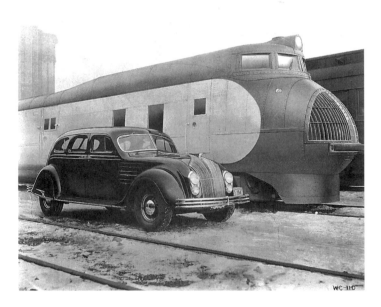

Fig. 445 Chrysler *Airflow* 4-Door sedan, 1934. Engine 8 cyl., L-head, 122 h.p. Steel body, broadcloth seats. Designer Chrysler Styling Section. Manufacturer Chrysler Corporation, Detroit. Chrysler Corporation Historical Archives, Detroit, Michigan.

Century of Progress Exposition in Chicago in 1934, the future of his three-wheeled, rear engine *Dymaxion* automobile (Fig. 444) was in jeopardy. Capable of reaching 120 mph with a 90 horsepower engine (a standard 1934 sedan required a 300 horsepower engine to attain the same speed), it consumed 30 percent less fuel at 30 mph and 50 percent less at 50 mph than comparable automobiles. Few, however, believed it to be safe. Late in 1933, a representative of British car-racing interests, who had flown to Chicago to test drive the *Dymaxion*, was injured and his driver killed when the automobile collided with another near the entrance to the Century of Progress Exposition. The public wanted the security of an engine out in front where they could see it. Engineers blamed the incident on "fishtailing": they noted that when a driver steered the front end of the *Dymaxion* car away from an oncoming vehicle, he also steered the rear end into it.

The first production model streamlined car was the Chrysler *Airflow* (Fig. 445), which abandoned the teardrop ideal and adopted the look of the new streamlined trains. (It is pictured here with the 1934 Union Pacific *Streamliner*.) The man who inspired Chrysler to develop the automobile was Norman Bel Geddes. Geddes was a poster and theatrical designer when he began experimenting, in the late 1920s, with the design of planes, boats, automobiles, and trains—things he thought of as "more vitally akin to life today than the theatre." When, after the stock market crash in 1929, his staff of twenty engineers, architects, and draftsmen found themselves with little or nothing to do, he turned them loose on a series of imaginative projects, including the challenge to dream up some way to transport "a thousand luxury lovers from New York to Paris fast. Forget the limitations." The specific result was his *Air Liner Number 4* (Fig. 446), designed with the assistance of Dr. Otto Koller, a veteran

airplane designer. With a wingspan of 528 feet, Geddes estimated that it could carry 451 passengers and 115 crew members from Chicago to London in 42 hours. It passenger decks included a dining room, game deck, solarium, barber shop and beauty salon, nursery, and private suites for all on board. Among the crew were a nursemaid, a physician, a masseuse and a masseur, wine stewards, waiters, and an orchestra.

Although Geddes insisted that the plane could be built, it was the theatricality and daring of the proposal that really captured the imagination of the American public. Geddes was, in fact, something of a showman. In November 1932 he published a book entitled *Horizons* that included most of the experimental designs he and his staff had been working on since the stock market collapse. It was wildly popular. And its popularity prompted Chrysler to go forward with the *Airflow*. Walter P. Chrysler hired Geddes to coordinate publicity for the new automobile. In one ad, Geddes himself, tabbed "America's foremost industrial designer," was the spokesman, calling the *Airflow* "the first sincere and authentic streamlined car...the first *real* motor car." Despite this, the car was not a success. Though it drew record orders after its introduction in January 1934, the company failed to reach full production before April, by which time many orders had been withdrawn, and serious production defects were evident in those cars the company did manage to get off the line. The *Airflow* attracted over 11,000 buyers in 1934, but by 1937, only 4,600 were sold, and Chrysler dropped the model.

This didn't stop Geddes, however, because he was busy streamlining the rest of the world. First in *The Ladies' Home Journal*, and then in *Horizons*, Geddes projected *The House of Tomorrow* (Fig. 447), a sort of marriage between streamlining and the International Style. Speed was obviously no longer at issue; style was. To be modern,

Fig. 446 Norman Bel Geddes, with Dr. Otto Koller, *Air Liner Number 4*, 1929. Norman Bel Geddes Collection, Theatre Arts Collection, Harry Ransom Humanities Research Center, The University of Texas at Austin.

Fig. 447 Norman Bel Geddes, *The House of Tomorrow*, 1931. Norman Bel Geddes Collection, Theatre Arts Collection, Harry Ransom Humanities Research Center, The University of Texas at Austin.

Fig. 449 Raymond Loewy, Pencil sharpener, 1933. Prototype. Collection Jack Solomon, Circle Fine Art Corporation.

Fig. 448 Norman Bel Geddes, "Soda King", c. 1935. Syphon bottle, chrome-plated and enamelled metal with rubber fittings. Made by Walter Kidde Sales Company. The Brooklyn Museum. 82.168.2, H. Randolph Lever Fund.

Fig. 450 Russel Wright, "American Modern" dinnerware, designed 1937, introduced 1939. Made by Steubenville Pottery, East Liverpool, Ohio. Glazed earthenware. The Brooklyn Museum 84.124.3, 80.169.2 and 5, 83.108.21, 32, 35, 42-44. Gifts of Russel Wright, Paul F. Walter, Ina and Andrew Feuerstein.

Fig. 451 Russel Wright, "American Modern" dinnerware, designed 1937, introduced 1939. Made by Steubenville Pottery, East Liverpool, Ohio. Glazed earthenware. Department of Special Collections, George Arents Research Library, Syracuse University.

everything now had to be streamlined, including the siphon bottle on the opposite page, designed by Geddes himself (Fig. 448). Other designers quickly joined the rush. For Raymond Loewy, one of the most successful American designers and creator of the Exxon logo (Fig. 188), streamlining was "a state of mind." For him, it was "the perfect interpretation of the modern beat." Streamlining, he wrote, "symbolizes simplicity—eliminates cluttering detail and answers a sub- conscious yearning for the polished, orderly essential." Thus it was no contradiction at all, from his point of view, to adopt a style created to satisfy the practical need for more efficient modes of transportation to

a object as mundane as a pencil sharpener (Fig. 449). Writing in 1938, designer Russel Wright asserted that it was in objects such as Loewy's streamlined pencil sharpener and Wright's own streamlined tableware (Fig. 451) that the "American character" of a "distinct American design" could be felt. Like Geddes's *The House of Tomorrow*, Wright's stainless-steel flatware (Fig. 450), designed four years before the dinnerware, melds streamlining effects with the geometries of the International Style. But the dinnerware, completely influenced by the trend toward streamlining, is almost completely organic and antigeometric in feel, announcing, once again, a new direction in American design.

An African Spoon

This ceremonial spoon of the Dan people native to Liberia and the Ivory Coast is symbolic of the female and is carried by the most hospitable woman of the clan. Known as a *wunkirle*, this woman is recognized for her spirit of giving, and the spoon itself, which is in the form of a woman, substitutes a large scoop, nearly one foot in length, for the *wunkirle's* head. Translated, this scoop is called the "belly pregnant with rice." The reverse side is carved in incised lines that represent the quest for fertility.

The *wunkirle* carries this spoon as a staff at festivals in her honor, at which she dances and sings dressed in men's clothing because, in the words of one *wunkirle*, "only men are taken seriously." As other *wunkirles* arrive, the festival becomes a competition, as each strives to give away more than the others. Finally the most generous *wunkirle* of all is proclaimed, and the men sing in her honor.

Source: *Praise Poems: The Katherine White Collection* (Seattle, Wash.: Seattle Art Museum, 1984).

Fig. 452 Feast-making spoon, back view. The Seattle Art Museum. Gift of Katherine C. White and the Boeing Company, 81.17.204.

Fig. 453 Feast-making spoon, Liberia/Ivory Coast, Dan, 20th century. Wood and iron, height 24 ¼ in. The Seattle Art Museum, Gift of Katherine C. White and the Boeing Company, 81.17.204.

The Forties and Fifties

The fully organic forms of Russel Wright's "American Modern" dinnerware anticipate the major shift in direction away from design dominated by the right angle and toward the looser, more curvilinear style announced by the Museum of Modern Art's 1940–1941 competition, "Organic Design in Home Furnishings." The first prize in that competition was awarded jointly to Charles Eames and Eero Saarinen, both young instructors at the Cranbrook Academy of Art in Michigan. Under the direction of the architect Eliel Saarinen, Eero's father, Cranbrook was similar in many respects to the Bauhaus, especially in terms of its emphasis on interdisciplinary work related particularly to architectural environments. It was, however, considerably more open to experiment and innovation than the Bauhaus, and the Eames-Saarinen entry in the Museum of Modern Art competition was the direct result of the elder Saarinen encouraging his young staff to rethink entirely just what furniture should be.

All of the furniture submitted by Eames and Saarinen to the show (Fig. 454) made use of molded plywood shells in which the wood veneers were laminated to layers of glue. The resulting forms almost demand to be seen from more than a single point of view. The problem, as Eames wrote, "becomes a sculptural one." The furniture was very strong, comfortable, and reasonably priced. Because of the war, production and distribution was necessarily limited, but, in 1946, the Herman Miller Company made 5,000 units of a chair Eames designed with his wife, Ray Eames, also a Cranbrook graduate (Fig. 455). Instantly popular and still in production today, the chair consists of two molded plywood forms that float on elegantly simple steel rods. The effect is amazingly dynamic: the back panel has been described as "a rectangle about to turn into an oval," and the seat almost seems to have molded itself to the sitter in advance.

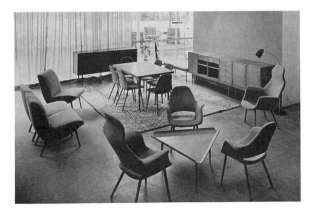

Fig. 454 Installation view from the exhibition "Organic Design in Home Furnishings." September 24, 1941 through November 9, 1941. The Museum of Modern Art, New York. Photograph courtesy, The Museum of Modern Art, New York.

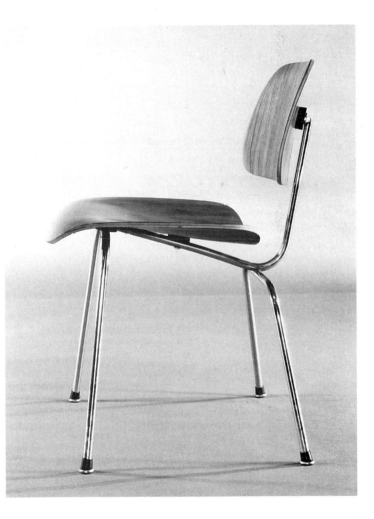

Fig. 455 Charles and Ray Eames, Side chair, Model DCM, 1946. Molded walnut plywood, steel rods, and rubber shock mounts, height 29 1/2 × 20 1/2 × 21 1/2 in. Collection, The Museum of Modern Art, New York. Gift of Herman Miller Furniture Company.

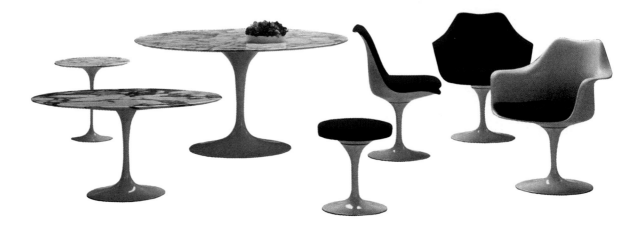

Fig. 456 Eero Saarinen, *Tulip Pedestal Furniture*, 1955–1957. Chairs: plastic seat, painted metal base; tables: wood or marble top, plastic laminate base. Saarinen Collection designed by Eero Saarinen in 1956 and 1957, courtesy of The Knoll Group.

Eero Saarinen took the innovations he and Eames had made in the "Organic Design in Home Furnishings" competition in a somewhat different direction. Unlike Eames, who in his 1946 chair had clearly abandoned the notion of the one-piece unit as impractical, Saarinen continued to seek a more unified design approach, feeling that it was more economical to stamp furniture from a single piece of material in a machine. His *Tulip Pedestal Furniture* (Fig. 456) is one of his most successful solutions. Saarinen had planned to make the pedestal chair entirely out of plastic, in keeping with his unified approach, but he discovered that a plastic stem would not take the necessary strain. Forced, as a result, to make the base out of cast aluminum, he nevertheless painted it the same color as the plastic in order to make the chair appear of a piece.

Saarinen's architectural work is likewise unified in design, and likewise derives from natural forms. Probably his two most successful buildings are airline terminals that were completed after his death in 1961. The TWA terminal at Kennedy International Airport in New York (Figs. 457 & 458) was designed in 1956. The building's interior space is defined by a contrast between the openness provided by the broad expanses of window and the sculptural mass of the reinforced-concrete walls and roof. What results is a constant play of light and shadow throughout the space. The exterior—two huge concrete wings that appear to hover above the runways—is a symbolic rendering of flight. Washington's Dulles International Airport (Fig. 459), designed in 1959, is much larger than the TWA terminal. Out-thrust column-like piers hold a vast canopy in place so that the roof appears to be a giant wing, soaring in space. The air-traffic control tower, rising behind the terminal like a floating Chinese pagoda, underscores the international character of both the building and the cosmopolitan city it serves.

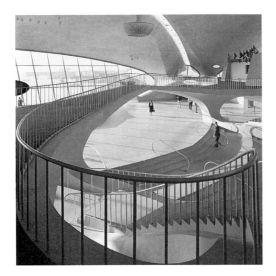

Figs. 457 & 458 Eero Saarinen, TWA Terminal, Kennedy International Airport, New York, 1962. Photos: Ezra Stoller © Esto.

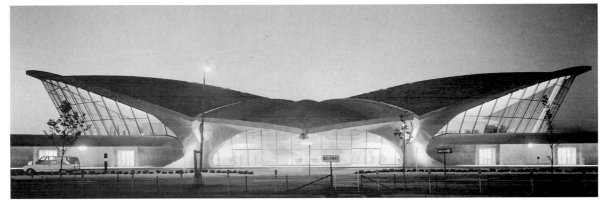

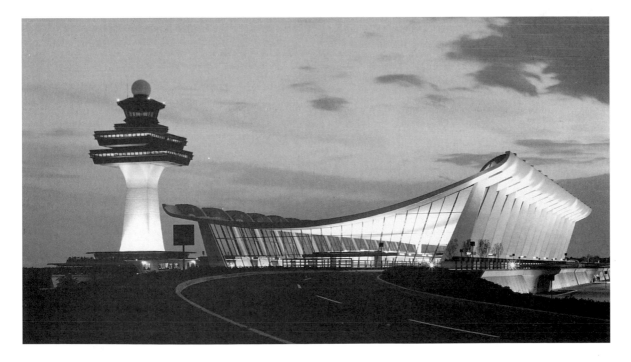

Fig. 459 Eero Saarinen, Dulles International Airport, Chantilly, Virginia, 1962. Photo: Ezra Stoller © Esto.

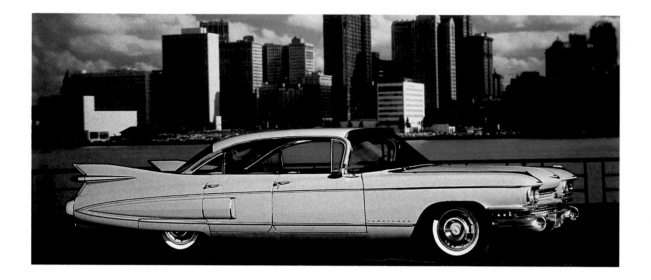

Fig. 460 Cadillac Fleetwood, 1959. Courtesy General Motors Corp.

There was an explosion of new American design after the end of World War II, due, at least in part, to the rapid expansion of the economy as 12 million American men and women were demobilized. New home starts rose from about 200,000 in 1945 to 1,154,000 in 1950. These homes had to be furnished, and new products were needed to do the job. Passenger car production soared from 70,000 a year in 1945 to 6,665,000 in 1950, and in the following ten years Americans built and sold over 58 million automobiles. In tune with the organic look of the new furniture design, these cars soon sported fins, suggesting both that they moved as gracefully as fish and that their speed was so great that they needed stabilizers. The fins were, in fact, inspired by the tail fins on the U.S. Air Force's P-38 "Lightning" fighter plane, which Harley Earl, chief stylist at General Motors, had seen during the war. He designed them into the 1948 Cadillac as an aerodynamic symbol. But by 1959, when the craze hit its peak, fins no longer had anything to do with aerodynamics. As the Cadillac (Fig. 460) made clear, it had simply become a matter of the bigger the better.

In many ways, the Cadillac's excess defines American style in the 1950s. This was the decade that brought the world fast food (both the McDonald's hamburger and the TV dinner), Las Vegas, *Playboy* magazine, and a TV in every home. But there were, in the 1950s, statements of real elegance. One of the most notable was the graphic design of the Swiss school, notably that of Armin Hofmann. Recognizing, in his words, that "the whole of sensory perception has been shifted by the photographic image," he freely incorporated photographs into his poster designs. Like Saarinen in his air terminal designs, Hofmann placed his emphasis on finding a symbolic form or image appropriate to the content of his message. The poster for the ballet *Giselle* (Fig. 461) immediately conveys the idea of dance, but it is in the studied contrast between light and dark, between the blurred, speeding form of the dancer and the static clarity of the type, between, finally, the geometry of the design and the organic movement of the body that Hofmann arrives at something like a synthesis of the competing stylistic forces at work in the history of modern design.

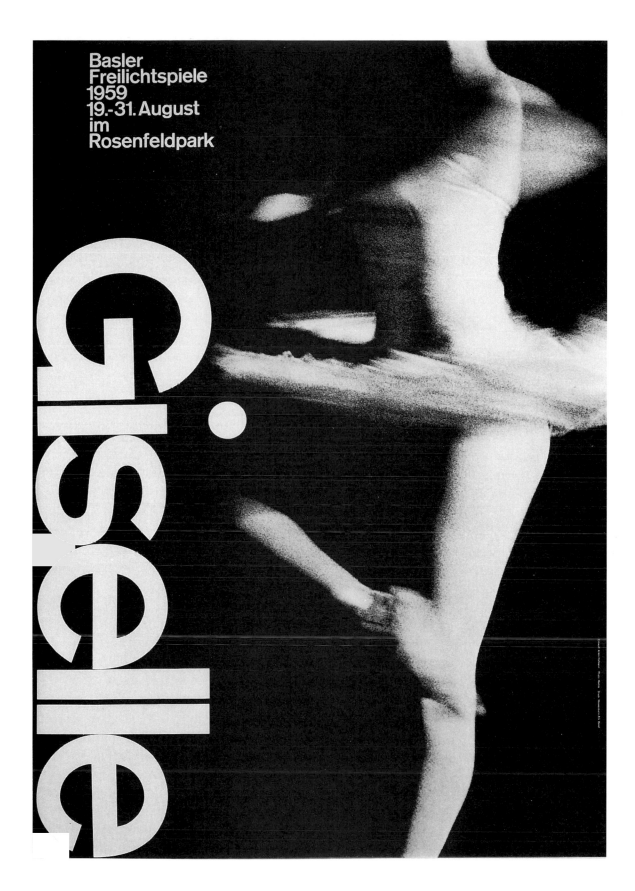

Fig. 461 Armin Hofmann, *Giselle*, 1959. Offset lithograph, 50 ³/₄ × 35 ⁵/₈ in. Courtesy Reinhold-Brown Gallery, New York.

Fig. 462 Philip Johnson, Glass House, New Canaan, Connecticut, 1949. Photo: Ezra Stoller

Contemporary Design

One way to view the evolution of design since 1960 is to recognize a growing tendency to accept the organic/geometric and natural/mechanical split that dominates its history as not so much an either/or situation as a question of both/and. In its unification of competing and contrasting elements, Hofmann's graphic design anticipates this synthesis. So, indeed, does the Eames chair, with its contrasting steel-support structure and molded plywood seat and back.

But, as has been indicated in the earlier discussion of postmodernism, the contemporary has been marked by a willingness to incorporate just anything and everything into a given design. This is not simply a question of the organic versus the geometric. It is, perhaps even more, a question of the collisions of competing cultures of an almost incomprehensible diversity and range. On our shrinking globe, united by television and the telephone, by the fax machine and the copier, and especially by increasingly interdependent economies, we are learning to accept, perhaps faster than we realize, a plurality of styles.

Until the mid-1970s, the design professions operated as a sort of research laboratory for producing *standardized* objects of *universal appeal.* At worst, there was a desire to create a vast, homogeneous mass market. At best, the goal was to speak a language of beauty so universal that it would, inevitably, appeal to all. It is this second aim that initially moved the architect Philip Johnson, who as a young man authored the foreword to the Museum of Modern Art's 1932 "Modern Architecture" exhibit, to design his own home (Fig. 462). Clearly inspired by Miës van der Rohe, the glass block rises directly out of the surrounding space and opens, through its glass walls, into it. Except for the central round brick cylinder containing toilet and bath, the practical side of living in a transparent glass house has been almost entirely ignored. It is a pure aesthetic statement, meant to be considered

only as a thing of beauty. In Johnson's own words, "If the business of getting the house to run well takes precedence over your artistic invention the result won't be architecture at all; merely an assemblage of useful parts."

Johnson has continued to design buildings up to the present day, but, by the late 1940s, he had abandoned the International Style, which might be said to have reached its ultimate statement in his glass house anyway. He turned instead to a more contemporary design vocabulary of multiple styles, usually working in collaboration with the younger architect, John Burgee.

Postmodernism has in many ways been defined by the work's willful *eclecticism* (the word *eclectic* means "made up of diverse styles"). Johnson and Burgee's design for the College of Architecture at the University of Houston (Fig. 463) could be described, paraphrasing Johnson's words quoted above, as an assemblage of *unuseful* parts. That is, the classical colonnade on the roof seems as out of place as a maraschino cherry on a scoop of egg salad. Conceived as a crown on the building's roof, visible from all over the campus, the colonnade does identify the College of Architecture and is symbolic of the kind of work that goes on within it. But to many eyes it is merely decorative, and in terms of style, it certainly bears no relation to the main building below it.

The Johnson and Burgee design was not uniformly adored, not least of all because it seemed to many to lack the sense of "artistic invention" that Johnson claimed had motivated the design of the Glass House. The design of the College of Architecture, by contrast, directly recalls the eighteenth-century architect Claude-Nicolas Ledoux's design for the House of Education, a never-constructed building that he planned to include in the utopian community at Chaux, France (Fig. 464). This *appropriation* of an earlier work purposely undermines the idea of originality

Fig. 463 Philip Johnson and John Burgee, College of Architecture, University of Houston, Texas, 1983–1985. Photo: Richard Payne.

Fig. 464 Claude-Nicolas Ledoux, House of Education, Chaux project, 1773–1779. Engraved by Van Maelle and Mailla.

and invention as necessary artistic goals. It suggests that the idea of "originality" is a something of a fiction, that everything we make and do derives from and depends upon historical precedent. For postmodern artists, architects, and designers, such an idea is liberating, freeing them to use whatever seems appropriate to their purposes. In the case of Johnson and Burgee, it is likely that in their reference to Ledoux they wished to create, on the University of Houston campus, something of the same utopian sense of community that had inspired Ledoux's project 200 years before.

Fig. 465 Raymond Loewy, Coca-Cola bottle. "Coke," "Coca-Cola" and the Dynamic Ribbon device are trademarks of The Coca-Cola Company and are used with permission.

What we mean when we speak of the stylistic pluralism of contemporary design is clear if we compare a traditional corporate identity package with a conspicuously post-modern one. Although the Coca-Cola bottle has changed over the course of time, Raymond Loewy's 1957 redesign of the bottle (Fig. 465) makes it slightly more streamlined and sleeker than earlier versions and changes the embossed lettering to white paint—the script logo itself has remained constant almost since the day Dr. John Pemberton first served the concoction on May 8, 1886 at Jacob's Pharmacy in downtown Atlanta, Georgia. Coke claims that today more than 90 percent of the world's men, women, and children easily recognize the bottle.

By contrast, the Music Television Network, MTV, and the designers of Swatch watches, the Swiss husband and wife team Jean Robert and Käti Durrer, conceive of their design identities as kinetic, ever-changing variations on a basic theme (Figs. 466 & 468). In recent years, both the television and music industries have more and more turned from producing shows and recordings designed to appeal to the widest possible audience to a concentration on appealing to more narrowly defined, specialized audiences. Television learned this lesson with the series "St. Elsewhere," which had very low overall ratings, but which attracted large numbers of married, young, upper middle-class professionals—yuppies—with enough disposable income to attract, in turn, major advertising accounts.

In the light of this situation, it is no longer necessary to standardize a corporate identity. It may not even be desirable. Illustrated here are eight of the approximately 300 watch designs produced by Robert and Durrer between 1983 and 1988, which were

Fig. 466 Basic MTV logo and variations. Manhattan Design; designers Pat Rogoff, Frank Olinsky, Pat Gorman. MTV: MUSIC TELEVISION logo is a registered trademark of MTV Networks, a division of Viacom International Inc. © 1993. All Rights Reserved.

inspired by a variety of cultures, from Japanese to Native American, and styles. Each watch is designed to allow the wearer's unique individuality to assert itself. "In 1984," Robert and Durrer recall, "we saw a gentleman sitting in the back of his Rolls Royce. We couldn't help noticing a Swatch on his wrist. That showed us how great the breakthrough had been."

Nothing is perhaps more representative of the change from a uniform design sensibility to a pluralist vision than the poster at the right by graphic designers April Greiman and Jayme Odgers (Fig. 467). Greiman, in all her work, likes to juxtapose opposites. In this collaboration with Odgers, the trapezoidal form of the design makes the top of the poster appear to move back into space away from the bottom, as if it were simultaneously two- and three-dimensional. In the words of one critic, "Her designs make opposites play on a common field: East/West, Stability/Change, Order/Randomness… Tension/Balance, Technical/Tribal… Classic/Eclectic, Cerebral/Sensual, New Wave/No Wave."

Fig. 467 April Greiman and Jayme Odgers, Moving announcement for Douglas W. Schmidt, 1980. Trapezoidal poster, top 17 in., bottom 21 in., height 24 in. Courtesy April Greiman.

Fig. 468 Jean Robert and Käti Durrer, Swatch watches, 1983–1988. Courtesy Swatch AG Biel.

Fig. 469 Ettore Sottsass, *Casablanca* cabinet, 1981. Laminate print.
Production: Memphis srl, Milano.

Fig. 470 Lisa Krohn, *Phonebook*, 1986. Injection-molded plastic.

The development of this pluralist design vision has been aided and abetted by a widespread reaction in the design community against the "good taste" aesthetic of mass consumption. One of the chief figures in this movement has been the Italian Ettore Sottsass, who designed Olivetti's first electronic typewriter in 1958. In the mid-1970s, Sottsass spearheaded an Italian-based international design cooperative known as Memphis. For Sottsass, personal expression takes precedence over mass appeal, and appearance is more important than function. His *Casablanca* cabinet (Fig. 469) does indeed function as a cabinet, but it is primarily a visual statement. As one Memphis designer has put it: "Industry must face up to a new strategy of production, no longer based on the great semantic reductions which classical design furnished, but rather based on a new and intensive process of imparting cultural significance to the product; a product able to choose its own user, able to create its own market, and most importantly able to exhibit qualities, no longer seemingly objective (and substantially anonymous), but personal and subjective.… From high-tech to high-touch."

The pluralist sensibility is also a function of the vast amount of information with which we are constantly bombarded in a technological society. The computer industry—especially in its personal computer and lap-top lines—has striven to create products designed to help us integrate and control this flow of information. An elegant example is Cranbrook graduate Lisa Krohn's 1986 *Phonebook*. (Fig. 470). At once a telephone and an answering machine, it stores telephone numbers and messages, as well as transcribing and thermally printing messages and conversations. Each of its functions is initiated with the flip of a page. The appeal of its design, however, depends upon how it manages these operations at human scale, integrating high-tech and high-touch, the technology of the machine and the intimacy of the book.

9 ARCHITECTURE

In design schools such as the Bauhaus the ultimate art was architecture. The feeling was that architecture contained all the other arts: paintings and fabrics were made to be hung upon its walls, sculpture was created to ornament its exterior facades, and furniture was designed to decorate its interior spaces. And yet architecture itself is but a part of a much larger structural unit. Each building, each home, is a part of the community as whole. And the community must, in its turn, fit into the complex fabric that we have come more and more to recognize as the "global village" in which we must all learn to live and operate.

It is not easy to conceive, visually, just what this global village might look like. We have no image of it, other than the look of the planet Earth from an orbiting satellite, and that is an image designed by forces larger than humankind. Nonetheless, the global village *has* been designed by us. Even these days, it may seem to resemble Paul Citroen's dizzying collage cityscape *Metropolis* (Fig. 471), done when he was a student at the Bauhaus. Amplified by our own knowledge of the untold wealth and unimaginable poverty of the late twentieth century, Citroen's image suggests that we can, even should, begin to think about what it is we have made.

Topography and Technology

The "look" of our built environment depends on two different factors and their interrelation. In the first place, the distinct landscape characteristics of the local site—its **topography**—have traditionally influenced the ways in which we build. The built environment reflects the natural world and the conception of the people who inhabit it of their place within the natural scheme of things. A building's form might echo the world around it, or might contrast with it—but, in each case, the choices

Fig. 471 Paul Citroen, *Metropolis*, 1923. Collage of photographs, prints, and postcards, 30 × 23 in. Prentenkabinet der Rijksuniversiteit Leiden, The Netherlands.

Fig. 472 Small Shinto shrine at Hotaka, Nagano-Ken, Japan.

builders make reveal their attitudes toward the world around them. The Shinto shrine on a mountain top at Hotaka, Nagano-Ken, Japan (Fig. 472), is, in effect, a "found" building. Conceived to honor the *kami*, or spirits, who live in nature, it is composed of two upright stones and a giant horizontal slab that has fallen to form the cave-like structure. The shrine does not merely imitate nature, it *is* nature, and reflects the Shinto belief in the inherent sacredness of such sites.

The focal point of the great city of Teotihuacán ("the place of the gods") is the monumental Pyramid of the Sun (Fig. 473). Built by an agricultural people on a square base 738 feet across, with a total height of nearly 246 feet, its contour mirrors the mountain behind it. It is from this mountain that life-giving water flows, and the Pyramid of the Sun is, in fact, a monument to the seasonal cycle of life. Human sacrifices, performed in the temple that once stood at its top, were intended to sustain the natural order of things.

The entire complex at Teotihuacán appears to have been planned with the natural world in mind. The Pyramid of the Sun is situated precisely at the point on the horizon where the sun sets at the summer solstice. Running in front of it is the so-called Avenue of the Dead, culminating at its north end in the Plaza and Pyramid of the Moon, a somewhat smaller pyramid situated to reflect the builders' ideas about astronomy. Even as the city reached its maximum size, in the second and third centuries A.D., with a population of as many as 200,000, it continued to grow with a remarkable regularity and order. Rivers were even rechanneled as city blocks based on modules of 187 feet divided the city into a mathematically precise grid that undoubtedly reflected some spiritual significance.

The forms of the built environment are determined as well by the **technologies** available to the builder. Of course, little or no technology at all was required to make the Shinto shrine, but its form is essentially that of the

Fig. 473 Pyramid of the Sun (in the distance) and Avenue of the Dead (running from bottom center diagonally to the right), Teotihuacán, Mexico, c. 100 B.C.–A.D. 650.

most ancient of construction devices, the **post-and-lintel**, which may have derived from such natural formations. Post-and-lintel construction consists of a horizontal beam supported at each end by a vertical post or a wall. In essence, the downward force of the horizontal bridge holds the vertical posts in an upright position, and conversely, the posts support the stone above in a give-and-take of directional force and balance. This type of construction can be seen in its most basic form in the Lion Gate at Mycenae, Greece, which was built around 1250 B.C. (Fig. 473). So large are the stones used to build this gate—both the length of the lentil and the total height of the post-and-lintel structure are roughly 13 feet—that later Greeks believed it could only have been built by the mythological race of one-eyed giants, the Cyclops.

Fig. 474 The Lion Gate, Mycenae, Greece, 1250 B.C.

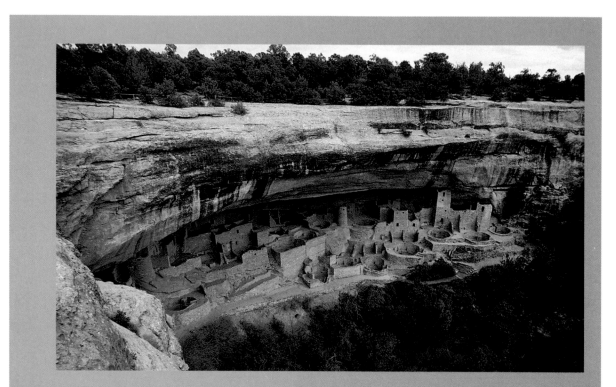

Fig. 475　Mesa Verde, Spruce Tree House, c. 3000–1500 B.C.

The Anasazi Cliff Dwelling

The architecture of the vast majority of early civilizations was designed to imitate natural forms. Thus in Egypt, as one approached the mammoth pyramids, covered in limestone to reflect the sun, the eye was carried skyward to the god Re, the Sun itself. The pyramidlike structures of Mesopotamia are flatter and wider than their Egyptian counterparts, as if imitating the shape of the foothills that were the source of water in that culture.

This Anasazi cliff dwelling, known as Spruce Tree House (Fig. 475), at Mesa Verde National Park in southwestern Colorado, reflects a similar relation between man and nature. Although we will never know just why the Anasazi withdrew from the mesa tops where they had first settled into caves in the cliffsides, it seems probable that the cave

provided security, and that to build there was to be closer to the people's origin and, therefore, to the source of their strength. Why in about A.D. 1300, the cliff dwellings were themselves also abandoned is an even greater mystery. There appears to have been a severe drought from 1276 to 1299. It is also possible that disease, a shortened growing season, or warfare with Apache and Shoshone tribes also caused the Anasazi to leave the highland mesas and to migrate south into Arizona and New Mexico.

At the heart of the Anasazi culture was the *kiva*, a round, covered hole in the center of the communal courtyard in which all ceremonial life took place. In the kiva floor was a *sipapu*, a small, round hole symbolic of the Anasazi creation myth, which told of the emergence of

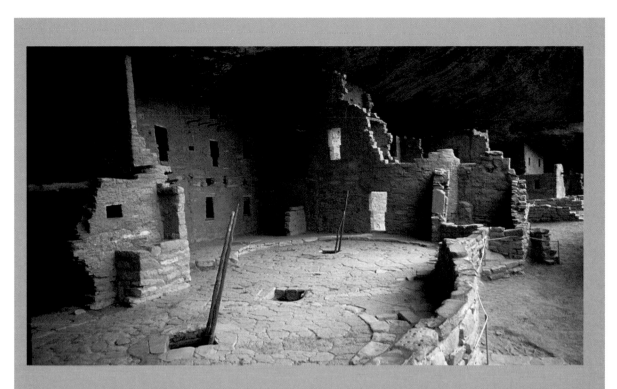

Fig. 476 North courtyard of Spruce Tree House formed by restoration of the roofs over two underground kivas.

the Anasazi's ancestors from the depths of the earth. In the parched Southwestern desert country it is equally true that water, like life itself, also seeps out of small fissures in the earth. Thus, it is as if the entire Anasazi community, and everything necessary to its survival, emerges from mother earth.

Spruce Tree House was occupied between A.D. 1200 and 1300, and consists of 114 rooms, in buildings rising as high as three stories, and 8 kivas. Between 150 and 200 people lived in the community. The roofs of two underground kivas on the north end of the ruin have been restored. Constructed of horizontally laid logs built up to form a dome, with an access hole, they come together so that the people could utilize these roofs as a common area (Figs. 476 & 477).

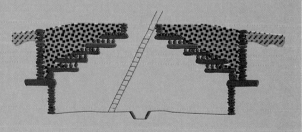

Fig. 477 Cribbed roof construction of a kiva (after a National Park Service pamphlet).

Source: William M. Furguson and Arthur H. Rohn, *Anasazi Ruins of the Southwest in Color* (Albuquerque: University of New Mexico Press, 1987).

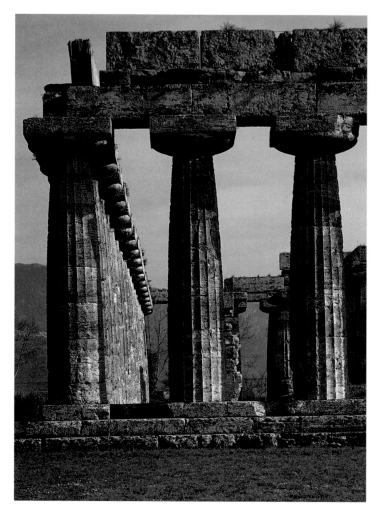

Fig. 478 Corner of the Basilica, Paestum, Italy, c. 550 B.C.

Post-and-lintel construction is fundamental to all Greek architecture. As can be seen in the Basilica at Paestum (Fig. 478), the columns, or posts, supporting the structure were placed relatively close together. This was done for practical reasons, since if stone lintels, especially of marble, were required to span too great a distance, they were likely to crack, and eventually collapse. Each of the columns in the Basilica is made of several pieces of stone, called *barrels*. *Fluting*, or grooves, run the length of the column and unite these pieces into a single unit. Each column tapers dramatically toward the top and slightly toward the bottom, an architectural feature known as *entasis*. Entasis deceives the eye and makes the column look absolutely vertical. It also gives the column a sense of almost human musculature and strength. The columns in fact suggest the bodies of human beings, holding up the roof like miniature versions of the giant Atlas, who carried the world on his shoulders.

The geometrical order of the Greek temple suggests a conscious desire on the Greek's part to control the natural world. So strong was this impulse that their architecture seems defiant in its belief that the intellect is superior to the irrational forces of nature. We can read this same impulse in Roman architecture—the will to dominate the site. The Sanctuary of Fortuna, or Fate, at Praeneste, in the foothills of the Apennines east of Rome (Figs. 479 & 480), seems to embrace the whole of the landscape below in one giant sweep of its mammoth ramps and terraces, as if it were literally the Roman Empire itself, engulfing the entire Mediterranean world. But despite its enormous size, the temple seems to fit into the hillside it occupies, as if in harmony with the landscape, not in opposition to it. As a temple to Fortune, or Fate, it seems to assert the inevitability of empire, the destiny of Rome to control and oversee the entire world. It is as if the Roman state is so large, so magnificent, it *is* nature.

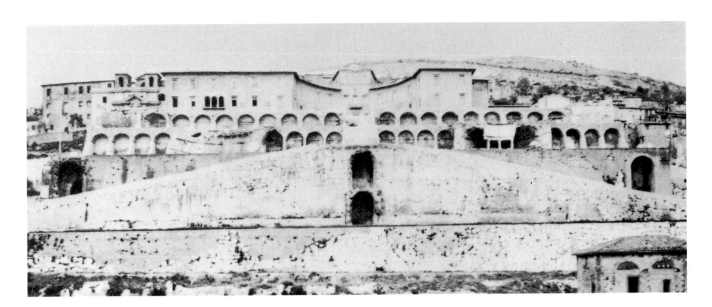

Fig. 479 Sanctuary of Fortuna Primigneia, Praeneste (Palestrina), Italy. Early 1st century B.C.

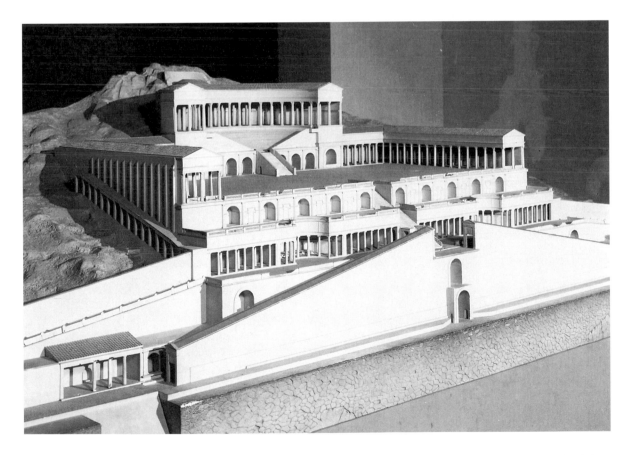

Fig. 480 Reconstruction model of the Sanctuary of Fortuna Primigneia, Praeneste (Palestrina), Italy. Museo Archeologico Nazionale, Palestrina, Italy.

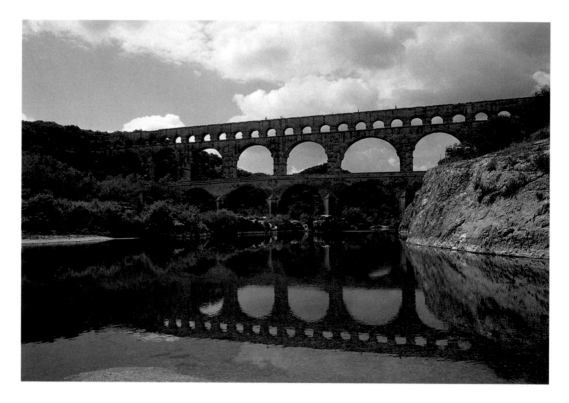

Fig. 481 Pont du Gard, near Nîmes, France. Late 1st century B.C.

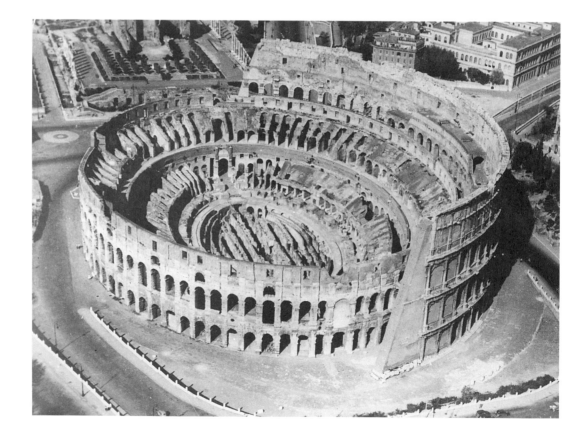

Fig. 482 The Colosseum (aerial view), Rome, 72–80 A.D.

The development of the arch and the vault revolutionized the built environment. Although they did not invent the **arch** (Fig. 483), it was the Romans who, at the end of the first century B.C., perfected its form. They recognized that the arch would allow them to make structures with a much larger span than was possible with post-and-lintel construction. Made of wedge-shaped stones, called *voussoirs*, each cut to fit into the semicircular form, an arch is not stable until the *keystone*, the stone at the very top, has been put into place. At this point, equal pressure is exerted by each stone on its neighbors, and the scaffolding that is necessary to support the arch while it is under construction can be removed. The arch supports itself, with the weight of the whole transferred downward to the posts. A series of arches could be made to span a wide canyon with relative ease. One of the most successful Roman structures is the Pont du Gard (Fig. 481), an aqueduct used to carry water from the distant hills to the Roman compound in Nîmes, France. Still intact today, it is an engineering feat remarkable not only for its durability, but, like most examples of Roman architecture, for its incredible size.

With the development of the **barrel**, or **tunnel vault** (Figs. 483 and 484), which is essentially an extension in depth of the single arch by lining up one arch behind another, the Romans were able to create large, uninterrupted interior spaces. Such is the strength of the vaulting structure of the Roman Colosseum (Figs. 482 & 484), that more than 50,000 spectators could be seated in it. The Colosseum is an example of an *amphitheater* (literally meaning a "double theater"), in which two theaters are brought face to face, a building type invented by the Romans to accommodate large crowds. Built for gladiatorial games and other "sporting" events, including mock naval battles and fights to the death between humans and animals, the Colosseum is constructed both with barrel vaults and with **groined vaults** (Figs. 483 &

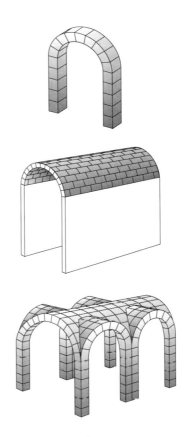

Fig. 483 Arch and vault construction.

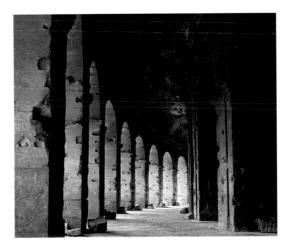

Fig. 484 Barrel vaulted gallery, ground floor of the Colosseum, Rome.

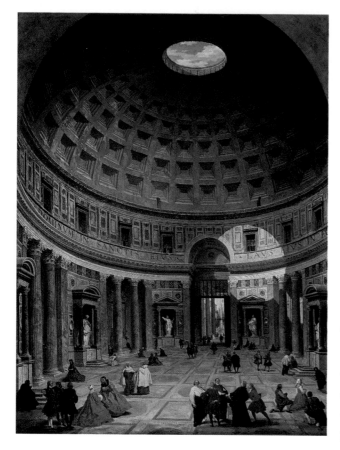

Fig. 485 Interior, Pantheon, 117–125 A.D. As seen in an eighteenth-century painting by Giovanni Paolo Panini. © 1992 National Gallery of Art, Washington, D.C., Samuel H. Kress Collection.

484), the latter created when two barrel vaults are made to meet at right angles. These vaults, originally covered with elaborate stucco decorations, provided so many exit and entry points that large crowds were able to flow rapidly in and out of the structure.

The Romans were also the first to perfect the **dome**, which is a roof in the shape of a hemisphere. Conceived as a temple to celebrate all their gods, the Pantheon (Fig. 485)—from the Greek words *pan* ("every") and *theos* ("god")—consists of a 142-foot-high dome set on a cylindrical wall 140 feet in diameter. Every interior dimension appears equal and proportionate, even as its scale overwhelms the viewer. The dome is concrete, which was poured in sections over a huge mold supported by a complex scaffolding. Over 20 feet

thick where it meets the walls—a point called the *springing*—it thins to only six feet at the circular opening, 30 feet in diameter, at the dome's top. Through this *oculus*, Latin for "eye," the building's only source of illumination, worshipers could make contact with the heavens. As the sun shone through it, casting a round spotlight into the interior, it seemed as if the eye of Jupiter, king of the gods, shone upon the Pantheon walls.

The basic architectural inventions of the Romans provided the basis for building construction in the Western world for nearly 2,000 years. The idealism, even mysticism of the Pantheon's vast interior space, with its evocation of the symbolic presence of Jupiter, found its way into Christian churches as the Christian religion came to dominate the West. Large congregations could gather beneath the high barrel vaults of churches, which were constructed on Roman architectural principles. The culmination of this spiritual direction is the immense interior space of the great Gothic cathedrals (Figs. 486 & 487), which arose throughout Europe beginning in about A.D. 1150. A building such as the Pantheon, with a 30-foot hole in its roof, was simply impractical in the severe climates of Northern Europe. As if in response to the dark and dreary climate outside, the interior of the Gothic cathedral rises to an incredible height, lit by stained-glass windows that transform a dull day with a warm and richly radiant light.

The great height of the interior space of the Gothic cathedral is achieved by means of a system of pointed, rather than round arches. The height of a rounded arch is determined by its width, but the height of the **pointed arch** (Fig. 488) can readily be extended by straightening the curve of the sides upward to a point, the weight descending much more directly down the wall. By utilizing the pointed arch in a scheme of groined vaults, the almost ethereal space of the Gothic cathedral, soaring upward as if toward God, is realized.

Fig. 486　Cathedral of Notre-Dame, Paris, France, 1163–1250.

Fig. 487　Interior, Notre-Dame, Paris.

Fig. 488　Pointed arch.

Fig. 489 Minakshi Temple and Madurai City, temple constructed c. 1500–1700; as seen c. 1977.

A Hindu Temple

The Minakshi temple at Madurai in south India (Fig. 489) dates from the sixteenth and seventeenth centuries, when warriors from the region to the north conquered the city and redesigned it according to principles laid down in ancient Hindu texts dealing with urban planning. According to these texts, the temple was to be the central shrine of the city, and the city was to be laid out around it.

Consequently, Madurai was rebuilt around the temple, which was understood as the symbolic center of the universe. Following other precepts of Hindu texts, both the temple and the city were constructed to face east, the direction of the rising sun. Furthermore, a gate tower, called a *gopuram*, was erected in the middle of each of the temple's four sides, these corresponding to the cardinal points of the compass. These *gopurams* thus define the perimeter of a sacred circle, called a *mandala*, that symbolizes the structure of the entire Hindu universe. Another smaller version of the same scheme was constructed within the outer square, forming an inner court at the center of which was a small, windowless room called the *garbha-griha* (a Sanskrit word meaning "womb house"). It was believed that the god Shiva and his consort Meenakshi lived within this room.

Madurai itself mirrors the Minakshi Temple's concentric layout. As one moves out from the center of the universe symbolized by the temple itself, one moves down the Hindu hierarchy of caste, with the wealthiest and "purest" strata of society nearer the temple, and the poorest—the so-called "untouchables," whose occupations are menial and "impure"—at the fringes of the city. Thus, the closer one lives to the heart of the city, the closer one is to attaining the universal oneness of Brahman, "the Absolute beyond name and form."

Source: Susan Lewandowski, "The Hindu Temple in South India," in *Buildings and Society: Essays on the Social Development of the Built Environment*, ed. Anthony D. King (London: Routledge & Kegan Paul, 1980).

All arches tend to spread outwards, creating a risk of collapse, and early on the Romans learned to support the sides of the arch to counteract this *lateral thrust*. In the great French cathedrals the problem was solved by building a series of arches on the outside whose thrusts would counteract the outward force of the interior arches. Extending inward from a series of columns or *piers*, these **flying buttresses** (Fig. *490*), so named because they lend to the massive stone architecture a sense of lightness and flight, are an aesthetic response to a practical problem. Perhaps as much as any element of Gothic design, they reveal the desire of the builder to elevate the cathedral above the humdrum of daily life in the medieval world. The cathedral became a symbol not only of the divine, but of the human ability to exceed, in art and in imagination, our own limitations and circumstances.

Until the nineteenth century, the history of architecture is determined by innovations in the ways the same materials—mostly stone—could be employed. In the nineteenth century, a new material absolutely transformed the built environment—**steel**. It is the sheer strength of steel that makes the modern skyscraper a reality. Structures with stone walls require thicker walls on the ground floor the higher they rise. A 16-story building, for instance, would require ground-floor walls approximately six feet thick. But the steel cage, connected by concrete floors, themselves reinforced with steel bars, overcomes this necessity. The simplicity of the resulting structure can be seen clearly in Le Corbusier's 1914 drawing for the Domino Housing Project (Fig. 491). The design is almost infinitely expandable, both sideways and upward. Any combination of windows and walls can be hung on the frame. Internal divisions can be freely designed in an endless variety of ways, or, indeed, the space can be left entirely open. Even the stairwell can be moved to any location within the structural frame.

Fig. 490 Flying buttresses, Notre-Dame, Paris.

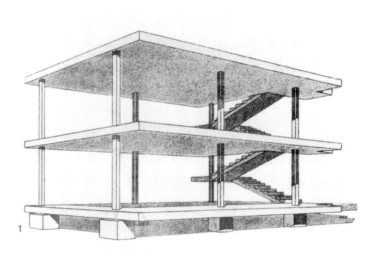

Fig. 491 Le Corbusier, Perspective drawing for Domino Housing Project, 1914.

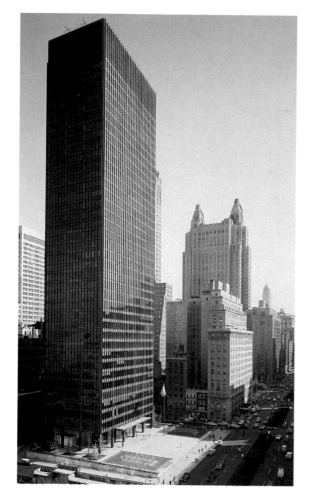

Fig. 492 Miës van der Rohe and Philip Johnson, Seagram Building, New York City, 1958. Photo: Ezra Stoller © Esto. All rights reserved.

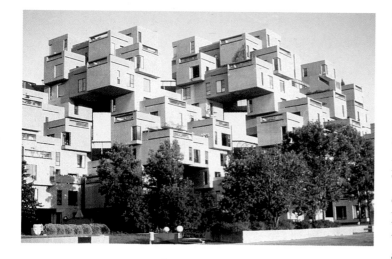

Fig. 493 Moshe Safdie, Habitat, EXPO 67, Montreal, 1967. Photo: T. Safdie.

The culmination of Le Corbusier's plan is the International Style skyscraper, the most notable of which is probably the Seagram Building in New York City (Fig. 492), a collaboration between Miës van der Rohe and Philip Johnson. The design solution presented by the Seagram Building is extremely elegant. The exposed structural **I-beams** (that is, steel beams that seen in cross-section look like the capital letter "I") are finished in bronze to match the amber-tinted glass sheath. At the base, these exterior beams drop unsheathed to courtyard, creating an open-air steel colonnade around a recessed glass lobby. New York law requires that buildings must conform to a "set-back" restriction: buildings that at ground level occupy an entire site must stagger-step inward as they rise in order to avoid "walling-in" the city's inhabitants. But the Seagram Building occupies less than one-half its site, and as a result, it is free to rise vertically out of the plaza at its base. At night, the lighted windows activate the building's exterior, and by day, the surface of the opaque glass reflects the changing world around it.

Community Life

However lovely we find the Seagram Building, the uniformity of its grid-like facade, employed by less skillful architects, came to represent, for many, the impersonality and anonymity of urban life, a symbol of conformity and mediocrity. Moshe Safdie's Habitat (Fig. 493), created for the international trade fair EXPO 67 in Montreal, is an attempt to take the basic architectural unit as conceived by Le Corbusier and to enliven it by stacking the prefabricated units in unpredictable ways. This is architecture as assemblage, the roof of one unit providing a private deck for another. It recognizes the practicality of mass-production, and yet its forms are rearranged to create a visually stimulating environment. The driving ambition for Safdie's design is to create a livable urban space, one in which collective life might be able to thrive.

New Japanese Architecture

Hiroyuki Wakabayashi's Children's Museum, in the Unagidani district of Osaka, Japan (Fig. 494), is actually a tenant building with 22 stores, selling primarily children's clothing and toys. The building is a deliberate attempt on Wakabayashi's part to work against what he calls the "clean, square buildings in regular formation" that dominate urban life, even in Japan. "Despite some excellent design," he says, "it is becoming increasingly boring."

The Children's Museum was inspired by the architect's childhood in the same district of Osaka. "When I was a child," he explains, "I used to play in Unagidani, especially in the loft of an abandoned house near my home. For some reason that loft remains in my memory. The stairs twisted around, shacks occupied the narrow gaps between the buildings, and it was a complex mess of a place. For children there were many terrific hideouts. Now, as an adult, I need refined spaces, but some part of me still seeks the kind of spaces I played in as a child."

The Children's Museum is actually composed in a rigid grid of posts and beams arranged in 60 square meter sections. In each section is a scaled-down house, shrine, or temple, connected by a free floating and unpredictable set of exterior balconies, stairways, and pathways. Almost surrealist in feeling, to Wakabayashi the whole is "like a dream freed from the cares of this world."

Source: *Emerging Japanese Architects of the 1990s*, ed. Jackie Kestenbaum (New York: Columbia University Press, 1991).

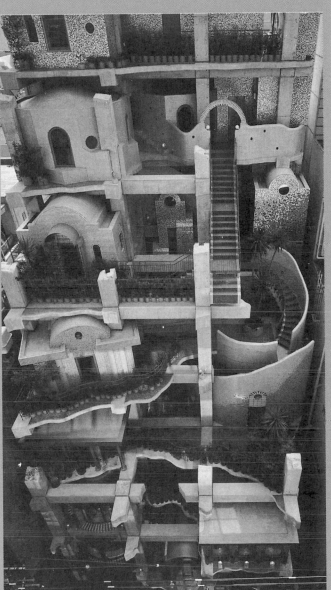

Fig. 494 Hiroyuki Wakabayashi, Children's Museum, Osaka, Japan, 1989.

Fig. 495 Frederick Law Olmsted and Calvert Vaux, Central Park, New York City, 1857–1887.

Fig. 496 Henry Flitcroft and Henry Hoare, The Park at Stourhead, Wiltshire, England, 1744–1765.

Safdie's plan accepts the crowded conditions of urban life, even as it revises the city's visual vocabulary. But since the middle of the nineteenth century, there have been numerous attempts to reestablish the values of rural life within the urban context. New York's Central Park (Figs. 495 & 497), designed by Frederick Law Olmsted and Calvert Vaux after the city of New York acquired the 840–acre tract of land in 1856, is an attempt to put city-dwelling humans back in touch with their roots in nature. Olmsted developed a system of paths, fields, and wooded areas modeled after the eighteenth-century gardens of English country estates (Fig. 496). The English garden was asymmetrical, informal, and varied in its views and plantings. Usually consisting of a serpentine lake, winding paths, and irregularly planted trees and shrubs, it *appeared* wholly natural, but was in actuality extremely artificial, with man-made lakes, fake Greek ruins, and exotic plants alien to the British climate (as can be

Fig. 497 Central Park, New York City, aerial view.

seen in the illustration here, where the plants have been transformed into macabre forms by the frost).

Olmsted favored a park similarly conceived, with, in his words, "gracefully curved lines, generous spaces, and the absence of sharp corners, the idea being to suggest and imply leisure, contemplativeness and happy tranquility." In such places the rational eighteenth-century mind had sought refuge from the trials of daily life. Likewise, in Central Park, Olmsted imagined the city dweller escaping the rush of urban life. "At every center of commerce," he wrote, "more and more business tends to come under each roof, and, in the progress of building, walls are carried higher and higher, and deeper and deeper, so

that now 'vertical railways' [that is, elevators] are coming in vogue." Both the city itself for Olmsted and neoclassical Greek and Roman architectural features in the English garden offer geometries—emblems of reason and practicality—to which the "gracefully curved" lines of the park and garden stand in counterpoint. In community design the dialogue between the geometric and the organic, so fundamental to the history of design proper, becomes especially central.

So successful was Olmsted's plan for Central Park that he was subsequently commissioned to design many others, including South Park in Chicago and the parkway system of the City of Boston, Mont Royal in Montreal, and the grounds at Stanford

Fig. 498 Olmsted, Vaux & Co., landscape architects, General plan of Riverside, Illinois, 1869. Frances Loeb Library, Graduate School of Design, Harvard University.

Fig. 499 Los Angeles Freeway Interchange. Photo courtesy California Division of Highways, Sacramento.

University and the University of California at Berkeley. But he perhaps showed the most foresight in this belief that the growing density of the inner city demanded the growth of what would later become known as the *suburb*, a residential community lying outside but within commuting distance of the city. "When not engaged in business," Olmsted wrote, "[the worker] has no occasion to be near his working place, but demands arrangements of a wholly different character. Families require to settle in certain localities which minister to their social and other wants, and yet are not willing to accept the conditions of town-life…but demand as much of the luxuries of free air, space and abundant vegetation as, without loss of town-privileges, they can be enabled to secure." As early as 1869, Olmsted laid out a general plan for the city of Riverside, Illinois, one of the first suburbs of Chicago (Fig. 498), which was situated along the Des Plaines River. The plan incorporated the railroad as the principle form of transportation into the city. Olmsted strived to create communal spirit by subdividing the site into small "village" areas linked by drives and walks, all situated near common areas that were intended to have "the character of informal village greens, commons and playgrounds."

Together with Forest Hills in New York, Llewellyn Park in New Jersey, and Lake Forest, also outside Chicago, Olmsted's design for Riverside set the standard for suburban development in America. The pace of that development was steady but slow until the 1920s, when suburbia exploded. During that decade, the suburbs grew twice as fast as the central cities. Beverly Hills in Los Angeles grew by 2,500 percent, and Shaker Heights outside Cleveland by 1,000 percent. The Great Depression and World War II slowed growth temporarily, but by 1950, the suburbs were growing at a rate ten times that of the cities. Between 1950 and 1960, American cities grew by 6 million people or 11.6 percent. In that

Fig. 500 Baltimore, Inner Harbor.

same decade, suburban population grew by 19 million, a rate of 45.6 percent. And, for the first time, some cities actually began to lose population: the populations of both Boston and St. Louis declined by 13 percent.

There were two great consequences of this suburban emigration: first, the rise of the automobile as the primary means of transportation and the consequent development of the highway system, and second, the collapse of the financial base of the urban center itself. As early as 1930, there were 800,000 automobiles in Los Angeles—two for every five people—and the city quite consciously decided not to spend public monies on mass transit but to support instead a giant freeway system (Fig. 499) that essentially overlaid the rectilinear grid of the city's streets with continuous, streamlined ribbons of highway. In 1940, the Pennsylvania Turnpike, running the length of

the state, opened to enormous public enthusiasm, with traffic volume far exceeding expectations, and that same year, the first stretches of the Pasadena Freeway opened.

It was as if not only automobiles, but money, drove down these highways out of the central city. Faced with discouraging and destructive urban decline, as early as the 1950s Boston and Baltimore began working to revitalize the central city. At first both tried to develop the downtowns by attracting office and corporate headquarters to the areas, but led by the Baltimore developer James Rouse, both cities turned their attention to redesigning their port areas (Fig. 500). Rouse restored old warehouse and market buildings to create a multiple-use environment of boutiques, restaurants and bars, hotels, up-scale residential areas, and major tourist attractions, such as aquariums and tall-masted schooners.

Baltimore's Inner Harbor and Boston's Quincy Market and Boston Waterfront projects were huge undertakings—the Baltimore project covers 250 acres and cost $260 million—but marked economic benefits were almost immediately realized. The idea was to create an essentially theatrical space in the heart of the city, a downtown area of spectacle and glamour that would attract not only suburbanites (and their dollars) back into the city on a weekly or monthly basis but tourists as well. The downtown is thus reconceived not as a business center but as an entertainment complex. Today, Baltimore's Inner Harbor attracts over 22 million visitors a year, of whom 7 million are tourists, roughly comparable to the number who visit Walt Disney World in Florida. It is, in fact, Walt Disney World, with its Main Street U.S.A. (Fig. 501) that provides the model for the new inner city—an arena of wholesome family entertainment, notably free of crime and drugs, thronging with happy people having a good time and spending money. Walt Disney World may be an imaginary kingdom, but it functions in the contemporary imagination like a continuous World's Fair, a Tomorrow-land projection of how we would like the real world to appear.

Fig. 501 Walt Disney World, Florida. © The Walt Disney Company.

PART V

THE VISUAL RECORD

Placing the Arts in Historical Context

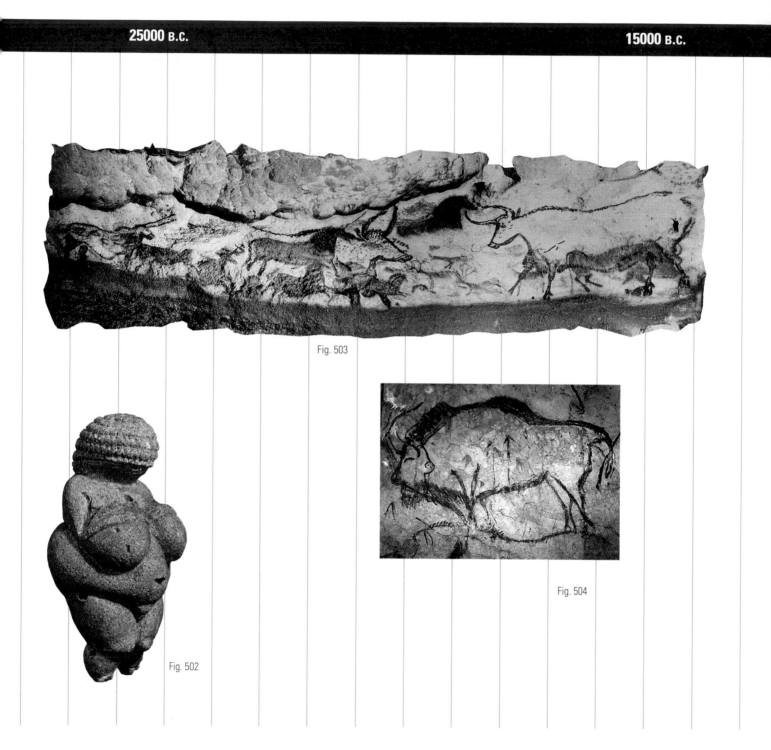

Fig. 503

Fig. 504

Fig. 502

Fig. 502 *Venus of Willendorf*, Lower Austria, c. 25000–20000 B.C. Limestone, height 4 ½ in. Naturhistoriisches Museum, Vienna. Found near Willendorf, Austria, this small sculpture is probably a fertility figure, judging from its exaggerated breasts, belly, and genitals, and lack of facial features. We know little about it, and we can only guess at its significance.

Fig. 503 Hall of Bulls, Lascaux, France, c. 15000–13000 B.C. Approximately life size. These images were drawn with chunks of red and yellow ocher that was mixed with something like animal fat as a medium. Many flat stones have been discovered that served as palettes for mixing colors.

Fig. 504 *Bison with Arrows*, Niaux, Ariège, France, c. 15000–13000 B.C. Length 50 in. The arrows connect the animal imagery directly to hunting. In addition, sharp gouges in the side of the bison suggest that actual spears were hurled at this image, perhaps to invoke success in an upcoming hunt.

- **70000 – 40000 B.C. Neanderthals use flint tools and fire**
- **35000 – 8000 B.C. Paleolithic peoples develop as nomadic hunter-gatherers**

Fig. 505

Fig. 505 *Sorcerer*, Trois-Frères, Ariège, France, c. 13000–11000 B.C. Height 24 in. This is one of only two images of human beings in the early cave paintings. It may depict a hunter in camouflage, or it may be a magician or shaman wearing the antlers of a deer, a bear's paws, a wolf's tail, the body of a lion, and a human beard.

The following pages are designed to help place the works of art so far discussed in A World of Art *into a broader historical context. The brief chronological survey and illustrations trace the major developments and movements in art from the earliest to the most recent times. Contemporaneous historical events are noted throughout across the top of each page. The history of art is inevitably tied to these broader cultural developments and in many ways reflects them.*

The Earliest Art

It is not until the emergence of Homo sapiens in the Paleolithic Era, between 40000 and 30000 B.C., the time of the last great Ice Age, that we find artifacts that might be called works of art. The word "Paleolithic" derives from the Greek *palaios*, "old," and *lithos*, "stone," and refers to the use of stone tools, which represent a significant advance beyond the flint instruments used by the Neanderthal. With these tools, works of art could be fashioned. The earliest of these are small sculptural objects representing animals and women that serve no evident practical function. Many of these are highly polished, a result of continuous handling.

The scale of these small objects is dwarfed by the paintings that have been discovered over the course of the last 125 years in caves concentrated in southern France and northern Spain. In 1879, near Santander in northern Spain, a local amateur archeologist, Marcelino de Sautuola, and his daughter were investigating the Altamira caves when the girl noticed the forms of some painted bulls on the low cave roof just above her father's head. These works were initially dismissed as forgeries, until cave after cave of similar paintings were discovered elsewhere in the region.

The cave paintings are almost exclusively of animals—bison, mammoths, reindeer, horses, cows, and bears. Humans are only rarely represented. It is difficult to say what role these works played in Paleolithic society, but it is likely that they were associated in some way with the hunt, perhaps giving the hunter good luck. It is possible that in painting an animal, the hunter symbolically "captured" it.

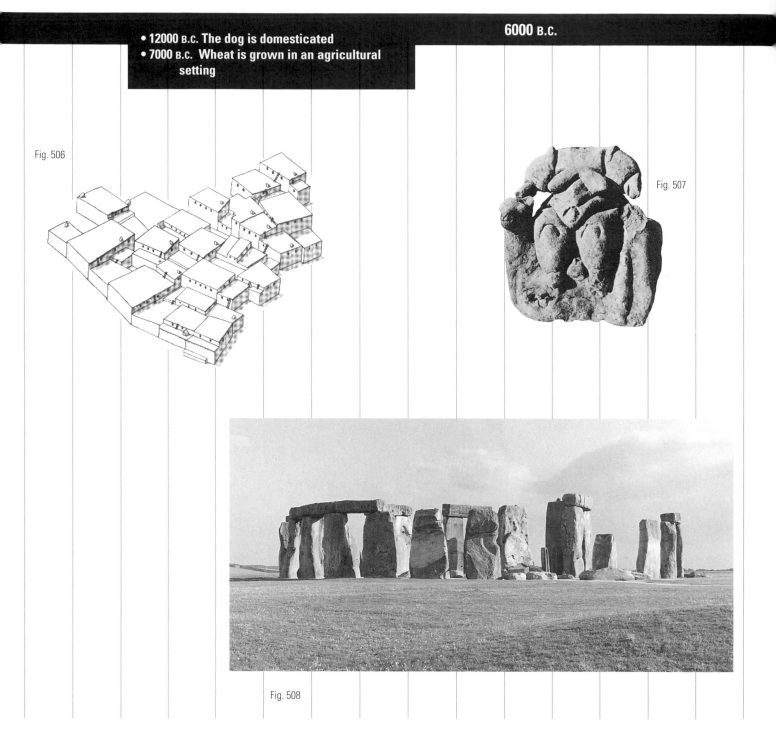

Fig. 506

Fig. 507

Fig. 508

Fig. 506 Houses and shrines at Çatal Hüyük, Turkey, c. 6000 B.C. Schematic reconstruction after J. Mellart. First excavated between 1961 and 1965, this village was built of mud bricks and timber. There are no streets, only courtyards, and people passed between houses via the rooftops.

Fig. 507 Fertility goddess from Çatal Hüyük, c. 6000 B.C. Baked clay, height 8 in. Archeological Museum, Ankara, Turkey. One in five buildings at Çatal Hüyük was a shrine, usually containing small statuettes such as this one, a Neolithic descendant of the *Venus of Willendorf*.

Fig. 508 Stonehenge, Salisbury Plain, Wiltshire, England, c. 2000 B.C. Diameter of circle 97 ft., height approximately 24 ft. Built of huge blocks of sandstone, without mortar, this remarkable site served a religious function. Oriented toward the point where the sun rises at the summer solstice, it probably was connected with sun worship.

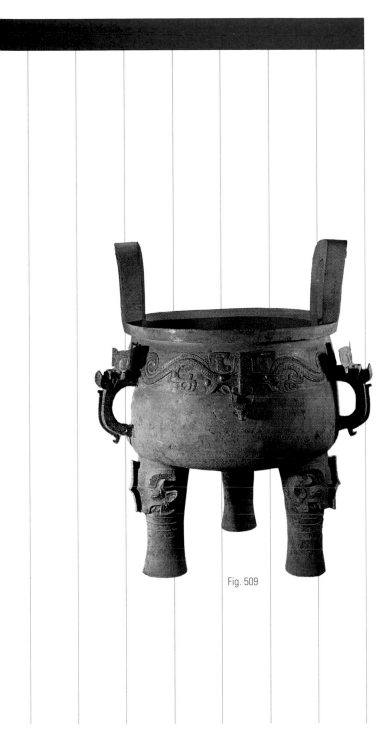

Fig. 509

Fig. 509 Five-eared *ding* with dragon pattern. Bronze: height 48 in.; diameter at mouth, 32 3/4 in. Chunhua County Cultural Museum. This bronze was created to hold food during ceremonies dedicated to the worship and memory of ancestors. The symmetrical animal mask that decorates it is typical of the bronze work of the period.

The most magnificent of these caves was discovered at Lascaux, in the Dordogne region of France, near the city of Montignac, in 1940, when a dog belonging to some local boys fell into a hole. The caves were closed to the public in 1963, after it became evident that moisture and carbon dioxide from the breath of visitors were causing destructive fungi to grow over the paintings.

As the Ice Age waned, around 8000 B.C., humans began to domesticate animals and cultivate food grains, practices that started in the Middle East and spread slowly across Greece and Europe for the next 6,000 years, reaching Britain last. Gradually, Neolithic—or New Stone Age—peoples abandoned temporary shelters for permanent structures built of wood, brick, and stone. Crafts, pottery, and weaving in particular, began to flourish. Religious rituals were regularized in shrines dedicated to that purpose. Remains of highly developed Neolithic communities have been discovered at Jericho, which reached a height of development around 7500 B.C. in modern-day Jordon, and at Çatal Hüyük, a community that developed in Turkey about 1,000 years later. Jericho was built around a fresh water spring, vital to life in the near-desert conditions of the region, and was surrounded by huge walls for protection. Çatal Hüyük was a trade center with a population of about 10,000 people.

Neolithic society developed most quickly in the world's fertile river valleys. By 4000 B.C., urban societies had developed on the Tigris and Euphrates rivers in Mesopotamia and on the Nile River in Egypt. Similarly complex urban communities were flourishing, by 2200 B.C., in the Indus and Ganges valleys of India and, by 2000 B.C., in the Huang Ho and Yangtze valleys of China.

Excavations begun at Anyang in northern China, in 1928, have revealed the existence of what is known as the Shang dynasty, which ruled China from about 1766 to 1122 B.C. The great art form of the Shang dynasty was the richly decorated bronze vessel, made by a casting technique as advanced as any ever used, suggesting that bronze vessels must have been made for several centuries before Anyang became the center of Chinese culture. Many vessels are decorated with symmetrical animal forms, often mythological, spread out across the face of the bronze.

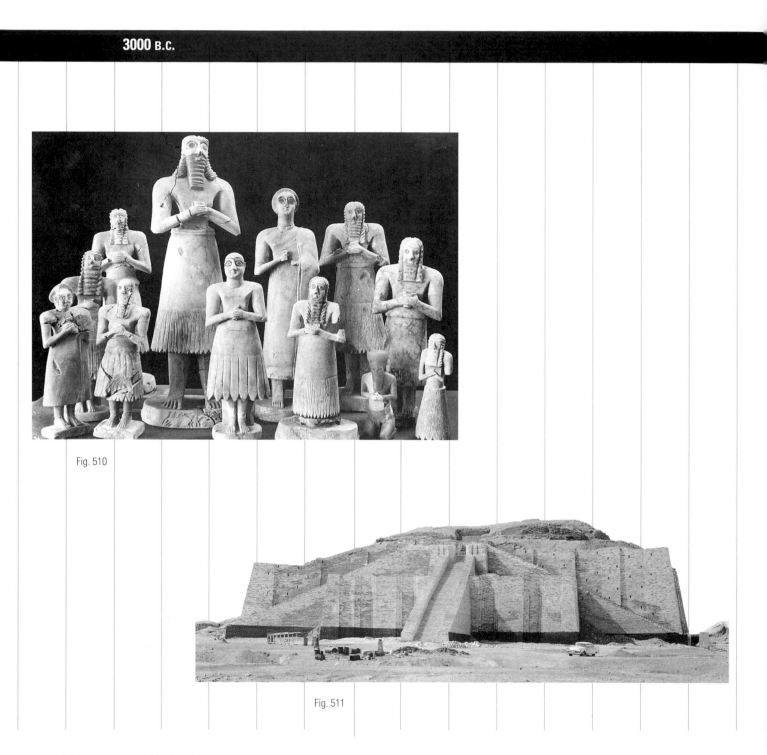

Fig. 510

Fig. 511

Fig. 510 Worshippers and deities from the Abu Temple, Tell Asmur, Iraq, c. 2700–2500 B.C. Gypsum, height of tallest figure, 30 in. The Iraq Museum, Baghdad, and the Oriental Institute, University of Chicago. The tallest figure here is Abu, the Sumerian god of vegetation. Next to him is a mother goddess. The smaller statues represent worshippers and are stand-ins for actual persons, enabling worshippers, at least symbolically, to engage in continuous prayer and devotion. Eyes were considered by the Sumerians to be the "windows to the soul," which explains why the staring eyes in these sculptures are so large.

Fig. 511 Ziggurat, Ur, c. 2100 B.C. Fired brick over mud-brick core, 210 × 150 ft. at base. The Sumerians believed that the mountaintops were not only the source of water but the dwelling place of the gods, and the ziggurat was constructed as an artificial mountain in which a god—in this case, the moon god, Nanna-Sin—could reside.

Fig. 512

Fig. 512 The Great Sphinx, Giza, Egypt, c. 2530 B.C. Sandstone, height 65 ft. With the body of a lion, the king of beasts, and the head of a man, thought to be the Pharaoh Chephren, whose tomb is nearby, the sphinx embodies passive, composed, and enduring rule.

Complex combinations of different animals often appear on the same vessel. These are reminiscent of the Paleolithic *Sorcerer* in the cave of the Trois-Frères in Ariège, France, though in the Chinese works the various animals are combined together in a unified design.

Sumerian Culture

As irrigation techniques were developed on the Tigris and Euphrates rivers between 4000 and 3000 B.C., a complex society emerged, one credited, for instance, with both the invention of the wheel and the invention of writing. By the time they were finally overrun by other peoples in 2030 B.C., the Sumerians had developed schools, libraries, and written law. Ancient Sumeria consisted of a dozen or more cities, each with a population of between 10,000 and 50,000, and each with its own reigning deity. Each of the local gods had the task of pleading the case of their particular communities with the other gods, who controlled the wind, the rain, and so on. A human steward transmitted the commands of the god to the people. Communication with the god occurred in a *ziggurat*, a stepped temple, that rose high in the middle of the city. An early Mesopotamian text calls the ziggurat "the bond between heaven and earth."

Egyptian Civilization

At about the same time that Sumerian culture developed in Mesopotamia, Egyptian society began to flourish along the Nile River. As opposed to Sumeria, which was constantly threatened by invasion, Egypt, protected on all sides by sea and desert, cherished the ideals of order, stability, and endurance, and these ideals are reflected in its art.

Egyptian culture was dedicated to providing a home for the *ka*, that part of the human being that defines personality and that survives life on earth after death. The enduring nature of the *ka* required that artisans decorate tombs with paintings that the spirit could enjoy after death. Small servant figures might be carved from wood to serve the departed in the afterlife. The *ka* could find a home in a statue of the deceased. Mummification—the preservation of the body by treating it with chemical solutions and then wrap-

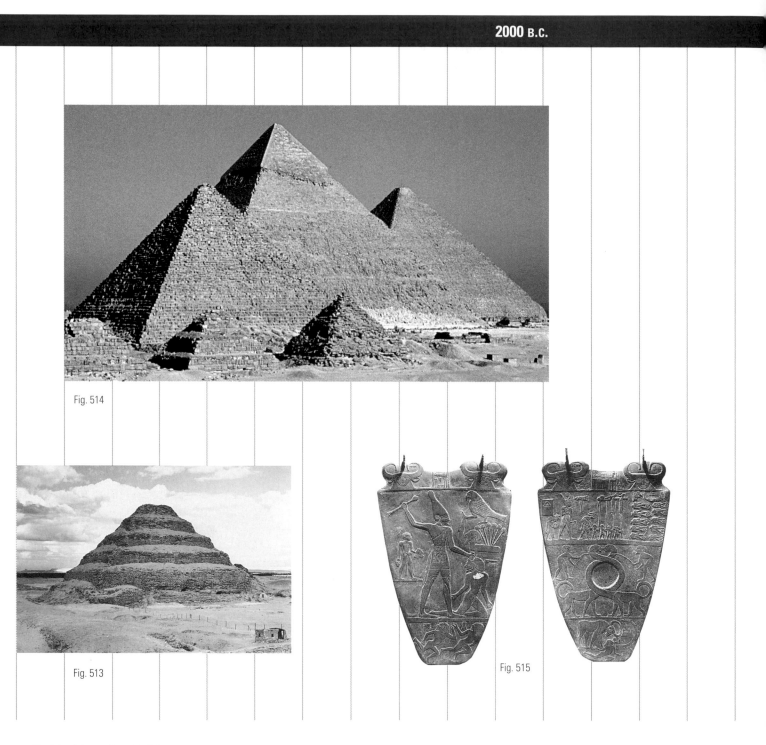

Fig. 514

Fig. 513

Fig. 515

Fig. 513 Imhotep, Pyramid of King Zoser, Third Dynasty, Saqqara, c. 2600 B.C. This stepped pyramid can be seen as a series of progressively smaller *mastabas*—rectangular stone structures with sloped sides and flat roofs erected over a tomb—piled one upon the other. Zoser's tomb thus rises with a commanding presence over the funerary complex around it.

Fig. 514 Pyramids of Mycerinus (c. 2470 B.C.), Chephren (c. 2500 B.C.), and Cheops (c. 2530 B.C.). Original height of Pyramid of Cheops 480 ft., length of each side at base 755 ft. The significance of the pyramidal form is debatable, but it may derive from the image of the sun god Re, who in ancient Egypt was symbolized by the rays of the sun descending to earth. A text in one pyramid reads: "I have trodden these rays as ramps under my feet."

Fig. 515 *Palette of King Narmer* (front and back), Hierakonpolis, Upper Egypt, c. 3000 B.C. Slate, height 25 in. Egyptian Museum, Cairo. Used as a surface upon which to prepare eye makeup, this early representation shows the king, on one side, about to sacrifice an enemy, and, in the top band of the other side, reviewing the beheaded bodies of his foes, a pile we see from a bird's-eye perspective.

- **2400 B.C.** Domesticated chickens in Babylon
- **1300 B.C.** Alphabet used in Mesopotamia

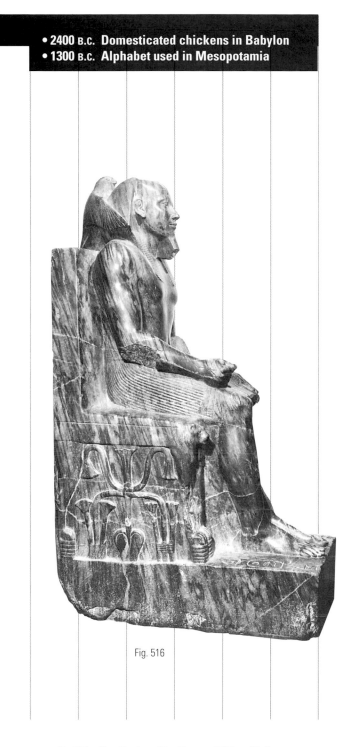

Fig. 516

Fig. 516 *King Chephren*, Giza, Egypt, c. 2530 B.C. Diorite, height 66 1⁄8 in. Egyptian Museum, Cairo. The rigorous geometry governing Egyptian representation is apparent in this statue of the same Chephren whose head sits atop the Great Sphinx (Fig. 512). Chephren's frontal pose is almost as rigid as the throne upon which he sits. It is as if he had been composed as a block of right angles.

ping it in linen—provided a similar home, as did the elaborate coffins in which the mummy would be placed. The pyramids were, of course, the largest of the resting places designed to house the *ka.*

The pyramids were designed as part of vast funerary cities which embodied the permanence and stability of Egyptian society. The first such *necropolis*—literally, city of the dead—was built at Saqqara in about 2610 B.C. for King Zoser of the Third Dynasty. (A dynasty is a period of pharaonic rule.) The designer was Imhotep, the first artist whose actual name comes down to us. Imhotep was celebrated as one of the most learned men in the ancient world. He was not only the first artist and architect, but the first medical doctor as well. Zoser's pyramid was a stepped tomb unlike the famous pyramids at Giza, a few miles north of Saqqara, which were built a century later for the pharaohs of the Fourth Dynasty. The largest of these three pyramids, that of Cheops, was twice as high as Zoser's, rising 480 feet above the west bank of the Nile, the sunset side of the river where the dead were always buried to facilitate their voyage to the afterlife.

The enduring quality of the *ka* accounts for the unchanging way in which, over the centuries, Egyptian figures, especially the pharaohs, were represented. A canon of ideal proportions was developed that was almost universally applied. The figure is, in effect, drawn on a grid. The feet rest on the bottom line of the grid, the ankles are placed on the first horizontal line, the knee on the sixth, the navel on the thirteenth (higher on the female), elbows on the fourteenth, and the shoulders on the nineteenth. The figure is almost always seen in profile at a right angle to the line of vision, with the shoulders and a single eye portrayed in frontal view. The horizontality of this mode of representation is mirrored in the organization of the pictorial field, which is divided into a series of horizontal bands that define the ground upon which the various figures stand. The conventions of representation do not apply, however, to the face itself. Great care was taken in the realistic depiction of the individual facial features of the figure, and, architecture aside, portraiture may be considered one of the greatest accomplishments of Egyptian art.

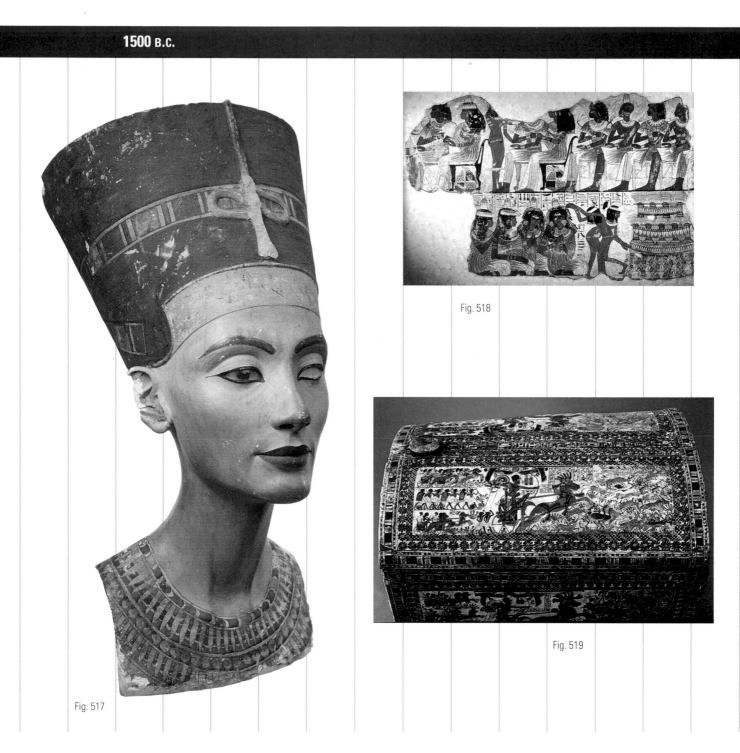

Fig. 518

Fig. 519

Fig. 517

Fig. 517 *Queen Nefertiti*, Teel-Amarna, c. 1365 B.C. Painted limestone, height 19 5/8 in. Agyptisches Museum, Berlin. Akhenaton's queen, Nefertiti, is depicted here in the new curvilinear style, clearly evident in the graceful curve of her neck, that was introduced into Egypt during Akhenaton's reign.

Fig. 518 *Banquet Scene*, Tomb of Negamum, Thebes, c. 1400 B.C. Fresco fragment, approx. 23 1/2 × 36 1/4 in. British Museum, London. The traditional formulas for representation are used here, except that the way in which the two center musicians and the two dancers in the lower band have been depicted anticipates the freedom of the Akhenaton style. Or it may simply indicate that entertainment was so free an activity that it was free of formal regulation as well.

Fig. 519 Painted chest, tomb of Tutankhamen, Thebes, c. 1350 B.C. Length approx. 20 in. Egyptian Museum, Cairo. The scene of the young king hunting is conventional in its scale, showing Tutankhamen as larger than life. Nevertheless, the sense of movement and action, and the abandonment of the traditional ground line in the wild chaos of the animals on the right, shows the influence of the freer Akhenaton style.

For a brief period, in the fourteenth century B.C., under the rule of the Emperor Akhenaton, the realism of Egyptian portraiture was extended to the figure as a whole. Akhenaton declared an end to traditional Egyptian religious practices, relaxing especially the longstanding preoccupation with the *ka*. The Egyptians turned their attention to matters of life instead of death, and a sense of naturalistic form developed in their art that, until this time, could be seen only in representations of people of lower rank, such as entertainers. For the first time, Egyptian art showed a taste for the curved form, and for a softness of contour, rather than for the harsh and rigid geometries demanded by the Egyptian canon of proportion.

The reason we know this style so well today is because it has survived in the only unplundered Egyptian tomb to have come down to us, discovered at Thebes in 1922, that of Akhenaton's successor, Tutankhamen, known as "King Tut." Among the thousands of artifacts recovered at that time was the tomb of King Tut himself, which consists of three coffins, one set within the other. The innermost coffin is made of 243 pounds of beaten gold inlaid in lapis lazuli, turquoise, and carnelian.

The Akhenaton style did not survive long in Egypt. Soon after King Tut's death, traditional religious practices were reestablished, and a revival of the old style of art, with its unrelentingly stiff formality, quickly followed. For the next 1,000 years, the Egyptians maintained the conventions and formulas their forefathers had initiated in the first half of the third millennium B.C.

Aegean Civilizations

The Egyptians had significant contact with other civilizations in the eastern Mediterranean, particularly with the Minoan civilization on the island of Crete and with Mycenae on Greek Peloponnesus, the southern peninsula of Greece. The origin of the Minoans is unclear—they may have arrived on the island as early as 6000 B.C.—but their culture reached its peak between 1600 and 1400 B.C. Palaces built for the Minoan kings were lavishly decorated with frescos, and were of such intricate design that they probably gave rise to the later Greek myth of the labyrinth. This was the maze built for King Minos by Daedalus to house the Minotaur, the fearsome bull to whom Athenian

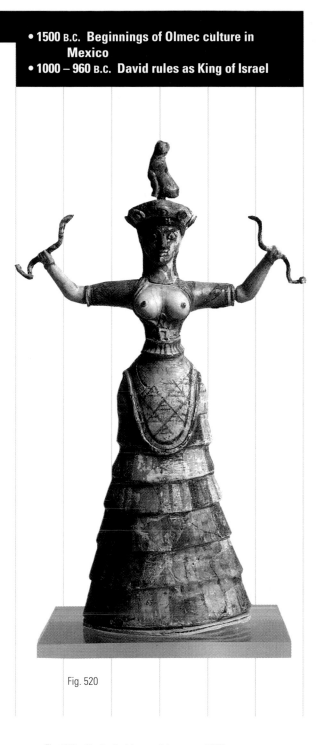

Fig. 520

Fig. 520 *Snake Goddess* or *Priestess*, c. 1600 B.C. Faience, height 11 ⅝ in. Archeological Museum, Heraklion, Crete. The chief deity of Minoan culture was a fertility goddess represented in several different forms. Here, her bare breasts indicate female fertility, while the snakes she carries are associated with male fertility.

Fig. 521

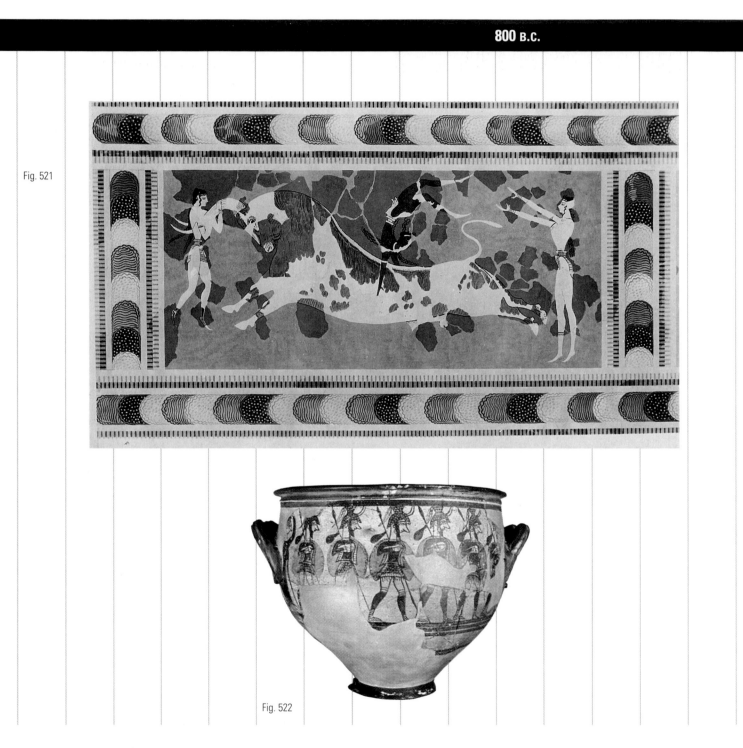

Fig. 522

Fig. 521 *The "Toreador" Fresco*, Knossos, Crete, c. 1500 B.C. Height including upper border approx. 24 ½ in. Archeological Museum, Heraklion, Crete. This fresco, from the Minoan palace at Knossos, does not actually depict a bullfight, as its title suggests. In Minoan culture, the bull was an animal of sacred significance. The animal depicted here was part of a ritual activity of grace and agility in which trained athletes leaped over its back.

Fig. 522 *The Warrior Vase*, Mycenae, c. 1200 B.C. Height approx. 14 in. National Museum, Athens. Here we see Mycenaean soldiers marching to war, perhaps to meet the Dorian invaders who destroyed their civilization soon after 1200 B.C. The Dorian weapons were iron and, therefore, superior to the softer bronze Mycenaean spears seen here.

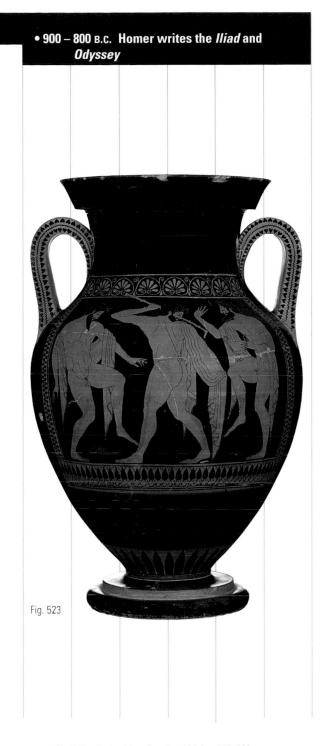

Fig. 523

Fig. 523 Euthymides, *Revelers*, Vulci, c. 510–500 B.C. Height approx. 24 in. Staatliche Antikensammulungen, Munich, Germany. This amphora, or two-handled vase, was designed to store provisions such as wine, oil, or honey. The inscription taunts Euthymides' chief competitor—"Euphronios never did anything like it," it reads, indicating the growing self-consciousness of the Greek artist.

youths and maidens were sacrificed until he was killed by the hero Theseus.

It is unclear why Minoan culture abruptly ended in approximately 1450 B.C. Great earthquakes and volcanic eruptions may have destroyed the civilization, or, perhaps, it fell victim to the warlike Mycenaeans from the mainland, whose culture flourished between 1400 and 1200 B.C. It is this culture, immortalized by Homer in the *Iliad* and the *Odyssey*, that sacked the great Trojan city of Troy. The Mycenaeans built stone fortresses on the hilltops of Peloponnesus (see Fig. 474), a peninsula forming part of the Greek mainland. They buried their dead in so-called beehive tombs which, dome-shaped, were full of gold and silver, including masks of the royal dead, a burial practice similar to that of the Egyptians, with whom they had contact.

Greek Art

The rise of the Greek city-state, or polis, marks the moment when Western culture begins to celebrate its own human strengths and powers—the creative genius of the mind itself—over the power of nature. The Western world's gods now became personified, taking human form and assuming human weaknesses. Though immortal, they were otherwise versions of ourselves, no longer angry beasts or natural phenomena such as the earth, the sun, or the rain.

In about 1200 B.C., just after the fall of Mycenae, the Greek world consisted of various tribes, separated by the geographical features of the peninsula, with its deep bays, narrow valleys, and jagged mountains. These tribes soon developed into independent and often warring city-states, with their own constitutions, coinage, and armies. We know that in 776 B.C. these feuding states declared a truce in order to hold the first Olympic games. So significant were these understood to be that the Greeks later took them as the starting point of their history.

The human figure is the most important subject of Greek art, from the Archaic period on, c. 700 B.C. In this Archaic vase by Euthymides, an example painted in the red-figure style (Fig. 523), there is a real interest in studying and rendering the body in action. Only during the short reign of Pharaoh Akhenaton, in Egypt (Fig. 517), had there

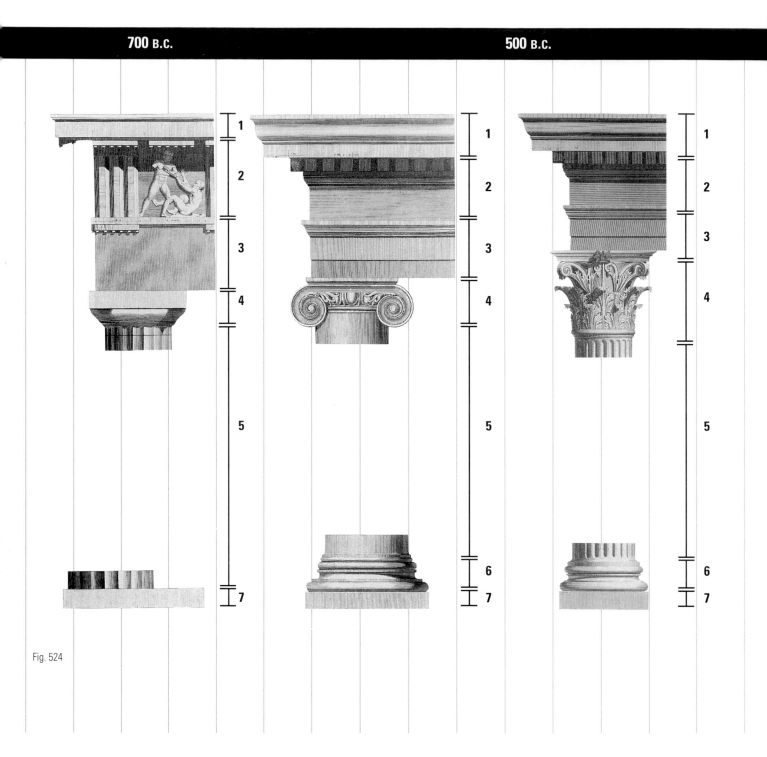

Fig. 524

Fig. 524 The Greek orders, from James Stuart, *The Antiquities of Athens*, London, 1794. The vertical design, or *elevation*, of the Greek temple is composed of three elements—the *platform*, the *column*, and the *entablature*. The relationship among these three units is referred to as its *order*. The Doric is the earliest and plainest of the three; the Ionic, later, more elaborate, and organic, and the Corinthian more organic still. The elevation of each order begins with a platform, the *stylobate*. The column in the Doric order consists of two parts, the *shaft* and the *capital*, to which both the Ionic and Corinthian orders add a base. The orders are most quickly distinguished by their capitals. Each has two parts, the *abacus*, which supports the stone blocks of the entablature, and below it the *echinus*. The echinus of the Doric capital is plain, marked only by a subtle outward curve. The Ionic capital is much more elaborate and is distinguished by its scroll. The Corinthian is decorated with stylized acanthus leaves. The entablature consists of three parts, the *architrave*, or weight-bearing and weight-distributing element, the decorated *frieze*, and the *cornice*.

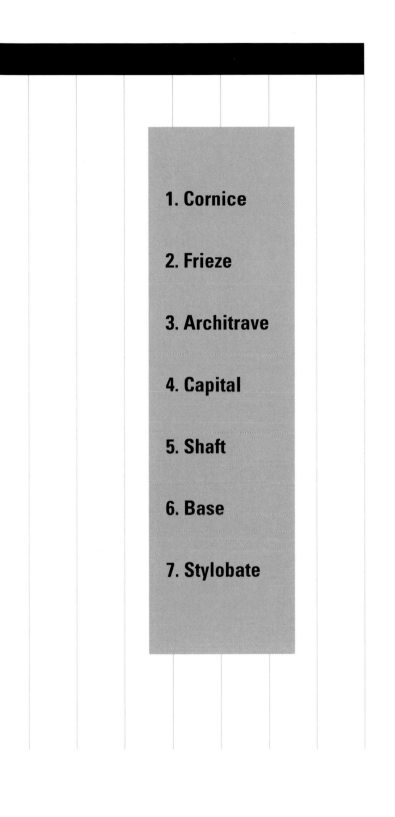

1. Cornice

2. Frieze

3. Architrave

4. Capital

5. Shaft

6. Base

7. Stylobate

been such concern to depict the human form in a realistic manner.

By the fifth century B.C., this interest in humanity is reflected throughout Greek culture. The philosopher Plato developed theories not only about social and political relations but about education and aesthetic pleasure. The physician Hippocrates systematically studied human disease, and the historian Herodotus, in his account of the Persian Wars, began to chronicle human history. Around 500 B.C., in Athens, all free male citizens were included in the political system, and *democracy*—from *demos*, meaning "people," and *kratia*, meaning "power"—was born. It was not quite democracy as we think of it today: slavery was considered natural, and women were excluded from political life. Nevertheless, the concept of individual freedom was cherished.

The values of the Greek city-state were embodied in its temples. The temple was usually situated on an elevated site, above the city—an *acropolis*, from *akros*, meaning "top," of the *polis*, "city"—and was conceived as the center of civic life. Its colonnade, or row of columns set at regular intervals around the building and supporting the base of the roof, was constructed according to the rules of geometry and embodied cultural values of equality and proportion. So consistent were the Greeks in developing a generalized architectural type for their temples that it is possible to speak of them in terms of three distinct architectural orders—the Doric, the Ionic, and the Corinthian, the last of which was rarely used by the Greeks themselves but later became the standard order in Roman architecture. In ancient times, the heavier Doric order was considered masculine, and the more graceful Ionic order feminine. The latter was introduced to the Acropolis in Athens when the city sought the aid of the Ionian city-states in Asia Minor after war broke out with Sparta in 431 B.C. The Ionic order is slimmer and much lighter in feeling than the Doric.

The crowning achievement of Greek architecture is the complex of buildings on its Acropolis, which was built to replace those destroyed by the Persians in 480 B.C. Construction began in about 450 B.C., under the leadership of the great Athenian statesman, Pericles. The central building of the

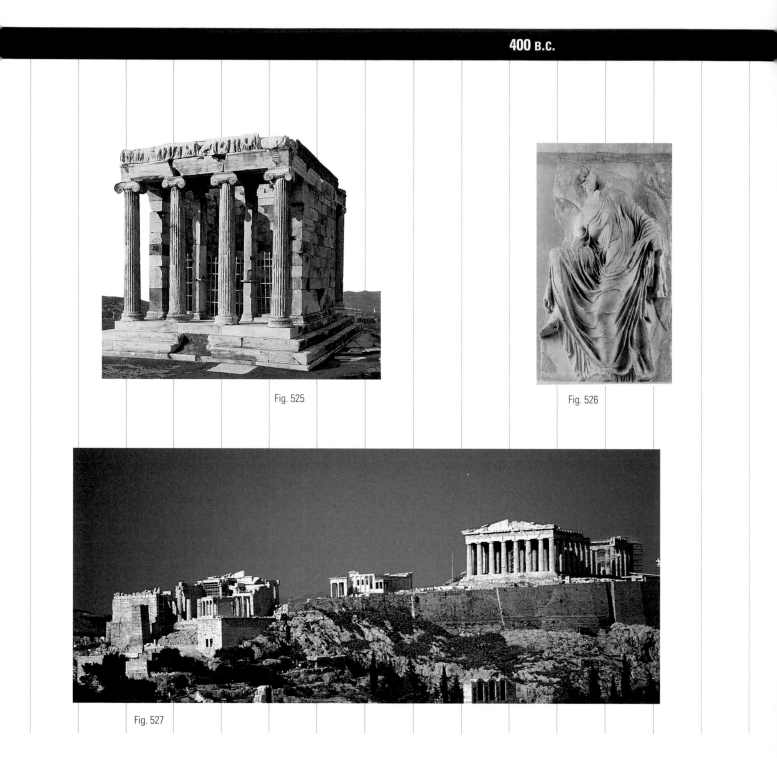

Fig. 525

Fig. 526

Fig. 527

Fig. 525 Temple of Athena Nike, Acropolis, Athens, 427–424 B.C. The earliest Ionic temple on the Acropolis, its name means "bringer of victory," and it was specifically built to assert the military prowess of Athens in its war with the neighboring city-state of Sparta.

Fig. 526 *Nike*, from the balustrade of the Temple of Athena Nike, c. 410–407 B.C. Marble, height 42 in. Acropolis Museum, Athens. This perfect example of the Phidian style shows Nike, the goddess of victory, bending to take off her sandal.

Fig. 527 The Acropolis today, viewed from the southwest, Athens, Greece. The largest building here is the Parthenon. Constructed between 448 and 432 B.C., it dominates the horizon like the prow of a great ship sailing across the Athenian sky.

Fig. 528

Fig. 528 Unknown, perhaps a pupil of Lysippos, Statue of a Victorious Athlete, Greek, last quarter of the 4th century B.C. Bronze, 59 5/8 in. Collection of J. Paul Getty Museum, Malibu, California. Court sculptor to Alexander the Great, Lysippos is known to us only through Roman copies of his work. This piece, recently discovered in the Adriatic Sea, captures the body in its fleeting movements with such naturalness—the Lyssipic ideal—that some scholars feel it may be the work of the master himself.

new complex, designed by Ictinus and Callicrates, was the Parthenon, dedicated to the city's name-sake, Athena Parthenos, the goddess of wisdom. A Doric temple of the grandest scale, it is composed entirely of marble. At its center was an enormous ivory and gold statue of Athena, sculpted by Phidias, who was in charge of all the ornamentation and sculpture for the project. The Athena is long since lost, and we can imagine his achievement only by considering the sculpture on the building's pediment and its friezes, all of which reflect Phidias's style and may be his design.

The Phidian style is marked by its naturalness. The human figure often assumes a relaxed, seemingly effortless pose, or it may be caught in the act of movement, athletic or casual. In either case, the precision with which the anatomy has been rendered is remarkable (see Figs. 338–340). The drapery the figures wear both reveals and conceals the body beneath. Sometimes appearing to be transparent, sometimes dropping in deep folds and hollows, it contributes importantly to the sense of reality conveyed by the sculpture. It is as if we can see the body literally push forward out of the stone and press against the drapery.

The Greek passion for individualism, reason, and accurate observation of the world continued on even after the disastrous defeat of Athens in the Peloponnesian War in 404 B.C., which led to a great loss of Athenian power, and the decline of the confederacy of Greek city-states. In 338 B.C., the army of Philip, King of Macedon, conquered Greece, and after Philip's death two years later, his son, Alexander the Great, came to power. Philip greatly admired Athenian culture and, as a result, Alexander had been educated by the philosopher Aristotle, who in turn persuaded the young king to impose Greek culture throughout his empire. *Hellenism*, or the culture of Greece, thus came to dominate the Western world. At Alexander's death, the empire was divided among his generals, who had become his provincial governors. The new cultural centers of the Hellenistic Age were their capitols—Antioch in Syria, Alexandria in Egypt, and Pergamon in Asia Minor.

In the sculpture of the fourth century B.C., we discover a graceful even sensuous beauty, marked by *contrapposto* and three-dimensional realism (see Fig. 89). The depiction of physical beauty

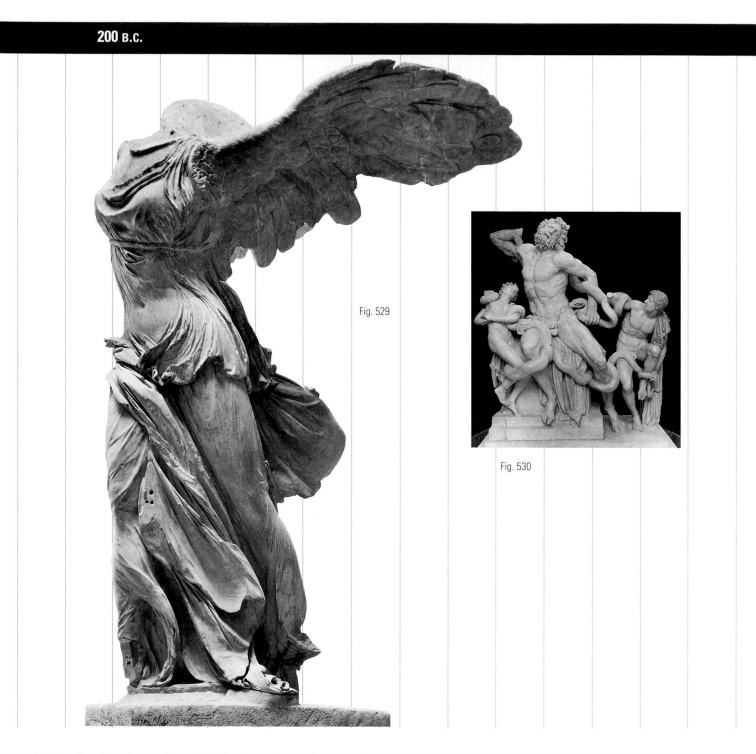

Fig. 529

Fig. 530

Fig. 529 *Nike of Samothrace*, c. 190 B.C. Marble, height approx. 8 ft. Musée du Louvre, Paris. The *Nike of Samothrace* is a masterpiece of Hellenistic realism. The goddess has been depicted as she alights on the prow of a victorious war galley, and one can almost see the wind as it buffets her and feel the surf that has soaked her garment so that it clings revealingly to her torso.

Fig. 530 *The Laocoön Group*, Roman copy, perhaps after Agesander, Athenodorus, and Polydorus of Rhodes, 1st century A.D. Marble, height 7 ft. Vatican Museums, Rome. The swirl of line that was once restricted to drapery overwhelms the entire composition of the *Laocoön*, as serpents surround the Trojan priest and his sons. So theatrical is the group that to many eyes it verges on melodrama, but its *expressive* aims are undeniable. The sculptor is no longer content simply to represent the figure realistically; sculpture must convey emotion as well.

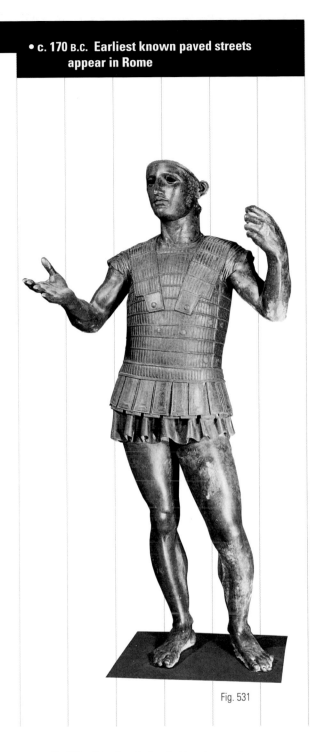

Fig. 531

Fig. 531 *Mars from Todi*, early 4th century B.C. Bronze, height 56 in. Vatican Museums, Rome. Many of the realist aspirations of Greek sculpture are apparent in this Etruscan bronze of a young man in military garb.

becomes an end in itself, and sculpture increasingly seems to be more about the pleasures of seeing than anything else. At the same time the desire to achieve a greater and greater degree of realism continues, and in the sculpture of the Hellenistic Age we find an increasingly animated and dramatic treatment of the figure.

Roman Art

Although the Romans conquered Greece (in 146 B.C.), like Philip of Macedon and Alexander, they regarded Greek culture and art as superior to any other. Thus, like the Hellenistic Empire before it, the Roman Empire possessed a distinctly Greek character. The Romans imported thousands of original Greek artworks, and had them copied in even greater numbers. In fact, much of what we know today about Greek art, we know only through Roman copies. The Greek gods were adapted to the Roman religion, Jupiter bearing a strong resemblance to Zeus, Venus to Arphrodite, and so on. As we have already indicated, the Romans used the Greek architectural orders in their own buildings and temples, preferring especially the highly decorative Corinthian order. Many, if not most, of Rome's artists were, in fact, of Greek extraction, though "Romanized" to the point of being indistinguishable from the Romans themselves.

Roman art derives, nevertheless, from at least one other source. Around 750 B.C., at about the same time the Greeks first colonized the southern end of the Italian peninsula, the Etruscans, whose language has no relation to any known tongue, and whose origin is somewhat mysterious, established a vital set of city-states in the area between present-day Florence and Rome. Destroyed and rebuilt by Roman armies in the second and third centuries B.C., little remains of the Etruscan cities, and we know their culture largely through their sometimes richly decorated tombs. At Veii, just north of Rome, the Etruscans established a sculptural center that gave them a reputation as the finest metalworkers of the age. They traded widely, and from the sixth century on, a vast array of bronze objects, from statues to hand mirrors, were made for export. Perhaps influenced by the Greeks, they aspired to a similar level of realism in their work.

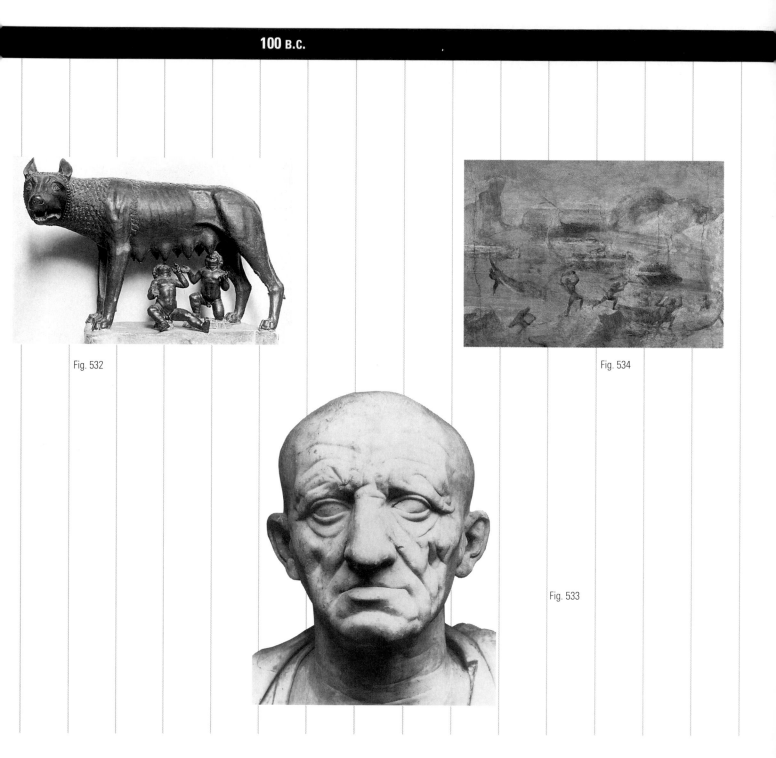

Fig. 532

Fig. 534

Fig. 533

Fig. 532 *She-Wolf*, c. 500 B.C. Bronze, height 33 ½ in. Museo Capitolino, Rome. The she-wolf, here suckling Romulus and Remus (who are Renaissance additions to the original), has served as the totem of the city of Rome ever since a statue of a she-wolf, possibly this Etruscan bronze, was dedicated on the Capitoline Hill in Rome in 296 B.C.

Fig. 533 *Portrait of a Roman*, c. 80 B.C. Marble, lifesize. Palazzo Torlonia, Rome. Metropolitan Museum of Art, New York. Rogers Fund, 1912. The Roman inclination to represent the figure without idealizing it is embodied in this portrait of an unknown man.

Fig. 534 *Ulysses in the Land of the Lestrygonians*, from a Roman patrician house, 50–40 B.C. Fresco, height 60 in. Vatican Library, Rome. This illusionistic landscape portrays a moment from Homer's *Odyssey* in which the crew of Ulysses, the epic's hero, is devoured by a race of giant cannibals.

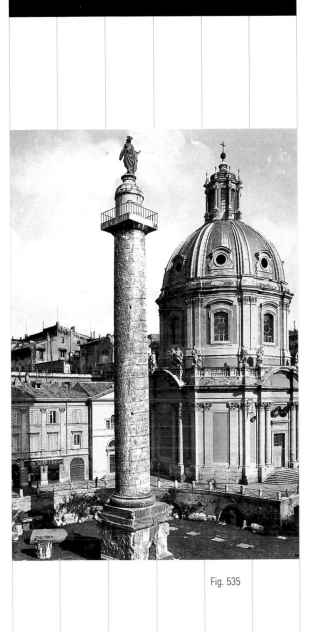

Fig. 535

Fig. 535 Attributed to Apollodorus, Column of Trajan, A.D. 113. Marble, height originally 128 ft.; length of frieze approx. 625 ft. Rome. Encircled by a spiraling band of relief sculpture, the column details the Emperor Trajan's two successful campaigns in present-day Hungary and Romania. The 150 separate episodes celebrate not only military victories but Rome's civilizing mission as well.

The Romans traced their ancestry to the Trojan prince Aeneas, who escaped after the sack of Troy and who appears in Homer's *Iliad*. The city of Rome itself was founded early in Etruscan times—in 753 B.C., the Romans believed—by Romulus and Remus, twins nurtured by a she-wolf, an animal important in Etruscan mythology and an image, for the Romans and probably for the Etruscans as well, of the fiercely protective loyalty and power of their motherland.

Beginning in the fifth century B.C., Rome dedicated itself to the conquest and creation of an empire that included all areas surrounding the Mediterranean and that stretched as far north as present-day England. By the time they conquered Greece, their interest in the accurate portrayal of human features was long established, and Hellenistic art only supported this tendency. They made death masks, called *imagines*, usually of wax, of their ancestors, and kept these likenesses in their homes. But where the Greeks had sought to idealize their figures, to render them perfectly proportioned and beautiful to the eye, the Romans preferred absolute realism. No matter how unflattering the subject's features, they were portrayed as they were.

In painting, the Romans were dedicated to a similar *verism*, or truth to nature. They had still lifes and illusionistic "window views" painted in fresco on the walls of their villas (see Figs. 291 & 292). Though the perspectival space of these works is by no means perfect, the artists clearly intended to create the illusion that we are looking out "through" the wall into recessional space. Linear perspective was, in fact, not employed at all, but, normally, figures in these works diminished in size as they got further away, and atmospheric perspective was commonplace. Three-dimensional effects were also achieved by means of chiaroscuro.

The perfection of the arch and the development of structural concrete were, as we have seen in Part 4, the major architectural contributions of the Romans. As the empire solidified its strength under the Pax Romana—150 years of peace initiated by the Emperor Augustus in 27 B.C.—a succession of emperors celebrated the glory of the empire in a variety of elaborate public works and monuments, including the Colosseum and the Pantheon (see Figs. 484–486). The most extravagant architectural

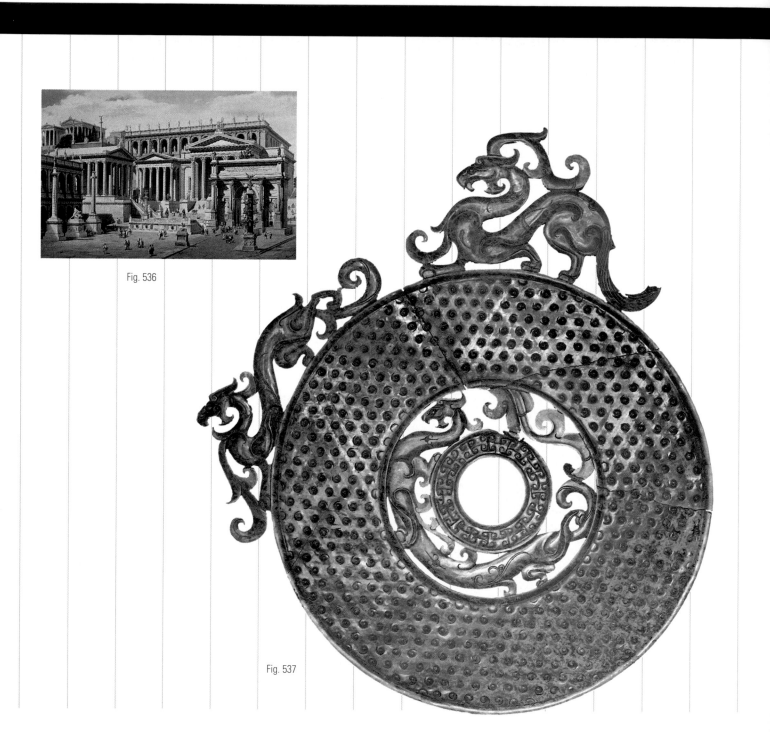

Fig. 536

Fig. 537

Fig. 536 Bechetti, *Reconstruction of the Roman Forum, Northern Part*. Watercolor. Superintendent of Architecture, Rome. At the time represented in this imaginary reconstruction, Rome's population approached 1 million. Most of its inhabitants lived in apartment buildings surrounding the Forum area. An archival record indicates that, at this time, there were only 1,797 private homes in the city.

Fig. 537 *Pi* (disc), late Chou dynasty, 6th to 3rd century B.C. Jade, diameter 6 ½ in. Nelson Gallery, Atkins Museum, Kansas City, Missouri. Nelson Fund. Jade, it was believed, had the power to preserve the body from decay. This particular disc, found in a tomb, is decorated with a dragon and a phoenix, which are commonly found in the context of the Chinese wedding ceremony, often hanging together as a pair over the table at the wedding feast. The tradition goes back to a time when the ancient peoples of China were united in an historic alliance of those from western China who worshipped the dragon with those from eastern China who worshipped the phoenix.

- **215 B.C. Great Wall of China built to keep out invaders (1,400 miles long)**
- **100 B.C. Chinese ships initiate trade with India**
- **A.D. 58 Emperor Ming-Ti introduces Buddhism**

Fig. 538

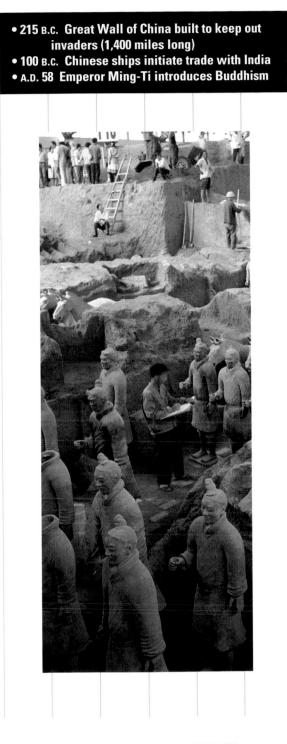

Fig. 538 Tomb of Emperor Shih Huang Ti, 221–206 B.C. Painted ceramic figures, lifesize. Discovered in 1974 at Shensi, the tomb of Shih Huang Ti contained more than 6,000 lifesize ceramic figures of soldiers and horses. Bronze horses and chariots have also been discovered. All were designed to serve as immortal bodyguards for the emperor.

expression of the Roman state was the Forum Romanum, the political center of Rome. The Etruscans had developed the site as a marketplace, but in a plan developed by Julius Caesar and implemented by Augustus, the Forum became the symbol of Roman power and grandeur, paved in marble and dominated by colonnaded public spaces, temples, basilicas, and state buildings such as the courts, the archives, and the Curia, or senate house.

Though Rome became extraordinarily wealthy, the empire began to falter after the death of Marcus Aurelius in A.D. 180. Invasions of Germanic tribes from the north, Berbers from the south, and Persians from the east wreaked havoc upon its economic, administrative, and military structure. By the time the Emperor Constantine decided to move the capital to Byzantium in A.D. 323—renaming it Constantinople, today's Istanbul—the empire was hopelessly divided, and the establishment of the new capital only underscored the division.

Developments in China

The early artistic traditions developed during the Shang dynasty in China, particularly the casting of bronze vessels, were continued to a large degree by the Chou, whose dynasty ruled from 1027 until 256 B.C. By the sixth century B.C., the empire had begun to dissolve into a number of warring feudal factions. The resulting political and social chaos brought with it a powerful upsurgence of philosophical and intellectual thought that focused on how to remedy the declining social order. In the context of this debate, Confucius, who died in 479 B.C., ten years before the birth of Socrates, introduced the idea that high office should be obtained by merit not birth, and that all social institutions, from the state to the family, should base their authority on loyalty and respect not sheer might. At the same time, the Taoists developed a philosophy based on the universal principle, or Tao: the achievement by the individual of a pure harmony with nature.

The long period of unrest ended in 221 B.C., when Shih Huang Ti, the first emperor of Ch-in (the origin of the name China) united the country under one rule. He imposed order, establishing a single code of law, requiring the use of a single language,

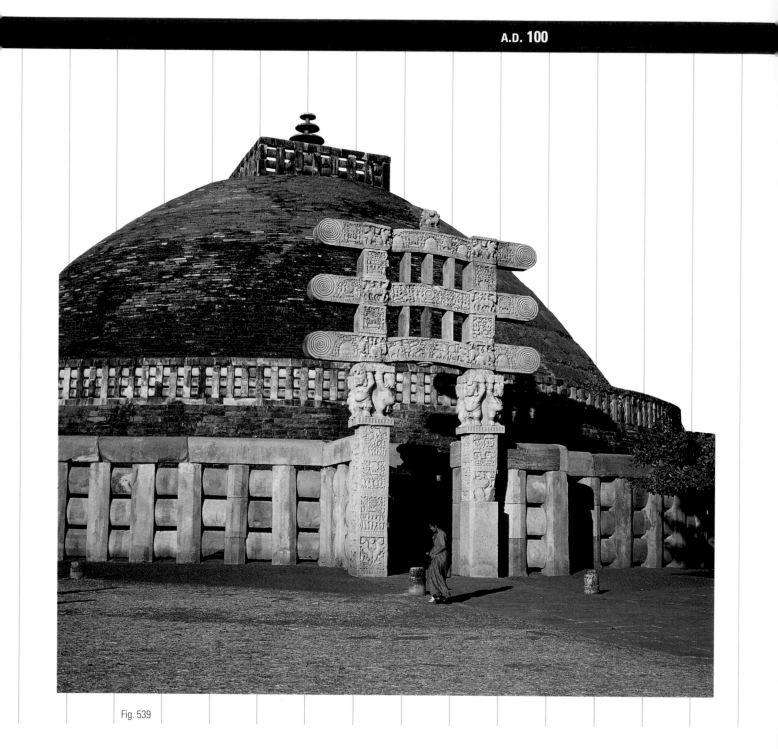

Fig. 539

Fig. 539 The Great Stupa, Sanchi, India. Begun 3rd century B.C., with later additions. Brick and rubble, originally faced with painted and gilded stucco, with rails of white stone. The stupa is literally a burial mound, dating from prehistoric times, but by the time this stupa was made (and it is the earliest surviving example of the form), it had come to house important relics of Buddha himself or the remains of later Buddhist holy persons. This stupa is made of rubble, piled on top of the original shrine, that has been faced with brick to form a hemispherical dome that symbolizes the earth itself. A railing—in this case, made of white stone and clearly visible in this photograph—encircles the sphere. Ceremonial processions moved along the narrow path behind this railing. Pilgrims would circle the stupa in a clockwise direction on another wider path, at ground level, retracing the path of the sun, thus putting themselves in harmony with the cosmos, and symbolically walking the Buddhist Path of Life around the World Mountain. Four 32-foot-high gateways, located at each of the cardinal points—North, South, East, and West—provide access to the stupa. They are intricately carved with both stories from the life of Buddha and ancient fertility gods and goddesses, called *yakshas* and *yakshis* respectively.

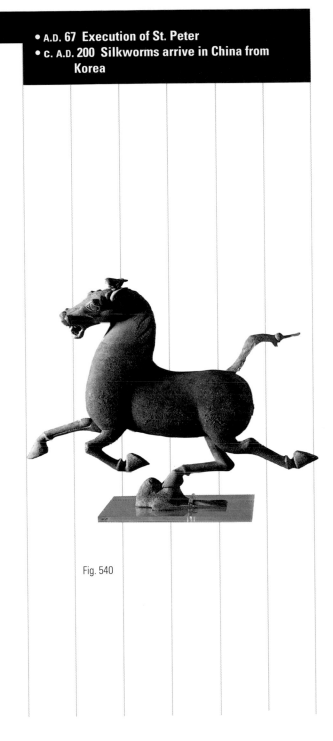

Fig. 540

Fig. 540 Flying Horse Poised on One Leg on a Swallow, from a tomb at Wuwei, Kansu, Late Han dynasty, 2nd century A.D. Bronze, height 13 1/2 in.; length 17 3/4 in. The Exhibition of the Archeological Finds of the People's Republic of China. An example of the Chinese mastery of bronze casting, this horse perfectly balances on one leg on a swallow, so that it seems to have taken flight like the bird itself.

standardizing weights and measures, burning historical books, and burying alive thousands of Confucian scholars. Under his rule, the Great Wall was built, and a massive tomb, designed to insure his immortality after death, was constructed by a work force of 700,000 men.

Upon the death of Shih Huang Ti in 207 B.C., a new dynasty, the Han, restored Confucianism to prominence. We know through surviving literary descriptions that the Han emperors built lavish palaces, richly decorated with wall paintings. In one of the few imperial Han tombs to have been discovered, that of the Emperor Wu Ti's brother and his wife, both bodies were dressed in suits made of over 2,000 jade tablets sewn together with gold wire. The prosperity of the Han dynasty was due largely to the expansion of trade, particularly the export of silk, which was available even in the markets of the Roman Empire. After the collapse of the Han dynasty, in A.D. 220, China endured a 400-year period of disorder and instability.

Early Buddhist Art

Buddha, "The Enlightened One," was born as Siddhartha Gautama around 556 B.C. Until he achieved *nirvana*—the release from worldly desires that ends the cycle of death and reincarnation and begins a state of permanent bliss—he preached a message of self-denial and meditation across northern India, attracting converts from all levels of Indian society. The religion gained strength for centuries after Buddha's death in about 480 B.C.,and finally became institutionalized in India under the rule of Asoka (273–232 B.C.) Deeply saddened by the horrors of war, and believing that his power rested ultimately in religious virtue and not military force, Asoka became a great patron of the Buddhist monks, erecting some 84,000 shrines, called *stupas*, throughout India, all elaborately decorated with sculpture and painting.

Early Christian and Byzantine Art

Christianity spread through the Roman world at a very rapid pace, in large part due to the missionary zeal of St. Paul. By A.D. 250, fully 60 percent of Asia Minor had converted to the religion, and when the Roman Emperor Constantine declared it the official state religion in the Edict of

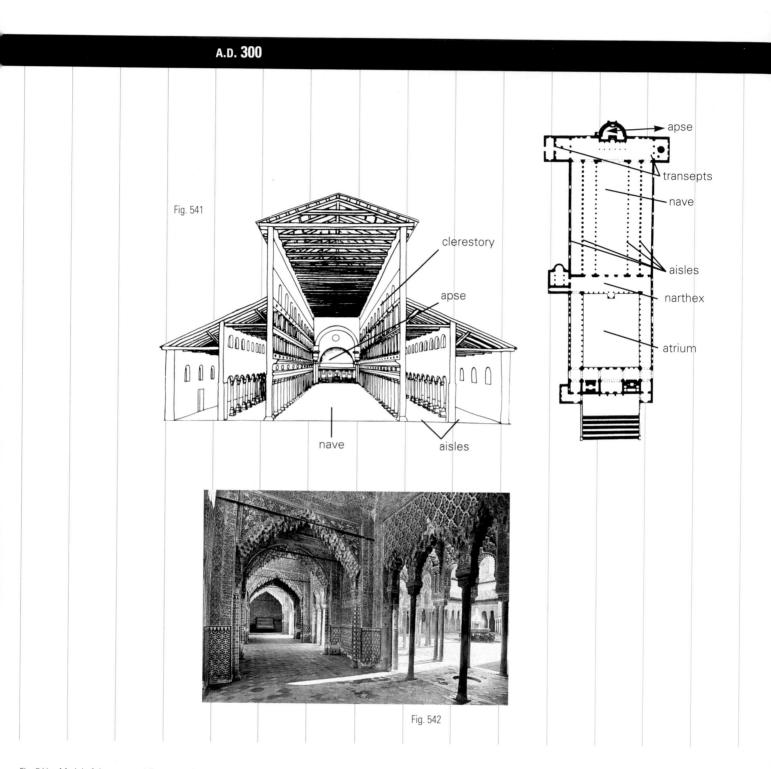

Fig. 541

clerestory

apse

nave

aisles

apse

transepts

nave

aisles

narthex

atrium

Fig. 542

Fig. 541 Model of the nave and floor plan, Old St. Peter's Basilica, Rome, c. 333–390. Approached through a traditional Roman atrium, or open courtyard, St. Peter's was the basis for church design for centuries to come. It faced east, with a long 368-foot *nave*, the central part of the church used by the congregation. The nave was flanked by side aisles and capped by an *apse*, the semicircular recess at the east end. In Roman times, the apse would have housed a statue of the Emperor. In the new Christian church, the *cathedra*, the "throne of the bishop" (and the source of the word "cathedral") was located there. To each side of the apse was a *transept*, consisting of two armlike wings extending north and south from the nave. The entire structure, therefore, took on the shape of the Christian cross. Traditionally, St. Peter's is believed to have been built over the grave of St. Peter, the first pope.

Fig. 542 Interior view, looking down the nave toward the apse, Sant' Apollinaire in Classe, near Ravenna, 533–549. Sant' Apollinaire is one of the earliest Christian basilicas that has survived more or less intact. This view gives us a good sense of the basilica's interior space, the wooden trusses supporting the gable roof, and the shimmering light provided by the *clerestory* windows, windows, that is, set above an adjacent roof, in this case above the roof over the side aisles.

● A.D. **320 Gupta dynasty begins to unify India**
● A.D. **325 Teotihuacán in Mexico mentioned**

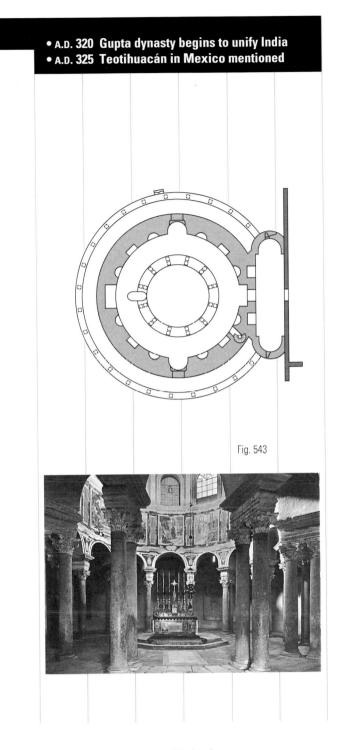

Fig. 543

Fig. 543 Santa Costanza, Rome, c. A.D. 354. Interior view and floor plan. Perhaps inspired by the pool-enclosing rotundas of the Roman public baths, the basic scheme of this small mausoleum, which would come to be commonly used for the baptisteries adjoining basilica churches—which did indeed contain the baths used for baptisms—was developed and amplified in monumental terms by later Byzantine architects.

Milan in A.D. 313, Christian art became imperial art. The classical art of Greece and Rome emphasized the humanity of its figures, their corporeal reality. But the Christian God was not mortal, could not even be comfortably represented in human terms, and though His Son, Jesus, was human enough, it was the mystery of both his Immaculate Conception and His rising from the dead that most interested the early Christian believer. The world that the Romans had celebrated on their walls in fresco—a world of still lifes and landscapes—was of little interest to a Christian mind that was more concerned with the spiritual and the heavenly rather than with the material trappings of the here and now.

Constantine deliberately chose to make early Christian places of worship as unlike classical temples in their design as possible. The building type that he preferred was the rectangular **basilica**, which the Romans had used for the architecture of public administration, especially courthouses. The original St. Peter's in Rome, constructed circa A.D. 333–390 but destroyed in the sixteenth century to make way for the building that now occupies the site, was a basilica.

Equally important for the future of Christian religious architecture was Santa Costanza, the small mausoleum built circa A.D. 354 for the tomb of Constantine's daughter, Constantia. Circular in shape and topped with a dome supported by a barrel vault, the building defines the points of the traditional Greek cross, which has four equal arms. Surrounding the circular space is a passageway known as an *ambulatory* that was used for ceremonial processions.

The circular form of Santa Costanza appears often in later Byzantine architecture. By the year 500, most of the western empire, traditionally Catholic, had been overrun by barbarian forces from the north. When the Emperor Justinian assumed the throne in Constantinople in 527, he dreamed of restoring the lost empire. His armies quickly recaptured the Mediterranean world, and he began a massive program of public works. At Ravenna, in Italy, at one time the imperial capital, Justinian built San Vitale, a new church modeled on the churches of Constantinople. Although the exterior is octagonal, the interior space is essentially circular, like Santa Costanza before it. Only in

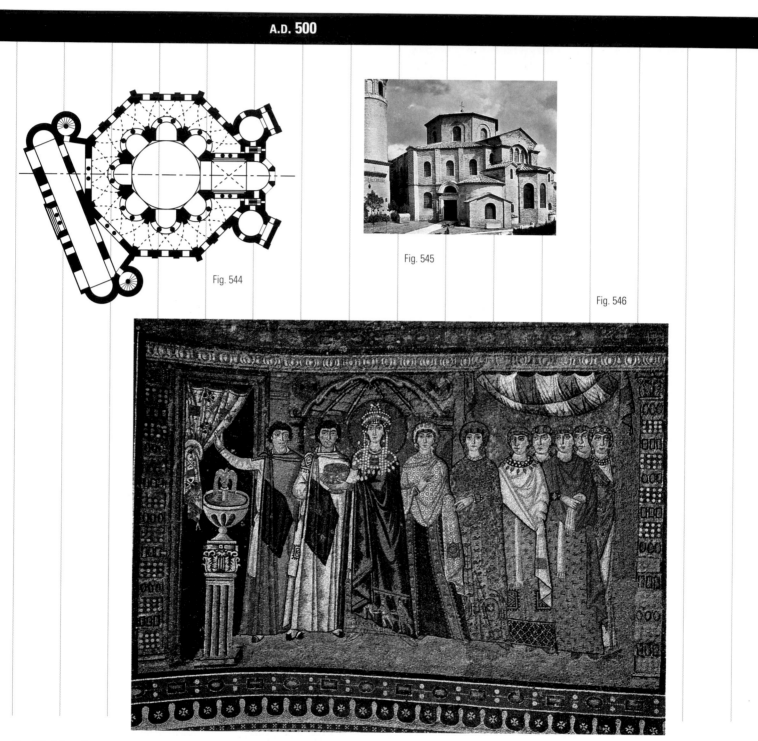

Figs. 544 & 545 San Vitale, Ravenna, A.D. 526–547. The ambulatory around the central domed area of the church was designed with a second story, or gallery, reserved for women, a standard feature in Byzantine churches.

Fig. 546 *Theodora and Her Attendants*, c. 547. Mosaic, sidewall of the apse, San Vitale. Theodora, wife of Justinian, had at one time been a circus performer, but was one of the emperor's most trusted advisers, sharing with him a vision of a Christian Roman Empire. On the opposite wall from the mosaic of Theodora and her attendants is one depicting Justinian and his retinue, visible in Figure 547. He carries a bowl containing bread, and she a golden cup of wine. Together they are bringing to the Church an offering of bread and wine for the celebration of the Eucharist. The haloed Justinian is to be identified with Christ, surrounded as he is by twelve advisors, like the Twelve Apostles. And the haloed Theodora, with the three Magi bearing gifts to the Virgin and newborn Christ embroidered on the hem of her skirt, is to be understood as a figure for Mary. In this image, the Church and the state become one and the same.

Fig. 547

Fig. 547 San Vitale, interior view, looking into the apse. The classical origin of the capitals of the columns supporting the arches around the circular nave of the church has been disguised with an elaborate relief of vines and tendrils. Visible in this view is the mosaic of the Emperor Justinian and his attendants, which is on the sidewall of the apse facing the figures depicted in Figure 546.

the altar and the apse, which lie to the right of the central domed area in the floor plan, is there any reference to the basilica structure that dominates western church architecture. Considering that Sant' Apollinaire, was built at virtually the same time, and in virtually the same place, there is some reason to believe that San Vitale was conceived as a political and religious statement, an attempt to persuade the people of the Italian peninsula to give up their Catholic ways and to adopt the Orthodox point of view—that is, to reject the leadership of the Church by the pope.

Sant' Apollinaire and San Vitale do share one very important feature. The facades of both are very plain, more or less unadorned local brick. Inside, however, both churches are elaborately decorated with marble and glittering mosaics. It is inner beauty that matters most in Christian doctrine, the human soul not the body which is its mortal container.

This is, of course, an extremely anticlassical position, one that bears no relation to the naturalism that dominated Greek and Roman culture. In the mosaics at Ravenna, the human figure is depicted wearing long robes that hide its musculature and cause a loss of individual identity. Although each face has unique features—some of Justinian's attendants, for example, are bearded, while others are not, and the hairstyles vary—all have identical wide open eyes, curved brows, and long noses. The feet of the figures turn outward, as if to flatten the space in which they stand. They are disproportionately long and thin, a fact that lends them an ethereal lightness. And they are motionless, standing before us without gesture, as if eternally still. The Greek ideal of sculpture in the round, with its sense of the body caught in an intensely personal, even private moment—Nike taking off her sandal, for instance, or Laocoön caught in the intensity of his torment—no longer has meaning. All sense of drama has been removed from the idea of representation.

Mosaics are made of small pieces of stone called *tesserae*, from the Greek word *tesseres*, meaning "square." In Hellenistic Rome, they were a favorite decorative element, used especially to embellish villa floors because they were capable of withstanding the constant wear and tear of

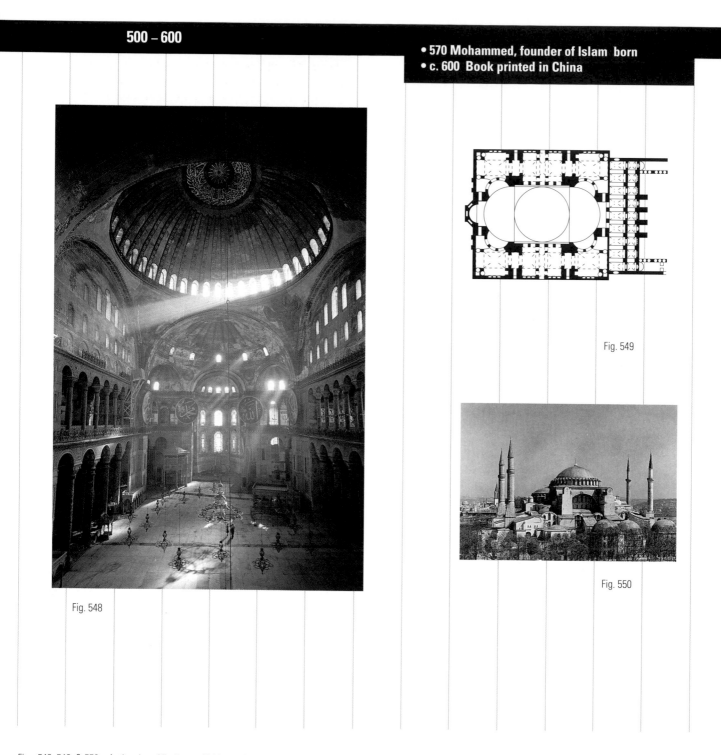

Fig. 548

Fig. 549

Fig. 550

Figs. 548, 549, & 550 Anthemius of Tralles and Isidorus of Milletus, Hagia Sophia, Istanbul, 532–537. Justinian attached enormous importance to architecture, believing that nothing better served to underscore the power of the emperor. The church of Hagia Sofia, meaning "Holy Wisdom," was his imperial place of worship in Constantinople. The huge interior, crowned by a dome, is reminiscent of the circular, central plan of Ravenna's San Vitale, but this dome is abutted at either end by half-domes that extend the central core of the church along a longitudinal axis reminiscent of the basilica, with the apse extending in another smaller half-dome out one end of the axis. These half-domes culminate in arches that are repeated on the two sides of the dome as well. The architectural scheme is, in fact, relatively simple—a dome supported by four *pendatives*, the curved, inverted triangular shapes that rise up to the rim of the dome between the four arches themselves. This dome-on-pendative design was so enthusiastically received that it became the standard for Byzantine church design, and its architects' names have never been forgotten.

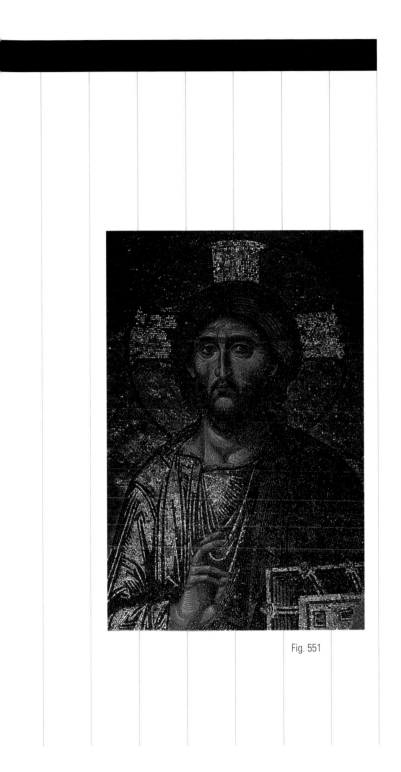

Fig. 551

Fig. 551 *Christ*, from *Deësis* mosaic, 13th century. Hagia Sophia, Istanbul. During the eighth and ninth centuries, Iconoclasts, meaning "image-breakers," believing literally in the Bible's commandment against the worship of graven images, destroyed much Byzantine art. Forced to migrate westward, Byzantine artists discovered Hellenistic naturalism and incorporated it into later Byzantine design. This posticonoclastic *Christ* is representative of that synthesis.

being walked on. But the Romans rarely used mosaic on their walls, where they preferred the more refined and naturalistic effects that were possible with fresco. For no matter how skilled the mosaic artist, the naturalism of the original drawing would inevitably be lost when the small stones were set in cement.

The Byzantine mosaic artists, however, had little interest in naturalism. Their intention was to create a symbolic, mystical art, something for which the mosaic medium was perfectly suited. Gold tesserae were made by sandwiching gold leaf between two small squares of glass, and polished glass was also used. By setting the tesserae unevenly, at slight angles, a shimmering and transcendent effect was realized that was heightened by the light from the church's clerestory windows.

Many of the original mosaics that decorated Hagia Sofia, Justinian's magnificent church in Constantinople, were later destroyed or covered over. Though only a few of the originals have been restored, the light in the interior is still almost transcendental in feel, and one can only imagine the heavenly aura when gold and glass reflected the light that entered the nave through the many windows that surround it. In Justinian's own words: "The sun's light and its shining rays fill the temple. One would say that the space is not lit by the sun without, but that the source of light is to be found within, such is the abundance of light.... The scintillations of the light forbid the spectator's gaze to linger on the details; each one attracts the eye and leads it on to the next. The circular motion of one's gaze reproduces itself to infinity.... The spirit rises toward God and floats in the air, certain that He is not far away, but loves to stay close to those whom He has chosen."

Justinian's reign marked the apex of the early Christian and Byzantine era. By the seventh century, barbarian invaders had taken control of the western empire, and the new Muslim empire had begun to expand to the east. Reduced in area to the Balkans and Greece, the Byzantine empire nevertheless held on until 1453 when the Turks finally captured Constantinople and renamed it Istanbul, converting Hagia Sophia into a mosque.

Fig. 553

Fig. 554

Fig. 552

Fig. 552 Hinged clasp from the Sutton Hoo burial ship, 7th century. Gold with garnets, mosaic, glass, and filigree. British Museum, London. Typical of the so-called animal style of the pre-Christian Germanic tribes, this clasp combines abstract decorative elements and, on each end, stylized animal forms.

Fig. 553 Cross page from the *Lindisfarne Gospels*, c. 700. 13 1/2 × 9 1/4 in. British Library, London. The basically simple design of the traditional stone Celtic crosses seen across Ireland has been complicated here by an elaborate interlace of fighting beasts with spiraling tails, extended necks, and clawing legs. The page is representative of the ways in which Christian and pagan motifs came to function together.

Fig. 554 *St. Matthew* from the *Lindisfarne Gospels*, c. A.D. 700. Approx. 11 × 9 in. British Library, London. The difficulties faced by the artist trained in the linear Celtic tradition in coping with the naturalistic traditions of Roman art are evident in this *Saint Matthew*, copied from an earlier Italian original. Here, the image is flat, the figure has not been modeled, and the perspective is completely off. It is pattern that really interests the artist, not accurate representation.

Fig. 555

Fig. 555 *St. Matthew from the Gospel Book of Charlemagne*, c. 800–810. 13 × 10 in. Kunsthistorisches Museum, Vienna. This page, from a gospel book reportedly found in the tomb of Charlemagne, shows the impact of Roman illusionism on the art of Northern Europe. Done only 100 years after the *Lindsfarne St. Matthew*, it looks almost as if it could have been painted in classical Rome.

Christian Art in Northern Europe

Until the year 1000, the center of Western civilization was located in the Middle East, at Constantinople. In Europe proper, tribal groups with localized power held sway: the Lombards in what is now Italy, the Franks and the Burgundians in regions of France, and the Angles and Saxons in England. Though it possessed no real political power, the Papacy in Rome had begun to work hard to convert the pagan tribes and to reassert the authority of the Church. As early as 496, the leader of the Franks, Clovis, was baptized into the Church. Even earlier (c. 430), St. Patrick had undertaken an evangelical mission to Ireland, establishing monasteries and quickly converting the native Celts. These new monasteries were designed to serve a missionary function, and at the same time that their educational role became more and more firmly established, the sacred texts they produced came to reflect native Celtic designs, which are elaborately decorative, highly abstract, and in which there is no attempt at naturalistic representation.

In 597, Gregory the Great, the first monk to have been made pope, sent Saint Augustine of Canterbury on a mission to convert the Anglo-Saxons. This mission brought Roman religious and artistic traditions into direct conflict with the Celtic-influenced religious art already in place, and slowly but surely Roman culture began to dominate the Celtic-Germanic world. When Charlemagne (Charles, or Carolus, the Great) assumed leadership of the Franks in 771, this process of Romanization was almost certainly assured. At papal request, Charlemagne conquered the Lombards, becoming their King, and on Christmas Day, 800, he was crowned emperor of the Holy Roman Empire by Pope Leo III at St. Peter's Basilica in Rome. The new fusion of Germanic and Mediterranean styles that reflected this new alliance between Church and state is known as **Carolingian** art, a term referring to the art produced during the reign of Charlemagne and his immediate successors.

Charlemagne was intent on restoring the glories of Roman civilization. He actively collected and had copied the oldest surviving texts of the classical Latin authors. He created schools in monasteries and cathedrals across Europe in

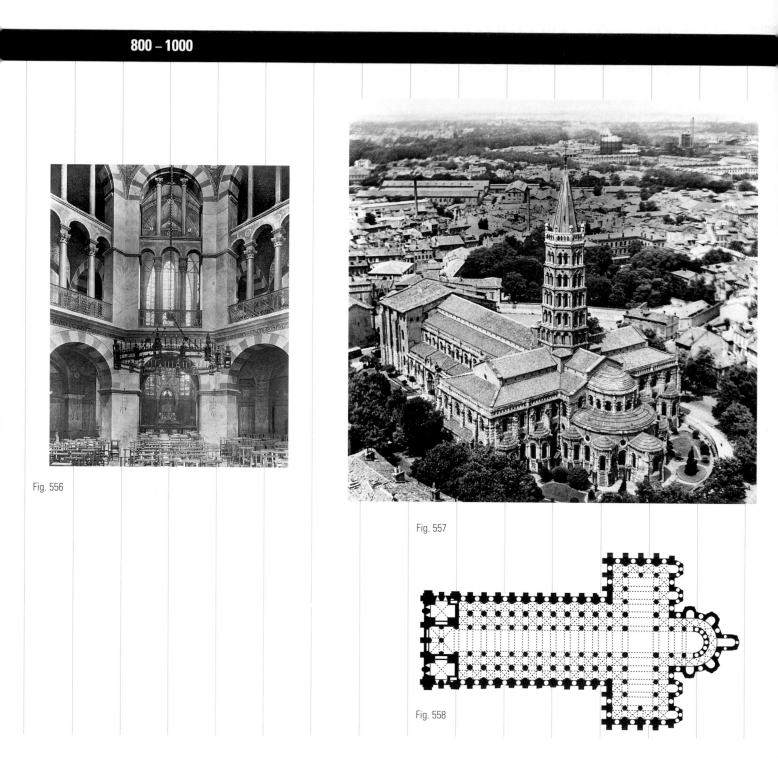

Fig. 556

Fig. 557

Fig. 558

Fig. 556 Interior of the Palace Chapel of Charlemagne, Aachen, Germany, 792–805. The chapel is much more massive in feel than its model, San Vitale, and anticipates Romanesque architecture. The octagonal shape of San Vitale's interior space is essentially disguised by the semicircular niches that surround it (see Fig. 544). But here that shape is emphasized by the angles clearly articulated at the point where each arch meets.

Figs. 557 & 558 St. Sernin, Toulouse, France, c. 1080–1120. The plan of this church is one of great symmetry and geometric simplicity. It reflects the Romanesque preference for rational order and logical development. Every measurement is based upon the central square at the crossing. Each square in the aisles, for instance, is one-quarter the size of the crossing square. Each transept extends two full squares from the center. The tower that rises over the crossing was completed in Gothic times and is taller than it was originally intended to be.

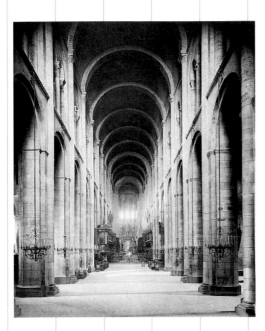

Fig. 559

Fig. 559 Interior view of nave and choir, St. Sernin, Toulouse. Typical of most Romanesque churches is St. Sernin's barrel vault.

which classical Latin was the accepted language. And a new script, with Roman capitals and new lower-case letters, the basis of modern print, was introduced. At Aachen, the Frankish capital in Germany, he built a "new Rome." Perhaps inspired by San Vitale—he had visited Ravenna in 789—Charlemagne's Palace Chapel contained columns and capitals removed from Rome by permission of the pope. Making one of its first appearances in this chapel, and distinguishing it particularly from San Vitale, was a monumental entrance structure called the *westwork*, a two-towered facade that subsequently came to dominate church architecture in the Middle Ages.

Romanesque Art

After the dissolution of the Carolingian state, Europe disintegrated into a large number of small feudal territories. The emperors were replaced by an array of rulers of varying power and prestige who controlled smaller or larger fiefdoms, areas of land worked by persons under obligation to the ruler, and whose authority was generally embodied in a chateau or castle surrounded by walls and moats. Despite this atomization of political life, a recognizable style that we have come to call **Romanesque** developed throughout Europe beginning about 1050. Although details varied from place to place, certain features remained constant for nearly 200 years.

Romanesque architecture is characterized by its easily recognizable geometric masses—rectangles, cubes, cylinders, and half-cylinders. The wooden roof that St. Peter's Basilica had utilized was abandoned in favor of fireproof stone and masonry construction, apparently out of bitter experience with the invading nomadic tribes, who burned many of the churches of Europe in the ninth and tenth centuries. Flat roofs were replaced by vaulted ceilings that, of structural necessity, were supported by massive walls that often lacked windows sufficient to provide adequate lighting. The churches were often built along the roads leading to the pilgrimage centers, usually monasteries that housed important Christian relics, and they had to be large to accommodate large crowds of the faithful. St. Sernin, in Toulouse, in the South of France, for instance, was on the pilgrimage route to Santiago

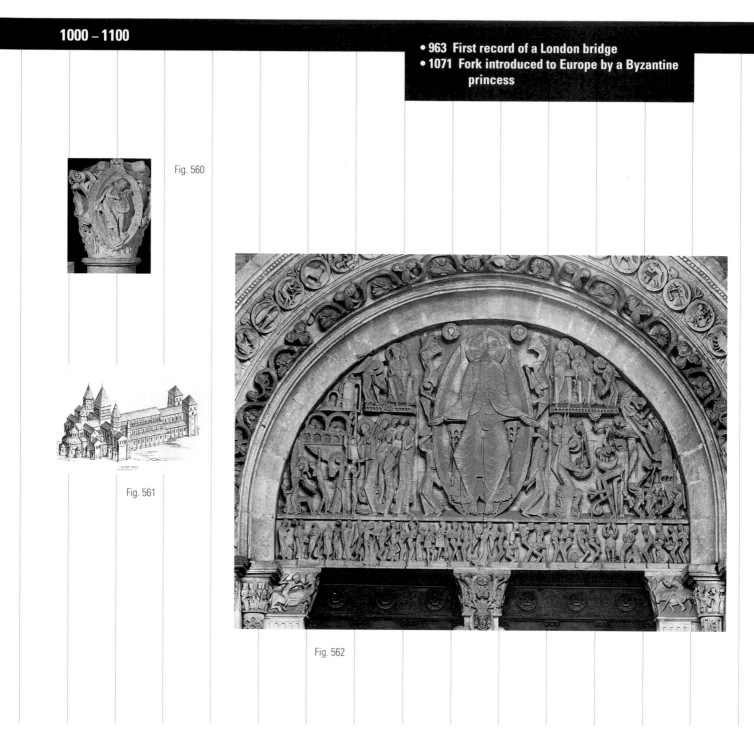

Fig. 560

Fig. 561

Fig. 562

Fig. 560 Capital with relief representing the Third Tone of Plainsong, from the choir, Abbey Church of St. Pierre, Cluny. Musée Lapidaire du Farinier, Cluny, France. This Corinthian capital, one of ten that survives from the original Abbey Church at Cluny, shows the continued importance of Roman art even in a Christian context. The almond-shaped inset hollowed into the acanthus leaves contains a figure playing a lyre, underscoring the importance of the arts in the Clunaic order.

Fig. 561 Reconstruction of the third Abbey Church of St. Pierre, Cluny, France, c. 1085–1130. Until the building of the new St. Peter's in Rome, the church at Cluny was the largest in the Christian world. It was 521 feet in length, and its nave vaults rose to a height of 100 feet. The height of the nave was made possible by the use of pointed arches. Destroyed in the French Revolution, only part of one transept survives.

Fig. 562 Gislebertus, *Last Judgment*, tympanum and lintel, west portal, Cathedral, Autun, France, c. 1125–1135. Stone, approx. 12 ft. 6 in. × 22 ft. To the viewer's left, the blessed arrive in heaven, while on the right, the damned are seized by devils. Combining all manner of animal forms, the singular monstrosity of these creatures recalls the animal style of the Germanic hordes.

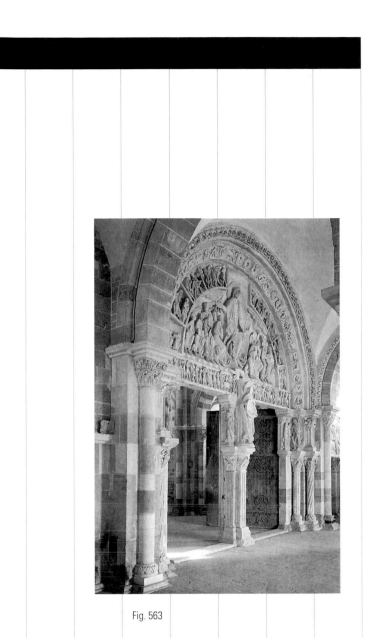

Fig. 563

Fig. 563 Central portal, Abbey Church of La Madeleine,
Vézelay, France, 1120–1132. Vézelay is closely
associated with the Crusades. In 1095, Pope Urban II had
intended to begin the First Crusade here. The Second
Crusade, in 1146, was preached here, and in 1190, King
Richard the Lion-Hearted of England left from Vézelay on
the Third Crusade. The Crusades were seen as the
"second mission of the Apostles," and, as a result, the
Apostles decorate the tympanum.

de Compostela, in Spain, where the body of St.
James had been discovered.

Thanks in large part to Charlemagne's
emphasis on monastic learning, monasteries had
flourished ever since the Carolingian period,
many of them acting as feudal landlords as well.
The largest and most powerful was Cluny, near
Mâcon, France. A Benedictine order, it stressed
the intellectual life, the study of music, and the
pursuit of the arts. Though almost all of the art
that once decorated Cluny was destroyed during
the French Revolution, we know it was richly dec-
orated, particularly with sculpture.

With the decline of Hellenistic Rome, the art
of sculpture had largely declined in the West. The
reasons for its reemergence in the Romanesque
period are not clear, but certainly the idea of edu-
cating the masses in the Christian message
through architectural sculpture on the facades of
the pilgrimage churches contributed to its rebirth.
The area around the portal, or main entrance, to
the church was considered particularly well suit-
ed for this purpose, and the sculptures there were
often painted in polychrome. The most important
sculptural work was usually located on the *tym-
panum*, the semicircular arch above the lintel on
the church's main door, and it often showed Christ
with His Twelve Apostles. Another favorite theme
was the Last Judgment, full of depictions of sin-
ners suffering the horrors of hellfire and damna-
tion. Narrative and decorative motifs were also
carved on the *archivolts*, the semicircular molding
surrounding the tympanum, on the *jambs*, the
areas on each side of the cathedral's doors, and
on the *trumeau*, the central post between the
double doors of the entrance.

The design of these portals was not left to
the artist, but was planned in detail by monastic
authorities. According to Church doctrine, "The
composition is not the invention of the artist but
the result of church legislation and custom. The
skill alone belongs to the artist." The artist's skill-
ful use of linear rhythms, reminiscent of manu-
script decoration, is evident in the portal of the
church at Vézelay, France, just north of Cluny (Fig.
563). The architectural vocabulary of Rome is still
evident, especially in the columns and their capi-
tals, but the abundant sculptural detail on the
facade is uniquely Romanesque.

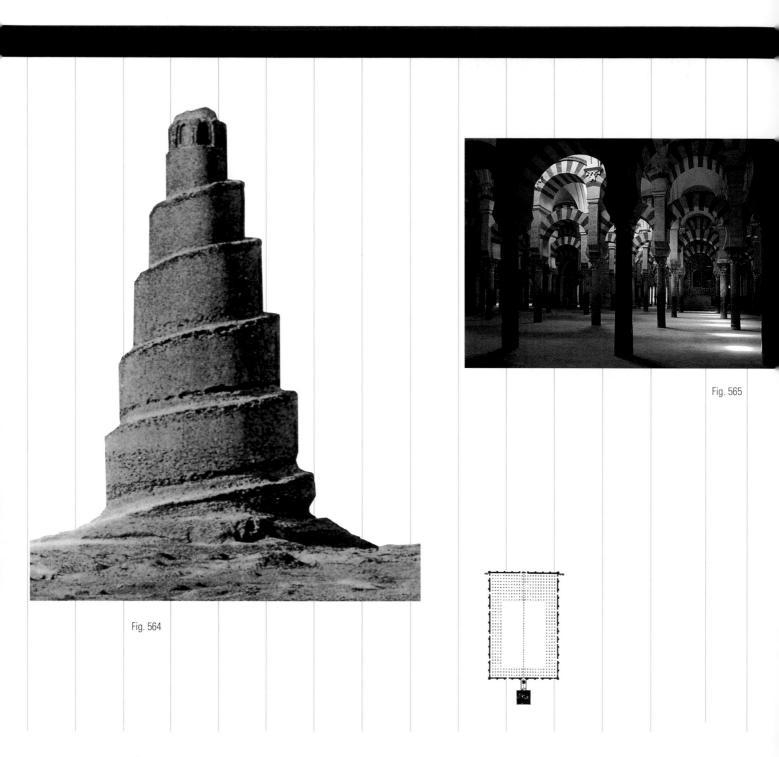

Fig. 564

Fig. 565

Fig. 564 Great Mosque at Samarra (with plan at right), Iraq, 648–852. Now ruined, the mosque at Samarra was once the largest in the Islamic world. Its single minaret, modeled on the ziggurats of ancient Mesopotamia, stood before the entrance, opposite the *mihrab* on the *qibla* wall, and above a ten-acre site, half of which was covered by a wooden roof. The roof was supported by 464 columns arranged in aisles around an open center court. Once a week, the entire community would convene in the mosque to hear a sermon preached by the *imam*, or leader of collective worship, who would address the people from a pulpit, or *minbar*, near the *qibla* wall. Attendance at the sermon was not merely a religious act, but an act of allegiance to the *imam*. Thus a mosque had to be large enough to contain the entire community.

Fig. 565 Interior of the sanctuary of the mosque at Córdoba, Spain, 786–987. With its 36 piers and 514 columns, the mosque at Córdoba gives us some sense of what Samarra might once have looked like. Between 786 and 987, it was enlarged seven times, showing the versatility of *hypostyle* construction, in which the many columns supporting a single roof can be added to without threatening the structural integrity of the building.

The Art of Islam

Pope Urban II declared the First Crusade in 1095 at Vézelay because he wanted to liberate Jerusalem from control by the Muslims. Ever since the Prophet Mohammed had fled Mecca for Medina in 622, the Muslim empire had expanded rapidly. By 640, Mohammed's successors, the Caliphs, had conquered Syria, Palestine, and Iraq. Two years later, they defeated the Byzantine army at Alexandria, and, by 710, they had captured all of northern Africa and moved into Spain. They advanced north until 732, when Charles Martel, grandfather of Charlemagne, defeated them at Poitiers, France. But the Caliphs' foothold in Europe remained strong, and they did not leave Spain until 1492. Even the Crusades failed to reduce their power. During the First Crusade 50,000 men were sent to the Middle East, where they managed to hold Jerusalem and much of Palestine for a short while. The Second Crusade, in 1146, failed to regain control, and, in 1187, the Muslim warrior Saladin reconquered Jerusalem. Finally, in 1192, Saladin defeated King Richard the Lion-Hearted of England in the Third Crusade. A proposed Fourth Crusade never materialized.

The major architectural form of Islam was the mosque. All mosques feature a *qibla* wall facing the direction of Mecca, the holy site toward which all Muslims must turn in prayer. The entrance was opposite this wall, so that a given mosque might be oriented in any direction depending upon its relation to Mecca. Situated in the center of the *qibla* wall is a niche, called the *mihrab*, symbolic of the spot in Mohammed's house at Medina where he stood to lead communal prayers. *Minarets* rise over Muslim mosques, the towers from which five times each day the *muezzin*, or crier, calls the faithful to prayer.

All Muslim design, be it architecture, carpets (see Fig. 433), stucco reliefs, colored tiles, or mosaics, is characterized by a visual rhythm realized through symmetry and the regular repetition of certain patterns and motifs. Perhaps the most highly developed of the arts, and certainly the most highly esteemed, was the art of calligraphy (see Figs. 14 & 16), which reflects the emphasis placed by Islamic culture on knowledge of the text of the Koran, the book of God's revelations to the Prophet Mohammed.

Fig. 566

Fig. 566 The Queen's Chamber, the Alhambra, Granada, Spain, c. 1354–1391. Considered by many the finest creation of Islamic architecture, the walls and ceilings of the Alhambra, the last Islamic stronghold in Spain, are covered in a lacework of stucco relief that makes the building seem almost immaterial. The design, containing Arabic calligraphy as well as abstract ornamental patterning, is unified through both symmetry and repetition.

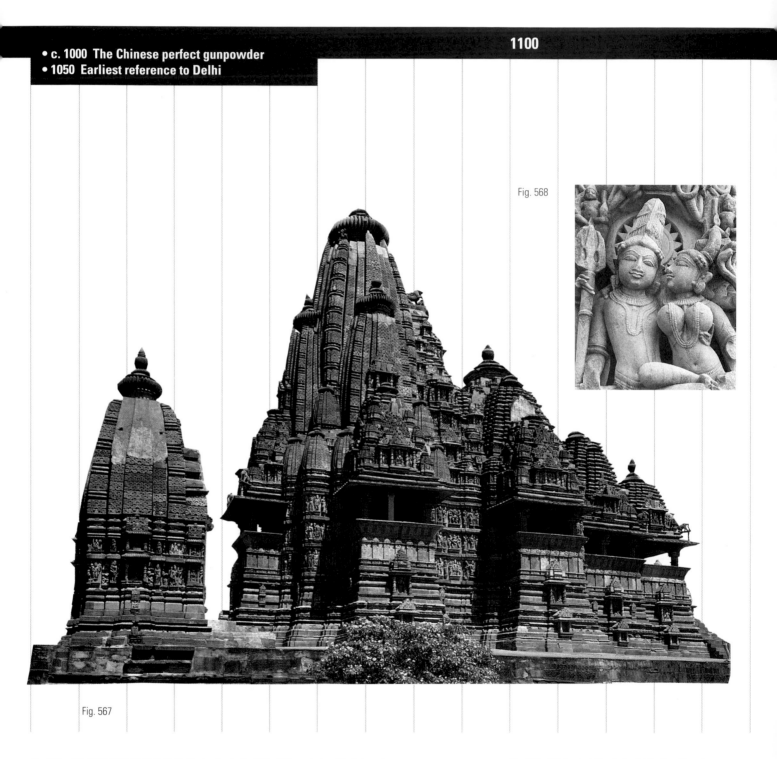

Fig. 568

Fig. 567

Fig. 567 Kandariya Mahadeva Temple, Khajuraho, India, 10th–11th centuries. Hindu temples were designed to capture the rhythms of the cosmos. Completed only a few years before the great Romanesque cathedrals of Europe, the main tower at Kandariya is like a mountain peak, showing the summit of the paths one must follow to attain salvation. The entirety is covered by intricate reliefs representing the gods, stories from Hindu tradition, and erotic encounters. For an illustration of a present-day Hindu temple see Fig. 489.

Fig. 568 Wall relief, Kandariya Mahadeva Temple, Khajuraho, India, 10th–11th centuries. Hindu temples were often decorated with frankly erotic scenes, for the pleasures of erotic love were understood as reflecting the pleasures of the eventual union with the god, and carnal love was seen as an aspect of spiritual love. The achievement of sexual bliss was thus considered to be one of the many paths of virtue leading to redemption.

Hindu Art

The origins of Hinduism in India can be traced back to the Vedic religions that arose about 1500 B.C. when invading Aryan tribesmen from Central Asia overwhelmed Indian culture. The Vedic traditions of the light-skinned Aryans, written in religious texts called the Vedas, allowed for the development of a class system based on racial distinctions. Status in one of the four classes—the priests (*Brahmans*), the warriors and rulers (*kshatriyas*), the farmers and merchants (*vaishayas*), and the serfs (*shudras*)—was determined by birth, and one could only escape one's caste through reincarnation. Buddhism, which began about 563 B.C., was in many ways a reaction against the Vedic caste system, allowing for salvation by means of individual self-denial and meditation, and it gained many followers. Over time, the old Vedic laws were slowly formalized into Hinduism proper, and after the Gupta Empire (c. A.D. 320–540) began to support the new religion, it came to dominate Indian religious life.

The Hindu religion has myriad gods, headed by the trinity of Brahma, Vishnu, and Shiva. Brahma is the virtually unapproachable creator of the cosmos, and contains all things. Indeed, the Hindu gods usually incorporate all aspects of the human personality, and are incarnated in a variety of forms. Vishnu's most popular incarnation is as the voluptuous Krishna, but in his ninth and last incarnation, in a gesture perhaps aimed at disarming the rival Buddhist religion, the Hindus believe that Vishnu is Buddha. Shiva is at once masculine and feminine, represented as a phallus when associated with fertility, as the benign Mahadeva when associated with the maintenance of all things, and as the dancer Nataraja when, embodying the cyclic nature of existence, he is both creator and destroyer of the cosmos.

Gothic Art

The great era of Gothic art begins in 1137 with the rebuilding of the choir of the abbey church of St. Denis, located just outside Paris. St. Denis has a long history, and was closely tied to the great Carolingian kings. Not only had Charlemagne been consecrated king in the church, but both his father, Pepin, and his grand-

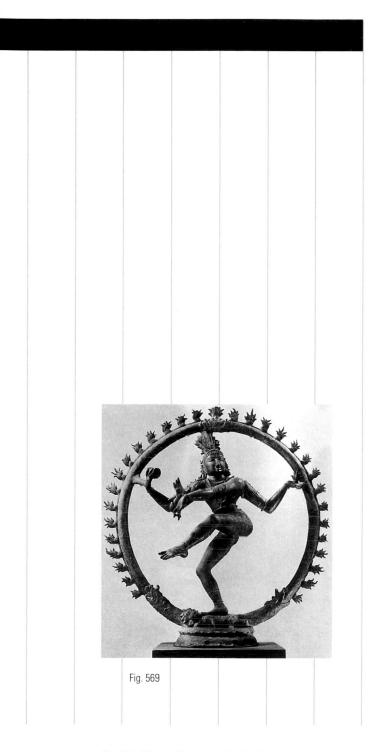

Fig. 569

Fig. 569 Shiva as Nataraja, Lord of the Dance, South India, Chola Period, 11th century. Copper, height 43 7/8 in.; width, 40 in. Cleveland Museum of Art, Purchase the J. H. Wade Fund. Here Shiva dances with one foot on the Demon of Ignorance. He stands inside the circle of the cosmos, which is itself ringed by flames, symbolizing both its inevitable destruction and the cycle of life, death, and rebirth. Shiva's many arms testify to his supernatural powers.

• **1066 Norman invasion of England**
• **c. 1100 Third Pueblo period in Southwest region of present-day United States**

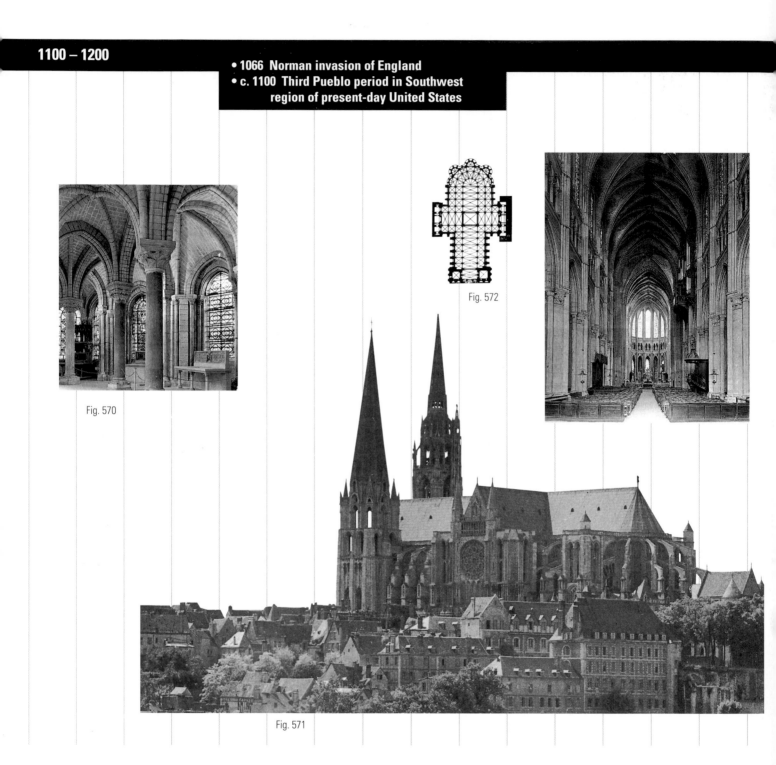

Fig. 570

Fig. 572

Fig. 571

Fig. 570 Interior and plan, St. Denis, near Paris, 1140–1144. The open areas behind the columns that encircle the ambulatory in St. Denis are the spaces that had been individual chapels in Romanesque churches. As a result of opening these spaces up, the church as a whole felt more spacious and airy.

Fig. 571 Chartres Cathedral, 1145–1220. Erected on a hill in the middle of the town, Chartres Cathedral can be seen for miles around.

Fig. 572 Nave and plan, Chartres Cathedral. The plan of Chartres reveals it to be an extremely balanced structure, the area encompassing the choir and apse (called the *chevet*), the nave, and the transept being almost equal in dimension. The interior is thus dramatically opened, creating a sense of space that photography cannot begin to capture.

Fig. 573

Fig. 573 Transverse section of Chartres Cathedral showing flying buttress. The flying buttress was first employed about 1180 to brace the nave of Notre Dame in Paris. Chartres is the first of the Gothic cathedrals where use of the flying buttress was planned from the beginning. The buttress arches across the lower vaults of aisle and gallery and abuts the nave wall at exactly the point of greatest outward thrust.

father, Charles Martel, who had defeated the Muslims at Poitiers, were buried there. The Abbot of St. Denis, Suger, saw his new church as being both the political and spiritual center of a new France, united under King Louis VI.

Clearly familiar with Romanesque architecture, then at its height, Suger chose to abandon it in principle. As we have noted, the Romanesque church was difficult to light because the structural need to support the nave walls from without meant that clerestory windows had to be eliminated. Suger envisioned something different. He wanted his church flooded with light as if by the light of Heaven itself. The new St. Denis, he wrote, "will shine with the wonderful and uninterrupted light of the most luminous windows, pervading the interior beauty [of the church itself]." For Suger, this light was deeply theological in meaning. "Marvel not at the gold and the expense but at the craftsmanship of the work," he wrote. "Bright is the noble work; but, being nobly bright, the work should brighten the minds, so that they may travel, through the true light, to the True Light where Christ is the true door."

St. Denis contains many Romanesque features, notably a choir and an apse surrounded by an arcaded ambulatory. But instead of creating separate chapels behind the ambulatory, as was customary, the ambulatory and chapel areas were merged into a continuous and open space. This space consists of seven wedge-shaped areas, articulated by columns and arches, that fan out from the center of the apse, each capped by a groined vault of pointed arches. The stained-glass windows (see Figs. 32 & 200) at the back of each wedge fill the entire wall area, admitting a relatively large amount of light into the church. Filled with stained glass instead of stone, the walls seem to disappear. What made this all possible was the *flying buttress*, a structural device that was intended to absorb the pressure exerted on the outside walls by the vaults. With this unique combination of the pointed arches, groined vaults, and flying buttresses, the architect of the Gothic church was able to vault the central nave to an extraordinary height. Supported by the buttress system, the interior stonework was made to appear almost fragile, even weightless, especially where it framed the stained glass.

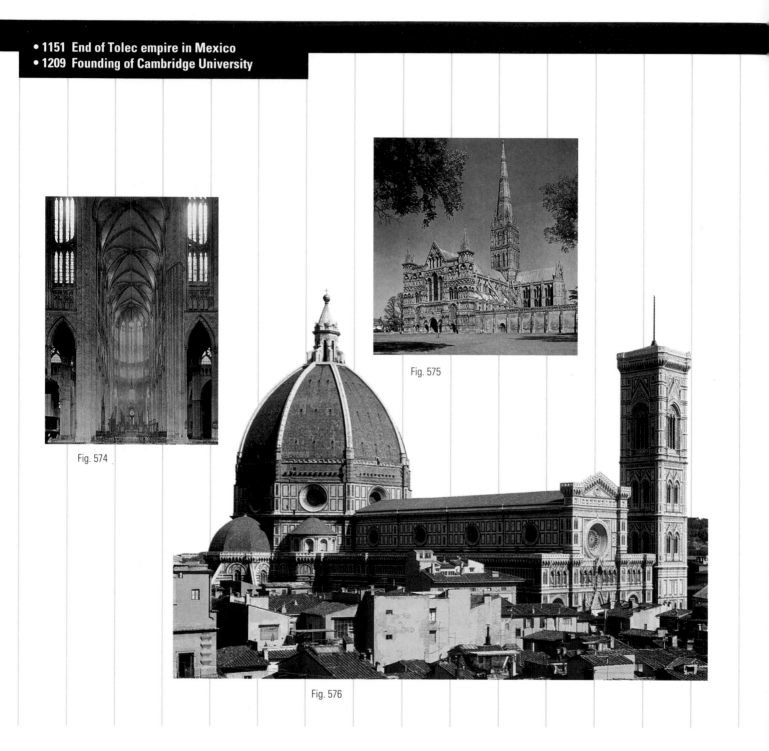

Fig. 574

Fig. 575

Fig. 576

Fig. 574 Choir of Beauvais Cathedral, 1272, vaults rebuilt after 1284. The upward thrust of the nave vault is nowhere higher than at Beauvais. The nave at Chartres is 118 feet high; that at Beauvais was designed to be 157 feet high, but, in 1284, the vaults collapsed. It is not altogether clear why, and it remains a matter of schloraly debate. In rebuilding the vaults something of the grace of the original design was sacrificed, but the 157-foot height was achieved.

Fig. 575 Salisbury Cathedral, England, 1220–1270. Though it cannot be mistaken for anything but a Gothic cathedral, Salisbury is proof of the freedom with which the Gothic was adapted outside France. The verticality of the French Gothic is abandoned in English Gothic. The flying buttresses seem merely a decorative afterthought. Instead of being located at city center, the cathedral's setting is a park. In form if not detail, the facade could as well be Romanesque as Gothic.

Fig. 576 Florence Cathedral (Santa Maria del Fiore), begun by Arnolfo de Cambio, 1296; dome by Filippo Brunelleschi, 1420–1436. A separate campanile, or bell tower, takes the place of the facade towers typical in the North. Designed by the artist Giotto, it is composed of a rising set of cubes, the geometric simplicity of which affirms an apparent Italian unwillingness to submit wholly to the emotional mysteries of the Gothic.

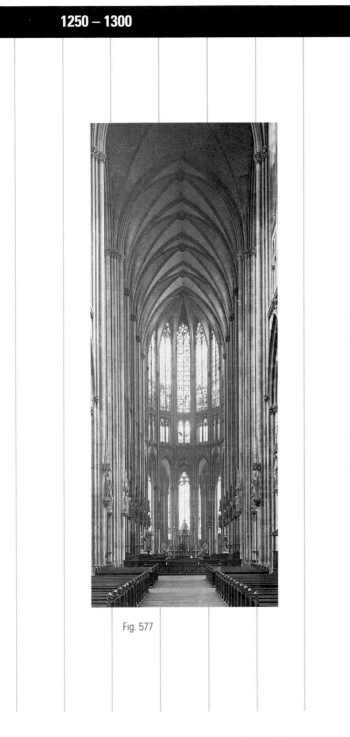

Fig. 577

Fig. 577 Choir of Cologne Cathedral, Germany, 13th and 14th centuries. Begun in 1248, the cathedral stood without a nave for five centuries until the nineteenth century, when its original plans were discovered. The stability of the structure was demonstrated during World War II, when it came under heavy Allied air attack. An early blast blew out all the windows, but the skeletal framework survived.

The Gothic style spread rapidly throughout Europe, though each particular region modified it to suit local tastes and conditions. The early English Gothic, at Salisbury for instance, tended to extend itself horizontally rather than vertically. This emphasis is clearly evident on the facade, and its effect is felt in the nave as well, where the eye does not automatically rise up to the vaults, as in a French Gothic cathedral, but instead runs down the length of the nave, marveling at the rhythmic effects achieved at eye level. In Germany's Cologne Cathedral, on the other hand, the width of the nave has been narrowed to such a degree that the vaults, almost as high as those at Beauvais, seem to rise even higher. Not finished until the nineteenth century, though built strictly in accordance with thirteenth century plans, its stonework is so slender, incorporating so much glass into its walls, that the effect is of almost total weightlessness. The Gothic style in Italy is unique. The exterior of Florence Cathedral, for instance, is hardly Gothic at all, and was, in fact, designed to match the dogmatically Romanesque octagonal Baptistry that stands before it. But the interior space is clearly Gothic in character. Each side of the nave is flanked by an arcade that opens almost completely into the nave by virtue of four wide pointed arches. Thus nave and arcade become one, and the interior of the cathedral feels more spacious than any other. Nevertheless, rather than the mysterious and transcendental feelings evoked by most Gothic churches, Florence Cathedral produces a sense of tranquility and of measured, controlled calm.

The Gothic style in architecture inspired an outpouring of sculptural decoration. There was, for one thing, much more room for sculpture on the facade of the Gothic church than had been available on the facade of the Romanesque church. On the west facade there were now three doors where there had been only one before, and portals were added to the transepts as well. Romanesque sculpture, such as that on the tympanum at Autun, France (see Fig. 562), was characterized by the frenzied, jerky movement of a wealth of figures that are virtually crammed into the confined space of the semicircle. The elongated bodies of the Romanesque figure are distributed in a very shallow space.

- **1214 Peking captured by Genghis Khan**
- **1220 Giraffes exhibited in Europe**
- **1233 Coal mined in Newcastle, England**

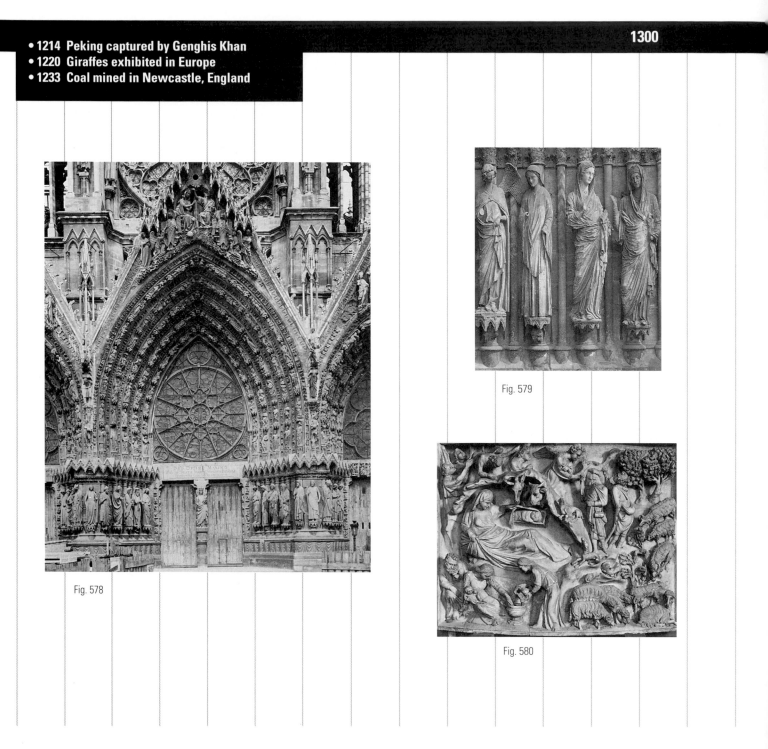

Fig. 578

Fig. 579

Fig. 580

Fig. 578 Central portal of the west facade of Reims Cathedral, c. 1225–1290. The portal at Reims, which notably substitutes a stained-glass rose window for the Romanesque tympanum and a pointed for a rounded arch, is sculpturally also much lighter. The jamb statues seem almost completely free of the columns on which they stand, and are carved in an animated, indeed almost casual style.

Fig. 579 *Annunciation* and *Visitation*, detail, west portal, Reims Cathedral, c. 1225–1245. Here, each pair of jamb figures is engaged in a narrative scene. The angel in the *Annunciation* group on the left smiles at the more somber Virgin. The pair at the left seems about to step off their pedestals. What is most remarkable is that the space between the figures is bridged by shared emotion, as if feeling is able to unite them in a common space.

Fig. 580 Giovanni Pisano, *The Nativity*, detail of pulpit, Pisa Cathedral, 1302–1310. Marble. Pisano sets the figures in this relief loose of their architectural mooring by situating them in a landscape. Notice, particularly, how the sheep below the tree on the right seem to graze down the hillside toward us. If the Virgin is, realistically speaking, too large, showing the continued influence of medieval hierarchies, Pisano has been able to give expression to his naturalistic impulses.

Fig. 581

Fig. 581 The Limbourg Brothers, *October*, from *Les Très Riches Heures du Duc de Berry*, 1413–1416. Musée Condé, Chantilly. Here, for the first time since classical antiquity, human beings are represented as casting actual shadows upon the ground. The architecture is rendered in some measure of perspectival accuracy. The scene is full of realistic detail, and the potential of land-scape to render a sense of actual space, evident in the earlier Pisano *Nativity*, is fully realized.

In contrast, the sculpture of the Gothic cathedral is more naturalistic. The proportions of the figures are more natural, and they assume more natural poses as well. The space they occupy is deeper—so much so that they appear to be fully realized sculpture-in-the-round, freed of the wall behind them. Most important of all, many of the figures seem to assert their own individuality, as if they were actual persons. The generalized "types" of Romanesque sculpture are beginning to disappear.

The Early Renaissance

Just when the Gothic era ended and the Renaissance began is by no means certain. In Europe, toward the end of the thirteenth century, a new kind of art began to appear, at first in the South, and somewhat later in the North. As we have seen in our discussion of Florence Cathedral, the Gothic had never fully taken hold in the South anyway. By the beginning of the fifteenth century, this new era, marked by a revival of interest in the arts and sciences that had not been seen since antiquity, was firmly established. We have come to call this revival the Renaissance, meaning "rebirth."

The Gothic era has been called a long overture to the Renaissance, and we can see, perhaps, in the jamb sculptures at Reims Cathedral, which date from the last half of the thirteenth century, the beginnings of the spirit that would develop into the Renaissance sensibility. These figures are no longer archetypical and formulaic representations; they are, almost, *real* people, displaying *real* emotions. This tendency toward more and more naturalistic representation in many ways defines Gothic art, but, in the Renaissance, it is no longer a tendency. We can witness the forces that would give rise to Renaissance naturalism at work in the thirty year period, between 1280 and 1310, that separates Cimabue's completion of his *Madonna Enthroned* and the treatment of the same subject by Giotto, architect of the campanile of the Florence Cathedral (see Figs. 286 & 287). Cimabue's Madonna is flat compared to the more rounded and modeled version by Giotto. In Giotto's frescos in the Arena Chapel in Padua (see Fig. 293), the implications of this growing naturalism—especially its ability to involve the viewer as if

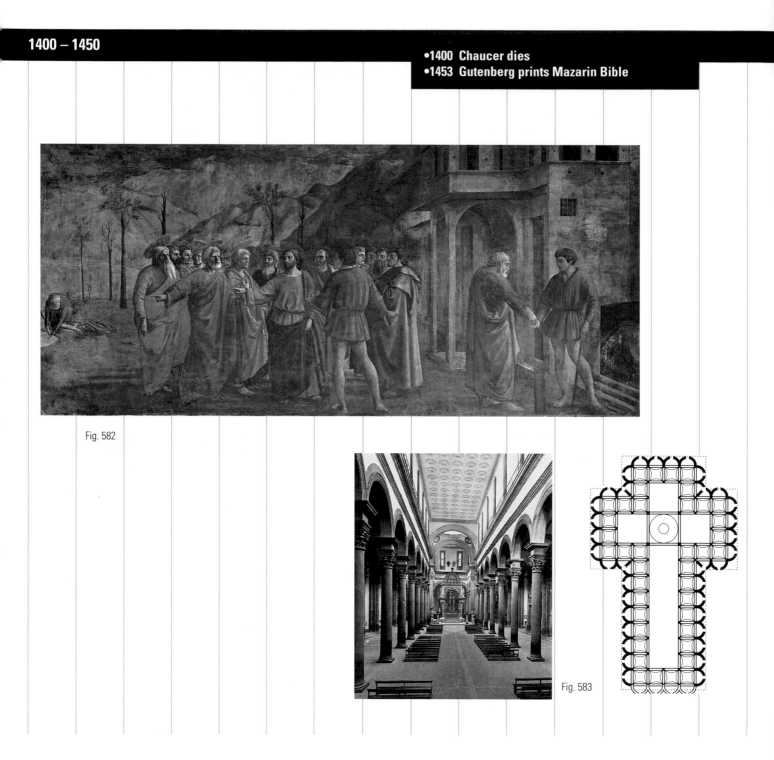

Fig. 582

Fig. 583

Fig. 582 Masaccio, *The Tribute Money*, c. 1427. Fresco. Brancacci Chapel, Santa Maria del Carmine, Florence. In the center, Christ tells St. Peter and the other disciples that they will find the coin necessary to pay the imperial tax collector, whose back is to us, in the mouth of a fish. At the left, St. Peter extracts the coin from the fish's mouth, and, at the right, he pays the required tribute money to the tax collector. The figures here are modeled by means of chiaroscuro in a light that falls upon the scene from the right (notice their cast shadows). We sense the physicality of the figures beneath their robes, the landscape is rendered through atmospheric perspective, and the building on the right is rendered in a one-point perspective scheme, with a vanishing point behind the head of Christ. All of these artistic devices are in themselves innovations; together, they constitute one of the most remarkable achievements in the history of art, an extraordinary advance toward a fully realistic representation.

Fig. 583 Filippo Brunelleschi, nave and original plan, Church of Santo Spirito, Florence, begun 1436. Brunelleschi's fame rests on the mathematical simplicity of his design, here a simple proportional system of 1:1, 1:2, 1:4, and 1:8, realized in a cubic space. The central square, for instance, is four times the basic unit used for each bay of the side aisles. The bays of the aisles are four times as high as they are wide, and the nave is twice the height of the aisles.

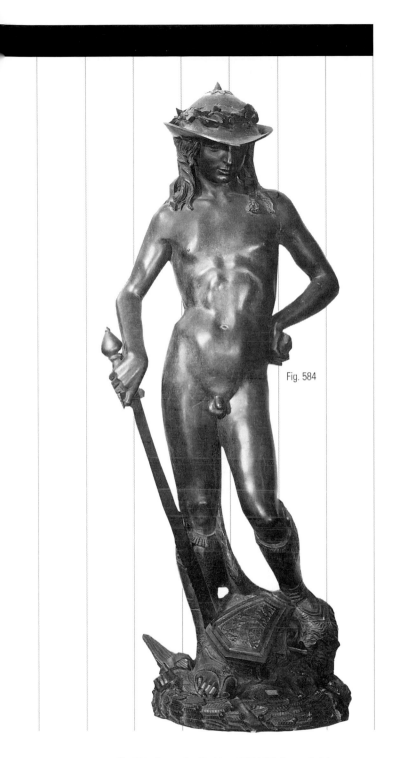

Fig. 584

Fig. 584 Donatello, *David*, c. 1425-1430. Bronze, height 62 1/4 in. Museo Nazionale del Bargello, Florence. The first lifesize nude sculpture since antiquity, Donatello's hero is posed in perfectly classical *contrapposto*. But the young hero—almost antiheroic in the youthful fragility of his physique—is also fully self-conscious, his attention turned almost narcissistically upon himself as an object of physical beauty.

physically in the space of the painting—are even more deeply felt. But simply put, if the figures in the Reims portal seem about to step off their columns, in the Renaissance they will do so.

The Renaissance is, perhaps most of all, the era of the individual. As early as the 1330s, the poet and scholar Petrarch had conceived of a new Humanism, a philosophy that emphasized the unique value of each person. From his point of view, since the birth of Christ the world had entered an "age of faith" that had blinded it to learning and, thus, condemned it to darkness. In the study the study of classical languages, literature, history, and philosophy—what we call the "humanities"—a new enlightened stage of history could dawn. People should be judged, he felt, by their actions. It was not God's will that determined who they were and of what they were capable; rather, glory and fame were available to anyone daring to seize them. Writing in 1485, the philosopher Giovanni Pico della Mirandola—Pico, as he is known—addressed himself to every ordinary (male) person: "Thou, constrained by no limits, in accordance with thine own free will…shalt ordain for thyself the limits of thy nature. We have set thee at the world's center…[and] thou mayst fashion thyself in whatever shape thou shalt prefer." Out of such sentiments were born not only the archetypical Renaissance genius—Michelangelo and Leonardo—but also Niccolò Machiavelli's wily and pragmatic Prince, for whom the ends justify any means, and the legendary Faust, who sold his soul to the devil in return for youth, knowledge, and magical power.

Under the leadership of the extraordinarily wealthy and beneficent Medici family—with first Cosimo de' Medici and, subsequently, his grandson, Lorenzo the Magnificent, assuming the largest roles—the city of Florence became the cultural center of the early Renaissance. But the three leading innovators of the arts in fifteenth-century Florence—the painter Masaccio, who died in 1428 at the age of 27, having worked only six short years, the sculptor Donatello, and the architect Filippo Brunelleschi—were already firmly established by the time Cosimo assumed power in 1434. Brunelleschi was the inventor of geometric, linear perspective, a system he probably developed in order to study the ancient ruins

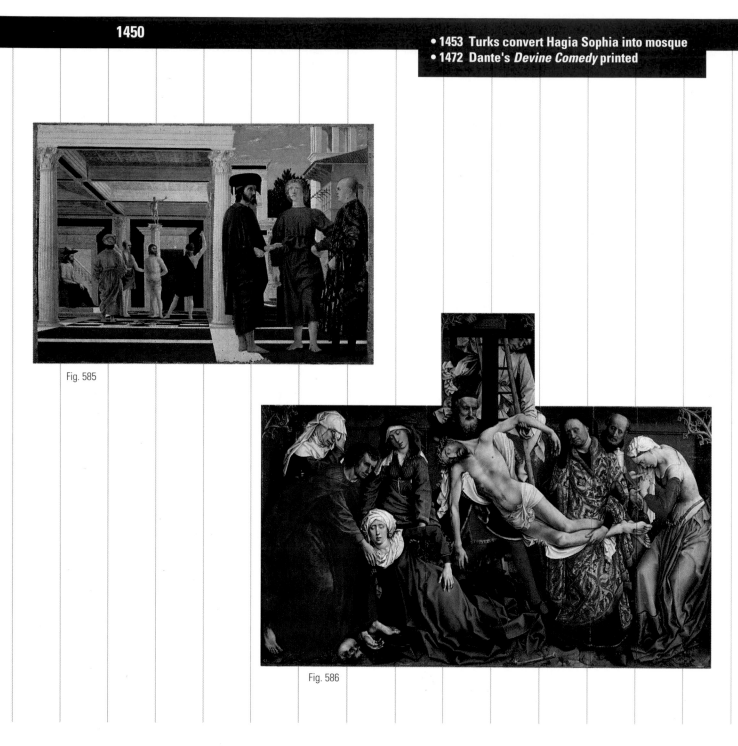

Fig. 585

Fig. 586

Fig. 585 Piero della Francesca, *The Flagellation of Christ*, c. 1451. Tempera on wood, 32 ³/₄ × 23 ¹/₃ in. Palazzo Ducale, Galleria Nazionale delle Marche, Urbino. Virtually a demonstration of the rules of linear perspective, the scene depicts Pontius Pilate watching as executioners whip Christ. Though much more architecturally unified, the painting pays homage to Masaccio's *Tribute Money*.

Fig. 586 Rogier van der Weyden, *Deposition*, c. 1435–1438. Oil on wood, 7 ft. 1 ⁵/₈ in. × 8 ft. 7 ¹/₈ in. The Prado, Madrid. Emotionally speaking, Rogier's *Deposition*, a product of the Northern, Flemish sensibility, has almost nothing in common with Piero's *Flagellation*. It is as if Piero has controlled the violence of his emotionally charged scene by means of mathematics, while Rogier has emphasized instead the pathos and human feeling that pervades his scene of Christ being lowered from the cross. While Piero's composition is essentially defined by a square and a rectangle, with figures arranged in each in an essentially triangular fashion, Rogier's composition is controlled by two parallel, deeply expressive, and sweeping curves, one defined by the body of Christ and the other by the swooning figure below him. Next to the high drama of Rogier's painting, Piero's seems almost static, but the understated brutality of Christ's flagellation in the background of Piero's painting is equally compelling.

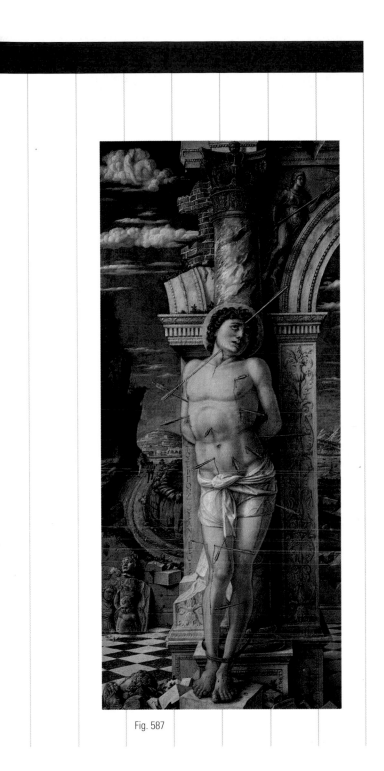

Fig. 587 Andrea Mantegna, *St. Sebastian*, c. 1455–1460. Tempera on panel, 26 3/4 × 11 7/8 in. Kunsthistorisches Museum, Vienna. In Venice, and its neighboring Padua, Mantegna's home, the work of the Flemish masters was well known by 1450. Not only is Mantegna's light indebted to this Flemish influence—and it is remarkable given that his chosen medium was tempera—but so is the detailed background (compare van Eyck's *Madonna of Chancellor Rolin*, Fig. 298).

of Rome. In 1420, he accepted a commission to design and build a dome over the crossing of the Florence Cathedral. The result, which spans a space 140 feet wide, was a major technological feat. But it was, above all, his sense of measure, order, and proportion that defined his sensibility—and that of the Italian Renaissance as a whole. Brunelleschi's God is a reasonable one, not the mysterious force that manifests itself in the ethereal light of the Gothic cathedral. Donatello had traveled to Rome in 1402 with his friend Brunelleschi. The Greek and Roman statuary he studied there had a great influence on his own work, which reflects the classical interest in the human body in motion and in articulating that body through the use of drapery. Masaccio, 15 years younger than Donatello, and 24 years younger than Brunelleschi, learned from them both, translating Donatello's naturalism and Brunelleschi's sense of proportion into the art of painting.

In the North of Europe, in Flanders particularly, a flourishing merchant society, with close economic ties to Florence by virtue of the presence of bankers connected to the Medicis, promoted artistic developments that in many ways rivaled those of Florence. The Italian revival of classical notions of order and measure was, for the most part, ignored in the North. Rather, the Northern artists were deeply committed to rendering believable space in the greatest and most realistic detail. The *Mérode Altarpiece* executed by the Master of Flémalle (see Fig. 297) is almost exactly contemporary with Masaccio's *Tribute Money*, but in the precision and clarity of its detail—in fact, an explosion of detail—it is radically different in feel. The chief reason for the greater clarity is, as we have discussed in Part III, a question of medium, namely the development of oil paint by the Northern artists in the first half of the fourteenth century. The dazzling effects of light that could be achieved on the surface of the painting—as opposed to the *matte*, or nonreflective, surface of both fresco and tempera—recalls, on the one hand, the Gothic style's emphasis on the almost magical light of the stained-glass window, and in that sense it seems transcendent. But it also lends the depicted objects a sense of *material* reality, and thus caters to the material desires of the North's rising mercantile class.

Fig. 589

Fig. 588

Fig. 590

Fig. 588 Liang Kai, *The Poet Li Bo Walking and Chanting a Poem*, Southern Song Dynasty, c. 1200. Hanging scroll, ink on paper, 31 3/4 × 11 7/8 in. Tokyo National Museum, Japan. This depiction of the Tang Poet Li Bo juxtaposes the quick strokes of diluted ink that form the robe to the detailed brushwork of the face, an opposition that is intended to correspond to the tension between the freedom of the poet's spirit and the intensity of his intelligence.

Fig. 589 Chu-Yin-Ming, handscroll with poem, *Eight Immortals of the Wine Cup*, Tang dynasty, 8th century. Museum of Fine Arts, Boston. Helen S. Coolidge Fund. Still considered by many Chinese a higher art than painting, calligraphy is believed to express most faithfully the character and emotions of the artist.

Fig. 590 Cheng Sixiao, *Ink Orchids*, Yuan dynasty, 1306. Handscroll, ink on paper, 10 1/8 x 16 3/4 in. Municipal Museum of Fine Art, Osaka. According to the inscription, this painting was done to protest the "theft of Chinese soil by invaders," referring to the Mongol conquest of China. The orchids, therefore, have been painted without soil around their roots, showing an art flourishing even though what sustains it has been taken away.

Art in China

In 1275, a young Venetian by the name of Marco Polo arrived in Peking, China, and quickly established himself as a favorite of the Mongol ruler Kublai Khan, first emperor of the Yuan dynasty, who came to power in 1279. Polo served in an administrative capacitiy in Kublai Khan's court and for three years ruled the city of Yangchow. Shortly after his return to Venice, in 1295, he was imprisoned after being captured by the army of Genoa in a battle with his native Venice, and while there he dictated an account of his travels. His description of the luxury and magnificence of the Far East, by all accounts reasonably accurate, was virtually the sole source of information about China available in Europe until the nineteenth century.

With the collapse of the Han Empire in A.D. 220, Buddhism was introduced to China from India, and Buddhism, in turn, deeply influenced the growth of Taoism as an organized religion in its own right. The Taoists emphasized the importance of self-expression, especially through the arts, most notably calligraphy, poetry, and landscape painting. The centrality of these to Chinese intellectual life is celebrated in the small carved bamboo brush-holder, made during the Jin dynasty (A.D. 265–317), which recreates a gathering of the Seven Sages of the Bamboo Grove (see Fig. 340). During the Tang dynasty (A.D. 618–906), professional artists and sages took up residence at court, and the Song dynasty, which restored order to China in 960, ruling the empire until it was overrun by Kublai Khan in 1279, appointed poets, calligraphers, and painters to the most important positions of state. It was during this period that Guo Xi painted his *Early Spring* (see Fig. 307).

At the time of Marco Polo's arrival, many of the scholar-painters of the Chinese court, unwilling to serve under foreign domination, were retreating into exile from public life, but in exile they conscientiously sought to keep traditional values and arts alive by cultivating earlier styles in both painting and calligraphy. In 1368, the Mongols were finally overthrown when Zhu Yuanzhang drove the last Yuan emperor north into the desert and declared himself first emperor of the new Ming dynasty. China was once again ruled by the Chinese.

Fig. 591

Fig. 591 Wu Chen, *Bamboo*, 1350. Album leaf, ink on paper, 16 × 21 in. Collection of the National Palace Museum, Taipei, Taiwan, Republic of China. Like the orchids of Cheng Sixiao, bamboo was a political symbol aimed at the hated non-Chinese Yuan rulers—the plant might bend, but it would not break. Wu Chen's efforts to keep the traditions of China alive (see also Fig. 228) are evident in his inscription to this painting, written in the same wild "cursive" as the Tang dynasty poem in Fig. 589.

- **1492 First reference to smoking tobacco**
- **1492 Columbus lands in Bahamas, Cuba, Haiti**
- **1497 Vasco da Gama rounds Cape of Good Hope, November 22, on voyage to India**

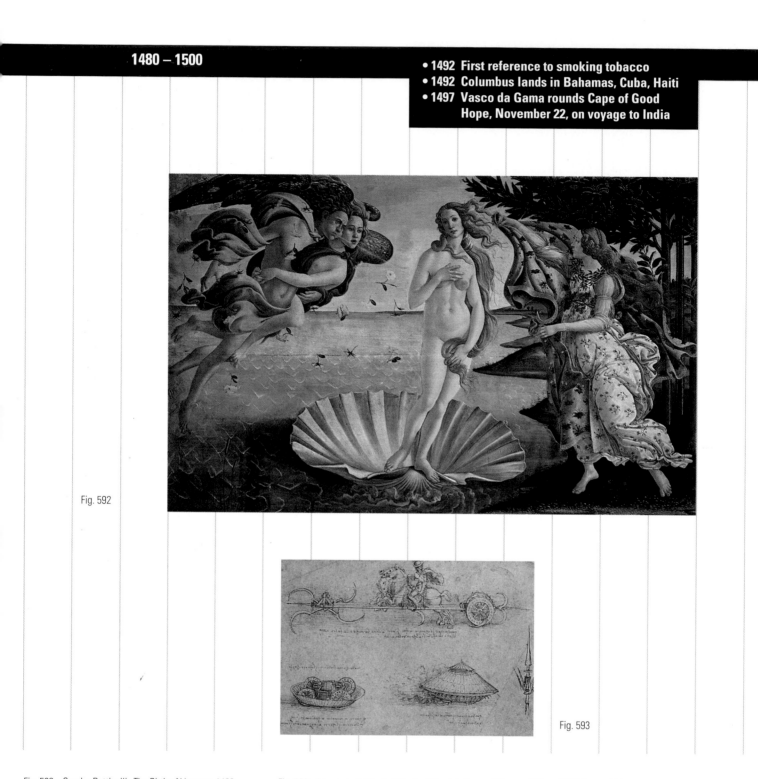

Fig. 592

Fig. 593

Fig. 592 Sandro Botticelli, *The Birth of Venus*, c. 1482. Tempera on canvas, 5 ft. 8 7/8 in. × 9 ft. 1 7/8 in. Galleria degli Uffizi, Florence. Botticell's Venus is the first monumental representation of the nude goddess since ancient times. In Neo-Platonic terms, the nude Venus is innocence itself, and represents a divine beauty free of any hint of the physical and the sensual. It was this form of beauty that the soul aspiring to salvation was expected to contemplate.

Fig. 593 Leonardo da Vinci, *A Scythed Chariot, Armored Car, and Pike*, c. 1487. Pen and ink and wash, 6 3/4 × 9 3/4 in. The British Museum, London. Indicative of the breadth of Leonardo's imagination, this drawing was executed for Lucovico Sforza, the Duke of Milan. "I will make covered vehicles," he wrote in a letter to Sforza, "which will penetrate the enemy and their artillery, and there is no host of armed men so great that they would not be broken by them." The chariot is equipped with scyths to cut down the enemy. The armored car, presented in an upside down view as well as scooting along in a cloud of dust, was to be operated by eight men.

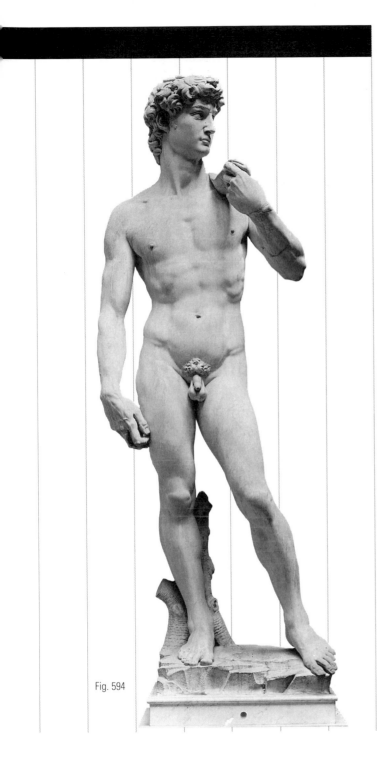

Fig. 594 Michelangelo, *David*, 1501–1504. Marble, height of figure, 13 ft. 5 in. Galleria dell'Accademia, Florence. Michelangelo had studied Donatello's *David* intensely, but only the nudity of the two statues links them. Michelangelo's hero is larger than lifesize, possessing an emotional presence and scale that heightens its dramatic intensity. In every swollen vein and taut muscle, we feel the concentrated energy that the heroic David is about to unleash upon Goliath.

The High Renaissance

When Lorenzo de' Medici assumed control of his family in 1469, Florence was still the cultural center of the Western world. Lorenzo founded the Platonic Academy of Philosophy, where one of his favorite artists, Sandro Botticelli, studied a brand of Neo-Platonic thought that transformed the writings of the great Greek philosopher into what amounted to a religion. In the contemplation of beauty, the inherently corrupt soul could transform its love for the physical and material into a purely spiritual love—in short, into a love of God. Thus, Botticelli's aim in using mythological themes (see Fig. 296 and *The Birth of Venus* at the left) is to transform his pagan imagery into a source of Christian inspiration and love. But such a transformation was by no means clear to the uninitiated, and when the Dominican monk Girolamo Savonarola denounced the Medici as pagan, the majority of the Florentines accepted the judgment, and, in 1494, the family was banished.

Still, for a short period at the outset of the sixteenth century, when the three great artists of the High Renaissance—Leonardo, Michelangelo, and Raphael—all lived and worked in the city, Florence was again the focal point of artistic activity. As a young man, Michelangelo had been a member of Lorenzo de' Medici's circle, but with the Medici's demise in 1494 he fled to Bologna, when not yet 20 years old. He returned to Florence seven years later in order to work on a giant piece of marble left over from an abandoned commission. Out of this, he carved his monolithic *David*, a piece of such extraordinary power that the city fathers, who had initially commissioned it for Florence Cathedral, placed it in the square outside the Palazzo Vecchio, at the city's center, as a symbol of the city itself.

Leonardo, some 23 years older than Michelangelo, had left Florence as early as 1481 for Milan. There he offered his services to the great Duke of Milan, Ludovico Sforza, first as a military engineer and, only secondarily, as an architect, sculptor, and painter. From 1495 to 1498, Leonardo painted his now world famous *Last Supper*, which many consider to be the first painting of the High Renaissance, in Santa Maria delle Grazie, a monastic church under the protection of the Sforza family (see Fig. 98). Leonardo

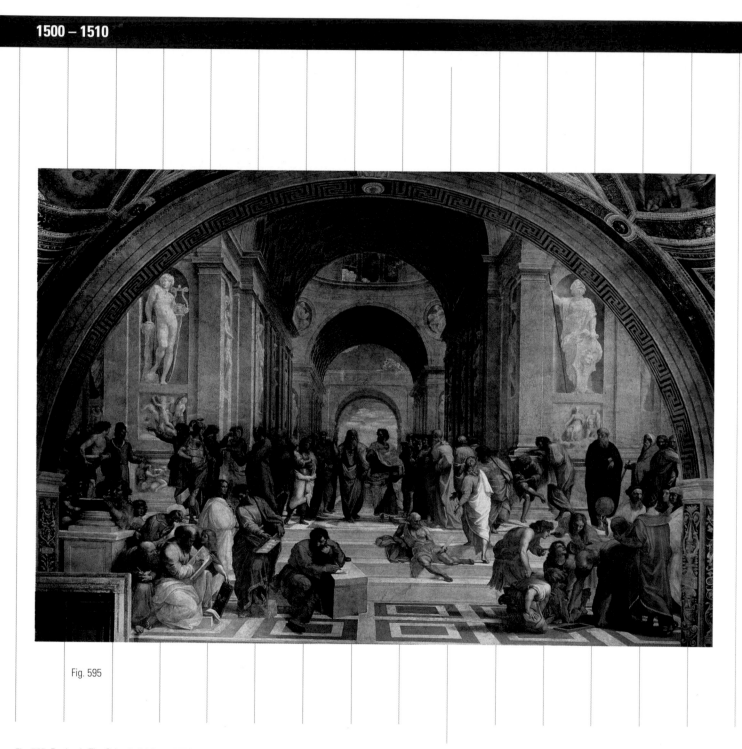

Fig. 595

Fig. 595 Raphael, *The School of Athens*, 1510–1511. Fresco. Stanza della Segnatura, Vatican Palace, Rome. The epitome of the classical spirit of the High Renaissance, Raphael's painting depicts a gathering of the greatest philosophers and scientists of the ancient world. The centering of the composition is reminiscent of Leonardo's *Last Supper,* but the perspectival rendering of space is much deeper. Where, in Leonardo's masterpiece, Christ is situated at the vanishing point, in Raphael's work, Plato and Aristotle occupy that position. These two figures represent the two great, opposing schools of philosophy, the Platonists, who were concerned with the spiritual world of ideas (thus Plato points upwards), and the Aristotelians, who were concerned with the matter-of-factness of material reality (thus Aristotle points over the ground upon which he walks). The expressive power of the figures owes much to Michelangelo, who, it is generally believed, Raphael portrayed as the philosopher Heraclitus, the brooding, self-absorbed figure in the foreground.

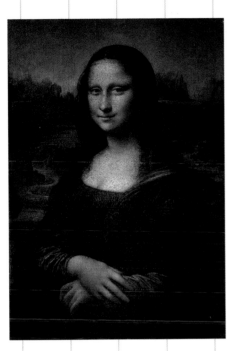

Fig. 596

Fig. 596 Leonardo da Vinci, *Mona Lisa*, c. 1503–1505. Oil on wood, 30 1/4 × 21 in. Musée du Louvre, Paris. Painted in Florence, and perhaps portraying the wife of the banker Zanobi del Giocondo, this painting conveys a psychological depth that has continued to fascinate viewers up to the present day. Its power derives, at least in part, from a manipulation of light and shadow that imparts a blurred imprecision to the sitter's features, creating an aura of ambiguity and mystery.

left Milan soon after the French invaded in October 1499, and by April he had returned to Florence where he concentrated his energies on a lifesize cartoon for *The Virgin, Child, and St. Anne* (see Fig. 235), an object of such immediate fame that throngs of Florentines flocked to see it.

When Raphael, 21 years old, arrived in Florence in 1504, he discovered Leonardo and Michelangelo locked in a competition over who would get the commission to decorate the city council chamber in the Palazzo Vecchio with pictures celebrating the Florentine past. Leonardo painted a *Battle of Anghiari* and Michelangelo a *Battle of Cascina*, neither of which survives. We know the first today only by reputation and early drawings. A cartoon survived well into the seventeenth century and was widely copied, most faithfully by Peter Paul Rubens. Of the Michelangelo we know very little. What is clear, however, is that the young Raphael was immediately confronted by the cult of genius that in many ways has come to define the High Renaissance. Artists of genius and inspiration were considered to be different from everyone else, and to be guided in their work by an insight that, according to the Neo-Platonists, was divine in origin. For the Neo-Platonists, the goals of truth and beauty were not guaranteed by following the universal rules and laws of classical antiquity—notions of proportion and mathematics. Nor would fidelity to visual reality promise beautiful results; in fact, given the fallen condition of the world, quite the opposite was more likely, as Leonardo's studies of the physiognomies of his fellow citizens had amply demonstrated (see Fig. 28). Instead, the artist of genius had to rely on subjective and personal intuition—what the Neo-Platonists called the "divine frenzy" of the creative act—to *transcend* the conditions of everyday life. Plato had argued that painting was mere slavish imitation of an already existing thing—it was a diminished reality. The Neo-Platonists turned the argument of the father of their philosophy on its head. Art now exceeded reality. It was a window not upon nature, but upon the divine itself.

Raphael learned much from both Leonardo and Michelangelo, and, in 1508, he was awarded the largest commission of the day, the decoration of the papal apartments at the Vatican in Rome.

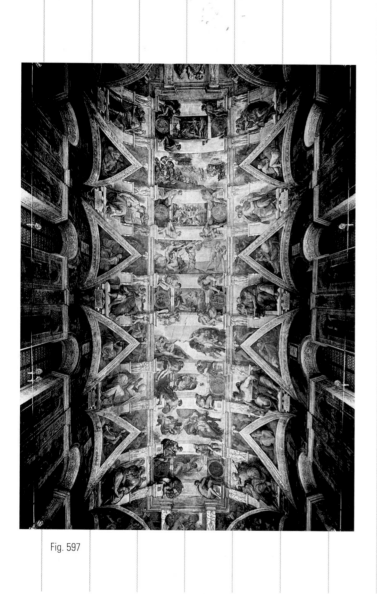

Fig. 597

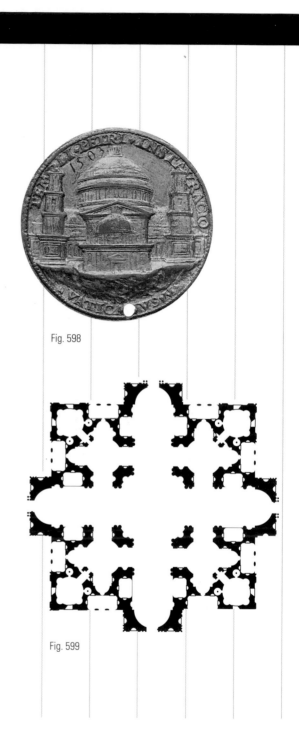

Fig. 598

Fig. 599

Fig. 597 Michelangelo, ceiling frescos, interior of the Sistine Chapel, 1508–1512. The Vatican, Rome. The ceiling is composed of a series of four large and five small central panels, illustrating passages from Genesis. The most famous are the large fourth and sixth panels, depicting *The Creation of Adam* and *The Expansion from the Garden of Eden* respectively. Directly over the altar is the primary act of creation, God's division of Light and Darkness.

Fig. 598 Christoforo Foppa Caradosso, bronze medal showing Bramante's design for the new St. Peter's, 1503. This medal commemorates the start of the building campaign for Julius II's new St. Peter's. The medal gives only a partial sense of the size of the project, which, Bramante boasted, would dwarf all previous architecture. The small domed portico below the central dome is about the same size as the original St. Peter's.

Fig. 599 Donato Bramante, original plan for the new St. Peter's, Rome, c. 1505. Bramante chose to replace the basilica plan of Constantine's St. Peter's with a central plan of almost perfect balance and symmetry, based on the circle and the square. Each facade was to have been identical, and so too the four apses, except that one would have contained the altar. The scale of the proposal is such that the entire old basilica would have comfortably fit into any of the four apses!

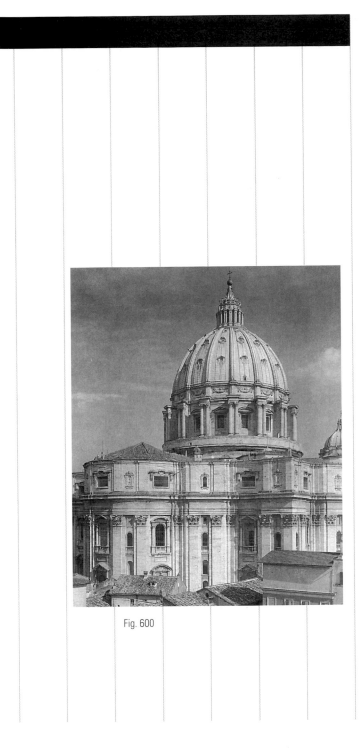

Fig. 600

Fig. 600 Michelangelo, St. Peter's, Rome, seen from the west, and plan, 1546–1564 (dome completed by Giacomo della Porta, 1590). After Bramante's death in 1514, various architects tried to work with his design until finally, in 1546, Michelangelo was appointed to complete the building. He simplified Bramante's plan, changing it to a cross and square. But his most beautiful contribution was the dome that seems to rise from the building's base rather than to rest over it.

On the four walls of the first room, the Stanza della Segnatura, he painted a fresco representing each of the four domains of knowledge—Theology, Law, Poetry, and Philosophy—the most famous of which is the last, portraying *The School of Athens*. If we are struck today by the absence in this group of the Arts—painting, sculpture, and architecture—that is because it was in the fifteenth and sixteenth centuries that the arts established themselves as more than mere craft, as a brand of knowledge, inspiration, insight, and creative genius.

Raphael's commission in Rome is typical of the rapid spread of Renaissance culture to the rest of Italy and Europe. From 1506 until 1508, Leonardo traveled back and forth between Florence and Milan, where he was employed by the city's new French governor, Charles d'Amboise. Until he died, in May 1519, he worked for the French either in Milan or in France itself. Michelangelo had been called to Rome, in 1505, to design a tomb for Pope Julius II, who envisioned filling the holy city with a vast array of great new works of art, thus establishing it as the new cultural center of the Western world. That same year, Julius commissioned the architect Donato Bramante to design a new St. Peter's to replace the old basilica dating from the age of Constantine in the fourth century A.D. Bramante had worked with Leonardo in the Sforza's court in Milan, and he shared with Leonardo a respect for balance and harmony, but in the enormously ambitious scale of his project, he had more in common with Michelangelo, to say nothing of the pope for whom both worked.

Julius's cultural ambitions could hardly be contained. It was he who brought Raphael to Rome to paint the papal apartments. He planned his own tomb to be a magnificent shrine including over 40 lifesize marble statues. A project of such vast scope would have consumed the rest of Michelangelo's life, but the pope soon gave up on the idea, probably in order to dedicate himself to the rebuilding of St. Peter's, and Michelangelo completed only three sculptures for the tomb. Probably in the hope that Julius II would revive his plans for his tomb, Michelangelo, in 1508, agreed to paint the ceiling of the Sistine Chapel, the private chapel of the popes at the Vatican (see Figs. 154 & 155). Though he insisted he was

- **1517 Coffee arrives in Europe**
- **1529 Women first appear on Italian stage**
- **1539 First Christmas tree at Strasborg Cathedral**

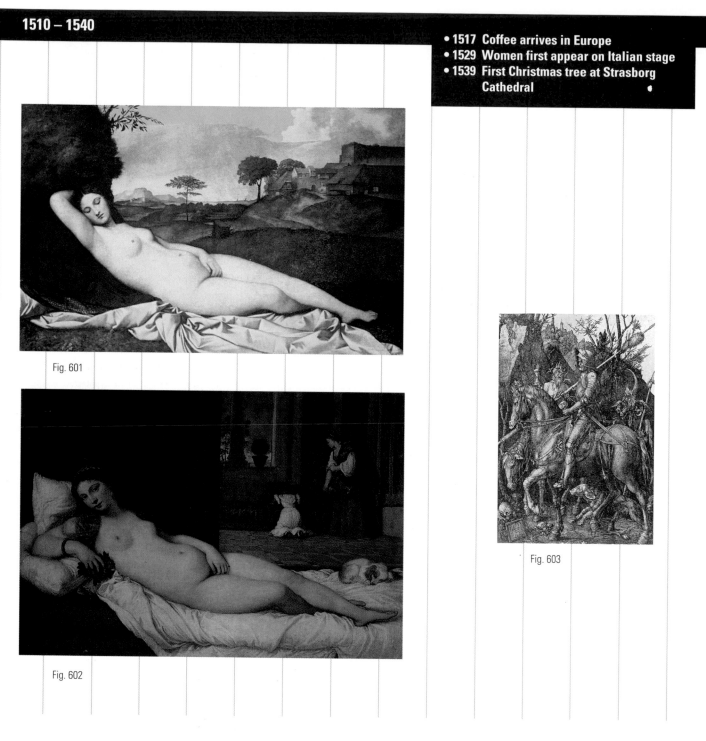

Fig. 601

Fig. 602

Fig. 603

Fig. 601 Giorgione (completed by Titian), *Sleeping Venus*, c. 1510. Oil on canvas, 42 3/4 × 69 in. Staatliche Gemäldegalerie, Dresden. This lifesize figure, bathed in a luminous light, is frankly erotic and, not surprisingly, painted for a male patron.

Fig.602 Titian, *Venus of Urbino*, 1538. Oil on canvas, 47 × 65 in. Uffizi Gallery, Florence. Titian's painting is modeled upon Giorgione's but is much more frank in its eroticism. Titian has positioned his figure on the crumpled sheets of a bed, rather than in a pastoral landscape. Instead of innocently sleeping, as Giorgione's Venus does, Titian's Venus gazes directly at us.

Fig. 603 Albrecht Dürer, *Knight, Death, and the Devil*, 1513. Engraving, 9 7/8 × 7 1/2 in. Library of Congress, Fine Print Collection, Washington, D.C. Here Dürer's knight and horse are perfect embodiments of Renaissance ideals set within a late Gothic landscape. The same tension can be felt in his famous engraving *Adam and Eve* (see Fig. 270), where the two figures are realized in an idealized and Italinate manner, but find themselves in a distinctly northern woods.

not a painter by profession, nevertheless, in four years, lying on his back 70 feet above the floor, he painted 5,800 square feet of ceiling.

The ideals of the Italian Renaissance affected art and culture throughout Europe. In Venice, however, painting developed somewhat independently of the Florentine manner. The emphasis in Venitian art is on the sensuousness of light and color and the pleasures of the senses. The closest we have come to it so far is in the mysterious glow that infuses Leonardo's *Mona Lisa*, but what is only hinted at in Leonardo's work explodes in Venetian painting as full-blown theatrical effect. Partly under the influence of Leonardo, who had visited Venice after leaving Milan in 1499, Giorgione developed a painting style of blurred edges and softened forms. After his teacher's death in the great plague of 1510, Giorgione's student, Titian, took this style even further, developing a technique that employed a painterly brushstroke to new sensuously expressive ends.

In the North of Europe, the impact of the Italian Renaissance is perhaps best understood in the work of the German artist Albrecht Dürer. As a young man he had copied prints by Mantegna and Pollaiuolo (see Fig. 236), and, in 1495, he traveled to Italy from his home in Germany to study the Italian masters. From this point on, he strived to establish the ideals of the Renaissance in his native country. Yet not even Dürer could quite synthesize the northern love for precise and accurate naturalism—the desire to render the world of real things—with the southern idealist desire to transcend the world of real things.

Pre-Columbian Art in Mexico

The term **Pre-Columbian** refers to the cultures of all the peoples who lived in Mexico, Central America, and South America prior to the arrival of the Europeans at the end of the fifteenth century. The cultures of the Pre-Columbian peoples are distinguished by their monumental architecture and their preference for working in stone, both of which lend their art a quality of permanence that differentiates it from the more fragile art forms of the Native American peoples living in what is now the United States and Canada. The permanence of their art was the result of a cultural stability gained around 4000 B.C., when they

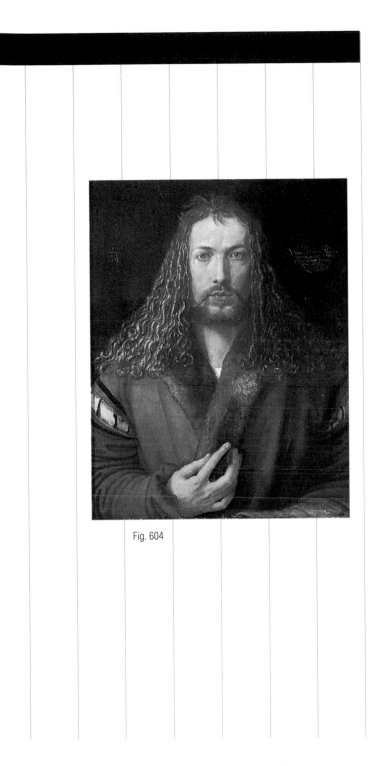

Fig. 604

Fig. 604 Albrecht Dürer, *Self-Portrait,* 1500. Oil on panel, 26 1/4 × 19 1/4 in. Pinakothek, Munich. The first artist to be fascinated by his own image, Dürer painted self-portraits throughout his career. In this act, he asserts his sense of the importance of the individual, especially the individual of genius and talent, such as himself. Here, he presents himself almost as if he were Christ. Certainly, he means to evoke his own spirituality.

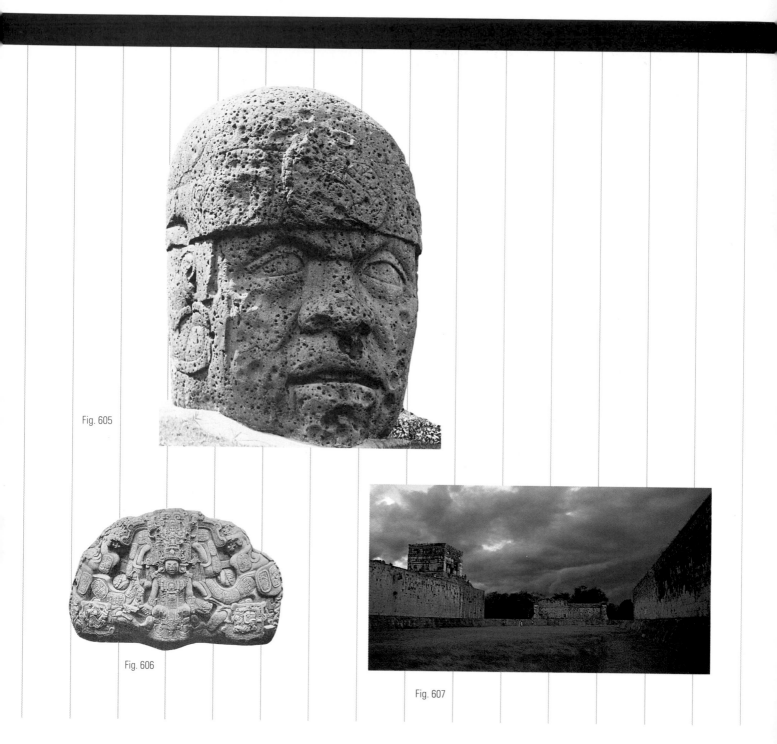

Fig. 605 Colossal head, Villahermosa, Mexico, Olmec culture, c. 800–200 B.C. Basalt, height 7 ft. Museo Nacional de Antropologia, Mexico City. More than a dozen such heads have been discovered, some of them up to 12 feet high. The closest source for the stone used to make this head from La Venta, in present-day Villahermosa, is 60 miles away, across swampland.

Fig. 606 *Great Dragon*, Maya, Quiriguá, Mexico, sixth century A.D. Height 7 ft. 3 in. Narrative relief carving was one of the predominant means of artistic expression in Pre-Columbian culture. The relief on the face of this huge river boulder shows one of the last rulers of the Mayan city of Quiriguá, in present-day Guatemala, sitting in the gaping mouth of a giant monster wearing an elaborate headdress. The monster does not so much threaten the ruler as evoke his power.

Fig. 607 The Great Ball Court, Chichen Itzá, c. 900–1200. The largest of its kind in Mexico, the court is nearly 160 yards long and 38 yards wide. On it, a game was played by two teams of seven members, in which a solid rubber ball was passed through rings set 26 feet up each side wall. Reliefs carved under the rings indicate that the victorious team would decapitate the losing team in a ceremony after the game.

- **1519** Hernando Cortés enters Aztec capitol of Tenochtitlan
- **1540** G. L. de Cardenas discovers the Grand Canyon in present-day Arizona

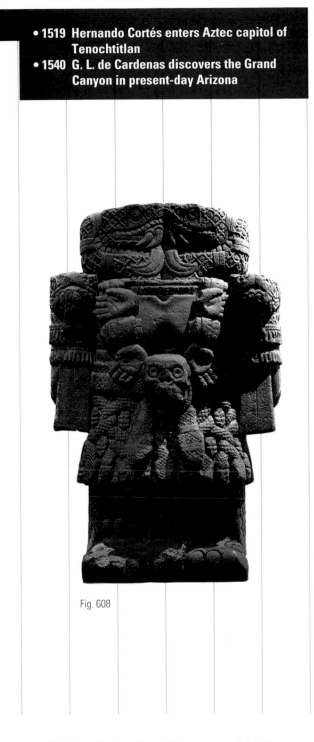

Fig. 608

Fig. 608 *Coatlicue*, Aztec, 15th century A.D. Height 8 ft. 3 in. Coatlicue was the Aztec goddess of life and death and reveals the centrality of blood sacrifice to Aztec culture. Coatlicue's head is composed of two fanged serpents, which are symbolic of flowing blood. She wears a necklace of human hearts, severed hands, and a skull. The connection of blood to fertility is clear in the snake that descends between her legs, which suggests both menstruation and the phallus.

developed agricultural, as opposed to nomadic, civilizations based especially upon the production of maize, or yellow corn.

The major cultures of Mexico were the Olmec; the Maya, the civilization that developed with the great city of Teotihuacán as its center (see Fig. 473); and the Aztec, who called themselves Mexica, and whose culture was not even 200 years old at the time of the Spanish conquest of Mexico in 1519. Led by Hernando Cortés, the Spanish discovered, at the Aztec capital of Tenochtitlan (now Mexico City), a city that was, in the words of one of Cortés's men, "like the enchantments in the book of [the late medieval romancer] Amadís, because of the high towers…and other buildings, all of masonry, which rose from the water. Some of our soldiers asked if what we saw was not a dream." Albrecht Dürer recounts seeing the treasures Cortés sent home to Charles V: "a sun entirely of gold, a whole fathom broad; likewise a moon entirely of silver, just as big…all so precious that they were valued at a hundred thousand guilders. I have never seen in all my days that which so rejoiced my heart, as these things." Within seventy-five years of the Spanish conquest, disease had ravaged the native peoples of the region, reducing their population from about 20 million to about 1 million, and the Pre-Columbian culture that Dürer praised had literally faded from the face of the earth. Indeed, the treasures that Dürer had seen were melted down for currency.

The first Pre-Columbian culture was that of the Olmecs, who lived in present-day Tabasco and Veracruz, states on the bottom edge of the Gulf of Mexico. As early as 1500–800 B.C., the Olmecs created a huge ceremonial center at La Venta. The basis of planning in Mexico and Central America for many centuries to come, La Venta's design revolved around a central pyramid, perhaps echoing the shape of a volcano, facing a ceremonial courtyard, all laid out on an axis that was determined astronomically. The courtyard was decorated with four giant stone heads, three to the south and one to the north.

By about the sixth century B.C., widespread use of both a 260-day and a 365-day calendar system begins to appear throughout Mexico. The latter corresponds to the true solar year, while

Pre-Columbian Art in Mexico 441

- **c. 1550 Beginnings of Ukiyo-e tradition in Japan**
- **1578 Population of China reaches 60 million**
- **1590 Galileo describes experiments with dropping various bodies**

1540 – 1600

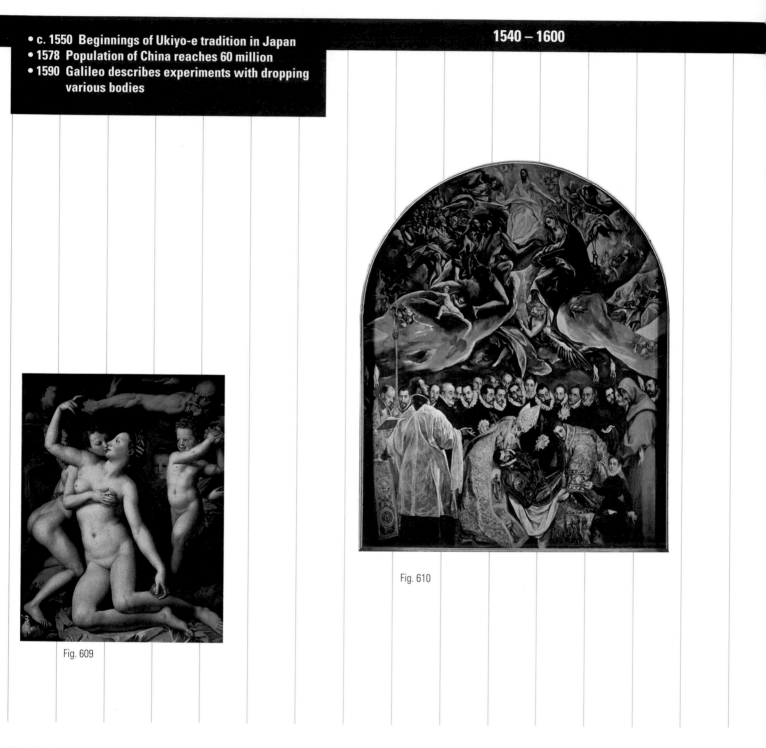

Fig. 609

Fig. 610

Fig. 609 Bronzino, *Venus, Cupid, Folly, and Time (The Exposure of Luxury)*, c. 1546. Oil on wood, approx. 61 × 56 ³/₄ in. National Gallery, London. At the upper right, Time, and, at the upper left, Truth, part a curtain to reveal the shallow space in which Venus is fondled by her son Cupid. Folly is about to shower the pair in rose petals. Envy tears her hair out at center left. The Mannerist distortion of space is especially evident in the distance separating Cupid's shoulders and head.

Fig. 610 El Greco, *The Burial of Count Orgaz*, 1586. Oil on canvas, 16 ft. × 11 ft. 10 in. S. Tomé, Toledo, Spain. Born in Crete and trained in Venice and Rome, where he studied Titian, Tintoretto, and the Italian Mannerists, El Greco moved to Toledo, Spain, in 1576, where he lived for the rest of his life. The realism of the lower ensemble, which includes local Toledo nobility and clergy of El Greco's day, even though the painting represents a burial that took place in 1323, gives way in the upper half to a much more abstract and personal brand of representation. El Greco's elongated figures—consider the hand of St. Peter, in the saffron robe behind Mary on the upper left, with his long piercing fingers on a longer, almost drooping hand, to say nothing of the bizarrely extended arm of Christ himself— combine with oddly rolling clouds that rise toward an astonishingly small representation of Christ. So highly eclectic and individual is this painter's style that it is difficult to label it even as Mannerist.

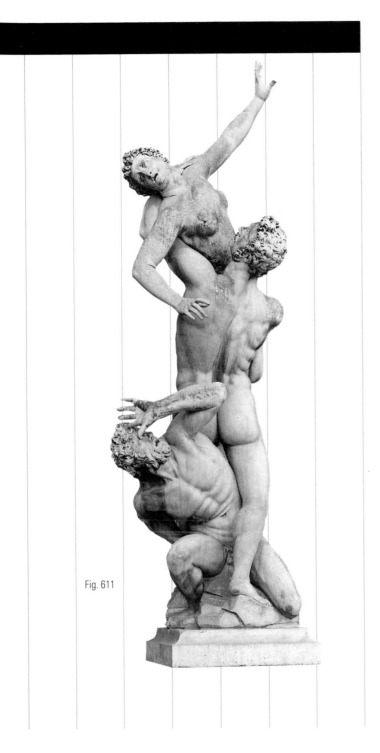

Fig. 611　Giovanni da Bologna, *The Rape of the Sabine Women*, completed 1583. Marble, height 13 ft. 6 in. Loggia dei Lanzi, Florence. Here, classical contrapposto gives way to a sort of rising spiral. Though impossible to represent in a photograph the sculpture changes dramatically as the viewer walks around it and experiences it from each side.

the former is based upon the length of the gestation of human life from the first missed menstrual flow to birth, and both were often used simultaneously. A given day in one calendar will occur on the same day in the other every 52 years, and each 52-year cycle was widely celebrated, particularly by the Aztecs. Such systems, which were inscribed in stone, provide a sense of continuity between the Pre-Columbian cultures.

Mayan civilization began to reach its peak in southern Mexico and Guatemala around A.D. 250, shortly after the rise Teotihuacán in the north, and it flourished until about the year 900. At Chichen Itzá, on the Yucatan peninsula, the declining Maya merged with the northern Toltec culture to build a city of remarkable vitality, and the Aztecs, who were preoccupied with understanding the past, came to see the Toltecs as the forefathers of their own culture, conflating all Pre-Columbian development into Toltec civilization. "The Tolteca were wise," the Aztecs reported to the Franciscan friar Bernardino de Sahagún in the sixteenth century. "Their works were all good, all perfect, all wonderful, all marvelous.... They were thinkers, for they originated the year count, the day count."

Mannerism

Shortly after the death of Raphael in 1520, the tendency in High Renaissance art to depend more upon the artist's subjective interpretation of nature than upon its faithful imitation licensed many Italian painters to embark on a stylistic course that was highly individualistic and *mannered*, or consciously artificial. "Invention" was the call word of the day, and the technical and imaginative virtuousity of the artist became of paramount importance. Each Mannerist artist may, therefore, be easily identified by his own "signature" style. Where the art of the High Renaissance had sought to create a feeling of balance and proportion, quite the opposite is the goal of Mannerist art. In the late work of Michelangelo, for example, particularly the great fresco of the Last Judgment on the altar wall of the Sistine Chapel, executed in the years 1534–1541, we find figures of grotesque proportion arranged in an almost chaotic, certainly athletic swirl of line. Space begins to be represented

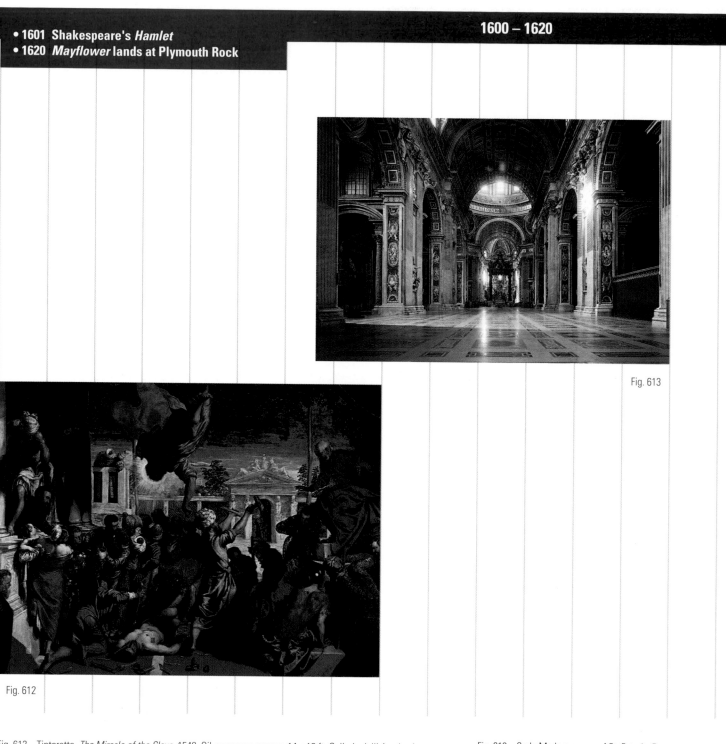

Fig. 613

Fig. 612

Fig. 612 Tintoretto, *The Miracle of the Slave*, 1548. Oil on canvas, approx. 14 x 18 ft. Galleria dell' Academia, Venice. The drama of Tintoretto's painting is heightened by the descent of the vastly foreshortened St. Mark who hurtles in from above to save the slave from his executioner. The rising spiral line created by the central three figures—the slave, the executioner holding up his shattered instruments of torture, and St. Mark—is characteristic of Mannerism, but in the theatricality of the scene, heightened by its dramatic contrast of light and dark, the painting anticipates the Baroque.

Fig. 613 Carlo Maderno, nave of St. Peter's, Rome, 1607–1615, with Gianlorenzo Bernini's *baldacchino*, 1624–1633, at the crossing over the altar. Bernini's canopy is over 100 feet high, an indication of the massive scale of the interior of the St. Peter's.

in unpredictable and ambiguous ways, so that bodies sometimes seem to fall out of nowhere into the frame of the painting. Often the space will seem too shallow for what is depicted, a feeling emphasized by the frequent use of radical fore-shortening. The figure itself might be distorted or elongated, as in Bronzino's *Exposure of Luxury* (Fig. 609), and the colors are often bright and clashing. As in Tintoretto's *Last Supper* (see Fig. 131), or El Greco's *Burial of Count Orgaz*, there will often be more than one focal point, and these will seem contradictory, creating a sense of ambiguity that was especially exploited by sculptors.

The Baroque

The Baroque style was, in many respects, a creation of the Papacy in Rome. Around 1600, faced in the North with the challenge of Protestantism, which had grown steadily more powerful ever since Martin Luther had protested papal indulgences in 1517, inaugurating the Reformation, the Vatican took action. It called together as many talents as it could muster with the clear intention of turning Rome, "for the greater glory of God and the Church," into the most magnificent city in the world. At the heart of this effort was an ambitious building program. In 1603, Carlo Maderno was assigned the task of adding an enormous nave to Michelangelo's cen-tral plan for St. Peter's, converting it back into a giant basilica. Completed in 1615, the scale of the new basilica was even more dramatically empha-sized when Gianlorenzo Bernini, the greatest sculptor and architect of the sixteenth century, added a monumental oval piazza surrounded by colonnades to the front of the church. Bernini had also been assigned the task of decorating Maderno's sweeping interior. Over the main altar he constructed a 100-foot-high *baldacchino*, or canopy constructed of four spiral columns. At each corner of the canopy are four colossal angels, and behind each of these, a serpentine bracket rises to meet at an orb and cross, symbols of the triumph of the Church. The rising serpentine energy of the entire construction recalls, on the one hand, the Mannerist sculpture of Giovanni da Bologna's *Rape of the Sabine* Women (Fig. 611), and, on the other, the elaborate motion and feeling of the *Laocoön* group (Fig. 530), then acknowl-

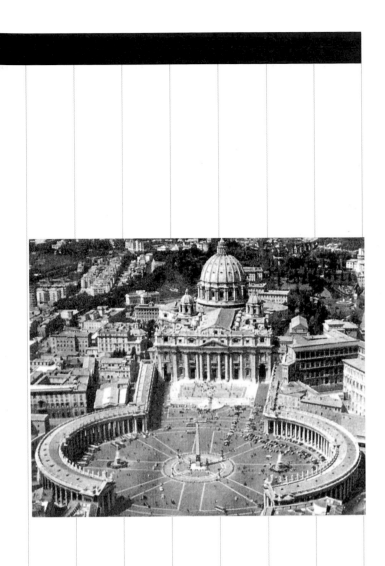

Fig. 614

Fig. 614 Aerial view of St. Peter's, Rome, with plan. Nave and facade by Carlo Maderno, 1607–1615, colonnade by Gianlorenzo Bernini, 1657. Bernini conceived of his colonnade as an architectural embrace, as if the church were reaching out its arms to gather in its flock. The wings that connect the facade to the semicircular colonnade tend to diminish the horizontality of the facade and emphasize the vertical thrust of Michelangelo's dome.

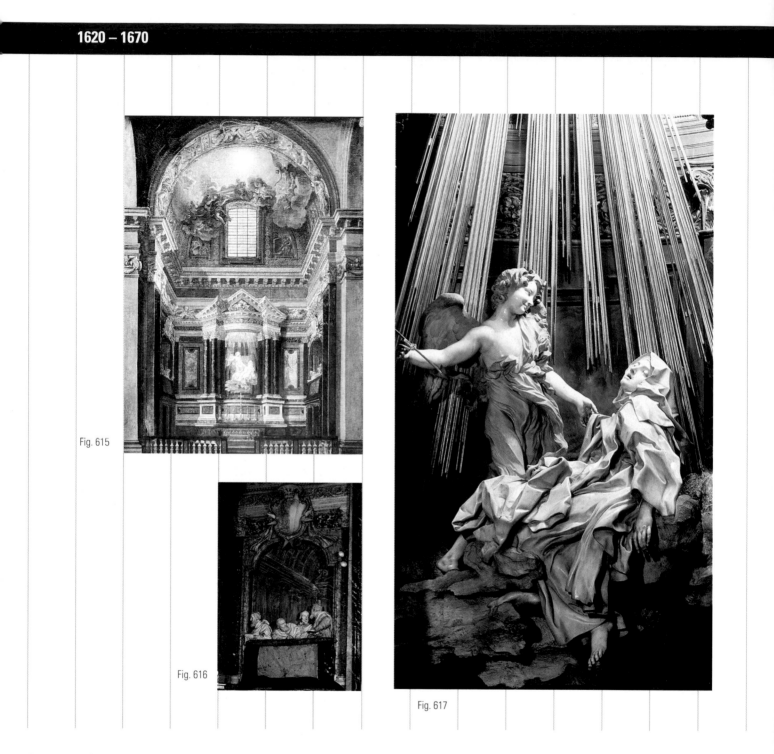

Fig. 615

Fig. 616

Fig. 617

Figs. 615–617 Gianlorenzo Bernini, interior of the Cornaro Chapel (18th-century painting, Staatliches Museum, Schwerin, Germany); the Cornaro family in a theater box (marble, lifesize); and *The Ecstacy of St. Theresa* (marble, lifesize), all 1645–1652, Cornaro Chapel, Santa Maria della Vittoria, Rome. St. Theresa was a nun whose conversion took place after the death of her father, when she experienced visions, heard voices, and felt a persistent and piercing pain in her side caused, she believed, by the flaming arrow of Divine Love, shot into her by an angel: "The pain was so great I screamed aloud," she wrote, "but at the same time I felt such infinite sweetness that I wished the pain to last forever. . . . It was the sweetest caressing of the soul by God." The paradoxical nature of St. Theresa's feelings is typical of the complexity of Baroque sentiment. Bernini fuses the angel's joy and St. Theresa's agony into an image that depicts what might be called St. Theresa's "anguished joy." Even more typical of the Baroque sensibility is Bernini's use of every device available to him to dramatize the scene. In the Cornaro Chapel, the sculpture is illuminated by a hidden window above, so that the figures seem to glow in a magical white light. Gilded bronze rays of heavenly light descend upon the scene as if from the burst of light painted high on the frescoed ceiling of the vault. To the left and right of the chapel are theater boxes containing marble spectators, like ourselves witnesses to this highly charged, operatic moment.

edged as the masterpiece of Hellenistic sculpture. But unlike either of these earlier works, Bernini's work is not self-contained. Rather, it is integrally related to its surroundings, so much so that it is difficult to think of it in sculptural rather than architectural terms. The two have become fused.

This fusion of sculpture and architecture is one of the defining characteristics of the Baroque—its insistence on merging the various media in order to achieve the most theatrical effects. Illusionistic ceiling painting of the kind done by Fra Andrea Pozzo for the nave of Sant' Ignazio in Rome (see Fig. 294), where the heavens seem to open above the heads of the gathered worshippers, became especially popular. Architectural space and the space of painting thus merge in an illusionistic zone designed to elevate the spectator out of literal space and into a dimension that can only be described as spiritual. Bernini's Cornaro Chapel in Santa Maria della Vittoria is perhaps the most highly developed of these dynamic and theatrical spaces. Bernini was, in fact, a man whose interests ranged across all the arts. The marble theater boxes at the sides of the Cornaro Chapel explicity convert *The Ecstasy of St. Theresa* into a dramatic action. In a gesture typical of the Baroque, Bernini extended his flair for drama to all the arts. In 1644, an English traveler in Rome reported seeing a public opera staged by Bernini for which "he painted the scenes, cut the statues, invented the engines, composed the music, writ the comedy and built the theater."

As vast as Bernini's artistic ambitions were, he was comparatively classical in his tastes. If we compare the interior of the Carnaro Chapel to Francesco Borromini's facade for San Carlo alle Quattro Fontane in Rome, we notice immediately how symmetrical Bernini's design appears. Beside Borromini's facade, Bernini's colonnade of St. Peter's seems positively conservative, despite its magnificent scale. And Borromini's extravagance was immediately popular. The head of the religious order for whom San Carolo alle Quattro Fontane was built wrote with great pride, "Nothing similar can be found anywhere in the world. This is attested by the foreigners who…try to procure copies of the plan. We have been asked for them by Germans, Flemings, Frenchmen,

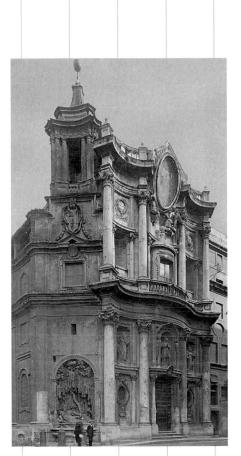

Fig. 618

Fig. 618 Francesco Borromini, facade, San Carlo alle Quattro Fontane, Rome, 1665–1667. The complexity of Borromini's facade is achieved in a play of apparently unintegrated parts and contradictory shapes. Convex and concave windows across the second story alternately pull the facade in upon itself in and push it out. By rounding the corner with a sort of narrow second facade topped by its own tower, Borromini even undermines the symmetry of the main facade.

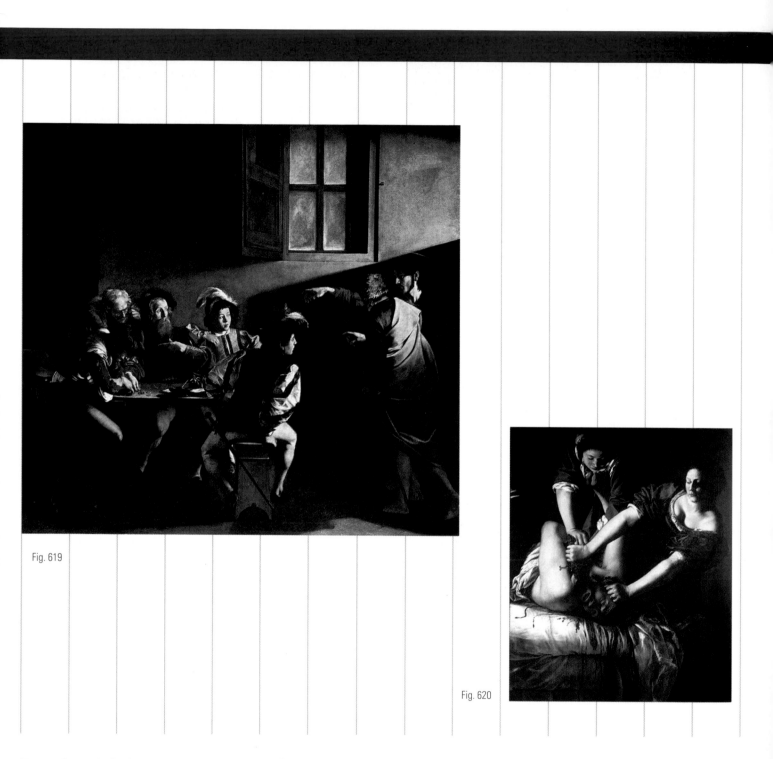

Fig. 619

Fig. 620

Fig. 619 Caravaggio, *The Calling of St. Matthew*, c. 1599–1602. Oil on canvas, 11 ft. 1 in. × 11 ft. 5 in. Contarelli Chapel, San Luigi dei Francesci, Rome. Caravaggio's naturalism is nowhere so evident as in this large work painted, somewhat surprisingly, for a church. The scene is a tavern. St. Matthew, originally a tax collector, sits counting the day's take with a band of his agents, all of them apparently prospering if we are to judge from their attire. From the right, two barefoot and lowly figures enter the scene, calling St. Matthew to join them. He points at himself in some astonishment. Except for the undeniably spiritual quality of the light, which floods the room as if it were revelation itself, the only thing telling us that this is a religious painting is the faint indication of a halo above Christ's head.

Fig. 620 Artemisia Gentileschi, *Judith Decapitating Holofernes*, c. 1612–1613. Oil on canvas, 62 1/2 × 49 3/8 in. Capodimonte Museum, Naples. This scene represents the moment just before that described in Fig. 132. In the other painting the drama is intensified by the approach of some-one from "off stage," but here we find ourselves in the middle of the scene. In both paintings, Gentileschi's light, like that used by Caravaggio, intensifies the dramatic action.

• 1642 Income and property tax first introduced
 in England
• 1650 World population estimated at 500 million

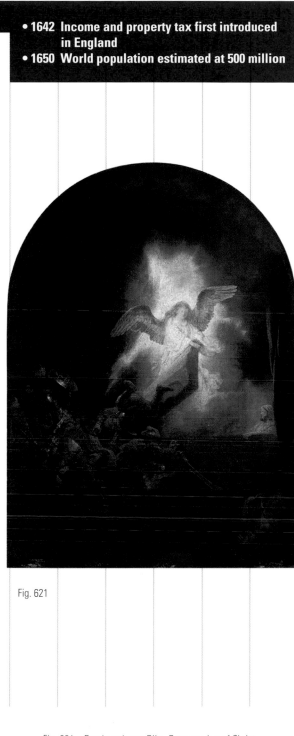

Fig. 621

Fig. 621 Rembrandt van Rijn, *Resurrection of Christ*,
c. 1635–1639. Oil on canvas, 36 1/4 × 26 3/8 in. Alte
Pinakothek, Munich. The emotional contrast between
light and dark is employed here to underscore the emo-
tional difference between the chaotic world of the
Roman soldiers, sent reeling into a darkness symbolic
of their own ignorance by the angel pulling open the lid
of Christ's sepulchre, and the quiet calm of Christ him-
self as He rises in a light symbolic of true knowledge.

Italians, Spaniards, and even Indians." We can
detect, in these remarks, the Baroque tendency to
define artistic genius more and more in terms of
originality, the creation of things never before
seen. As Bernini's colonnade at St. Peter's makes
clear, the virtues of the classical were continually
upheld, but emerging for the first time, often in the
work of the same artist, is a countertendency, a
sensibility opposed to tradition and dedicated to
invention. This opposition between upholding the
traditional values of art and discovering new and
original means of expression will play a great role
in the development of Western art well into the
twentieth century.

As we can tell by the widespread desire to
copy Borromini's plan for San Carlo alle Quattro
Fontane, the Baroque style quickly spread beyond
Rome and throughout Europe. Elaborate Baroque
churches were constructed, especially in
Germany and Austria. In the early years of the
seventeenth century, furthermore, a number of
artists from France, Holland, and Flanders, were
strongly influenced by the work of the Italian
painter Caravaggio. Caravaggio openly disdained
the great masters of the Renaissance, creating a
highly individualistic brand of painting that sought
its inspiration not in the proven styles of a former
era but literally in the streets of contemporary
Rome. Upon viewing his work it is often difficult to
tell that his subject is a religious one, so ordinary
are his people and so dingy and commonplace his
settings. Yet despite Caravaggio's desire to secu-
larize his religious subjects, their light imbues
them with a spiritual reality. It was, in fact, the
contrast in his paintings between light and dark,
mirroring the contrast between the spiritual con-
tent of the painting and its representation in the
trappings of the everyday, that so powerfully influ-
enced painters across Europe.

Though not directly influenced by
Caravaggio, Rembrandt, the greatest master of
light and dark of the age, knew Caravaggio's art
through the work of a large number of Dutch
artists who had studied the Italian master's work.
Rembrandt extends the sense of dramatic opposi-
tion achieved in Caravaggio's contrast of light and
dark by manipulating light across a full range of
tones, changing its intensity and modulating its
brilliance, so that one feels in every beam and

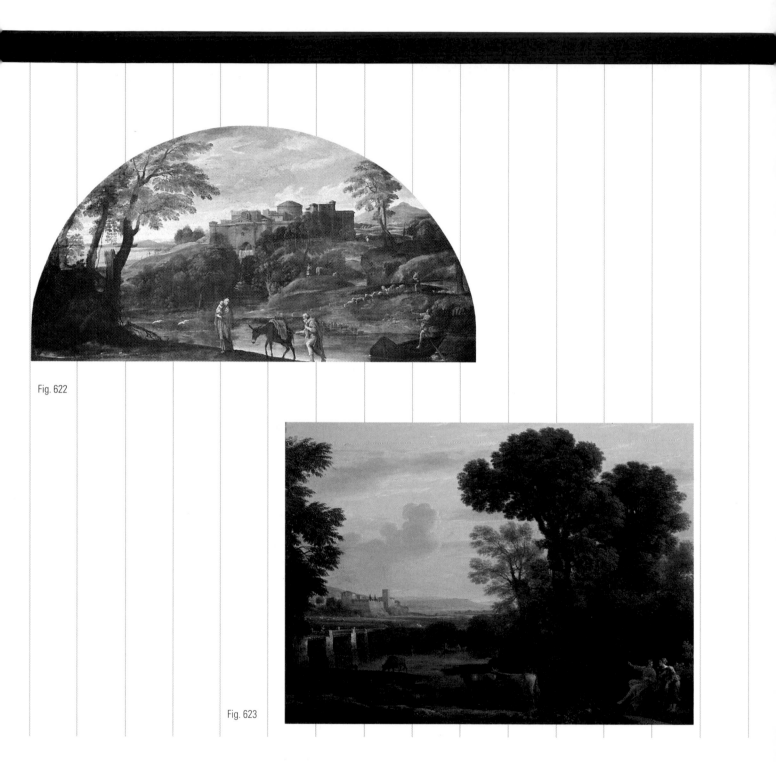

Fig. 622

Fig. 623

Fig. 622 Annibale Carracci, *Landscape with Flight into Egypt*, c. 1603. Oil on canvas, 48 1/4 × 98 1/2 in. Galleria Doria Pamphili, Rome. The figure here is incidental to the landscape. In fact, the biblical story has been transferred to a highly civilized Italian landscape. This is the pastoral, a middle ground of purity and simplicity where people can live free of the corruption and decadence of city and court life.

Fig. 623 Claude Lorrain, *A Pastoral Landscape*, c. 1650. Oil on copper, 15 1/2 × 21 in. Yale University Art Gallery, New Haven, Connecticut. Leo C. Hanna, Jr., Fund. On of the most idyllic of all landscape painters, developing the pastoral vision of Carraci even further, Claude, as he is usually known, casts the world in an eternally poetic light, employing atmospheric perspective to soften all sense of tension and opposition and to bring us to a world of harmony and peace. Here the best civilization has to offer has been melded with the best of a wholly benign and gentle nature.

- **1637** First public opera house opens in Venice
- **1666** Issac Newton invents calculus, measures the moon's orbit
- **1667** Publication of Milton's *Paradise Lost*

Fig. 624

Fig. 624 Jacob van Ruisdael, *View of Haarlem from the Dunes at Overveen*, c. 1670. Oil on canvas, 22 × 24 ³/₈ in. Mauritshuis, The Hague, The Netherlands. Giving up two-thirds of the picture to the infinite dimensions of the heavens, Ruisdael's *View* is not so much about the land as it is about the sky—and the light that emanates from it, alternately casting the earth in light and shadow, knowledge and ignorance.

shadow a different emotional content. Light becomes, in Rembrandt's hands, an index to the psychological meaning of his subjects, often hiding as much as it reveals, endowing them with a sense of mystery as often as it seems to reveal their souls. In the black-and-white medium of etching, which Rembrandt brought to a new level (see Figs. 69 & 271), these tonal modulations are realized with special power.

In Northern Europe, where strict Protestant theology had purged the churches of religious art (see Fig. 13), and, furthermore, even classical subjects were frowned upon as pagan, realism thrived. Works with secular, or nonreligious, subject matter became extremely popular: still life painting was popular (see Jan de Heem's *Still Life with Lobster and Fruit*, Fig. 299); representations of everyday people living out their daily lives, that is, *genre painting*; and landscape. In Spain, where the royal family had deep historical ties to the North, the visual realism of Veláquez came to dominate painting (see Fig. 204). Spurred on by the great wealth it had acquired in its conquest of the New World, Spain helped to create a thriving market structure in Europe. Dutch artists quickly introduced their own goods—that is, paintings—into this economy, with the Spanish court as one of its most prestigious buyers. No longer working for the Church, but for this market, artists painted the everyday things that they thought would appeal to the bourgeois tastes of the new consumer.

Of all of the new secular subject matter that arose during the Baroque Age, the genre of landscape perhaps most decisively marks a shift in Western thinking. Since God made the earth, one could begin to sense the majesty of His soul in His handiwork much as one could read emotion in a painter's gesture upon canvas. The grandeur of God's vision was symbolically suggested in the panoramic sweep of the extended view. The beam of light that in Caravaggio's painting suggests the spiritual presence of Christ becomes, in landscape, a beam of light from the "Sun/Son," a pun popular among English poets of the period, including John Donne. Initially conceived as an ideal space, governed by Divine law, and, therefore, almost Edenic in character, by the last half of the century, it is as if the real space of the Dutch landscape had become the ideal.

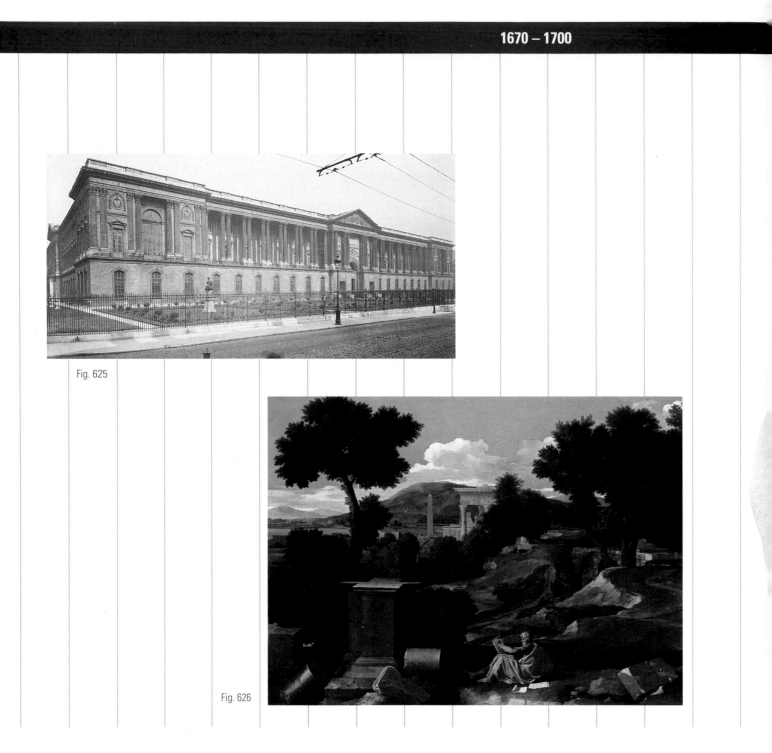

Fig. 625

Fig. 626

Fig. 625 Claude Perrault, with Louis Le Vau and Charles Lebrun, east front of the Louvre, Paris, 1667–1670. The classicism of Bernini's colonnade for St. Peter's in Rome has been fully developed here. All vestiges of Baroque sensuality have been banished in favor of a strict and linear classical line. At the center of the facade is a Roman temple from which wings of paired columns extend outward, each culminating in a form reminiscent of the Roman triumphal arch.

Fig. 626 Nicolas Poussin, *Landscape with St. John on Patmos*, 1640. Oil on canvas, 40 × 53 ½ in. A. A. Munger Collection, © 1993 The Art Institute of Chicago. All Rights Reserved. Here, the small figure of St. John is depicted writing the *Revelations*. Not only does the architecture lend a sense of classical geometry to the scene, but even nature has been submitted to Poussin's classicizing order. Notice, for instance, how the tree on the left bends just enough as it crosses the horizon to form a right angle with the ridge of the distant mountain.

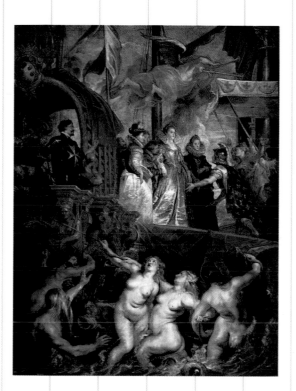

Fig. 627

Fig. 627 Peter Paul Rubens and his workshop, *The Arrival and Reception of Marie de' Medici at Marseilles*, 1621–1625. Oil on canvas, 13 x 10 ft. Musée du Louvre, Paris. One of 21 paintings by Rubens commissioned by Marie de' Medici to decorate the Luxembourg Palace in Paris with a history of her life, the painting depicts Marie's arrival in France as the new wife of the French king, Henry IV. Its sensuous and twisting Baroque style turns life into spectacle and pageant.

The Eighteenth Century

The conflict of sensibility evident if we compare the architecture of Bernini to that of his contemporary Borromini—the one enormous in scale but classical in principle, the other extravagant in form and so inventive that it seems anticlassical in intention—dominates the history of European art in the eighteenth century. In France, especially, anticlassical developments in Italian art were rejected. As early as 1665, Jean-Baptiste Colbert had invited Bernini to Paris to complete construction of the Louvre, the palace of King Louis XIV. But Louis considered Bernini's plans too elaborate—he envisioned demolishing all the extant palace—and the Louvre finally was built in a highly classical style, based on the plan of a Roman temple.

One of the architects of this new Louvre was Charles Lebrun, a court painter who had studied in Rome with the classical painter Nicolas Poussin. Poussin believed that the aim of painting was to represent the noblest actions of men with as absolute clarity as possible. To this end, distracting elements—particularly color, but anything that appeals primarily to the senses and not to the intellect—had to be suppressed. As head of the Royal Academy of Painting and Sculpture, Lebrun installed Poussin's views as an official, royal style. By Lebrun's standards, the greatest artists were the ancient Greeks and Romans, followed closely by Raphael and Poussin; the worst painters were the Flemish and Dutch, who not only "overemphasized" color and appealed to the senses not the mind but who also favored "lesser" genres, such as landscape and still life.

By the beginning of the eighteenth century, Lebrun's hold on the French Academy was being questioned by a large number of painters who championed the work of the great Flemish Baroque painter Peter Paul Rubens over that of Poussin. Rubens, who had painted a cycle of 21 paintings celebrating the life of Marie de' Medici, Louis XIV's grandmother, was a painter of extravagant Baroque tastes. Where the design of Poussin's *Landscape with St. John on Patmos* (Fig. 626) is based upon horizontal and vertical elements arranged parallel to the picture plane, Rubens's forms, in *The Arrival and Reception of Marie de' Medici* (Fig. 627) are dispersed across a

- **1721 Bach writes *The Brandenburg Concertos***
- **1732 Benjamin Franklin's *Poor Richard's Almanac* published**
- **1756 Porcelain factory founded at Sèvres**
- **1760 Josiah Wedgewood founds pottery works**

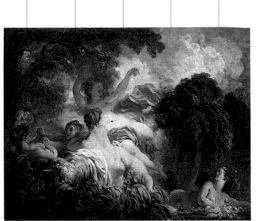

Fig. 629

Fig. 628

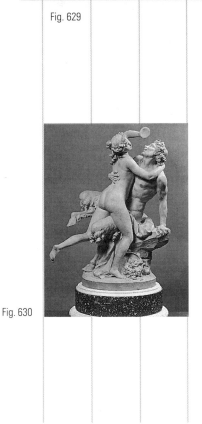

Fig. 630

Fig. 628 Antoine Watteau, *A Pilgrimage to the Island of Cythera*, 1717. Oil on canvas, 51 × 76 ¹/₂ in. Musée du Louvre, Paris. Watteau depicts a party of aristocrats on a pilgrimage to Cythera, the mythical home of Venus, an ideal place of pleasure and love that exists, Watteau suggests, only in our imaginations. The reality of romantic love in the French court of Louis XV was far more decadent.

Fig. 629 Jean-Honoré Fragonard, *Bathers*, c. 1765. Oil on canvas, 25 ¹/₄ × 31 ¹/₂ in. Musée du Louvre, Paris. The Rococo sensibility was obsessed with sensuality, and one can easily see in the mermaids at the bottom of Rubens's painting (Fig. 627) the origins of Fragonard's scene. Fragonard's bathers are designed to appeal to the tastes of the eighteenth-century French court, the world of Pierre Choderlos de LaClos's infamous novel, *Dangerous Liaisons*.

Fig. 630 Claude-Michel Clodion, *Bacchante and Faun*, c. 1775. Terracotta, height 23 ¹/₄ in. The Metropolitan Museum of Art, New York. Bequest of Benjamin Altman, 1913 (14.40687). This small sculpture was designed for a table top. Cloaked in the respectability of its Greek theme, its purpose was to lend an erotic tone to its environment.

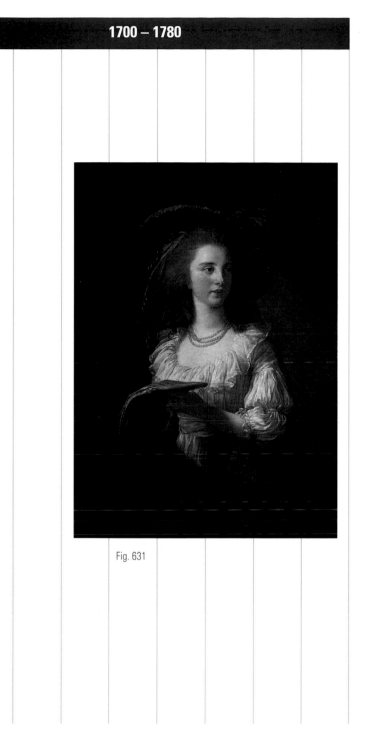

Fig. 631

Fig. 631 Marie-Louise-Elisabeth Vigée-Lebrun, *The Duchess of Polignac*, 1783. Oil on canvas, 38 3/4 × 28 in. © The National Trust Waddesdon Manor, England. Vigée-Lebrun's subject here is feminine beauty. In this portrait, the Rococo combines in exquisite fashion all of the tools of the Baroque sensibility, from Rembrandt's dramatic lighting to Rubens's sensual curves and, given the musical score in the Duchess's hand, even Bernini's sense of theatrical moment.

pair of receding diagonals. In the latter painting our point of view is not frontal and secure, as it is in the Poussin, but curiously low, perhaps even in the water. Poussin, in his design, focuses on his subject, while Rubens creates a multiplicity of competing areas of interest. Most of all, Poussin's style is defined by its linear clarity. Rubens's work is painterly, dominated by a play of color, dramatic contrasts of light and dark, and sensuous, rising forms. Poussin is restrained, Rubens exuberant.

With the death of Louis XIV in 1715, French life itself became exuberant. This was an age whose taste was overseen by society women with real, if covert, political power, especially Louis XV's mistress, Madame de Pompadour. The salons, each held by a particular hostess on a particular day of the week, were the social event of the day. Mozart might play the clavichord at one salon, while at Mme. Geoffrin's on Mondays, for example, artists and art lovers would always gather. A highly developed sense of wit, irony, and gossip was necessary to succeed in this society. So skilled was the repartee in the salons that the most biting insult could be made to sound like the highest compliment. Sexual intrigue was not merely commonplace but expected. And all this transpired in a stylistic atmosphere of elegant refinement known as the **Rococo**.

The word *Rococo* is derived from the French *rocaille*, meaning the small stones and shells that decorate the interiors of grottoes, the underground cavelike places so popular at the time, and the shell form itself became one of the characteristic design elements of the style. Architecturally, Rococo was an extension of Borromini's curvilinear Baroque style. In painting the Rococo was deeply indebted to the Baroque sensibility of Rubens. Its light is somewhat softer—as in the earlier landscapes of Claude Lorrain, it always seems to be dawn or dusk—and the paint seems thin, barely clinging to the surface, as if the gesture of a moment's whim. In sculpture the Rococo was Bernini eroticized.

Yet the seventeenth-century French taste for the classical style did not disappear, and when Herculaneum and Pompeii were rediscovered in 1738 an 1748 respectively, interest in Greek and Roman antiquity revived as well. The discovery fueled an increasing tendency among

- **1775** Paul Revere's ride
- **1783** Britian recognizes U.S. independence
- **1789** The French Revolution
- **1791** Mozart's *The Magic Flute* performed in Vienna

1780 – 1800

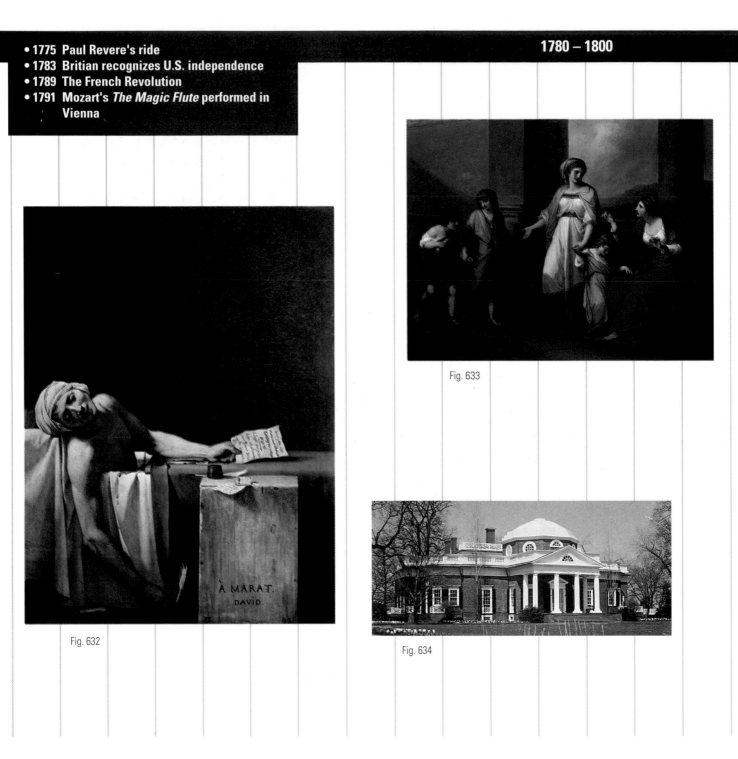

Fig. 633

Fig. 632

Fig. 634

Fig. 632 Jacques Louis David, *The Death of Marat*, 1793. Oil on canvas, 65 × 50 ½ in. Musées Royaux des Beaux-Arts de Belgique, Brussels. Inspired by the French Revolution's supression of the Church, David fully secularizes the religious motif of Christ's Deposition (compare Rogier 's *Deposition*, Fig. 586). A dramatic Caravaggesque light falls over the revolutionary hero, slain in his bath, his virtue embodied in the Neoclassical simplicity of David's design.

Fig. 633 Angelica Kauffmann, *Cornelia, Pointing to Her Children as Her Treasures*, c. 1785. Oil on canvas, 40 x 50 in. Virginia Museum of Fine Arts, Richmond. The Adolph D. and Wilkins C. Williams Fund. In declaring to her visitor that her two sons are "jewels," Cornelia states her Neoclassical virtue, that is, her absolute devotion to her family, and by extension to the state. Her virtue is reinforced by her clothing, particularly in the simple lines of her bodice.

Fig. 634 Thomas Jefferson, Monticello, Charlottesville, Virginia, 1770–1784; 1796–1806. In his private home, which is fronted by stately Doric columns, Jefferson has adapted Greek architecture to brick and wood construction. Jefferson saw the Neoclassical "Greek revival" style as the very embodiment of reason and order, the fundamental principles of the government which he was in the midst of founding even as he built Monticello.

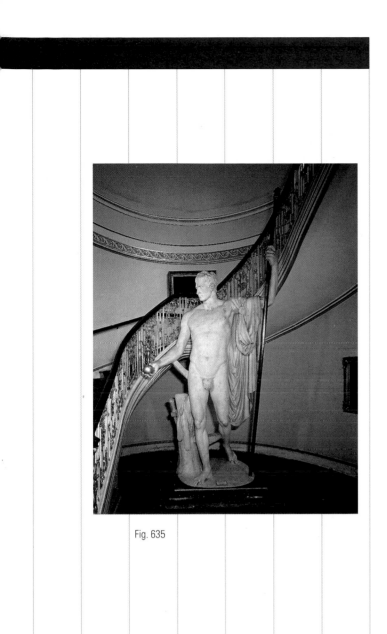

Fig. 635

Fig. 635 Antonio Canova, *Napoleon*, 1806. Marble, over lifesize. Apsley House, London. The most famous artist in the world from the 1790s well into the nineteenth century, the Italian Canova was invited to Paris by Napoleon to carve a sculpture of the emperor as Mars. The head is recognizably Napoleon's, but the body is based on classical models. The British government purchased the statue as a present for the Duke of Wellington after he defeated Napoleon at Waterloo.

the French to view the Rococo style as symptomatic of a widespread cultural decadence, epitomized by the luxurious lifestyle of the aristocracy. The discovery also caused people to identify instead with the public-minded values of Greek and Roman heroes, who placed moral virtue, patriotic self-sacrifice, and "right action" above all else. A new **Neoclassicism** supplanted the Rococo almost overnight.

The most accomplished of the Neoclassical painters was Jacques Louis David, whose work has been discussed at length in the text (see Figs. 84 & 85, 205 & 206). David took an active part in the French Revolution in 1789, recognizing as an expression of true civic duty and virtue the desire to overthrow the irresponsible monarchy that had, for two centuries at least, squandered France's wealth. The same sensibility informs the Neoclassical architecture of Thomas Jefferson. For Jefferson, the Greek orders embodied democratic ideals, possessing not only a sense of order and harmony but a moral perfection deriving from measure and proportion. The colonnade thus came to be associated with the ideal state, and, in the United States, Jefferson's Neoclassical architecture became an almost official Federal style.

The Nineteenth Century

The uncertain years that followed the French Revolution in France were brought to an end in 1799 when a young military commander, Napoleon Bonaparte, was made First Consul of the French Republic. As this title suggests, Napoleon's government was itself modeled on Roman precedents. He established a centralized government and instituted a uniform legal system. He invaded Italy and brought home with him many examples of classical sculpture, including the *Laocoön* (Fig. 530) and the *Apollo of Belvedere* (Fig. 26). In Paris itself, he built triumphal Roman arches, including the famous Arc de Triomphe, a column modeled on Trajan's in Rome, and a church, La Madeleine, modeled after the temples of the first Roman emperors. In 1804, Napoleon was himself crowned Emperor of the largest empire since Charlemagne.

Neoclassical art was used to legitimate this empire. David himself saw Napoleon as the salvation of France (so confused had Revolutionary

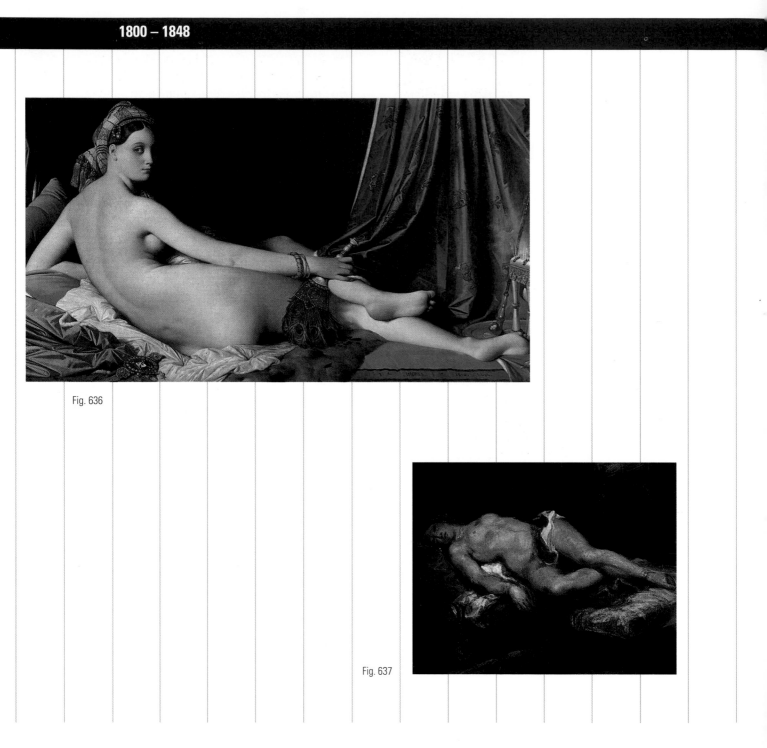

Fig. 636

Fig. 637

Fig. 636 Jean-Auguste-Dominique Ingres, *Grande Odalisque*, 1814. Oil on canvas, 35 1/4 × 63 3/4 in. Musée du Louvre, Paris. Ingres often places his figures in the foreground, which makes them seem to emerge from the picture plane like low-relief sculpture. This effect is also apparent in David's *Death of Marat* (Fig. 632), where the note resting on the crate next to the tub appears to emerge into the viewer's space.

Fig. 637 Eugène Delacroix, *Odalisque*, 1845–1850. Oil on canvas, 14 7/8 × 18 1/4 in. Fitzwilliam Museum, University of Cambridge, England. From the moment that Delacroix exhibited his painting *The Massacre at Chios* in 1824, he and Ingres became rivals. Each had his critical champions, each his students and followers. For Ingres, drawing was everything and his painting is, above all, linear in style. Delacroix is fascinated by the texture of paint itself, and in his painterly attack upon the canvas we begin to sense the artist's own passionate temperament. Next to the Delacroix, the pose of the odalisque in Ingres's painting is positively conservative, and, in fact, Ingres felt he was upholding traditional values in the face of the onslaught represented by the uncontrolled individualism of by his rival.

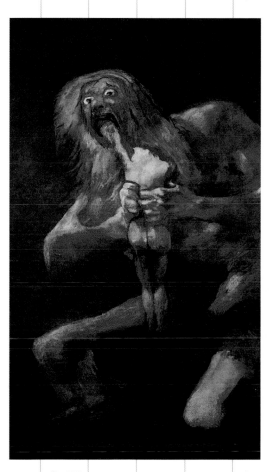

Fig. 638

Fig. 638 Francisco Goya, *Saturn Devouring One of His Sons*, 1820–1822. Fresco, transferred to canvas, 57 7/8 × 32 5/8 in. Museo del Prado, Madrid. Saturn is allegorically a figure for Time, which consumes us all. But it is the incestuous cannibalism of the scene, the terrible monstrosity of the vision itself, that tells us of Goya's own despair. Like the other Black Paintings, incidentally, this one was painted originally on the wall of the dining room in his own home.

France been that David himself had been imprisoned, a sure sign, he thought, of the chaos and confusion of the day), and he received important commissions from the new emperor. But it was David's finest pupil, Jean-Auguste-Dominique Ingres who became the champion of Neoclassical ideals in the nineteenth century. In 1806, he painted *Napoleon on his Imperial Throne* (see Fig. 11), and in the same year was awarded the Prix de Rome. Ingres departed for Italy where he remained for 18 years, studying Raphael in particular, and periodically sending new work back to France, including the astonishing *Jupiter and Thetis* (see Fig. 90).

Ingres's Neoclassicism was "looser" than his master's. While Jupiter, for instance, is dogmatically classical in spirit, the sensuous Thetis is almost Rococo in treatment. Looking at a painting such as the *Grande Odalisque*, from 1814, with its long, gently curving limbs, we are more clearly in the world of Mannerist painting than that of the Greek nude. Ingres's color is as rich as Bronzino's in *The Exposure of Luxury* (see Fig. 609), and, in fact, his theme is much the same. An "odalisque" is a Turkish harem girl, and Ingres's painting seems more decadent than not, deeply involved in a world of satins, peacock feathers, and, at the right, hashish. Certainly, it is not easy to detect much that reminds the viewer of Poussin's high moral tone.

But beside Eugene Delacroix's treatment of a similar theme, Ingres's classicism becomes more readily apparent. As far as Ingres was concerned, Delacroix's work (see also Figs. 86 & 87), representing a sort of Neo-Baroque sensibility in contrast to his own Neoclassicism, was barbaric. We have come to call the kind of art exemplified by Delacroix **Romanticism**. At the heart of this style is the belief that reality is determined in the self, and that the artist's task is to reveal that self. Individualism reigned supreme, and, as a result, Romantic art sometimes seems to consist of as many styles as artists. What unifies the movement, in fact, is more a philosophical affirmation of the power of the individual mind than a coherent set of formal principles.

One of the most individual of the Romantics was the Spanish painter Francisco de Goya y Lucientes. After a serious illness in 1792,

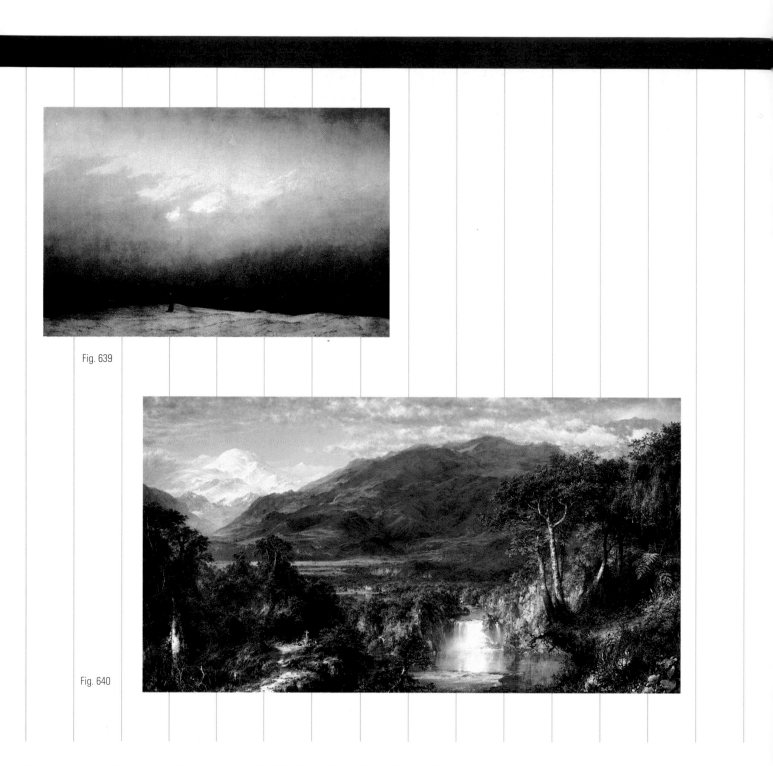

Fig. 639

Fig. 640

Fig. 639 Caspar David Friedrich, *Monk by the Sea*, 1809-1810. Oil on canvas, 42 1/2 × 67 in. Schloss Charlottenburg, Berlin. No painting of the period more fully captures the terrifying prospect of the Sublime than this. It indicates just how thoroughly the experience of the infinite—that is, the experience of God—can be found in Nature. But the real terror of this painting lies in its sense that the infinite space faced by the monk may be a meaningless void.

Fig. 640 Frederic Edwin Church, *The Heart of the Andes*, 1859. Oil on canvas, 66 1/8 × 119 1/4 in. The Metropolitan Museum of Art, New York. Bequest of Margaret E. Dows, 1909 (09.95). The work was first exhibited in 1859 in New York in a one-picture, paid-admission showing. The dramatic appeal of the piece was heightened by framing it so that it seemed to be a window in a grand house looking out upon this very scene and also by brightly lighting the picture and leaving the remainder of the room dark. Deemed by critics "a truly *religious* work of art," it was a stunning success. The insignificance of man can be felt in the minuteness of the two figures praying at the cross in the lower left, but the scene is by no means merely Sublime. It is also beautiful and pastoral in feeling, and, in the careful rendering of plant life, almost scientific in its fidelity to nature.

- **1825 Baseball club organized in Rochester, N.Y.**
- **1833 Abolition of slavery in British Empire**
- **1836 Ralph Waldo Emerson's *Nature* published**

Fig. 641

Fig. 641 John Constable, *Hampstead Heath*, 1821. Oil sketch, 10 × 12 in. Burt Art Gallery and Museum, Lancaster, England. Constable believed in painting from the direct observation of nature, and he painted many studies out-of-doors in order to capture, in particular, the effects of sky and clouds. The sky, he said, was "the key note . . . and the chief organ of sentiment."

Goya turned from a late Rococo style and began to produce a series of paintings depicting inmates of a lunatic asylum and a hospital for wounded soldiers. When Napoleon invaded Spain in 1808, Goya recorded the atrocities in both painting and a series of etchings, *The Disasters of War*, which remained unpublished until long after his death. His last, so-called Black Paintings, were brutal interpretations of mythological scenes that revealed a universe operating outside the bounds of reason, a world of imagination unchecked by a moral force of any kind. The inevitable conclusion is that, for Goya, the world was a place full of terror, violence, and horror. What we recognize in his work is his own despair.

This sense of the terrible is by no means unique to Goya. In his own *Journal*, Delacroix would write, "[The poet] Baudelaire...says that I bring back to painting...the feeling which delights in the terrible. He is right." It was in the face of the *Sublime* that this enjoyment of the terrible was most often experienced. Theories of the Sublime had first appeared in the seventeenth century, most notably in Edmund Burke's *Inquiry into the Origin of Our Ideas of the Sublime and the Beautiful* (1756). For Burke, the Sublime was a feeling of awe experienced before things that escaped the ability of the human mind to comprehend them—mountains, chasms, storms, and catastrophes. The Sublime exceeded reason; it presented viewers with something vaster than themselves, thereby making them realize their smallness, even their insignificance, in the face of the infinite.

American landscape painters such as Albert Bierstadt (see Fig. 233) and Frederic Church continually sought to capture the Sublime in their paintings of the vast spaces of the American West. Church even traveled to South America in order to bring evidence of its exotic and remarkable landscapes to viewers in America and Europe. The landscapes of the English painter J. M. W. Turner, with their dramatic stress on the play of light and atmosphere, served as a primary model for the Americans (see Figs. 128, 142, & 143). Even in John Constable's views of familiar stretches of rural English countryside, we feel a monumental sense of space, as if the sky itself were limitless and the clouds and light a source of constant drama.

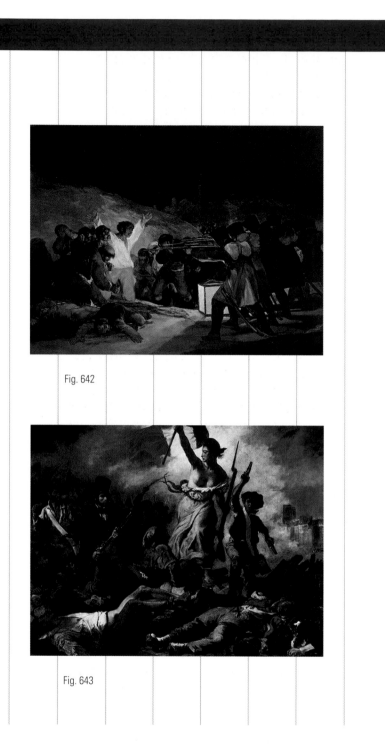

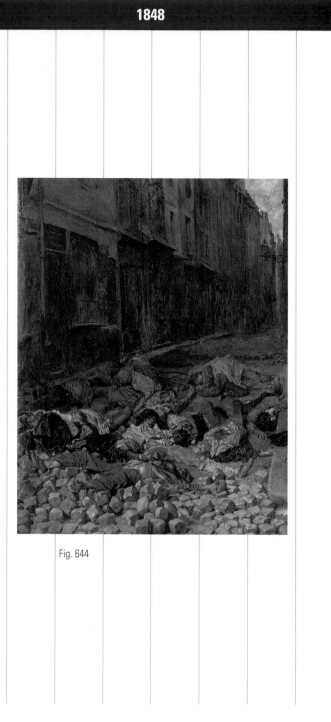

Fig. 642

Fig. 643

Fig. 644

Fig. 642 Francisco Goya, *The Third of May, 1808*, 1814–1815. Oil on canvas, 8 ft. 9 in. × 13 ft. 4 in. Museo del Prado, Madrid. Goya's painting depicts an actual event, the execution of the citizens of Madrid by Napoleon's invading army. Its dramatic lighting and the outstretched arms of the man about to be shot reflect the conventions of Baroque religious art, here used to convey a sense of the horrible realities of war.

Fig. 643 Eugène Delacroix, *Liberty Leading the People*, 1830. Oil on canvas, 8 ft. 6 3/8 in. × 10 ft. 8 in. Musée du Louvre, Paris. Though Delacroix represents Liberty as an allegorical figure, the battle, which took place during the July Revolution of 1830, is depicted in a highly realistic manner, with figures lying dead on the barricades and Notre Dame Cathedral at the distant right shrouded in smoke.

Fig. 644 Ernest Meissonier, *Memory of Civil War (The Barricades)*, 1849. Oil on canvas, 11 1/2 × 8 3/4 in. Musée du Louvre, Paris. With a growing sense of realism in painting, the convention of showing warfare as glorious was increasingly replaced by a desire to show it as it really was. All the nobility of war has been drained from Meissonier's picture, which shows the French tricolor as reduced to tattered clothing and blood.

Fig. 645

Fig. 645 Honoré Daumier, *Fight between Schools,
Idealism and Realism*, 1855. Daumier's biting social
commentary (see Figs. 278 & 279) here takes on the two
competing styles of the mid-nineteenth century. The
realist, with his square palette, house painter's brush,
and wooden shoes battles the aged, but still classically
nude, idealist, who wears, atop his head, the helmet of
a Greek warrior.

But the Romantic painter was interested in
more than the Sublime. "Painting is for me but
another word for feeling," Constable once said. A
Romantic artist might render a beautiful scene as
well as a Sublime one, or one so pastoral in feel-
ing that it recalls, often deliberately, Claude's soft
Italian landscapes (see Fig. 623). It was the love
of Nature itself that the artist sought to convey. In
Nature, the American poet and essayist Ralph
Waldo Emerson believed, one could read eternity.
It was a literal "sign" for the Divine Spirit.

The painter, then, had to decide whether to
depict the world with absolute fidelity or to
reconstruct imaginatively a more perfect reality
out of a series of accurate observations. As one
writer put it at the time, "A distinction must be
made…between the elements generated
by…direct observation, and those which spring
from the boundless depth and feeling and from
the force of idealizing mental power." Because of
their faith in the individual temperament, the
Romantics tended to prefer representing those
things that spring from the idealizing mind, and
there was ample art-historical support for such a
position. In the Renaissance, Alberti had retold
the story of the Greek painter Zeuxis, who wish-
ing to paint an ideal woman, and knowing beauty
to be dispersed and rare, "chose, therefore, the
five most beautiful young girls from the youth of
that land in order to draw from them whatever
beauty is praised in woman." Church's *Heart of
the Andes* (Fig. 640) is just such a idealist compi-
lation of diverse scenes, but in many of its
details—in, for instance, the accuracy with
which the foliage has been rendered—it depends
upon a direct observation.

Church's interest in foliage reflects the
importance of scientific, empirical observation to
the nineteenth century as a whole, a way of see-
ing that runs counter to, and exists alongside, the
imaginative and idealist tendencies of not only his
own art but of Romantic painting as a whole. So
thoroughly did the painter Gustave Courbet come
to believe in recording the actual facts of the
world around him that he would declare, in 1861:
"Painting is an essentially *concrete* art and can
only consist of the presentation of *real and exist-
ing things*. It is a completely physical language,
the words of which consist of all visible objects."
Artists should confine their representation to

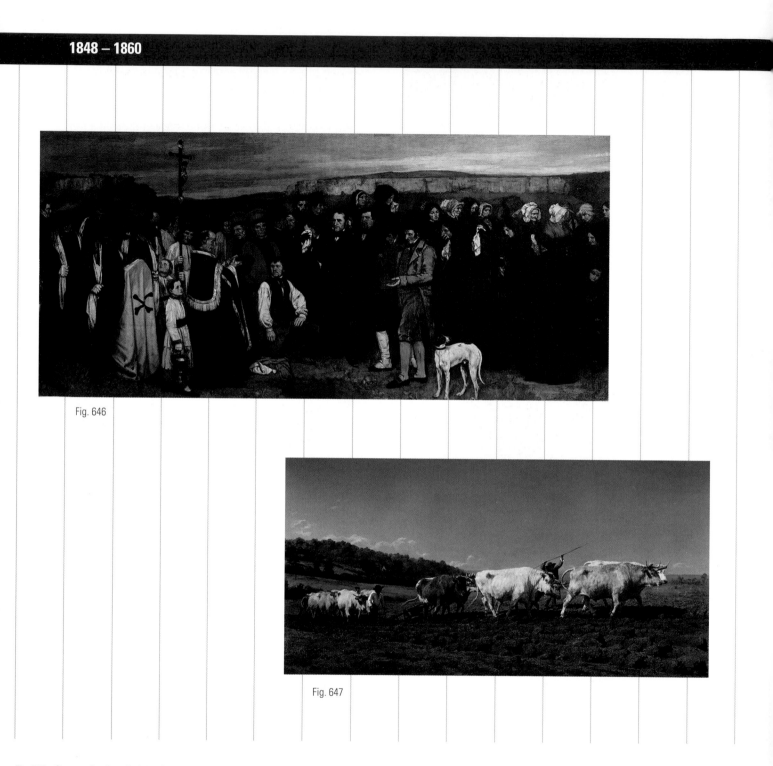

Fig. 646

Fig. 647

Fig. 646 Gustave Courbet, *Burial at Ornans*, 1849. Oil on canvas, 10 ft. 3 ½ in. × 21 ft. 9 in. Musée d'Orsay, Paris. This gigantic painting seems, at first glance, to hold enormous potential for symbolic and allegorical meaning, but just the opposite is the case. In the foreground is a hole in the ground, the only "eternal reward" Courbet's scene appears to promise. No one, not even the dog, seems to be focused on the event itself. Courbet offers us a panorama of distraction, of common people performing their everyday duties, in a landscape whose horizontality reads like an unwavering line of monotony. If the cruxifix rises into the sky over the scene, it does so without deep spiritual significance. In fact, its curious position, as if it were set on the horizon line, lends it a certain comic dimension. The painting was rejected by the jury of the Universal Exposition of 1855, and Courbet opened a one-person exhibition outside the Exposition grounds, calling it the Pavilion of Realism.

Fig. 647 Rosa Bonheur, *Plowing in the Nivernais*, 1849. Oil on canvas, 5 ft. 9 in. × 8 ft. 8 in. Musée d'Orsay, Paris. Bonheur's painting, commissioned in response to the the Revolution of 1848, reveals her belief in the virtue of toil and the common life of the French peasant. It was, however, her extraordinary ability to depict animals with the utmost realism that made her the most famous woman artist of her day.

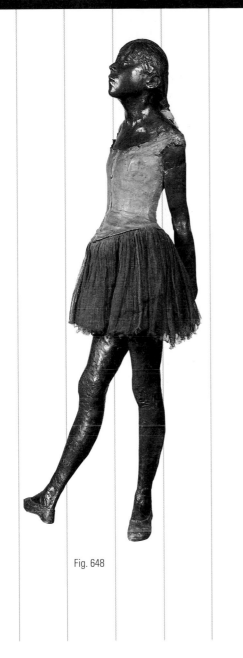

Fig. 648

Fig. 648 Edgar Degas, *The Little Dancer of Fourteen*, c. 1880–1881. Bronze, muslin, satin, 39 in. Sterling and Francine Clark Art Institute, Williamstown, MA. Degas's realistic bronze wears real clothing, and her hair is tied back with real ribbon. If the pose seems artificial, it is the artificiality of the dance itself that Degas portrays. But he captures as well the young girl's awkwardness. As a result, even in her posturing, she seems immediately real and unidealized.

accurate observation and notation of the phenomena of daily life. No longer was there necessarily any "greater" reality beyond or behind the facts that lay before their eyes.

It was, at least in part, this spirit that led to the invention of photography in the 1830s (see Figs. 314–320). And it was also in this spirit that Karl Marx, in *The Communist Manifesto*, would say: "All that was solid and established crumbles away, all that is holy is profaned, and man is at last compelled to look with open eyes upon his conditions of life and true social relations." Marx's sentiments, written in response to the wave of revolutions that swept Europe in 1848, are part and parcel of the realist enterprise. It was, suddenly, socially important, even imperative, to paint neither the Sublime nor the beautiful nor the picturesque, but the everyday, the commonplace, the low, and the ugly. Painters must represent the reality of their time and place, whatever it might look like.

As Daumier's cartoon of the battle between Idealism and Realism makes clear (Fig. 645), the art of the past, exemplified by the Classical model, was felt to be worn-out, incapable of expressing the realities of contemporary life. "*Il faut être de son temps*"—"it is necessary to be of one's own time"—is the way that the poet Charles Baudelaire put it. He looked everywhere for a "painter of modern life." The modern world was marked by change, by the uniqueness of every moment, each instant like a photograph different from the last. Painting had to accommodate itself to this change. There were no longer any permanent eternal truths.

Baudelaire's painter of modern life was Edouard Manet. When in 1863 Manet submitted his painting *Luncheon on the Grass*, more commonly known by its French name *Déjeuner sur l'herbe*, to the conservative jury that picked paintings for the annual Salon exhibition, it was rejected along with many other paintings considered "modern." Such an outcry at the jury process ensued that Napoleon III issued a decree creating a Salon des Refusés, or exhibition of works refused by the Salon proper, in order to let the public judge for themselves the individual merits of the rejected works. Even at the Salon des Refusés, where expectations were already low,

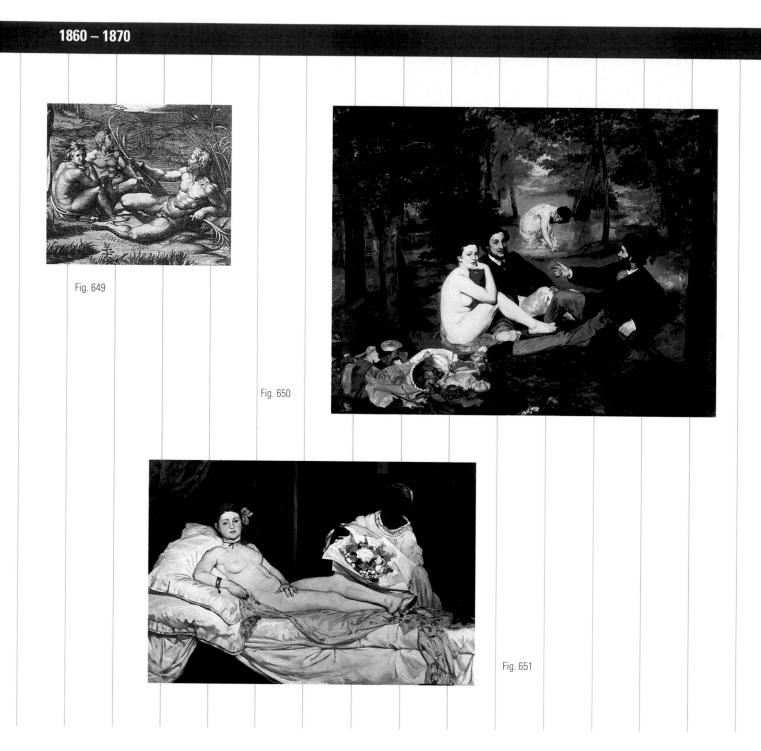

Fig. 649

Fig. 650

Fig. 651

Fig. 649 Marcantonio Raimondi, after Raphael, *The Judgment of Paris* (detail), c. 1520. Engraving. Raphael's original figures, upon which Manet modeled the central group in his *Luncheon on the Grass*, are themselves derived from a depiction of river gods on a 3rd-century A.D. Roman sarcophagus.

Fig. 650 Edouard Manet, *Luncheon on the Grass* (*Déjeuner sur l'herbe*), 1863. Oil on canvas, 7 ft. × 8 ft. 10 in. Musée d'Orsay, Paris. One of the most disarming characteristics of this painting is our own involvement in it, for we seem to have attracted the attention of the seated nude. More disarming is the fact that, even though apparently interrupted she makes no effort to hide herself. It was perhaps this shamelessness that most shocked Parisian society.

Fig. 651 Edouard Manet, *Olympia*, 1863. Oil on canvas, 51 × 74 3/4 in. Musée d'Orsay, Paris. If the gaze of the woman in *Déjeuner* is direct, Olympia's is even more so. Again, the visitor, who is implicitly male, becomes a voyeur, as the female body is subjected to the male gaze. It is as if the visitor, who occupies our own position, had brought the flowers, and the cat, barely discernible at Olympia's feet, had arched its back to hiss at the visitor's approach.

- **1864 Tolstoy's *War and Peace* published**
- **1866 Alfred Nobel invents dynamite**
- **1869 Princeton and Rutgers inaugurate intercollegiate football**

Manet's painting created a scandal. Some years later, in his novel *The Masterpiece*, Manet's friend Emile Zola would write a barely fictionalized account of the painting's reception:

> It was one long-drawn-out explosion of laughter, rising in intensity to hysteria.... A group of young men on the opposite side of the room were writhing as if their ribs were being tickled. One woman had collapsed on to a bench, her knees pressed tightly together, gasping, struggling to regain her breath.... The ones who did not laugh lost their tempers.... It was an outrage and should be stopped, according to elderly gentlemen who brandished their walking sticks in indignation. One very serious individual, as he stalked away in anger, was heard announcing to his wife that he had no use for bad jokes.... It was beginning to look like a riot...and as the heat grew more intense faces grew more and more purple.

Two years later, at the Salon of 1865, Manet exhibited another picture that caused perhaps an even greater scandal. *Olympia* was a depiction of a common prostitute posed in the manner of the traditional odalisque. Though it was not widely recognized at the time, Manet had, in this painting, by no means abandoned tradition completely in favor of the depiction of everyday life in all its sordid detail. *Olympia* was directly indebted to Titian's *Venus of Urbino* (compare Fig. 602), and the *Déjeuner sur l'herbe* was based upon a composition by Raphael that Manet knew through an engraving etched after the original by one of Raphael's students. Manet's sources were classical. His treatment, however, was anything but. In fact, what most irritated both critics and public was the apparently "slipshod" nature of his painting technique. The body of the seated nude in *Le Déjeuner* lacks any sense of modeling, and *Olympia's* body is virtually flat. Manet painted with large strokes of thick paint, and if the perspective in *Le Déjeuner* seems distorted—the bather in the background seems about to spill forward into the picnic—then he has eliminated perspective altogether in the shallow space of the *Olympia*, where the bed appears to be no wider than a foot or two.

Manet's rejection of traditional painting techniques was intentional. He was drawing attention to his very modernity, to the fact that he was breaking with the past. His manipulation of his traditional sources supported the same intentions. In Marx's words, Manet is looking "with open eyes upon his conditions of life and true social relations." If Raphael had depicted the classical *Judgment of Paris*, the mythological

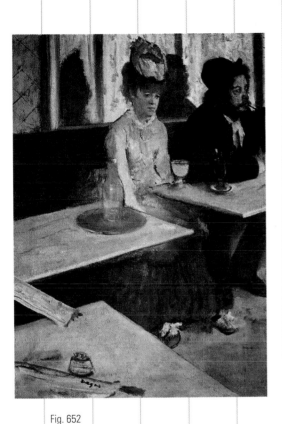

Fig. 652

Fig. 652 Edgar Degas, *The Glass of Absinthe*, 1876. Oil on canvas, 36 × 27 in. Musée d'Orsay, Paris. An essay in loneliness, Degas's painting reveals the underside of Parisian café society. Absinthe was an alcoholic drink that attacked the nerve centers, eventually causing severe cerebral damage. Especially popular among the working classes, it was finally banned in France in 1915.

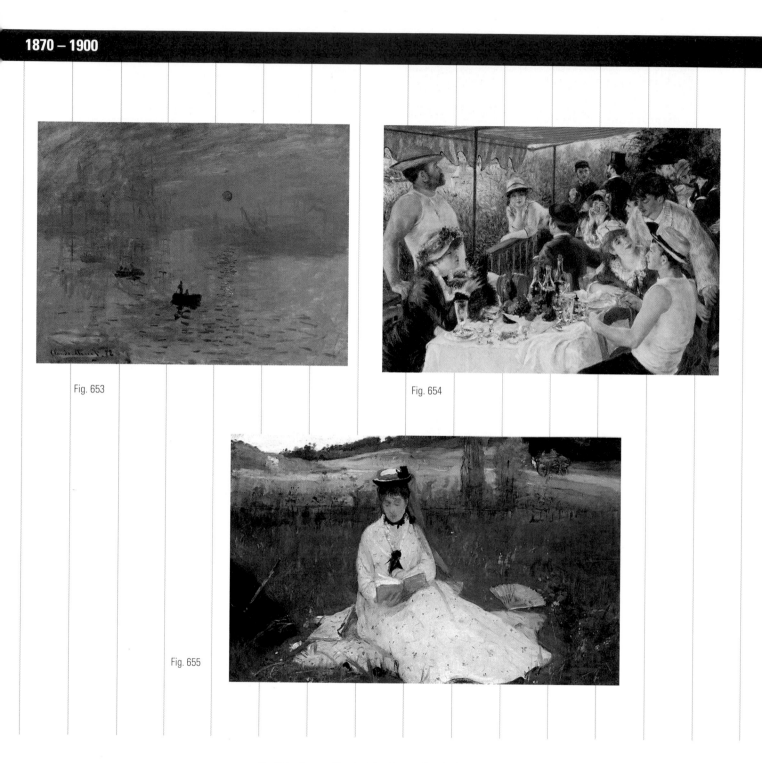

Fig. 653

Fig. 654

Fig. 655

Fig. 653 Claude Monet, *Impression-Sunrise*, 1872. Oil on canvas, 19 1/2 × 25 1/2 in. Musée Marmottan, Paris. This is the painting that gave Impressionism its name when it was exhibited in 1874 in the first of a series of independent exhibitions organized by painters rejected by the Salon. Among them were Cézanne, Degas, Monet, Morisot, Pissarro, Renoir, and Sisley—the heart of the group we now call the Impressionists.

Fig. 654 Auguste Renoir, *A Luncheon at Bougival* (or *The Luncheon of the Boating Party*), 1881. Oil on canvas, 51 × 68 in. © The Phillips Collection, Washington, D.C. All of the figures here were Renoir's friends, including his future wife, Aline Charigot, pursing her lips at the little dog. When he saw the painting in 1872, one critic accurately summarized the spirit of both it and the party it depicts: "For them eternity is in their glass, in their boat, and in their songs."

Fig 655 Berthe Morisot, *The Artist's Sister, Mme. Pontillon, Seated on the Grass*, 1873. Oil on canvas, 17 3/4 × 28 1/2 in. Cleveland Museum of Art. Gift of the Hanna Fund, 50.89. Probably one of four paintings Morisot exhibited at the first Independents Exhibition in 1874, the painting exhibits all of the loose, rapid brushwork that can be found in Monet's *Impression Sunrise*. Note especially, the rendering of the cart on the path at the top right.

• 1871 Trade unions legalized in Britian
• 1877 First public telephones in U.S.
• 1880 Thomas Edison develops the first
 practical electric lights

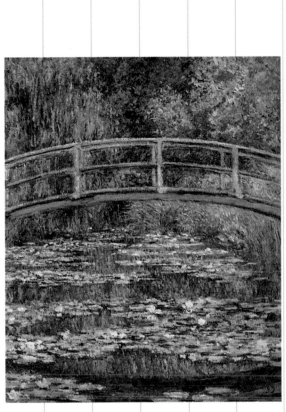

Fig. 656

Fig. 656 Claude Monet, *Bridge over a Pool of Water Lilies*, 1899. Oil on canvas, 36 1/2 × 29 in. The Metropolitan Museum of Art, New York. Bequest of Mrs. H. O. Havemeyer, 1929. The H. O. Havemeyer Collection (29.100.113). In 1883, Monet moved to Giverny, where he painted many of his greatest works, including the "Haystacks" (see Figs. 24 & 167). By 1900, he had turned from depicting "modern life," choosing instead to paint the "presentness" of his garden (see also, Fig. 179).

contest in which Paris chose Venus as the most beautiful of the goddesses, a choice that led to the Trojan War, in his depiction of a decadent picnic in the Bois de Bologne, Manet passes judgment upon a different Paris, the modern city in which he lives. The world has changed. It is less heroic, less grand. Similarly, the Venus that once strode the heights of Mt. Olympus, home of the gods, is now the common courtesan, Olympia, her "love" now a commodity, a body to be bought and sold.

Impressionism and Post-Impressionism

In his brushwork, particularly, Manet pointed painting in a new direction. His friend Zola, who was the first to defend *Olympia*, described it this way: "He catches his figures vividly, is not afraid of the brusqueness of nature and renders in all their vigor the different objects which stand out against each other. His whole being causes him to see things in splotches, in simple and forceful pieces." Directly influenced by the somewhat older Manet, Claude Monet began to paint in the same rich and thick strokes of the older painter, but with an even looser hand. He would combine two or more pigments on a single wide brush and allow them to blend as they were brushed onto the canvas. He would paint "wet on wet," that is with wet pigment over and through an already painted surface that had not yet dried. Most of all, he painted with far more intense hues made possible by the development of synthetic pigments.

But unlike the Realist painters of a generation earlier, the painters of Monet's generation were less interested in social criticism and far more interested in depicting in their work the pleasures of life itself, including the pleasures of simply seeing. **Impressionism** is, first of all, characterized by a way of seeing, an attempt to capture the fleeting effects of light by applying paint in small, quick strokes of color. But it is also characterized by an intense interest in images of leisure that the Realists would have rejected as unworthy of their own high moral purposes. The Impressionists painted life in the Parisian theaters and cafés, the grand boulevards teeming with shoppers, country gardens bursting with flowers,

Fig. 657

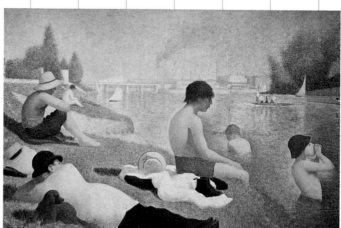

Fig. 658

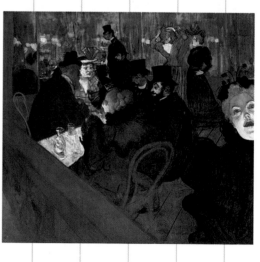

Fig. 659

Fig. 657 James McNeill Whistler, *Nocturne in Black and Gold, the Falling Rocket*, c. 1875. Oil on oak panel, 23 3/4 × 18 3/8 in. © The Detroit Institute of Arts. Gift of Dexter M. Ferry, Jr. Whistler saw the painting as "an arrangement of line, form, and color," but believing that art should possess strong moral content, John Ruskin was blind to Whistler's abstraction. He wrote that Whistler was "flinging a pot of paint in the public's face," and Whistler, in turn, sued Ruskin for libel.

Fig. 658 Georges Seurat, *The Bathers*, 1883–1884. Oil on canvas, 79 1/2 × 118 1/2 in. The National Gallery, London. Reproduced by courtesy of the Trustees. Though Seurat's subject matter is Impressionist, his composition is not. It is architectural, almost like Poussin's in its design. The surface of Seurat's painting consists of thousands of small dots of paint painstakingly arranged in strict accordance with the laws of color theory.

Fig. 659 Henri de Toulouse-Lautrec, *At the Moulin Rouge*, 1892–1895. Oil on canvas, 48 3/8 × 55 1/4 in. Helen Birch Bartlett Memorial Collection. © 1993 The Art Institute of Chicago. All Rights Reserved. This painting, especially in the grotesquely gas-lit features of the figure on the right, captures the decadence that, by century's end, pervaded the Parisian life that the Impressionists once had celebrated.

- **1890** First moving-picture shows appear in New York
- **1893** Henry Ford builds his first car
- **1897** J. J. Thomson discovers electron

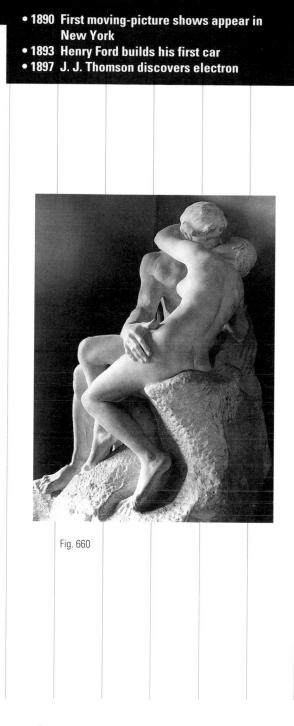

Fig. 660

Fig. 660 Auguste Rodin, *The Kiss*, 1886–1898. Marble, over lifesize. Rodin Museum, Paris. Rodin leaves the mark of the chisel, like a painter's brushstroke, readily visible in the stone in order to reveal the *process* of sculpture, whereby formal beauty slowly emerges out of raw stone. Here the sensuality and passion of the embrace is heightened in the contrast between the smooth surface of the couple's bodies and the rough-hewn stone in which they sit.

the racetrack and seaside, the suburban pleasures of boating and swimming on the Seine.

Again, Manet had pointed them in this direction. He was a famous *flâneur*, a Parisian type of impeccable dress and perfect manners known for strolling the city, observing its habits, and commenting on it with the greatest subtlety, wit, and savoir-faire. The type can be seen strolling toward the viewer in Gustave Caillebotte's *Place de l'Europe* (Fig. 104). Wrote Manet's friend Antonin Proust, "With Manet, the eye played such a big role that Paris has never known a *flâneur* like him nor a *flâneur* strolling more usefully." If the younger Impressionists looked at the world around them with a somewhat less critical eye than had their mentor, Manet, they nevertheless seemed compelled to document its every side.

Increasingly, this urge to observe the world in its most minute particulars led to the investigation of optical reality in and for itself. As early as the 1870s, in his paintings of boats on the river at Argenteuil, Monet began to paint the same subject over and over again, studying the ways in which light itself transformed his impressions. This working method led to his later serial studies of the haystacks, Rouen Cathedral, and his garden at Giverny. For many, painting began to be an end in itself, a medium whose relation to the actual world was at best only incidental. In England, the American expatriate painter James McNeill Whistler equated his paintings to musical compositions by titling them "nocturnes" and "symphonies." He painted, he said, "as the musician gathers his notes, and forms his chords, until he brings forth from chaos glorious harmony." Painting was, for Whistler, primarily an abstract arrangement of shapes and colors; only incidentally did it refer to the world.

Although, by the 1880s, Impressionism's subject matter had come to seem trivial to many artists, they were still interested in investigating and extending its formal innovations and in reexamining the symbolic possibilities of painting. Monet's work at Giverny can be seen as an example of just such an ongoing formal exploration. A number of other painters—among them Paul Cézanne, Georges Seurat, Vincent van Gogh, Paul Gauguin, and Henri de Toulouse-Lautrec—embarked on a similar brand

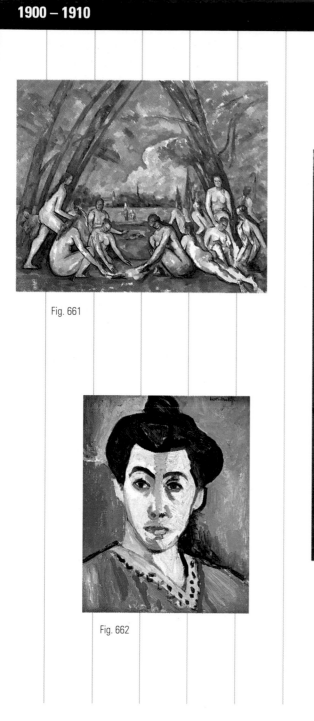

Fig. 661

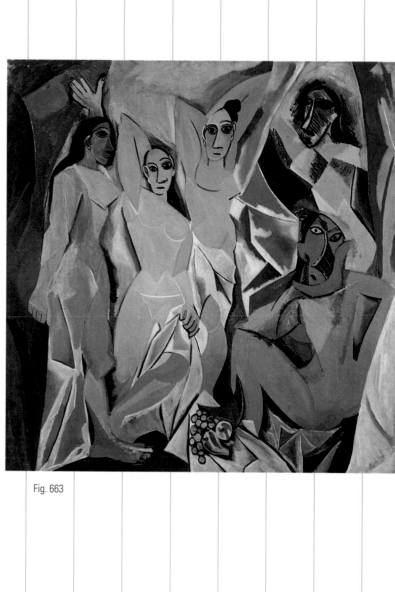

Fig. 663

Fig. 662

Fig. 661 Paul Cézanne, *The Large Bathers*, 1906. Oil on canvas, 82 × 99 in. Philadelphia Museum of Art. Purchased: The W. P. Wilstach Collection. The pyramidal structure of this composition draws attention to the geometry that dominates even the individual faceting of the wide brushstrokes, which he laid down as horizontals, verticals, or diagonals. The simplification of the treatment of the human body here profoundly affected Picasso.

Fig. 662 Henri Matisse, *The Green Stripe* (*Madame Matisse*), 1905. Oil and tempera on canvas, 15 7/8 × 12 7/8 in. Statens Museum for Kunst, Copenhagen. J. Rump Collection. Matisse carried the freedom with which Gauguin and van Gogh used color to new heights in this painting exhibited in 1905. No longer was color necessarily tied to representational ends; rather it became freely expressive.

Fig. 663 Pablo Picasso, *Les Demoiselles d'Avignon*, 1907. Oil on canvas, 8' × 7' 8" in. Collection, The Museum of Modern Art, New York. Acquired through the Lillie P. Bliss Bequest. In this complex and influential work, Picasso radicalizes the traditional nineteenth-century harem or brothel scene by simplifying his figures in the manner of Cézanne, creating a very flat and ambiguous space, and then transforming the nudes on the right into willfully distorted images.

- **1900** Max Planck formulates quantum theory
- **1905** First neon light signs appear
- **1905** Albert Einstein formulates Special Theory of Relativity

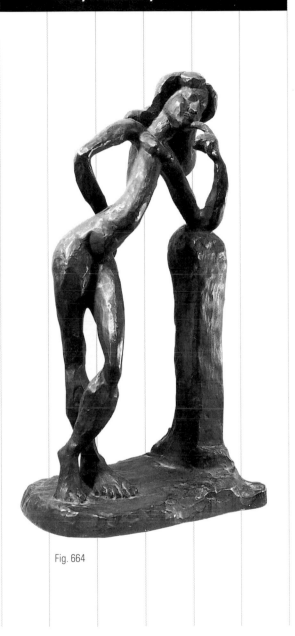

Fig. 664

Fig. 664 Henri Matisse, *La Serpentine*, 1909. Bronze, height 22 1/4 × 11 × 7 1/2 in., including base. Collection, The Museum of Modern Art, New York. Gift of Abby Aldrich Rockefeller. The difference in temperament between Matisse and Picasso is nowhere better revealed than by comparing the languid and long line of this sculpture to the tortured geometry of Picasso's nudes in *Les Demoiselles*. Matisse remains in all things—from color to line—a sensualist; Picasso a furiously driven intellect.

of **Post-Impressionism**, each dedicated to furthering the Impressionist enterprise either formally or symbolically or both. Van Gogh and Gauguin, it was felt even at the time, released artists from the need to copy nature. If, for both Gauguin and van Gogh, in order to create a complementary contrast with the orange dirt of the Southern French landscape, tree trunks had to be painted blue, then so be it (see Fig. 169). In their work, both Toulouse-Lautrec and van Gogh directly criticized the quality of modern life, and Gauguin did so less directly by leaving Europe altogether and seeking out a new life in the South Seas. Seurat sought to impose a formal order upon the world, and in the process revealed its rigid lack of life. Cézanne, working alone in the south of France, more and more came to deemphasize his subject matter. In his *Large Bathers* (Fig. 661) and in a series of studies of Mont Sainte Victoire reminiscent of Monet's serial compositions, he pushed toward an idea of painting that established for the picture an existence independent of its subject matter, leaving it to be judged in terms of purely formal interrelationships.

Modern Art

In the autumn of 1906 and throughout 1907, as Pablo Picasso painted his portrait of Gertrude Stein (see Fig. 35) and then embarked on his monumental and groundbreaking painting *Les Demoiselles d'Avignon*. Paris was inundated by exhibitions of the late work of Cézanne that were to have a profound effect on the development of modern art. In his letters to the painter Emile Bernard, which appeared in the Paris press, Cézanne advised painters to study nature in terms of "the cylinder, the sphere, the cone." Cézanne died in October 1906, and in June 1907, a retrospective of 79 of his last watercolors were exhibited at the Bernheime-Jeune Gallery. At the Salon in the autumn, another retrospective of late paintings, mostly oils, appeared. Picasso was already under the influence of Cézanne when he painted *Les Demoiselles*, and when Georges Braque saw first Picasso's painting and then the Cézannes, he began to paint a series of landscapes based on their formal innovations (see Fig. 120). Together, over the course of the next decade, Picasso and Braque would create the movement known as **Cubism**. The name

- 1910 Stravinsky's ballet *The Firebird* performed in Paris
- 1912 Titanic sinks on maiden voyage after colliding with iceberg; 1,513 drown

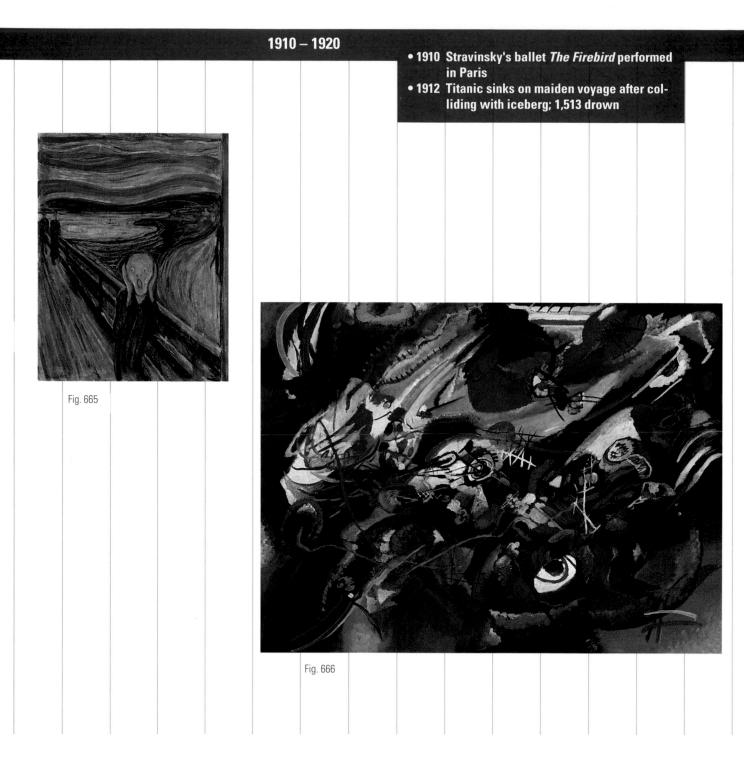

Fig. 665

Fig. 666

Fig. 665 Edvard Munch, *The Scream*, 1893. Tempera and casein on cardboard, 36 × 29 in. Nasjonalgalleriet, Oslo. Nearly 100 years later, Munch's solitary individual tranforms the melancholy of Friedrich's *Monk by the Sea* (Fig. 639) into anguish. We recognize in this painting the turmoil of line—and by extension, mind—that marks van Gogh's *Starry Night* (Fig. 71), painted only five years earlier. This is extremely personal painting, full of emotion.

Fig. 666 Wassily Kandinsky, *Sketch I* for *"Composition VII,"* 1913. India ink, 30 3/4 × 39 3/8 in. Kunstmuseum, Bern, Switzerland. Collection Felix Klee. Nothing of the order and rationality of Cubism can be detected in Kandinsky's early paintings. Only when he joined the Bauhaus, in the twenties, did the geometric begin to interest him at all. Like Whistler, Kandinsky considered his painting to be equivalent to music, and his works are alive in nonfigurative movement and color. Each color and each line carried, for Kandinsky, explicit expressive meaning, and he believed that paintings like his had "the power to create [a] spiritual atmosphere" that would "lead us away from the outer to the inner basis."

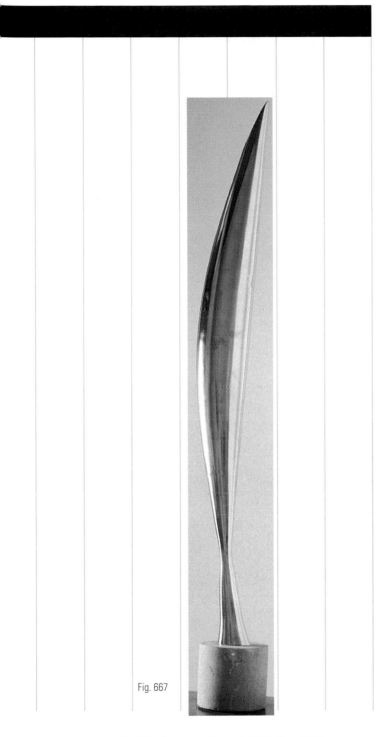

Fig. 667

Fig. 667 Constantine Brancusi, *Bird in Space*, 1928. Bronze (unique cast), 54 × 8 1/2 × 6 1/2 in. Collection, The Museum of Modern Art, New York. Given anonymously. Inspired by the teachings of a Tibetan monk, Brancusi believed that in certain abstract forms he could capture "the idea, the essence of things." Though much more simple—and indeed, more elegant—than Kandinsky's ink sketch, Brancusi's sculpture shares the same spiritual yearnings and aspirations.

derived from a comment made by the critic Louis Vauxcelles in a small review that appeared directly above a headline announcing the "conquest of the air" by the Wright brothers: "Braque...reduces everything, places and figures and houses, to geometric schemes, little cubes." It was, as the accidental juxtaposition of Cubism and the Wright brothers suggested, a new world.

Other artists, particularly Juan Gris (see Figs. 224, 225, & 354), soon followed the lead of Picasso and Braque. And the impact of their art can be felt everywhere—from the work of Stuart Davis (see Fig. 166) and Jacob Lawrence (see Figs. 226 & 308) to the photography of Alfred Stieglitz and Charles Sheeler (see Fig. 321), to the graphic design of Cassandre and Benito (see Figs. 420 & 421). For the Cubist, art was primarily about form. Analyzing the object from all sides and acknowledging the flatness of the picture plane, the Cubist painting represented the three-dimensional world in increasingly two-dimensional terms. Perhaps most important, it separated painting itself from the necessity of representing the world. Painting was to be primarily about painting.

The term *modernism*, as it is used in art history, refers to the development of a number of artistic strategies concerned with the processes of making art. Thus the history of painting in the twentieth century becomes a history of the exploration of the medium, particularly the flatness of the canvas. In these terms, painting increasingly ignores anything outside itself—from the representation of perspectival space, already apparent in Cubism, to the representation of anything recognizable at all, since, the argument goes, objects are distracting. The exploration of the formal properties of painting, it is felt, can reveal spiritual, even universal truths and feelings. Nonobjective paintings, like those of Kasimir Malevich (see Fig. 23), an early example, or those of Frank Stella, a later one (see Fig. 34), are the inevitable result of this logic. The history of sculpture, on the other hand, focuses more and more on the implications of three-dimensional shapes as they are arranged in space, and sculptural means such as bas-relief, closer to painting's concern with flatness, went out of favor. If each medium was to explore the formal properties most unique to it, then sculpture had to explore the possibilities of volumes experienced in space.

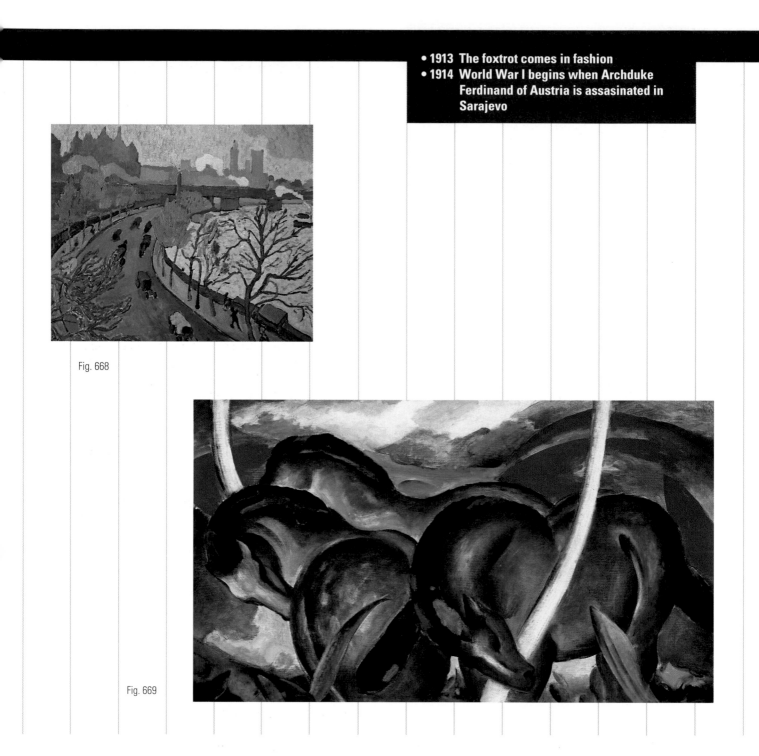

Fig. 668

Fig. 669

Fig. 668 André Derain, *Westminster Bridge*, 1906. Oil on canvas, 31 7/8 × 39 1/8 in. Musée d'Orsay, Paris. This is the kind of painting that gave Fauvism its name and inspired the German expressionist use of color. The Fauves freed color from its conventional uses, which satisfied the German desire, in the words of the painter Ernst Kirchner, "to create for ourselves freedom of life and of movement against the long-established older forces."

Fig. 669 Franz Marc, *The Large Blue Horses*, 1911. Oil on canvas, 41 5/16 × 71 1/4 in. Collection, Walker Art Center, Minneapolis. Gift of T.B. Walker Foundation, Gilbert M. Walker Fund, 1942. A member of the Blue Rider group, Marc adapted Kandinsky's color symbolism to depictions of animals. "I try to heighten my feeling for the organic rhythm of all things," he wrote, "to feel myself pantheistically into the trembling and flow of the blood of nature." More than any other German painter, Marc understood the sensuality of Matisse's line and employed it in his work. His use of color, which echoes, of course, the name of the movement to which he belonged, is liberated from the world of appearance, but it is highly emotional and charged with emotion. He painted horses over and over again. Sometimes they were blue—Marc associated blue with masculinity, strength, and purity—sometimes red, sometimes yellow, depending on his emotions as he was painting. Marc was killed fighting on the Western front in 1916.

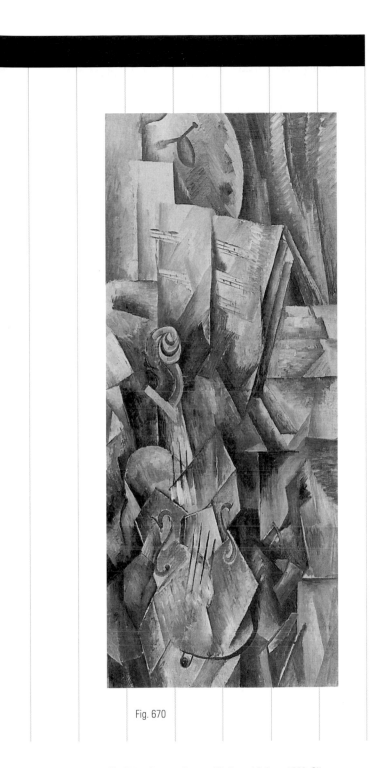

Fig. 670

Fig. 670 Georges Braque, *Violin and Palette*, 1909. Oil on canvas, 36 1/8 × 16 7/8 in. Solomon R. Guggenheim Museum, New York. Photo: Robert E. Mates © The Solomon R. Guggenheim Foundation, New York, FN 54.1412. In this painting, the highly realistic nail at the painting's top, casting its own shadow, can be seen either as part of the painting, holding up the palette, or as real, holding the painting to the wall.

But modern art—as opposed to "modernism"—includes many other approaches, and as the century comes to a close, its "pluralist" character has become increasingly clear. Twentieth-century art history was, perhaps, dominated for a brief time by the "modernist," or formalist sensibility, but many other artistic possibilities and directions coexisted with it. One of the most dominant is **Expressionism**, grounded in nineteenth century Romanticism's emphasis on the individual self and the idealizing power of the mind. Just as a more formalist modernism rejected the depiction of real things because it drew attention away from painting proper and toward the things of the outer world, Expressionism also quickly came to reject the world of things. But it was not so much to draw attention to the act of painting as it was to emphasize its deeply subjective nature. In Vienna, an art possessing an almost neurotic sense of decadence developed with Gustave Klimt at its center (see Fig. 417), and in Dresden, a group of artists known as *Die Brücke* ("The Bridge"), among them Ernst Kirchner and Emil Nolde (see Fig. 264), advocated a raw and direct style, epitomized by the slashing gouges of the woodblock print. A group of artists known as *Der Blaue Reiter* ("The Blue Rider") formed in Munich around the Russian Wassily Kandinsky in the shared belief that through color and line alone works of art could communicate the feelings and emotions of the artist directly to the viewer. In the 1890s, Kandinsky had seen an exhibition of Monet "Haystacks," and they had convinced him, as the haystacks themselves seemed to disintegrate in the diffuse light, that "the importance of an 'object' as the necessary element in painting" was suspect. The painting of Henri Matisse, which he saw in Paris, convinced him that through color he could eliminate the object altogether. "Color," Kandinsky wrote in his 1911 essay *Concerning the Spiritual in Art*, "is able to attain what is most universal yet at the same time most elusive in nature: its inner force."

Though the Cubists tended to deemphasize color in order to emphasize form, Matisse favored working with color for its expressive possibilities. Matisse, in a sense, synthesized the art of Cézanne and Seurat, taking from the former his broad, flat zones of color and from the latter his interest in set-

Fig. 671

Fig. 672

Fig. 673

Fig. 671 Pablo Picasso, *Standing Female Nude*, 1910. Charcoal, 19 1/16 × 12 5/16 in. The Metropolitan Museum of Art, New York. The Alfred Stieglitz Collection, 1949 (49.70.34). By 1910, Cubism had almost entirely left the object behind. We can, perhaps, make out a head and torso, a breast, and a single bent leg. But the image is remote enough from reality that the photographer Alfred Stieglitz, who owned this drawing, always referred to it as "the fire escape."

Fig. 672 Giacomo Balla, *Dynamism of a Dog on a Leash*, 1912. Oil on canvas, 35 3/8 × 43 1/2 in. Albright-Knox Art Gallery, Buffalo. Bequest of A. Conger Goodyear and Gift of George F. Goodyear, 1964. Balla's painting captures the Futurist fascination with movement, but indicates, as well, its debt to new technological media, in particular, photography (see Muybridge's work, Fig. 60) and the new art of film.

Fig. 673 Marcel Duchamp, *Nude Descending a Staircase, No. 2*, 1912. Oil on canvas, 58 × 35 in. Philadelphia Museum of Art. Louise and Walter Arensberg Collection. Duchamp's painting could be said to animate the Cubist drawing of Picasso with a Futurist sense of motion. It seems to mechanize the nude, denature her, and, as a result, cast a shadow of doubt across the promise of the new century.

L.H.O.O.Q.

Fig. 674

Fig. 674 Marcel Duchamp, *L.H.O.O.Q.*, 1919. Rectified Readymade (reproduction of Leonardo da Vinci's *Mona Lisa* altered with pencil), 7 3/4 × 4 1/8 in. Private collection, Paris. Just as surely as he saw it as his duty to challenge all tradition and authority, Duchamp always did so in a spirit of fun. Saying the letters of the title with French pronunciation reveals it to be a pun, *elle a chaud au cul*, roughly translated as "she's hot in the pants." Such is the irreverence of Dada.

ting competing complementary hues beside one another. Under the influence of van Gogh, whose work had not been seen as a whole until an exhibition at the Bernheim-Jeune Gallery in 1901, he felt free to use color arbitrarily. A number of other young painters joined him, and in the fall of 1905, they exhibited together at the Salon where they were promptly labeled **Fauves** ("Wild Beasts"). The object of ridicule to some, their work was seen by others as promising a fully abstract art. The painter Maurice Denis wrote of the exhibition: "One feels completely in the realm of abstraction. Of course, as in the most extreme departures of van Gogh, something still remains of the original feeling of nature. But here one finds, above all in the work of Matisse, the sense of...painting in itself, the act of pure painting."

If abstraction was the hallmark of the new century, certain thematic concerns defined it as well. The world had become, quite literally, a new place. In the summer of 1900, with the opening of the World's Fair, Paris found itself electrified, its nights almost transformed to day. The automobile, a rarity before the new century, dominated the city's streets by 1906. People were flying aeroplanes. Albert Einstein proposed a new theory of relativity and Neils Bohr a new model for the atom. It seemed to many that there could be no tradition, at least not one worth imitating, in the face of so much change.

In February 1909, an Italian poet named Filippo Marinetti published in the French newspaper *Le Figaro* a manifesto announcing a new movement in modern art, **Futurism**. Marinetti called for an art that would champion "aggressive action, a feverish insomnia, the racer's stride...the punch and the slap." He had discovered, he wrote "a new beauty; the beauty of speed. A racing car whose hood is adorned with great pipes, like serpents of explosive breath...is more beautiful than the Victory of Samothrace." He promised to "destroy the museums, libraries, academies," and "sing of the multicolored, polyphonic tides of revolution in the modern capitals." There were, at the time, no Futurist painters. Marinetti had to leave Paris, go back to Italy, and recruit them. But as they traveled a show of Futurist painting around Europe from 1912 until the outbreak of World War I in 1914, out-

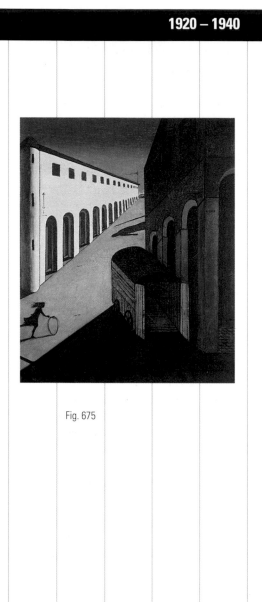

Fig. 675

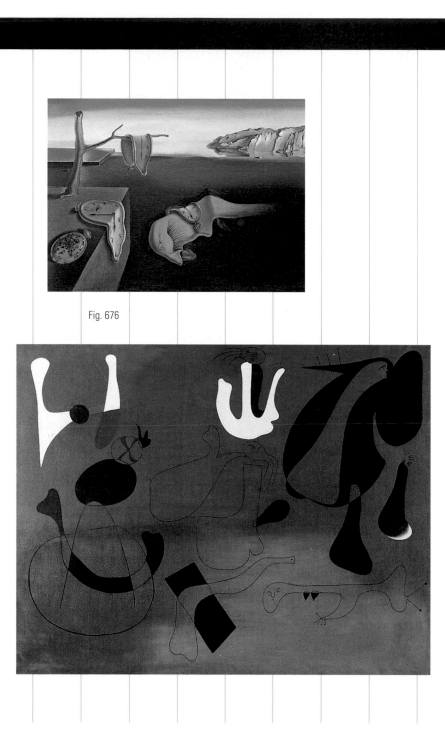

Fig. 676

Fig. 677

Fig. 675 Giorgio de Chirico, *Melancholy and Mystery of a Street*, 1914. Oil on canvas, 24 1/4 × 28 1/2 in. Private collection. Acknowledged as an important precursor to the Surrealist movement by the Surrealists themselves, de Chirico claimed not to understand his own paintings. They were simply images that obsessed him, and they conveyed, André Breton felt, the "irremediable anxiety" of the day.

Fig. 676 Salvador Dali, *The Persistence of Memory*, 1931. Oil on canvas, 9 1/2 × 13 in. Collection, The Museum of Modern Art, New York. Given anonymously. Dali called his paintings "hand-painted dream photographs." They contain admittedly paranoid imagery and seem to verge on madness. It is as if we were helpless before the nightmare-producing power of our unconscious minds, like the limbless figure lying here, its giant lashes shut in sleep over who knows what kind of vision.

Fig. 677 Joan Miró, *Painting*, 1933. Oil on canvas, 51 3/8 × 64 1/8 in. Wadsworth Atheneum, Hartford. The Ella Gallup Sumner and Mary Catlin Sumner Collection. Miró's biomorphic, amoebalike forms float in a space that suggests a darkened landscape. Although, if we look closely, faces, hair and hands begin to appear, everything in this composition appears to be fluid, susceptible to continuing and ongoing mutation.

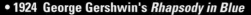

Fig. 678

Fig. 678 Piet Mondrian, *Composition (Blue, Red, and Yellow)*, 1930. Oil on canvas, 28 1/2 × 21 1/4 in. Courtesy Sidney Janis Gallery, New York. By seeming to crop the field of vision arbitrarily, so that the viewer feels the painting could go on and on in every direction. Mondrian created a work whose calm, asymmetric balance extends beyond the frame and into our world.

raging as many as they pleased, these painters—Umberto Boccioni, Carlo Carrà, Luigi Russolo, Giacomo Balla, and Gino Severini—embodied the spirit of the machine and of rapid change that seemed to define the century itself.

World War I more than dampened this exuberance. The war was catastrophic. As many as 10 million men were killed and 20 million wounded, most in grueling trench warfare on the Western front, a battleline running from Oostend on the Dutch coast, past Rheims and Verdun, to Lunéville in France, which remained virtually stationary for three years. World War I represented to many the bankruptcy of Western thought, and it served notice that all that had come before needed to be swept away. Founded simultaneously in Zurich, Berlin, Paris, and New York during the war, **Dada** took up Futurism's call for the annihilation of tradition but without its sense of hope for the future. Its name referred, some said, to a child's first words; others claimed it was a reference to a child's hobbyhorse; and still others celebrated it as a simple guttural nonsense sound. As a movement, it championed senselessness, noise, illogic. Dada was, above all, against art, at least art in the traditional sense of the word. Its chief strategy was insult and outrage. In New York, Marcel Duchamp submitted a common urinal to the Independents Exhibition, claiming for it the status of sculpture, and, on its pedestal, in the context of the museum, it looked to some as if it were just that. Challenging the traditional distinctions between art and non-art, Duchamp did not so much invalidate art as he authorized the consideration of all manner of things in aesthetic terms. His logic was not without precedent. Cubist collage (see Figs. 224 & 354) had brought "real things" like newspaper clippings into the space of painting, and photography, especially, was as often as not about the revelation of aesthetic beauty in common experience. But Duchamp's move, like Dada generally, was particularly challenging and provocative. "I was interested," he explained, "in ideas—not merely in visual products."

The art of **Surrealism** was born of Dada's preoccupation with the irrational and the illogical, as well as its interest in ideas. When the French writer André Breton issued the First Surrealist Manifesto

Fig. 679

Fig. 680

Fig. 681

Fig. 679 Edward Hopper, *Nighthawks*, 1942. Oil on canvas, 30 × 60 in. Friends of American Art Collection, © 1993 The Art Institute of Chicago. All Rights Reserved. Hopper's depiction of the emotional isolation of the average American is powerfully supported by the visual simplicity of his design, a geometry inspired by the example of Mondrian. It is as if his figures are isolated from one another in the vast horizontal expanse of the canvas.

Fig. 680 Georgia O'Keeffe, *Purple Hills Near Abiquiu*, 1935. Oil on canvas, 16 1/8 × 30 1/8 in. San Diego Museum of Art. Gift of Mr. and Mrs. Norton S. Walbridge. Utilizing the sensuous line of the German Expressionist painter Franz Marc, O'Keeffe creates a landscape itself that almost seems to be alive, a body capable of moving and breathing.

Fig. 681 Stuart Davis, *House and Street*, 1931. Oil on canvas, 26 × 42 1/4 in. Collection of Whitney Museum of American Art. Purchase 41.3. Even more than Hopper's canvas, Davis's painting reveals the growing tendency in American realism to employ a Cubist-inspired geometric flatness to represent the American scene.

Fig. 682

Fig. 682 Lee Krasner, *Untitled*, c. 1940. Oil on canvas, 30 × 25 in. © The Estate of Lee Krasner. Courtesy Robert Miller Gallery, New York. Probably more than any other artist of her day, Krasner understood how to integrate the competing aesthetic directions of modernist abstraction. In this painting she has wholly abandoned realism, fusing the geometric and expressionist tendencies of modern art in a single composition.

in 1924, it was clear that the nihilist spirit of Dada was about to be replaced by something more positive. Breton explained the direction his movement would take: "I believe in the future resolution of these two states, dream and reality, which are seemingly so contradictory, into a kind of absolute reality, a surreality." To these ends, the new art would rely on chance operations, automatism (or random, thoughtless, and unmotivated notation of any kind), and dream images—the expressions of the unconscious mind. Two different sorts of imagery result, one containing recognizable if fantastic subject matter, typified by the work of Salvador Dali and René Magritte (see Fig. 300), and the other virtually abstract, presenting us with a world of visual riddles that are almost undecipherable. The painting of the Spanish artist Joan Miró and many of the early mobiles of Alexander Calder (see Fig. 62) fall into this second category. Between the two we can position the fantastic landscapes of Yves Tanguy (see Fig. 36).

If Surrealism sought to discover the truth by delving into the realms of the unconscious, both the Russian Suprematist painters, led by Kasimir Malevich (see Fig. 23), and the painters associated with the **De Stijl** movement (see Figs. 424–426) in Holland found "absolute truth" in geometric forms. In his geometric abstraction, the Dutch painter Piet Mondrian purged all reference to the world. He relied only upon the horizontal, the vertical, the three primary colors, and black and white, which were, he felt, "the expression of pure reality." Like his Russian counterparts, who sought to create a new art for their new revolution, Mondrian's aims were, essentially, ethical—he wanted to purify art in order to purify the spirit.

The abstract tendencies of modern art were not, however, thoroughly accepted everywhere, especially in the United States. Instead, many artists preferred a realist approach, reminiscent in many respects to that which followed the European revolutions of 1848. This realist movement was supported, on the one hand, by the growing popularity of photography, and, on the other, by an increasing conviction that art, in the face of the harsh realities of the Great Depression of the 1930s, should deal with the problems of daily life. Although these realists were opposed to what

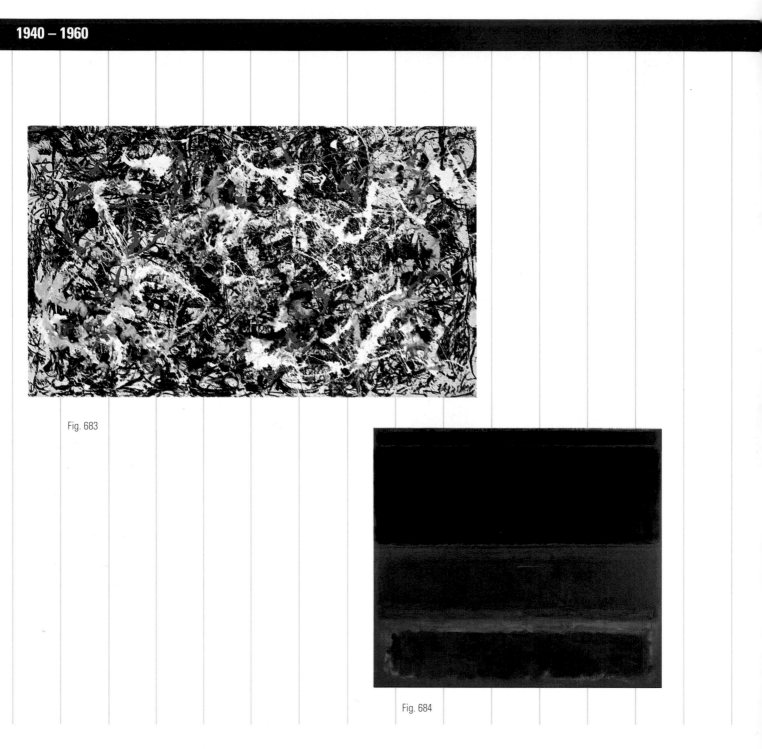

Fig. 683

Fig. 684

Fig. 683 Jackson Pollock, *Convergence*, 1952. Oil on canvas, 93 1/2 × 155 in. Albright-Knox Art Gallery, Buffalo, New York. Gift of Seymour H. Knox, 1956. In reproduction it is difficult to feel the way in which this painting absorbs the viewer, drawing the eye into its web of line and color. The space, created by swirling lines of paint that pass over each other again and again, has aptly been labeled "galactic," and almost seems to contain the energy of an exploding nebula.

Fig. 684 Mark Rothko, *Four Darks in Red*, 1958. Oil on canvas, 102 × 116 in. Collection of Whitney Museum of American Art, New York. Purchase, with funds from the Friends of the Whitney Museum of American Art, Mr. and Mrs. Eugene M. Schwartz, Mrs. Samuel A. Seaver, and Charles Simon, 68.9. Next to the Action Painting of Pollock and de Kooning, Rothko's canvas is positively serene. Rothko's so-called color field is a meditative, not active space.

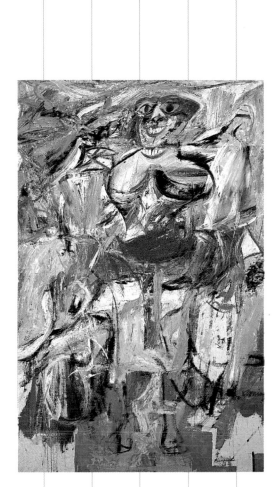

Fig. 685

Fig. 685 Willem de Kooning, *Woman and Bicycle*, 1952–1953. Oil on canvas, 76 1/2 × 49 in. Collection of Whitney Museum of American Art, New York. Purchase, 55.35. Though often seen as an attack upon women, de Kooning's hashed-out, scribbled-over, loosely gestural painting is equally a celebration of his own freedom from the conventions of figural representation. "I do not think…of art," he said, "as a situation of comfort."

they considered the self-indulgence of abstraction, they were not against learning from the formal discoveries of their more abstraction-oriented contemporaries, and we are, in fact, often as attracted to the form of their work as to their subject matter.

The Great Depression and the outbreak of World War II, nevertheless, provided the impetus for the development of abstract painting in the United States. President Roosevelt's WPA (Works Progress Administration) had initiated, in 1935, a Federal Art Project that allowed artists to work as they pleased. Furthermore, many leading European artists emigrated to the United States in order to escape ever-worsening conditions in Europe. Suddenly, in New York, American painters found themselves in the company of Fernand Léger, Piet Mondrian, Yves Tanguy, Marcel Duchamp, and André Breton. A style of painting referred to as **Abstract Expressionism** soon developed. It harked back to Kandinsky's nonobjective work 1910–1920, but it was not unified in its stylistic approach. Rather, the term grouped together a number of painters dedicated to the expressive capacities of their own individual gestures and styles.

Jackson Pollock was deeply influenced by the Surrealist notion of automatism, the direct and unmediated expression of the self. Pouring and flinging paint onto canvas generally on the floor, he created large "all-over"—completely covered, large-scale—surfaces with no place for the eye to rest (see Figs. 180 & 181). "When I am in my painting," he would write in 1947, "I'm not aware of what I'm doing. It is only after a sort of 'get acquainted' period that I see what I have been about. I have no fears about making changes, destroying the image, etc., because the painting has a life of its own. I try to let it come through. It is only when I lose contact with the painting that the result is a mess. Otherwise there is pure harmony, an easy give and take, and the painting comes out well."

Because of the energy and movement of such paintings, the drama of the painter painting, the Abstract Expressionism of Pollock has been labeled "Action Painting." Willem de Kooning's work, with its visible application of paint to the surface, is the definitive example of this approach.

The monumental quietness of Mark Rothko's canvases convey almost the opposite feeling. In place of action, we find a carefully modulated field of color that suggests the luminous space and light

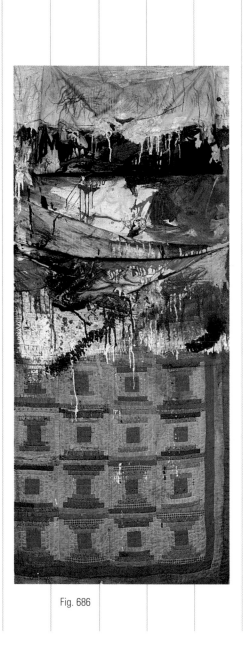

Fig. 687

Fig. 688

Fig. 686 Robert Rauschenberg, *Bed*, 1955. Combine painting: oil and pencil on pillow, quilt, and sheet on wood supports, 6 ft. 3 ¼ in. × 31 ½ in. × 8 in. Fractional gift of Leo Castelli in honor of Alfred H. Barr, Jr. to The Museum of Modern Art, New York. Here, Rauschenberg literally splashes paint over the "dream fabric." The formal vocabulary of Abstract Expressionism is present here, but none of its high seriousness.

Fig. 687 Frank Stella, *Empress of India*, 1965. Metallic powder in polymer emulsion on shaped canvas, 6 ft. 5 in. × 18 ft. 8 in. Collection, The Museum of Modern Art, New York. Gift of S. I. Newhouse. Consisting of four interlocked V's, Stella's shaped canvas is pure design. It possesses no meaning other than the visual pleasure derived from its composition.

Fig. 688 Roy Lichtenstein, *Whaam!*, 1963. Magna on two canvas panels, 5 ft. 8 in. × 13 ft 4 in. Tate Gallery, London. Based on an actual Sunday cartoon strip, Lichtenstein's giant painting indicates, by its very size, the powerful role of popular culture in our emotional lives. This is an image of power, one that most American boys of the 1950s were raised to believe in wholly.

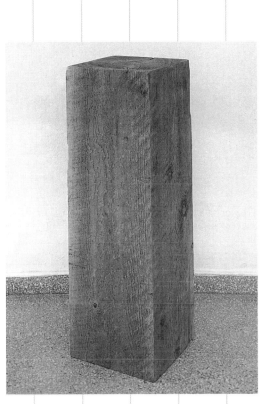

Fig. 689

Fig. 689 Carl Andre, *Herm (Element Series)*, 1976. Western red cedar, 36 × 11 ³/₄ × 11 ¹/₂ in. Solomon R. Guggenheim Museum, New York. Gift of Angela Westwater, 1986. Photo: David Heald © The Solomon R. Guggenheim Museum, New York, FN 86.3440. Apparently a found object, this sculpture has been manipulated by the unknown hand that sawed and squared the original log. A "herm," incidently, is a Greek stone pillar topped by a head of Hermes, god of travel and fertility.

of Monet's "Haystacks," only now, finally, the image has been dispensed with. Nevertheless, because Rothko emphasizes the horizontal band and the horizon line, the point where land meets sky, is suggested. The bands of color bleed mysteriously into one another or into the background, at once insisting on the space they occupy by the richness of their color and then dissolving at the edges like mist. "I am interested only in expressing the basic human emotions—tragedy, ecstasy, doom, and so on," Rothko would explain, "and the fact that lots of people break down and cry when confronted with my pictures shows that I communicate with those basic human emotions. The people who weep before my pictures are having the same religious experience I had when I painted them."

By the middle of the 1950s, as Abstract Expressionism established itself as the most important style of the day, a number of young painters began to react against it. Robert Rauschenberg parodied the high seriousness of the Action Painters by using its gestures—supposed markers of the artist's sincerity—to paint over literal junk. Like the Cubists before him, he cut out materials from newspapers and magazines (see Fig. 356) and silkscreened media images into his prints (see Fig. 281), but he went further, incorporating stuffed animals, tires, even his own bedding when he was short of canvas, into the space of art.

Inspired by Rauschenberg's example, in the 1960s, another group of even younger artists, led by Andy Warhol, Claes Oldenburg, and Roy Lichtenstein, invented a new American realism, **Pop Art**. Pop represented life as America lived it, a world of Campbell's soup cans (see Fig. 220), Coca-Cola bottles, and comic strips. It transformed the everyday into the monumental, turning a clothespin and a garden trowel into giant sculptural objects (see Figs. 211 & 283). Most importantly perhaps, it gave up on traditional artistic mediums like painting, turning instead to slick renderings made by means of mechanical reproduction techniques such as photolithography that evoked commercial illustration more than fine art.

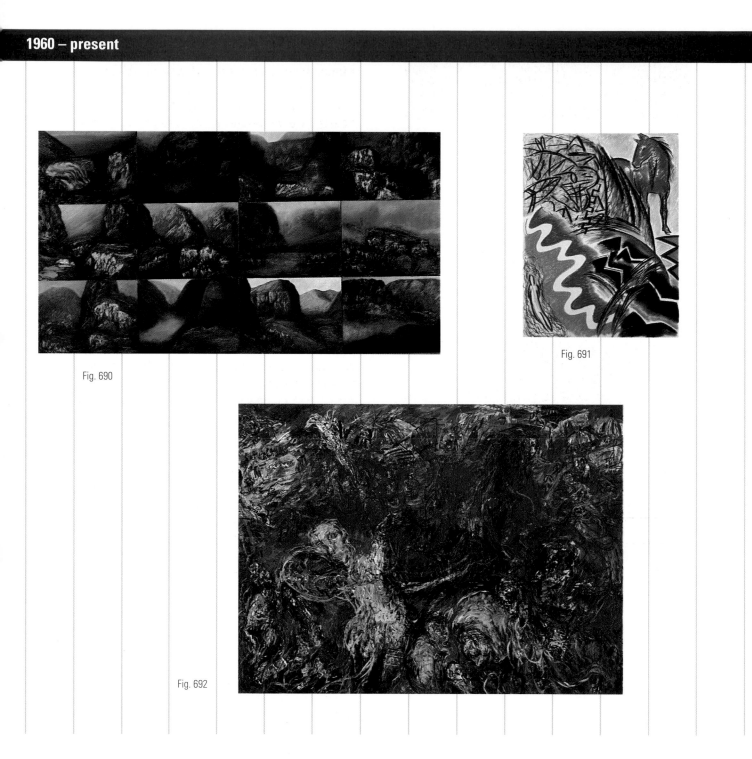

Fig. 690

Fig. 691

Fig. 692

Fig. 690 James Lavadour, *The Seven Valleys and the Five Valleys*, 1988. Oil on canvas, 54 × 96 in. Collection of Ida Cole. Courtesy of Elizabeth Leach Gallery, Portland, Oregon. Lavadour's paintings constantly negotiate the boundaries between abstraction and realism. Close up they seem to dissolve into painterly surface—scraped, dripped, and brushed—and yet they evoke the Romantic landscapes of Bierstadt and Church.

Fig. 691 Jaune Quick-to-See Smith, *Petroglyph Park*, 1986. Pastel on paper, 30 × 22 in. Courtesy Steinbaum Krauss Gallery, New York. Making direct allusion to the Blue Rider of Kandinsky and Marc, Smith draws an analogy between the fate of the wild horse and the fate of the Native American. Everything in this painting refers to lost peoples—from the makers of the petroglyphs to Marc's early death in World War I—and the presence of those peoples in our memory.

Fig. 692 Chou Yu Dong (Joe Earthstone), *Meditation Wild Lily*, 1990. Oil on canvas, 72 3/4 × 102 3/8 in. Courtesy the artist. The German Expressionist's pure delight in pigment, the freedom to manipulate paint, is at the heart of Chou's attempt to capture the "Chi" of experience, the dance of energy that animates all living things. Here the people of Taipei, Taiwan—criminals, prostitutes, laborers, business people—swirl in a pool of red paint that is transformed into a flower in bloom.

• 1961 Berlin Wall is built
• 1963 President John F. Kennedy assassinated
• 1964 Martin Luther King leads civil rights
 march from Selma to Montgomery, Ala.

Fig. 693

Fig. 693 Chuichi Fujii, *Untitled*, 1985. Japanese cypress, height 118 in; width 145 3/4 in; depth 114 1/4 in. Los Angeles County Museum of Art. Anonymous gift. Japanese artist Chuichi Fujii claims that, in this work, he means to evoke the "cry" of the tree, its agony at being cut. He has spring-loaded Carl Andre's Minimalist logs, bending them in order that they might be reinvested if not with their original life then at least with the ominous power to snap back at those who harvested them.

Another reaction against Action Painting led, in the same period, to a style of art known as **Minimalism**. In contrast to Pop works, Minimalist pieces were, in their way, elegant. They addressed notions of space—how objects take up space and how the viewer relates to them spatially—as well as questions of their dogmatic material presence. For Frank Stella, the shape of the painting might determine its content, a series of parallel lines that could have been drawn with a compass or protractor. "I always get into arguments with people who want to retain the old values in painting," Stella muses. "My painting is based on the fact that only what can be seen is there. It is really an object.... All I want anyone to get out of my paintings, and all I ever get out of them is the fact that you can see the whole idea without confusion. What you see is what you see." This is contentless painting. It has no spiritual aspirations. It does not contain the emotions of the painter. It is simply there, before the viewer, a fact in and of itself. Stella has deliberately set out to make a work of art that has no narrative to it, that cannot, at least not very easily, be written about. The same is true of Carl Andre's work. Like the Pop artists, Andre works with found materials. He might set a group of boulders into a common area in Hartford, Connecticut (see Figs. 46–48), or he might, even more minimally, set a cedar beam on end and call it sculpture. Yet for all the seeming simplicity of Andre's means and media, he almost inevitably creates works that resonate with history, causing even the antagonistic viewer to contemplate the forces that brought his piece to the condition of "art." If the work seems minimal, the *idea* generating it is not. Closely related to Minimal Art is **Conceptual Art**, which developed in the late 1960s and early 1970s. It became possible, in fact, to think of art as idea alone, to create, for instance, a set of instructions that the audience might or might not act upon (see George Brecht's *Event*, Fig. 140, and Sol LeWitt's line installations, Figs. 74–76).

From the time of Gauguin's retreat to the South Pacific and Picasso's fascination with African masks, Western artists have turned to non-Western cultures for inspiration, seeking "authentic," new ways to express their emotions in art. The African features of the two figures on the right of Picasso's *Les Demoiselles d'Avignon* (Fig. 663) are

- **1968 Martin Luther King assassinated**
- **1969 Woodstock music festival**
- **1970 Four students killed at Kent State University by National Guard**

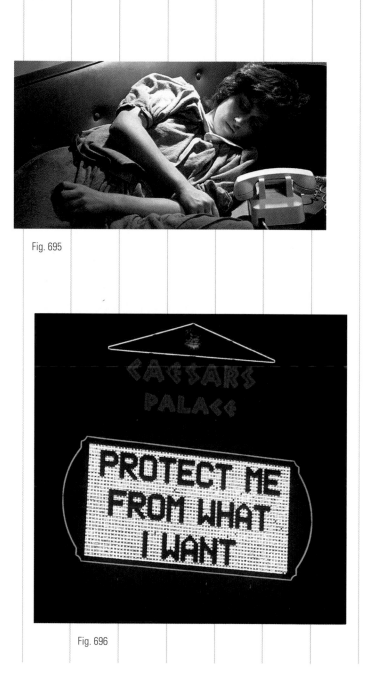

Fig. 695

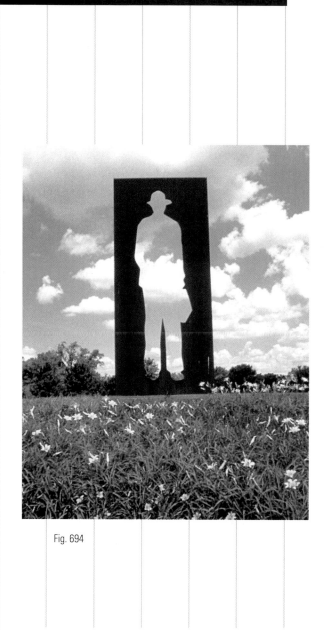

Fig. 694

Fig. 696

Fig. 694 Jonathan Borofsky, *Man with a Briefcase*, 1987. Corten steel, 30 ft. × 13 1/2 ft. × 2 1/2 in. General Mills, Minneapolis, Minnesota. Courtesy Paula Cooper Gallery, New York. This image is a monument to the faceless mass of American workers and, at the same time, Borofsky explains, "this figure is me too—the traveling salesman who goes around the world with his briefcase full of images and thoughts. The briefcase has always been a metaphor for my brain."

Fig. 695 Cindy Sherman, *Untitled # 96*, 1981. Color photograph, 24 x 48 in. Courtesy Metro Pictures, New York. Many of Sherman's photographs are self-portraits, sometimes presented at a scale of the film still and other times the scale of a large poster. They are, in fact, performances that address issues such as voyeurism, vulnerability, and loneliness. In this case, we are witness to an unnamed adolescent reverie at once ordinary and touching.

Fig. 696 Jennie Holzer, selection from "The Survival Series," 1986. Dectronic Starburst double-sided electronic display signboard, 10 × 40 ft. Installation, Caesar's Palace, Las Vegas. Courtesy Barbara Gladstone Gallery, New York. Holzer's medium is language displayed on the electronic signboard. From New York's Times Square to the Las Vegas strip, Holzer's sayings eerily invade the space of advertising like messages from our own cultural subconscious.

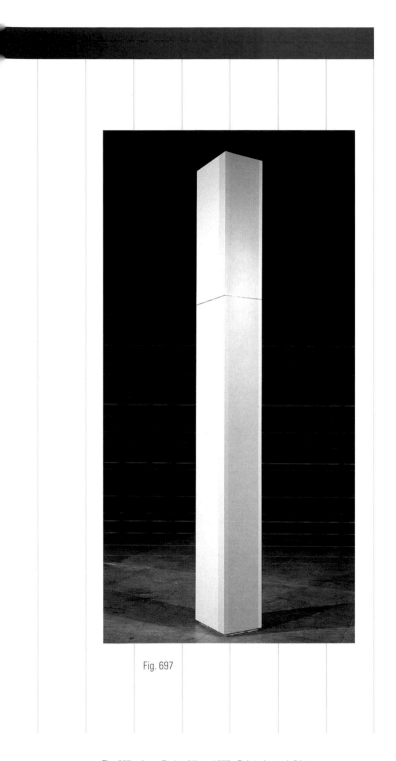

Fig. 697

Fig. 697 Anne Truitt, *Nicea*, 1977. Painted wood, 84 ½ × 10 × 8 in. Courtesy André Emmerich Gallery, New York. Nominally minimalist, Truitt's sculptures are deeply autobiographical, relating directly to the architectural forms of her youth in Delaware. The formal innovation of this subtly colored piece lies in the way that its colors "turn" the corner, at once emphasizing the verticality of the column and drawing us around it.

a prime example of this. At the same time, other cultures have been dramatically affected by Western traditions. Although we normally think of the Western world's impact on these other cultures in negative terms—in the process of Westernization, ancient customs are lost, at the same time that cultural artifacts are looted and carried off for display in Western museums—many non-Western artists have incorporated the art of the West into their own in positive ways. As Native American artist Jimmie Durham has put it: "We took glass beads, horses, wool blankets, wheat flour for fry-bread, etc., very early, and immediately made them identifiably 'Indian' things. We are able to do that because of our cultural integrity and because our societies are dynamic and able to take in new ideas." Similarly, the aboriginal painters of Australia have adopted the use of acrylic paint, integrating the medium into their own cultural traditions (see Fig. 310). Native American painter Jaune Quick-to-See Smith, who studied at the University of New Mexico, puts it this way: "With a university training, you're exposed to classic art and traditions from around the world. You wouldn't be true to yourself if you didn't incorporate what you were familiar with."

Since the mid-1970s the world of art has become increasingly diverse and plural in character. Little sense of a coherent stylistic tradition—or even of competing stylistic traditions—has emerged. Today artists are increasingly unbound by any rules or systems. They can draw on personal experiences or stylistic trends and address their work to a wide audience or a relatively narrow one. Anne Truitt's Minimalism, for instance, is deeply rooted in her own biography, and can best be approached through her published journals, *Daybook* (1982) and *Turn* (1986). In *Turn* she describes the source of her love for geometric simplicity, tracing it back to her childhood:

> The people around me, except for my baby nurse…and my father when he was well, were not only inexpressive but preoccupied. I turned to my physical environment, the garden's trees, grass, flowers, bushes. The garden was bisected by a brick path. I noticed the pattern of its rectangles, and then saw that they were repeated in the brick walls of the houses of Easton [Delaware]; their verticals and horizontals were also to be found in clapboard walls, in fences, and in lattices. In my passion (no other word will do for the ardor I

Fig. 698

Fig. 699

Fig. 700

Fig. 698 Barbara Kruger, *Untitled (We won't play nature to your culture)*, 1983. Photograph 72 × 48 in. Courtesy Ydessa Hendeles Art Foundation, Toronto. Kruger addresses issues of gender in contemporary culture. Here, she exposes the traditional nature/culture dichotomy for what it is—a strategy that authorizes the cultural and intellectual domination of the male over a passive and yielding female nature.

Fig. 699 Brice Marden, *Cold Mountain 3*, 1989–1991. Oil on linen, 9 × 12 ft. Courtesy Mary Boone Gallery, New York. One of a series of recent works that takes its name from the Chinese poet called Cold Mountain, this painting is like a minimalist version of Jackson Pollock. It is as if the high energy of Pollock had turned meditative and the quick, almost violent motion of Pollock's line had become reinvented as a sort of slow dance suspended in a quiet space.

Fig. 700 Susan Rothenberg, *Biker*, 1985. Oil on canvas, 74 × 69 1/2 in. The Museum of Modern Art, New York. Fractional gift of Paine Webber Group, Inc., 1986. A cycler charges straight at the viewer, water splashing up from the bike's tires, at once recalling Futurism and de Kooning's *Woman and Bicycle*. No painter has more successfully married the gestural means of Abstract Expresssionism to realist subject matter.

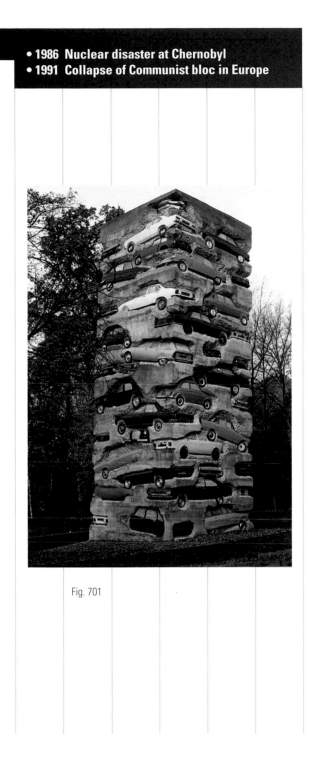

Fig. 701

Fig. 701 Arman, *Long-Term Parking*, 1975–1982. Sixty automobiles embedded in concrete, 65 × 20 × 20 ft. Foundation Cartier, Jouy-en-Josas, France. Photo: Courtesy of the artist. At once a commentary on the "planned obsolescence" of modern consumer goods, a totem to consumerism, and an ironic poke at the commuter lifestyle, Arman's sculpture rises up in the middle of a large sculpture park just outside Paris, its urban theme directly at odds with its garden environment.

felt) for something to love, I came to love these proportions—and years later, in 1961, when I was forty years old, this love welled up in me and united with my training in sculpture to initiate and propel the work that has occupied me ever since.

Truitt's work seems superficially to fulfill the desire of modernism to create art that explores the formal dimensions of its own medium. But it is her autobiographical anecdote that lends the work its special richness.

One of the distinguishing characteristics of **Postmodernism** in art has, in fact, been its antiformalist mood, its willingness to let all manner of things having little or nothing to do with its formal qualities invade and inform the work. Pop Art's introduction of mass culture into the arena of "high art" was understood as an invitation for the arts as a whole to critique the cultural institutions of the day, and the purely visual aspirations of modernism have been supplanted by work that self-consciously reflects social, political, and economic reality. In painting, representational imagery has reemerged in full force. Narrative and storytelling have come to play important roles. Much work has been inspired by performance art. Cindy Sherman's theatrical self-portraits, for example, seem to be outtakes from longer stories, documents of events whose meanings are only hinted at. The styles of the past—from Mannerism to the Rococo, from Cubism to Abstract Expressionism—have been raided and appropriated to the context of the present. The mass media—from television and video to electronic signboards and commercial photography—are increasingly not only the subject of contemporary art but its means. It is, perhaps, above all, the new electronic technologies that are most affecting art. In the same way that we can access, via satellite, hundreds of different television programs from around the world, we can access an almost endless array of art objects. The great French writer André Malraux spoke, in the first half of this century, of a "museum without walls," made possible by the invention of photographic reproduction and the wide availability of art in books such as this one. Today, CD-ROMs, laser discs, the fax machine, cable television, and so on, all promise to expand this museum even further. In this electronic "global village," this brave new world of art, our ways of seeing are almost limitless.

Glossary

Words in *italics* are also defined in the glossary.
Page numbers following the entries refer to the page or pages in the text where a detailed discussion of the term begins and where the appropriate illustration can also be found.

abacus The thin slab of stone that forms the uppermost portion of the *capital* of a *column*, supporting the *architrave* (392).

abstract In art, the rendering of images and objects in a stylized or simplified way so that though they remain recognizable, their *formal* or *expressive* aspects are emphasized (18). Compare both *representational* and *nonobjective*.

Abstract Expressionism A painting style of the late 1940s and early 1950s, predominantly American, characterized by its rendering of *expressive content* by *abstract* or *nonobjective* means (485).

acrylic A plastic resin that, when mixed with water and pigment, forms an inorganic and quick-drying paint *medium* (247).

actual line As opposed to implied or perceptual line, a line that exists in fact; a line that is literally drawn (50).

actual texture As opposed to *implied* or *visual texture*, the literal tactile quality or feel of a thing (126).

additive 1) In color, the adjective used to describe the fact that, when different *hues* of colored light are combined, the resulting mixture is higher in *key* than the original hues and brighter as well, and as more and more hues are added, the resulting mixture is closer and closer to white (110); 2) In sculpture, an adjective used to describe the process in which form is built up, shaped, and enlarged by the addition of materials, as distinguished from *subtractive* sculptural processes, such as carving (270).

aerial perspective See *atmospheric perspective*.

aesthetic Pertaining to the appreciation of the beautiful, as opposed to the functional or utilitarian, and, by extension, to the appreciation of any form of art, whether overtly "beautiful" or not.

afterimage In color, the tendency of the eye to see the *complementary* color of an image after the image has been removed (116).

ambulatory A covered walkway, especially around the *apse* and *choir* of a church (405).

analogous color scheme A combination of two or more *hues* that are adjacent to each other on the *color wheel* (114).

apse A semi-circular recess placed, in a Christian church, at the end of the *nave* after the *choir* (404).

aquatint An *intaglio* printmaking process, in which the acid bites around powdered particles of resin resulting in a *print* with a granular appearance. The resulting *print* is also called an aquatint (212).

arbitrary color Color that has no *realistic* or natural relation to the object that is depicted, as in a blue horse, or a purple cow, but which may have emotional or *expressive* significance (123).

arch A curved, often semicircular architectural form that spans an opening or space built of wedge-shaped blocks, called *voussoirs*, with a *keystone* centered at its top (367).

architrave In architecture, the *lintel*, or horizontal beam, that forms the base of the *entablature* (392).

archivolt Any one of the series of moldings above an arched opening in a Romanesque or Gothic church, usually decorated with sculptural detail (413).

Art Deco A popular art and design style of the 1920s and 1930s associated with the 1925 Exposition Internationale des Arts Décoratifs et Industriels Modernes in Paris and characterized by its integration of organic and geometric forms (326).

Art Nouveau The art and design style, characterized by undulating, curvilinear, and organic forms, that dominated popular culture at the turn of the century, and that achieved particular success at the 1900 International Exposition in Paris (318).

assemblage An *additive* sculptural process in which various and diverse elements and objects are combined together (273).

asymmetric balance Balance achieved in a composition when neither side reflects or mirrors the other (143).

atmospheric perspective A technique, often employed in landscape painting, designed to suggest *three-dimensional space* in the *two-dimensional space* of the *picture plane*, and in which forms and objects distant from the viewer become less distinct, often bluer or cooler in color, and in which contrast among the various distant elements is greatly reduced (92).

autographic line Any use of line that is distinct to the artist who employs it and is therefore recognizable as a kind of "signature" style (59).

avant-garde Those whose works can be characterized as unorthodox and experimental (329).

axonometric projection A technique for depicting space, often employed by architects, in which all lines remain parallel rather than receding to a common *vanishing point* as in *linear perspective* (91).

baldacchino A canopy on columns, often installed over an altar (445).

Baroque A dominant style of art in Europe in the seventeenth century characterized by its theatrical, or dramatic, use of light and color, by its ornate forms, and by its disregard for *classical* principles of composition (445).

barrel vault A masonry roof, constructed on the principle of the *arch*, that is, in essence, a continuous series of arches, one behind the other (367).

basilica In Roman architecture, a rectangular public building, entered on one of the long sides. In Christian architecture, a church loosely based on the Roman design, but entered on one of the short ends, with an *apse* at the other end (405).

bas-relief See *low-relief.*

Bauhaus A German school of design, founded by Walter Gropius in 1919 and closed by Hitler in 1933 (334).

buon fresco See *fresco.*

burin A metal tool with a V-shaped point used in *engraving* (207).

burr In *drypoint* printing, the ridge of metal that is pushed up by the *engraving* tool as it is pulled across the surface of the *plate* and that results, when inked, in the rich, velvety *texture* of the drypoint print (210).

calligraphy The art of handwriting in a fine and "beautiful" way (12).

calotype The first photographic process to utilize a negative image, discovered by William Henry Fox Talbot in 1841 (250).

Canon (of *proportion*) The "rule" of perfect proportions for the human body as determined by the Greek sculptor Polykleitos in a now lost work, known as the *Canon*, and based on the idea that each part of the body should be a common fraction of the figure's total height (161).

cantilever An architectural form that projects horizontally from its support, employed especially after the development of reinforced concrete construction techniques ((316).

capital The crown, or top, of a *column*, upon which the *entablature* rests (392).

Carolingian art European art from the mid-eighth to the early tenth century, given impetus and encouragement by Charlemagne's desire to restore the civilization of Rome (411).

cartoon As distinct from common usage, where it refers to a drawing with humorous content, any full size drawing, subsequently transferred to the working surface, from which a painting or tapestry is made (178).

casting The process of making sculpture by pouring molten material—often bronze—into a mold bearing the sculpture's impression (270). See also *lost-wax casting.*

chiaroscuro In drawing and painting, the use of light and dark to create the effect of three-dimensional, *modeled* surfaces (96).

cire-perdue See *lost-wax casting.*

Classical style In Greek art, the style of the fifth century B.C., characterized by its emphasis on balance, proportion, and harmony; by extension, any style that is based on logical, rational principles (66).

classical line A kind of line that is mathematical, precise, and rationally organized, epitomized by the vertical and horizontal grid, as opposed to *expressive line* (66).

clerestory The windowed part of a building that rises above the roof of a lower part, admitting light into the interior (404).

closed palette See *palette.*

collage A work made by pasting various scraps or pieces of material—cloth, paper, photographs—onto the surface of the *composition* (279).

color wheel A circular arrangement of *hues* based on one of a number of various color theories (109, 119).

column A vertical architectural support, usually topped by a *capital* (392).

comparative process The basic critical tool of art history and criticism, in which works of art are compared and contrasted with one another in order to establish both continuities and similarities between various works or styles and significant differences or stylistic changes that have occurred historically (46).

complementary colors Pairs of colors, such as red and green, that are directly opposite each other on the *color wheel* (116).

composition The organization of the formal elements in a work of art (19).

conceptual art An art form in which the idea behind the work and the process of its making are more important than the final product (102, 489).

connotation The meaning associated or implied by an image, as distinguished from its *denotation* (223).

Constructivism A Russian art movement, fully established by 1921, that was dedicated to *nonobjective* means of communication (332).

Conté crayon A soft drawing tool made by adding clay to graphite (195).

content The meaning of an image, beyond its overt *subject matter* (6) as opposed to form (21).

contour The visible border of an object in space (50).

contrapposto The disposition of the human figure in which the hips and legs are turned in opposition to the shoulders and chest, creating a counterpositioning of the body (265).

convention A traditional, habitual, or widely accepted method of representation (24).

cool colors Those colors in which blue is dominant, including greens and violets (114).

cornice The upper part of the *entablature*, frequently decorated (392).

cross-hatching Two or more sets of roughly parallel and overlapping lines, set at an angle to one another, in order to create a sense of three-dimensional, *modeled* space (57). See also *hatching*.

Cubism A style of art pioneered by Pablo Picasso and Georges Braque in the first decade of the twentieth century, noted for the geometry of its forms, its fragmentation of the object, and its increasing abstraction (475).

cyberspace See *virtual reality*.

Dada An art movement that originated during World War I in a number of world capitals, including New York, Paris, Berlin, and Zurich, and that was so antagonistic to traditional styles and materials of art that it was considered by many to be "anti-art" (481).

daguerreotype One of the earliest forms of photography, invented by Louis Jacques Mandé Daguerre in 1839, made on a copper plate polished with silver (248).

delineation The descriptive representation of an object by means of *outline* or *contour* drawing (189).

denotation The direct or literal meaning of an image, as distinguished from its *connotations* (223).

De Stijl A Dutch art movement of the early twentieth century that emphasized abstraction and simplicity, reducing form to the rectangle and color to the *primaries*—red, blue, and yellow (330, 483).

dome A roof generally in the shape of a hemisphere or half-globe (368).

drypoint An *intaglio* printmaking process in which the copper or zinc *plate* is incised by a needle pulled back across the surface leaving a *burr*. The resulting *print* is also called a drypoint (210).

echinus The portion of the *capital* directly below the *abacus* (392).

edition In printmaking, the number of images authorized by the artist made from a single *plate* (202).

elevation The side of a building, or a drawing of the side of a building (392).

encaustic A method of painting with molten beeswax fused to the support after application by means of heat (225).

engraving An *intaglio* printmaking process in which a sharp tool called a *burin* is used to incise the *plate*. The resulting *print* is also called an engraving (207).

entablature The part of a building above the *capitals* of the *columns* and below the roof (392).

entasis The slight swelling in the middle of a *column* design to make the column appear straight to the eye (364).

environment A form of art that is large enough for the viewer to move around in (282).

etching An *intaglio* printmaking process in which a metal *plate* coated with wax is drawn upon with a sharp tool down to the plate and then placed in an acid bath. The acid eats the away at the plate where the lines have been drawn, the wax is removed, and then the plate is inked and printed. The resulting *print* is also called an etching (208).

Expressionism An art that stresses the psychological and emotional content of the work, associated particularly with German art in the early twentieth century (477). See also *Abstract Expressionism*.

expressive line A kind of line that seems to spring directly from the artist's emotions or feelings—loose, gestural, and energetic—epitomized by curvilinear forms (58, 61), as opposed to *classical line* (66).

Fauvism An art movement of the early twentieth century characterized by its use of bold *arbitrary color*. Its name derives from the French word "fauve," meaning "wild beast" (479).

figure-ground relationship In a two-dimensional work, the relationship between a form or figure and its background (73).

fixative A thin liquid film sprayed over *pastel* and charcoal drawings to protect them from smudging (190).

fluting The shallow vertical grooves or channels on a *column* (364).

flying buttress On a Gothic church, an exterior *arch* that opposes the lateral thrust of a vault or arch, arching inward toward the exterior wall from the top of an exterior *column* or pier (371, 421).

focal point In a work of art, the center of visual attention, often different from the physical center of the work (148).

foreshortening The use of *perspective* to represent the apparent visual contraction of an object or figure that extends backwards from the *picture plane* at an angle approaching the perpendicular (83).

form 1) The literal shape and mass of an object or figure. 2) More generally, the materials used to make a work of art, the ways in which these materials are utilized in terms of the formal elements (line, light, color, etc.), and the *composition* that results (19).

formline In the art of Northwest Coast Native Americans, an almost continuous line of varying width that lends substance and body to the figure at the same time that it *outlines* it (57).

freestanding sculpture As opposed to *relief,* sculpture that requires no wall support and that can be experienced in the round—that is, from all sides (265).

fresco secco See *fresco.*

fresco Painting on plaster, either dry (*fresco secco*) or wet (*buon* or *true fresco*). In the former, the paint is an independent layer, separate from the plaster proper; in the latter, the paint is chemically bound to the plaster, and is integral to the wall or support (225).

frieze The part of the *architrave* between the *entablature* and the *cornice,* often decorated (392).

Futurism An early twentieth-century art movement, characterized by its desire to celebrate the movement and speed of modern, industrial life (479).

genre painting Painting that emphasizes some aspect of everyday life (451).

gesso A plaster mixture used as a *ground* for painting (231).

glaze In oil painting, a thin, transparent, or semi-transparent layer put over a color usually in order to give it a more luminous quality (234).

Golden Section A system of *proportion* developed by the ancient Greeks obtained by dividing a line so that the shorter part is to the longer part as the longer part is to the whole, resulting in a ratio that is approximately 5 to 8 (161).

Gothic A style of architecture and art dominant in Europe from the twelfth to the fifteenth century, characterized, in its architecture, by *pointed arches,* ribbed *vaults, flying buttresses,* and a verticality symbolic of the ethereal and heavenly (419).

gouache A painting medium similar to *watercolor,* but opaque instead of transparent (242).

groined vault A masonry roof constructed on the *arch* principle and consisting of two *barrel vaults* intersecting at right angles to one another (367).

ground A coating applied to a canvas or other surface to prepare it for painting (208).

Happening A spontaneous, often multimedia event, conceived by artists and performed not only by the artists themselves but often by the public present at the event as well (288).

hatching An area of closely spaced parallel lines, employed in drawing and *engraving,* to create the effect of shading or *modeling* (183). See also *crosshatching.*

heightening The addition of *highlights* to a drawing by the application of white or some other pale color (183).

Hellenistic art The art of the third and second centuries B.C. in Greece characterized by its physical realism and emotional drama (395).

high (haut-) relief In sculpture, where the figures and objects remain attached to a background plane and project off of it by at least half their normal depth (267).

high contrast A maximum of contrast between light and dark (101).

highlight The spot or one of the spots of highest *key* or *value* in a picture (98).

hue A color, usually one of the six basic colors of the *spectrum*—the three *primary colors* of red, yellow, and blue, and the three *secondary colors* of green, orange, and violet (101, 109).

hyperspace See *virtual reality.*

hypostyle construction A building technique in which the roof is supported by a series of *columns* (416).

iconography The images and symbols *conventionally* associated with a given subject (24).

idealism As opposed to *realism,* the representation of things according to a preconceived ideal form or type.

impasto Pigment applied very thickly to canvas or support (129, 236).

implied line As opposed to *actual line,* a line created by movement or direction, such as the line established by a pointing finger, the direction of a glance, or a body moving through space (52).

impression In printmaking, a single example of an *edition* (202).

Impressionism A late nineteenth-century art movement, centered in France, and characterized by its use of discontinuous strokes of color meant to reproduce the effects of light (469).

intaglio Any form of printmaking in which the line is incised into the surface of the printing plate, including *aquatint, drypoint, etching, engraving,* and *mezzotint* (207).

intensity The relative purity of a color's *hue,* and a function of its relative brightness or dullness; also known as *saturation* (113).

intention What the artist means to convey in a work of art, as opposed, for instance, to the way the work is interpreted (41).

intermediate colors The range of colors on the *color wheel* between each primary color and its neighboring *secondary colors;* yellow-green, for example (109).

International Style A twentieth-century style of architecture and design marked by its almost austere geometric simplicity (338).

jamb The vertical side of a doorway; in church architecture, often embellished with sculpture (413).

Jugendstil The "style of youth" in turn-of-the-century German art and design, closely related to *Art Nouveau* (324).

ka In ancient Egypt, the immortal substance of the human, in some ways equivalent to the Western soul (385).

key The relative lightness or darkness of a picture or the colors employed in it (98), used in preference to *value* (104).

keystone The central and uppermost *voussoir* in an *arch* (367).

kinetic art Art that moves (52).

kitsch Sentimental, slick, and mass-produced art designed to appeal to the widest possible popular audience (129).

linear perspective A system for depicting *three-dimensional space* on a *two-dimensional* surface that depends upon two related principles: that things perceived as far away are smaller than things nearer the viewer, and that parallel lines receding into the distance converge at a *vanishing point* on the horizon line (76).

linocut A form of *relief* printmaking, similar to a *woodcut*, in which a block of linoleum is carved so as to leave the image to be printed raised above the surface of the block. The resulting *print* is also known as a *linocut* (205).

lithograph Any print resulting from the process of *lithography* (213).

lithography A printmaking process in which a polished stone, often limestone, is drawn upon with a greasy material; the surface is moistened and then inked; the ink adheres only to the greasy lines of the drawing; and the design is transferred to dampened paper, usually in a printing press (213).

local color As opposed to *optical* or *perceptual color*, the actual *hue* of a thing, independent of the ways in which different conditions of light and atmosphere might affect it (121).

lost-wax casting method A bronze-casting method in which a figure is molded in wax and covered with clay; the whole is then fired, melting away the wax and hardening the clay; the resulting hardened mold is then filled with molten metal (270).

low (bas-) relief In sculpture, where the figures and objects remain attached to a background plane and project off of it by less than one-half their normal depth (267).

low contrast A minimum of contrast between light and dark, so that the image is either predominantly dark or predominantly light (103).

Mannerism The style of art prevalent especially in Italy from about 1525 until the early years of the seventeenth century, characterized by its dramatic use of light, exaggerated *perspective*, distorted forms, and vivid colors (443).

mastaba Ancient Egyptian rectangular brick tomb with a sloping side and a flat top (386).

medium 1) Any material used to create a work of art (177). 2) In painting, a liquid added to the paint that makes it easier to manipulate (113).

metalpoint A drawing technique, also known as *silverpoint*, popular in the fifteenth and sixteenth centuries, in which a stylus with a point of gold, silver, or some other metal was applied to a sheet of paper treated with a mixture of powdered bones (or lead white) and gumwater (183).

mezzotint A *intaglio* printmaking process in which the plate is ground all over with a *rocker*, leaving a burr raised on the surface that if inked would be rich black. The surface is subsequently lightened to a greater or lesser degree by scraping away the burr. The resulting *print* is also known as a *mezzotint* (212).

mihrab A niche set in the wall of a mosque indicating the direction of Mecca (417).

minaret A tall, slender tower attached to a mosque from which the people are called to prayer (417).

Minimalism A style of art, predominantly American, that dates from the mid-twentieth century, characterized by its rejection of expressive content and its use of "minimal" formal means (489).

modeling In sculpture, the shaping of a form in some plastic material, such as clay or plaster (270); in drawing, painting, and printmaking, the rendering of a form, usually by means *hatching* or *chiaroscuro*, to create the illusion of a three-dimensional form (96).

modernism The various strategies and directions employed in the twentieth century—*Cubism, Futurism, Expressionism*, etc.—to explore the particular formal properties of any given *medium* (475).

monochromatic color scheme A color composition consisting of one basic hue and closely related variants of it (114).

mosaic An art form in which small pieces of tile, glass, or stone are fitted together and embedded in cement on surfaces such as walls and floors (407).

mudra The various hand positions of the Buddha (26).

narrative art A *temporal* form of art that tells a story (131).

naturalistic Synonymous with *representational*; descriptive of any work that resembles the natural world.

nave The central part of a church, running from the entrance to the *choir* (404).

negative space Empty space, surrounded and shaped so that it acquires a sense of volume or form (73).

Neoclassicism A style of the late eighteenth and early nineteenth centuries that was influenced by the Greek *Classical style* and that often employed Classical themes for its subject matter (457).

nonobjective art Art that makes no reference to the natural world and that explores the inherent expressive or aesthetic potential of the formal elements—line, shape, color—and the formal *compositional* principles of a given medium (19).

objective As opposed to *subjective*, free of personal feelings or emotion; hence, without bias (30).

oblique projection A system for projecting space, commonly found in Japanese art, in which the front of the object or building is parallel to the picture plane and the sides, receding at an angle, remain parallel to each other, rather than converging as in *linear perspective* (91).

oculus A round, central opening at the top of a *dome* (368).

one-point linear perspective A version of *linear perspective* in which there is only one *vanishing point* in the composition (76).

open palette See *palette*.

Optical Painting (Op Art) An art style particularly popular in the 1960s in which line and color are manipulated in ways that stimulate the eye into believing it perceives movement (134).

optical or perceptual color The color as perceived by the eye, changed by the effects of light and atmosphere, in the way, for instance, that distant mountains appear to be blue (122).

order In Classical architecture, a style characterized by the design of the *column* and its *entablature* (392).

original print A *print* created by the artist alone and that has been printed by the artist or under the artist' direct supervision (203).

outline The *contour* of a shape or figure depicted by an *actual line* drawn or painted on the surface (50).

palette Literally a thin board, with a thumb-hole at one end, upon which the artist lays out and mixes colors, but by extension, the range of colors used by the artist. In this last sense, a *closed* or *restricted palette* is one employing only a few colors and an *open palette* is one utilizing the full range of *hues* (113, 121).

pastel 1) A soft crayon made of chalk and pigment. Also any work done in this *medium* (193). 2) A pale, light color (193).

pencil A drawing tool made of graphite encased in a soft wood cylinder (195).

pendative A triangular section of a masonry hemisphere, four of which provide the transition from the vertical sides of a building to a covering dome (408).

penumbra The lightest of the three basic parts of a shadowed surface, providing the transition from the lighted area to the *umbra*, or core of the shadow (98).

perceptual line Any line that is perceived but not actually drawn, such as a horizon line (50).

performance art A form of art, popular especially since the late 1960s, that includes not only physical space but the human activity that goes on within it (289).

perspective A formula for projecting the illusion of *three-dimensional space* onto a *two-dimensional* surface (75). See also *linear perspective, one-point linear perspective, two-point linear perspective,* and *atmospheric perspective.*

photogenic drawing With the *daguerreotype*, one of the first two photographic processes, invented by William Henry Fox Talbot in 1839, in which a negative image is fixed to paper (248).

photorealistic art Art rendered with such a high degree of *representational* accuracy that it appears to be photographed rather than drawn or painted (17, 34).

picture plane The surface of a picture (49).

planographic printmaking process Any printmaking process in which the *print* is pulled from a flat, planar surface, chief among them *lithography* (213).

plein-air painting Painting done on site, in the open air (122).

pointed arch An *arch* that is not semicircular but rather rises more steeply to a point at its top (368).

polychromatic color scheme A color composition consisting of a variety of *hues* (121).

ponderation The principle of the weight shift, in which the relaxation of one leg serves to create a greater sense of naturalism in the figure (265).

Pop Art A style arising in the early 1960s characterized by its emphasis on the forms and imagery of mass culture (487).

post-and-lintel construction A system of building in which two posts support a crosspiece, or *lintel*, that spans the distance between them (361).

Post-Impressionism A name that describes the painting of a number of artists, working in widely different styles, in the last decades of the nineteenth century in France (473).

Postmodernism A term used to describe the willfully plural and eclectic art forms of contemporary art (172, 355, 493).

primary colors The hues that in theory cannot be created from a mixture of other hues and from

which all other hues are created—namely, in pigment, red, yellow, and blue, and in light, red-orange, green, and blue-violet (109).

print Any one of multiple *impressions* made from a master image (202).

proof A trial *impression* of a *print*, made before the final *edition* is run, so that it may be examined and, if necessary, corrected (203).

proportion In any composition, the relationship between the parts to each other and to the whole (160).

qibla wall The wall of a mosque that, from the interior, is oriented toward the direction of Mecca, and that contains the *mihrab* (417).

radial balance A circular composition in which the elements project outward from a central core at regular intervals like the spokes of a wheel (147).

realism As opposed to *idealism*, the representation of things with relative fidelity to their appearance in visible nature (222-223).

realistic art See *representational art*.

relief 1) In sculpture, where images and forms are attached to a background and project off it. See *low-relief* and *high-relief* (265). 2) In printmaking, any process in which any area of the plate not to be printed is carved away, leaving the original surface higher in order to be printed (203).

representational art Any work of art that seeks to resemble the world of natural appearance (17).

reserve An area of a work of art that retains the original color and texture of the untouched surface or *ground* (73).

rocker A sharp, curved tool utilized in the *mezzotint* printmaking process (212).

Rococo A style of art popular in the first seventy-five years of the eighteenth century, particularly in France, characterized by curvilinear forms, *pastel* colors, and its light, often frivolous subject matter (455).

Romanesque art The dominant style of art and architecture in Europe from the eighth to the twelfth centuries, characterized, in architecture, by Roman precedents, particularly the round *arch* and the *barrel vault* (413).

Romanticism A dramatic, emotional, and *subjective* art arising in the early nineteenth century in opposition to the austere discipline of *Neoclassicism* (459).

saturation See *intensity*.

scale The comparative size of a thing in relation to another like thing or its "normal" or "expected" size (157).

secondary colors A *hue* created by combining two *primary colors*; in pigment, the secondary colors are traditionally considered to be orange, green, and blue; in light, yellow, magenta, and cyan (109).

serigraphy Also known as screenprinting, a stencil printmaking process in which the image is transferred to paper by forcing ink through a mesh; areas not meant to be printed are blocked out (218).

sfumato From the Italian word for "smoke," a means of softening outlines in order to attain a hazy or soft quality in the image (190).

shade A color or *hue* modified by the addition of another color resulting in a hue of lower *key* or *value*, in the way, for instance, that the addition of black to red results in maroon (101).

silkscreen Also known as a serigraph, a print made by the process of *serigraphy* (218).

silverpoint See *metalpoint*.

simultaneous contrast A property of *complementary colors* when placed side by side, resulting in the fact that both appear brighter and more intense than when seen in isolation (116).

sinopie The *cartoon* or underpainting for a *fresco* (190).

spectrum The colored bands of visible light created when sunlight passes through a prism (109).

springing The lowest stone of an arch, resting on the supporting post (368).

still life A work of art that consists of an arrangement of inanimate objects, such as flowers, fruit, and household objects (49).

stippling In drawing and printmaking, a pattern of closely placed dots or small marks employed to create the effect of shading or *modeling* (207).

stupa A large mound-shaped Buddhist shrine (402).

style Any constant, recurring, or conventional manner of treatment or execution of works of art that is characteristic of a particular civilization, time period, artistic movement, or individual artist.

stylobate The base, or platform, upon which a *column* rests (392).

subject matter The literal, visible image in a work of art, as distinguished from its *content*, which includes the *connotative*, symbolic, and suggestive aspects of the image (6).

subjective As opposed to *objective*, full of personal emotions and feelings (30).

sublime That which impresses the mind with a sense of grandeur and power, inspiring a sense of awe (177).

subtractive 1) In color, the adjective used to describe the fact that, when different hues of colored pigment are combined, the resulting mixture is lower in key than the original hues and duller as well, and as more and more hues are added, the

resulting mixture is closer and closer to black (110). 2) In sculpture, an adjective used to describe the process in which form is discovered by the removal of materials, by such means as carving, as distinguished from *additive* sculptural processes, such as assemblage (253).

Super realism See *photorealistic art.*

Surrealism A style of art of the early twentieth century that emphasized dream imagery, chance operations, and rapid, thoughtless forms of notation that expressed, it was felt, the unconscious mind (30, 481).

symbol An image, sign, or element, such as a color, that is understood, by *convention* or context, to suggest some other meaning.

symmetry When two halves of a *composition* correspond to one another in terms of size, shape, and placement of forms (141).

tempera A painting *medium* made by combining water, pigment, and, usually, egg yolk (231).

temperature The relative warmth or coolness of a given *hue*, those in the yellow-orange-red range considered to be warm, and those in the green-blue-violet range considered cool (114).

temporal art Any form of art that possesses a clear beginning, middle, and end, or that takes place over time (131).

tesserae Small pieces of glass or stone used in making *mosaic* (407).

texture The actual tactile characteristics of a thing, or the visual simulation of such characteristics (126).

three-dimensional space Any space that possesses height, width, and depth (72).

tint A color or *hue* modified by the addition of another color resulting in a hue of higher *key* or *value*, in the way, for instance, that the addition of white to red results in pink (101).

transept The crossarm of a church that intersects, at right angles, with the *nave*, creating the shape of a cross (404).

trompe l'oeil A form of representation that attempts to depict the object as if it were actually present before the eye in *three-dimensional space*; literally "eye-fooling" (235).

trumeau The pillar in the center of a *Gothic* or *Romanesque* church door (413).

tusche A greasy material used for drawing on a *lithography* stone (217).

two-dimensional space Any space that is flat, possessing height and width, but no depth, such as a piece of drawing paper or a canvas (73).

two-point linear perspective A version of *linear perspective* in which there are two (or more) *vanishing points* in the *composition* (79).

tympanum The space between the *arch* and *lintel* over a door, often decorated with sculpture (413).

Ukiyo-e A style of Japanese art, meaning "the floating world," that depicted, especially, the pleasures of everyday life (77).

umbra The heart, or core, of a shadow (98).

value See *key.*

vanishing point In *linear perspective*, the point on the horizon line where parallel lines appear to converge (79).

vantage point In linear perspective, the point where the viewer is positioned (79).

verisimilitude In representation, the apparent "truth" or accuracy of the depiction (85).

video art An art form that employs television as its *medium* (296).

virtual reality An artificial three-dimensional *environment*, generated through the use of computers, that the viewer experiences as real space (137).

voussoir A wedge-shape block used in the construction of an *arch* (367).

watercolor A painting *medium* consisting of pigments suspended in a solution of water and gum arabic (238).

wet-plate collodion process A photographic process, developed around 1850, that allowed for short exposure times and quick development of the print (250).

wood engraving Actually a *relief* printmaking technique, in which fine lines are carved into the block resulting in print consisting of white lines on a black ground. The resultant *print* is also called a *wood engraving* (204).

woodcut A *relief* printmaking process, in which a wooden block is carved so that those parts not intended to print are cut away, leaving the design raised. The resultant *print* is also called a *woodcut* (203).

ziggurat A pyramidal structure, built in ancient Mesopotamia, consisting of three stages or levels, each stage stepped back from the one below (385).

Index

All references are to page numbers. **Boldface** numbers indicate an illustration.

Gauguin, Paul, 471–73; *Watched by the Spirit of the Dead (Manao Tupapau)*, **204**, 204

Geddes, Norman Bel, *Air Liner Number 4*, 344–45, **345**; *Horizons*, 345; *House of Tomorrow*, **345**, 345, 347; "Soda King," **346**, 347

Geese of Medum, **226**, 226

Geffroy, Gustave, on Manet, 21–23

Gehry, Frank, *Gehry House*, **139**, 139–40, 172–73

Gehry House (Gehry), **139**, 139–40, 172–73

Genesis, 9, 103, 104

Genre painting, 451

Gentileschi, Artemisia, *Judith and Maidservant with the Head of Holofernes*, 96–97, **97**; *Judith Decapitating Holofernes*, **448**, 448; *Self-Portrait as an Allegory of Painting*, 220–22, **221**

George Washington (Greenough), **71**, 71

German Pavilion (Mies van der Rohe), **339**, 339

Gertrude Stein (Picasso), **30**, 30, 473

Giant Trowel (Oldenberg), **157**, 157, 487

Gifford, Sanford, *October in the Catskills*, 114, **115**

Giorgione, *Sleeping Venus*, **438**, 438

Giorno, John, 295

Giotto, Florence Cathedral (Santa Maria del Fiore), campanile design, **422**, 422; *Lamentation*, **228**, 228, 425, 427; *Madonna and Child Enthroned*, 222–24, **223**, 425

Girl Running, 270, **271**

Giselle (Hofmann), 352, **353**

Gislebertus, *Last Judgement*, **414**, 414, 423

Giza, Egypt, Great Sphinx, **385**, 385

Glass House (Johnson), **354**, 354–55

Glass of Absinthe (Degas), **467**, 467

Glassware (ancient), 319

Glassware I, drawing for (Eddy), **195**, 195

Glazing, in painting, 234–35

Glorification of Saint Ignatius (Pozzo), 228, **229**, 447

God Bless America (Ringgold), 5–6

God (detail) (Perez), **11**, 11

God (van Eyck), **10**, 10–11

Goethe, Johann Wolfgang von, *Metamorphosis of Plants*, 337; theory of color, 103–4, 105, 106

Gogh, Vincent van, 129, 471–73, 479; *Les Alyscamps*, **123**, 123, 473; *Night Cafe*, **124**, 124; *Road to Tarascon*, **185**, 185, 189; *Starry Night*, **58**, 58–59, 474

Gohlke, Frank, *Housing Development South of Fort Worth, Texas*, **163**, 163

Goldin, Nan, *Brian with the Flintstones, New York City*, 256, **257**; *The Ballad of Sexual Dependency*, 256

Goll, Claire, 333–34

Goodman, Nelson, *The Languages of Art*, 4

Gorman, Pat, MTV logo and variations, **356**, 356

Gospel Book of Charlemagne, St. Matthew, **411**, 411

Gothic art, 368–69, 371, 419–25; early, 147; Suger on, 27–28

Goya, Francisco, *Disasters of War*, 461; *Saturn Devouring One of His Sons*, **459**, 459; *Third of May, 1808*, **462**, 462

Grainstack (Snow Effect) (Monet), **21**, 21, 23, 131, 469, 477, 487

Grand Odalisque (Ingres), **458**, 458, 459

Graves, Nancy, *Zeeg*, **143**, 143

Great Ball Court (Chichen Itzá), **440**, 440

Great Dragon (Maya), **440**, 440

Great Mosque at Samarra (Islam), **416**, 416

Great Sphinx (Giza), **385**, 385

Great Stupa (Sanchi, India), **402**, 402, 403

Great Train Robbery (Porter), **136**, 136

Great Wave Off Kanagawa (Hokusai), **159**, 159, 206

Greek art, 265–68, 364, 391–97

Greek orders, 392–93, 457

Greenough, Horatio, *George Washington*, **71**, 71

Green River (Colorado) (O'Sullivan), **252**, 252–53, 465

Green Stripe (Madame Matisse) (Matisse), **472**, 472

Greiman, April, moving announcement for Douglas W. Schmidt, **357**, 357

Gris, Juan, *Breakfast*, **166**, 167, 475, 481; *The Open Book*, **167**, 167, 475; *The Table*, 279–80, **280**, 481

Gropius, Walter, 334–35; Bauhaus (design for school), 334, **338**, 338

Grosman, Tatyana, 216–18

Grünewald, Matthias, *Crucifixion* (detail from *Isenheim Alterpiece*), **37**, 37–38

Guild of Handicraft, 313

Guimard, Hector, entrance to Paris métro, 320, **321**

Gutenberg Bible, 202

Habitat (Safdie), **372**, 372, 374

Hagia Sophia, Istanbul, Anthemius of Tralles and Isidorus of Milletus, **408**, 408, 409

Haida, appliqued shirt, **57**, 57

Hall of Bulls (Lascaux), **380**, 380

Hammons, David, *Spade with Chains*, **273**, 273

Hampstead Heath (Constable), **461**, 461

Han dynasty, *Flying Horse Poised on One Leg on a Swallow*, **403**, 403

Happenings, 288–29

Harmony in Red (Matisse), **90**, 90

Harper's Magazine, 154

Harushige, Suzuki, *Beauty on the Balcony*, **77**, 77

Harvest of Death, Gettysburg, Pa. (O'Sullivan), **251**, 251, 465

Hassam, Childe, *Allies Day, May 1917*, **2**, 3, 5

Hatching, 183, 207

Havemeyer, Mrs. H. O., 194

Haystack at Sunset near Giverny (Monet), **122**, 122, 131–33, 469, 477, 487

Heart of the Andes (Church), **460**, 460, 463

Heightening, 183

Helmet mask (Baule, Ivory Coast), **22**, 22

Hepworth, Barbara, *Two Figures*, **74**, 74

Herm (Element Series) (Andre), **487**, 487

Herodotus, 393

Hershman, Lynn, *Lorna*, **298**, 298

Herskovits , M. J., "Art and Value," 9

Hesse, Eva, *Contingent*, **275**, 275–76

Higgins, Dick, *Winter Carol*, 292

Hindu art, 418–19; *Shiva as Nataraja, Lord of the Dance*, **419**, 419; Kandariya Mahadeva Temple, **418**, 418; wall relief in, **418**, 418; Minakshi temple (Madurai, India), **370**, 370, 418

Hinged clasp (Sutton Hoo), **410**, 410

Hippocrates, 265, 393

Hiroshige, Ando, *Naito Shinjuku, Yotsuya*, **77**, 77

Hitler, Adolf, 337

Hoare, Henry, Park at Stourhead, **374**, 374–75

Hockney, David, *Untitled*, **201**, 201

Hoffman, Josef, Palais Stoclet, 324, **325**